ROLLING STONE ®

A ROLLING STONE PRESS BOOK
EDITOR *Corey Seymour*
EXECUTIVE EDITOR *Nina Pearlman*
EDITORIAL CONTRIBUTORS *Brian Hiatt, David Swanson*
EDITORIAL INTERN *William Goodman*

ART DIRECTOR *Amid Capeci*
DESIGNER *Andrew Horton*
DESIGN ASSOCIATE *Christine Bower*

PRODUCTION MANAGER *KellyAnn S. Kwiatek*
PHOTOGRAPHER *Robert Buckley*

ABRAMS, NEW YORK
EDITOR *Andrea Danese*
DESIGNER *Robert McKee*
PRODUCTION MANAGER *Jane Searle*

Library of Congress Cataloging-in-Publication Data

Rolling stone : 1,000 covers : a history of the most influential magazine in pop culture
/ introduction by Jann S. Wenner.
 p. cm.
 Rev. and updated ed. of: Rolling stone, the complete covers, 1967–1997. 1997.
 ISBN 13: 978-0-8109-5865-4 ISBN 10: 0-8109-5865-1
 1. Rolling stone (San Francisco, Calif.) 2. Magazine covers—California—
San Francisco.

 NC974.4.R66R67 2006
 741.6'520973—dc22
 2006010798

FRONT COVER: *Cover courtesy of Rolling Stone LLC*
PHOTOGRAPH BY *Annie Leibovitz*
BACK COVER: *Cover courtesy of Rolling Stone LLC*
PHOTOGRAPH BY *Platon*

ON THE BELLYBAND: *Front: Covers courtesy of Rolling Stone LLC.*
Photographs, from left to right: John Zimmerman, Annie Leibovitz, Mark Seliger,
David LaChapelle and Albert Watson. Back: Covers courtesy of Rolling Stone LLC.
Photographs, clockwise from top left: Annie Leibovitz, Annie Leibovitz, Patrick
Demarchelier, Annie Leibovitz, Danny Clinch, David LaChapelle,
Matthew Rolston, Herb Ritts, Mark Seliger and Herb Ritts.

PRINTED AND BOUND IN SINGAPORE
10 9 8 7 6 5 4 3

HNA ■ ■ ■ ■ ■
harry n. abrams, inc.
a subsidiary of La Martinière Groupe

115 West 18th Street
New York, NY 10011
www.hnabooks.com

Rolling Stone

1,000 COVERS

A HISTORY OF THE MOST INFLUENTIAL MAGAZINE IN POP CULTURE

INTRODUCTION BY
Jann S. Wenner

ABRAMS, NEW YORK

ROLLING STONE

November 9, 1967
VOL. I, NO. 1

OUR PRICE:
TWENTY-FIVE CENTS

MFP

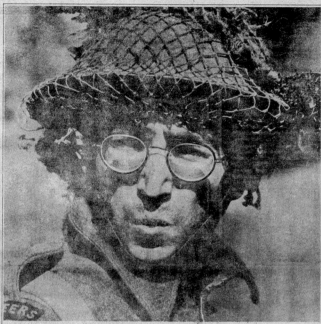

Recognize Private Gripweed? He's actually John Lennon in Richard Lester's new film, How I Won the War. An illustrated special preview of the movie begins on page 16.

Tom Rounds Quits KFRC

Tom Rounds, KFRC Program Director, has resigned. No immediate date has been set for his departure from the station. Rounds quit to assume the direction of Charlatan Productions, an L.A. based film company experimenting in the contemporary pop film.

Rounds spent seven years as Program Director of KPOI in Hawaii before coming to San Francisco in 1966. He successfully effected the tight format which made KFRC the number one station in San Francisco.

Les Turpin, former program director of KGB in San Diego will replace Tom Rounds at KFRC. Turpin has spent the last year as a consultant in the Drake-Chenault programming service.

The new appointment could mean a tightening up of programming policies. Rounds liberalization of KFRC's play-list may well become more restricted.

THE HIGH COST OF MUSIC AND LOVE: WHERE'S THE MONEY FROM MONTEREY?

BY MICHAEL LYDON

A weekend of "music, love, and flowers" can be done for a song (plus cost) or can be done at a cost (plus songs). The Monterey International Pop Festival, a non-profit, charity event, was, despite its own protestations, of the second sort: a damn extravagant three days.

The Festival's net profit at the end of August, the last date of accounting, was $211,451. The costs of the weekend were $290,233. Had it not been for the profit from the sale of television rights to ABC-TV of $288,843, the whole operation would have ended up a neat $77,392 in the red.

The Festival planned to have all the artists, while in Monterey, submit ideas for use of the proceeds.

In the confusion the plan miscarried and the decision on where the profits should go has still not been finally made.

So far only $50,000 has definitely been been allocated to anyone: to a unit of the New York City Youth Board which will set up classes for many ghetto children to learn music on guitars donated by Fender. Paul Simon, a Festival governor, will personally over see the program.

Plans to give more money to the Negro College Fund for college scholarships is now being discussed; another idea is a sum between ten and twenty thousand for the Monterey Symphony.

However worthy these plans, they are considerably less daring and innovative than the projects mentioned in the spring: the Diggers, pop conferences, and any project which would "tend to further national interest in and knowledge and enjoyment of popular music." The present plans suggest that the Board of Governors, unable or unwilling to make their grandiose schemes reality, fell back on traditional charity.

The Board of Governors did decide that the money would be given out in a small number of large sums. This has meant, for instance, that the John Edwards Memorial Foundation, a folk music archive at the University of California at Los Angeles, had its small request overlooked.

In ironic fact, what happened at the Festival and its financial affairs looks in many ways like the traditional Charity Ball in hippie drag.

The overhead was high and the net was low. "For every dollar spent, there was a reason," says Derek Taylor, the Festival's PR man and one of its original officers.

Yet many of the Festival's expenses, however reasonable to Taylor, seem out of keeping with its announced spirit. The Festival management, with amateurish good will, lavished generosity on their friends.

• Producer Lou Adler was able to find a spot in the show for his own property, Johnny Rivers; Paul Simon for his friend, English folk singer Beverly; John Phillips for the Group Without A Name and Scott MacKenzie. None of them had the musical

Airplane high, but no new LP release

Jefferson Airplane has been taking more than a month to record their new album for RCA Victor. In a recording period of five weeks only five sides have been completed. No definite release date has been set.

Their usual recording schedule in Los Angeles begins at 11:00 p.m. in the evening and extends through six or seven in the morning. When they're not in the studios, they stay at a fabulous pink mansion which rents for $5,000 a month. The Beatles stayed at the house on their last American tour.

The house has two swimming pools and a variety of recreational facilities. It's a small small little paradise in the hills above Hollywood. Maybe suntans and guitars don't make it together.

status for an international pop music festival.

It is ironic that the Rivers and the rest appeared "free," but the money it cost the Festival to get them to Monterey and back, feed them, put them up (Beverly

—Continued on Page 7

1960s

1967

This book, the complete collection of ROLLING STONE's covers from 1967 to the present, represents not just the evolution of a magazine but a record of our times. For almost four decades, no surer sign has heralded the arrival of a performer, artist or personality than an appearance on the cover of ROLLING STONE. Virtually every important rock musician and movie star has appeared on one of the nearly one thousand covers reproduced here, along with the politicians, comedians, cartoon characters, filmmakers, pop singers and TV actors who have helped to shape our era.

Many of them have gladly turned up time and again: Mick Jagger, who has been on the cover twenty-seven times – sometimes alone, sometimes with the band or Keith – claims the all-time record. The shrewdest among our cover subjects collaborated with us in the creation and refinement of their public images. Many of those powerful pictures have since grown to define an era. When I started ROLLING STONE in November 1967, the magazine's initial charter was to cover rock & roll music with intelligence and respect. Even then, we knew the fervor sweeping our generation encompassed more than just music. And so we gradually broadened the charter to include everything the music touched, embraced or informed: politics, movies, television, video games, the Internet, sports, crime, comic books, gurus, groupies, hippies, Jesus freaks, narcs, pimps, drugs and all the other forms of American social behavior, pathological, heroic and otherwise.

These events and personalities were captured for the cover of ROLLING STONE by some of the finest photographers of our time. A partial list would include Annie Leibovitz, Mark Seliger, Richard Avedon, Anton Corbijn, Albert Watson, Herb Ritts, David LaChapelle, Martin Schoeller, Hiro, Platon, Francesco Scavullo, Matt Mahurin and Matthew Rolston. In addition, a great roster of illustrators and cartoonists have conjured and invented for the cover: Matt Groening, Mike Judge, Garry Trudeau, Trey Parker and Matt Stone, Ralph Steadman, Maurice Sendak, Paul Davis, Milton Glaser, Robert Grossman, Gottfried Helnwein, Daniel Maffia, Andy Warhol and Anita Kunz, among others.

Many of these covers have been controversial, even shocking, so

RS 1 | JOHN LENNON | November 9th, 1967 | 'HOW I WON THE WAR' FILM STILL

[RS 1] Under the art direction of John Williams, ROLLING STONE makes its debut as an 11-by-17-inch magazine, printed on newsprint and folded in half. The cover/first page is black and white with a publicity photograph of John Lennon from the film *How I Won the War*.

here now is fair warning to those who are offended by flesh: Plenty of skin has been artfully arranged and displayed beneath our famous logo. ROLLING STONE pioneered the trend of nude "star" covers with John Lennon and Yoko Ono's full-body shots in November 1968. At the time, nudity was a political statement, health clubs were for the weird and obsessed, and I had yet to fully appreciate readers' insatiable curiosity about the naked bodies of their heroes and heroines.

John and Yoko's self-portraits were taken in their London flat for the front and back covers of their album *Two Virgins* – which their label's distributor had issued wrapped in brown paper, despite John's status as the leader of the Beatles. At the suggestion of ROLLING STONE's cofounder, writer Ralph J. Gleason, I telexed our friend Derek Taylor, the Beatles' publicist and soul mate, in London with an offer to print said pictures in our magazine. The photo wound up on the cover of our first anniversary issue (*RS 22*) – our first sellout issue, and the first time we went back to press. Although it may seem tame from today's perspective, the idea of someone so famous and so physically average standing stark naked for all the world to see was quite extraordinary – shocking, to be sure, but above all revolutionary and moving.

Magazine-making is a collaborative art, and over the years I have worked with the most dedicated and talented people in publishing, including editors whose duties included writing the lines of cover text that tease the newsstand browser into a purchase. "Dial Om for Murder," for an account of criminal behavior in a religious sect, "He's Hot, He's Sexy and He's Dead," for a story on Jim Morrison's posthumous

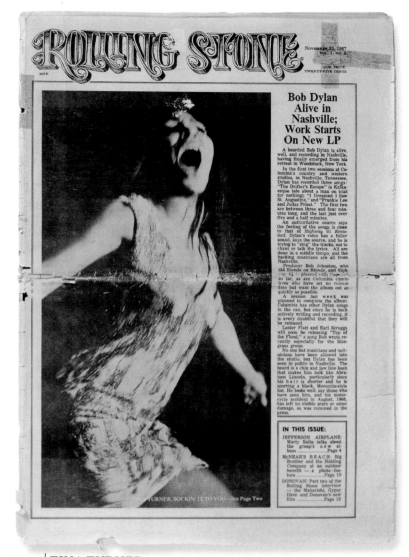

RS 2 | TINA TURNER | November 23rd, 1967 | PHOTOGRAPH BY BARON WOLMAN

"IT WAS RAUNCHY TINA, LEGS OPEN, HER RED lips, her long hair. Wild! They thought I was just another of those raunchy singers 'cause no one knew the other side. Only people very close to me knew. I've always been very spiritual but my image – in terms of my work – was very far from that."

—*Tina Turner*

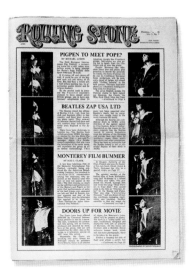

[RS 3] The ROLLING STONE logo gets color. Further production changes of the magazine continue to affect the cover; on RS 8, for instance, an extra quarter-fold alters the cover's size, decreasing it to 8 1/2 inches by 11 inches, and a bit more color is used.

success and "Naked Lunch Box," for Annie Leibovitz's provocative undressed shots of teen idol David Cassidy, are among my favorites.

* * * * *

WHEN THE MAGAZINE STARTED IN 1967, I didn't understand the importance of a cover and all the things it could do. It not only defines a magazine's identity, but greatly determines sales and also confers a special status to the cover subject. There were some odd choices in the early years, but on the whole they were adventurous, and often powerful – we simply weren't driven by newsstand considerations in the first ten years.

The cover of *RS 1* – November 9th, 1967 – was a wonderful, revealing accident. The photograph of John Lennon was a publicity still from a mostly forgotten film by Richard Lester called *How I Won the War*. (The ROLLING STONE logo was an unfinished draft of a design by San Francisco psychedelic-poster artist Rick Griffin, who was planning to refine it until I used his sketch in order to get it to the printer on time.) In hindsight, it was prescient of us to feature John Lennon on the first cover. That one image speaks volumes about the marriage of music and movies and politics that came to define ROLLING STONE.

In the early Sixties, there was no tradition of rock photography. In London some good photographers – David Bailey, Snowden and Sir Cecil Beaton among them – had shot the Stones, the Beatles and a few other bands. In San Francisco, New York and Los Angeles, however, that hadn't happened yet. Photographs of rock

RS 3 | THE BEATLES' 'MAGICAL MYSTERY TOUR'
December 14th, 1967
PHOTOGRAPHER UNKNOWN

RS 5 | JIM MORRISON
February 10th, 1968
PHOTOGRAPHS BY BARON WOLMAN

RS 4 | DONOVAN, JIMI HENDRIX, OTIS REDDING
January 20th, 1968
VARIOUS PHOTOGRAPHERS

RS 6 | JANIS JOPLIN, GATHERING OF THE TRIBES BE-IN
February 24th, 1968
PHOTOGRAPHS BY BARON WOLMAN

> "I started playing the camera [shooting at concerts]. I could almost anticipate the licks. It sounds really hokey, but I got fabulous photos, one after another, because I was really in tune with what [Jimi] was doing."
>
> —*Baron Wolman*

stars were generally publicity stills or shots from the stage, with a microphone obscuring much of the performer's face. I decided we should do better than that and took on a friend and professional, Baron Wolman, as our first staff photographer. Bringing Baron into the mix, along with the feisty Jim Marshall, a San Franciscoan who had been avidly shooting the jazz and folk scene, and a few other West Coast photographers who were just beginning to do good work, distinguished us quickly. They didn't create a particular look or impose a particular style on the bands as much as produce clean, crisp photography, well-composed and artfully lit. Perhaps most valuably, they lived the life, knew the bands and understood what they wanted to say.

Our first full-time art director was Robert Kingsbury, a wood sculptor and teacher who had never worked for a publication. Bob turned out to be brilliant at sifting through all the black-and-white stills we were accumulating to find a striking image. It was still a few years before we were shooting photographs specifically for covers, and Bob did wonders with what we had on hand.

Those covers were done on the fly, and yet many of them stand up. The blue solarized cover of Eric Clapton (*RS 10*) was taken by Linda Eastman, later to become Linda McCartney – the first woman to shoot a ROLLING STONE cover. Linda went on to take many memorable early photographs, including some of Jimi Hendrix and Janis Joplin.

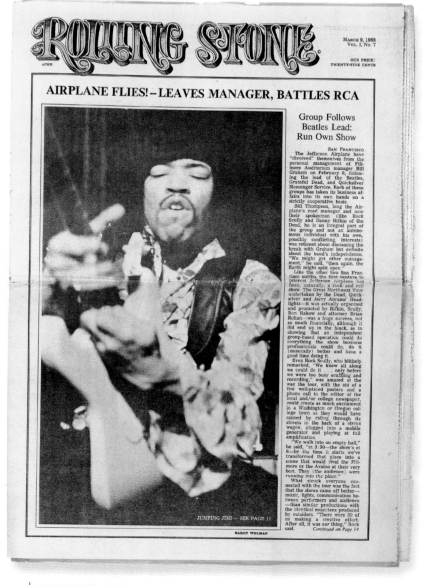

ROLLING STONE

MARCH 9, 1968
VOL. I, No. 7

OUR PRICE:
TWENTY-FIVE CENTS

AIRPLANE FLIES! – LEAVES MANAGER, BATTLES RCA

Group Follows Beatles Lead: Run Own Show

SAN FRANCISCO
The Jefferson Airplane have "divorced" themselves from the personal management of Fillmore Auditorium manager Bill Graham on February 6, following the lead of the Beatles, Grateful Dead, and Quicksilver Messenger Service. Each of these groups has taken its business affairs into its own hands on a strictly cooperative basis.

Bill Thompson, long the Airplane's road manager and now their spokesman (like Rock Scully and Danny Rifkin of the Dead, he is an integral part of the group and not an autonomous individual with his own, possibly conflicting, interests) was reticent about discussing the break with Graham but definite about the band's independence. "We might get other management," he said, "then again, the Earth might split open."

Like the other two San Francisco outfits, the first venture to interest Jefferson Airplane has been, naturally, a rock and roll show. The Great Northwest Tour undertaken by the Dead, Quicksilver and Jerry Abrams' Headlights—it was actually organized and promoted by Rifkin, Scully, Ron Rakow and attorney Brian Rohan—was a huge success, not so much financially, although it did end up in the black, as in showing that an independent group-based operation could do everything the show business professionals could do, do it (musically) better and have a good time doing it.

Even Rock Scully, who blithely remarked, "We knew all along we could do it . . . only before we were too busy scuffling and recording," was amazed at the way the tour, with the aid of a few well-placed posters and a phone call to the editor of the local and/or college newspaper, could create as much excitement in a Washington or Oregon college town as they would have caused by riding through its streets in the back of a circus wagon, plugged into a mobile generator and playing at full amplification.

"We walk into an empty hall," he said, "at 3:30—the show's at 8—by the time it starts we've transformed that place into a scene that would rival the Fillmore or the Avalon at their very best. They (the audience) were *running into the place.*"

What struck everyone connected with the tour was the fact that the shows came off better—music, lights, communication between performers and audience—than similar productions with the identical musicians produced by outsiders. "There were 30 of us making a creative effort. After all, it was our thing," Rock said.

Continued on Page 14

JUMPING JIMI -- SEE PAGE 11

BARON WOLMAN

RS 7 | JIMI HENDRIX | March 9th, 1968 | PHOTOGRAPH BY BARON WOLMAN

* * * * *

ANOTHER OF OUR EARLY LESSONS in publishing was that death sells. When Janis Joplin and Jimi Hendrix died within weeks of each other, our staff placed simple, classic portraits on the cover, with type stating just the artist's name and dates of birth and death. There was nothing more to say. That began a form of tribute that we've followed ever since. When somebody in the magazine's purview dies, the cover is created with dignity and respect,

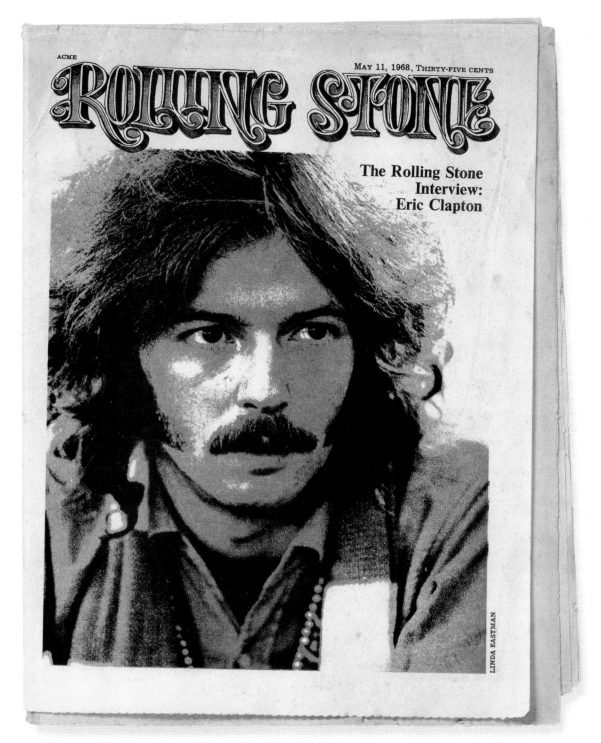

The Rolling Stone
Interview:
Eric Clapton

ACME

MAY 11, 1968, THIRTY-FIVE CENTS

LINDA EASTMAN

RS 10 | ERIC CLAPTON | May 11th, 1968 | Photograph by Linda Eastman

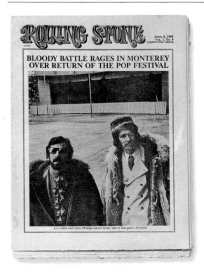

RS 8 | MONTEREY POP FESTIVAL
April 6th, 1968
PHOTOGRAPHER UNKNOWN

RS 9 | JOHN LENNON & PAUL McCARTNEY
April 27th, 1968
ILLUSTRATION BY HEINZ EDELMANN

RS 11 | ROCK FASHION
May 25th, 1968
PHOTOGRAPH BY BARON WOLMAN

and the coverage inside is exhaustive, sometimes highly personal and in many cases brilliant.

In 1970, a twenty-year-old art student named Annie Leibovitz brought her portfolio to us. "She had just returned from a year in Israel," Bob Kingsbury remembers, "and I liked one of her pictures from the trip. I thought she showed a lot

[RS 8] ROLLING STONE's first-ever news cover featured the Monterey Pop Festival and its organizers, producer Lou Adler and John Phillips of the Mamas and the Papas.

[RS 11] The first concept cover: "Rock Fashion." According to photographer Baron Wolman, art director John Williams didn't care for his proposed cover portraits of B.B. King and Johnny Cash, but loved a photo Wolman had taken of his wife, Julianna. Since there was a fashion story and Ms. Wolman looked very stylish, she became the cover.

of potential, and she was just a kid. We hired her." While still attending the San Francisco Art Institute, Annie became the magazine's second staff photographer. Later that year, she flew with me to New York for her first major assignment, a commissioned cover portrait of John Lennon to accompany my historic interview "Lennon Remembers."

What turned out to be the cover shot was taken during a light-meter reading. John, who was "thinking nothing," as he later recalled, looked right through the lens at Annie. For her (and for the magazine), this was a defining moment, what she has called her "first encounter" with a subject. It's John's humanity that comes through in the shot. It was not the one she had wanted as our cover, but to me this photo was so simple and so stark, it was a natural choice. The directness of the eye contact, the simplicity and the truth in it all presage the best of Annie's work. I still have the framed picture near

my desk. I've carried it around with me from office to office since 1971.

Annie considered herself a photojournalist at the time, working with a thirty-five-millimeter camera and, for the most part, natural lighting, which was the foundation for most of her later work. Over the next three or four years, her work began to mature, and the ROLLING STONE covers became portraits. And so for a while the covers are portrait after portrait; not all of them are Annie's, but they're all in the mold we began to establish with the John Lennon cover.

* * * * *

IN FEBRUARY 1973, WE CHANGED printers and began regularly publishing four-color covers. After years of black-and-white or two-color covers, the new format opened up endless possibilities and challenges. A few months later we went from a quarter-fold to a tabloid format, increasing the size of our covers from 8 ½ inches by 11 inches to

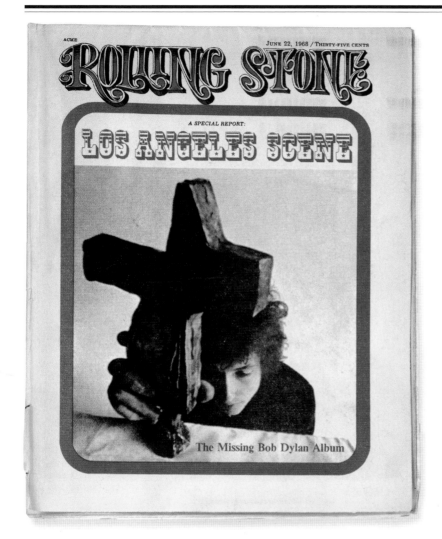

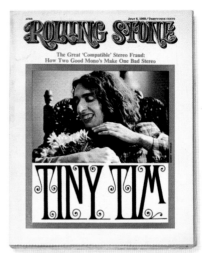

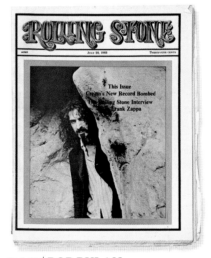

10 $\frac{1}{2}$ inches by 15 inches. I brought in Michael Salisbury, the very imaginative and brash art director of the Sunday rotogravure magazine of the *Los Angeles Times*. He was our first professional art director – with a live-wire personality and his own historical references as the one-time art director of *Surfer* magazine.

Michael brought us into the world of illustration and "concept covers," and we started getting a little crazier. Michael's first cover was an illustration for an interview I'd done with Daniel Ellsberg, of "Pentagon Papers" fame (*RS 147*). Michael showed it to me at the last minute (which would become a habit of his), so there was no chance of changing it. But it was perfect: a heroic profile of Ellsberg – as if on a coin or a sculpture – accompanied by a cover line we took from the Declaration of Independence: "Let facts be submitted to a candid world." The image illustrated the point exactly.

"ROLLING STONE's identity was in not only how it read, but also how

RS 12 | BOB DYLAN
June 22nd, 1968
PHOTOGRAPHER UNKNOWN

RS 13 | TINY TIM
July 6th, 1968
PHOTOGRAPH BY BARON WOLMAN

RS 14 | FRANK ZAPPA
July 20th, 1968
PHOTOGRAPH BY BARON WOLMAN

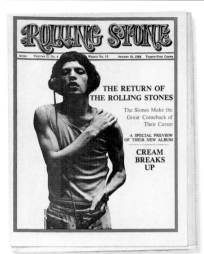

RS 15 | MICK JAGGER
August 10th, 1968
PHOTOGRAPH BY DEAN GOODHILL

RS 16 | THE BAND
August 24th, 1968
PHOTOGRAPH BY ELLIOTT LANDY

it looked," Michael says. "And that was defined by the photography. The typography and the newspaper format gave a young publication legitimacy and credibility, but the pictures added personality and depth."

Our illustrated covers were often as whimsical as they were memorable: Witness Robert Grossman's visions of a blimp-like Jerry Garcia (*RS 148*) and the members of the Who tangled in microphone cords (*RS 275*). "Artwork can be more iconic than photos," says Grossman, who calls ROLLING STONE "a friend to illustrators." Doonesbury creator Garry Trudeau has drawn four covers for the magazine so far, beginning with an image of his Uncle Duke character, whom he had based on Hunter S. Thompson (*RS 194*). "That cover was my hip moment – which meant I had to pretend it was no big deal," Trudeau says. "But of

course it was. I may have hung it in my closet, but it was framed. Nicely." Sought-after illustrator Daniel Maffia took an alternate, more photorealistic approach, creating evocative watercolor images of Jackson Browne (*RS 228*) and Pete Townshend (*RS 252*). "I wasn't into music, but I respected the magazine very much," says Maffia. "It gave me a lot of creative freedom."

[RS 16] The magazine's first full-time art director, sculptor Robert Kingsbury, designs his inaugural issue.

In September 1974, Tony Lane became the magazine's third full-time art director. Tony, who came from *Holiday* and *Harper's Bazaar*, had a distinct vision and style, and he wanted badly to work with Annie. Tony proceeded to take the cover to a

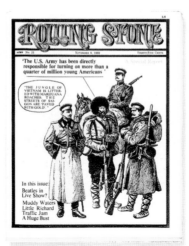

sparer, poster-type look. Annie was still learning, soaking up everything, honing her craft and doing a great number of covers along the way.

The next year, Annie came with me to lunch at the studio of Richard Avedon. I had begun discussions with him about photographic coverage of the 1976 presidential elections and thought it would be fun for Annie to meet Dick, and to ex-

plore new ideas and new directions for the magazine.

That day we planned the heroic black-and-white cover photograph of Mick and Keith that appeared on our July 17th, 1975, issue (*RS 191*). I was trying to get Annie to imitate Avedon's more formal style of working, and suggested she make it very simple and shoot the two Stones as partners. It worked brilliantly and is

still one of my favorites.

Annie busted loose with marvelous covers: Bob Marley in the throes of ecstasy (*RS 219*), Paul Simon in his window overlooking Central Park (*RS 216*). One of the most memorable to me is the portrait of Beach Boys founder Brian Wilson, reemerged after years of exile inside his bedroom (*RS 225*). Annie shot a black-and-white pho-

to of Brian as surf patriarch in his bathrobe, holding a board. We had it hand-colored in the style of an old pastel postcard.

Another of my favorites is the Fleetwood Mac cover (*R*S 235). Annie posed them on an unmade bed, which brilliantly solved the perennial graphic problem of getting multiple group members in the frame in a new and interesting way. And I loved Annie's lush image of Bette Midler on a bed of roses (*R*S 306): What a beauty.

Annie's attitude was, "Give me a great idea – who cares where it comes from?" Our collaboration was nearly always a happy one. We

subjects was tighter, smaller and, for the most part, devoid of the public-relations mavens who attend to celebrities now. Those we didn't know personally, we certainly knew by reputation. And they knew us.

In 1977, we moved our entire operation from the San Francisco warehouse district to New York's Fifth Avenue. Within five days of our arrival, somebody walked into my new office and said, "Elvis is dead." We postponed the planned special issue celebrating our move and found a great picture of a smiling Elvis in his prime – an obscure old poster none of us had ever seen.

In April 1976, Roger Black, who

Portrait Gallery in Washington, D.C., outside the columned building two large images were suspended from the arches: Gilbert Charles Stuart's George Washington and Annie's cover portrait of Patti Smith before a wall of flames (*R*S 270).

In 1980, Mick Jagger and I were having a late-night discussion about ROLLING STONE. Mick is a very serious reader; he understands how the magazine works. He didn't really like the new logo because, he said, we had taken out much of the character, the funkiness. So we put back the curlicue at the end of the *E*, made the loop on the bottom of the *G*, restored ligatures and swashes and brought the "roll" back in to the *R*. Thanks Mick, you were right.

We planned to unveil the "new" logo – the Jagger revision – simultaneously with another paper-quality upgrade and a different trim size. Our first issue of 1981 was to feature a new Annie photograph of John and Yoko timed with the completion of their upcoming album, *Double Fantasy*.

"*I hadn't posed nude for* pictures before. We were just being honest – that was its strength." —*Yoko Ono*

were working together constantly, thinking up things to do with the cover, and our work was *us*.

In 1976, ROLLING STONE published "The Family," a special issue of Avedon's portraits (*R*S 224), for which we won the magazine industry's highest honor, a National Magazine Award. Dick wanted to shoot the entire political and economic power structure of the United States. It was a months-long adventure, with Dick traveling around the country shooting presidents, corporate bosses, labor leaders and family matriarch Rose Kennedy: the real American establishment. It was an instant classic. I don't think any magazine had ever before done anything like it. This marked the start of Avedon's relationship with ROLLING STONE. In a few years, we had him collaborating with the likes of Prince and Eddie Murphy.

We had the access. The world inhabited by ROLLING STONE and its

was a typographer by training, took over as art director. Suddenly, type became very important. The Roman numeral *X* was Roger's idea for our Tenth Anniversary cover, which also marked the end of our funky, hand-drawn logo and the initiation of a new, bolder logo typeface. We took it from all caps to upper- and lowercase characters and eliminated the swashes and ligatures between some of the letters. (Jim Parkinson, who did the new version, became our in-house type designer.) It was the beginning of another phase, and in my Editor's Note I wrote that the new logo "symbolizes as much as anything what we are up to: respectful of our origins, considerate of new ideas and open to the times to come."

Annie's covers at this time were, as always, brilliant: The Blues Brothers painted blue (*R*S 285) seemed so clichéd but turned out to be timeless. Years later, when Annie's work was hung at the National

At this session, on December 8th, 1980, they greeted Annie like an old friend, and the pictures show three people working with commitment. From a Polaroid test shot, John and Yoko chose the image they wanted for the cover. That night John was assassinated outside his home. The haunting, spectral image of John, naked and curled around Yoko in the fetal position – along with the photos inside – were the last portraits taken of him. In the wake of his death, there was no need for a headline, and for the first time in the magazine's history, we ran a cover without one. If I had to choose, I guess this is the best cover we've ever done.

In 1983, after ten years as chief photographer and 142 covers, Annie left the magazine. Her legacy and remarkable body of work con-

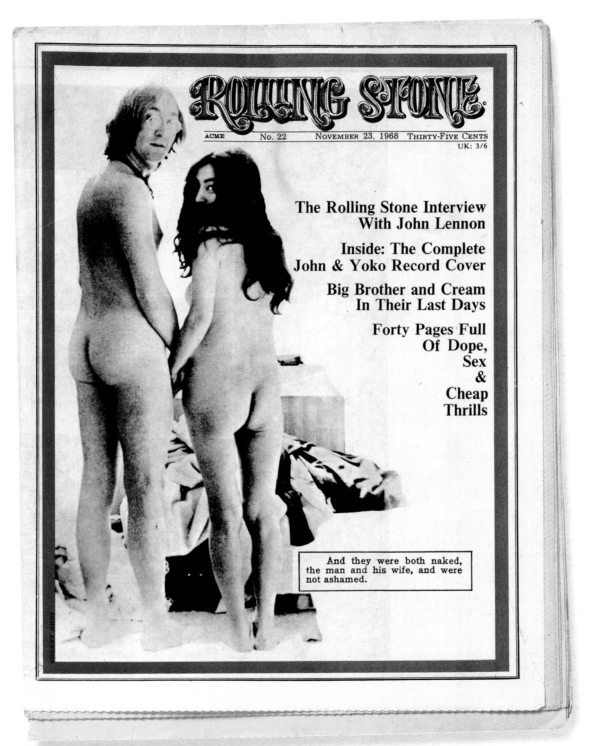

ROLLING STONE

ACME No. 22 NOVEMBER 23, 1968 THIRTY-FIVE CENTS
UK: 3/6

The Rolling Stone Interview
With John Lennon

Inside: The Complete
John & Yoko Record Cover

Big Brother and Cream
In Their Last Days

Forty Pages Full
Of Dope,
Sex
&
Cheap
Thrills

And they were both naked,
the man and his wife, and were
not ashamed.

RS 22 | JOHN LENNON & YOKO ONO | November 23rd, 1968 | PHOTOGRAPH BY JOHN LENNON

tinue to influence the art of photography and the lives of young photographers, and she is one of the handful of people who can be said to have been a principal in creating what ROLLING STONE became.

We could not replace Annie, so we took the opportunity to use a wide array of photographers. Avedon shot covers, as did Albert Watson, David Bailey, Hiro, Bonnie Schiffman, Steven Meisel and Matthew Rolston.

Herb Ritts, a master of celebrity portraiture, captured the look of the Eighties in his best work. For a good stretch he became our most-featured cover photographer, contributing forty-six covers over two decades. He ran his sessions like a sure-handed movie director, confident in his ability to create a hip, stylized kind of beauty. The understated sexiness of Herb's covers flows naturally from attitude, not props or tricks. He photographed Bruce Springsteen, Tom Cruise, Michael Jackson, David Bowie, Paul McCartney, Claudia Schiffer, Warren Beatty, Julia Roberts, Arnold Schwarzenegger and many more stars for us. "At the end of the day, Herb loved shooting for ROLLING STONE because he was allowed to create the images he wanted to create," says Herb's longtime executive producer, Mark McKenna. "Herb thrived on spontaneity."

Herb's shot of a topless Cindy Crawford standing on a Malibu beach at sunset (𝑅𝒮 672/673) proved to be one of our best-selling covers ever. He believed that everybody should look beautiful, and he could make anybody look like an idol or a god, whether that person was Cindy Crawford or a sixty-year-old Bob Dylan (𝑅𝒮 882). His final cover for the magazine, depicting a shirtless Justin Timberlake (𝑅𝒮 914), was on the newsstands

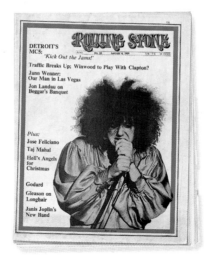

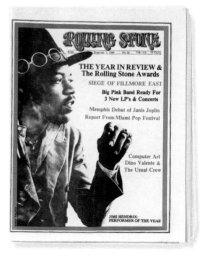

𝑅𝒮 23 | DOUG & SEAN SAHM
December 7th, 1968
PHOTOGRAPH BY BARON WOLMAN

𝑅𝒮 24 | THE BEATLES
December 21st, 1968
PHOTOGRAPHER UNKNOWN

𝑅𝒮 25 | ROB TYNER
January 4th, 1969
PHOTOGRAPHER UNKNOWN

𝑅𝒮 26 | JIMI HENDRIX
February 1st, 1969
PHOTOGRAPH BY BARON WOLMAN

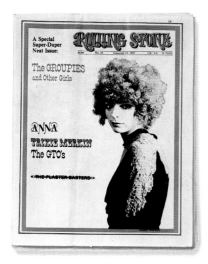

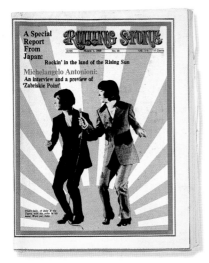

just after the photographer died of pneumonia in 2002 at age fifty. It's one of our sexiest male covers ever.

* * * * *

BY 1987, I'D BECOME RESTLESS AND wanted a new art director, a fresh collaboration. Fred Woodward, whom we had been watching set fire to *Texas Monthly*, confessed to me in our initial meeting that he had dreamed of being the art director of ROLLING STONE since he was fifteen. Fred arrived at his dream job as we were counting down to a Twentieth Anniversary special issue. It was perfect timing. He and his new staff hit the bound volumes of past issues to conduct a blitzkrieg retrospective of our design history – on deadline. "I was running on pure adrenaline, and I was scared to death," Fred recalls. "I wanted to do work that measured up to that twenty-year legacy."

Fred successfully reconnected the magazine's new look to its past, producing an amazing body of work that not only kept ROLLING STONE supplied with awards for design excellence but earned him a place in the Art Director's Hall of Fame, as its youngest member ever. At one time or another, his covers violated every rule. Only someone of Fred's idiosyncratic vision could have seen the dark graphic power of the Batman cape (𝑅𝒮 634/635) or chosen to illustrate our "Portraits" issue with a simple, stunning shot of Elvis's gold lamé Nudie suit on a hanger (𝑅𝒮 643). Over fifteen years as art director, Fred's imagination wove itself into the life of ROLLING STONE.

In the Nineties, we hired Mark Seliger as our new chief photographer, the first since Annie and only the third in our history. "Shooting your first cover of ROLLING STONE is like your first romance, or the first time you got a car – except magnified ten-fold," Mark says. "It was a big world to step into, but once I gained momentum, I tried to push it in every way." Mark told me that from his teenage years, he was a student of ROLLING STONE, and it shows. There were qualities in Mark's early work – his wit, his use of space – that were as close to Annie as I had ever seen. "Mark brought back the kind of concept cover that Annie invented," says our current director of photography, Jodi Peckman. "A whole new generation started getting the excitement of these wonderfully produced photographs." On more than a hundred covers – Neil Young in a scarecrow pose (𝑅𝒮 648), the *Seinfeld* cast in black leather (𝑅𝒮 660/661), Jennifer Aniston nude at the peak of her early fame (𝑅𝒮 729) – Mark created high-gloss, vivid images that helped us capture the spirit of a new decade.

Mark took definitive shots of the Nineties' new breed of rock bands, including Pearl Jam, Red Hot Chili Peppers, Soundgarden and Smashing Pumpkins. But the most compelling among them was our first Nirvana cover (𝑅𝒮 628). Before a brief photo shoot in Melbourne, Australia, Mark gave the trio a routine warning not to wear shirts with writing on them. Kurt Cobain, who was in a foul mood and complaining of stomach pain, responded by scrawling "corporate magazines still suck" on his ragged T-shirt. "He wouldn't change the shirt, and I felt like I hadn't delivered," Mark recalls. "On the way back, I was sweating in my seat, feeling like a complete failure." I thought it was great from the moment I saw it – it was funny. In the end, it was Cobain's endorsement of the magazine, a witty acknowledgement of the power and importance of ROLLING STONE to him.

Mark's 1994 cover shot of Brad Pitt (𝑅𝒮 696) came to life after the two drove together from California

to Mexico. Pitt wanted the photos to feel real, according to Mark. "We hoped to model it after an old, traditional ROLLING STONE shoot where you're living with a person for a period of time, rather than it just being a two-hour experience in a studio," Mark says. For the record, Mark came up with the idea of pairing Jenny McCarthy with a hot dog (𝑅𝑆 738/739) and dressing Ice-T, the rapper behind "Cop Killer," in a policeman's uniform (𝑅𝑆 637). "I don't know if Ice-T thought it was funny," Mark says. "But he just loved it."

During his years on staff, Mark took some extraordinary pictures of politicians, including three Clinton covers and one of Al Gore. Political leaders are challenging to shoot – they tend to be stiff and formal – but Mark managed to transcend that. When the Gore cover (𝑅𝑆 853) came out, someone on the radio took note of the bulge in his pants, and it became one of those mindless reverberating media things for a while. Al called me up and said, "Everybody's talking about this. Is this OK? Is this a bad thing?" How could it be anything but a good thing?

The late Nineties saw a new boom in slick teen pop, and in the tradition of our shirtless David Cassidy cover almost three decades earlier, we found its provocative side. Enter David LaChapelle. In the spring of 1999, he shot a seventeen-year-old Britney Spears in her bra and polka-dot panties (𝑅𝑆 810), lying on satin sheets and clutching a purple Teletubby. When Spears's then-manager objected to the pose during the shoot, she overruled him, LaChapelle recalls: "Britney said, 'Lock the door,' and unbuttoned her shirt wide open." This was the teenage version of Madonna, and it had not been seen before.

Spears's male counterparts – 'NSync (with future solo star Justin

[RS 30] This issue marked the first special issue devoted to a political topic, in this case the social movements and unrest prevalent in the late Sixties. Contributors included Black Panther Party Minister of Education George Mason Murray and Berkeley Free Speech Movement leader Michael Rossman.

Timberlake) and Backstreet Boys – all went on to collaborate with us on sexy, occasionally subversive covers. At the peak of that period, we shot five separate covers for one issue, each with a different member of 'NSync (𝑅𝑆 875). It was a fun gimmick, and they were all delighted.

Music's divas – including Spears, Mariah Carey, Courtney Love, Christina Aguilera and, of course, Madonna – have all worked closely with us over the years, helping to create some of our most unforgettable images. Madonna's work with Herb Ritts stands apart, with a series of iconographic covers that traced the trajectory of a superstar: cheek to cheek with Rosanna Arquette for their starring roles in *Desperately Seeking Susan* (𝑅𝑆 447), a Kabuki-painted Nefertiti in three-quarter profile (𝑅𝑆 508), the reigning queen of pop frolicking in the surf (𝑅𝑆 561). "Madonna liked to play with her image," says Mark McKenna, Herb's executive producer. "And she wanted to have fun. So Herb was able to bring a crew in and really collaborate on things."

The younger divas tend to arrive with large entourages (Aguilera, for one, brought bodyguards and two dogs to a shoot), and strong ideas of what they want. But with the help of our reputation and long history, we nearly always succeed in convincing them to collaborate.

Other artists need less prodding to participate in the give and take. Mick Jagger has always been a partner in shaping his image. He knows

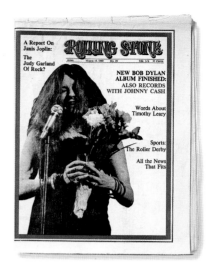

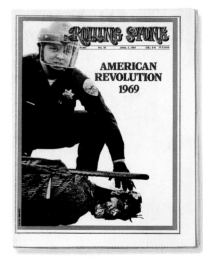

𝑅𝑆 29 | JANIS JOPLIN
March 15th, 1969
PHOTOGRAPHER UNKNOWN

𝑅𝑆 30 | AMERICAN REVOLUTION IN 1969
April 5th, 1969
PHOTOGRAPH BY NACIO BROWN

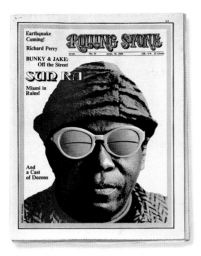

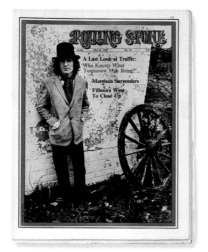

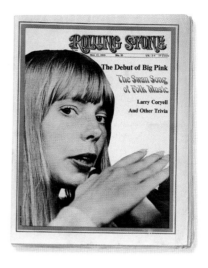

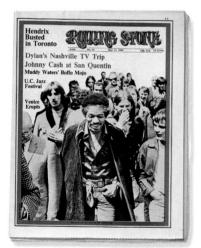

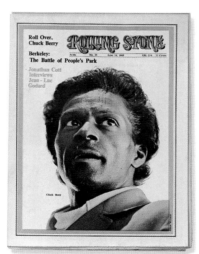

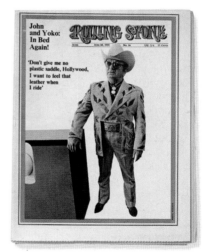

RS 31 | SUN RA
April 19th, 1969
PHOTOGRAPH BY BARON WOLMAN

RS 32 | STEVIE WINWOOD
May 3rd, 1969
PHOTOGRAPH BY DAVID DALTON

RS 33 | JONI MITCHELL
May 17th, 1969
PHOTOGRAPH BY BARON WOLMAN

RS 34 | JIMI HENDRIX
May 31st, 1969
PHOTOGRAPH BY FRANZ MAIER

RS 35 | CHUCK BERRY
June 14th, 1969
PHOTOGRAPH BY BARON WOLMAN

RS 36 | NUDIE COHN
June 28th, 1969
PHOTOGRAPH BY BARON WOLMAN

[RS 36] This little cowboy is Nudie Cohn, the flamboyant western-wear designer responsible for the lavishly decorated outfits favored by country stars of the Fifties and Sixties. He also created Elvis Presley's famous gold lamé suit, which graces the cover of RS 643.

what he wants to look like, but he's also fascinated by the photo-taking process, and is eager to hear our suggestions on photographers and concepts. Few artists would have posed for our cover wearing an ornate mask (*RS* 689) – and even fewer would have remained utterly recognizable.

Comic actors have been similarly eager to lend their ideas, from Steve Martin (who asked to be painted onto Franz Kline's artwork [*RS* 363]) to Jim Carrey (who gamely allowed a dog to pull off his bathing suit, recreating a Coppertone ad [*RS* 712/713]). During the Nineties, the *Seinfeld* cast posed as *Wizard of Oz* characters, while Jerry Seinfeld appeared solo as both the young and old Elvis Presley. Jerry was up for just about anything in these Mark Seliger shoots – though understandably, he did decline to wear a grotesque prosthetic tongue in imitation of Kiss' Gene Simmons.

* * * * *

WHEN THE WORLD TRADE CENter fell on September 11th, 2001, we had Alicia Keys scheduled for our cover. Keys happened to be wearing a New York T-shirt in the photograph we were planning to use, so we considered going with it. Within about five minutes, it became clear that we wanted to have our say about an era-defining event. We debated various red-white-and-blue treatments, and thought about using the "11" in "9/11" to represent the towers. Then I found a flag lapel-pin in my desk drawer at home. When I brought it into the office, everyone agreed: "That's the cover."

In the early 2000s, we experimented for a while with a flashier look, and a style influenced by a new breed of British magazines. But even in that period, the covers that worked best looked like traditional ROLLING STONE, whether it was the stark, black-and-white Seliger portrait of an aged Johnny Cash we ran

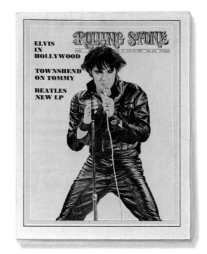

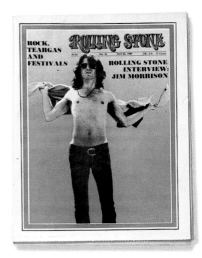

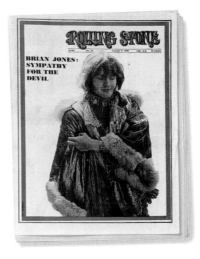

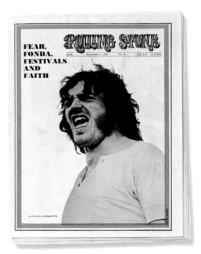

RS 37 | ELVIS PRESLEY
July 12th, 1969
PHOTOGRAPHER UNKNOWN

RS 38 | JIM MORRISON
July 26th, 1969
PHOTOGRAPHER UNKNOWN

RS 39 | BRIAN JONES
August 9th, 1969
PHOTOGRAPH BY JIM MARSHALL

RS 41 | JOE COCKER
September 6th, 1969
PHOTOGRAPH BY STEVEN SHAMES

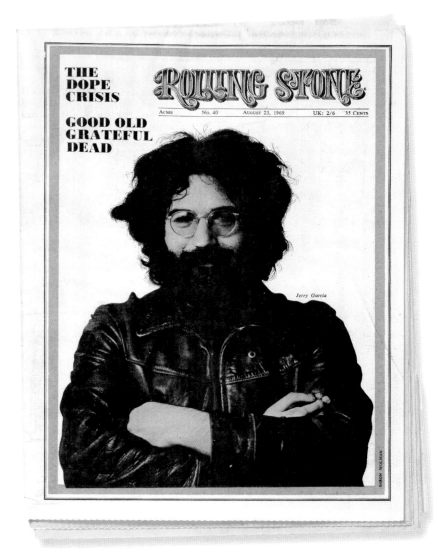

THE DOPE CRISIS

GOOD OLD GRATEFUL DEAD

Rolling Stone

ACME No. 40 AUGUST 23, 1969 UK: 2/6 35 CENTS

Jerry Garcia

RS 40 | JERRY GARCIA | August 23rd, 1969 | PHOTOGRAPH BY BARON WOLMAN

"HOW'D I GET TO people? They accepted me because *I was as fuckin' nuts as they were!*"

—*Jim Marshall*

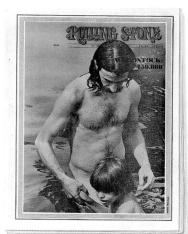

RS 42 | WOODSTOCK
September 20th, 1969
PHOTOGRAPH BY BARON WOLMAN

upon his death (*RS 933*), or Martin Schoeller's shot of Bruce Springsteen standing in front of a vast green field (*RS 903*). "Bruce has this humongous property in New Jersey, with all these great vistas, but he limited us to a very small corner that we could photograph in," Schoeller remembers. "I finally convinced him to move fifty feet to that field. I like that shot a lot – it feels very American, somehow."

In 2004, we wanted to send a signal that we were going back to the core journalistic values of ROLLING STONE, regardless of the newsstand sales consequences. In an effort to shift the magazine to be more topical, we proceeded with a series of political covers: Garry Trudeau's rendering of the war in Iraq (*RS 954*), Michael Moore (*RS 957*), the Vote for Change tour (*RS 959*), Jon Stewart (*RS 960*), John Kerry (*RS 961*). That created new energy and purpose, almost a kind of renewal. With our current art director, the news-oriented *Newsweek* alum Amid Capeci, we entered a new period of

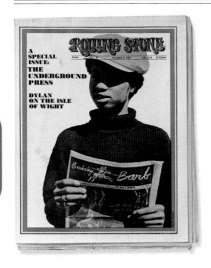
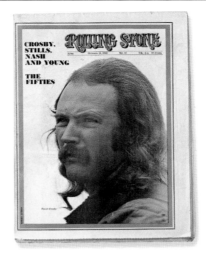
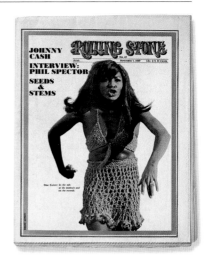
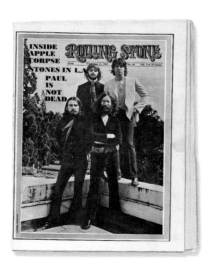
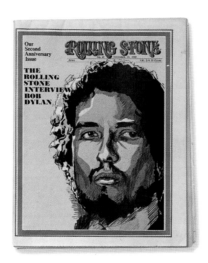
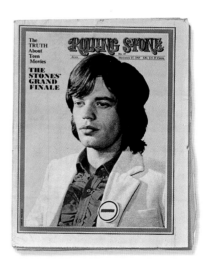

RS 43 | THE UNDERGROUND PRESS
October 4th, 1969
PHOTOGRAPH BY STEVEN SHAMES

RS 46 | THE BEATLES
November 15th, 1969
PHOTOGRAPHER UNKNOWN

RS 44 | DAVID CROSBY
October 18th, 1969
PHOTOGRAPH BY ROBERT ALTMAN

RS 47 | BOB DYLAN
November 29th, 1969
ILLUSTRATOR UNKNOWN

RS 45 | TINA TURNER
November 1st, 1969
PHOTOGRAPH BY ROBERT ALTMAN

RS 49 | MICK JAGGER
December 27th, 1969
PHOTOGRAPH BY BARON WOLMAN

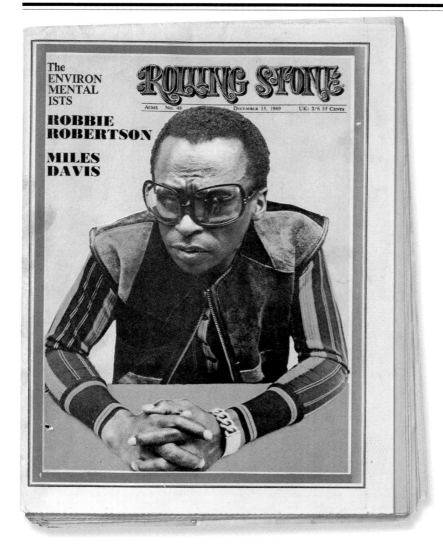

Inspired by the album art for *Sgt. Pepper's Lonely Hearts Club Band*, the 3-D cover we created concludes this book. It's a grand-scale celebration of our four decades at the heart of popular culture.

We are still looking for cover subjects who are authentic and honest, iconic or hot, people who stand for something, whether it's U2's Bono or Green Day's Billie Joe Armstrong. In the Nineties, we felt comfortable with the direction our nation's policy was going, so we could go out and have some fun. Now, though, the stakes are high, and we have a lot of serious things to say.

Still, in the end, the cover is forever a work in progress. There are rules, but it is so alive, so vital, so in the moment. That's part of what has made the cover of ROLLING STONE so thrilling over the years: It has always been unpredictable.

* * * * *

WHAT A LONG, STRANGE TRIP IT truly has been. Our mission took us from the Haight-Ashbury to the Oval Office, bringing us face-to-face with the cultural events and influential people of our time. Our readers have come along for the journey, cheering us on with their love letters and advice. Our subjects have been the architects of their times – presidents and poets, the outsiders and insiders. In the end, this collection of covers is a sprawling archive of the almost four decades we've been around – and a testament to the great work of our photographers, illustrators, art directors, photo editors and the cover subjects themselves. We have devoted ourselves to our task with all the passion, energy and talent that we had to give.

classic ROLLING STONE covers. "We moved toward a stripped-down, bold, newsy design," Amid says. "And we started photographing cover subjects in a serious light."

When my friend and longtime star writer and collaborator Hunter S. Thompson died on February 20th, 2005, there was no question that he would appear on our next cover. As we prepared a memorial package that filled much of the issue, the debate was whether to picture him in his youth or as a more recognizable and iconic older man. We decided on a little-seen vintage black-and-white shot of Hunter holding a cigarette. Surrounded by wisps of smoke, Hunter looks so handsome and elegant in the image; it's from the year we met and began to work together.

As our thousandth issue approached, we searched for a cover treatment worthy of the occasion.

—*Jann S. Wenner*

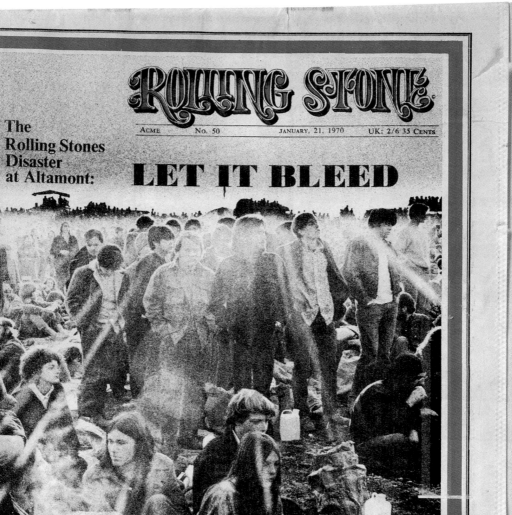

1970

"*I didn't know his name or anything, but he* was standing alongside of me. You know, we were both watching Mick Jagger, and a Hell's Angel – the fat one; I don't know his name or anything – he reached over. He didn't like us being so close or something, you know, we were seeing Mick Jagger too well, or something. He was just being uptight. He reached over and grabbed the guy beside me by the ear and hair and yanked on it, thinking it was funny, you know, kind of laughing. And so this guy shook loose; he yanked away from him."

"Now this guy that you're talking about, is this the black guy that got killed?"

"Yeah, right. He shook loose, and the Hell's Angel hit him in the mouth and he fell back into the crowd, and he jumped offstage and jumped at him. And he tried to scramble, you know, through the crowd to run from the Hell's Angel, and four other Hell's Angels jumped on him."

Robert Hiatt, a medical resident at the Public Health Hospital in San Francisco, was the first doctor to reach eighteen-year-old Meredith Hunter after the fatal wounds. He was behind the stage and responded to Jagger's call from the stage for a doctor. When Hiatt got to the scene, people were trying to get Hunter up on the stage, apparently in the hope that the Stones would stop playing and help could get through quicker.

"I carried him myself back to the first-aid area," Hiatt said. "He was limp in my hands and unconscious. He was breathing quite shallowly, and he had a very weak pulse. It was obvious he wasn't going to make it, but if anything could be done, he would have to get to a hospital quickly.

"He had very serious wounds. He had a wound in the lower back, which could have gone into the lungs; a wound in the back near the spine, which could have severed a major vessel; and a fairly large wound in the left temple. You couldn't tell how deep the wounds were, but each was about three-fourths of an inch long, so they would have been fairly deep.

"It was just obvious he wasn't going to make it."

[EXCERPT FROM RS 50 COVER STORY REPORTED BY LESTER BANGS, RENY BROWN, JOHN BURKS, SAMMY EGAN, MICHAEL GOODWIN, GEOFFREY LINK, GREIL MARCUS, JOHN MORTHLAND, EUGENE SCHOENFELD, PATRICK THOMAS AND LANGDON WINNER]

RS 50 | ALTAMONT | January 21st, 1970 | PHOTOGRAPH BY MICHAEL MAGGIA

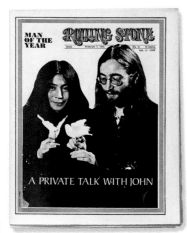

\mathcal{RS} 51 | JOHN LENNON
& YOKO ONO
February 7th, 1970
PHOTOGRAPH BY ANNETTE YORKE

Which of the John-and-Paul songs do you think were good?

I can't . . . well, you know, the early stuff like "I Wanna Hold Your Hand," "She Loves You" and stuff that was written together. I can't think of any others but things like that.

Not long ago, you told me you thought the 'Abbey Road' album was as good as 'Sgt. Pepper' and the White Album was also as good.

Yeah, yeah. I mean, I think each album since *Pepper* has been better. People just have this dream about *Pepper.* I mean, it was good for then, but it wasn't that spectacular when you look back on it. Like anything, it was great then. But I certainly prefer some of the tracks off the double album and some of the tracks off *Abbey Road* than all the tracks on *Pepper.* When you think back on *Pepper,* what do you remember? Just "A Day in the Life." You know. I go for individual songs, not for whole albums.

[EXCERPT FROM JOHN LENNON INTERVIEW
BY RITCHIE YORKE]

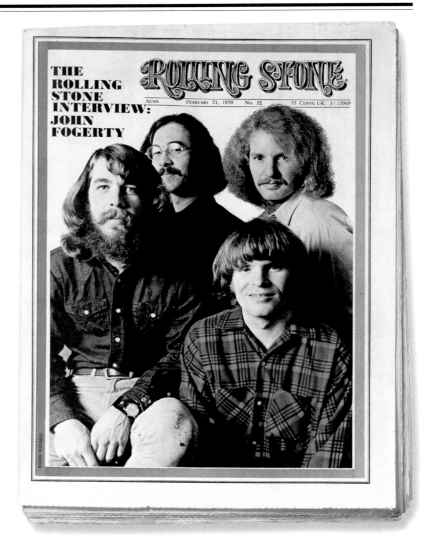

\mathcal{RS} 52 | CREEDENCE CLEARWATER REVIVAL
February 21st, 1970
PHOTOGRAPH BY BARON WOLMAN

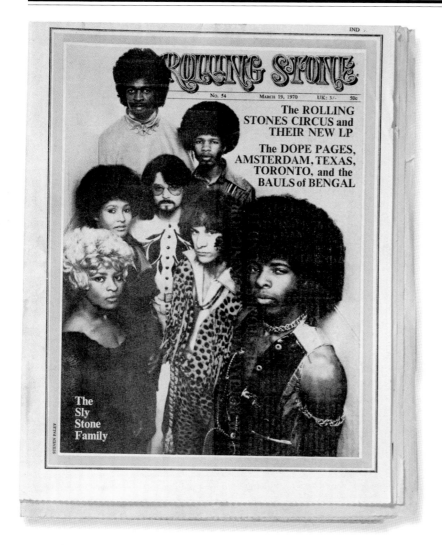

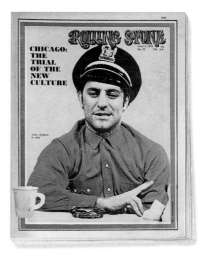

RS *54* | SLY & THE FAMILY STONE
March 19th, 1970
PHOTOGRAPH BY STEPHEN PALEY

RS *53* | MARK FRECHETTE
& DARIA HALPRIN
March 7th, 1970
'ZABRISKIE POINT' FILM STILL

RS *55* | ABBIE HOFFMAN
April 2nd, 1970
PHOTOGRAPH BY BILL MYERS

"THE CONCEPT BEHIND Sly and the [Family] Stone: I wanted everyone to get a chance to sweat. If there was anything to be happy about, then everybody'd be happy about it. Then, if we have a cross to bear, we bear it together." —*Sly Stone*

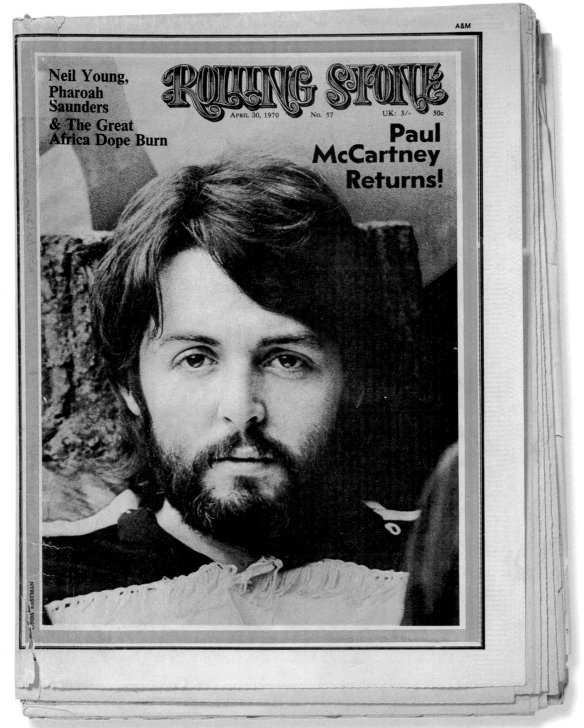

On the magazine cover:

Neil Young, Pharoah Saunders & The Great Africa Dope Burn

ROLLING STONE

APRIL 30, 1970 No. 57 UK: 3/- 50c

A&M

Paul McCartney Returns!

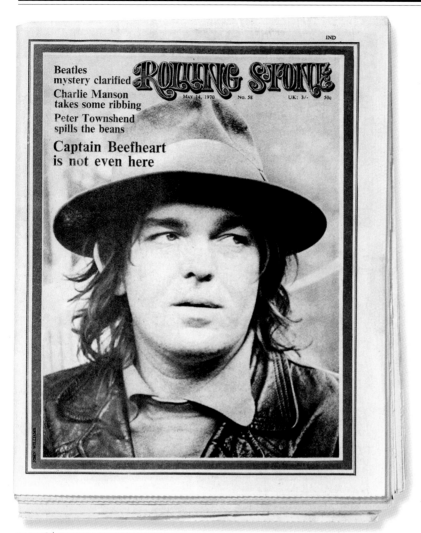

\mathcal{RS} 58 | CAPTAIN BEEFHEART | May 14th, 1970 | PHOTOGRAPH BY JOHN WILLIAMS

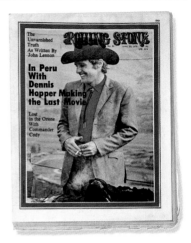

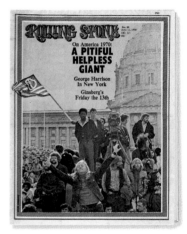

\mathcal{RS} 56 | DENNIS HOPPER
April 16th, 1970
PHOTOGRAPH BY MICHAEL ANDERSON JR.

\mathcal{RS} 60 | ANTIWAR
DEMONSTRATORS
June 11th, 1970
PHOTOGRAPH BY ANNIE LEIBOVITZ

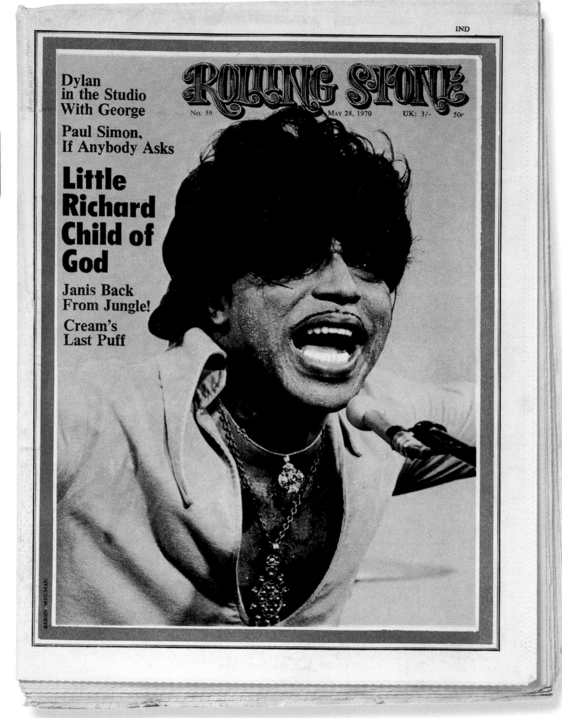

The cover shows *ROLLING STONE* No. 59, May 28, 1970, UK: 3/- 50¢

Dylan in the Studio With George

Paul Simon, If Anybody Asks

Little Richard Child of God

Janis Back From Jungle!

Cream's Last Puff

IND

RS 59 | LITTLE RICHARD | May 28th, 1970 | PHOTOGRAPH BY BARON WOLMAN

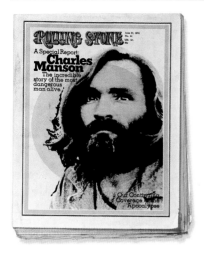

Can you explain the prophecies you found in the Beatles' double album?

[*Charlie starts drawing some lines on the back of a sheet of white paper. In the bottom area he writes the word SUB.*]

OK. Give me the names of four songs on the album.

[*We choose "Piggies," "Helter Skelter," "Blackbird," and he adds "Rocky Raccoon."*]

This bottom part is the subconscious. At the end of each song there is a little tag piece on it, a couple of notes. Or like in "Piggies" there's "oink, oink, oink." And all these sounds are repeated in "Revolution 9." Like in "Revolution 9," all these pieces are fitted together and they predict the violent overthrow of the white man. Like you'll hear "oink, oink," and then right after that, machine gun fire. AK-AK-AK-AK-AK-AK!

Do you really think the Beatles intended to mean that?

I think it's a subconscious thing. I don't know whether they did or not. But it's there. This music is bringing on the revolution, the unorganized overthrow of the Establishment. The Beatles know in the sense that the subconscious knows.

[EXCERPT FROM RS 61 COVER STORY BY DAVID FELTON AND DAVID DALTON]

"Jann Wenner . . . suggested that I and David Dalton do a story on Charles Manson. None of the editors liked the idea, including myself, but Jann figured there was a story there. "It turned out he was amazingly perceptive. Because Manson wanted his album plugged, he

granted us an exclusive prison interview. Because an assistant prosecutor thought we were a cute hippie rag with a circulation of maybe 10,000 (it was then about 250,000), he gave us a detailed on-the-record account of his case before trial, enabling us to scoop the established dailies. Because the Manson family thought of us as brothers under the ground, they let us view their mercenary attempts to cash in on their leader's story. After a few weeks, we knew we had something bigger than even Jann had anticipated.

"And certainly *longer* than Jann had anticipated – eventually the story took some 20,000 words and, more to the point, three months to write. And it was this *time* thing, I soon discovered, that tended to make Jann fret. I've always felt that anything worth doing is worth doing slowly. ('The Tortoise and the Hare' is one of my favorite stories, and someday I'm going to finish reading it.) But for some reason, Jann has never warmed to the idea. I remember the time I flew up to San Francisco to show him an outline for one section of the Manson story. I figured

I would meet with him for about an hour, then fly home. But when I walked into Jann's office, he seemed disturbed and a little chagrined, like someone who'd just learned of a bad investment. He'd been talking to my previous employer. 'I understand,' he said with a weak smile, 'that at the *L.A. Times* they called you the Stonecutter.' With that, he forbade me to leave the office until the section was completely written. I stayed there a week, night and day, without a toothbrush or a change of clothing, a rather unpleasant situation for both me and anyone in the immediate vicinity.

"That should have been the tipoff right there: clearly a violation of adult labor laws. But in fact I fell into Jann's trap again a month later while working on the introduction and was imprisoned for another week without warning or underwear. The end result was a six-part epic, which I still consider the best thing written on Manson and the culture. ROLLING STONE won a National Magazine Award for it. The assistant prosecutor was removed from the case because he talked too much."

—*David Felton*

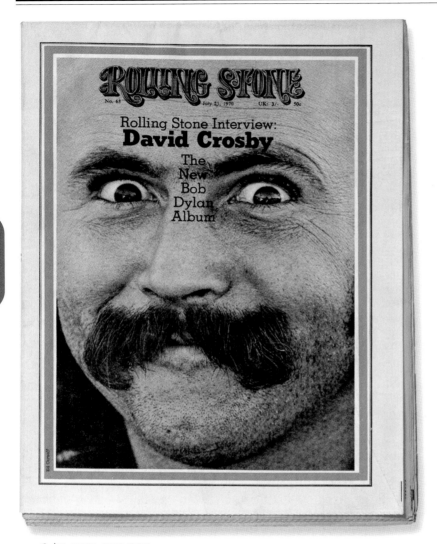

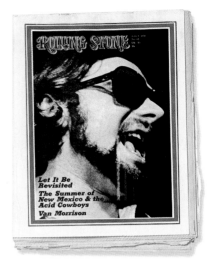

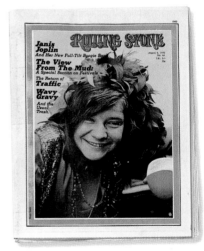

RS 63 | DAVID CROSBY
July 23rd, 1970
PHOTOGRAPH BY ED CARAEFF

RS 62 | VAN MORRISON
July 9th, 1970
PHOTOGRAPHER UNKNOWN

RS 64 | JANIS JOPLIN
August 6th, 1970
PHOTOGRAPH BY TONY LANE

"EVERY TIME, MAN, that I get stoned and put
on a guitar and somebody points me at a
microphone, I have – I can't say every time –
99 times out of a hundred – I have as good a
time as most people do balling." —David Crosby

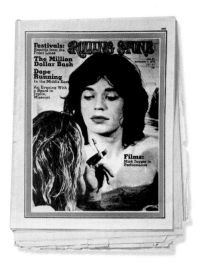

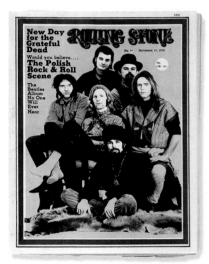

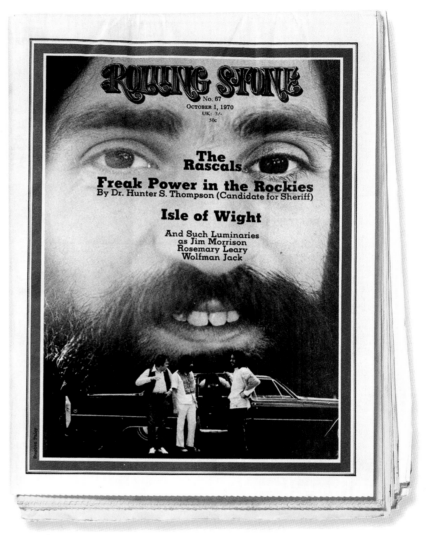

RS 65 | MICK JAGGER &
ANITA PALLENBERG
September 3rd, 1970
'PERFORMANCE' FILM STILL

RS 66 | THE GRATEFUL DEAD
September 17th, 1970
PHOTOGRAPH BY JIM MARSHALL

RS 67 | FELIX CAVALIERE & THE RASCALS
October 1st, 1970
PHOTOGRAPH BY STEPHEN PALEY

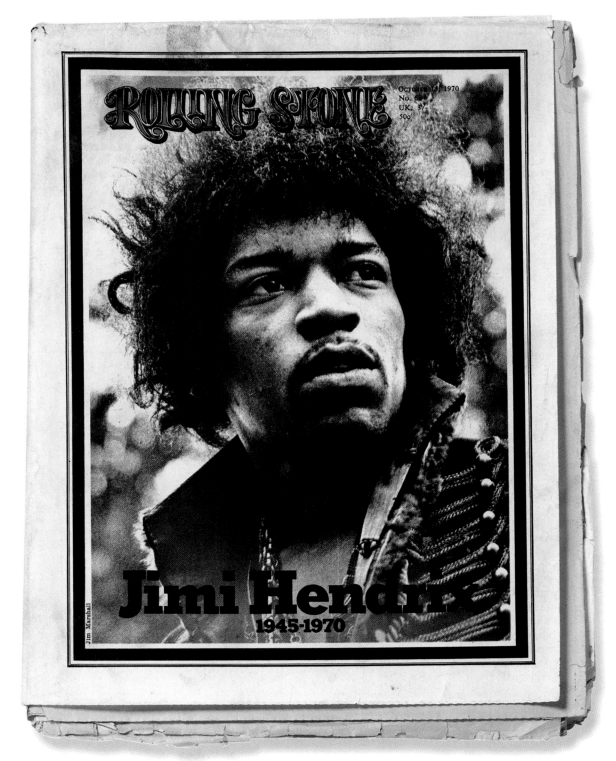

Jim Marshall

In 1967, Hendrix burst onto

the rock & roll scene not initially because of his music. Sure, it was far-out, but the most significant thing was the Hendrix Presence. The sexual savage electric dandy rock & roll nigger Presence! The voodoo child run wild in electric ladyland!

RS 68 | JIMI HENDRIX
October 15th, 1970
PHOTOGRAPH BY JIM MARSHALL

Fully aware that this would be Jimi's best starting image, his first LP and singles were heavy on Presence, light on his (ultimately) strongest facet. It was through live performances and the later recordings that the rock & roll audience was to discover his greatly more astounding side: He was perhaps the master virtuoso of electric guitar. It was Jimi Hendrix, more than any other guitarist, who brought the full range of sound from all the reaches of serious electronic music – a wider palette of sound than any other performing instrumentalist in the history of music ever had at his fingertips – plus the fullest tradition of black music – from Charley Patton and Louis Armstrong all the way to John Coltrane and Sun Ra – to rock & roll. Nobody could doubt that Jimi Hendrix was a rock & roll musician, yet to jazz musicians and jazz fans, he was also a jazz performer. When Jimi Hendrix took a solo, it had everything in it.

It is only three years and three months since [the Jimi Hendrix Experience made its first American appearance at the Monterey Pop Festival]. Most master musicians are granted a good deal more time to make their statement. (Charlie Parker lived thirty-five years.) The amazing thing is how rich a musical legacy Hendrix has left in so short a time.

Certainly there is a place in the chapter on rock & roll lyrics (in the *Whole History of Rock and Roll*, to be published a few years hence, when the whole trip is dead) for Jimi. It's not just that he was adept at slinging the words together. But clearly Hendrix has got to be viewed as the father of Narcotic Fantasia imagery. This was his role as a lyricist at the start of his career. It was important to the voodoo child image that his songs came off as far out as possible, and how are you going to come off farther out than by asking your listeners to " 'Scuse me while I kiss the sky . . ."? What about "Queen Jealousy, Envy, waits behind him, her fiery green gown sneers at the grassy ground"? . . .

Hendrix told interviewers that he had been scared to sing for a long time because he thought his voice wasn't up to it. Then he heard Dylan and dug what Dylan was doing and figured, What the hell, if that cat can do that much with no more voice than *he's* got, what's holding me back? In fact, he was a great singer, as distinctive as Neil Young, and a harder wailer (swinger, mover) than either of them. It was a light but rich voice, perfectly suited to the laughter-from-the-shadows insinuations, the purrs and gurgles and the high crooning shouts that were his means to a super-expressive style. . . .

There will never be another like him.

—*John Burks*

[EXCERPT FROM JIMI HENDRIX TRIBUTE]

"Janis was like a real person,

man. She went through all the changes we did. She went on the same trips. She was just like the rest of us – fucked up, strung out, in weird places. Back in the old days, the pre-success days, she was using all kinds of things, just like anybody, man.

"When she went out after something, she went out after it really hard, harder than most people ever think to do, ever conceive of doing.

"She was on a real hard path. She picked it, she chose it, it's okay. She was doing what she was doing as hard as she could, which is as much as any of us could do. She did what she had to do and closed her books. I don't know whether it's *the* thing to do, but it's what she had to do."

—*Jerry Garcia*

RS 69 | JANIS JOPLIN
October 29th, 1970
PHOTOGRAPH BY JIM MARSHALL

"SHE WAS IMPULSIVE, GENEROUS, SOFTHEARTED, SHY AND DETERMINED. She had style and class, and in a way, she didn't believe it. What did she want? It was all there for her but something that she knew wasn't fated to happen. Many people loved her a very great deal, like many people loved Billie Holiday, but somehow that was not enough.

"We'll never know and it doesn't matter, in a sense, because that brightly burning candle made an incredibly strong light in its brief life.

"They heard Janis Joplin 'round the world, loud and clear, and they will continue to hear her. I am only sorry for those who never had the flash of seeing her perform.

"Janis and Big Brother sang hymns at Monterey. It never seemed to me to be just music. I hope now that she's freed herself of that ball and chain, that she is at rest. She gave us a little piece of her heart and all of her soul every time she went onstage.

"Monterey, 1967. Otis, Jimi, Brian, Janis. Isn't that enough?

"Little girl blue, with the floppy hats and the brave attempt to be one of the guys. She took a little piece of all of us with her when she went. She was beautiful. That's not corny. It's true."

—*Ralph J. Gleason*

"WE USED TO GET DRUNK and play pool together. She beat me 80 percent of the time." —*Pigpen*

[EXCERPTS FROM JANIS JOPLIN TRIBUTE]

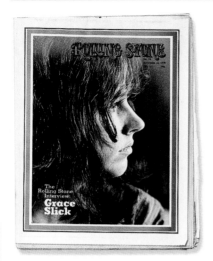

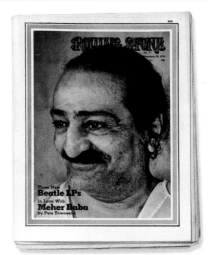

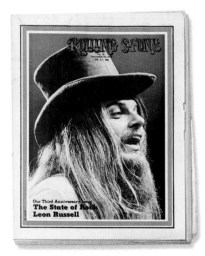

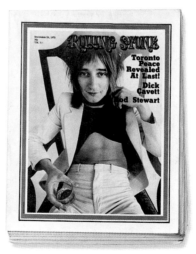

ℛ𝒮 70 | GRACE SLICK
November 12th, 1970
PHOTOGRAPH BY ANNIE LEIBOVITZ

ℛ𝒮 71 | MEHER BABA
November 26th, 1970
PHOTOGRAPHER UNKNOWN

ℛ𝒮 72 | LEON RUSSELL
December 10th, 1970
PHOTOGRAPH BY ED CARAEFF

ℛ𝒮 73 | ROD STEWART
December 24th, 1970
PHOTOGRAPH BY ANNIE LEIBOVITZ

[RS 71] Just why was Meher Baba on the cover of ROLLING STONE – and who was he, again? He was a sort of peace-extolling, mystical personal-actualization cult leader. The Who's Pete Townshend followed him (remember "Baba O'Riley" from *Who's Next*?) and wrote the accompanying cover story.

"JOHN LENNON was one of my first covers for ROLLING STONE [it was her first commissioned portrait]. At the time – I was still in school – I felt the cover shot was, like, the mediocre picture, the secondary consideration. A photograph to me was not a portrait – anyone can do that. I was addicted to hardcore journalism, newspaper stuff, capture the moment in time, Cartier-Bresson. I liked to combine the composition with the action. I carried a camera every second, and I was constantly framing life into little thirty-five-millimeter squares.

"So when I shot Lennon I was carrying three thirty-five-millimeter cameras, and on one of them I kept a 105 lens, which I used for light-meter readings. It was a long lens, I came in close on Lennon's face, and while I was taking the light-meter reading, he looked at me, and I just snapped one picture. And then I did all my other pictures. But I got back to ROLLING STONE, and Jann Wenner went through the contact sheets and immediately pulled out that picture for a cover. I said, 'Oh Jann, ughh-hh!' I couldn't understand why he liked that picture. I think it took me ten, twelve years to come to an understanding of what that picture was. Maybe I was a little bit reluctant to have somebody look back at me. . . . And that shooting, at the very beginning of my career, set a precedent for my work with anyone of any notoriety or fame after that."

—*Annie Leibovitz*

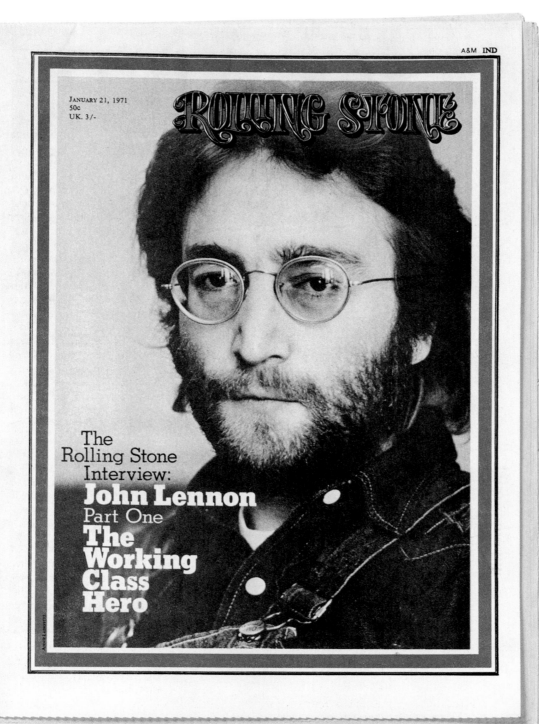

The Rolling Stone Interview:
John Lennon
Part One
The Working Class Hero

JANUARY 21, 1971
50c
UK. 3/-

A&M **IND**

RS 74 | JOHN LENNON | January 21st, 1971 | Photograph by Annie Leibovitz

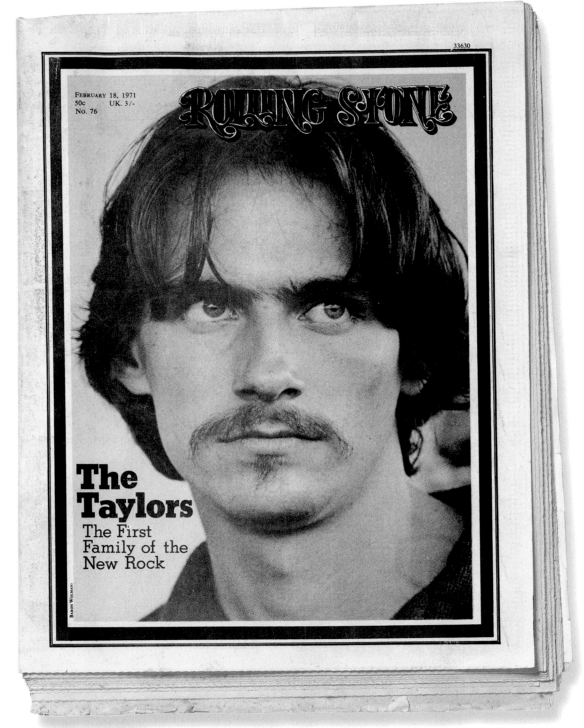

FEBRUARY 18, 1971
50c UK. 3/-
No. 76

Rolling Stone

The Taylors
The First Family of the New Rock

BARON WOLMAN

33630

RS 76 | JAMES TAYLOR | February 18th, 1971 | PHOTOGRAPH BY BARON WOLMAN

[RS 78] Muhammad Ali was the first athlete to grace the cover of ROLLING STONE. He remains the athlete with the most cover appearances, three. Brian Hamill's photo shows the then-undefeated champ as unscratched (the only scar on his face came from running his bicycle into a wall as a child).

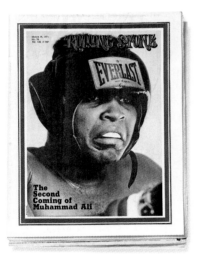

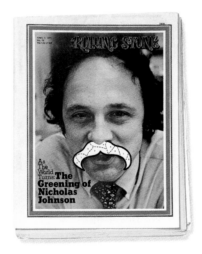

RS 75 | JOHN LENNON & YOKO ONO
February 4th, 1971
PHOTOGRAPH BY ANNIE LEIBOVITZ

RS 77 | BOB DYLAN
March 4th, 1971
PHOTOGRAPHER UNKNOWN

RS 78 | MUHAMMAD ALI
March 18th, 1971
PHOTOGRAPH BY BRIAN HAMILL

RS 79 | NICHOLAS JOHNSON
April 1st, 1971
PHOTOGRAPH BY ANNIE LEIBOVITZ

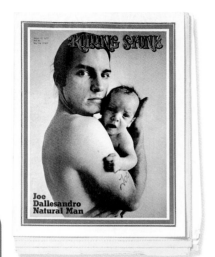

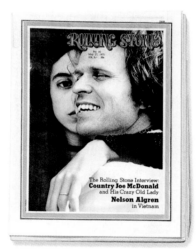

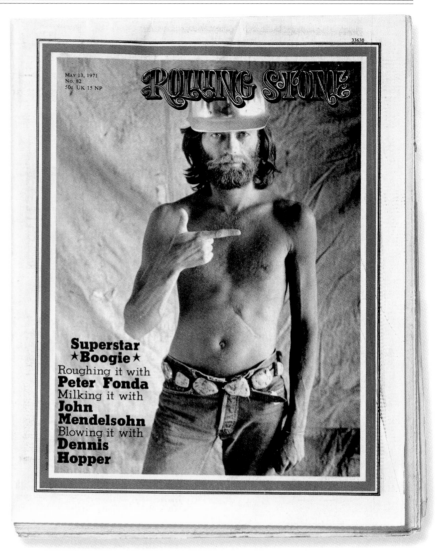

RS *80* | JOE DALLESANDRO
April 15th, 1971
PHOTOGRAPH BY ANNIE LEIBOVITZ

RS *83* | COUNTRY JOE
McDONALD & ROBIN MENKEN
May 27th, 1971
PHOTOGRAPH BY ANNIE LEIBOVITZ

RS *82* | PETER FONDA
May 13th, 1971
PHOTOGRAPH BY ANNIE LEIBOVITZ

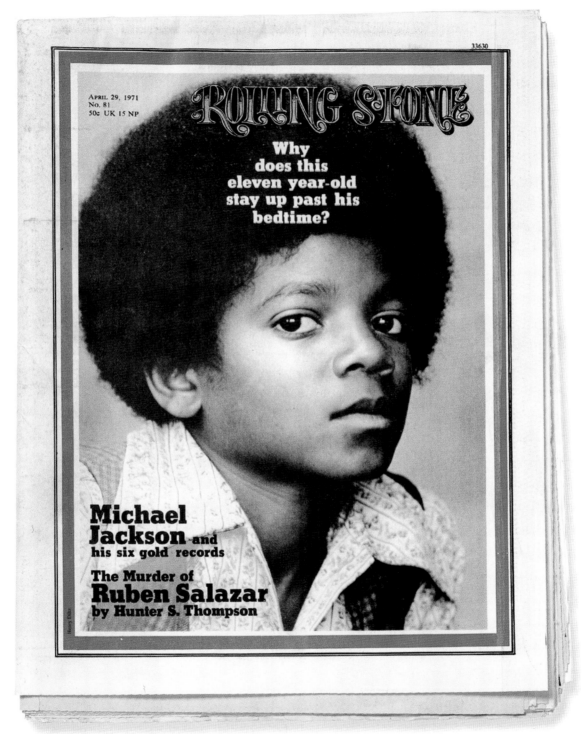

RS 81 | MICHAEL JACKSON | April 29th, 1971 | Photograph by Henry Diltz

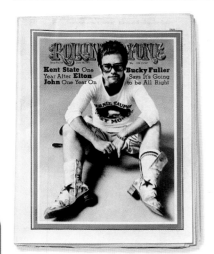

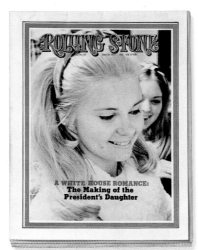

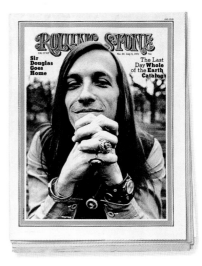

RS 84 | ELTON JOHN
June 10th, 1971
PHOTOGRAPH BY ANNIE LEIBOVITZ

RS 85 | TRICIA NIXON
June 24th, 1971
PHOTOGRAPHER UNKNOWN

RS 86 | DOUG SAHM
July 8th, 1971
PHOTOGRAPH BY BARON WOLMAN

I woke up one morning,

pretty hung over, and started poking around the apartment looking for something to read, and I found Jim's poetry manuscript. I sat down and read it and thought, Holy smoke, this is fantastic, and I was just sort of like ragingly delighted to find such a beautiful first book of poetry. When Jim came down later, I told him what I thought, and we talked about it a bit, and he was interested in what to do with it. . . . Jim was very serious about being a poet, and he didn't want to come in on top of being Jim-Morrison-the-big-rock-singer. . . .

Later, when the book had been published and the first copies arrived by mail in L.A., I found Jim in his room, crying. He was sitting there, holding the book, crying, and he said, "This is the first time I haven't been fucked." He said that a couple of times, and I guess he felt that that was the first time he'd come through as himself. . . .

I think that any two people who know each other closely probably influence each other. If I influenced him, he influenced me as well. It's hard to have a friend whose work you like where there's not some kind of mutual feedback. It's perfectly obvious in reading this book that Jim already had his own style and that he was already his own person. As to his potential for growth – well, he started out so good that I don't know how much better he could've gotten. He started off like a heavyweight.

[EXCERPT FROM TRIBUTE TO JIM MORRISON
BY MICHAEL McCLURE]

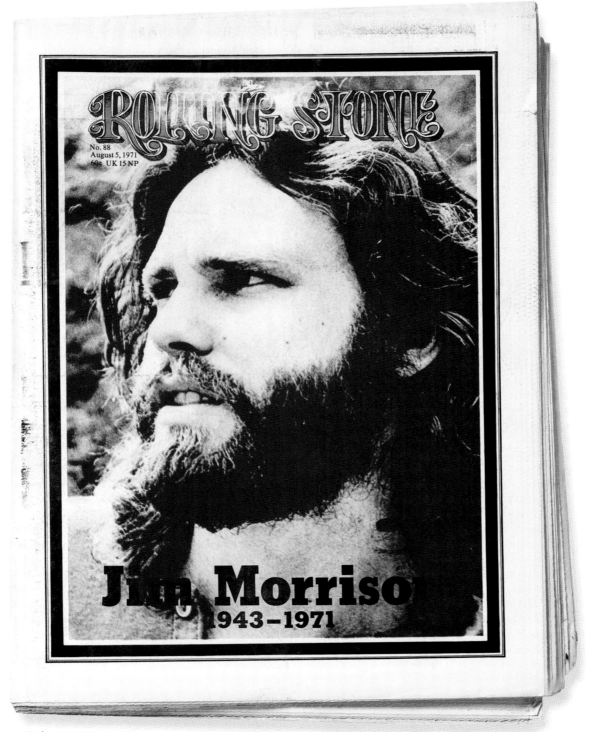

RS 88 | JIM MORRISON | August 5th, 1971 | PHOTOGRAPHER UNKNOWN

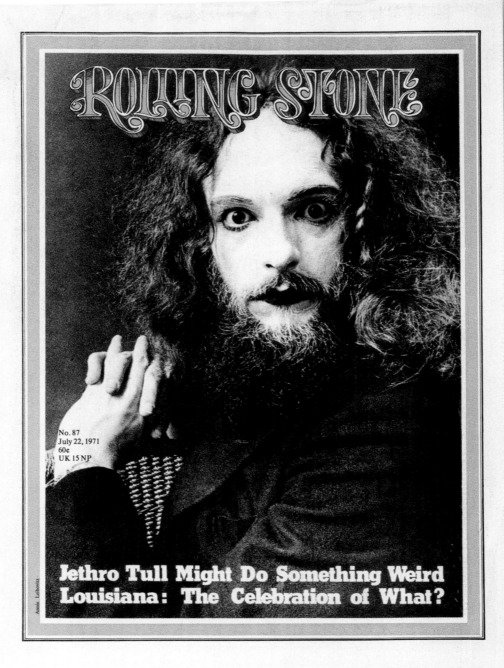

No. 87
July 22, 1971
60¢
UK 15 NP

Annie Leibovitz

Jethro Tull Might Do Something Weird
Louisiana: The Celebration of What?

RS 87 | IAN ANDERSON | July 22nd, 1971 | Photograph by Annie Leibovitz

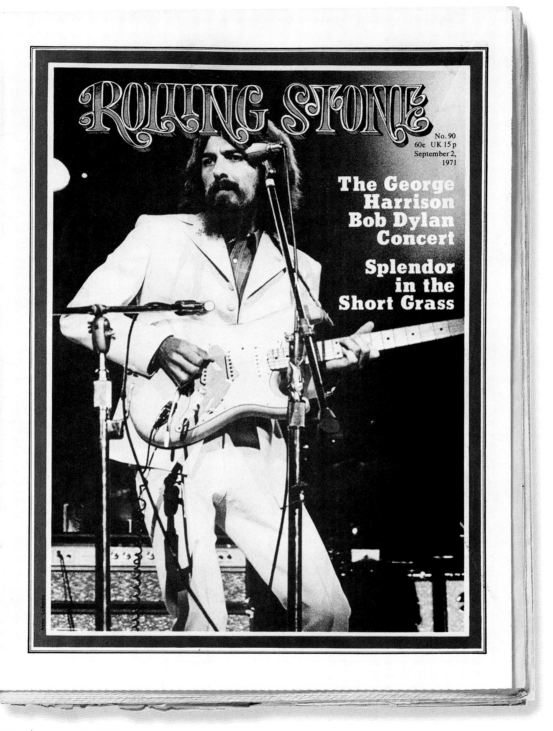

ROLLING STONE

No. 90
60¢ UK 15 p
September 2,
1971

The George
Harrison
Bob Dylan
Concert

Splendor
in the
Short Grass

Annie Leibovitz

RS 90 | GEORGE HARRISON | September 2nd, 1971 | PHOTOGRAPH BY ANNIE LEIBOVITZ

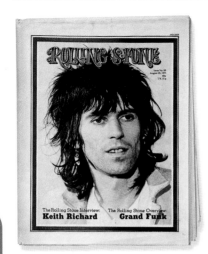

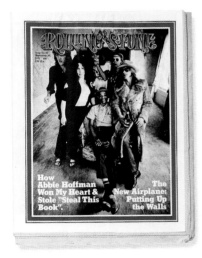

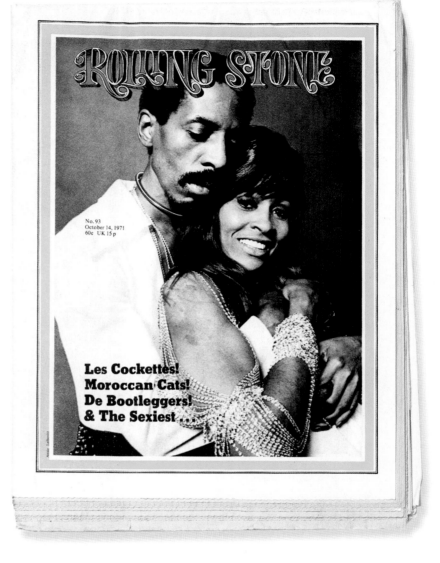

\mathcal{RS} 89 | KEITH RICHARDS
August 19th, 1971
PHOTOGRAPH BY ROBERT ALTMAN

\mathcal{RS} 92 | JEFFERSON AIRPLANE
September 20th, 1971
PHOTOGRAPH BY ANNIE LEIBOVITZ

\mathcal{RS} 93 | IKE & TINA TURNER | October 14th, 1971 | PHOTOGRAPH BY ANNIE LEIBOVITZ

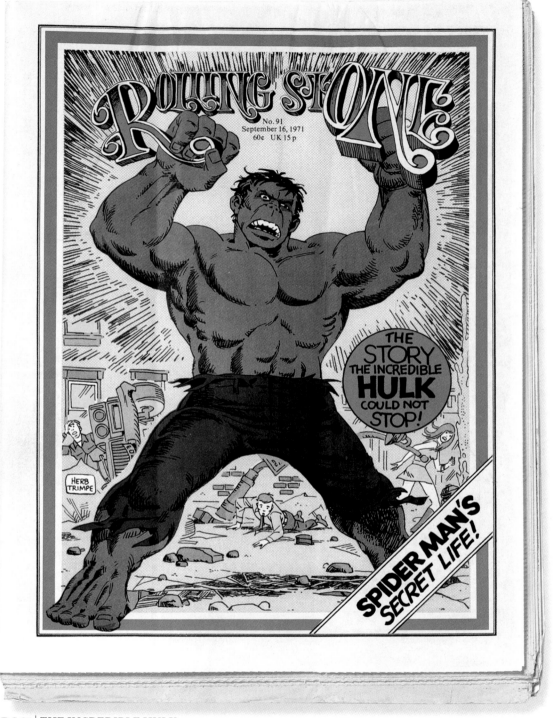

RS 91 | THE INCREDIBLE HULK | September 16th, 1971 | ILLUSTRATION BY HERB TRIMPE

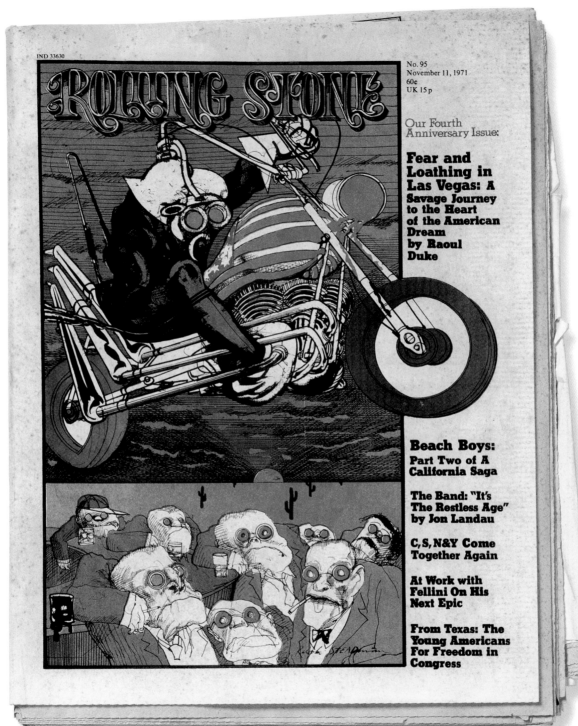

[RS 98] The name the Lyman family doesn't ring a bell? Its leader Mel Lyman was yet another "spiritual" leader prominent in the early Seventies. He was a sort of death-extolling quasi-mystical cult guru and author of *Mirror at the End of the Road.* He had some interesting ideas: "I am going to turn ideals to shit. I am going to shove hope up your ass." Ditto infrastructure renovations: "I am going to burn down the world, and then I am going to burn the rubble." This cover assignment, reportedly, was a day in the park for David Felton, coauthor of the six-part Charles Manson exposé.

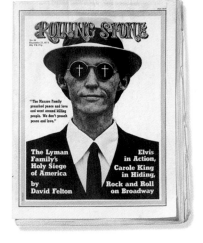

RS 94 | THE BEACH BOYS
October 28th, 1971
PHOTOGRAPH BY ANNIE LEIBOVITZ

RS 97 | PETE TOWNSHEND
December 9th, 1971
PHOTOGRAPH BY NEVIS CAMERON

RS 96 | FEAR AND LOATHING
IN LAS VEGAS, PART TWO
November 25th, 1971
ILLUSTRATION BY RALPH STEADMAN

RS 98 | EVANGELIST
MEL LYMAN
December 23rd, 1971
PHOTOGRAPH BY DAVID GAHR

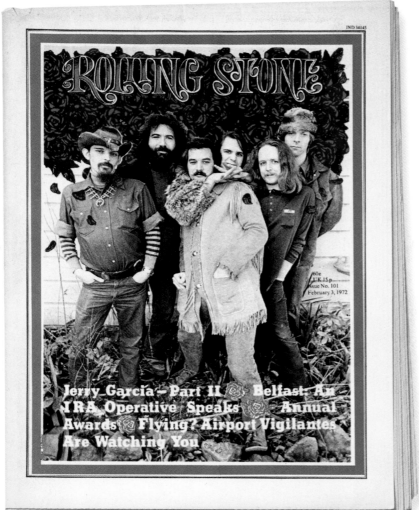

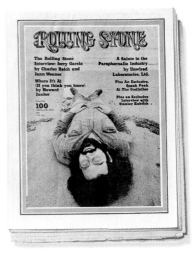

\mathcal{RS} 101 | THE GRATEFUL DEAD | February 3rd, 1972 | Photograph by Annie Leibovitz

\mathcal{RS} 99 | CAT STEVENS
January 6th, 1972
Photograph by Annie Leibovitz

\mathcal{RS} 100 | JERRY GARCIA
January 20th, 1972
Photograph by Annie Leibovitz

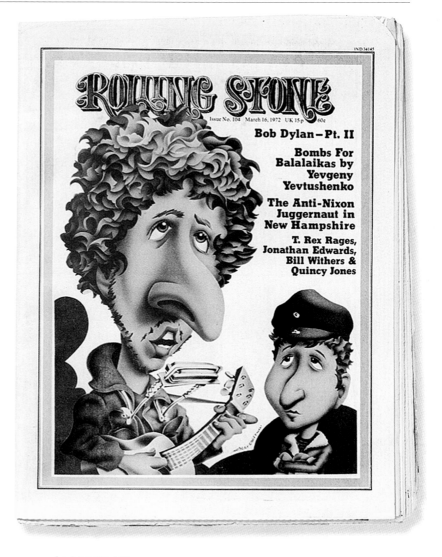

RS 102 | GERRITT VAN RAAM,
NARCOTICS AGENT
February 17th, 1972
PHOTOGRAPHER UNKNOWN

RS 103 | BOB DYLAN
March 2nd, 1972
ILLUSTRATION BY MILTON GLASER

RS 104 | BOB DYLAN | March 16th, 1972 | ILLUSTRATION BY ROBERT GROSSMAN

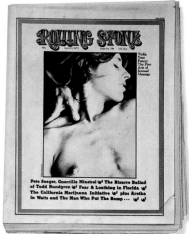

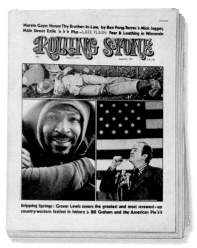

RS 105 | ALICE COOPER | March 30th, 1972 | Photograph by Annie Leibovitz

RS 106 | THE ART OF
SENSUAL MASSAGE
April 13th, 1972
Photograph by Robert Foothorap

RS 107 | VARIOUS
April 27th, 1972
Photographs by Annie Leibovitz

1970s

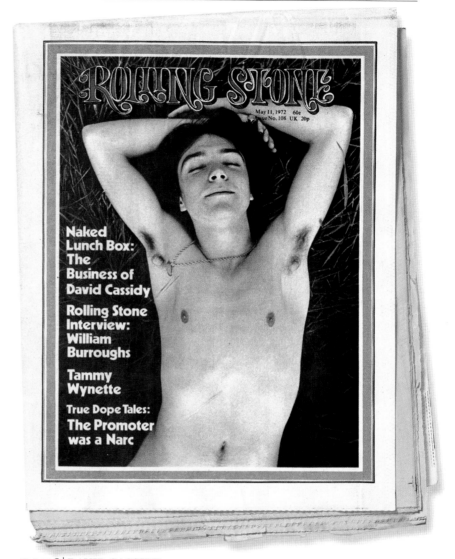

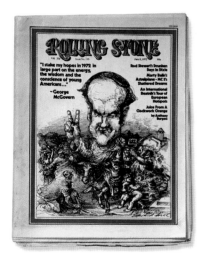

\mathcal{RS} *109* | JANE FONDA
May 25th, 1972
PHOTOGRAPH BY ANNIE LEIBOVITZ

\mathcal{RS} *110* | GEORGE McGOVERN
June 8th, 1972
ILLUSTRATION BY EDWARD SOREL

\mathcal{RS} *108* | DAVID CASSIDY | May 11th, 1972 | PHOTOGRAPH BY ANNIE LEIBOVITZ

"IT PISSED OFF EVERYBODY that was really profiting from the business of David Cassidy. I had fan letters that came to me – and there were hundreds of thousands of them, literally – in defense of me by fans of mine, that said, 'Oh David, I know that you couldn't possibly have done this because I know that you would never have posed nude for photographs.' And the fact was, I had, had willingly done so, had thought about it. I scratched my head and thought, You know, this David Cassidy business has really gotten outta hand."

—*David Cassidy*

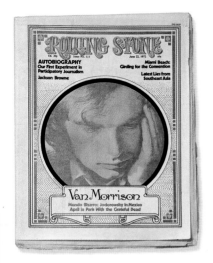

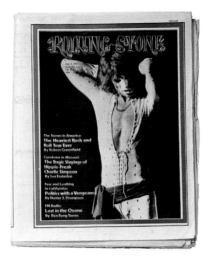

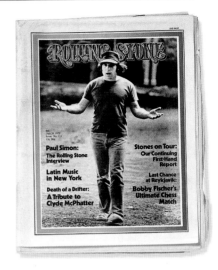

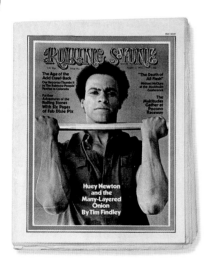

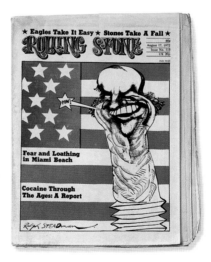

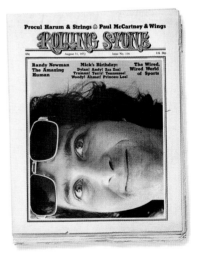

RS 111 | VAN MORRISON
June 22nd, 1972
PHOTOGRAPH BY ANNIE LEIBOVITZ

RS 114 | HUEY NEWTON
August 3rd, 1972
PHOTOGRAPH BY ANNIE LEIBOVITZ

RS 112 | MICK JAGGER
July 6th, 1972
PHOTOGRAPH BY ANNIE LEIBOVITZ

RS 115 | 1972 DEMOCRATIC
CONVENTION
August 17th, 1972
ILLUSTRATION BY RALPH STEADMAN

RS 113 | PAUL SIMON
July 20th, 1972
PHOTOGRAPH BY PETER SIMON

RS 116 | RANDY NEWMAN
August 31st, 1972
PHOTOGRAPH BY ANNIE LEIBOVITZ

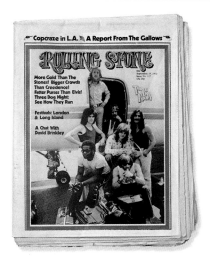

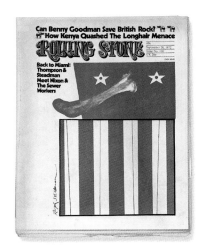

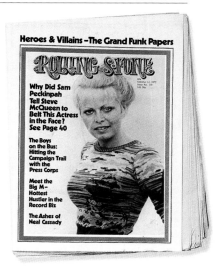

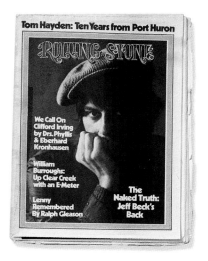

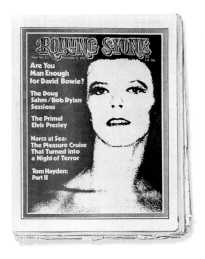

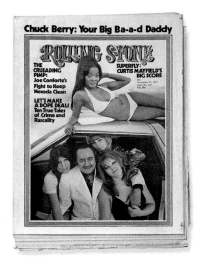

RS 117 | THREE DOG NIGHT
September 14th, 1972
PHOTOGRAPH BY ANNIE LEIBOVITZ

RS 120 | JEFF BECK
October 26th, 1972
PHOTOGRAPH BY HERBIE GREENE

RS 118 | 1972 REPUBLICAN
CONVENTION
September 28th, 1972
ILLUSTRATION BY RALPH STEADMAN

RS 121 | DAVID BOWIE
November 9th, 1972
PHOTOGRAPH BY MICK ROCK

RS 119 | SALLY STRUTHERS
October 12th, 1972
PHOTOGRAPH BY MEL TRAXEL

RS 122 | PIMP JOE CONFORTE
& HIS WORKING GIRLS
November 23rd, 1972
PHOTOGRAPH BY ANNIE LEIBOVITZ

<div style="float:left">

1970s

</div>

"*I suppose*

to most people I'm probably seen as an amiable idiot . . . a genial twit. I think I must be the victim of circumstance, really. Most of it's me own doing. I'm a victim of me own practical jokes."

—*Keith Moon*

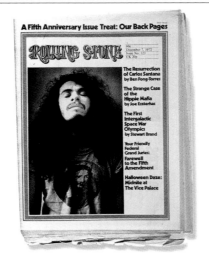

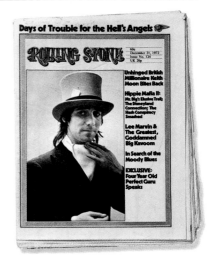

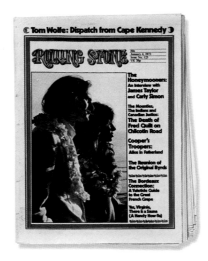

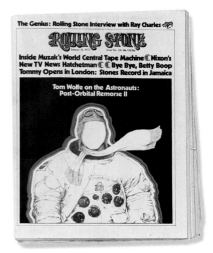

𝑅𝒮 *123* | CARLOS SANTANA
December 7th, 1972
PHOTOGRAPH BY ANNIE LEIBOVITZ

𝑅𝒮 *124* | KEITH MOON
December 21st, 1972
PHOTOGRAPH BY BOB GRUEN

𝑅𝒮 *125* | JAMES TAYLOR &
CARLY SIMON
January 4th, 1973
PHOTOGRAPH BY PETER SIMON

𝑅𝒮 *126* | APOLLO ASTRONAUT
January 18th, 1973
ILLUSTRATION BY DUGALD STERMER

You Won't Have 1972 to Kick Around Anymore (See Page 32)

ROLLING STONE

Issue No. 127
February 1, 1973
60¢ UK 20p

**The
Diana Ross
Story**

**Joan Baez'
Visit to Hanoi**

**Jesus Returns
to Jerusalem
as Superstar**

**The Oldest
Man in the USA**

RS 127 | DIANA ROSS | February 1st, 1973 | Photograph by Annie Leibovitz

Tom Wolfe: The Astronauts' Remorse

IND 34145

ROLLING STONE

February 15, 1973 60¢ UK 20p Issue No. 128

Hunter S. Thompson at the Superbowl 🏴 Hell's Angels' Day in Court 🏴 Stones' Coast Concert 🏴

The Gold Lamé Dream of Bette Midler

1970s

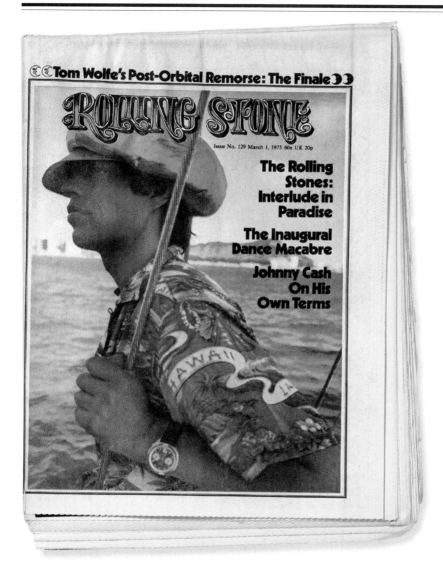

Tom Wolfe's Post-Orbital Remorse: The Finale ⊃⊃

Rolling Stone

Issue No. 129 March 1, 1973 60¢ UK 20p

The Rolling Stones: Interlude in Paradise

The Inaugural Dance Macabre

Johnny Cash On His Own Terms

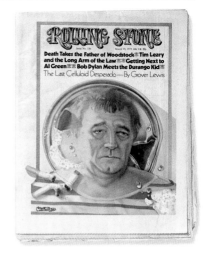

Rolling Stone

Death Takes the Father of Woodstock ⊞ Tim Leary and the Long Arm of the Law ⊞ Getting Next to Al Green ⊞ Bob Dylan Meets the Durango Kid ⊞

The Last Celluloid Desperado — By Grover Lewis

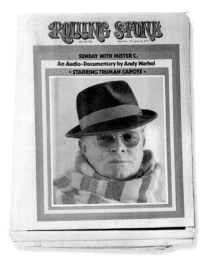

Rolling Stone

SUNDAY WITH MISTER C.
An Audio-Documentary by Andy Warhol
★ **STARRING TRUMAN CAPOTE** ★

R𝒮 129 | MICK JAGGER | March 1st, 1973 | PHOTOGRAPH BY ANNIE LEIBOVITZ

"I THINK [I REALLY STARTED TO ENJOY SHOOTING THE COVER] WHEN 'ROLLING STONE' went to color [RS 128]. I had to change to color, too, and it was very scary. I was glad I came from a school of black-and-white, because I learned to look at things in tones, highlights. ROLLING STONE was printed on newsprint, rag print, and ink sinks into the magazine. So the only thing that would make it on the cover were pictures that had two or three colors, primary colors, a very posterlike effect. In a strange way, you almost had to make the color look like black-and-white. So I developed a very graphic use of form and color just to survive the printing process."

—*Annie Leibovitz*

R𝒮 130 | ROBERT MITCHUM
March 15th, 1973
ILLUSTRATION BY CHARLES E. WHITE III

R𝒮 132 | TRUMAN CAPOTE
April 12th, 1973
PHOTOGRAPH BY HENRY DILTZ

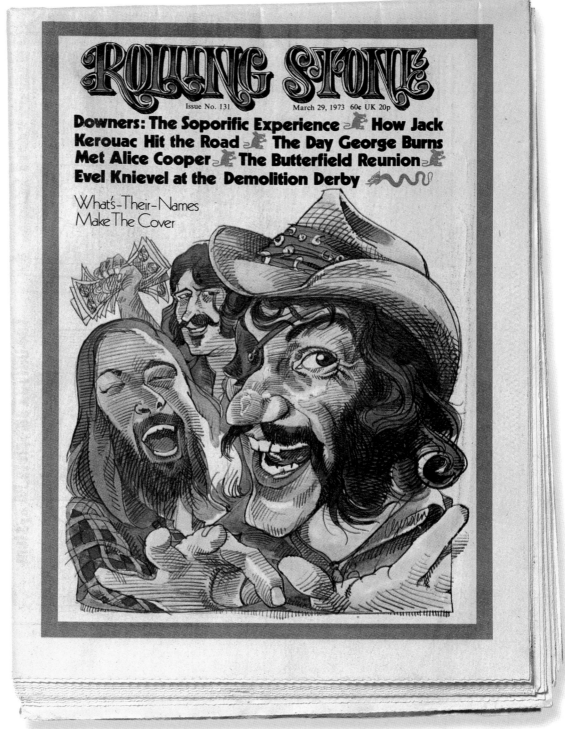

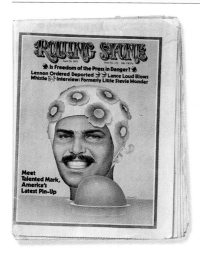

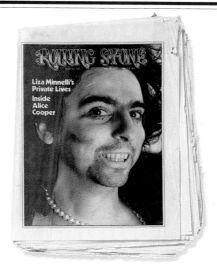

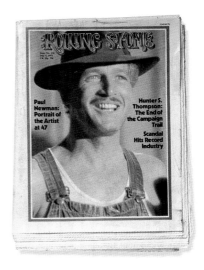

RS 133 | MARK SPITZ
April 26th, 1973
ILLUSTRATION BY IGNACIO GOMEZ

RS 134 | ALICE COOPER
May 10th, 1973
PHOTOGRAPH BY ANNIE LEIBOVITZ

RS 135 | CRIME VICTIM
DIRK DICKENSON
May 24th, 1973
ILLUSTRATION BY JAMES McMULLAN

RS 136 | JESUS FREAKS
June 7th, 1973
ILLUSTRATION BY EDWARD SOREL

RS 137 | ROD STEWART
June 21st, 1973
PHOTOGRAPH BY CHARLES GATEWOOD

RS 138 | PAUL NEWMAN
July 5th, 1973
PHOTOGRAPH BY STEPHEN SHUGRUE

[RS 131] How could ROLLING STONE not give them a cover?
Dr. Hook & the Medicine Show's "The Cover of Rolling Stone"
hit Number Six on the *Billboard* chart, March 17th, 1973.

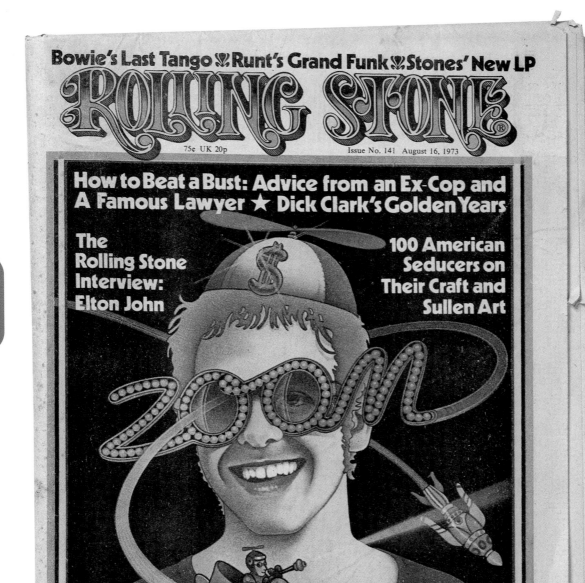

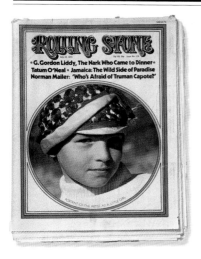

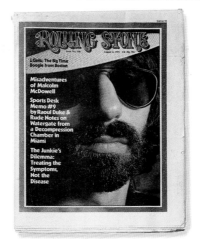

\mathcal{RS} 141 | ELTON JOHN
August 16th, 1973
ILLUSTRATION BY KIM WHITESIDES

One report in the national press awhile back said you'd once almost gotten married to a millionairess.
ELTON: Me?
And called it off three weeks before?
ELTON: Oh, that's true. I wouldn't say she was a millionairess, that's the national press boosting their headlines – "One-Armed Man Swims Channel" or something like that, you know what I mean. It was a girl I met when I was in Sheffield one miserable Christmas doing cabaret with John Baldry. She was six foot tall and going out with a midget in Sheffield who drove around in a Mini with special pedals on. He sued to beat her up! I felt so sorry for her and she followed me up the next week to South Shields – and I fell desperately in love and said to come to London and we'll find a flat. Eventually we got a nice flat in this dismal area. It was a very stormy six months, after which I was on the verge of a nervous breakdown. I attempted suicide and various other things, during which Bernie [Taupin] and I wrote nil, absolutely nothing.
BERNIE: Don't forget the gas.
ELTON: I tried to commit suicide one day. It was a very Woody Allen–type suicide. I turned on the gas and left all the windows open.

[EXCERPT FROM ELTON JOHN
INTERVIEW BY PAUL GAMBACCINI]

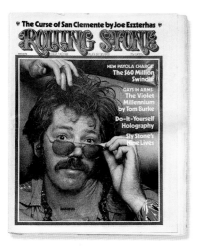

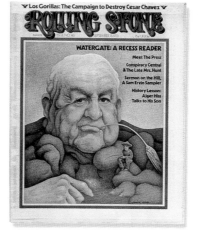

\mathcal{RS} 139 | TATUM O'NEAL
July 19th, 1973
PHOTOGRAPH BY STEVE JAFFE

\mathcal{RS} 142 | DAN HICKS
August 30th, 1973
PHOTOGRAPH BY ANNIE LEIBOVITZ

\mathcal{RS} 140 | PETER WOLF
August 2nd, 1973
PHOTOGRAPH BY ANNIE LEIBOVITZ

\mathcal{RS} 143 | SENATOR SAM ERVIN
September 13th, 1973
ILLUSTRATION BY CHARLES SHIELDS

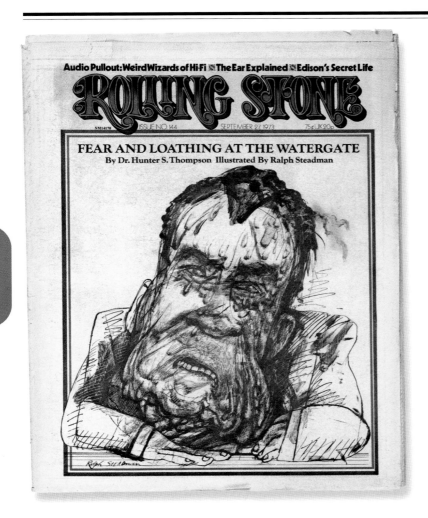

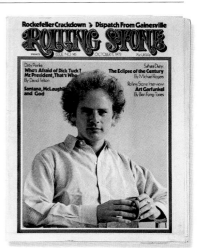

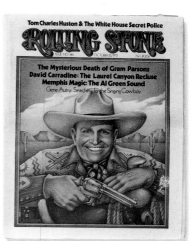

RS 144 | RICHARD NIXON
September 27th, 1973
ILLUSTRATION BY RALPH STEADMAN

RS 145 | ART GARFUNKEL
October 11th, 1973
PHOTOGRAPH BY JIM MARSHALL

RS 146 | GENE AUTRY
October 25th, 1973
ILLUSTRATION BY GARY OVERACRE

"*I wanted to* do something big and powerful because that's apparently what [Jerry] represents to the industry."

—*Robert Grossman*

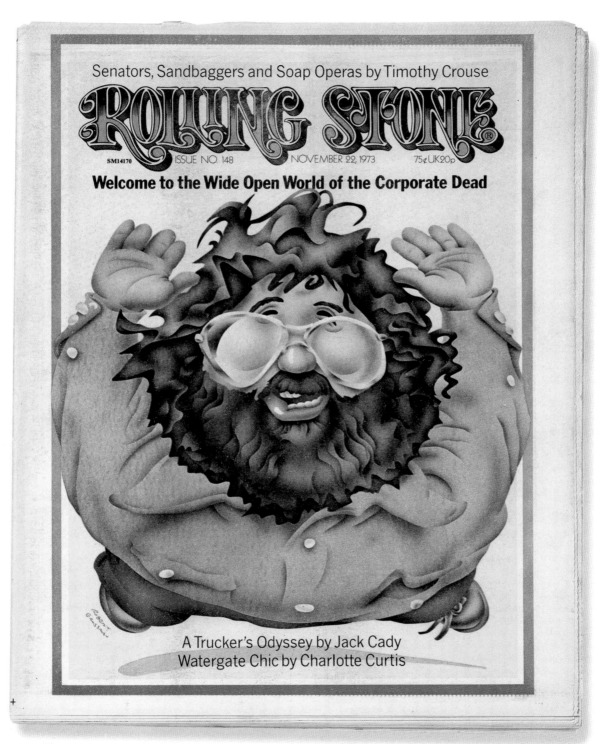

Senators, Sandbaggers and Soap Operas by Timothy Crouse

ROLLING STONE

SM14170 ISSUE NO. 148 NOVEMBER 22, 1973 75¢ UK 20p

Welcome to the Wide Open World of the Corporate Dead

A Trucker's Odyssey by Jack Cady
Watergate Chic by Charlotte Curtis

RS 148 | JERRY GARCIA | November 22nd, 1973 | ILLUSTRATION BY ROBERT GROSSMAN

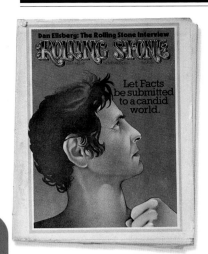

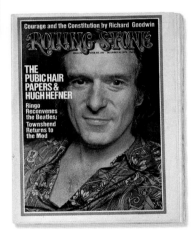

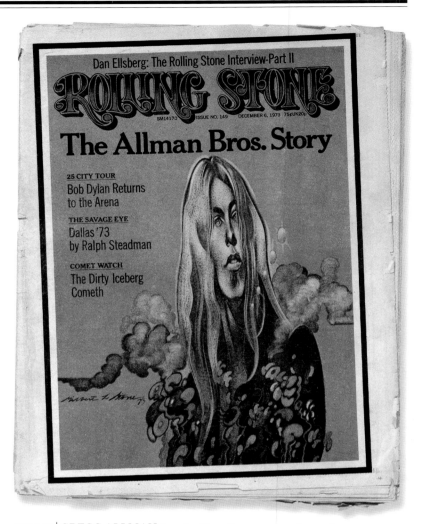

RS *147* | DANIEL ELLSBERG
November 8th, 1973
ILLUSTRATION BY DAVE WILLARDSON

RS *150* | HUGH HEFNER
December 20th, 1973
PHOTOGRAPH BY ANNIE LEIBOVITZ

RS *149* | GREGG ALLMAN | December 6th, 1973 | ILLUSTRATION BY GILBERT STONE

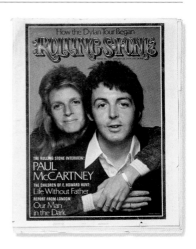

R&S 153 | PAUL & LINDA
MCCARTNEY
January 31st, 1974
PHOTOGRAPH BY FRANCESCO SCAVULLO

[RS 147] Michael Salisbury, a
renowned Los Angeles designer, and
his associate Lloyd Ziff temporarily
move into Annie Leibovitz's San
Francisco loft and take over ROLLING
STONE's design while Robert
Kingsbury is on a leave of absence for
nine covers (RS 147–RS 155). They
collaborate on RS 156, with Salisbury
taking the helm officially for RS 157.

R&S 151 | FUNKY CHIC
January 3rd, 1974
ILLUSTRATION BY PETER PALOMBI

R&S 152 | RICHARD NIXON
January 17th, 1974
ILLUSTRATION BY ROBERT GROSSMAN

R&S 154 | BOB DYLAN
February 14th, 1974
PHOTOGRAPH BY BARRY FEINSTEIN

R&S 155 | FEAR AND LOATHING
AT THE SUPER BOWL
February 28th, 1974
ILLUSTRATION BY HANK WOODWARD

Dismantle the Presidency by Richard N. Goodwin

ROLLING STONE

ISSUE NO. 156 MARCH 14, 1974 75¢ UK25p

The Poet's Poet
by Michael McClure

ROCK ME MAHARAJ JI
The Little Guru
Without A Prayer

UP FROM CBS
The Smothers Brothers
Slow Road Back

Paul Davis

1970s

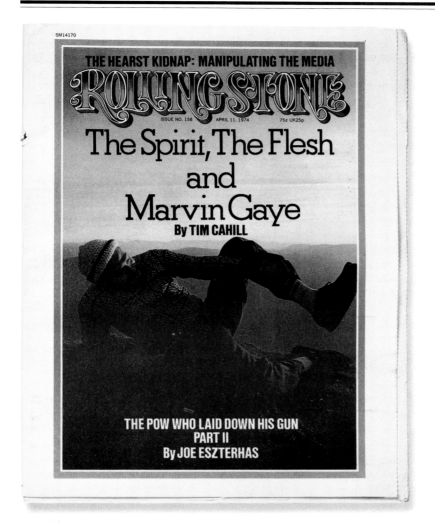

THE HEARST KIDNAP: MANIPULATING THE MEDIA

ROLLING STONE

ISSUE NO. 158 · APRIL 11, 1974 · 75¢ UK25p

The Spirit, The Flesh and Marvin Gaye
By TIM CAHILL

THE POW WHO LAID DOWN HIS GUN PART II
By JOE ESZTERHAS

R S 158 | MARVIN GAYE | April 11th, 1974 | PHOTOGRAPH BY ANNIE LEIBOVITZ

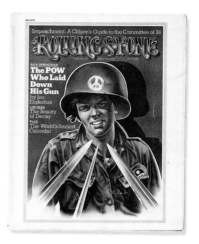

Impeachment: A Citizen's Guide to the Committee of 38

ROLLING STONE

RICK SPRINGMAN
The POW Who Laid Down His Gun
By Joe Eszterhas
LOU REED
The Beauty of Decay
PLUS
The World's Sexiest Calendar

R S 157 | P.O.W. RICK SPRINGMAN
March 28th, 1974
ILLUSTRATION BY PETER PALOMBI

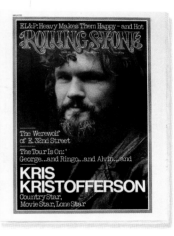

EL&P: Heavy Makes Them Happy — and Hot

ROLLING STONE

The Werewolf of E. 32nd Street
The Tour Is On: George...and Ringo...and Alvin...and
KRIS KRISTOFFERSON
Country Star, Movie Star, Lone Star

R S 159 | KRIS KRISTOFFERSON
April 25th, 1974
PHOTOGRAPH BY ANNIE LEIBOVITZ

"MARVIN LIKED THOSE SHOTS [I TOOK OF HIM IN 1971] AND AGREED TO several sessions. I had always thought there was something regal about Marvin Gaye, and I saw him with mountains in the background. When I drove up to his house outside of Los Angeles, I was amazed. There were mountains all around. Just before sunset, Marvin took the jeep out over the trails. The cover photo is one shot from that day."

—*Annie Leibovitz*

RS 161 | JACKSON & ETHAN BROWNE

May 23rd, 1974

PHOTOGRAPH BY ANNIE LEIBOVITZ

BOXES OF WIPE DIPE are in both the living room and the adjoining bedroom, where the baby's crib sits at the foot of his parents' tattered-quilt-covered bed. On one shelf, tucked back against a wall, is an unopened box of IT'S A BOY! ROI-TAN cigars. Outside, across the patio that serves as the cover of *For Everyman*, past the well and under the bambooed eaves of one walkway, a voice sings a lullaby in a foreign tongue. It is the housekeeper, a woman from San Salvador, and she is in the kitchen, cradling Ethan in her arms while his father is out shopping. . . .

Jackson picks Ethan up and begins to pose for a photographer. He flips through the Polaroids and finds the one shot he'd like to duplicate: of him holding a broadly laughing Ethan. Back in the bedroom, he works with his free hand, slapping fingers together, and he makes gurgling noises and sings the refrain from "The Cover of ROLLING STONE." Ethan laughs, and Jackson is as unknowingly open as his baby: "I love it when he laughs," he says. "His little voice. His little throat."

[EXCERPT FROM RS 161 COVER STORY BY CAMERON CROWE]

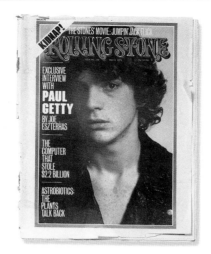

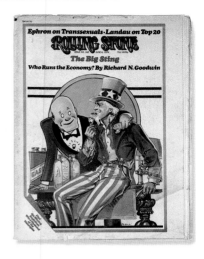

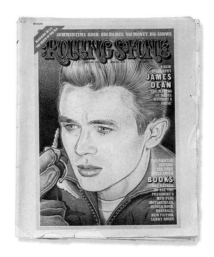

RS 160 | PAUL GETTY

May 9th, 1974

PHOTOGRAPH BY ANNIE LEIBOVITZ

RS 163 | JAMES DEAN

June 20th, 1974

ILLUSTRATION BY JOHN VAN HAMERSVELD

RS 162 | THE ECONOMY

June 6th, 1974

ILLUSTRATION BY PETER PALOMBI

RS 164 | KAREN & RICHARD CARPENTER

July 4th, 1974

PHOTOGRAPH BY ANNIE LEIBOVITZ

The Strange Behavior of the SLA

ROLLING STONE

NO. 161 3, 1974 75¢ UK25p

BOY WONDER
GROWS UP

Jackson Browne

Aretha Franklin

THE MAGNIFICENT
HOMEBODY

TRAVEL SPECIAL:

Get Lost

YOUTH FARE
LIVES

PAUL BOWLES
IN MOROCCO

ALLEN GINSBERG
EVERYWHERE

THE SECRET NEGOTIATIONS TO FREE PATTY HEARST

ROLLING STONE

ISSUE NO. 165 JULY 18, 1974 75c UK25p

THE
RESTORATION
OF
ROMAN
POLANSKI
By TOM BURKE

THE
FRIED
ICE CREAM
PAPERS
By KEN KESEY

THE ROLLING STONE
INTERVIEW:
ERIC CLAPTON

PHILIP HAYS

RS 165 | ERIC CLAPTON | July 18th, 1974 | Illustration by Philip Hays

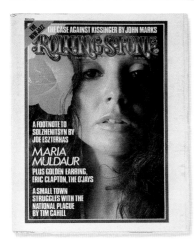

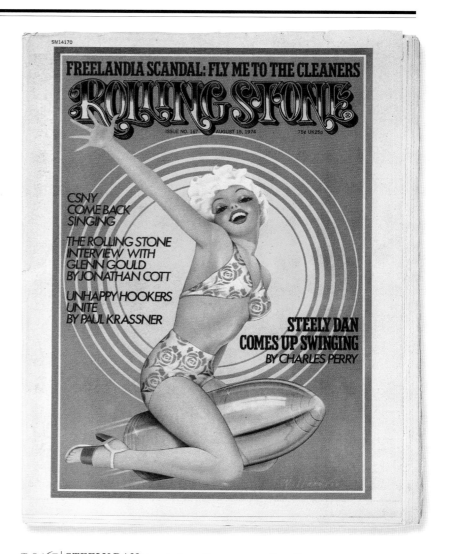

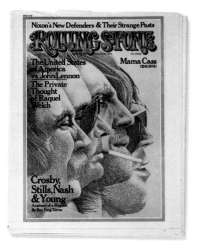

RS 166 | MARIA MULDAUR
August 1st, 1974
PHOTOGRAPH BY ANNIE LEIBOVITZ

RS 168 | CROSBY, STILLS,
NASH & YOUNG
August 29th, 1974
ILLUSTRATION BY DUGALD STERMER

RS 167 | STEELY DAN | August 15th, 1974 | ILLUSTRATION BY DAVE WILLARDSON

[RS 167] Though ROLLING STONE has raised eyebrows over many of its covers, most have been more overtly controversial than the illustration for this Steely Dan story. Is the bathing-suit-clad cover girl riding a silver vibrator? Yes, the concept was this: Walter Becker and Donald Fagen named their group after a vibrator called Steely Dan in William S. Burroughs's *Naked Lunch.* Apparently, when Dave Willardson completed his airbrushed image, art director Michael Salisbury hid it from the rest of the staff until the issue was running on press – just in case there was any nay-saying.

ROLLING STONE

ISSUE NO. 169 SEPTEMBER 12, 1974 75¢ UK25p

THE QUITTER
Our Memories of a Broken Ruler

Nixon's
Last Days
by Annie
Leibovitz

The Tragic History of Jan & Dean

1946-1974

WHEN RICHARD NIXON RESIGNED IN 1974, ROLLING STONE had been around only slightly longer than Nixon had been president. From time to time, the magazine commented on the former president and his actions. For RS 169, seven editors read over the preceding 168 issues to see what had been written about Nixon. They looked for "bright, breezy material as well as the kind of vicious, distorted, hysterical reporting that got ROLLING STONE banned from the White House for all but the last months, when the pit began to open up at Nixon's feet."

Meanwhile, writer Richard Goodwin and Annie Leibovitz had been busy with, respectively, an essay on Nixon and a photo record of his last days. Goodwin had been in Washington setting up the ROLLING STONE operation there. Leibovitz appeared twice on television: once in San Clemente climbing the podium of Nixon's Special Counsel James St. Clair and the other time shooting the former president's long and lachrymose walk from the Oval Office to the waiting helicopter.

DICK AND PAT THOUGHT THAT CHINA WAS A very funny place. Everywhere they went, they found things to laugh at. Dick especially liked to make jokes.

They visited a place called the Forbidden City. Their new friend Chou showed them a pretty room in an old palace. Once, Chou told them, a child emperor ruled the country in this room. His mother hid behind the screen to tell him what to do.

"It's the same today," joked Dick. "The women are always the backseat drivers!"

Then Chou showed Dick a pair of ear stoppers. Emperors used to put them in their ears. That way they could not hear when people said bad things about them.

"Give me a pair of those. Then you can only hear the questions you want to!" said clever Dick.

[RS WHITE HOUSE CORRESPONDENTS, MARCH 30TH, 1972]

We urge the Congress to vote impeachment proceedings before Nixon can escape through resignation. And, in either event, we then want a trial to determine innocence or a conviction. And that is just the first step.

—*The Editors* [JUNE 7TH, 1973]

HE ATE A LOT OF CORNMEAL and pumped gas for his father's gas station. His father bought a Quaker meeting-house across the road and expanded the gas station into a grocery store. The boy took to studying in the bell-tower of the church/store. He was devoted to his mother. He once wrote her a letter that began: "My Dear Master" and ended "Your Good Dog, Richard." He had a habit of sitting in a big chair and staring into space . . .

He mixed with few people and hardly ever dated. When he did date, he asked the girls intimate questions: What would have happened to the world if Persia had conquered Greece? What would have happened if Plato had never lived?

—*Joe Eszterhas* [AUGUST 30TH, 1973]

Six months ago, Richard Nixon was the most powerful political leader in the history of the world, more powerful than Augustus Caesar, when he had his act rolling full bore – six months ago.

Now, with the passing of each sweaty afternoon, into what history will call "the Summer of '73," Richard Nixon is being dragged closer and closer – with all deliberate speed, as it were – to disgrace and merciless infamy. His place in history is already fixed: He will go down with Grant and Harding as one of democracy's classic mutations.

—*Hunter S. Thompson* [SEPTEMBER 27TH, 1973]

"I love Lily. I have this thing about her, a little crush. She's so good I get embarrassed, I get in awe of her. I'd seen her on *Laugh-In* and shit, and something about her is very sensual. You know, when she works, I'd like to ball her in all them different characters she does sometimes. Wouldn't you? I mean, have her around the house and have her do all that – be Ernestine one minute [*he imitates Ernestine, Lily's telephone operator*]: 'Oh [*snort, snort*], just put it in the proper place. Thank you [*snort, snort*].' "

—*Richard Pryor*

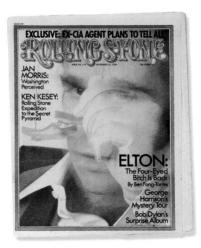

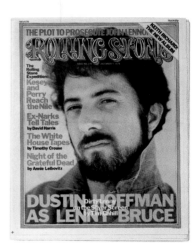

RS 170 | TANYA TUCKER
September 26th, 1974
PHOTOGRAPH BY DOUG METZLER

RS 172 | THE BEATLES
October 24th, 1974
PHOTOGRAPH BY TOM ROSE

RS 174 | ELTON JOHN
November 21st, 1974
PHOTOGRAPH BY ANNIE LEIBOVITZ

RS 175 | DUSTIN HOFFMAN
December 5th, 1974
PHOTOGRAPH BY STEVE SCHAPIRO

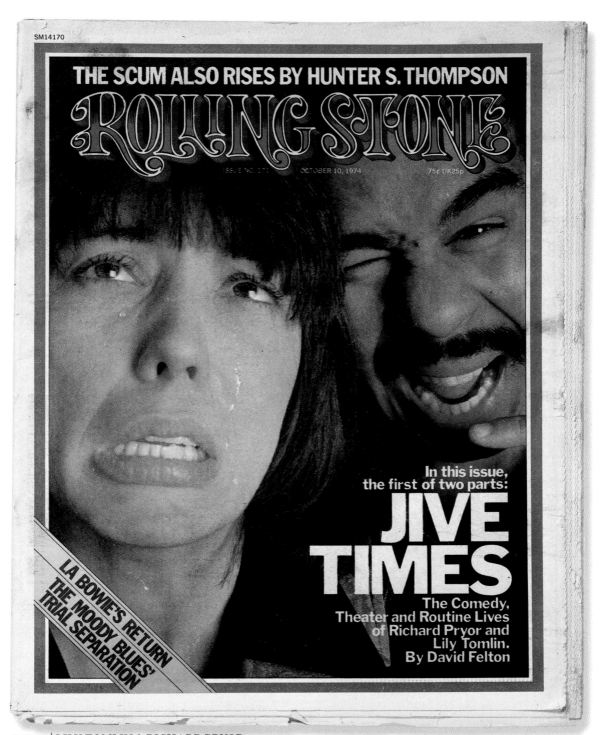

SM14170

Rolling Stone

ISSUE NO. 171 · OCTOBER 10, 1974 · 75¢ UK25p

In this issue,
the first of two parts:

JIVE TIMES

The Comedy,
Theater and Routine Lives
of Richard Pryor and
Lily Tomlin.
By David Felton

LA BOWIE'S RETURN
THE MOODY BLUES'
TRIAL SEPARATION

RS 171 | LILY TOMLIN & RICHARD PRYOR | October 10th, 1974 | Photograph by Annie Leibovitz

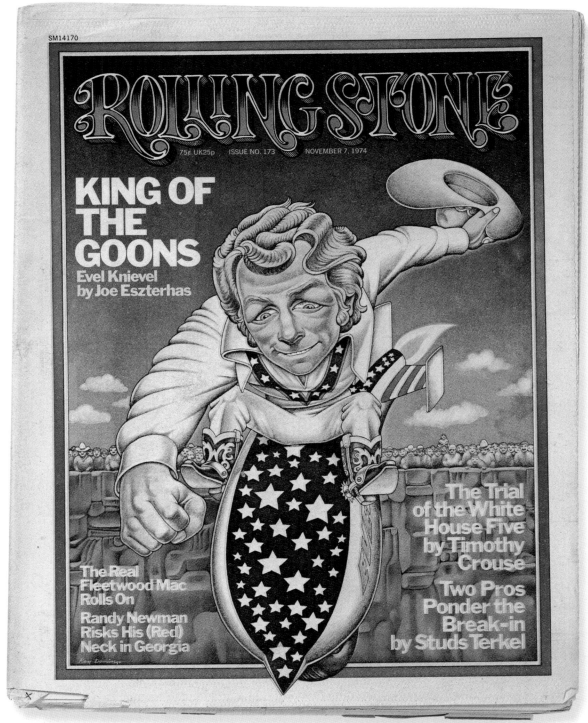

SM14170

ROLLING STONE

75¢ UK25p ISSUE NO. 173 NOVEMBER 7, 1974

KING OF THE GOONS

Evel Knievel
by Joe Eszterhas

The Real
Fleetwood Mac
Rolls On

Randy Newman
Risks His (Red)
Neck in Georgia

The Trial
of the White
House Five
by Timothy
Crouse

Two Pros
Ponder the
Break-in
by Studs Terkel

RS 173 | EVEL KNIEVEL | November 7th, 1974 | ILLUSTRATION BY RAY DOMINGO

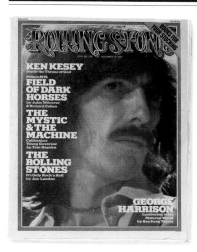

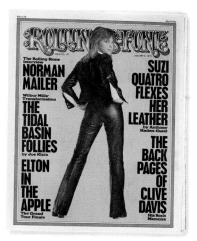

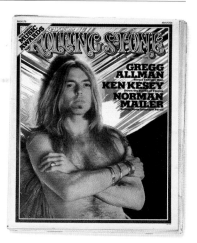

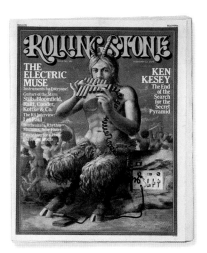

RS 176 | GEORGE HARRISON
December 19th, 1974
PHOTOGRAPH BY MARK FOCUS

RS 179 | FREDDIE PRINZE
January 30th, 1975
PHOTOGRAPH BY DON PETERSON

RS 177 | SUZI QUATRO
January 2nd, 1975
PHOTOGRAPH BY PETER GOWLAND

RS 180 | THE ELECTRIC
MUSE
February 13th, 1975
ILLUSTRATION BY PHIL CARROLL

RS 178 | GREGG ALLMAN
January 16th, 1975
PHOTOGRAPH BY PETE TURNER

RS 181 | KENNY LOGGINS
& JIM MESSINA
February 27th, 1975
PHOTOGRAPH BY ANNIE LEIBOVITZ

SM14170 APRIL 10th, 1975/ISSUE NO. 184 85¢UK30p

ROLLING STONE

1970s

What's Deaf, Dumb & Blind and Costs $3½ Million?

Tommy

Peter Bogdanovich and Cybill Shepherd Paint It White

Belfast, City of Sorrows by Gloria Emerson

A Big Hand for Little Feat

Rolling Stone Interview: Seymour Hersh, Toughest Reporter in America by Joe Eszterhas

The Secret Foreign Policy of Standard Oil: A Slippery Tale of Double Agents, Forgers and Arab Kings

RS 184 | ROGER DALTREY | April 10th, 1975 | PHOTOGRAPHER UNKNOWN

"THE QUEST TO LAND THE MAGAZINE'S first interview with Led Zeppelin was a rough one. The magazine had been tough on the band. Guitarist Jimmy Page vowed never to talk with them. While touring with the band for the *Los Angeles Times*, I attempted to talk them into speaking with me for ROLLING STONE, too. One by one they agreed, except for Page. I stayed on the road for three weeks, red-eyed from no sleep, until he finally relented . . . out of sympathy, I think. My mother was about ready to call the police to drag me home." —*Cameron Crowe*

LINDA RONSTADT WAS ALWAYS a lover. She learned about the birds and the bees, the boys and the girls, at age seven from a cousin who was one year older. In junior high in Tucson, Arizona, she started dressing up sexy. "I was trying to be Brigitte Bardot," she said. In rebellion against the nuns at the school – St. Peter and Paul – she went "boy crazy." At Catalina High, she went out with older men, among them a steel-guitar enthusiast with whom she left town at age 18. In Los Angeles, she sought a career in music and became the object of attention – the kind that led to too many wrong relationships, too many years of hating her own records and concerts, too many sad songs to sing and, today, to a still uncertain Linda Ronstadt.

[EXCERPT FROM RS 183 COVER STORY BY BEN FONG-TORRES]

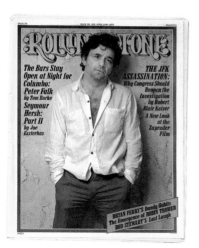

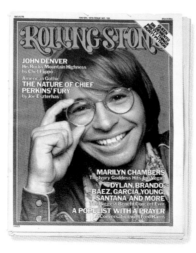

RS 182 | JIMMY PAGE
& ROBERT PLANT
March 13th, 1975
PHOTOGRAPH BY NEAL PRESTON

RS 185 | PETER FALK
April 24th, 1975
PHOTOGRAPH BY ANNIE LEIBOVITZ

RS 183 | LINDA RONSTADT
March 27th, 1975
PHOTOGRAPH BY ANNIE LEIBOVITZ

RS 186 | JOHN DENVER
May 8th, 1975
PHOTOGRAPH BY FRANCESCO SCAVULLO

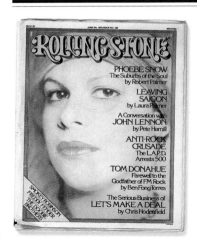

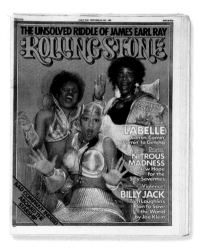

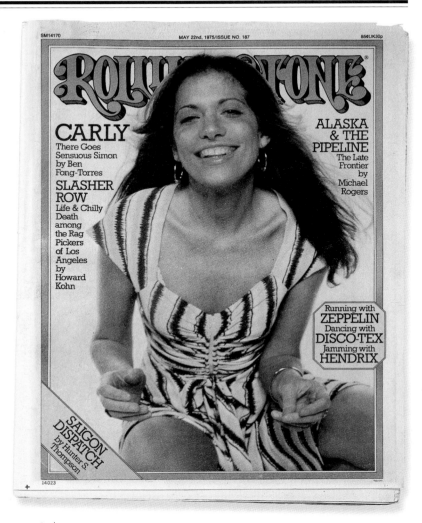

RS 188 | PHOEBE SNOW
June 5th, 1975
PHOTOGRAPH BY ANNIE LEIBOVITZ

RS 187 | CARLY SIMON
May 22nd, 1975
PHOTOGRAPH BY TONY LANE

RS 190 | LABELLE
July 3rd, 1975
PHOTOGRAPH BY HIRO

"ANNIE ALWAYS likes to get your shirt off by the end of the shoot." —Mick Jagger

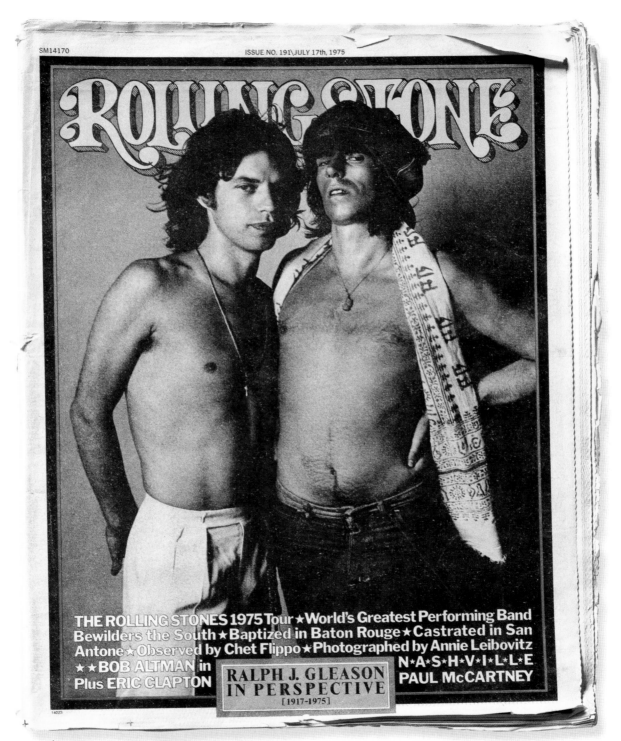

SM14170

ISSUE NO. 191\JULY 17th, 1975

ROLLING STONE

THE ROLLING STONES 1975 Tour ★ World's Greatest Performing Band Bewilders the South ★ Baptized in Baton Rouge ★ Castrated in San Antone ★ Observed by Chet Flippo ★ Photographed by Annie Leibovitz ★ BOB ALTMAN in Plus ERIC CLAPTON

RALPH J. GLEASON IN PERSPECTIVE [1917-1975]

N·A·S·H·V·I·L·L·E PAUL McCARTNEY

14023

RS 191 | MICK JAGGER & KEITH RICHARDS | July 17th, 1975 | Photograph by Annie Leibovitz

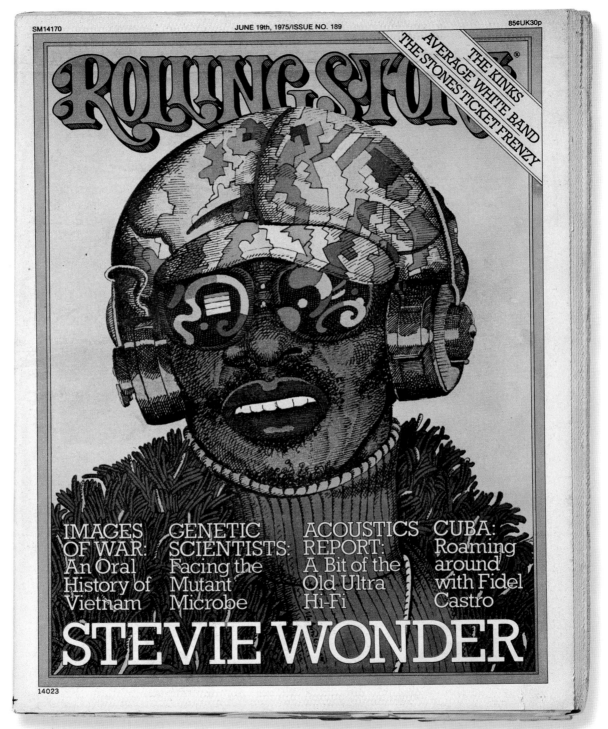

SM14170 JUNE 19th, 1975/ISSUE NO. 189 85¢UK30p

ROLLING STONE

THE KINKS
AVERAGE WHITE BAND
THE STONES TICKET FRENZY

IMAGES
OF WAR:
An Oral
History of
Vietnam

GENETIC
SCIENTISTS:
Facing the
Mutant
Microbe

ACOUSTICS
REPORT:
A Bit of the
Old Ultra
Hi-Fi

CUBA:
Roaming
around
with Fidel
Castro

STEVIE WONDER

14023

RS 189 | STEVIE WONDER | June 19th, 1975 | ILLUSTRATION BY MILTON GLASER

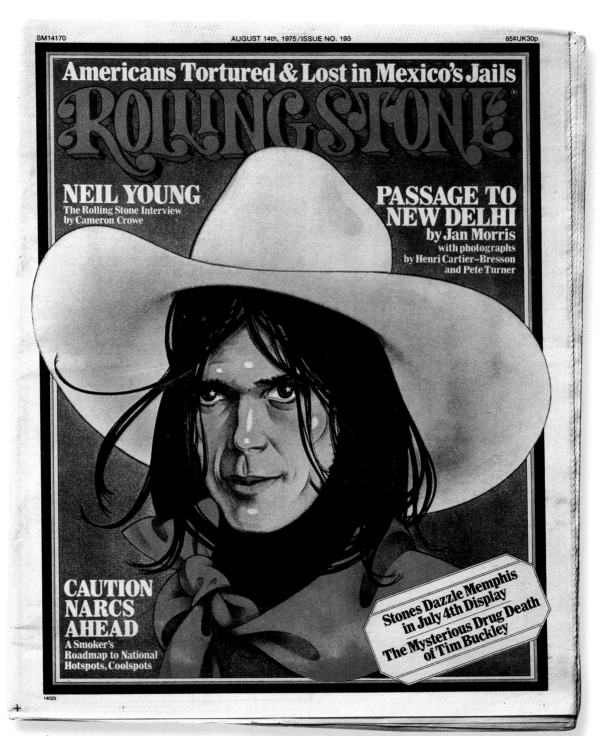

SM14170 AUGUST 14th, 1975 / ISSUE NO. 193 85¢UK30p

Americans Tortured & Lost in Mexico's Jails

ROLLING STONE

NEIL YOUNG
The Rolling Stone Interview
by Cameron Crowe

PASSAGE TO NEW DELHI
by Jan Morris
with photographs
by Henri Cartier-Bresson
and Pete Turner

CAUTION NARCS AHEAD
A Smoker's
Roadmap to National
Hotspots, Coolspots

Stones Dazzle Memphis
in July 4th Display
The Mysterious Drug Death
of Tim Buckley

14023

RS 193 | NEIL YOUNG | August 14th, 1975 | ILLUSTRATION BY KIM WHITESIDES

| RICHARD DREYFUSS
July 31st, 1975
PHOTOGRAPH BY BUD LEE

| DOONESBURY'S UNCLE DUKE
August 28th, 1975 | ILLUSTRATION BY GARRY TRUDEAU

[RS 194] This is the first of four covers that Pulitzer Prize–winning cartoonist Garry Trudeau has illustrated for ROLLING STONE. Doonesbury's gonzoid Uncle Duke arrived on the cover after he'd been appointed governor of American Samoa. The character infuriated the real Raoul Duke, Hunter S. Thompson, on whom the character is directly based. (Thompson had once claimed that Democratic Party Chairman Larry O'Brien had offered him the governorship.) Thompson said of Trudeau, characteristically, "If I ever catch that little bastard, I'll rip his lungs out."

88 • ROLLING STONE

ROLLING STONE

ROLLING STONES

Jumping, Booming, Bumping, Grinding to a Halt. Chronicled by Jonathan Cott, Dave Marsh, Jann Wenner & Annie Leibovitz

The Rolling Stone Interview with

ELDRIDGE CLEAVER

His Bold New Allegiance to the Flag and to the Republic for Which It Stands

Ganja Din:

REGGAE'S HAIRY EXPLOSION

Bob Marley & the Wailers
Toots and the Maytals
Secrets of Rasta Revealed!

14023

RS 195 | MICK JAGGER | September 11th, 1975 | Photograph by Annie Leibovitz

THE WEATHER UNDERGROUND, TAKE ONE On Location with Bernardine Dohrn and Co.

ROLLING STONE

1970s

Rod Stewart and His New Pal Britt Ekland

The Most Brilliant Sci-Fi Mind on Any Planet: Philip K. Dick

Afternoon of the Living Dead: Flashing Back with Garcia and Friends

RS 199 | ROD STEWART & BRITT EKLAND | November 6th, 1975 | PHOTOGRAPH BY ANNIE LEIBOVITZ

IN THE PROMISED LAND BY THOMAS POWERS

ROLLING STONE

NEIL SEDAKA
SECOND STAIRWAY TO HEAVEN

AEROSOL APOCALYPSE
BY MICHAEL ROGERS

ELTON'S FINEST HOUR

JACK NICHOLSON
CRAZY CHRIST OF THE CUCKOO'S NEST BY TIM CAHILL

WHITESIDES

DYLAN'S FAMOUS FOLKIE SHOW
JOAN BAEZ, RAMBLIN' JACK ELLIOTT, BOBBY NEUWIRTH, DAVID BLUE, RONEE BLAKLEY AND... ALLEN GINSBERG!

RS 201 | JACK NICHOLSON | December 4th, 1975 | ILLUSTRATION BY KIM WHITESIDES

1970S

[RS 198 AND RS 200] **About this groundbreaking scoop, the editors wrote: "To obtain the interviews, Howard Kohn and David Weir had to promise they would go to jail before revealing the names of their sources (a promise they would have made in any case). They were not allowed to tape the interviews, so to keep things as accurate as possible, separate notes were taken by the two journalists and Alison Weir, an editor of *Womensports*. The material was then checked with independent outside sources. The entire process – negotiations, interviews, research and writing – took four months, during which time Kohn and Weir retraced Patty's trail across America, including a visit to the farmhouse rented by Jack and Micki Scott in Pennsylvania. Ironically, as the layouts were being readied for the printer, Patty Hearst and the Harrises were apprehended in San Francisco. But the narrative remains a scoop in itself – the first detailed account of Tania's conversion, her paranoid flights across the country, her hiding out with the Scotts. Part Two will cover her life leading up to the bust, secret meetings between her friends and her parents and how the FBI finally broke the case. You might want to send $1 (for the issue plus postage) to Inside Story, Rolling Stone, 625 Third Street, San Francisco, CA 94107, and get Part Two before the FBI."**

SM14170 OCTOBER 25th, 1975/ISSUE NO. 198 85¢UK30p

Rolling Stone

THE INSIDE STORY

By HOWARD KOHN AND DAVID WEIR
Copyright© 1975 ROLLING STONE. All rights reserved.

PATTY HEARST and Emily Harris waited on a grimy Los Angeles street, fighting their emotions as they listened to a radio rebroadcasting the sounds of their friends dying. On a nearby corner Bill Harris dickered over the price of a battered old car.

Only blocks away, rifle cartridges were exploding in the dying flames of a charred bungalow. The ashes were still too hot to retrieve the bodies of the six SLA members who had died hours before on the afternoon of May 17th, 1974.

Bill Harris shifted impatiently as the car's owner patted a dented fender. "I want five bills for this mother."

The SLA survivors had only $400. Reluctantly Harris offered $350. The man quickly pocketed the money.

Minutes later Bill picked up Patty and Emily and steered onto a freeway north to San Francisco. They drove all night —the Harrises in the front seat of the noisy car and Patty in back, hidden under a blanket. They were too tense to sleep, each grappling with the aftershock of the fiery deaths.

They exited twice at brightly lit service station clusters that flank Interstate 5, checking out each before picking what looked like the safest attendant. They made no other

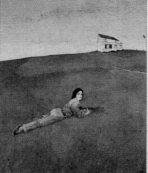

stops and reached San Francisco in the predawn darkness.

The three fugitives drove to a black ghetto with rows of ramshackle Victorians—and sought out a friend. Bill and Emily's knocks brought the man sleepy-eyed to the door.

"You're alive!" Then he panicked. "You can't stay here. The whole state is gonna be crawling with pigs looking for you." He gave them five dollars and shut the door. "Don't come back."

The Harrises returned to the car and twisted the ignition key. Patty poked her head out from under the blanket. "What's the matter? Why won't it start?"

The fugitives had no choice —to continue fiddling with the dead battery might attract attention—so they abandoned the car. Walking the streets, however, was a worse alternative.

"C'mon Tania," said Emily. "You better bring the blanket." Bill and Emily both carried duffel bags. Inside were weapons, disguises and tattered books.

A few blocks away, under a faded Victorian, they spotted a crawl space, a gloomy cave for rats and runaway dogs. As Patty and the Harrises huddled in the dirt under the old house, the noise of a late-night party began in the living room above. Patty gripped her homemade machine gun. "The pigs must have found the car!"

"Shhh," came a whispered response. "Shut up, goddamnit. Please shut up!"

[Continued on page 41]

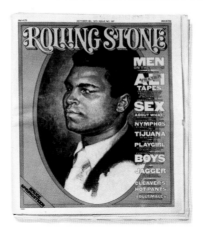

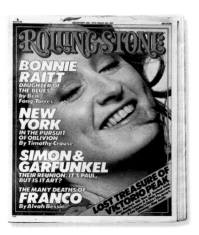

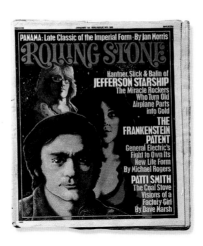

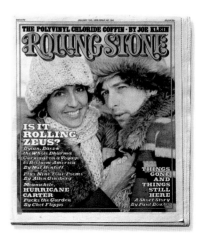

RS 196 | THE EAGLES
September 25th, 1975
PHOTOGRAPH BY NEAL PRESTON

RS 202 | BONNIE RAITT
December 18th, 1975
PHOTOGRAPH BY BILL KING

RS 197 | MUHAMMAD ALI
October 9th, 1975
ILLUSTRATION BY BRUCE WOLFE

RS 203 | JEFFERSON
STARSHIP
January 1st, 1976
ILLUSTRATION BY GREG SCOTT

RS 200 | THE PATTY
HEARST STORY, PART TWO
November 20th, 1975
PHOTOGRAPH BY TONY LANE

RS 204 | JOAN BAEZ
& BOB DYLAN
January 15th, 1976
PHOTOGRAPH BY KEN REGAN

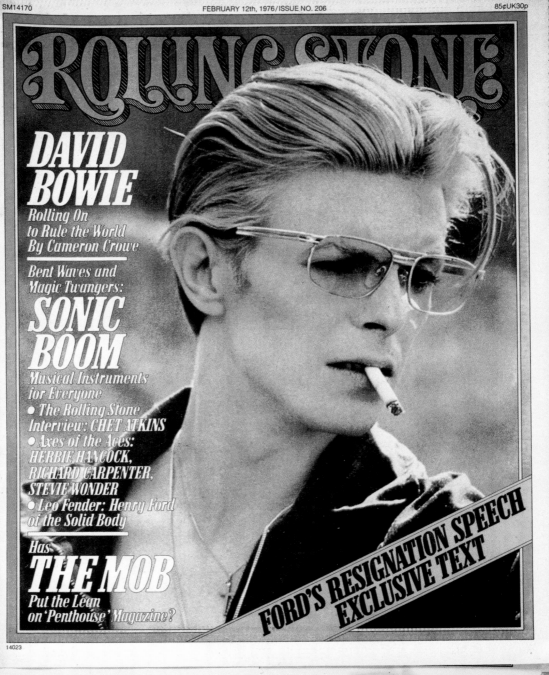

SM14170 FEBRUARY 12th, 1976/ISSUE NO. 206 85¢UK30p

ROLLING STONE

DAVID BOWIE

Rolling On
to Rule the World
By Cameron Crowe

Bent Waves and
Magic Twangers:

SONIC BOOM

Musical Instruments
for Everyone
• The Rolling Stone
Interview: CHET ATKINS
• Axes of the Aces:
HERBIE HANCOCK,
RICHARD CARPENTER,
STEVIE WONDER
• Leo Fender: Henry Ford
of the Solid Body

Has
THE MOB
Put the Lean
on 'Penthouse' Magazine?

**FORD'S RESIGNATION SPEECH
EXCLUSIVE TEXT**

14023

RS 206 | DAVID BOWIE | February 12th, 1976 | Photograph by Steve Schapiro

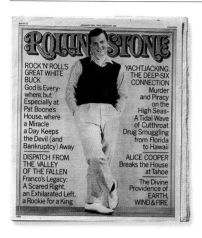

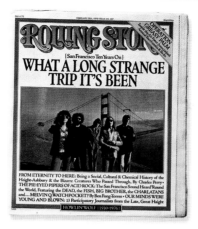

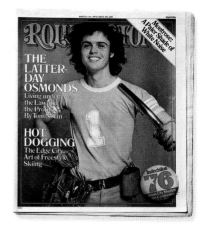

RS 205 | PAT BOONE
January 29th, 1976
PHOTOGRAPH BY BRUNO OF HOLLYWOOD

"THE CAMERA NEVER LIES. IN this case [RS 206], it only tells half the story. With a small target set up a few yards away, [I'd been] taking potshots with an oversized pistol. The gun was a present from one of my mid-Seventies 'friends.' I was definitely under the impression that I was merely 'passing through this world.' I didn't care where I came from and cared less where I was going; the present was futile and surreal. I ate little, but ingested a critically unfair amount of chemicals. . . ."
—*David Bowie*

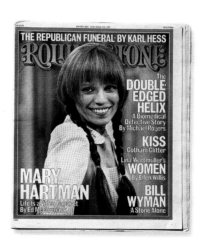

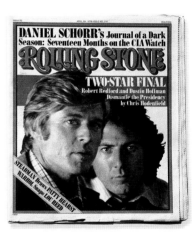

RS 207 | SAN FRANCISCO ROCKERS
February 26th, 1976
PHOTOGRAPH BY JIM MARSHALL

RS 209 | LOUISE LASSER
March 25th, 1976
PHOTOGRAPH BY BILL EPPRIDGE

RS 208 | DONNY OSMOND
March 11th, 1976
PHOTOGRAPH BY ANNIE LEIBOVITZ

RS 210 | ROBERT REDFORD & DUSTIN HOFFMAN
April 8th, 1976
PHOTOGRAPH BY STANLEY TRETICK

[RS 211] For this issue, Jann Wenner commissioned two photographs of Peter Frampton by two different photographers, was talked into using one image, then changed his mind and insisted on the other shot the day the cover was due to the printer. Different photographs appeared on early and later shipments.

It's like stepping into a scene

from *Blow-Up.* The white walls of Francesco Scavullo's Manhattan studio are covered with black-and-white portraits of blank-expressioned models. Young male assistants scurry around, each of them trying to act more hassled than the next.

In another room, looking very much out of place, twenty-five-year-old Peter Frampton waits to have his picture taken for the cover of ROLLING STONE. He squirms while a makeup man dabs colors on his cheeks and eyelids, readying him for a session with one of the world's most renowned fashion photographers. It's all happening so fast. Three months ago, Frampton was just another hardworking British rocker, crisscrossing the country with a four-album repertoire. Today, he is the brightest new star of '76.

Frampton pries himself away from the makeup man to greet his visitor. "You mean you still recognize me?" he jokes a little uneasily. "I'm in such a daze. Do you believe all that's happened? Number One? Do you believe it? What a giggle." He is quickly led before the camera and the blitz-clicking is on.

[EXCERPT FROM RS 211 COVER STORY BY CAMERON CROWE]

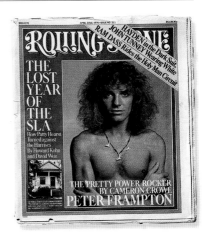

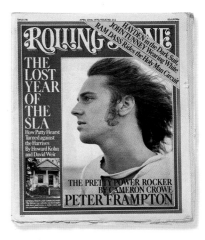

RS 211 | PETER FRAMPTON
April 22nd, 1976
PHOTOGRAPH BY FRANCESCO SCAVULLO

RS 211 | PETER FRAMPTON
April 22nd, 1976
PHOTOGRAPH BY BUD LEE

1970s

SM14170　　　　MAY 6th, 1976/ISSUE NO. 212　　　　85¢UK30p

ROLLING STONE

SEVEN MASTERS OF PHOTOGRAPHY
Ansel Adams, Avedon, Cartier-Bresson, J.H. Lartigue, Helmut Newton, Ken Regan and Warhol By Annie Leibovitz

BLOODSHED IS MY BUSINESS
The Hair-Curling Exploits of John Dane, International Mercenary, Troublemaker and Gentleman

KING QUEEN
Meet Steve Ostrow, Pitchman for the Pansexual Revolution By Tom Burke

The Mission Street Mystic Returns to His Earthy Ways By Rich Wiseman

SANTANA COMES HOME

14023

RS 212 | CARLOS SANTANA | May 6th, 1976 | PHOTOGRAPH BY ANNIE LEIBOVITZ

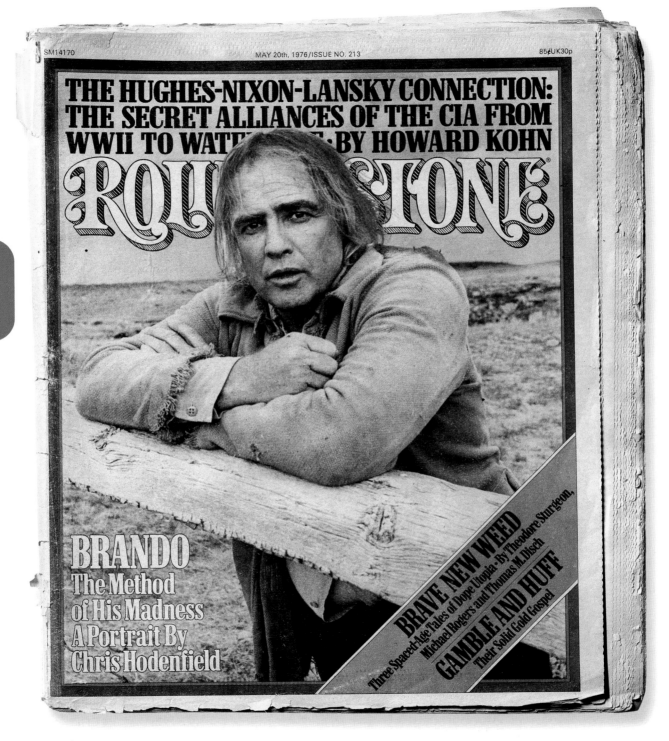

SM14170 MAY 20th, 1976/ISSUE NO. 213 85¢ UK30p

THE HUGHES-NIXON-LANSKY CONNECTION:
THE SECRET ALLIANCES OF THE CIA FROM
WWII TO WATERGATE · BY HOWARD KOHN

ROLLING STONE

BRANDO
The Method
of His Madness
A Portrait By
Chris Hodenfield

BRAVE NEW WEED
Three Spaced-Age Tales of Dope Utopia · By Theodore Sturgeon,
Michael Rogers and Thomas M. Disch

GAMBLE AND HUFF
Their Solid Gold Gospel

1970s

RS 213 | MARLON BRANDO | May 20th, 1976 | PHOTOGRAPH BY MARY ELLEN MARK

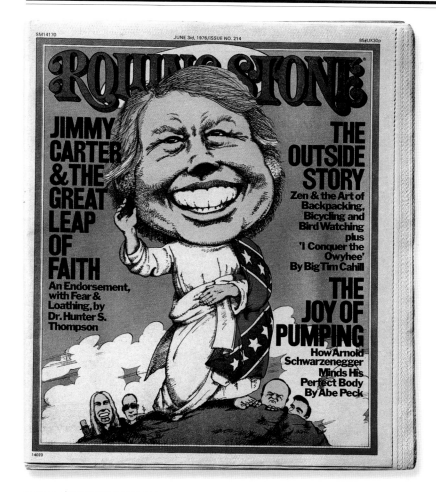

SM14170 JUNE 3rd, 1976/ISSUE NO. 214 85¢UK30p

ROLLING STONE

JIMMY CARTER & THE GREAT LEAP OF FAITH

An Endorsement, with Fear & Loathing, by Dr. Hunter S. Thompson

THE OUTSIDE STORY
Zen & the Art of Backpacking, Bicycling and Bird Watching
plus
'I Conquer the Owyhee'
By Big Tim Cahill

THE JOY OF PUMPING
How Arnold Schwarzenegger Minds His Perfect Body
By Abe Peck

14023

RS 214 | JIMMY CARTER | June 3rd, 1976 | ILLUSTRATION BY GREG SCOTT

"Jimmy Carter's Law Day speech was and still is the heaviest and most eloquent thing I have ever heard from the mouth of a politician."

—*Hunter S. Thompson*

"WHEN I FIRST HOISTED MYSELF into Marlon Brando's Dodge van, I was struggling badly with the electric shakes. It was the summer of 1975, and in the world of maximum-charisma actors, Brando was the unassailable king. Jack Nicholson had warned me that whatever I imagined Brando was going to be, in person he was going to be a *lot more.* You'd have thought I was meeting Mao Ze-dong.

"I was but a fresh-faced, longhaired punk, just twenty-five, in a psychedelic shirt out of *Arabian Nights.* I had flown to Montana on the promise of getting perhaps an hour with Brando, who was there filming *The Missouri Breaks.* The reasons for my stroke of good fortune were not entirely clear. Something I had written about director Robert Altman had appealed to one of Brando's allies. But the real reason, I expect, was that I was carrying credentials from ROLLING STONE.... Brando had a subscription. When Daniel Schorr wrote a big story about the CIA, for instance, Brando would call down for ten extra copies. A ROLLING STONE guy would want to know if the situation was cool....

"The only other person I would meet with an equal physical force field would be Kareem Abdul-Jabbar, who is seven feet tall. As I sat with Brando for what turned out to be a week of conversation, I was hanging onto a runaway train. But I had the ROLLING STONE writer's attitude to remind me that, loud shirt and all, I was in charge."

—*Chris Hodenfield*

*No one seems perturbed that the
leader of Wings is not on the loose,
the way a Robert Plant or Roger
Daltrey or Mick Jagger seems to be.
And even if they're married, they
don't display their wives up onstage
with them.*

I used to think of that, when
we first got together, had Linda
in the group. Oh, oh, we've had
it with the groupies now!
Everyone's gonna think we're
real old squares – *blimey!*
Married! God, at least we could
have just lived together or
something – that would have
been a bit hip. Then you realize
it doesn't matter. They really
come for the music. At first it
did seem funny to be up there
with a wife instead of just
friends or people associated
with the game. But I think
the nice thing that's happened
is it seems to be part of a trend
anyway, where women are
getting in a bit more, families
are a bit cooler than they were.
Things change.

[EXCERPT FROM PAUL McCARTNEY
INTERVIEW BY BEN FONG-TORRES]

1970s

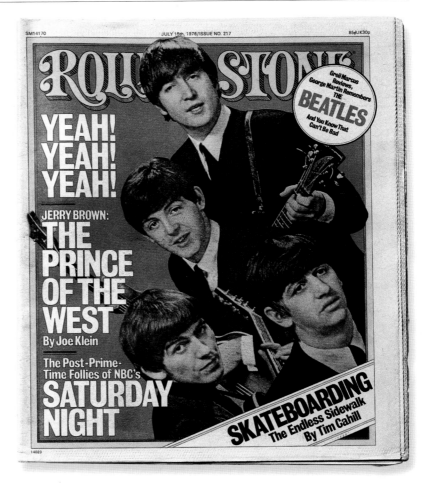

RS 217 | THE BEATLES | July 15th, 1976 | PHOTOGRAPH BY JOHN ZIMMERMAN

There's not a reason in the world to
think that were John, Paul, George and Ringo to
get together today they'd do more than bump into
each other. Yet when geniuses collide . . . whoever
said pop dreams were rational? Hearing what the
Beatles did, one can hardly suppress the desire to
turn artifact back into process.

[EXCERPT FROM RS 217 COVER STORY
BY GREIL MARCUS]

SM14170

JUNE 17th, 1976/ISSUE NO. 215

85¢UK30p

ROLLING STONE®

YESTERDAY TODAY & PAUL

A Beatle on the Wing,
a Band on the Run...
but Not Quite
the Act
You've Known
for All These Years
By Ben Fong-Torres

STEVE MILLER

More Disguises from the
Gangster of Love

THE ART OF UNCLOTHING THE EMPEROR

Jonathan Cott Meets
ORIANA FALLACI in the
Rolling Stone Interview

BUKOWSKI IN THE RAW

The Dirtiest Old Man in L.A.

14023

"I STARTED TO follow musical examples, not sociological examples. I realized that how you dressed or how you looked or what you said wasn't as important as whether you had the musical goods.

"I could certainly see George Gershwin as somebody to measure against. Leonard Bernstein is somebody to measure against. Which is not to say that I aspire to write songs like Leonard Bernstein or George Gershwin. But there was an excellence they achieved that was right for their time. . . .

"I don't feel that it is truly significant that my record goes to Number One or that I win a Grammy. Those things are pleasant rewards. . . . But I understand there's a higher standard that can be applied to the work. And then there's a higher standard even than that. When you get to be Gershwin, that doesn't make you Bartók."

—*Paul Simon*

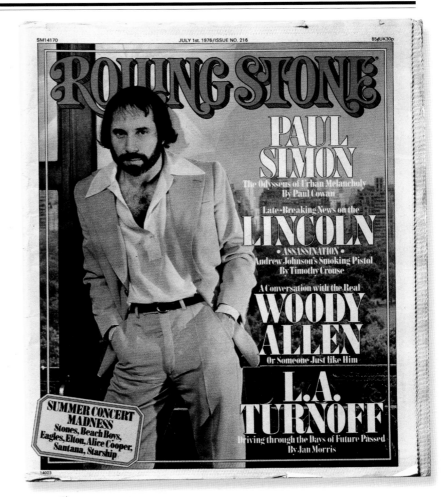

RS 216 | PAUL SIMON | July 1st, 1976 | PHOTOGRAPH BY ANNIE LEIBOVITZ

RS 218 | JACK FORD | July 29th, 1976 | PHOTOGRAPH BY ANNIE LEIBOVITZ

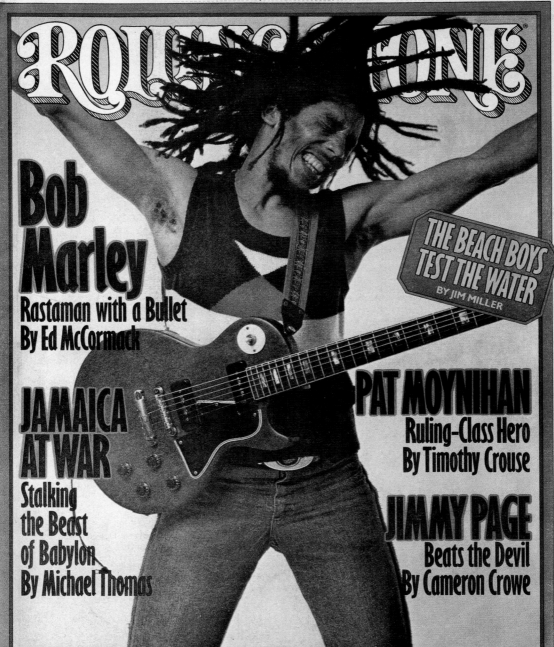

ROLLING STONE

Bob Marley
Rastaman with a Bullet
By Ed McCormack

THE BEACH BOYS
TEST THE WATER
BY JIM MILLER

JAMAICA AT WAR
Stalking the Beast of Babylon
By Michael Thomas

PAT MOYNIHAN
Ruling-Class Hero
By Timothy Crouse

JIMMY PAGE
Beats the Devil
By Cameron Crowe

1970s

14023

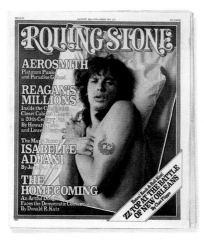

RS 219 | BOB MARLEY
August 12th, 1976
PHOTOGRAPH BY ANNIE LEIBOVITZ

"I FOUND THAT by taking the studio to the person, it looked like they posed for our cover and it built our credibility. With Bob Marley, I set up a studio in his dressing room and waited around. After two nights he started to feel sorry for me and posed for the cover shot."

—*Annie Leibovitz*

RS 220 | STEVEN TYLER
August 26th, 1976
PHOTOGRAPH BY ANNIE LEIBOVITZ

RS 222 | NEIL DIAMOND
September 23rd, 1976
PHOTOGRAPH BY ANNIE LEIBOVITZ

RS 221 | DOONESBURY'S GINNY SLADE & JIMMY THUDPUCKER
September 9th, 1976
ILLUSTRATION BY GARRY TRUDEAU

RS 223 | ELTON JOHN
October 7th, 1976
PHOTOGRAPH BY DAVID NUTTER

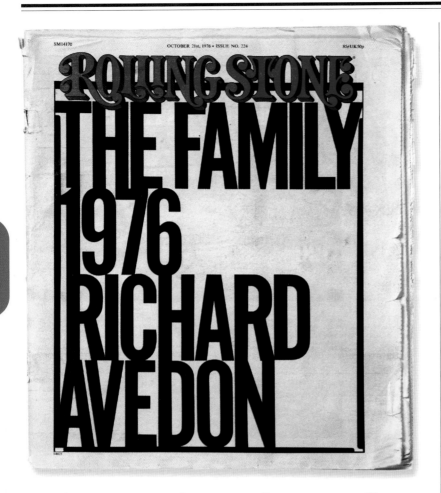

$R_{\mathcal{S}}$ 224 | RICHARD AVEDON'S PORTFOLIO "THE FAMILY 1976"
October 21st, 1976 | TYPOGRAPHY BY ELIZABETH PAUL

Early this year we asked Richard Avedon – one of the world's greatest photographers – to cover America's bicentennial presidential election. Our original idea was to publish a chronicle of the campaign – the candidates and the conventions – from beginning to end. Shortly after accepting our commission, Mr. Avedon called to say that there was more to the election than met the eye; that the real story was not simply the candidates, but a broad group of men and women – some of whom we had never heard of before – who constitute the political leadership of America. Thus began a special issue of ROLLING STONE, a collection of seventy-three portraits. This project was edited by Renata Adler, author of *Toward a Radical Middle* and the recently published novel *Speedboat.* Aside from the accompanying *Who's Who* biographies, there is no text; we think the portraits speak for themselves. [RS 224 EDITORS' NOTE]

$R_{\mathcal{S}}$ 225 | BRIAN WILSON
November 4th, 1976
PHOTOGRAPH BY ANNIE LEIBOVITZ

"BRIAN SEEMS to be on acid all the time. . . . except when he's in his room, where he's completely normal."

—*Annie Leibovitz*

I HAVE A WRITING BLOCK RIGHT NOW. Even today I started to sit down to write a song, and there was a block there. God knows what that is. Unless it's supposed to be there. I mean, it's not something you just kick and say, "Come on, let's go, let's get a song writ." If the block is there, it's there.

I believe that writers run out of material, I really do. I believe very strongly in the fact that when the natural time is up, writers actually do run out of material. To me, it's black-and-white. When there's a song, there's a song; when there's not, there's not. Of course, you run out, maybe not indefinitely, but everybody that writes runs out of some material for a while. And it's a very frightening experience. . . .

Another thing, too, is that I used to write on pills. I used to take uppers and write, and I used to like that effect. In fact, I'd like to take uppers now and write, because they give me, you know, a certain lift and a certain outlook. And it's not an unnatural thing. I mean, the pill might be unnatural and the energy, but the song itself doesn't turn out unnatural on the uppers. The creativity flows through. I'm thinking of asking the doctor if I can go back to those, yeah.

[EXCERPT FROM BRIAN WILSON INTERVIEW BY DAVID FELTON]

SM14170 NOVEMBER 4th, 1976 • ISSUE NO. 225 85¢ UK50p

ROLLING STONE

THE HEALING OF BROTHER BRIAN

A Multitrack Interview with Beach Boys Brian, Dennis, Carl, Mike and Al, plus Brian's Mom, His Dad, His Wife and His Shrink By David Felton

DRAWING FIRE: BILL MAULDIN

and His 35-Year Fight for Truth, Justice and the American Way By Donald R. Katz

GREGG ALLMAN'S UNHAPPY CONFESSIONS

14023

"BEFORE I OPENED THE BOX, I gave her a fifteen-minute preamble. 'Now Linda, this is a little far-out, let's try something real different. A fantasy.' I was scared stiff she would flip out. But I opened the box, and she just died. She loved it and put it on immediately. She sent her art director out to get red nail polish to match the underwear."
— *Annie Leibovitz*

1970s

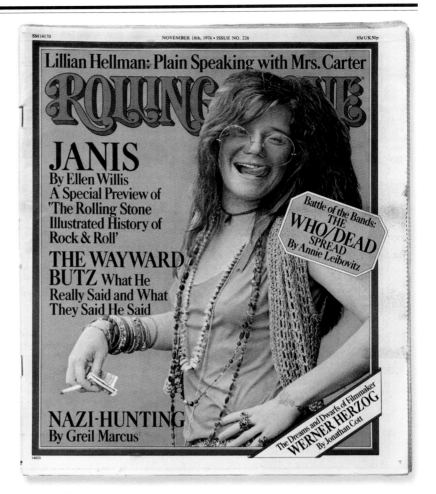

SM14170 NOVEMBER 18th, 1976 • ISSUE NO. 226 85¢ UK 50p

Lillian Hellman: Plain Speaking with Mrs. Carter

ROLLING STONE

JANIS
By Ellen Willis
A Special Preview of 'The Rolling Stone Illustrated History of Rock & Roll'

THE WAYWARD BUTZ What He Really Said and What They Said He Said

Battle of the Bands: THE WHO/DEAD SPREAD By Annie Leibovitz

NAZI-HUNTING
By Greil Marcus

The Dreams and Dwarfs of Filmmaker WERNER HERZOG By Jonathan Cott

RS 226 | JANIS JOPLIN | November 18th, 1976 | PHOTOGRAPH BY DAVID GAHR

Janis Joplin belonged to that select group of pop figures who matter as much for themselves as for their music; among American rock performers she was second only to Bob Dylan in importance as a creator/recorder/embodiment of her generation's history and mythology. She was also the only woman to achieve that kind of stature in what was basically a male club, the only Sixties culture hero to make visible and public women's experience of the quest for individual liberation, which was very different from men's. If Janis's favorite metaphors – singing as fucking (a first principle of rock & roll) and fucking as liberation (a first principle of the cultural revolution) – were equally approved by her male peers, the congruence was only on the surface. Underneath – just barely – lurked a feminist (or prefeminist) paradox.

[EXCERPT FROM RS 226 COVER STORY BY ELLEN WILLIS]

SM14170

DECEMBER 2nd, 1976 • ISSUE NO. 227

85¢ UK50p

ROLLING STONE

Linda Ronstadt

The Million-Dollar Woman

THE RAPE OF

Jimi Hendrix

A Scandal of Lawsuits and Laundered Money

THE NATURAL ACTS OF WINTER

Outside!

Adventure by Tim Cahill, Fiction by Michael Rogers, plus Hardware-Software and the Armchair Rambler

14023

SM14170

DECEMBER 16th, 1976 · ISSUE NO. 228

85¢ UK 50p

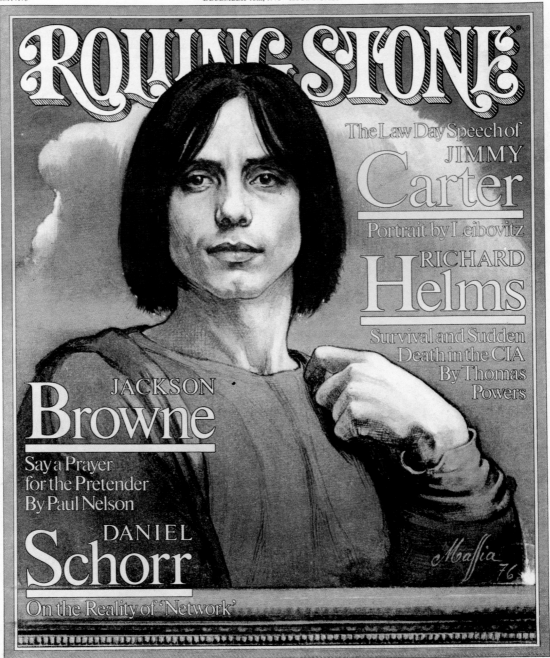

ROLLING STONE

The Law Day Speech of
JIMMY
Carter
Portrait by Leibovitz
RICHARD
Helms
Survival and Sudden
Death in the CIA
By Thomas
Powers

JACKSON
Browne
Say a Prayer
for the Pretender
By Paul Nelson

DANIEL
Schorr
On the Reality of 'Network'

Maffia 76

14023

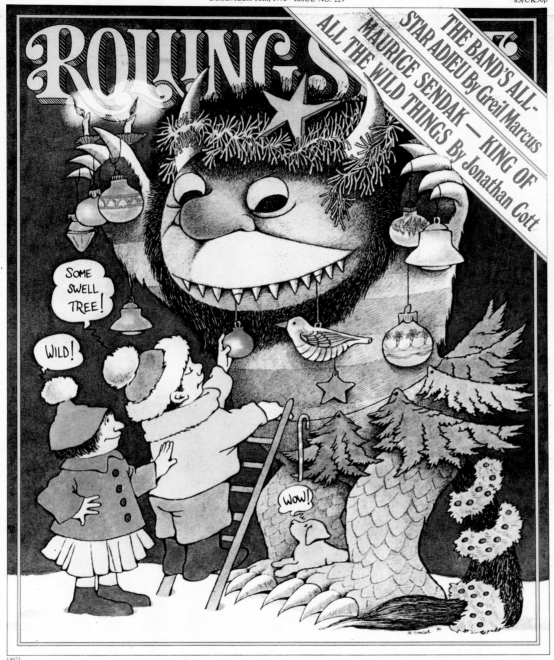

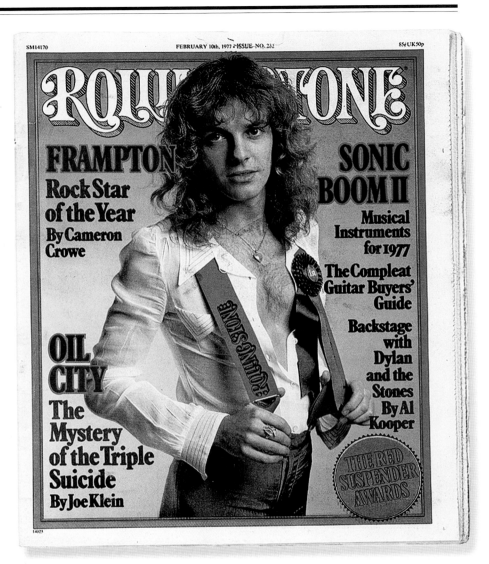

RS 230 | ROD STEWART
January 13th, 1977
PHOTOGRAPH BY DAVID MONTGOMERY

RS 232 | PETER FRAMPTON
February 10th, 1977
PHOTOGRAPH BY ANNIE LEIBOVITZ

RS 231 | JEFF BRIDGES
January 27th, 1977
PHOTOGRAPH BY ANNIE LEIBOVITZ

RS 234 | PRINCESS
CAROLINE
March 10th, 1977
PHOTOGRAPH BY NORMAN PARKINSON

1970s

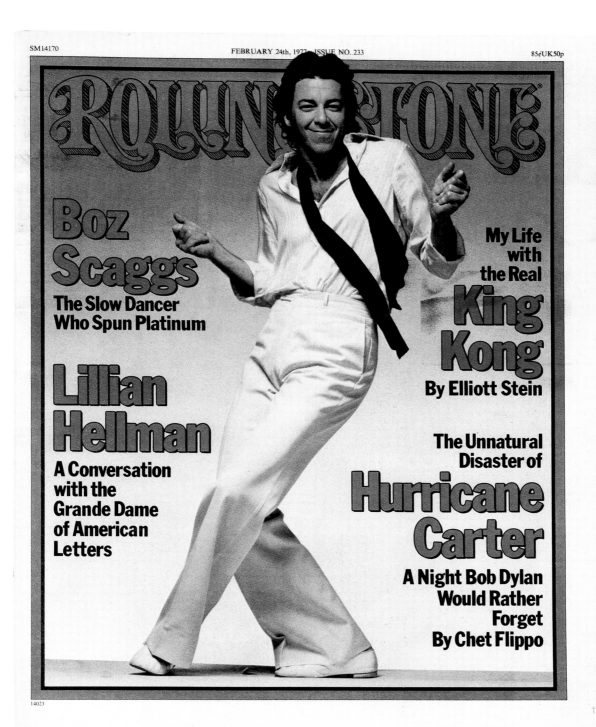

SM14170

85¢UK50p

ROLLING STONE

Boz Scaggs
The Slow Dancer Who Spun Platinum

Lillian Hellman
A Conversation with the Grande Dame of American Letters

My Life with the Real King Kong
By Elliott Stein

The Unnatural Disaster of Hurricane Carter
A Night Bob Dylan Would Rather Forget By Chet Flippo

14023

RS 233 | BOZ SCAGGS | February 24th, 1977 | PHOTOGRAPH BY ANNIE LEIBOVITZ

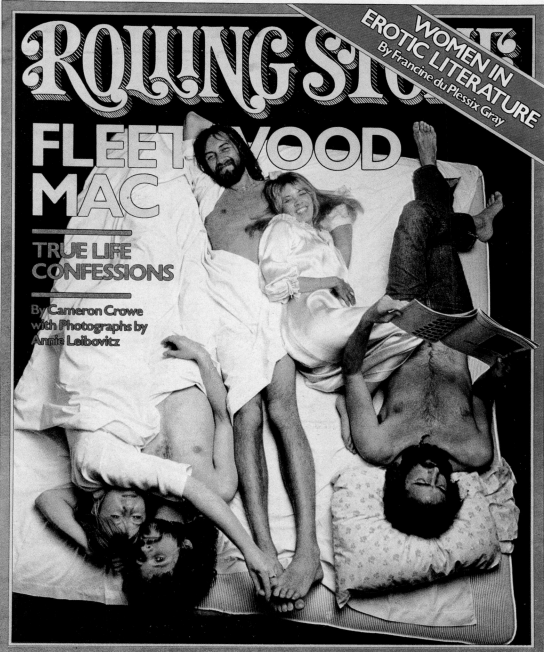

SM14170 MARCH 24th, 1977 • ISSUE NO. 235 $1.00

ROLLING STONE

WOMEN IN EROTIC LITERATURE
By Francine du Plessix Gray

FLEETWOOD MAC

TRUE LIFE CONFESSIONS

By Cameron Crowe
with Photographs by
Annie Leibovitz

1970s

14023

RS 235 | FLEETWOOD MAC
March 24th, 1977
PHOTOGRAPH BY ANNIE LEIBOVITZ

"[FLEETWOOD MAC] was sort of a soap opera – who was with whom, someone had just split up with another one. It was as if each one of them was sort of jumping from bed to bed. It seems like they'd all passed through each other's lives yet were still a *band*."

—*Annie Leibovitz*

RS 237 | DARYL HALL
& JOHN OATES
April 21st, 1977
PHOTOGRAPH BY ANNIE LEIBOVITZ

RS 239 | HAMILTON JORDAN
& JODY POWELL
May 19th, 1977
PHOTOGRAPH BY ANNIE LEIBOVITZ

RS 238 | MARK FIDRYCH
May 5th, 1977
PHOTOGRAPH BY ANNIE LEIBOVITZ

RS 241 | ROBERT DE NIRO
June 16th, 1977
PHOTOGRAPH BY LEONARD DE RAEMY

[RS 238] Mark Fidrych, 1976's Rookie of the Year, is the only baseball player to appear on the cover of ROLLING STONE. The six-foot-three Detroit Tigers all-star pitcher – nicknamed "the Bird" for his resemblance to Big Bird from *Sesame Street* – failed to live up to this early promise.

SM14170
APRIL 7th, 1977 • ISSUE NO. 236
85¢UK50p

ROLLING STONE

Bad Days for the ROLLING STONES

LILY TOMLIN'S
Broadway Baby
BY DAVID FELTON

ODYSSEY & ECSTASY
Search for Life on Mars
BY TIMOTHY FERRIS

KISS
Pagan Beasties of Teenage Rock
BY CHARLES M. YOUNG

INDIAN–FBI WAR
Execution at Pine Ridge

1970s

RS 236 | LILY TOMLIN | April 7th, 1977 | PHOTOGRAPH BY ANNIE LEIBOVITZ

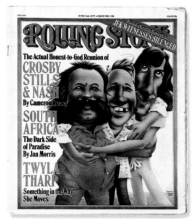

RS 240 | CROSBY,
STILLS & NASH
June 2nd, 1977
ILLUSTRATION BY ROBERT GROSSMAN

So Crosby, Stills and Nash –
CSN – are back together. It's 1977, eight years
since their first and only album became a rallying
point for a budding Woodstock generation. But
now Richard Nixon is out of office, the war is over,
marijuana is slowly being "decriminalized," and
a Democrat is in the White House. Rock music
is bigger business than ever, and artists like
Peter Frampton and Fleetwood Mac easily outsell
the entire CSN catalogue (with or without Neil
Young) with a single album.

And yet Young is back with his band, Crazy
Horse, and CSN are back in the studio. Another turn around the wheel . . .

There was a time in late 1970, with *Déjà Vu* at its peak, when CSNY were
just about the American Beatles. The four of them had clear and separate,
slightly adversary identities: Crosby, the former Byrd, the political voice,
the California dreamer; Nash, the Briton, the former Hollie, the spiritually
hungry searcher; Stills, the guitar hero from Buffalo Springfield; and Young,
the brooding dark horse from Canada. They were, at once, steeped in
mystique and still the guys next door. . . .

In 1970, after less than two years, CSNY shattered into four directions
several months after recording the single "Ohio," backed, ironically, with
"Find the Cost of Freedom." . . . But every year or so there was a tease. At
least three times they announced attempts to record another CSNY studio
album, but each one collapsed in bitterness. In their place, bands like the
Eagles, whose members once idolized them, emerged.

And then, two months ago, I got a phone call and invitation from Crosby:
"We're doin' it, man. It's CSN, just us this time, and it's coming out. C'mon
down and have a listen." A plane flight later, I learned that he was right. For
the first time since those nights in 1969, Crosby, Stills and Nash are in
harmony. Only one question: Does anybody out there still care?

[EXCERPT FROM RS 240 COVER STORY BY CAMERON CROWE]

RS 242 | DIANE KEATON
June 30th, 1977
Photograph by Hiro

1970s

RS 243 | THE BEE GEES
July 14th, 1977
Photograph by Francesco Scavullo

RS 244 | ANN & NANCY WILSON
July 28th, 1977
Photograph by Eric Meola

RS 245 | DIANA ROSS | August 11th, 1977 | Photograph by Annie Leibovitz

"*I remember* at one point glancing in the mirror and once again saying to myself, Will I have to sit in front of this mirror and spend hours putting on makeup for the rest of my life? This is what I have been doing since I was a child, putting this stuff on my face, then going onstage for two or two and a half hours, maybe three at the most and then having to undergo the misery of taking it all off again. It's not any fun, but there's no getting around it. The lights do strange things to the skin, and heavy stage makeup is necessary. So when I'm not working, I try not to wear much makeup. Particularly in the daytime. . . .

"Back to the face in the mirror. Who is this looking back at me? A woman who with each stroke of the eyeliner, with each brush of the rouge, is transforming into a stage personality. I breathe deeply, searching for relief from the reality in front of me. My mind wanders to distant places, anywhere but here, away from the pressure. When I travel, I love to be invited to use someone's private plane, because that way I can look funky. But that isn't always possible. Sometimes I have to walk through public airports where people see me, and there is this expectation that I look a certain way. I have to be Diana Ross, the performer, the star, not Diana, the human being, the weary traveler. This makes me smile as I write. It is yet another situation where my seemingly glamorous life is really quite difficult."

—*Diana Ross*

SM14170 AUGUST 11th, 1977 • ISSUE NO. 245 $1.00UK.50p

ROLLING STONE

DIANA
(Ross)
Reflections
By O'Connell
Driscoll

A Question of Style
DIANA
(Vreeland)
By Lally Weymouth

CSN AND YOUNG

SM14170　　　　　　　　　SEPTEMBER 8th 1977 • ISSUE NO. 247　　　　　　　　$1.00UK50p

ROLLING STONE

THE JUICE

OJ Simpson

A Man for All Seasons

By Tim Cahill

HI-FI '78

Sex Symbols & Their Sound Effects

10 Super Systems

Betamax: The Video Wars

Mono Nostalgia and More

ZEPPELIN DISASTER EMOTIONS REJOICE

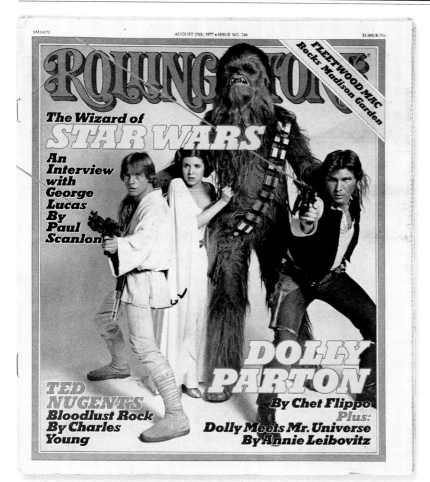

SM14170

AUGUST 25th, 1977 • ISSUE NO. 246

$1.00 UK 50p

ROLLING STONE

FLEETWOOD MAC
Rocks Madison Garden

The Wizard of
STAR WARS

An Interview with George Lucas By Paul Scanlon

DOLLY PARTON
By Chet Flippo
Plus:
Dolly Meets Mr. Universe
By Annie Leibovitz

TED NUGENT'S
Bloodlust Rock
By Charles Young

RS 246 | CAST OF 'STAR WARS' | August 25th, 1977 | PHOTOGRAPH BY TERRY O'NEILL

RS 247 | O.J. SIMPSON
September 8th, 1977
PHOTOGRAPH BY ANNIE LEIBOVITZ

[RS 247] The first football player to grace the cover of ROLLING STONE, O.J. Simpson was dabbling in film and becoming known as the TV spokesman for Hertz; his future notoriety was nearly two decades away.

"'*Star Wars*' is about 25 percent of what I wanted it to be. It's really down there quite a bit. It's still a good movie, but it fell so short of what I wanted it to be. And everyone said, 'Well, Jesus, George, you wanted the moon for Chrissake.' I think the sequels will be much, much better."
—*George Lucas*

ELVIS PRESLEY **was generally considered an overweight Las Vegas nightclub throwback by many rock fans when he died on August 16th, 1977. On the other hand, Jann Wenner, convinced that the man still mattered, decided to scrap an issue ready for the printer and create a brand-new one in honor of the King. His decision was the right one: The issue sold more copies than any other in the history of** ROLLING STONE.

1970s

"THE FIRST TIME I EVER HEARD HIS music, back in '54 or '55, I was in a car and heard the announcer say, 'Here's a guy who, when he appears onstage in the South, the girls scream and rush the stage.' Then he played 'That's All Right, Mama.' I thought his name was about the weirdest I'd ever heard. I thought for sure he was a black guy.

"Later on I grew my hair like him, imitated his stage act – once I went all over New York looking for a lavender shirt like the one he wore on one of his albums. I did stop liking his music pretty early, though. I felt wonderful when he sang 'Bridge Over Troubled Water,' even though it was a touch on the dramatic side – but so was the song." —*Paul Simon*

"I LAST SAW HIM LAST DECEMBER IN Las Vegas. Had a *fantastic* visit, almost two hours, from the time he came off to the time he went back on. We talked about the early days and the recent days. We talked about the people we admired – each other – and people who tried to really perform, from the heart, with soul, as opposed to trying to make commercial records.

"I hope people remember the impact – it's not only historical fact, but it's lingering fact." —*Roy Orbison*

Elvis was the king of rock

& roll because he was the embodiment of its sins and virtues: grand and vulgar, rude and eloquent, powerful and frustrated, absurdly simple and awesomely complex. He was the King, I mean, in our hearts, which is the place where the music really comes to life. And just as rock & roll will stand as long as our hearts beat, he will always be our King: forever, irreplaceable, corrupt and incorruptible, beautiful and horrible, imprisoned and liberated. And finally, rockin' and free, free at last.

—*Dave Marsh*
[EXCERPT FROM ELVIS PRESLEY TRIBUTE]

"I COULD NOT IMAGINE THAT GUY DYING. He was so incredibly important to me, to go on and do what I want to do. When I heard the news it was like somebody took a piece out of me. . . . To me, he was as big as the whole country itself, as big as the whole dream. He just embodied the essence of it and he was in mortal combat with the thing. It was horrible and, at the same time, it was fantastic. Nothing will ever take the place of that guy. Like I used to say when I introduced one of his songs: 'There have been a lotta tough guys. There have been pretenders. There have been contenders. But there is only one King.' " —*Bruce Springsteen*

ROLLING STONE

ELVIS PRESLEY
1935-1977

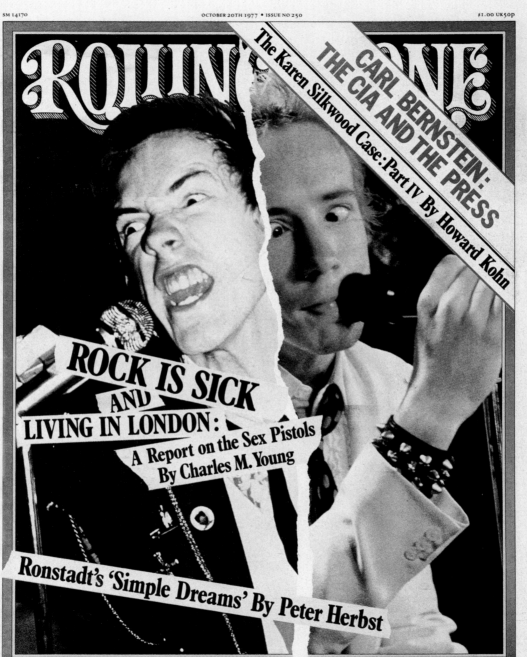

SM 14170

OCTOBER 20TH 1977 • ISSUE NO 250

$1.00 UK50p

ROLLING STONE

CARL BERNSTEIN:
THE CIA AND THE PRESS

The Karen Silkwood Case: Part IV By Howard Kohn

ROCK IS SICK
AND
LIVING IN LONDON:
A Report on the Sex Pistols
By Charles M. Young

Ronstadt's 'Simple Dreams' By Peter Herbst

A little before midnight, my taxi arrives at a club called the Vortex. Half a block away ten or twelve teenage boys dressed like horror-movie morticians jump up and down and hit each other. Their hair is short, either greased back or combed to stick straight out with a pomade of Vaseline and talcum powder. Periodically, one chases another out of the pack, grabs the other's arm and twists it until he screams with pain. Then they rush back laughing and leap about some more. Sitting oblivious against a building, a man dressed in a burlap bag nods gently as a large puddle of urine forms between his legs.

Shouting epithets at themselves in a thick proletarian accent, the boys finally bob down the street as another cab pulls up to the entrance. A man with curly, moderately long red hair, a pale face and an apelike black sweater gets out. It is Malcolm McLaren, manager of the Sex Pistols, the world's most notorious punk band, who I have flown from New York to meet and see perform. McLaren has been avoiding me for two days. I introduce myself and suggest we get together soon. He changes the subject by introducing me to Russ Meyer, the soft-core porn king of *Supervixens* and *Beyond the Valley of the Dolls* fame, who is directing the Sex Pistols' movie. "You're a journalist?" asks Meyer. "Do you know Roger Ebert? He won the Pulitzer Prize for film criticism, and he's writing the movie with me. You should talk to him. He's really into tits."

McLaren seizes the opportunity to disappear into the Vortex and is lost to me for the rest of the evening. The dense crowd inside consists of a few curiosity seekers and four hundred to five hundred cadaverous teenagers dressed in black or gray. Often their hair is dyed shades of industrial pink, green and yellow. Several blacks, also drably dressed and with rainbow stripes dyed into their short Afros, speckle the audience. The music over the loudspeakers is about two-thirds shrieking New Wave singles and one-third reggae tunes, which the kids respond to with almost as much enthusiasm as the punk rock. The dancing is frantic as a band called the Slits sets up. The style is called pogo dancing – jumping up and down and flailing one's arms around. It is as far as one can get from the Hustle, and it is the only way one can dance if one is wearing bondage pants tied together at the knees. Most are pogoing alone. Those with partners (usually of the same sex) grasp each other at the neck or shoulders and act like they are strangling each other. Every four or five minutes, someone gets an elbow in the nose and the ensuing punch-out lasts about thirty seconds amid a swirling mass of tripping bodies.

[EXCERPT FROM RS 250 COVER STORY BY CHARLES M. YOUNG]

RS 249 | BELLA ABZUG
October 6th, 1977
ILLUSTRATION BY ANDY WARHOL

[RS 249] To celebrate the magazine's relocation to New York City from San Francisco, ROLLING STONE devoted the entire feature well to New York and commissioned Andy Warhol to create a cover portrait of mayoral primary candidate Bella Abzug, who contributed her own personal guide to the city (she lost the election, by the way, to Ed Koch). Wrote the editors: "A Columbia University sociologist recently published a study which suggests that people who live in big cities appear to be mentally healthier than those who live in small towns and rural areas. At a time when mere residence in New York was thought to be hazardous to the central nervous system, this study was particularly heartening to us, poised as we were for a great leap across the country to our new offices in midtown Manhattan – after all, ROLLING STONE has been coming to you from various funky offices in San Francisco for nearly ten years.... It occurred to us that an issue devoted to New York would helps us come to grips with what some call the center of the universe and others call the pits, and at the same time announce that we were here."

RS 251 | RON WOOD
November 3rd, 1977
PHOTOGRAPH BY ANNIE LEIBOVITZ

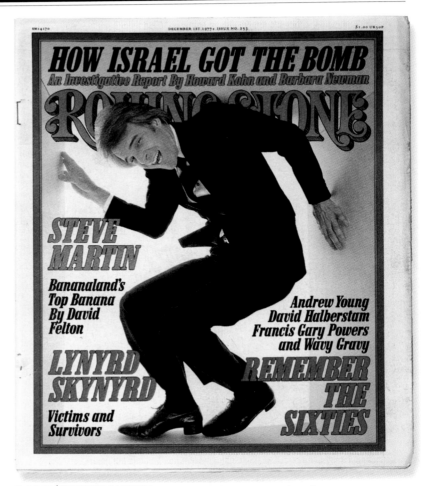

RS 253 | STEVE MARTIN | December 1st, 1977 | PHOTOGRAPH BY ANNIE LEIBOVITZ

"*I remember Martin Mull*
sent me a note, and he said, 'Congratulations on
being on the cover of ROLLING STONE. Too bad
you weren't on when it really meant something.'"

—*Steve Martin*

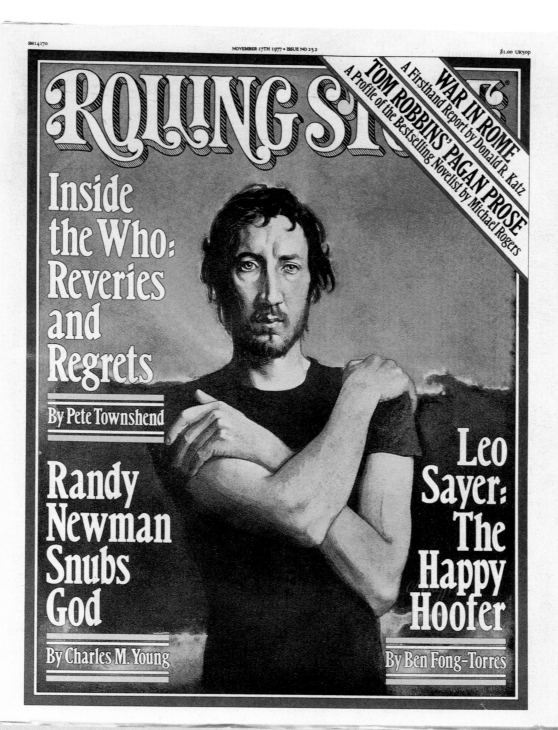

SM14170

NOVEMBER 17TH 1977 • ISSUE NO 252

$1.00 UK50p

ROLLING STO

WAR IN ROME
A Firsthand Report by Donald R. Katz

TOM ROBBINS' PAGAN PROSE
A Profile of the Bestselling Novelist by Michael Rogers

Inside the Who: Reveries and Regrets
By Pete Townshend

Randy Newman Snubs God
By Charles M. Young

Leo Sayer: The Happy Hoofer
By Ben Fong-Torres

RS 252 | PETE TOWNSHEND | *November 17th, 1977* | ILLUSTRATION BY DANIEL MAFFIA

SM14170: ISSUE NUMBER 254

THE TENTH ANNIVERSARY ISSUE

DECEMBER 15, 1977; $1.50 UK75P

Rolling Stone

DR. HUNTER S. THOMPSON

Fear & Loathing : The Banshee Screams for the Buffalo

ANNIE LEIBOVITZ

A special fifty-page color collection of Greatest Hits · Plus A Decade in the Life

1970s

Change – the ability to see it and live with it – explains much of what ROLLING STONE is about. In this issue we have yet another change: a new logo. It symbolizes as much as anything what we are up to: respectful of our origins, considerate of new ideas and open to the times to come.

—*Jann S. Wenner*

"'ROLLING STONE' HAS – FROM THE FIRST – covered events and personalities that are not always a purist's idea of rock & roll. What the purists forget is that 'rock & roll' means much more than just the music. Anyone who ever took those words to heart knows that; knows that there are books and movies and people and events and attitudes that matter more to a rock & roll way of life than do many records that are labeled rock & roll. Jack Kerouac was rock & roll; Bobby Rydell was not. Tom Robbins is rock & roll; Andy Gibb is not. *Star Wars* is rock & roll; *A Star Is Born* is not. . . .

"At this very minute, I can hear two other typewriters rattling away: Carl Bernstein is in the next office writing about the CIA, and next door to him John Swenson is hammering out a story on a near breakup of the Beach Boys. Both stories mean a great deal here, and that kind of mixture of subjects under the umbrella of rock & roll is exactly what ROLLING STONE is about."

—*Chet Flippo*
ASSOCIATE EDITOR

The Tenth Anniversary issue introduces a new logo, drawn by Jim Parkinson. It's based on "Roman and Italic typefaces that revolutionized printing in the Fifteenth Century," according to the editors. The issue's contents include a fifty-page portfolio of Annie Leibovitz's photography from 1970, when she first shot for the magazine, to 1977. Designer Bea Feitler, previously art director of *Harper's Bazaar* and *Ms.*, came aboard to work with art director Roger Black on putting together the photo section. Also featured were musings by the magazine's then so-called lifers: Hunter S. Thompson, Dave Marsh, Jon Landau, David Felton, Jonathan Cott and Chet Flippo.

"'ROLLING STONE' IS MORE than grinding out a magazine every two weeks, converting whole forests to self-serving pulp, exposing innocent lives, laughing at cripples and stomping on budding careers just to make a fast buck. It's people. Presently 101 people work full-time for the magazine, and all of them, practically without exception, are young, gifted, industrious, well groomed and ruggedly individualistic. Also completely nuts. Believe me, I know what I'm talking about; I've worked here for eight years. They are all nuts – maybe not dangerously nuts or dysfunctionally nuts or down-and-out, desperate-and-broken nuts, but they are definitely, certifiably and incorrigibly gonzo cuckoo bananas."

—*David Felton*
ASSOCIATE EDITOR

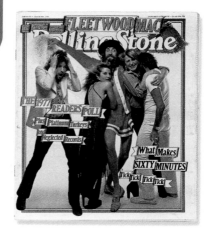

RS 255 | JAMES TAYLOR,
PETER ASHER & LINDA
RONSTADT
December 29th, 1977
Photograph by Annie Leibovitz

RS 256 | FLEETWOOD MAC
January 12th, 1978
Photograph by Annie Leibovitz

Rock & roll isn't rock & roll anymore.
 You're right, there's no more rock & roll. It's an imitation, we can forget about that. Rock & roll has turned itself inside out. I never did do rock & roll, I'm just doing the same old thing I've always done.
 You've never sung a rock & roll song?
 No, I never have, only in spirit.
 You can't really dance to one of your songs.
 I couldn't.
 Imagine dancing to "Rainy Day Woman #12 & 35." It's kind of alienating. Everyone thought it was about being stoned, but I always thought it was about being alone.
 So did I. You could write about that for years. . . . Rock & roll ended with Phil Spector. The Beatles weren't rock & roll either. Nor the Rolling Stones. Rock & roll ended with Little Anthony and the Imperials. Pure rock & roll.
 With "Goin' Out of My Head"?
 The one before that. Rock & roll ended in 1959.
 [EXCERPT FROM BOB DYLAN INTERVIEW BY JONATHAN COTT]

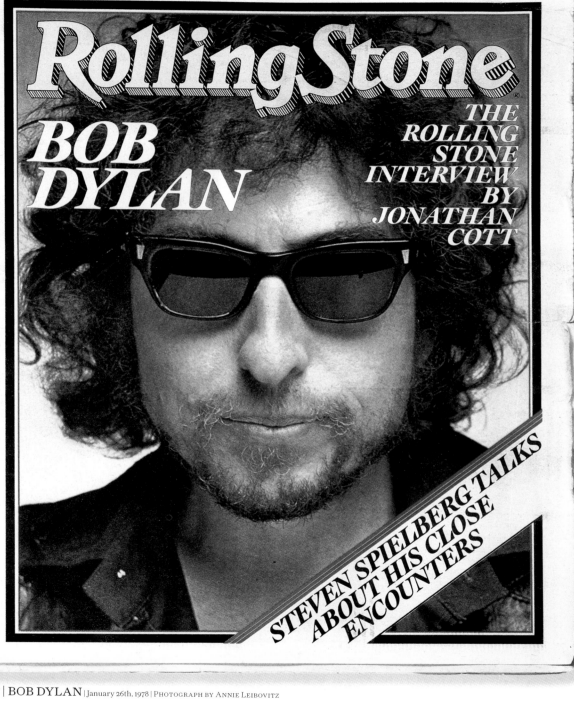

SM14170 JANUARY 26TH 1978 • ISSUE NO. 257 $1.00 UK 50P

RollingStone

BOB DYLAN

THE ROLLING STONE INTERVIEW BY JONATHAN COTT

STEVEN SPIELBERG TALKS ABOUT HIS CLOSE ENCOUNTERS

RS 257 | BOB DYLAN | January 26th, 1978 | PHOTOGRAPH BY ANNIE LEIBOVITZ

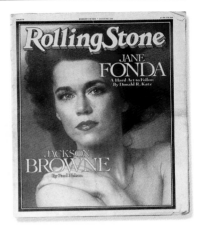

RS 260 | JANE FONDA
March 9th, 1978
PHOTOGRAPH BY ANNIE LEIBOVITZ

"WHEN I WAS TWELVE I WAS
on the cover, and it was the
first time I'd been on the
cover, and I was thrilled.
I felt so cool and so hip."
—*Brooke Shields*

RS 258 | DOONESBURY'S
JIMMY THUDPUCKER
February 9th, 1978
ILLUSTRATION BY GARRY TRUDEAU

RS 261 | DONNA SUMMER
March 23rd, 1978
PHOTOGRAPH BY BRIAN LEATART

RS 259 | RITA COOLIDGE &
KRIS KRISTOFFERSON
February 23rd, 1978
PHOTOGRAPH BY FRANCESCO SCAVULLO

RS 263 | THE BEE GEES &
PETER FRAMPTON
April 19th, 1978
ILLUSTRATION BY BRUCE WOLFE

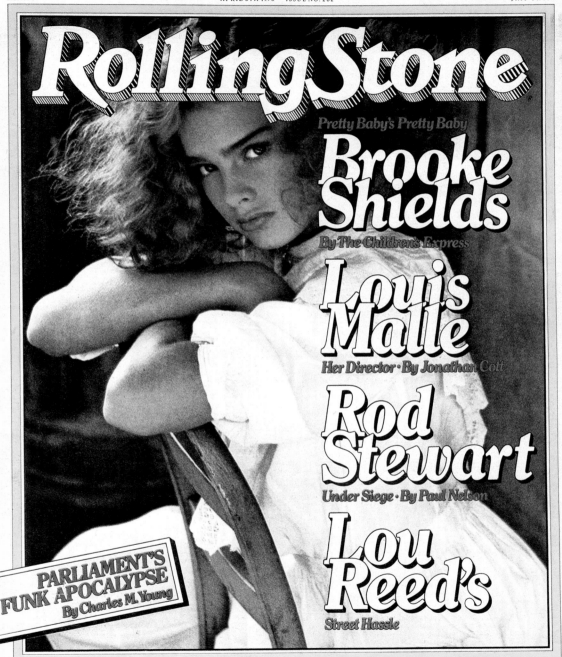

Rolling Stone

Pretty Baby's Pretty Baby

Brooke Shields
By The Children's Express

Louis Malle
Her Director · By Jonathan Cott

Rod Stewart
Under Siege · By Paul Nelson

Lou Reed's
Street Hassle

PARLIAMENT'S
FUNK APOCALYPSE
By Charles M. Young

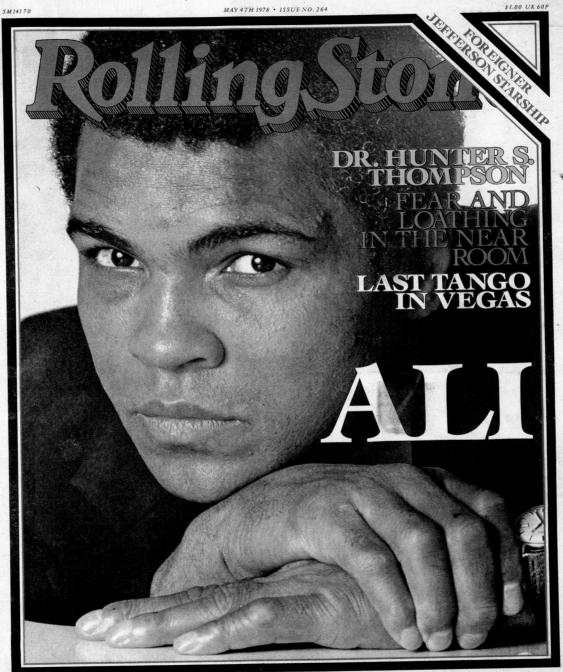

SM14170 MAY 4TH 1978 • ISSUE NO. 264 $1.00 UK 60P

RollingSton

FOREIGNER
JEFFERSON STARSHIP

DR. HUNTER S. THOMPSON
FEAR AND LOATHING IN THE NEAR ROOM
LAST TANGO IN VEGAS

ALI

RS *264* | MUHAMMAD ALI | May 4th, 1978 | Photograph by Annie Leibovitz

\mathcal{RS} 265 | JEFFERSON STARSHIP
May 18th, 1978 | Photograph by Annie Leibovitz

\mathcal{RS} 266 | CARLY SIMON
June 1st, 1978 | Photograph by Hiro

\mathcal{RS} 268 | MICK JAGGER
June 29th, 1978 | Photograph by Annie Leibovitz

1970s

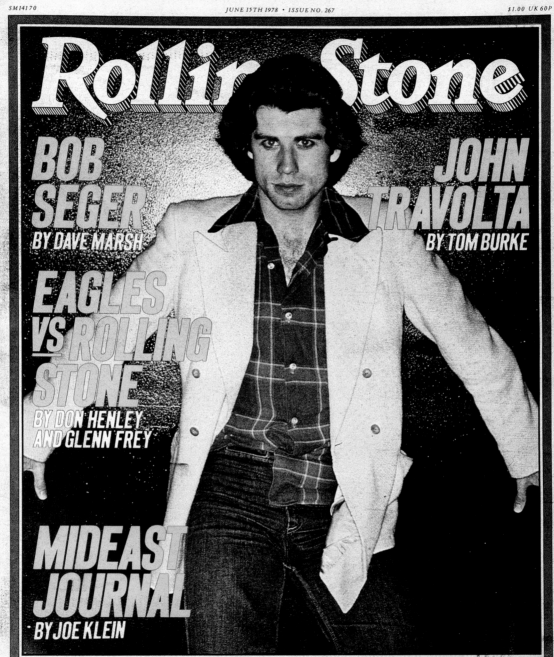

Rolling Stone

BOB SEGER
BY DAVE MARSH

JOHN TRAVOLTA
BY TOM BURKE

EAGLES VS ROLLING STONE
BY DON HENLEY AND GLENN FREY

MIDEAST JOURNAL
· BY JOE KLEIN

RS 267 | JOHN TRAVOLTA | June 15th, 1978 | Photograph by Annie Leibovitz

RS 269 | WILLIE NELSON | July 13th, 1978 | Photograph by Beverly Parker, Painted by Jack Doonan

SM14170 — JULY 27TH 1978 • ISSUE NO. 270 — $1.00 UK 60P

1970s

RollingStone

Patti Smith
CATCHES FIRE
BY CHARLES M. YOUNG

Neil Young's
WORLD TOUR
BY PAUL NELSON

Minnesota Fats
BY ROBERT SABBAG

Olivia Newton–John
BY BEN FONG-TORRES

"PEOPLE SAY TO ME, 'DO YOU THINK YOU SOLD OUT?' TO ME, THEY SHOULD BE SAYING, 'Oh wow, you're on AM radio.' Kids come up to me on the street and say, 'Patti, we're on ABC.' Because they fought with me, they know that the past four years it's been a tough struggle. They can see I was the black sheep. I'll probably always be a black sheep, maybe a richer one instead of a poorer one, but they see someone who felt alienated, who didn't belong anywhere. I stuck it out, you know, I stuck it out. And I'm determined to make us kids, us fuckups, us ones who could never get a degree in college, whatever, have a family, or do regular stuff, social stuff, prove that there's a place for us. So I think it's great that I have a hit single ['Because the Night']. To me, the place for us would be right out on the front line."

[EXCERPT FROM RS 270 COVER STORY BY CHARLES M. YOUNG]

RS 271 | JOHN BELUSHI
August 10th, 1978
PHOTOGRAPH BY HIRO

"[THE PATTI SMITH SHOT IS] REALLY A GOOD story on how a lot of planning can be worthless sometimes. I had an assistant come out from California – I was just starting to work with assistants then – and I said to him, 'Listen, I want this huge wall of flame behind Patti Smith, I don't care how you do it.' He said, 'I have it all figured out.' His idea was like this kerosene-soaked net behind her. Needless to say, it lasted about five seconds, because as soon as it burned out, it fell down to the floor. So then we lit big barrels of kerosene and practically burned down the place. I think Patti did get a burn on the back of her *tutu.* The whole backside of her was red.

"It's really a lot of fun taking pictures with me. And then I slap them in the mud! And then I hang them from the ceiling! And they say, 'I heard you were hard, Leibovitz. I heard it wasn't easy.' "

—*Annie Leibovitz*

"With all this attention, you become a child. It's awful to be at the center of attention. You can't talk about anything apart from your own experience, your own dopey life. I'd rather do something that can get me out of the center of attention. It's very dangerous. But there's no way, really, to avoid that."

— Mick Jagger

RS 273 | MICK JAGGER &
KEITH RICHARDS
September 7th, 1978
PHOTOGRAPH BY LYNN GOLDSMITH

WALKING THROUGH THE LOBBY OF THE MARQUIS LAST NIGHT, JUST after 2 a.m., I ran into Bruce, who asked if I wanted to walk over to Ben Frank's for something to eat. On the way I mentioned that there must be a lot of people in line at the Roxy just up the street. Bruce gave me a look. "I don't like people waiting up all night for me," he said.

Bruce ate another prodigious meal: four eggs, toast, a grilled-cheese sandwich, large glasses of orange juice and milk. And the talk ranged widely: surfing (Bruce had lived with some of the Jersey breed for a while in the late Sixties, and he's a little frustrated with trying to give a glimmer of its complexity to a landlocked ho-dad like me), the new album and its live recording ("I don't think I'll ever go back to the overdub method," he said, mentioning that almost all of the LP was done completely live in the studio, and that "Streets of Fire" and "Something in the Night" were first takes). But mostly we talked, or rather, Bruce talked and I listened.

Springsteen can be spellbinding, partly because he is so completely ingenuous, partly because of the intensity and sincerity with which he has thought out his role as a rock star. He delivers these ideas with an air of conviction, but not a proselytizing one; some of his ideas are radical enough for Patti Smith or the punks, yet lack their sanctimonious rhetoric.

I asked him why the band plays so long – their shows are rarely less than three hours – and he said: "It's hard to explain. 'Cause every time I read stuff that I say, like in the papers, I always think I come off sounding like some kind of crazed fanatic. When I read it, it sounds like that, but it's the way I am about it. It's like you have to go the whole way because . . . that's what keeps everything *real*. It all ties in with the records and the values, the morality of the records. There's a certain morality of the show, and it's very strict." Such comments can seem not only fanatical but also self-serving. The great advantage of the sanctimony and rhetoric that infests the punks is that such flaws humanize them. Lacking such egregious characteristics, Bruce Springsteen seems too good to be true when reduced to cold type. Nice guys finish last, we are told, and here's one at the top. So what's the catch? I just don't know.

[EXCERPT FROM RS 272 COVER STORY BY DAVE MARSH]

1970s

SM 14170 AUGUST 24TH, 1978 • ISSUE NO. 272 $1.00 UK 60P

RollingStone

BRUCE
SPRINGSTEEN
BY DAVE MARSH

ELO
THE INCREDIBLE
STRING BAND
BY MIKAL
GILMORE

GERRY RAFFERTY
'BAKER STREET' BLUES

POISON HARVEST
BRINGING THE WAR BACK HOME
BY HOWARD KOHN

RS 272 | BRUCE SPRINGSTEEN | August 24th, 1978 | Photograph by Lynn Goldsmith

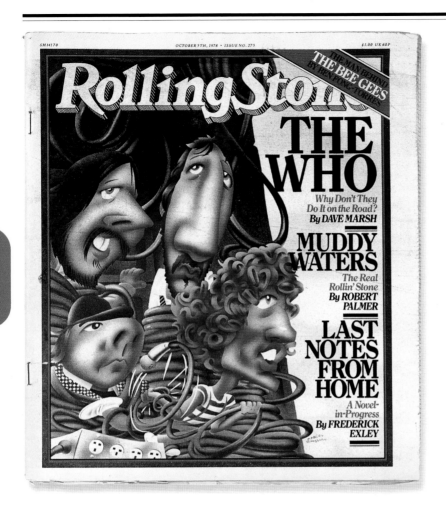

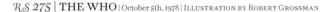

RS 275 | THE WHO | October 5th, 1978 | Illustration by Robert Grossman

RS 274 | GARY BUSEY
AS BUDDY HOLLY
September 21st, 1978
Photograph by Gemma Lamana

RS 276 | LINDA RONSTADT
October 19th, 1978
Photograph by Francesco Scavullo

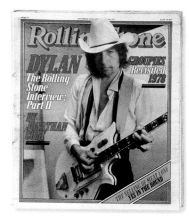

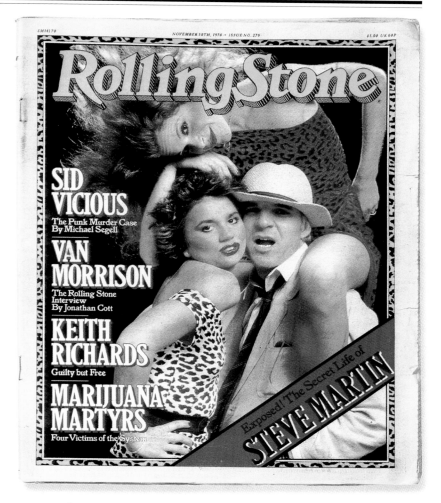

RS 277 | GILDA RADNER
November 2nd, 1978
PHOTOGRAPH BY FRANCESCO SCAVULLO

RS 278 | BOB DYLAN
November 16th, 1978
PHOTOGRAPH BY MORGAN RENARD

RS 279 | LINDA RONSTADT, GILDA RADNER & STEVE MARTIN
November 30th, 1978 | PHOTOGRAPH BY ANNIE LEIBOVITZ

[RS 278] Bob Dylan had apparently run out of patience with photo shoots by the time he appeared on the magazine's cover for the tenth time. For this cover, he refused to let ROLLING STONE's photographer snap the portrait. Instead, he had his friend Morgan Renard take his picture in the backstage men's room at Madison Square Garden. (Note the urinal in the background). This cover would be the last one designed by Roger Black; Mary Shanahan, ROLLING STONE's first and only female art director, would begin her term the following issue.

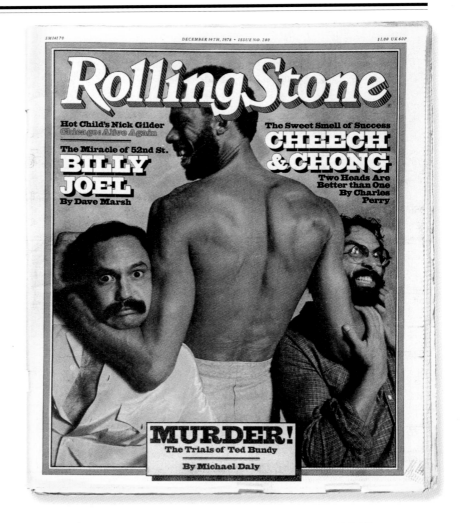

RS 281/282 | RICHARD DREYFUSS
December 28th, 1978 – January 11th, 1979
ILLUSTRATION BY JULIAN ALLEN

RS 283 | THE CARS
January 25th, 1979
PHOTOGRAPH BY JIM HOUGHTON

RS 280 | CHEECH & CHONG WITH KAREEM ABDUL-JABBAR
December 14th, 1978 | PHOTOGRAPH BY DAVID ALEXANDER

"THERE'S A CULTURE THAT A LOT OF PEOPLE ARE TRYING TO BURY, like they tried to bury rock & roll after a couple of years and said, 'Rock's dead.' They want to say, 'This is the Seventies, that stuff's dead.' But we will keep it alive for the rest of our lives. We are so much a part of the culture we make fun of, whatever comes down we will still be a part of it."
—*Tommy Chong*

RS 284 | NEIL YOUNG
February 8th, 1979
ILLUSTRATION BY JULIAN ALLEN

My parents occupied the bedroom above mine while I was growing up. Luckily they were heavy sleepers, and loud music late at night didn't seem to bother them – unless it was the high-pitched guitar or vocal work of Neil Young. On such occasions, my mother would trudge downstairs, rap at the door and stand there with a look that suggested the wrath of every deprived sleeper over the ages.

There was a time, sure, when I tried to explain to them what it was to be a Neil Young fan. "How important is an in-tune vocal?" "But it's *great* when he hits the same note thirty-eight times in 'Down by the River.' " Here was an *artist*, as opposed to an entertainer.

In 1972, my parents would hear "Heart of Gold" played in the supermarket, find it tuneful and begin to see things differently. When Neil Young announced he would be playing San Diego, our hometown, on a rare concert tour, it became a family outing.

Neil Young appeared right on time, nervously walking out in front of the screaming crowd, one arm upraised. He looked skittish and tired as he picked up a guitar and began to sing an acoustic song, called "Sugar Mountain." The audience rushed the stage, shouted for the electric songs and Young called his band out onstage. But instead of standards like "Down by the River," they played a set of reckless new music, causing no small tension in the arena. Then, during the final song of the evening, the pressure seemed to cause Neil Young to crack. He began to shout, "Wake up, San Diego. Get up, San Diego." The houselights were turned on and the hall was filled with an eerie silence. We didn't talk about Neil Young for the next few years.

Recently, I found myself back in the same old room late one night, typing this article and listening to Neil Young records, when a familiar knock came at the door. "Well," said my mother with a note of sentimentality. "A *survivor*."

[EXCERPT FROM RS 284 COVER STORY BY CAMERON CROWE]

FEBRUARY 22ND, 1979 • ISSUE NO. 283

$1.25 UK 60P

CHARLES MINGUS: 1922-1979

Rolling Stone

BLUES BROTHERS: SATURDAY NIGHT CONFIDENTIAL

DAN AYKROYD
Messin' with the Kid
By Timothy White

AEROSMITH
Bares Its Battle Scars
By Daisann McLane

FREDERICK EXLEY
Last Notes from Home · Part III

SONIC BOOM '79

1970s

"BY THE WAY, HOW DID YOU ASSEMBLE THE ORIGINAL BAND?"

"It was agony," says Jake, burying his face in his hands. "Elwood and I were a duo and when word got out we were forming a group, I got phone calls immediately, calls from heavy stars, saying, 'I wanna be in your band!' And it was a question of whether to assemble one or just get a band that was already established – some guys together for ten years so we could put 'em up there and let 'em just groove. I was thinking about getting Delbert McClinton's band, and Roomful of Blues, too. When we first resurfaced, Elwood and I did a gig at the Lone Star Café in New York in June [of 1978] with Roomful of Blues.

"But finally we just decided, 'Fuck the cost and the damage it will do to the feelings of people who aren't asked, and let's go for the best band we can get, *piece by piece.*' We got Bones Malone first and he recommended Cropper and Dunn. We really didn't know who they were," Jake snorts. "Then when he [Malone] said, 'You know, from "Knock on Wood" and "Soul Man," ' we said, 'Would *they* do it?!'

"I called them up, acting real arrogant," Jake recounts, "saying, '*Wellllll,* all right Cropper, you're in the group but you're a rhythm guitar player – ya got that?' and he went [*meekly*], 'I like playing rhythm guitar; I don't like all that lead stuff.' So I said [*sarcastically*], 'Oh, you're hard to work with, aren't ya?'

"Then I called Dunn up and said, 'I never met you but I'd like you to be in a group – but I understand you don't get along with Cropper.' He said, '*Aw no,* we get along all right!' I was just giving them all kinda shit, bustin' their balls," Jake guffaws, slapping Elwood on the back.

"But they both said yes, and, uh, incidentally . . . they didn't know who *we* were either."

[EXCERPT FROM RS 285 COVER STORY BY TIMOTHY WHITE]

"THE IDEA OF PAINTING THE BLUES BROTHERS BLUE IS TOO STUPID. IT'S JUST TOO stupid. But it's something I've learned to trust: The stupider the idea is, the better it looks. Painting the Blues Brothers blue is as stupid as the Blues Brothers being the Blues Brothers. They were taking themselves so seriously about being musicians, they were forgetting that they were actors and comedians. I mean, Belushi was saying, 'Did you hear Aykroyd on the harp? Better than Paul Butterfield!' And I said, 'Whoa . . . time to remember who you are.' That's when my job gets a little dangerous. Belushi didn't talk to me for six months. But Aykroyd always knew it was good. I knew it was good, too. It was a healthy thing to do, it was funny."

—Annie Leibovitz

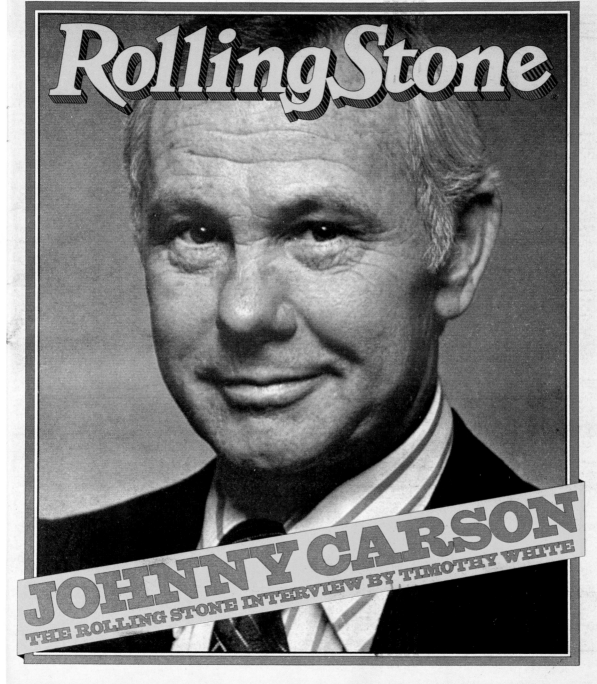

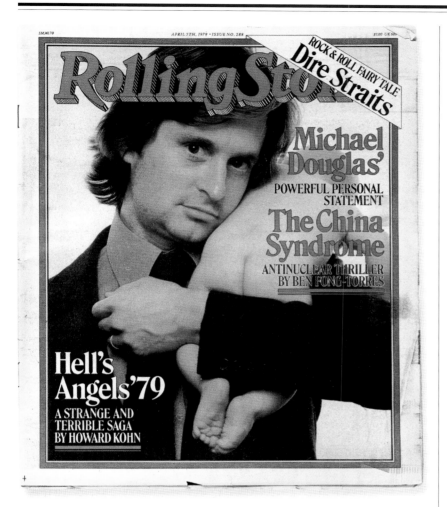

Rolling Stone

ROCK & ROLL FAIRY TALE
Dire Straits

Michael Douglas'
POWERFUL PERSONAL STATEMENT
The China Syndrome
ANTINUCLEAR THRILLER
BY BEN FONG-TORRES

Hell's Angels '79
A STRANGE AND TERRIBLE SAGA
BY HOWARD KOHN

\mathcal{RS} 288 | MICHAEL
& CAMERON DOUGLAS
April 5th, 1979
PHOTOGRAPH BY ANNIE LEIBOVITZ

\mathcal{RS} 287 | JOHNNY CARSON
March 22nd, 1979
PHOTOGRAPH BY ANNIE LEIBOVITZ

I've wondered if there was a certain moment of self-esteem and self-worth upon which you built every other experience.

There comes a time or a moment when you know in which direction you're going to go, but you don't know why exactly. I think that probably happened to me in grade school, where I could get attention by being different, by getting up in front of an audience and calling attention to myself. And I said, "Hey, I like that feeling." When I was a kid, I was shy, and to get that reaction is a strange feeling. It is a high that I don't think you can get from drugs or from anything else. It's a great feeling, and that's why many performers have very big highs and very big lows. I know I do.

So you had shyness to conquer?

[*Sheepishly*] Yeah, oh, yeah. I still feel uncomfortable in large groups of people. Not audiences, mind you. I can go out in front of 20,000 people because I'm in charge. Most entertainers feel that way. I think people who are creative, in the arts, also seem to have larger appetites for life than most people, to excess usually. Whether it be drinking, sex, anything, the appetites seem larger. Because I guess you are always trying to prove yourself. You're only as good as your last performance.

All things considered, are you happy with the way everything has turned out?

Yes, but it depends. Do you have a capacity for happiness? A lot of people don't have a capacity. I don't know how big my capacity is. It's not as big as a lot of people's, but I'm getting better at it all the time.

[EXCERPT FROM JOHNNY CARSON
INTERVIEW BY TIMOTHY WHITE]

RS 289 | THE VILLAGE PEOPLE
April 19th, 1979
PHOTOGRAPH BY BILL KING

RS 290 | RICHARD PRYOR
May 3rd, 1979
PHOTOGRAPH BY DAVID ALEXANDER

RS 292 | JON VOIGHT
May 31st, 1979
PHOTOGRAPH BY ANNIE LEIBOVITZ

RS 293 | CHEAP TRICK
June 14th, 1979
PHOTOGRAPH BY ANNIE LEIBOVITZ

RS 295 | PAUL McCARTNEY
July 12th, 1979
ILLUSTRATION BY JULIAN ALLEN

RS 296 | JONI MITCHELL
July 26th, 1979
PHOTOGRAPH BY NORMAN SEEFF

MAY 17TH, 1979 • ISSUE NO. 291

$1.25 UK 60P

RollingStone

BEE GEES

Stayin' Alive
in Too Much
Heaven
By Timothy
White

THREE MILE ISLAND: What Really Happened
By Mike Gray, Author of 'The China Syndrome'

SILKWOOD TRIAL: By Howard Kohn

ELVIS COSTELLO: On the Run

RS 291 | THE BEE GEES | May 17th, 1979 | PHOTOGRAPH BY RICHARD AVEDON

JUNE 28TH, 1979 • ISSUE NO. 294

$1.25 UK 60P

1970s

PLATINUM BLONDIE
Riding the Crest of the New Wave

IRAN
Aftermath of a Revolution
By Charles T. Powers

GRAHAM PARKER
The Secret Is Out
By James Henke

Home Studio Guide

RS 294 | BLONDIE | June 28th, 1979 | PHOTOGRAPH BY ANNIE LEIBOVITZ

RS 297 | RICKIE LEE JONES | August 9th, 1979 | Photograph by Annie Leibovitz

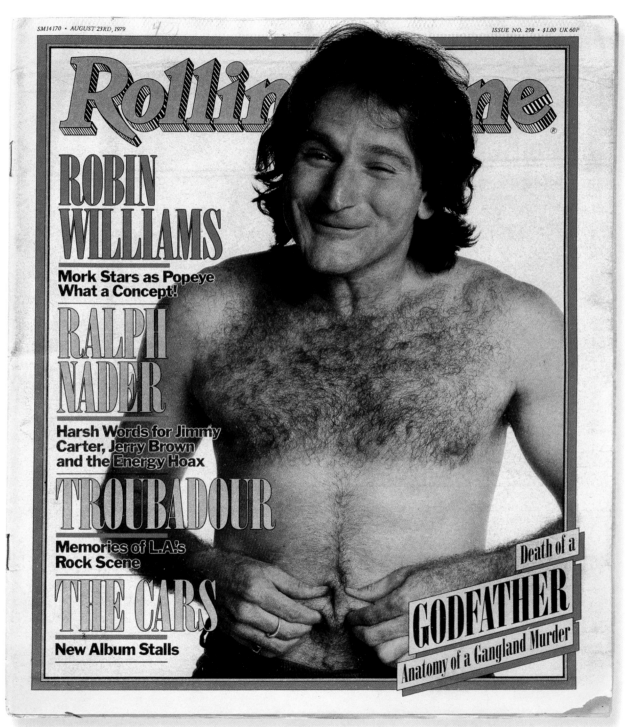

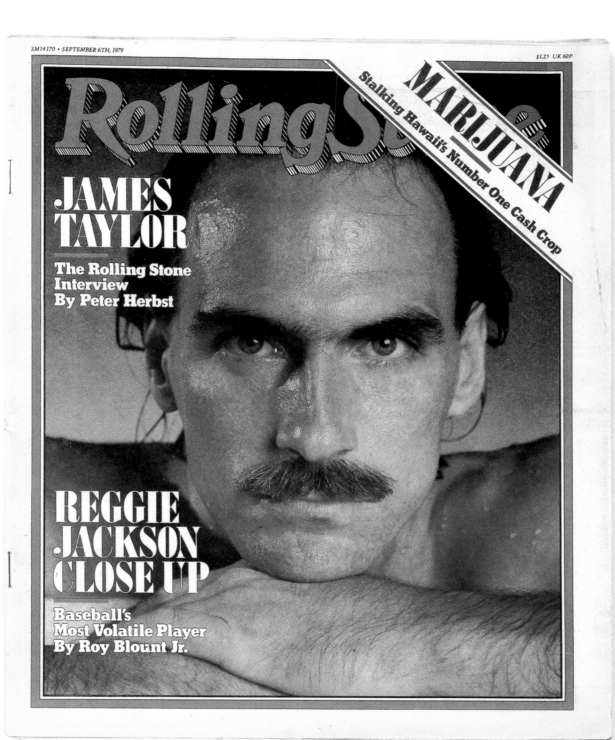

$1.25 UK 60P

Rolling Stone

JAMES TAYLOR

The Rolling Stone Interview By Peter Herbst

MARIJUANA

Stalking Hawaii's Number One Cash Crop

REGGIE JACKSON CLOSE UP

Baseball's Most Volatile Player By Roy Blount Jr.

RS 299 | JAMES TAYLOR | September 6th, 1979 | PHOTOGRAPH BY ANNIE LEIBOVITZ

[RS 305] What's wrong with this picture? Look closely at the Eagles' lower extremities. Norman Seeff shot the band against a dark backdrop, so when ROLLING STONE decided to run the picture using an orange background on the cover, one of the magazine's crack photo strippers had to cut around the band's silhouette. In doing so, he left guitarist Don Felder (second from left) legless. Though sources deny there was any connection with the goof, the Eagles disbanded (for the first time) shortly thereafter. (Conspiracy theorists take note: In an infamous softball game prior to this cover, the Eagles beat ROLLING STONE staffers 15–8.)

RS 300 | THE DOOBIE BROTHERS
September 20th, 1979
PHOTOGRAPH BY ANNIE LEIBOVITZ

RS 304 | MUSICIANS UNITED FOR SAFE ENERGY
November 15th, 1979
PHOTOGRAPH BY ANNIE LEIBOVITZ

RS 301 | JIMMY BUFFETT
October 4th, 1979
PHOTOGRAPH BY ANNIE LEIBOVITZ

RS 305 | THE EAGLES
November 29th, 1979
PHOTOGRAPH BY NORMAN SEEFF

SM14170 OCTOBER 18TH, 1979 • ISSUE NO. 302 $1.25 UK 60P

Rolling Stone

Sissy Spacek
A KNOCKOUT IN TWO NEW MOVIES

The Knack
NEW FAB FOUR ARE NO. 1

Monty Python
IS 'LIFE OF BRIAN' UNHOLY?

Paraguay
NAZI HEAVEN

JERRY BROWN
'YES, I'M RUNNING'

RS 302 | SISSY SPACEK | October 18th, 1979 | PHOTOGRAPH BY ANNIE LEIBOVITZ

RS *307/308* | 1979 YEAR
IN REVIEW
December 27th, 1979 – January 10th, 1980
TYPOGRAPHER UNKNOWN

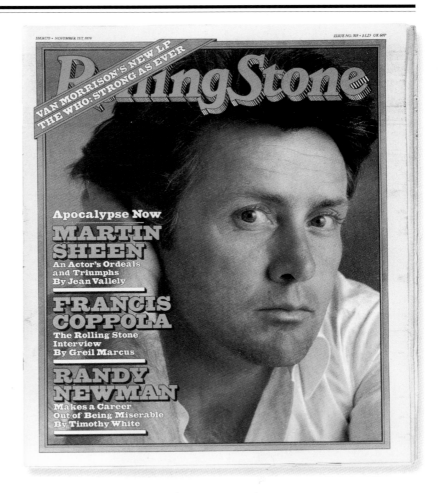

RS *303* | MARTIN SHEEN | November 1st, 1979 | PHOTOGRAPH BY ANNIE LEIBOVITZ

"*I remember some poor guy*
was sitting there with bleeding hands from
removing all the thorns on the roses. But it
was a fabulously pleasant experience when
[Annie] laid me down in all those flowers."

—*Bette Midler*

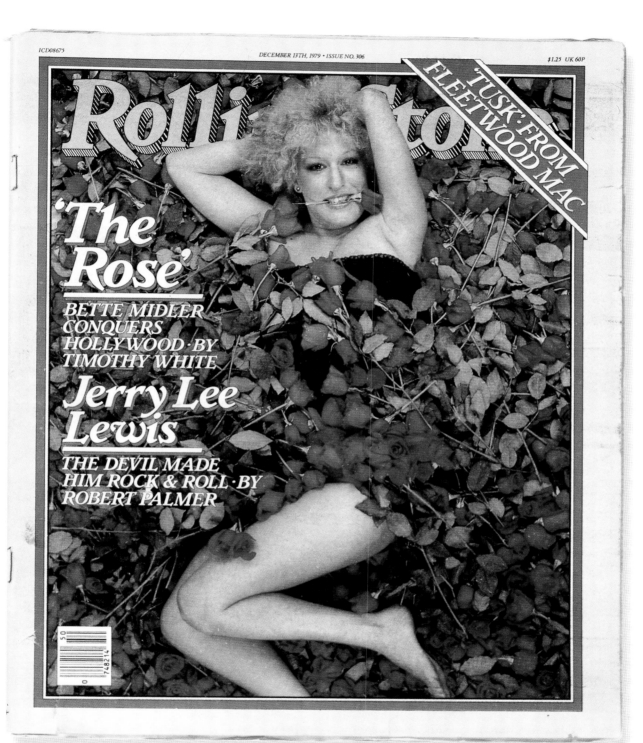

On the cover:

ICD08675

DECEMBER 13TH, 1979 • ISSUE NO. 306

$1.25 UK 60P

Rolling Stone

'TUSK' · FROM FLEETWOOD MAC

'The Rose'

BETTE MIDLER CONQUERS HOLLYWOOD · BY TIMOTHY WHITE

Jerry Lee Lewis

THE DEVIL MADE HIM ROCK & ROLL · BY ROBERT PALMER

RS 306 | BETTE MIDLER | December 13th, 1979 | PHOTOGRAPH BY ANNIE LEIBOVITZ

ICD08675 FEBRUARY 21ST, 1980 • ISSUE NO. 311 $1.25 UK 70P

Rolling Stone

Tom Petty
'Damn the Torpedoes' and Full Speed Ahead
By Mikal Gilmore

Henry Kissinger
The Prince of Power under Siege
By Tom Wicker

Hotline to Heaven
A 'Holy' Housewife Battles the Church

McCARTNEY BUSTED IN JAPAN
CAMBODIA BENEFIT: Wings, Who, Zeppelin, Rockpile, Elvis Costello, Clash

1980

Leafy ashes of vinyl, the byproduct of a Christmas rock & roll record-burning party, are still blowing around a frigid St. Paul parking lot when Petty and the Heartbreakers' tour bus pulls into town the next afternoon. These guys still remember the South Bible Belt bonfires that followed John Lennon's declaration in 1966 that the Beatles were "more popular than Jesus Christ." Maybe for that reason their show that evening seems to try to boast its own kind of hellfire.

"I called my mama on the phone today," Petty tells the audience in his introduction to Solomon Burke's "Cry to Me" (the song Petty performs on the *No Nukes* album). "I said, 'Mamma, I'm in St. Paul.' '*St. Paul?*' she said. 'I hear it gets pretty cold there.'"

Petty pauses and flashes the crowd a knowing grin. "'Yeah, mamma, but last night it got pretty hot.'" The audience lavishes him with a volley of cheers and a houseful of flickering Bic lights.

Tom Petty and the Heartbreakers' shows vary little from one to the next, but they do get more assaultive, like a blaring replication of Torpedoes' steam. And the older material benefits from that verve. In "American Girl," Mike Campbell and Benmont Tench embellish Petty's rock-constant rhythm guitar with fierce melodic undercuts, while Stan Lynch and Ron Blair direct the gun-burst tempo changes. In that majestic moment, the Heartbreakers fulfill a lot of promises that Roger McGuinn and company long ago forgot.

Petty, though, is the fulcrum. Yet it's something more than his mannered cockiness and stealthy catwalk that move me tonight. For one thing, it's the way he sings the pained pronouncement at the opening of "Even the Losers" – "I showed you the stars you could never see/ Baby, it couldn't have been that easy to forget about me" – in a voice that sounds like it lost more than it could afford, and will probably lose it all again.

It occurs to me, standing at the back of the hall, that most people I know who have ever found meaning in rock & roll have done so because they saw something heroic or romantic or intellectual or transcendent about the idiom. Petty's music offers a curious kind of transcendence, one that reminds me of something crime novelist James M. Cain once wrote about his own books: "I . . . write of the wish that comes true, for some reason a terrifying concept, at least to my imagination. [The reader realizes] that the characters cannot have this particular wish and survive."

[EXCERPT FROM RS 311 COVER STORY BY MIKAL GILMORE]

RS 311 | TOM PETTY | February 21st, 1980 | Photograph by Annie Leibovitz

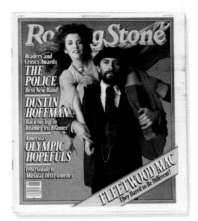

RS 309 | THE WHO
CONCERT TRAGEDY
January 24th, 1980
PHOTOGRAPHERS UNKNOWN

RS 310 | STEVIE NICKS
& MICK FLEETWOOD
February 7th, 1980
PHOTOGRAPH BY RICHARD AVEDON

RS 313 | BOB HOPE
March 20th, 1980
PHOTOGRAPH BY RICHARD AVEDON

RS 314 | LINDA RONSTADT
April 3rd, 1980
PHOTOGRAPH BY ANNIE LEIBOVITZ

RS 315 | JOE STRUMMER
& MICK JONES
April 17th, 1980
PHOTOGRAPH BY ANNIE LEIBOVITZ

RS 316 | BOB SEGER
May 1st, 1980
PHOTOGRAPH BY ANNIE LEIBOVITZ

"THIS IS AN IMPORTANT FACT: PEOPLE PREFER TO DANCE THAN
to fight wars. In these days, when everybody's fighting, mostly
for stupid reasons, people forget that. If there's anything we can
do, it's to get them dancing again." —*Mick Jones*

RS 312 | RICHARD GERE | March 6th, 1980 | Photograph by Terry O'Neill

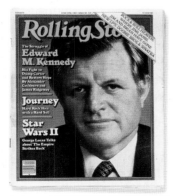

"In Britain, at the moment, we've got 2-Tone, we've still got punk, we've got Mod bands, we've got heavy-metal bands, we've got established supergroups, we've got all kinds of *different* families of music – *each* of which takes an enormous amount of adjustment. They're intense, and very socially . . . jagged. They don't fit neatly into existing society: They challenge it. . . .

"When you listen to the Sex Pistols, to 'Anarchy in the U.K.' and 'Bodies' and tracks like that, what immediately strikes you is that *this is actually happening.* This is a bloke, with a brain on his shoulders, who is actually saying something he *sincerely* believes is happening in the world, saying it with real venom and real passion. It touches you, and it scares you – it makes you feel uncomfortable. It's like somebody saying, 'The Germans are coming! And there's no way we're gonna stop 'em!' . . .

"You read the fucking words, they scare the shit out of you. The Pretenders – Chrissie Hynde's got a sweet voice, but she writes in double-speak: She's talking about getting laid by Hell's Angels on her latest record! And *raped.* The words are full of the most *brutal,* head-on feminism that has ever come out of any band, anywhere. . . ."

[EXCERPT FROM PETE TOWNSHEND INTERVIEW BY GREIL MARCUS]

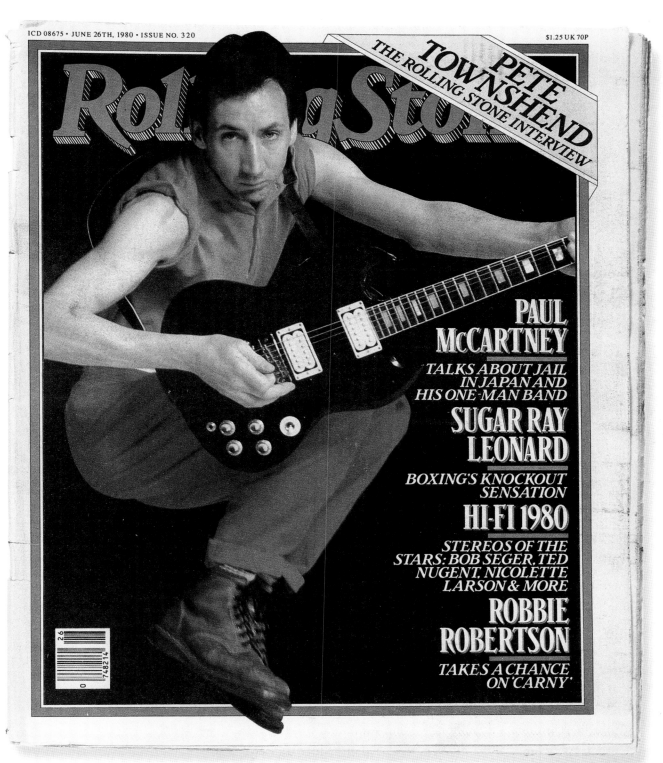

ICD 08675 • JUNE 26TH, 1980 • ISSUE NO. 320

$1.25 UK 70P

Rolling Stone

PETE TOWNSHEND
THE ROLLING STONE INTERVIEW

PAUL McCARTNEY

*TALKS ABOUT JAIL
IN JAPAN AND
HIS ONE-MAN BAND*

SUGAR RAY LEONARD

*BOXING'S KNOCKOUT
SENSATION*

HI-FI 1980

*STEREOS OF THE
STARS: BOB SEGER, TED
NUGENT, NICOLETTE
LARSON & MORE*

ROBBIE ROBERTSON

*TAKES A CHANCE
ON 'CARNY'*

ICD 08675 JULY 10TH, 1980 • ISSUE NO. 321 $1.25 UK 70P

Rolling Stone

JOHN TRAVOLTA
**The Pain and Passion
of a Private Life
By Timothy White**

NICARAGUA
ONE YEAR
AFTER
**The Revolution That
Actually Might Work**

LOS ANGELES
RENAISSANCE
**Local Bands
Thrive in Clubs**

**How to Choose
an Acoustic Guitar**

**The Pros Pick
the Best Keyboards**

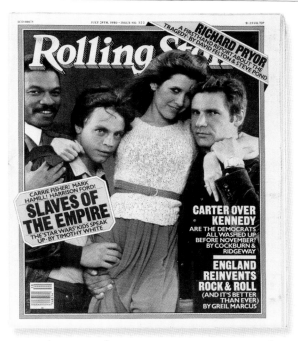

RS 322 | CAST OF 'THE EMPIRE STRIKES BACK'
July 24th, 1980
PHOTOGRAPH BY ANNIE LEIBOVITZ

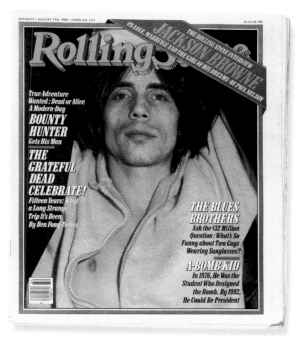

RS 323 | JACKSON BROWNE
August 7th, 1980
PHOTOGRAPH BY ANNIE LEIBOVITZ

Truly, there is a different John Travolta

making movies these days than the one who soared in *Saturday Night Fever*. He has developed the instincts to exploit the charisma that moved *New Yorker* film critic Pauline Kael to dub him "an original presence." Professionally, he has become as insulated as a working actor can possibly be. As for the mystery surrounding his personal life, it can be no accident that after years of extraordinary press coverage, we've learned precious little about who he is.

And so, when Travolta, 26, ambles in for an informal lunch, it isn't surprising that he exudes no particular panache beyond a boyish likability. He arrives alone, as he will for subsequent meetings. He shakes my hand, plops into a chair opposite mine and puzzles over the menu, trying to decide whether he should eat something nourishing or go straight for brownie cake topped with whipped cream. (He eventually opts for the latter.)

[EXCERPT FROM RS 321 COVER STORY BY TIMOTHY WHITE]

RS 326 | RODNEY DANGERFIELD | September 18th, 1980 | PHOTOGRAPH BY ANNIE LEIBOVITZ

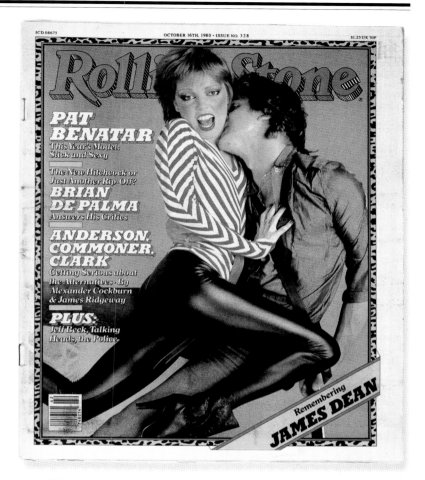

RS 324 | KEITH RICHARDS
& MICK JAGGER
August 21st, 1980
ILLUSTRATION BY JULIAN ALLEN

RS 325 | BILLY JOEL
September 4th, 1980
ILLUSTRATION BY KIM WHITESIDES

RS 328 | PAT BENATAR & NEIL GERALDO
October 16th, 1980
PHOTOGRAPH BY ANNIE LEIBOVITZ

"THE SHIT THE RECORD COMPANY puts out is embarrassing. I came back from the last tour and found out they'd made a cardboard cutout of me in my little tights. What has that got to do with anything? They also took out an ad in *Billboard* and airbrushed part of my top off. They knew I'd never pose like that, so they took the cover of the new record, moved the bottom line up a bit and airbrushed it to look like I'm naked. If that is gonna sell records, then it's a real sorry thing.

"The strange thing is, the bigger you get, the less control you really have. So when something gets really screwed up, you have to pull out the big guns and say, 'Look, cut it out or I won't sing.' I'm not ready to be Farrah Fawcett."
—*Pat Benatar*

RS 329 | THE CARS
October 30th, 1980
PHOTOGRAPH BY ANNIE LEIBOVITZ

"IT'S FUNNY, BUT WHEN I wasn't a so-called star, I still used to get recognized a lot, although for other reasons. I've felt rather like an outcast for most of my life, and I became comfortable with it at a young age. But it's not easy sometimes telling yourself that there's hope for your future, there's a reason to go on." Ocasek sits quietly for several seconds, staring down at his long, bony hands. "I used to think about how it would be turned around someday."

And now that things have turned around?

He shrugs casually. "That's the joke of the thing: you *can't* be loved by everybody. I know that, and I've really come to accept it. That denial of love, in fact, eases my mind."

[EXCERPT FROM RS 329 COVER STORY
BY MIKAL GILMORE]

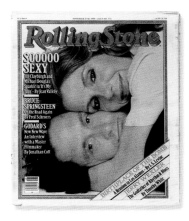

RS 327 | ROBERT REDFORD
October 2nd, 1980
PHOTOGRAPH BY ANNIE LEIBOVITZ

RS 331 | JILL CLAYBURGH & MICHAEL DOUGLAS
November 27th, 1980
PHOTOGRAPH BY ANNIE LEIBOVITZ

RS 330 | MARY TYLER MOORE
November 13th, 1980
PHOTOGRAPH BY ANNIE LEIBOVITZ

RS 333/334 | 1980 YEARBOOK
December 25th, 1980 – January 8th, 1981
TYPOGRAPHER UNKNOWN

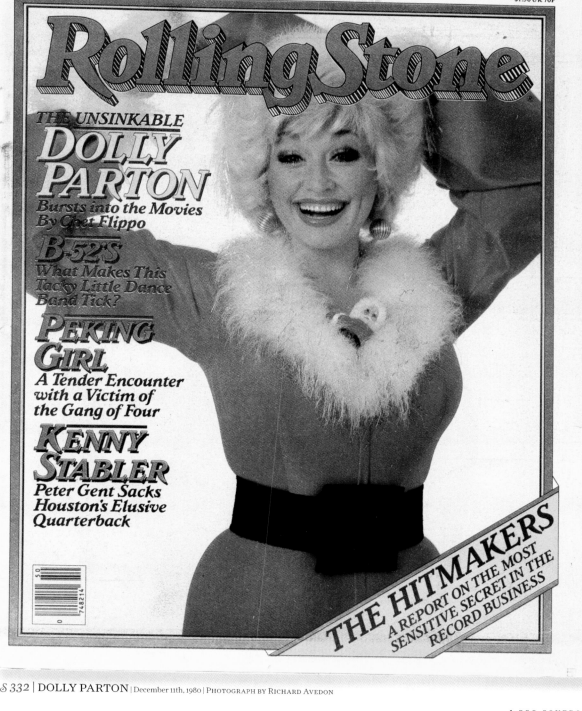

ICD 08675 DECEMBER 11TH, 1980 · ISSUE NO. 332 $1.50 UK 70P

RollingStone

THE UNSINKABLE
DOLLY PARTON
Bursts into the Movies
By Chet Flippo

B-52'S
What Makes This
Tacky Little Dance
Band Tick?

PEKING GIRL
A Tender Encounter
with a Victim of
the Gang of Four

KENNY STABLER
Peter Gent Sacks
Houston's Elusive
Quarterback

THE HITMAKERS
A REPORT ON THE MOST
SENSITIVE SECRET IN THE
RECORD BUSINESS

RS 332 | DOLLY PARTON | December 11th, 1980 | Photograph by Richard Avedon

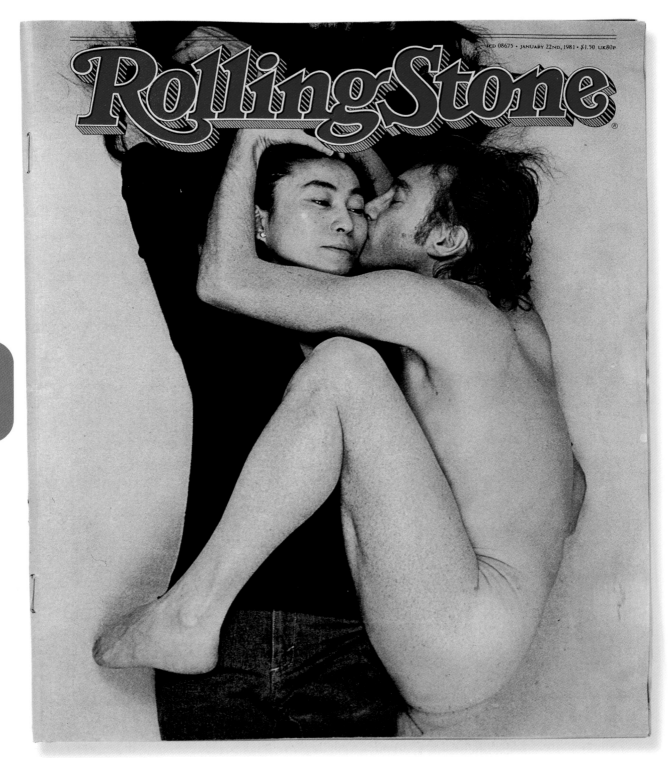

RED 08675 · JANUARY 22ND, 1981 · $1.50 UK80p

1980s

"*Man shot,* One West Seventy-second" was the call on the police radio just before eleven p.m. Officers Jim Moran and Bill Gamble were in the third blue-and-white that screamed to a halt outside the Dakota apartment building. The man who had been shot couldn't wait for an ambulance. They stretched him out on the backseat of their car and raced to Roosevelt Hospital, at the corner of Fifty-ninth Street and Ninth Avenue. They lifted the bloody body onto a gurney and wheeled it into the emergency room. There was nothing the doctors could do. They pronounced John Lennon dead at 11:07 p.m. . . .

Within minutes, the small, brick-walled ambulance courtyard outside the emergency room was filled with at least 200 people who were staring dumbly at the closed double doors. Some of the cabdrivers, who were depositing reporters at the rate of two or three a minute, joined the throng. One of them volunteered loudly that he had it from a good source that John Lennon had been dead on arrival. One young woman stood alone in the middle of Ninth Avenue and wept.

—*Chet Flippo* [EXCERPT FROM RS 335]

"I REMEMBER ARRIVING AT THE apartment that morning, December 8th, and John taking me aside and saying, 'Listen, I know they want to run me by myself on the cover, but I really want Yoko to be on the cover with me. It's really important.' They had just finished their *Double Fantasy* album, and I remember seeing the cover and being very *moved* by it, so of course when they lay down together, and John was nude curled up against her clothed, it was much more poignant. He looked much more vulnerable. I remember peeling the Polaroid and him looking at it and saying, 'This is it. This is our relationship.'

Several hours later John was murdered. I went to the Roosevelt Hospital waiting for an announcement. Early in the morning, the doctor came out – I remember that I was completely numb – I stood on a chair and I photographed the doctor giving the death announcement. I came in [to ROLLING STONE] the following day, and they were mocking up covers with John's portrait [close-ups of his face] and I said, 'Jann, I promised John that the cover would be him and Yoko.' And Jann backed me up. I said it was the last promise." —*Annie Leibovitz*

"We have lost a genius of the spirit."

—*Norman Mailer*

MORE THAN ANY OTHER ROCK MUSICIAN (with the possible exception of Bob Dylan), John Lennon personalized the political and politicized the personal, often making the two stances interchangeable but sometimes ripping out the seams altogether. Whereas Dylan expressed his personal and political iconoclasm mainly by expanding and exploding the narrative line, Lennon assaulted pop music from a dozen different directions. He not only attacked the war – any war – but questioned and confronted the very methods and structures he'd utilized in his attack, thereby pushing rock & roll up against the wall to test limits and demand answers. John Lennon believed passionately that popular music could and should do more than merely entertain. He changed the face of rock & roll forever. —*Stephen Holden* [EXCERPT FROM RS 335]

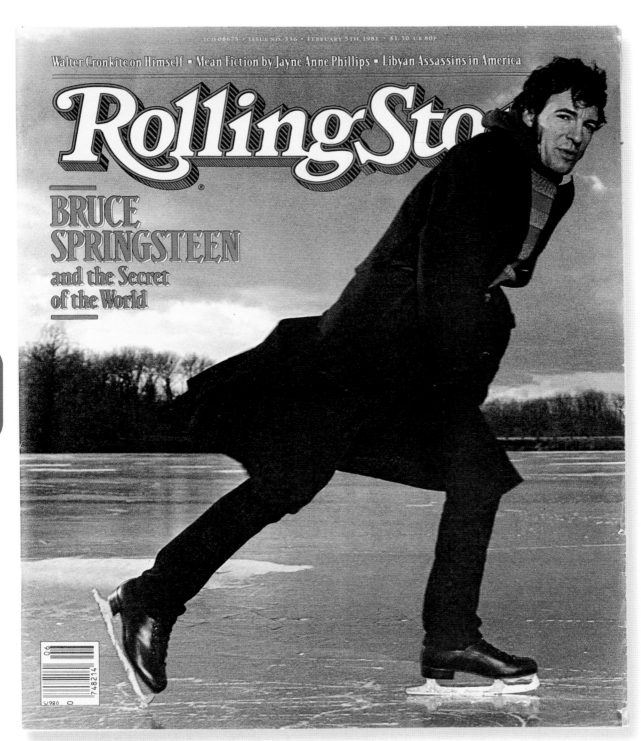

RS 336 | BRUCE SPRINGSTEEN | February 5th, 1981 | PHOTOGRAPH BY ANNIE LEIBOVITZ

\mathcal{RS} 337 | THE POLICE
February 19th, 1981
PHOTOGRAPH BY KLAUS LUCKA

\mathcal{RS} 338 | GOLDIE HAWN
March 5th, 1981
PHOTOGRAPH BY DENIS PIEL

\mathcal{RS} 340 | ROMAN POLANSKI
April 2nd, 1981
ILLUSTRATION BY JULIAN ALLEN

[RS 336] In discussing ROLLING STONE with Jann Wenner, Mick Jagger implies that the logo lost its character when it lost its balls. Hence the introduction of a redesigned logo by typographer Jim Parkinson combining elements of the previous logos. In addition, glossy paper and trimmed pages replace rough-edged newsprint, and the cover's dimensions decrease to 10 by 12 inches, the size it has remained ever since.

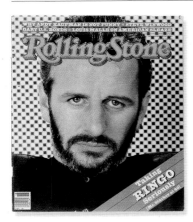

RS 342 | RINGO STARR
April 30th, 1981
PHOTOGRAPH BY MICHAEL CHILDERS

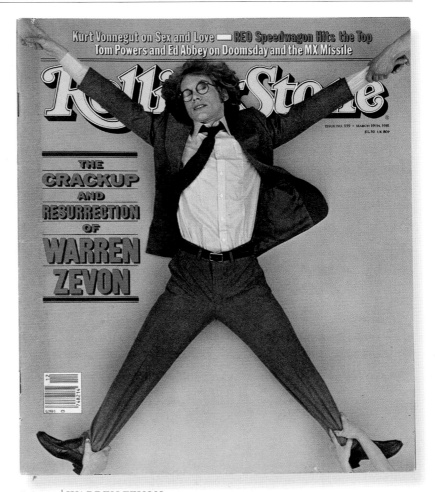

RS 339 | WARREN ZEVON | March 19th, 1981 | PHOTOGRAPH BY ANNIE LEIBOVITZ

[RS 341] Albert Watson traveled to Jack Nicholson's house in Aspen, Colorado, for this cover shot. When snow started falling hard, the actor asked Watson to leave him alone outdoors for fifteen minutes. Nicholson, by the way, had just completed work on *The Shining*, in which his character freezes to death. Perhaps still in character, Nicholson waited until he had slightly more than a dusting before getting his photo taken.

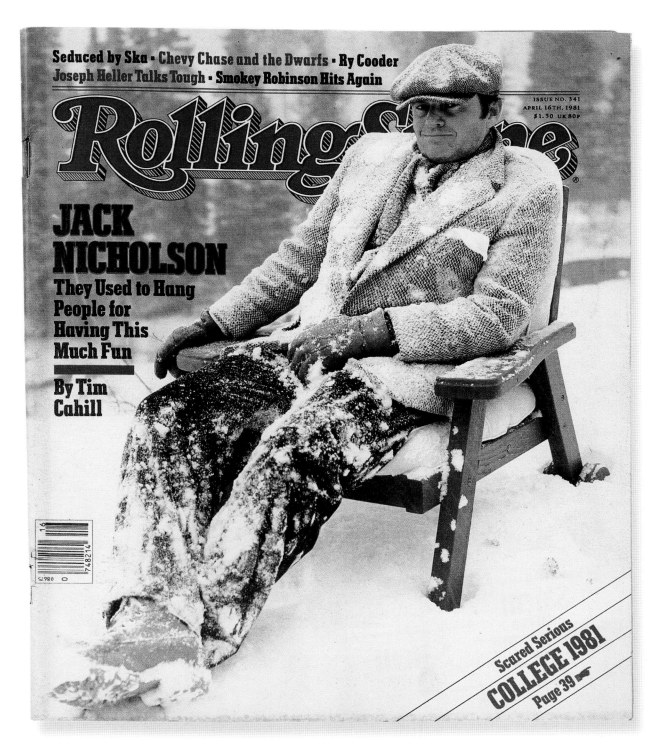

Seduced by Ska · Chevy Chase and the Dwarfs · Ry Cooder
Joseph Heller Talks Tough · Smokey Robinson Hits Again

Rolling Stone

ISSUE NO. 341
APRIL 16TH, 1981
$1.50 UK 80P

JACK NICHOLSON
They Used to Hang People for Having This Much Fun

By Tim Cahill

Scared Serious
COLLEGE 1981
Page 39

RS 341 | JACK NICHOLSON | April 16th, 1981 | PHOTOGRAPH BY ALBERT WATSON

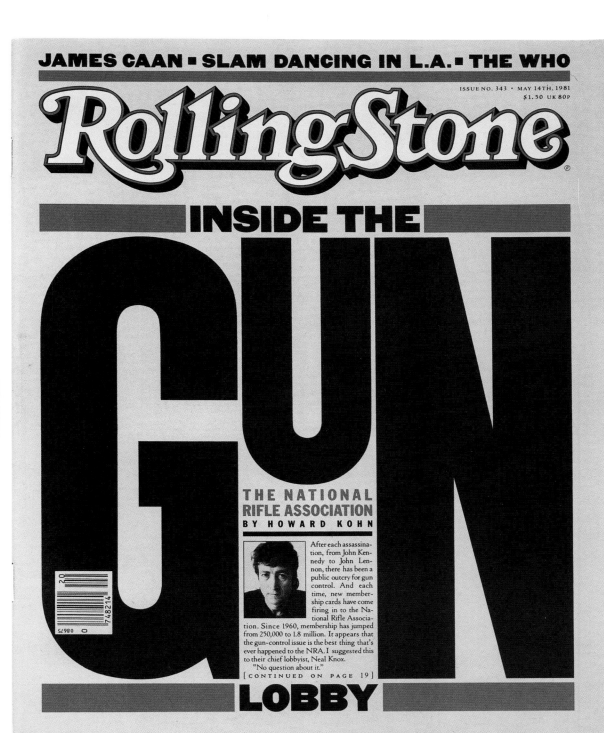

ISSUE NO. 343 • MAY 14TH, 1981
$1.50 UK 80P

JAMES CAAN ■ SLAM DANCING IN L.A. ■ THE WHO

Rolling Stone

INSIDE THE

GUN

THE NATIONAL RIFLE ASSOCIATION
BY HOWARD KOHN

After each assassination, from John Kennedy to John Lennon, there has been a public outcry for gun control. And each time, new membership cards have come firing in to the National Rifle Association. Since 1960, membership has jumped from 250,000 to 1.8 million. It appears that the gun-control issue is the best thing that's ever happened to the NRA. I suggested this to their chief lobbyist, Neal Knox.

"No question about it."

[CONTINUED ON PAGE 19]

LOBBY

1980s

RS 343 | GUN CONTROL & JOHN LENNON | May 14th, 1981 | PHOTOGRAPH BY ANNIE LEIBOVITZ

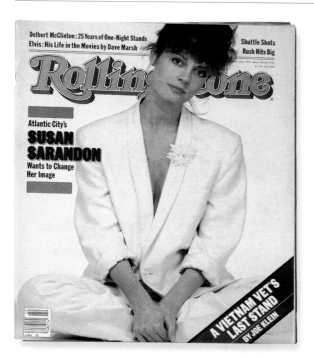

RS 344 | SUSAN SARANDON
May 28th, 1981
PHOTOGRAPH BY ALBERT WATSON

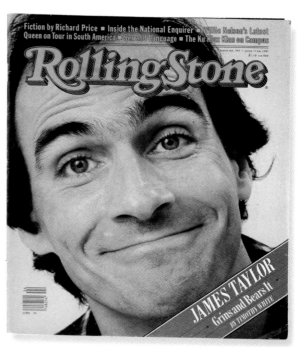

RS 345 | JAMES TAYLOR
June 11th, 1981
PHOTOGRAPH BY AARON RAPOPORT

MIDNIGHT, SATURDAY NIGHT. After I came clean with the cop and told him I was a reporter working on a story, he volunteered to put me in touch with a black-market gun dealer. The meeting place was the gunrunner's car in a motel parking lot. He patted me down for a hidden mike and then we drove around aimlessly, until he was satisfied there was no tail. He spoke with a Brooklyn accent, but his guns were from Florida – RG guns, the brand John Hinckley used.

The triggers and barrels and cylinders are imported from Germany and assembled in Miami, where labor is cheap. The RG Industries factory is a small whitewashed structure that looks as if it has been thrown up, ready to be abandoned at a moment's notice. Approximately 350,000 guns are assembled there each year.

"I don't buy right out of the factory. I buy wholesale," the gunrunner said. He showed me a large metal-frame suitcase. Zip-lock plastic bags were arranged by size among three dividers, and inside each bag was an RG Special. He conducts his business from motel rooms. Three or four times a week he changes locations in the suburbs around Washington. You have to find him. A lot of people do. "You

betcha," he said. "Some of my best customers are cabbies."

What if Congress were to pass a federal law like the one in D.C.? "Suits me. Business would go sky-high. I'd have to open franchises." How big is the black market today? A grin. No answer. Is the mob involved? "Not with me, no way. But you go ahead and get gun control passed and the mob's gonna be all over this business like flies over candy." He says he's a pessimist. Guns are part of America. Shut down RG Industries, lock up the gunrunners, legislate and confiscate all you want, and there will still be guns. Zip guns made from car aerials. Starter pistols with the barrels hollowed out and the gas ports covered with Silly Putty and needles for ammo. Shotguns fashioned from pipes, rubber bands, blocks of wood, firing nails. On the black market, the quality of merchandise varies, but prices tend to level out. The RG guns are bottom-of-the-line – Saturday-night specials. But you can buy a Smith & Wesson as well. Statistically, in gun crimes, quality merchandise is used as often as junk. As the National Rifle Association will tell you, all guns are equal before the Constitution.

[EXCERPT FROM RS 343 COVER STORY BY HOWARD KOHN]

RS 347 | MARGOT KIDDER
July 9th, 1981
PHOTOGRAPH BY DENIS PIEL

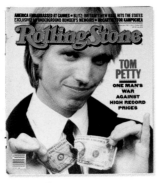

RS 348 | TOM PETTY
July 23rd, 1981
PHOTOGRAPH BY AARON RAPOPORT

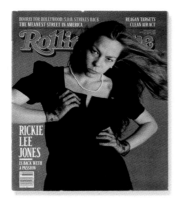

RS 349 | RICKIE LEE JONES
August 6th, 1981
PHOTOGRAPH BY ANNIE LEIBOVITZ

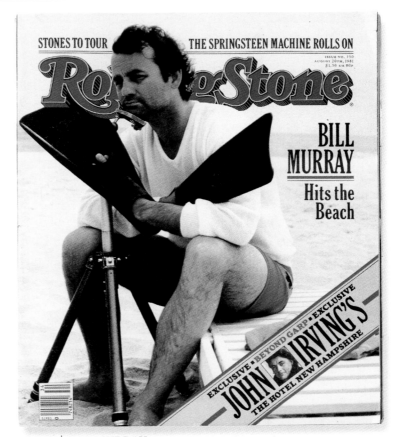

STONES TO TOUR THE SPRINGSTEEN MACHINE ROLLS ON

Rolling Stone

ISSUE NO. 350
AUGUST 20TH, 1981
$1.50 UK 80p

BILL MURRAY
Hits the Beach

EXCLUSIVE • BEYOND GARP • EXCLUSIVE
JOHN IRVING'S
THE HOTEL NEW HAMPSHIRE

RS 350 | BILL MURRAY | August 20th, 1981 | PHOTOGRAPH BY ANDREA BLANCH

"I WAS FIGHTING THE RECORD INDUSTRY TO KEEP PRICES DOWN TO $8.98.
So ROLLING STONE wanted me in a suit and tie to reflect some kind of
corporate angle. It really looked silly to me – like my head had been cut
off and pasted onto another body. I was not really all that comfortable
with it. But Mick Jagger told me not long afterwards that that cover had
helped them. The Stones really wanted to keep the price down on their
upcoming record, and they were at a meeting about it, and someone
brought that cover in, and it helped to resolve the whole argument. It
really did hold prices down for quite a while after that. I was sort of
proud of that – it's a case of using your position to speak to the masses
and send your opinion out."
—*Tom Petty*

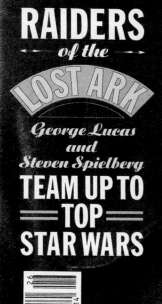

ISSUE NO. 346 • JUNE 25TH, 1981
$1.50 UK 80P

RollingStone

RAIDERS
of the
LOST ARK
George Lucas
and
Steven Spielberg
**TEAM UP TO
TOP
STAR WARS**

Harrison Ford
as
Indiana Jones

RS 346 | HARRISON FORD | June 25th, 1981 | Photograph by Bill King

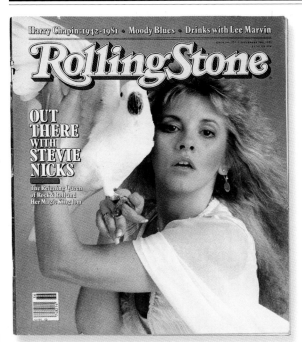

RS 351 | STEVIE NICKS
September 3rd, 1981
PHOTOGRAPH BY ANNIE LEIBOVITZ

1980s

RS 352 | JIM MORRISON
September 17th, 1981
PHOTOGRAPH BY GLORIA STAVERS

THE MOST FAMOUS (or infamous) cover line ROLLING STONE ever ran accompanied a 1968 photograph of Jim Morrison taken by his lover/confidante, longtime *16* magazine editor Gloria Stavers. During her stint (from 1957 to 1975) at the preeminent teen 'zine, Stavers – who would die two years after this issue, in 1983, of lung cancer – practically invented provocative cover lines. She was also an early champion of ROLLING STONE, writing a feature in *16* about the new rock rag not long after it began publication and later giving Jann Wenner advice about rock photography.

As for ROLLING STONE's cover line, a handful of staffers have taken credit for writing it, and, simply put, it works. As the cover story detailed, a full ten years after Morrison's death, Doors records were selling better than ever, hordes of kids were making the pilgrimage to his grave in Paris's Père-Lachaise cemetery and the lead singer's poetry was being revered.

The State of the Democrats by Joe Klein ■ **Smart Audio 1981**
Was Elvis Cheated? ■ **Wheelsucking in Boulder, Colorado**

RollingStone

SEPTEMBER 17TH, 1981
ISSUE NO. 352
$1.50 UK 80P

Jim Morrison

He's hot,
he's sexy
and he's dead

Santana Surfaces • A Special Report : College Life 1981

ISSUE NO. 353 • OCTOBER 1st, 1981
$1.50 UK 80p

RollingStone

Yoko

An Intimate Conversation

Photographs by Annie Leibovitz

By Barbara Graustark

"[WHEN THIS PHOTO was taken] I was walking in a daze. But I think it helped that it was Annie [who took the picture] rather than a stranger."

—*Yoko Ono*

I THINK JOHN'S DEATH MADE SEAN and me very strong. A lot of people are saying that because of what happened, he's going to grow up to be a neurotic kid, and I worried about that. But looking at Sean, I see only strength in him. And somehow I think that Sean is going to be all right. Not just all right, but beautiful.

"It's like this event – isn't that a terrible way of putting it? – affected us all in different ways, but we are all stronger and more aware for it, and probably for the better.

"I can't think it was all for the worse.

"When John and I were saying 'The world is one, one world,' it's almost like fate told us, 'Okay, prove it. Prove it with your life.' And that's what John did. At the time of his death, the world definitely became one. And though we might forget it, we're never going to lose that sense. It's in us, and it always will be. Somehow we're gonna be different. And the sense of oneness that we preached, well, John actually had to show it physically, and somehow he did it. That was his fate. And I keep thinking of it.

"It's like preaching is not enough. Let the whole world feel it. Let it happen."

[EXCERPT FROM YOKO ONO INTERVIEW BY BARBARA GRAUSTARK]

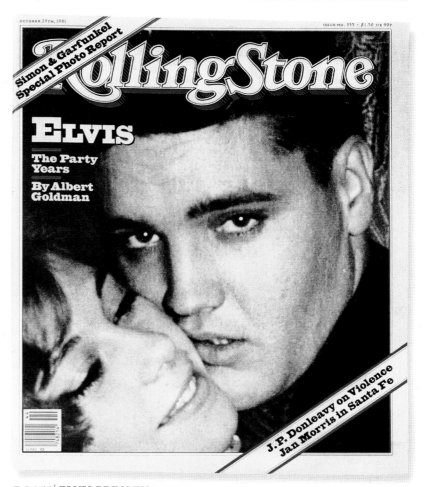

RS 355 | ELVIS PRESLEY | October 29th, 1981 | PHOTOGRAPH BY RUDOLF PAULINI

Foreigner Gets Good, Stones Get Great, Simon & Garfunkel Get Back

ISSUE NO. 354 • OCTOBER 15TH, 1981
$1.50 UK 80p

RollingStone

MERYL STREEP

RS 354 | MERYL STREEP | October 15th, 1981 | Photograph by Annie Leibovitz

186 • ROLLING STONE

"PUT YOURSELF IN THIS POSITION. You're passing the newsstand at Fifty-seventh Street and Sixth Avenue, and there's your face on the cover of a magazine. And one week later, you're on the subway, and there's that cover, with your face, on the floor. Somebody's probably pissed on it."

—Meryl Streep

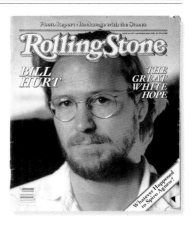

RS 357 | WILLIAM HURT
November 26th, 1981
PHOTOGRAPH BY ANNIE LEIBOVITZ

"*I was scheduled to shoot*

[Meryl Streep] for the cover of ROLLING STONE, *The French Lieutenant's Woman* was coming out, and that week [Francesco] Scavullo had shot her for the cover of *Time*, I think. And she'd had such a miserable time at that shooting – she was becoming this very big star, they wanted her to look like a big star, and she couldn't deal with it – that she canceled my shooting. So I called up her agent and screamed for forty-five minutes, and finally the agent said, 'She won't go anywhere with you. She'll come to your studio and give you between nine-thirty and twelve in the morning, and that's it.'

"I was shooting [John] Belushi at the time, I had all these clown books around the studio, and I was even thinking of a whiteface for Belushi. Actually, I bought the clown books originally for James Taylor, who had hepatitis and didn't want to be on the cover of ROLLING STONE because his face was all yellow.

"So she came to the studio and she told me about the *Time* shooting, and she said how she didn't want to be anybody, she was nobody, all she was was an actress. So I said, 'Well, be no one, be a mime. Let's try the whiteface.' And she really loved it. That's when she started to pull her cheeks out like this – she did that herself. It's just great when that stuff starts to happen."

—Annie Leibovitz

Back to the Barricades : inside the Environmental Movement

Rolling Stone

ISSUE NO. 356 • NOVEMBER 12TH, 1981 • $1.50 UK 90P

KEITH RICHARDS

No Regrets

The Rolling Stone Interview

By Kurt Loder

Stones Tour from the Front Row ● Jamie Lee Curtis

ISSUE NO. 358 · DECEMBER 10TH, 1981 · $1.50 UK 90P

RollingStone

Carly: Life without James

A Hollywood Fiction By Bruce Jay Friedman

RS 358 | CARLY SIMON | December 10th, 1981 | PHOTOGRAPH BY JIM VARRIALE

Will Success Spoil Mick Jagger? · Audio - Video 1982

ISSUE NO. 361 · JANUARY 21ST, 1982 · $1.50 UK 90P

RollingStone

John Belushi

More Than Just a Pretty Face

1980s

SCTV's Best Joke • The Paranoid Millionaires Convention

ISSUE NO. 362 • FEBRUARY 4TH, 1982 • $1.50 UK 90P

RollingStone

Timothy
Hutton
Is Too
Good To
Be True

Ali's Last Stand
By Harold Conrad

RS 362 | TIMOTHY HUTTON | February 4th, 1982 | PHOTOGRAPH BY ANNIE LEIBOVITZ

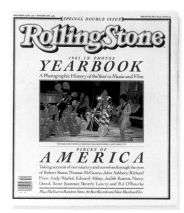

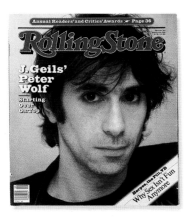

R𝒮 359/360 | THE
ROLLING STONES
December 24th, 1981 – January 7th, 1982
PHOTOGRAPH BY LYNN GOLDSMITH

R𝒮 364 | PETER WOLF
March 4th, 1982
PHOTOGRAPH BY ANNIE LEIBOVITZ

"*Steve Martin,* actually, he says to me, 'Annie, I've pushed myself in my movies and in my career; everything's gone further except for the photographs of myself.' And he was really interested in trying to take a new picture. He had just bought that Franz Kline, it was the kind of thing only museums can afford, and it seemed so strange to have it in his home. And he was just in love with it. He said, 'I see myself in that picture.'

"When I went out there I wanted to do him in tails, but then I realized he was already beyond the tails. This was a way of throwing away the tails so he could move forward – he could have been stuck in that *Pennies From Heaven* genre for some time. Originally we were going to paint him black, put him in the painting, but then I came up with the idea of painting the tux like the painting." *—Annie Leibovitz*

1980s

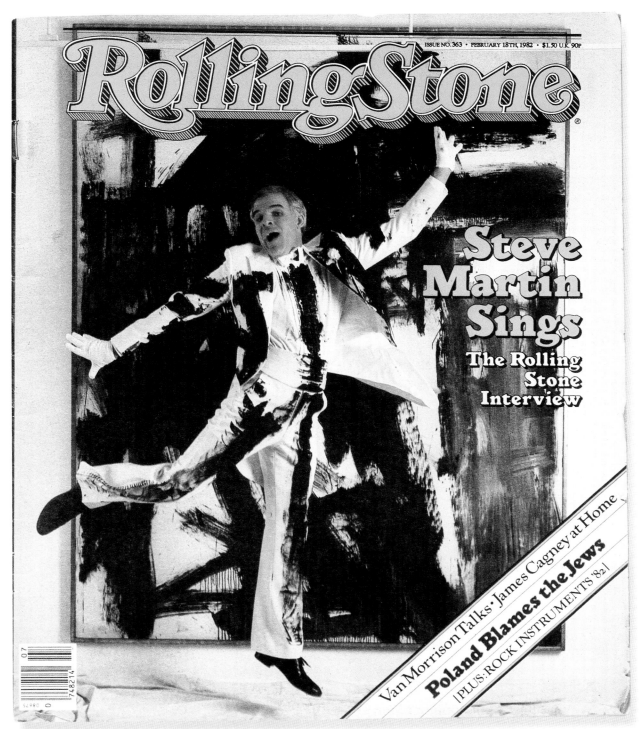

ISSUE NO. 363 • FEBRUARY 18TH, 1982 • $1.50 U.K. 90P

RollingStone

Steve Martin Sings

The Rolling Stone Interview

Van Morrison Talks • James Cagney at Home

Poland Blames the Jews

[PLUS: ROCK INSTRUMENTS '82]

RS 363 | STEVE MARTIN | February 18th, 1982 | PHOTOGRAPH BY ANNIE LEIBOVITZ

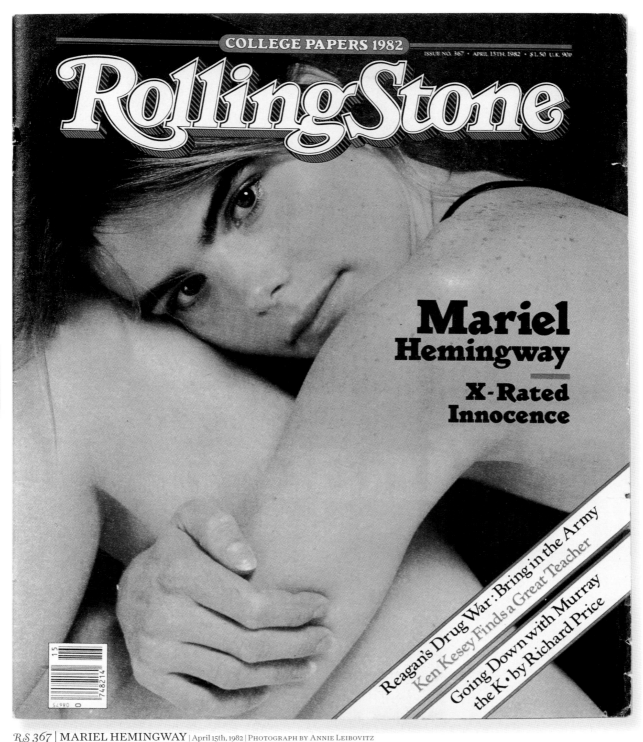

COLLEGE PAPERS 1982

ISSUE NO. 367 · APRIL 15TH, 1982 · $1.50 U.K. 90P

Rolling Stone

Mariel Hemingway

X-Rated Innocence

Reagan's Drug War: Bring in the Army
Ken Kesey Finds a Great Teacher

Going Down with Murray
the K · by Richard Price

RS 367 | MARIEL HEMINGWAY | April 15th, 1982 | PHOTOGRAPH BY ANNIE LEIBOVITZ

SIMON AND GARFUNKEL : A CLASS REUNION

Rod Stewart Cleans Up His Act
FRANCIS COPPOLA
The RS Interview

Admiral Rickover's Warning: 'Beware the Pentagon'

Warren Beatty

Seriously

By Aaron Latham

THELONIOUS MONK 1917-1982

RS 365 | ART GARFUNKEL & PAUL SIMON
March 18th, 1982
PHOTOGRAPH BY ANNIE LEIBOVITZ

RS 366 | WARREN BEATTY
April 1st, 1982
PHOTOGRAPH BY JACK MITCHELL

IT MAY BE AN IDEA WHOSE TIME HAS COME – AGAIN. Two men, one guitar, a body of beautifully crafted songs. Sounds retrograde, you say? Well, until six months ago, Paul Simon and Art Garfunkel probably would have agreed. But then, last September 19th, Simon and Garfunkel played a free concert in New York's Central Park. It was their first full performance together in eleven years, and nearly half a million people flocked to see it. In the aftermath of that unexpectedly successful event, as they worked on a live album and video, Simon and Garfunkel talked seriously about getting back together again. Now, they're considering a tour of Europe in May, and possibly some U.S. dates this summer. And if things go well, there may even be a new Simon and Garfunkel studio album.

If things go well. In all their years as a singing team, these two boyhood buddies somehow never learned how to talk to each other. Personal tics caused tension, and quibbles accumulated into quarrels. Nothing major, but unpleasant memories lingered. In fact, the Central Park show almost didn't come off.

"The weeks before the concert were so tense that there were times I really regretted having agreed to do it," said Simon, sitting in the palatial study of his apartment, which overlooks Central Park. "It was very rushed. Artie had to learn a lot of material very quickly. Basically, the show combined old Simon and Garfunkel arrangements with expanded orchestrations of arrangements I used on my *One-Trick Pony* tour. We didn't have time to make new arrangements."

It didn't matter – the concert was a spontaneous smash. And in the postconcert projects that followed – polishing the tapes for the recently released live double album, *The Concert in Central Park*; editing videotapes for a February 21st airing on Home Box Office; and planning a videocassette for commercial release – Simon and Garfunkel discovered that they could work together again. Better yet, they *wanted* to work together again. With their music as the focus, the old disputes fell away. As Garfunkel said, "We had a rapprochement."

[EXCERPT FROM RS 365 COVER STORY BY STEPHEN HOLDEN]

"*Even though he* was a bit of a monster, he was *our* monster, as well as a damned good person you could count on for help in the dark times. There was a ten-day period one recent summer when I sought refuge with him. We fooled around in his speedboat, dug clams and steamed them, and he lifted me out of the pit with his considerable powers as a host. The most drugs we did was a little pot, and he seemed as peaceful as I'd ever seen him.

"The last time he visited me, he caught my neighbor a bit offguard by 'borrowing' his truck for a spell. But, hell, he brought it back in pretty good condition. As far as I'm concerned, John is welcome at my house anytime, dead or alive. For me, John's epitaph is: THIS MAN WAS THE REAL THING. HE NEVER NEEDED PROPS."

—*Hunter S. Thompson*

"'NATIONAL LAMPOON'S ANIMAL HOUSE' was a lowball project in Hollywood when Sean Daniels asked me to develop it. I read the script and loved it, but the studio said no movie unless I got this guy named Belushi to play Bluto Blutarski. I flew to New York and arranged a meeting with John at the Drake Hotel. He came up to my room, ordered ten shrimp cocktails, twenty beers and ten Perriers. I told him that Bluto would be on screen less time than any of the other characters and that he'd have the least dialogue. In the end, the film was to be designed for Bluto's entrances and exits.

"John threw out ideas. I said no to all of them, thinking at the moment that I was losing my star and my movie.

" 'No?' he said.

" 'No,' I said.

" 'Good,' he said. 'I was just testing you. I'll do the film.' He got up and left, and then, of course, all the food and drink arrived."

—*John Landis*

"I NOT ONLY WORKED with John on the *Blues Brothers* film, I also worked with him on *Saturday Night Live*. He was the kind of guy who would volunteer to sit with me and help me prepare my lines, since I obviously could not rely on cue cards. He was a sweet, thoughtful man who did everything he could think of to make me feel comfortable.

"John was a loyal fan of rhythm & blues, and the Blues Brothers movie got a hell of a lot of people back into R&B. They especially helped people like Aretha Franklin and me reach the young kids who might not have even known we existed. As far as commercial interest in R&B is concerned, John helped get the ball rolling again. Man, we owe him."

—*Ray Charles*

"WHEN I WAS ON THE ROAD with John in *Lemmings*, we used to room together occasionally. I had a habit of putting my girlfriend's picture up on my bureau. John walked in one night, looked at the photo and said, 'Oh, you've got one of her too, eh? I've got the version with the donkey in the picture.' " —*Chevy Chase*

"A FEW WEEKS BEFORE HE DIED, JOHN grabbed me at a party in New York, threw me into the bathroom, barricaded the door and said, 'Listen, I want you to tell George Lucas that Danny and I want to be space monsters in the next *Star Wars* sequel! We're not leaving this bathroom till you agree.' I agreed. They would have been ideal as funky space monsters. I liked those little unexpected get-togethers with John. He once sat with me for three hours in a Beverly Hills beauty salon while I had my hair done, and he was like the world's largest puppy, charming the whole place." —*Carrie Fisher*

1980s

ISSUE NO. 368 · APRIL 29TH, 1982

$1.50 U.K. 90p

RollingStone

John Belushi

By Dan Aykroyd, Jim Belushi, Mitchell Glazer
Brian Doyle-Murray, Michael O'Donoghue
Jack Nicholson, Hunter S. Thompson
Laraine Newman, Don Novello
and friends...

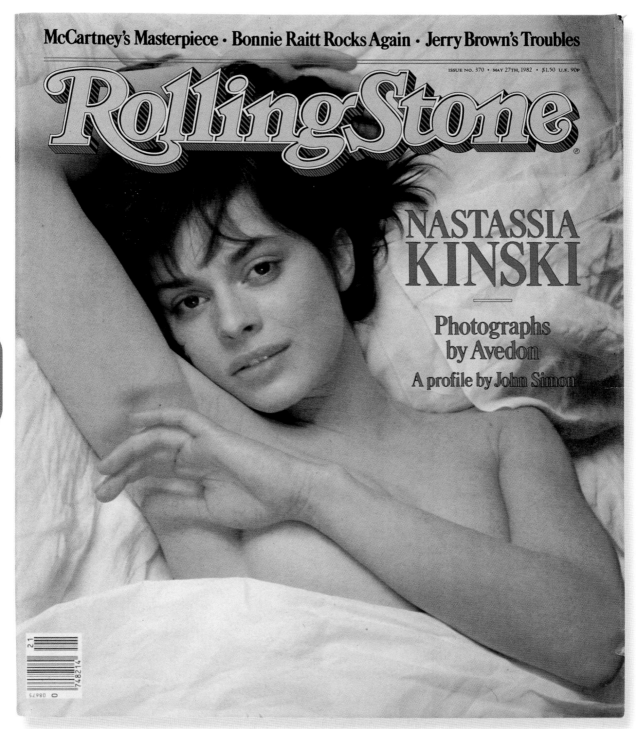

McCartney's Masterpiece · Bonnie Raitt Rocks Again · Jerry Brown's Troubles

ISSUE NO. 370 · MAY 27TH, 1982 · $1.50 U.K. 90P

Rolling Stone

NASTASSIA KINSKI

Photographs
by Avedon

A profile by John Simon

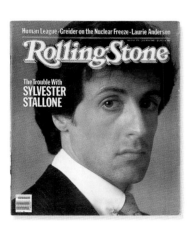

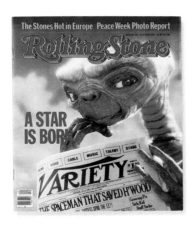

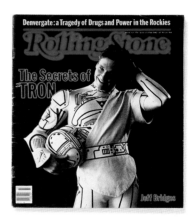

RS 369 | SISSY SPACEK
May 13th, 1982
PHOTOGRAPH BY ANNIE LEIBOVITZ

RS 371 | DAVID LETTERMAN
June 10th, 1982
PHOTOGRAPH BY HERB RITTS

RS 372 | PETE TOWNSHEND
June 24th, 1982
ILLUSTRATION BY JULIAN ALLEN

RS 373 | SYLVESTER STALLONE
July 8th, 1982
PHOTOGRAPH BY ANNIE LEIBOVITZ

RS 374 | E.T.
July 22nd, 1982
PHOTOGRAPH BY AARON RAPOPORT

RS 376 | JEFF BRIDGES
August 19th, 1982
PHOTOGRAPH BY ANNIE LEIBOVITZ

[RS 373] **Jann Wenner hires art director Derek Ungless, whose background was in European magazine design, to give ROLLING STONE a cleaner, more spare look.**

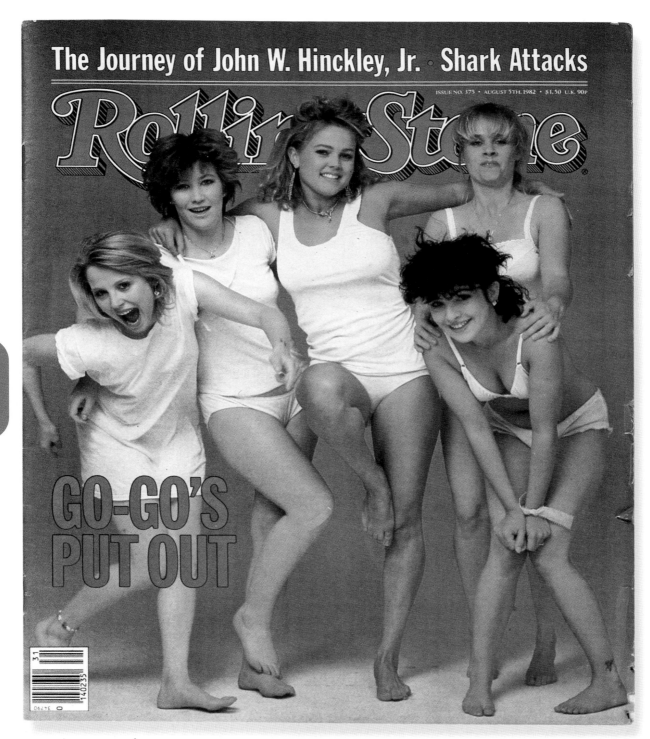

ISSUE NO. 375 · AUGUST 5TH, 1982 · $1.50 U.K. 90P

Rolling Stone

GO-GO'S
PUT OUT

1980s

RS 375 | THE GO-GO'S | *August 5th, 1982* | Photograph by Annie Leibovitz

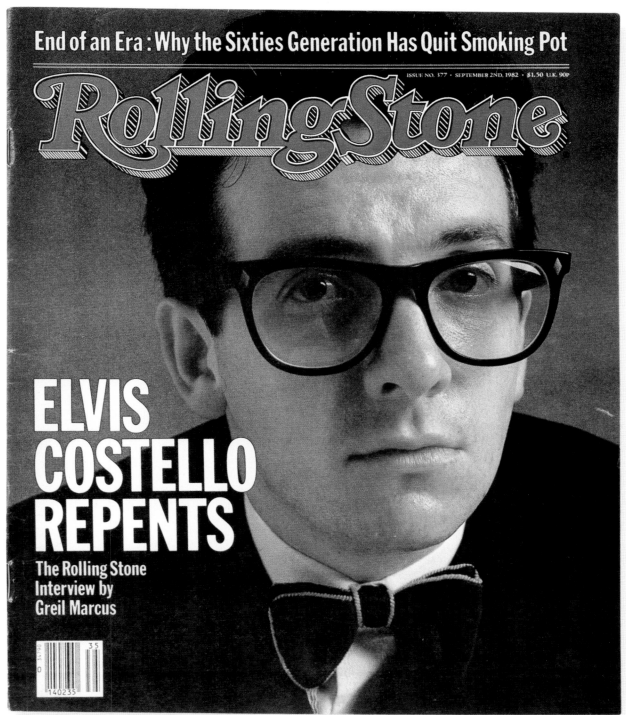

End of an Era : Why the Sixties Generation Has Quit Smoking Pot

ISSUE NO. 377 · SEPTEMBER 2ND, 1982 · $1.50 U.K. 90P

Rolling Stone

ELVIS COSTELLO REPENTS

The Rolling Stone
Interview by
Greil Marcus

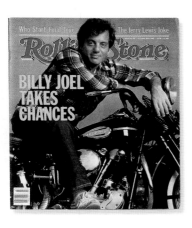

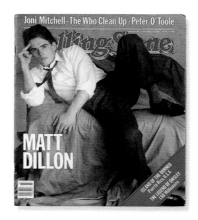

RS 378 | ROBIN WILLIAMS
September 16th, 1982
PHOTOGRAPH BY BONNIE SCHIFFMAN

RS 379 | RICHARD GERE
September 30th, 1982
PHOTOGRAPH BY HERB RITTS

RS 380 | JOHN LENNON
& YOKO ONO
October 14th, 1982
PHOTOGRAPH BY ALLAN TANNENBAUM

RS 381 | BILLY JOEL
October 28th, 1982
PHOTOGRAPH BY ANNIE LEIBOVITZ

RS 383 | MATT DILLON
November 25th, 1982
PHOTOGRAPH BY ANNIE LEIBOVITZ

RS 385/386 | 1982 YEARBOOK
December 23rd, 1982 – January 6th, 1983
VARIOUS PHOTOGRAPHERS

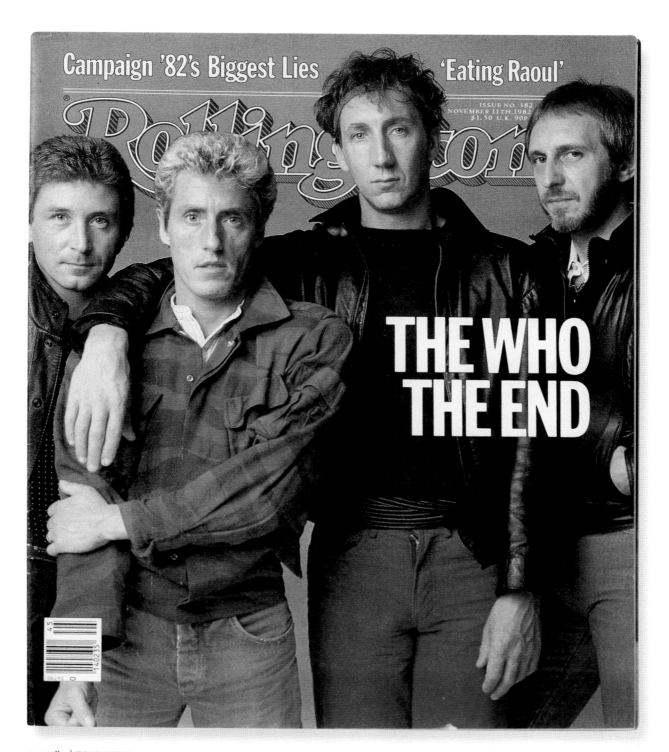

Campaign '82's Biggest Lies 'Eating Raoul'

Rolling Stone

ISSUE NO. 382
NOVEMBER 11TH, 1982
$1.50 U.K. 90P

**THE WHO
THE END**

RS 382 | THE WHO | November 11th, 1982 | PHOTOGRAPH BY ANNIE LEIBOVITZ

ISSUE NO. 384 · DECEMBER 9TH, 1982 · $1.50 U.K. 90P

RollingStone

The Divine
Ms. Midler

BETTE
NOIRE

1980s

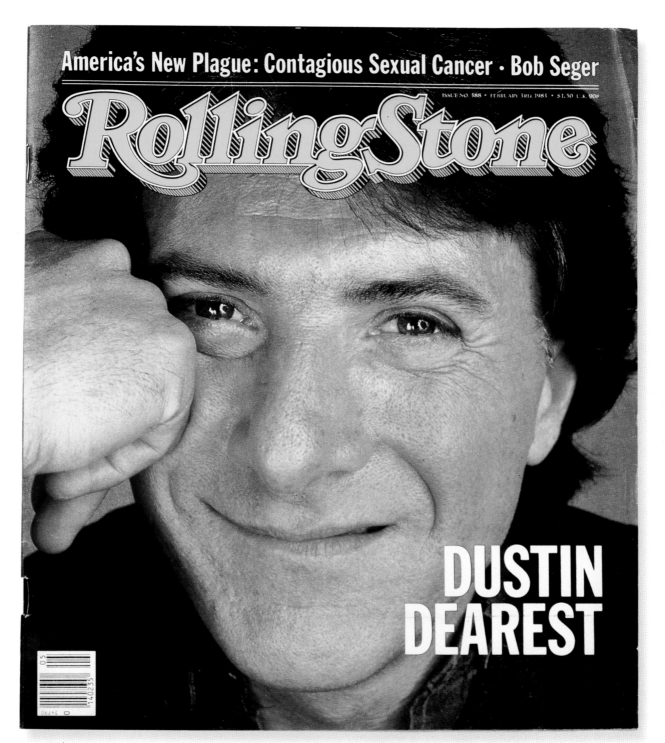

America's New Plague: Contagious Sexual Cancer · Bob Seger

ISSUE NO. 388 · FEBRUARY 3RD, 1983 · $1.50 U.K. 90p

RollingStone

DUSTIN DEAREST

RS 388 | DUSTIN HOFFMAN | February 3rd, 1983 | Photograph by Richard Avedon

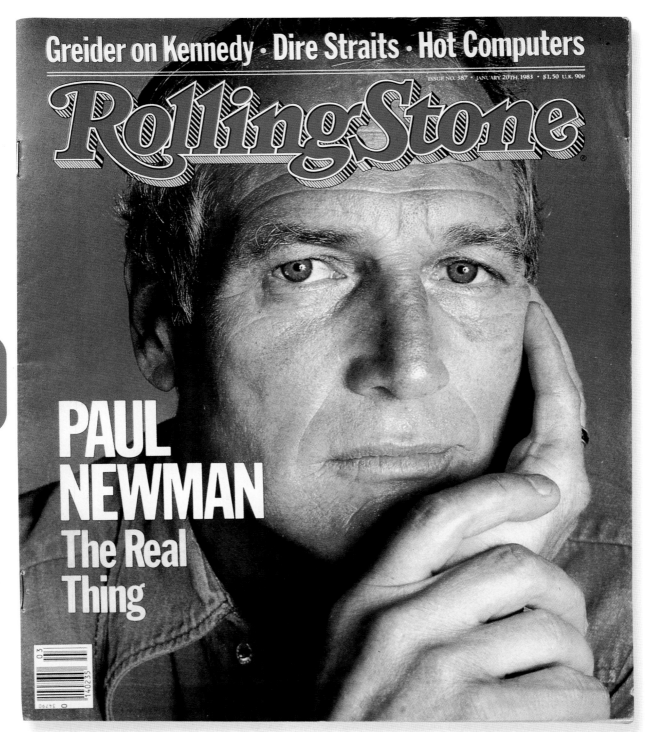

Greider on Kennedy · Dire Straits · Hot Computers

ISSUE NO. 387 · JANUARY 20TH, 1983 · $1.50 U.K. 90P

RollingStone

PAUL NEWMAN
The Real Thing

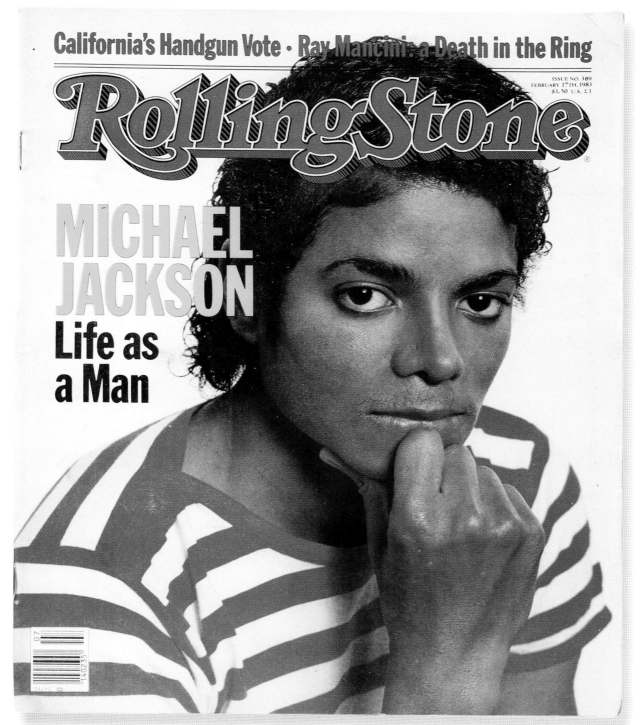

California's Handgun Vote · Ray Mancini: a Death in the Ring

RollingStone

ISSUE NO. 389
FEBRUARY 17TH, 1983
$1.50 U.K. £1

MICHAEL JACKSON
Life as a Man

RS 389 | MICHAEL JACKSON | February 17th, 1983 | PHOTOGRAPH BY BONNIE SCHIFFMAN

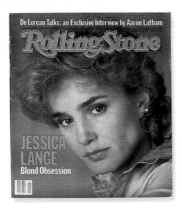

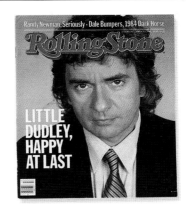

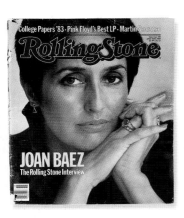

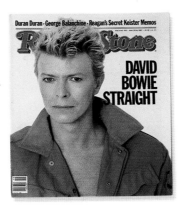

RS 392 | DUDLEY MOORE
March 31st, 1983
PHOTOGRAPH BY BONNIE SCHIFFMAN

"THE BEST THING IS TO HAVE absolutely no idea what you're doing. I much prefer the planned accident to the 'Well, if you turn your head this way, deah, your cheekbone stands out' approach. I've got to have a photograph that's sort of extraordinary looking rather than beautiful."
—David Bowie

RS 390 | THE STRAY CATS
March 3rd, 1983
PHOTOGRAPH BY RICHARD AVEDON

RS 391 | JESSICA LANGE
March 17th, 1983
PHOTOGRAPH BY JIM VARRIALE

RS 393 | JOAN BAEZ
April 14th, 1983
PHOTOGRAPH BY DAVID MONTGOMERY

RS 395 | DAVID BOWIE
May 12th, 1983
PHOTOGRAPH BY DAVID BAILEY

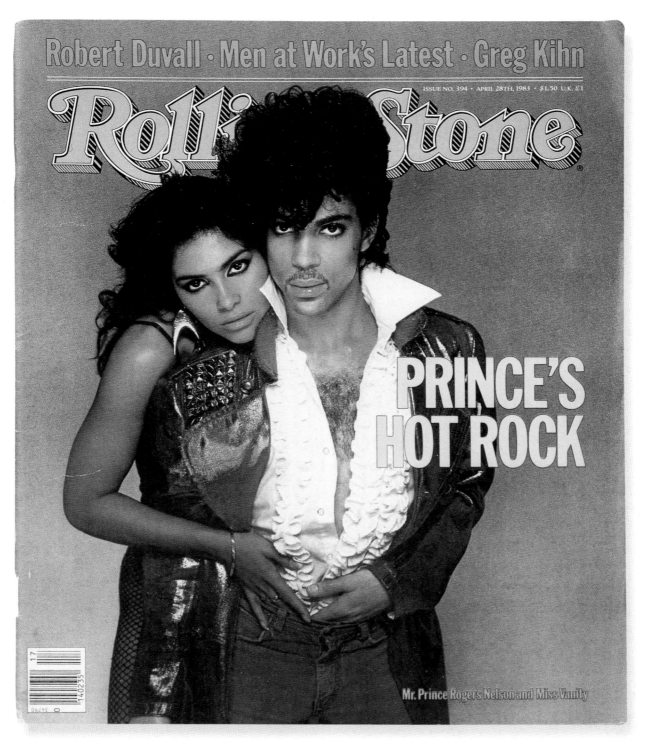

Robert Duvall · Men at Work's Latest · Greg Kihn

ISSUE NO. 394 · APRIL 28TH, 1983 · $1.50 U.K. £1

Rolling Stone

PRINCE'S HOT ROCK

Mr. Prince Rogers Nelson and Miss Vanity

RS 394 | PRINCE & VANITY | April 28th, 1983 | Photography by Richard Avedon

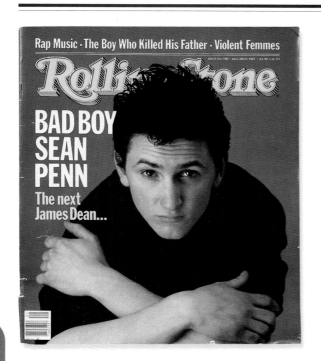

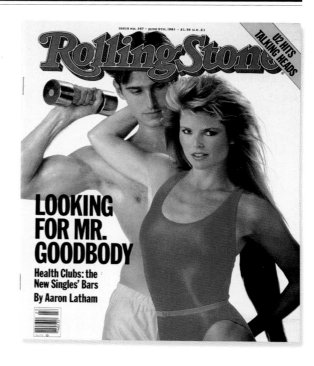

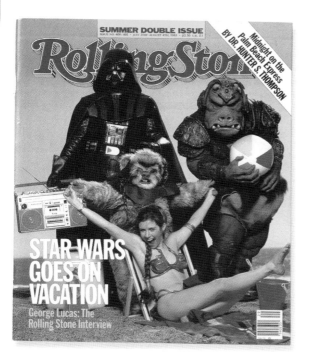

RS 396 | SEAN PENN
May 26th, 1983
PHOTOGRAPH BY MARY ELLEN MARK

RS 397 | CHRISTIE BRINKLEY
& MICHAEL IVES
June 9th, 1983
PHOTOGRAPH BY E.J. CAMP

RS 400/401 | CAST OF 'RETURN
OF THE JEDI'
July 21st – August 4th, 1983
PHOTOGRAPH BY AARON RAPOPORT

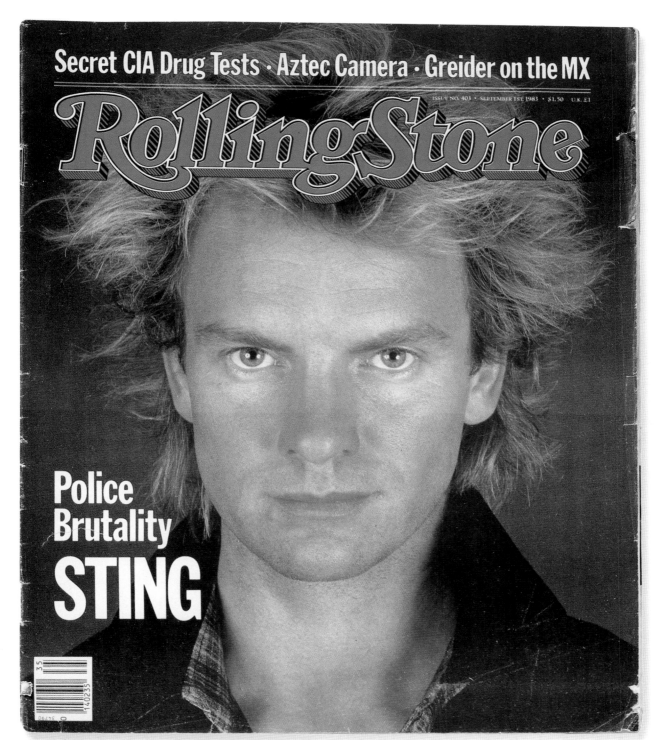

Secret CIA Drug Tests · Aztec Camera · Greider on the MX

RollingStone

ISSUE NO. 403 · SEPTEMBER 1ST 1983 · $1.50 U.K. £1

Police
Brutality
STING

35

0 140235

𝑅𝒮 398 | MEN AT WORK
June 23rd, 1983
PHOTOGRAPH BY AARON RAPOPORT

𝑅𝒮 404 | JACKSON BROWNE
September 15th, 1983
PHOTOGRAPH BY AARON RAPOPORT

𝑅𝒮 406 | CHEVY CHASE
October 13th, 1983
PHOTOGRAPH BY BONNIE SCHIFFMAN

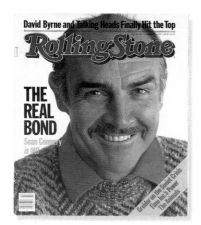

𝑅𝒮 407 | SEAN CONNERY
October 27th, 1983
PHOTOGRAPH BY DAVID MONTGOMERY

𝑅𝒮 405 | ANNIE LENNOX
September 29th, 1983
PHOTOGRAPH BY E.J. CAMP

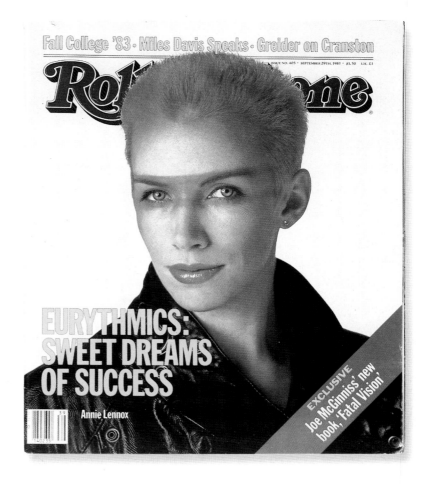

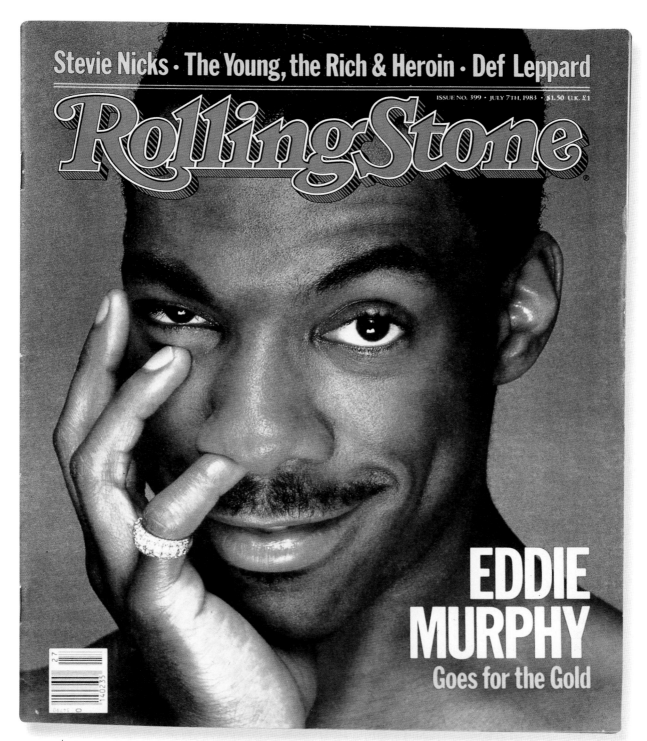

ISSUE NO. 399 • JULY 7TH, 1983 • $1.50 U.K. £1

RollingStone

EDDIE MURPHY
Goes for the Gold

RS 399 | EDDIE MURPHY | July 7th, 1983 | PHOTOGRAPH BY RICHARD AVEDON

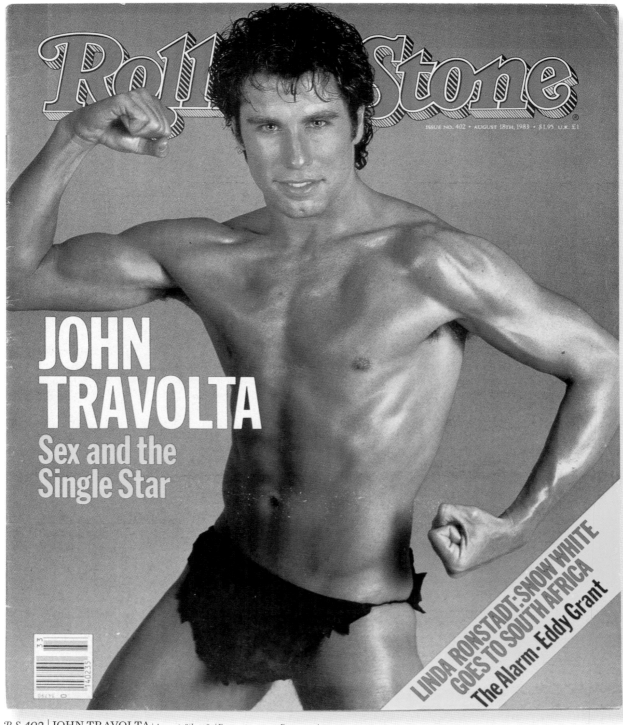

ISSUE NO. 402 · AUGUST 18TH, 1983 · $1.95 U.K. £1

JOHN TRAVOLTA
Sex and the Single Star

LINDA RONSTADT: SNOW WHITE GOES TO SOUTH AFRICA
The Alarm · Eddy Grant

RS 402 | JOHN TRAVOLTA | August 18th, 1983 | PHOTOGRAPH BY RICHARD AVEDON

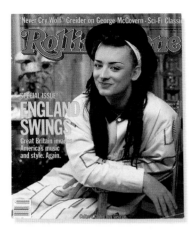

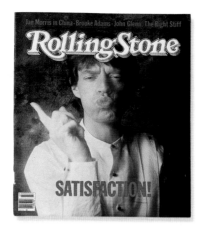

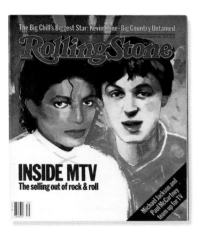

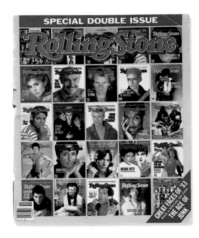

MTV IS PERFECT for a generation never weaned from television, because its videos contain few lines between fantasy and reality. Sexual fantasies blend with toothless gossip about a rock community that really does not exist, having dissipated maybe a decade ago. It doesn't matter. There are no dissenting opinions or alternative views telecast on MTV. Profit-making television creates an unreal environment to get people into what is called a "consumer mode"; MTV, as its executives boast, is pure environment. It is a way of thought, a way of life. It is the ultimate junk-culture triumph. It is a sophisticated attempt to touch the post-Woodstock population's lurking G spot, which is unattainable to those advertisers sponsoring *We Got It Made*.

It is easy to get lost in the fun-house environment of MTV, to spend idle hours in a dull stereo stupor, watching video clips and Martha Quinn, without glimpsing what is behind the visions with which MTV so relentlessly provides us. Behind the fun-house mirror is another story, one that makes the musical energy and optimism of the Sixties seem a thousand light-years ago. After watching hours and days of MTV, it's tough to avoid the conclusion that rock & roll has been replaced by commercials.

[EXCERPT FROM RS 410 COVER STORY
BY STEVEN LEVY]

RS 408 | BOY GEORGE
November 10th, 1983
PHOTOGRAPH BY DAVID MONTGOMERY

RS 409 | MICK JAGGER
November 24th, 1983
PHOTOGRAPH BY WILLIAM COUPON

RS 410 | MICHAEL JACKSON
& PAUL McCARTNEY
December 8th, 1983
ILLUSTRATION BY VIVIENNE FLESHER

RS 411/412 | 1983 YEARBOOK
December 22nd, 1983 – January 5th, 1984
VARIOUS PHOTOGRAPHERS

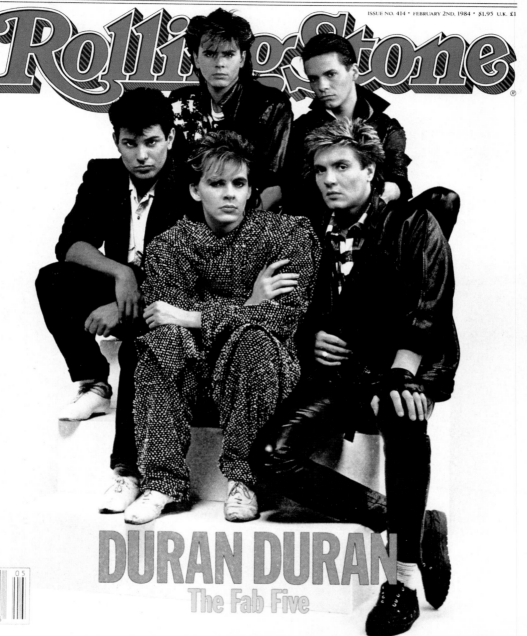

Rolling Stone

ISSUE NO. 414 • FEBRUARY 2ND, 1984 • $1.95 U.K. £1

1980s

DURAN DURAN
The Fab Five

RS 414 | DURAN DURAN | February 2nd, 1984 | PHOTOGRAPH BY DAVID MONTGOMERY

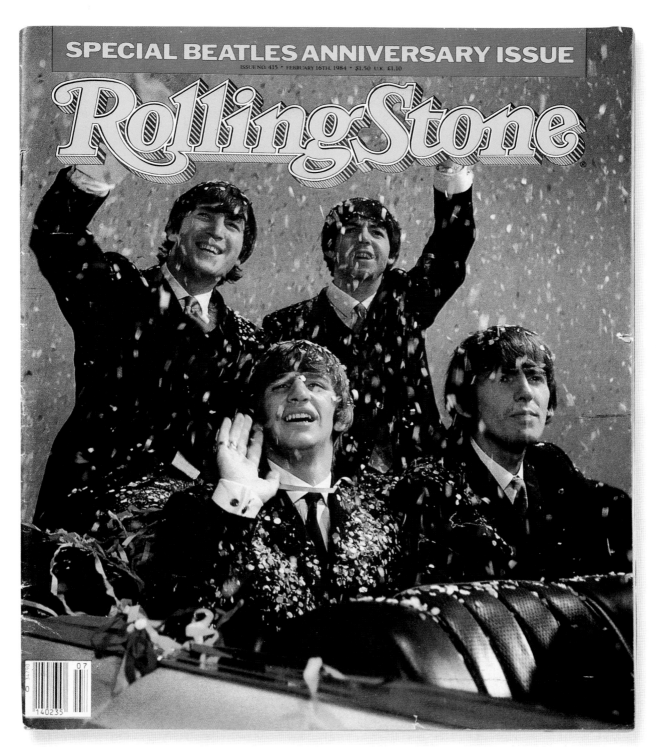

RollingStone

RS 415 | THE BEATLES | February 16th, 1984 | PHOTOGRAPH BY JOHN LAUNOIS

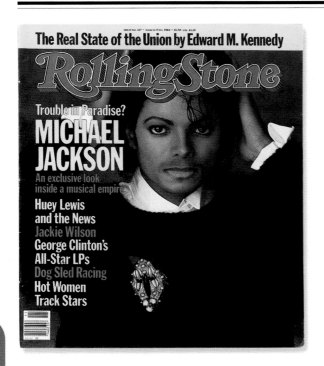

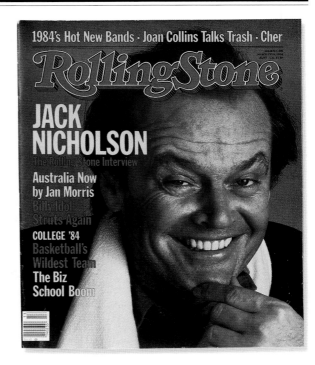

RS 417 | MICHAEL JACKSON
March 15th, 1984 | PHOTOGRAPH BY MATTHEW ROLSTON

RS 418 | JACK NICHOLSON
March 29th, 1984 | PHOTOGRAPH BY RICHARD AVEDON

RS 419 | EDDIE MURPHY
April 12th, 1984 | PHOTOGRAPH BY RICHARD AVEDON

"HERE'S WHAT I LEARNED FROM MICHAEL
Jackson. Michael will always ask everybody
questions, questions that sound very naive.
It was his form of research. And he was as
curious about why this wardrobe person
was using a certain kind of Scotch tape on
the hem of the trouser to whatever light or
lens or where I put the camera. It was like,
'Why does the snow fall, Daddy?' And that
was a very intelligent thing to do. I started
doing it, too, on commercials."
 —*Matthew Rolston*

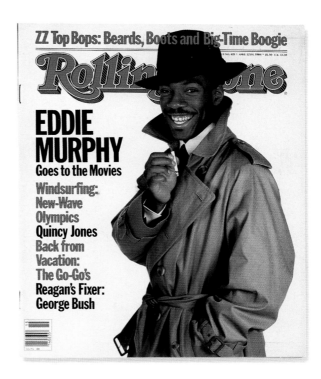

𝑅𝒮 413 | ARMS CONCERT
PARTICIPANTS
January 19th, 1984
PHOTOGRAPH BY BONNIE SCHIFFMAN

𝑅𝒮 416 | THE POLICE
March 1st, 1984
PHOTOGRAPH BY DAVID BAILEY

𝑅𝒮 420 | THE PRETENDERS
April 26th, 1984
PHOTOGRAPH BY AARON RAPOPORT

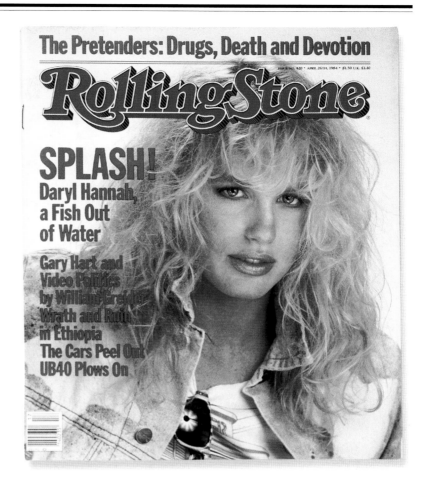

𝑅𝒮 420 | DARYL HANNAH | April 26th, 1984 | PHOTOGRAPH BY E.J. CAMP

[RS 420] In response to an angry reader's complaint at putting Daryl Hannah on the cover
while granting the Pretenders nothing more than a cover line, one ROLLING STONE editor
had this to say: "In a marketing test for issue 420, the Pretenders did appear on the cover
of newsstand copies distributed on the West Coast. Our advice to disgruntled Pretenders
fans in other regions of the country echoes that of a great newspaperman: Go West."

ISSUE NO. 421 • MAY 10TH, 1984 • $1.50 U.K. £1.10

RollingStone

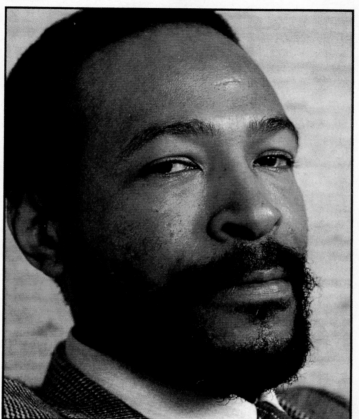

THE DEATH OF MARVIN GAYE
The Nightmare of the Final Days
The Genius of a Troubled Soul
A Look Back at Motown's Sexiest Singer

He was, above all, a preacher.

He came to preach to his people, to all people. He did so once, calling his sermon *What's Going On.* I believe he was called to preach again, to write and sing songs about the Jesus he loved so sincerely. But now we'll never know. A great artist – of the magnitude of Michelangelo and the sweetness of Mozart – is dead, and all we can do is praise the power that brought him forth.

His Oedipal struggle, his battles with the elements are finally laid to rest. He has written his own Greek tragedy – the story of a boy who became a man who became a god, only to be devoured, like Dionysus, by some demonic, self-destructive bent. The dark cloud that had long hung over his head has exploded. In his softly sloped eyes, in his exquisitely high-pitched speaking voice, even in his lighthearted, quick-witted banter, one heard the troubled vibe, the aching blue note. Marvin Gaye sang with a tear in his voice. He had the blues. His depressions were as deep as the Grand Canyon, his heartaches painful and prolonged. His romantic aura brings to mind Keats, a poet "half in love with easeful Death."

Like Mahalia Jackson's, his cry soars far beyond this world, reaching its crescendo in the arms of God. It is there where Marvin Gaye rests, peaceful at last. Whenever the voice of an angel is set free, there is cause for celebration. With Marvin, there is much to celebrate. He left behind a golden legacy. The gift of his genius and the truth of his preaching are now matters of historical record. He has not died, nor will he ever die. The message of his music is rooted in love, and love lives forever. [EXCERPT FROM MARVIN GAYE TRIBUTE BY DAVID RITZ]

RS 421 | MARVIN GAYE
May 10th, 1984
PHOTOGRAPH BY NEAL PRESTON

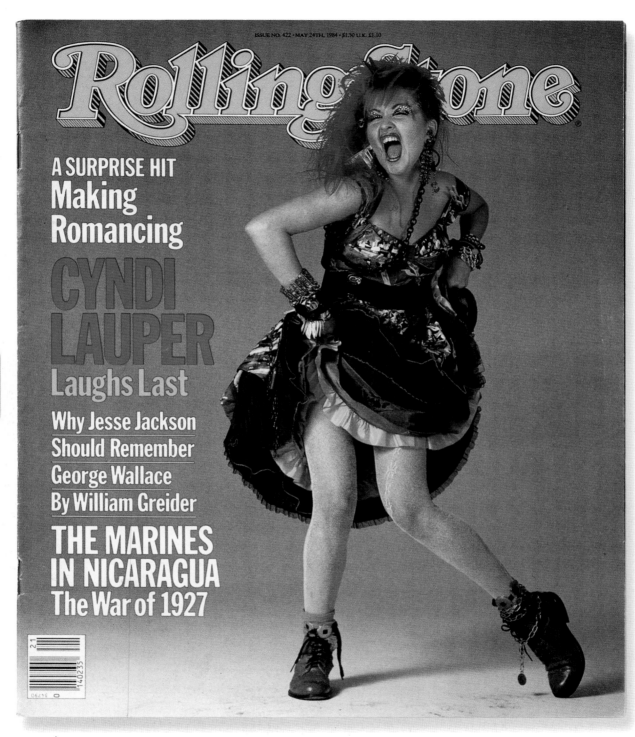

ISSUE NO. 422 • MAY 24TH, 1984 • $1.50 U.K. £1.10

Rolling Stone

A SURPRISE HIT

Making Romancing

CYNDI LAUPER

Laughs Last

Why Jesse Jackson Should Remember George Wallace
By William Greider

THE MARINES IN NICARAGUA
The War of 1927

1980s

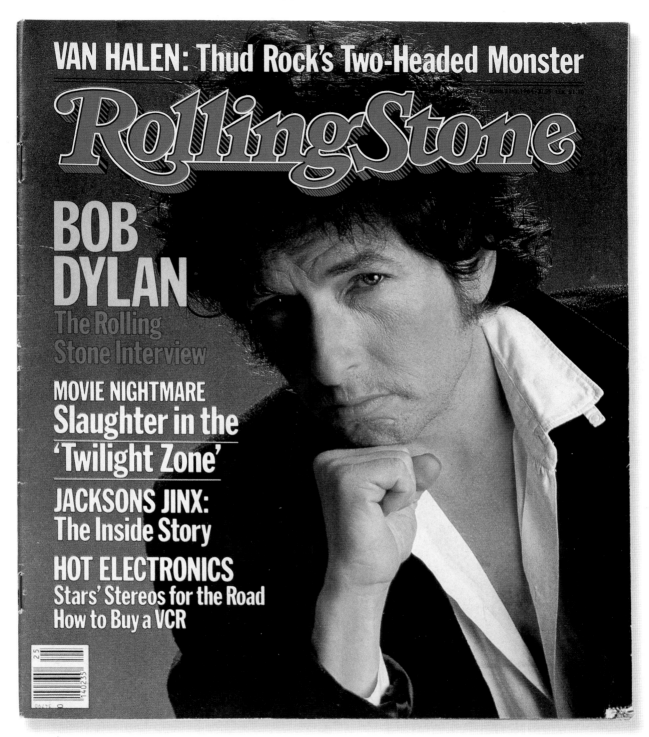

VAN HALEN: Thud Rock's Two-Headed Monster

Rolling Stone

BOB DYLAN
The Rolling
Stone Interview

MOVIE NIGHTMARE
Slaughter in the
'Twilight Zone'

JACKSONS JINX:
The Inside Story

HOT ELECTRONICS
Stars' Stereos for the Road
How to Buy a VCR

RS 424 | BOB DYLAN | June 21st, 1984 | Photograph by Ken Regan

ISSUE NO. 423 · JUNE 7TH, 1984 · $1.50 U.K. £1.10

Rolling Stone

CULTURE CLUB'S
BOY GEORGE
The Rolling Stone Interview

The Last Days of Dennis Wilson

HOW TO GET OFF COCAINE

Jacksons Tour in Chaos

1980s

ISSUE NO. 429 • AUGUST 30TH, 1984 • £1.20 U.K. $1.20

RollingStone

PRINCE SCORES
A Hit Album
A Hot Movie

WILLIAM GREIDER
The Democratic Convention

TOM WOLFE
'The Bonfire of the Vanities'

RS 429 | **PRINCE** | August 30th, 1984 | PHOTOGRAPH BY RICHARD AVEDON

RS 432 | TINA TURNER
October 11th, 1984
PHOTOGRAPH BY STEVEN MEISEL

Today, Tina looks better than ever, sings better than ever, and says she's now happier than ever, too. She has a new boyfriend – a younger man she'd rather not name – and is now attempting to find the "balance of equality between men and women." She sees herself performing until she's fifty, perhaps, and says she'd then like to become a teacher, a propagator of her beloved Buddhist beliefs. Apparently, it's preordained.

"I'm gonna focus on this," she says. "I think that's gonna be my message, that's why I'm here. And I think that's why I'm gonna be as powerful as I am. Because in order to get people to listen to you, you've got to be some kind of landmark, some kind of foundation. You don't listen to people that don't mean anything to you. You have to have something there to make people believe you. And so I think that's what's going on now. I'm getting their attention now, and then when I'm ready, they'll listen. And they'll hear."

[EXCERPT FROM RS 432 COVER STORY
BY KURT LODER]

RS 425 | THE GO-GO'S
July 5th, 1984
PHOTOGRAPH BY ALBERT WATSON

RS 428 | BILL MURRAY
August 16th, 1984
PHOTOGRAPH BY BARBARA WALZ

RS 426/427 | TOM WOLFE,
STEVEN SPIELBERG,
LITTLE RICHARD
July 19th – August 2nd, 1984
VARIOUS PHOTOGRAPHERS

RS 430 | HUEY LEWIS
September 13th, 1984
PHOTOGRAPH BY AARON RAPOPORT

ISSUE NO. 432 • OCTOBER 11TH, 1984 • $1.95 U.K. £1.20

Rolling stone

TINA TURNER
She's Got Legs!

FRANKIE GOES TO HOLLYWOOD
England's Music Sensation

TOM WOLFE
'The Vanities'

STYLE
Rebel without a Cause, 1984

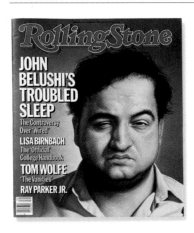

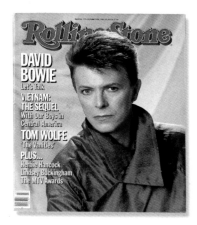

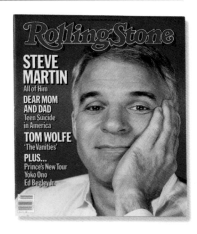

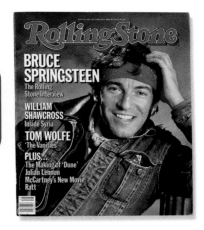

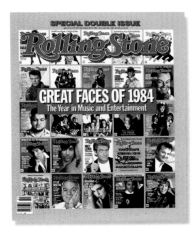

\mathcal{RS} 434 | STEVE MARTIN
November 8th, 1984
PHOTOGRAPH BY BONNIE SCHIFFMAN

IT'S LIKELY THAT HER VIDEOS were the breakthrough, as Madonna perfectly merged her dance training with her knowledge of the randier things in life. How did she manage to put across such seething sexuality where so many others have tried and failed? "I think that has to do with them not being in touch with that aspect of their personality," according to Madonna. "They say, 'Well, I have to do a video now, and a pop star has to come on sexually, so how do I do that?' instead of being in touch with that part of their self to begin with. I've been in touch with that aspect of my personality since I was five."

[EXCERPT FROM RS 435 COVER STORY BY CHRISTOPHER CONNELLY]

\mathcal{RS} 431 | JOHN BELUSHI
September 27th, 1984
ILLUSTRATION BY GOTTFRIED HELNWEIN

\mathcal{RS} 436 | BRUCE SPRINGSTEEN
December 6th, 1984
PHOTOGRAPH BY AARON RAPOPORT

\mathcal{RS} 433 | DAVID BOWIE
October 25th, 1984
PHOTOGRAPH BY GREG GORMAN

\mathcal{RS} 437/438 | GREAT FACES OF 1984
December 20th, 1984 - January 3rd, 1985
VARIOUS PHOTOGRAPHERS

ISSUE NO. 435 • NOVEMBER 22TH, 1984 • $1.50 U.K. £1.20

RollingStone

MADONNA GOES ALL THE WAY

SUBURBAN DEATH TRIP
A Kid Kills

TOM WOLFE
'The Vanities'

PLUS...
Van Morrison
Culture Club
Twisted Sister
The Fixx

RS 435 | MADONNA | November 22nd, 1984 | PHOTOGRAPH BY STEVEN MEISEL

ISSUE NO. 440 · JANUARY 31ST, 1985 · $1.95 U.K. £1.50

Rolling Stone

BILLY IDOL
Sneer of the Year

VANESSA WILLIAMS
The Real Miss America

TOM WOLFE
'The Vanities'

HONEYDRIPPERS
JOHN FOGERTY
U2 IN CONCERT

RS 440 | BILLY IDOL | January 31st, 1985 | PHOTOGRAPH BY E.J. CAMP

RS 439 | DARYL HALL
& JOHN OATES
January 17th, 1985
PHOTOGRAPH BY BERT STERN

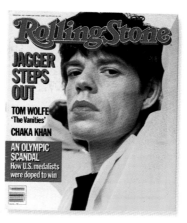

RS 441 | MICK JAGGER
February 14th, 1985
PHOTOGRAPH BY STEVEN MEISEL

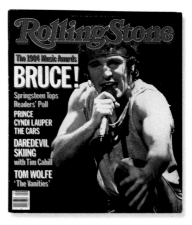

RS 442 | BRUCE SPRINGSTEEN
February 28th, 1985
PHOTOGRAPH BY NEAL PRESTON

HERE'S THE CHECK.

"I'll let you pay," says Billy, "but it better be a good article, you cunt."

"Right," I say.

"Otherwise, stick it up your ass. Don't tell me you'll pay for it."

"Okay," I say, laughing.

We are in a back booth at Emilio's in New York City's Greenwich Village. We are on a date set up by ROLLING STONE. Billy Idol has had two bottles of wine. It is one in the morning.

"Anyway, ROLLING STONE sucks," says Billy, affably. "If ROLLING STONE was clever, they would have bought their own TV channel. And put me on it. I *know* they're rich enough."

He's in a high mood.

"That's why, 'Don't fuck with me, motherfuckers!' " He bangs on the table. " 'Cause I'm going to be rich enough soon, I'll be at your economic level, and then fuck *you,* ROLLING STONE."

"Right," I say, paralyzed with delight.

"I want to be on the *back* of that motherfucker!" says Billy. "Don't put me on the front!" He pushes his dark

glasses up on his nose. "I think it sucks being on the front of ROLLING STONE!" He bends toward the tape recorder. "I love you *all,* you motherfuckers. But you should have fucking had a bit more respect when I came up in 1977, '78 to see you in your Fifth Avenue offices! But I don't care. Now maybe you understand that I *am* worth being on the front cover of your magazine, for the *right* reasons, motherfuckers! Don't put me on if you don't like me! Fucking *don't* put me on it!"

"Well, you're probably going to be on it," I say.

He drops his lower lip and looks for the cigarettes.

"Well, I better be real on there," he says, slapping his coat for the lighter. "We don't want no Cyndi Lauper this year."

"You'll be real," I say.

"I didn't like the picture they put of me in the year-end issue."

He lights up.

"You didn't?"

"No, I thought it sucked." He takes the cigarette out of his mouth and leans toward the recorder again. "You put the wrong picture in, and you know you did . . . ooooaaaah [*chuckling*] I know. I know. Don't fuck with me. All right. Let's go."

[EXCERPT FROM RS 440 COVER STORY BY E. JEAN CARROLL]

In America, their names are not household words, and their faces are unfamiliar even to some of their fans. They have yet to notch a Top Ten album or single. Only now are they beginning to tour arena-sized venues. But for a growing number of rock & roll fans, U2 – vocalist Paul "Bono" Hewson, twenty-four; guitarist Dave "the Edge" Evans, twenty-two; bassist Adam Clayton, twenty-four; and drummer Larry Mullen Jr., twenty-two – has become the band that matters most, maybe even the only band that matters. It's no coincidence that U2 sells more T-shirts and merchandise than groups that sell twice as many records, or that four of U2's five albums are currently on *Billboard*'s Top 200. The group has become one of the handful of artists in rock & roll history (the Who, the Grateful Dead, Bruce Springsteen) that people are eager to identify themselves with. And they've done it not just with their music but with a larger message as well – by singing "Pride (In the Name of Love)" while most other groups sing about pride in the act of love.

The band's appeal doesn't seem to be sexual; no member of U2 appears to have seen the inside of a health club or a New Wave haberdashery, and only Mullen could pass for a Cute Guy. U2's strength, it seems, goes deeper. Like most rock & roll bands, U2 articulates, at top volume, the alienation that young people can feel from their country, their hometown, their family, their sexuality. Like some of the best rock & roll bands, U2 also shows how that alienation might be overcome. But unlike anyone else in rock & roll, U2 also addresses the most ignored – and most volatile – area of inquiry: alienation from religion.

"Sadomasochism is not taboo in rock & roll," notes Bono. "Spirituality is." Indeed, when religion in America seems sadly synonymous with the electronic evangelism of Jimmy Swaggart and Jerry Falwell, U2 dares to proclaim its belief in Christianity – at top volume – while grappling with the ramifications of its faith. Each member is careful to avoid discussing the specifics of his beliefs (the perfectly amiable Mullen, in fact, customarily

declines to give interviews), and the band's musical message is hardly a proselytizing one. But even to raise the issue, to suggest that a person who loves rock & roll can unashamedly find peace with God as well, is a powerful statement. This is a band that onstage and offstage seems guided by a philosophy not included in such yuppie maxims as "feeling good" and "go for it": not how might we live our lives (what we can get away with) but how ought we to live our lives.

Lofty goals, but while the promise of U2's records has always been great, it is a promise that remains largely unfulfilled. In the past year and a half, U2 has found itself faced with several critical decisions: artistic, financial, personal, even patriotic. Each choice represented a test of whether the band could continue to articulate its message and fulfill its promise without drowning in contradictions. And while the outcome isn't settled yet, U2 seems to have come through its crises in good shape – due in large part, perhaps, to the band members' willingness to acknowledge their own weaknesses.

"It interests me that I'm portrayed as some sort of strong man," says Bono with genuine perplexity. "I don't see myself in that way. I know my weaknesses. When I see the albums, I don't see them as anthemic. I think that's what's uplifting, that's what connects with people. I think people relate to U2 because they've seen us fall on our face so many times."

[EXCERPT FROM RS 443 COVER STORY BY CHRISTOPHER CONNELLY]

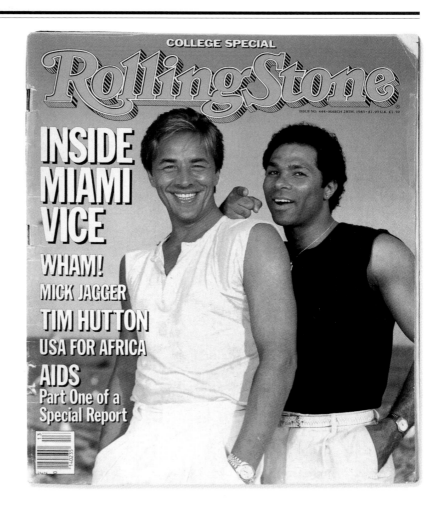

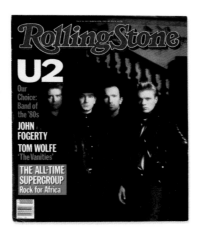

RS 444 | DON JOHNSON & PHILLIP MICHAEL THOMAS
March 28th, 1985
PHOTOGRAPH BY DEBORAH FEINGOLD

RS 443 | U2
March 14th, 1985
PHOTOGRAPH BY REBECCA BLAKE

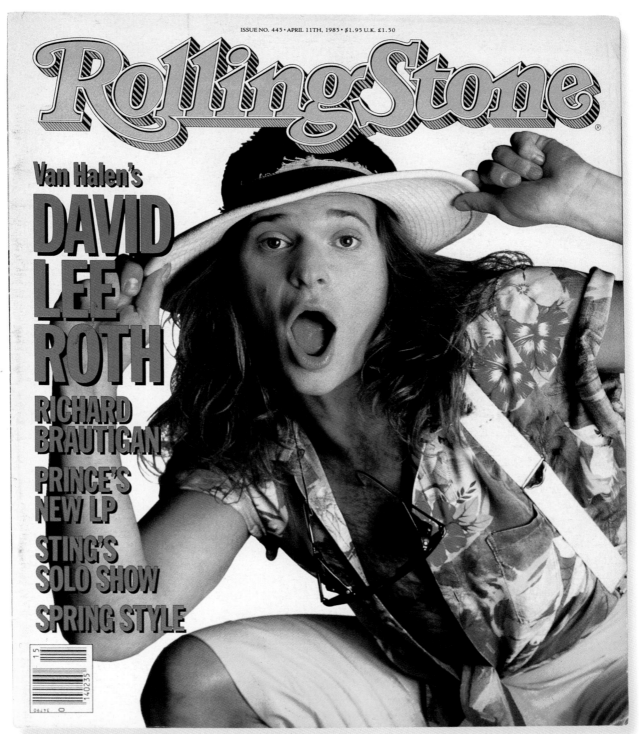

ISSUE NO. 445 • APRIL 11TH, 1985 • $1.95 U.K. £1.50

RollingStone

Van Halen's
DAVID LEE ROTH

RICHARD BRAUTIGAN

PRINCE'S NEW LP

STING'S SOLO SHOW

SPRING STYLE

1980s

RS 445 | DAVID LEE ROTH | April 11th, 1985 | Photograph by Bradford Branson

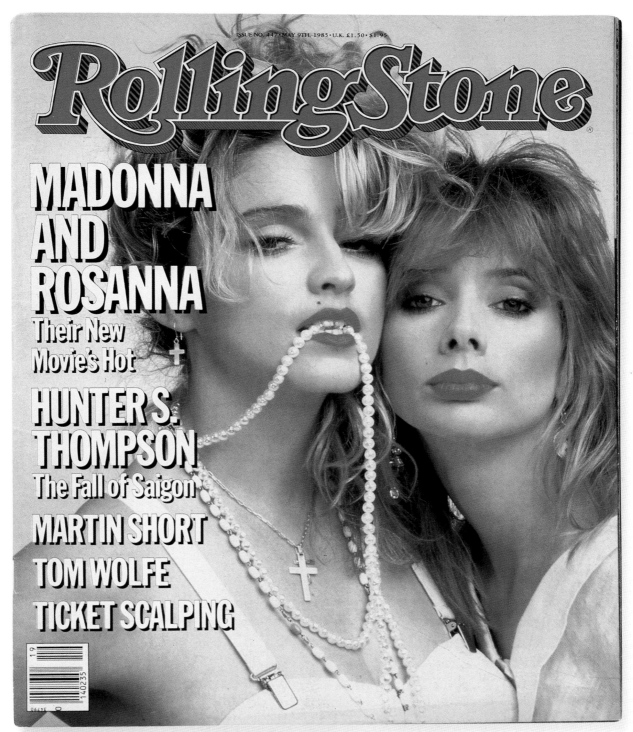

RollingStone

MADONNA AND ROSANNA
Their New Movie's Hot

HUNTER S. THOMPSON
The Fall of Saigon

MARTIN SHORT
TOM WOLFE
TICKET SCALPING

RS 447 | MADONNA & ROSANNA ARQUETTE | May 9th, 1985 | Photograph by Herb Ritts

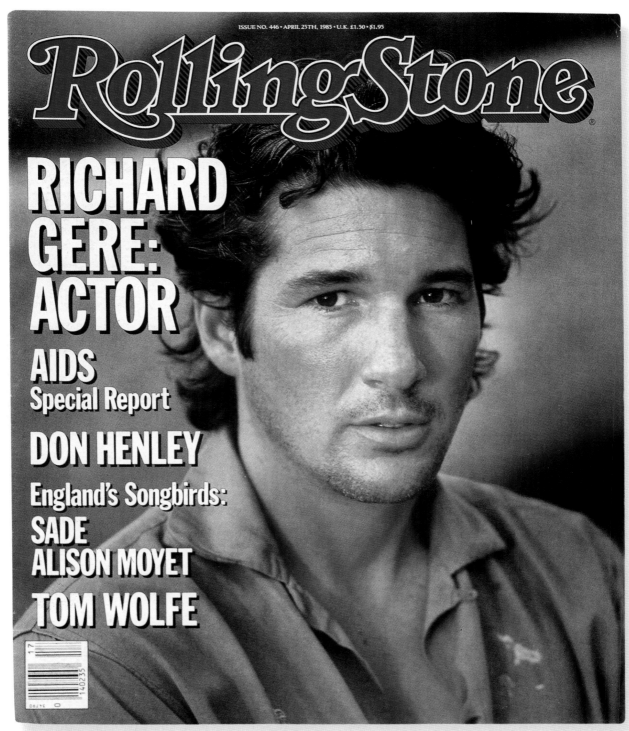

ISSUE NO. 446 • APRIL 25TH, 1985 • U.K. £1.50 • $1.95

RollingStone

RICHARD GERE: ACTOR

AIDS
Special Report

DON HENLEY

England's Songbirds:
SADE
ALISON MOYET

TOM WOLFE

RS 446 | RICHARD GERE | April 25th, 1985 | PHOTOGRAPH BY HERB RITTS

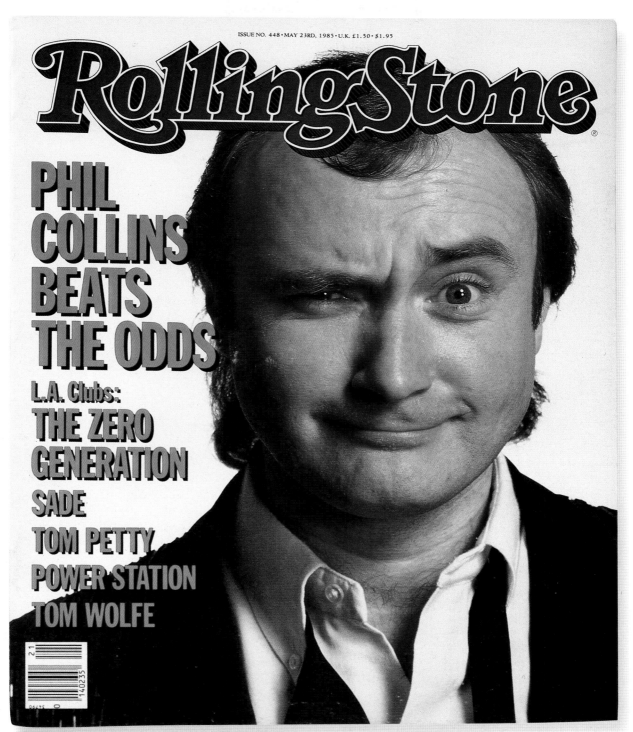

ISSUE NO. 448 · MAY 23RD, 1985 · U.K. £1.50 · $1.95

Rolling Stone

PHIL COLLINS BEATS THE ODDS

L.A. Clubs:
THE ZERO GENERATION

SADE

TOM PETTY

POWER STATION

TOM WOLFE

RS 448 | PHIL COLLINS | May 23rd, 1985 | Photograph by Aaron Rapoport

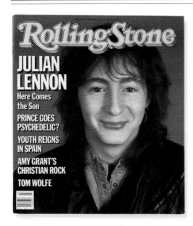

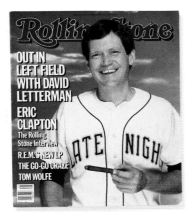

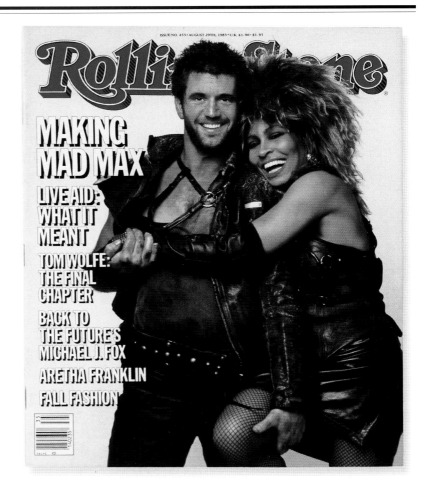

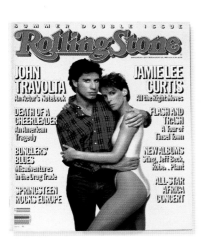

RS 449 | JULIAN LENNON
June 6th, 1985
PHOTOGRAPH BY RICHARD AVEDON

RS 450 | DAVID LETTERMAN
June 20th, 1985
PHOTOGRAPH BY DEBORAH FEINGOLD

RS 452/453 | JOHN TRAVOLTA
& JAMIE LEE CURTIS
July 18th – August 1st, 1985
PHOTOGRAPH BY PATRICK DEMARCHELIER

RS 455 | MEL GIBSON
& TINA TURNER
August 29th, 1985
PHOTOGRAPH BY HERB RITTS

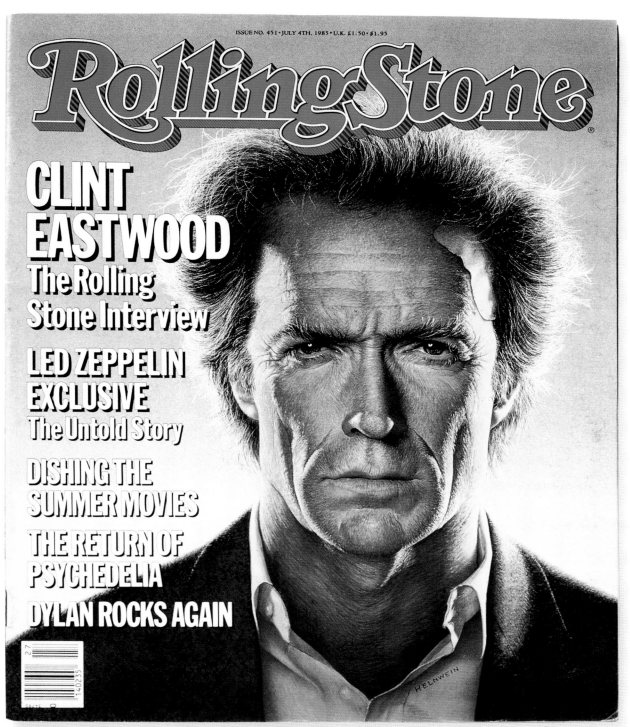

RS 451 | CLINT EASTWOOD | July 4th, 1985 | ILLUSTRATION BY GOTTFRIED HELNWEIN

THE 1985 READERS AND CRITICS POLL

Rolling Stone

ARTIST OF THE YEAR
BRUCE DOES IT AGAIN

U2
DIRE STRAITS
TINA TURNER
TEARS FOR FEARS
TALKING HEADS

HEADHUNTING IN NEW GUINEA

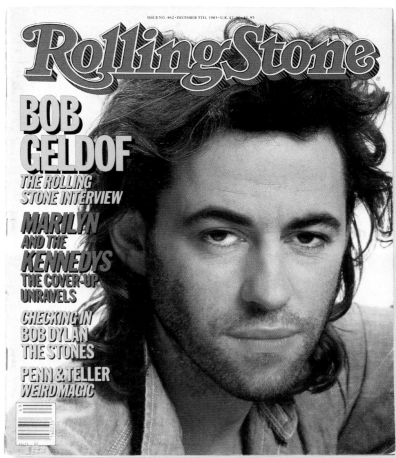

ISSUE NO. 462 · DECEMBER 5TH, 1985 · U.K. £1.00 · £1.95

Rolling Stone

BOB GELDOF

THE ROLLING STONE INTERVIEW

MARILYN AND THE KENNEDYS THE COVER-UP UNRAVELS

CHECKING IN
BOB DYLAN
THE STONES

PENN & TELLER
WEIRD MAGIC

HALL OF FAME: ROCK'S NIGHT TO REMEMBER

Rolling Stone

JIM McMAHON
CHICAGO'S ROCK & ROLL QUARTERBACK

HOW REAGAN FIGHTS CIVIL RIGHTS

HOLLYWOOD'S BOX OFFICE BLUES

BANGLES' HOT LP

THE PAYOLA SCANDAL, HEART, MR. MISTER, YOKO ONO

Rolling Stone

Wendy and Lisa
PRINCE'S WOMEN

NAILED
Papa John Phillips Tells How He Ruined His Life

MEET THE EQUALIZER

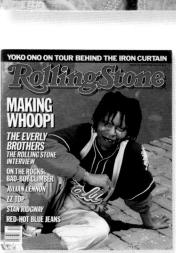

YOKO ONO ON TOUR BEHIND THE IRON CURTAIN

Rolling Stone

MAKING WHOOPI

THE EVERLY BROTHERS
THE ROLLING STONE INTERVIEW

ON THE ROCKS:
BAD-BOY CLIMBER
JULIAN LENNON
ZZ TOP
STAN RIDGWAY
RED-HOT BLUE JEANS

RS 462 | BOB GELDOF
December 5th, 1985
PHOTOGRAPH BY DAVIES & STARR

RS 468 | BRUCE SPRINGSTEEN
February 27th, 1986
PHOTOGRAPH BY AARON RAPOPORT

RS 469 | JIM McMAHON
March 13th, 1986
PHOTOGRAPH BY KEN REGAN

RS 472 | PRINCE WITH WENDY & LISA
April 24th, 1986
PHOTOGRAPH BY JEFF KATZ

RS 473 | WHOOPI GOLDBERG
May 8th, 1986
PHOTOGRAPH BY BONNIE SCHIFFMAN

1980s

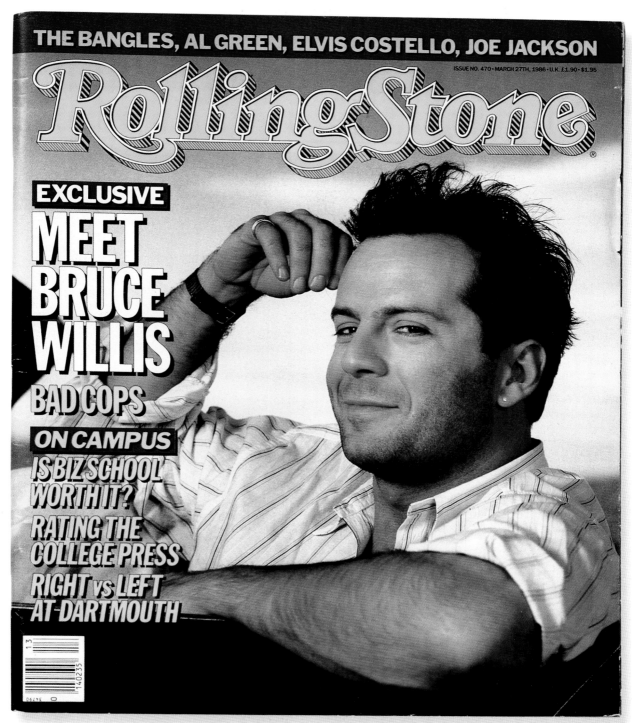

THE BANGLES, AL GREEN, ELVIS COSTELLO, JOE JACKSON

ISSUE NO. 470 • MARCH 27TH, 1986 • U.K. £1.90 • $1.95

RollingStone

EXCLUSIVE
MEET BRUCE WILLIS

BAD COPS

ON CAMPUS

IS BIZ SCHOOL WORTH IT?

RATING THE COLLEGE PRESS

RIGHT vs LEFT AT DARTMOUTH

RS 470 | BRUCE WILLIS | March 27th, 1986 | PHOTOGRAPH BY BONNIE SCHIFFMAN

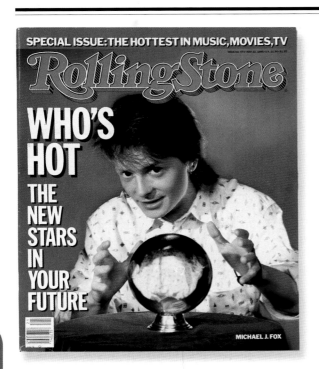

SPECIAL ISSUE: THE HOTTEST IN MUSIC, MOVIES, TV

Rolling Stone

WHO'S
HOT

THE
NEW
STARS
IN
YOUR
FUTURE

MICHAEL J. FOX

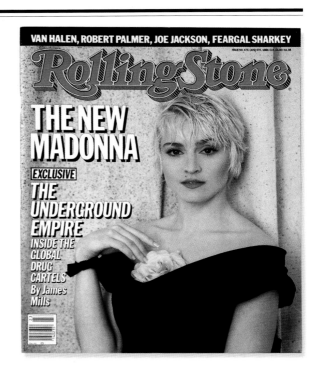

VAN HALEN, ROBERT PALMER, JOE JACKSON, FEARGAL SHARKEY

Rolling Stone

THE NEW
MADONNA

EXCLUSIVE
THE
UNDERGROUND
EMPIRE
INSIDE THE
GLOBAL
DRUG
CARTELS
By James
Mills

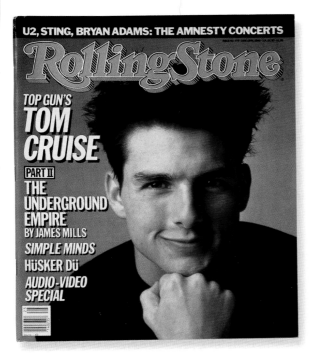

U2, STING, BRYAN ADAMS: THE AMNESTY CONCERTS

Rolling Stone

TOP GUN'S
TOM
CRUISE

PART II
THE
UNDERGROUND
EMPIRE
BY JAMES MILLS

SIMPLE MINDS
HÜSKER DÜ

AUDIO-VIDEO
SPECIAL

P.J. O'ROURKE ON WHAT'S REALLY WRONG WITH EUROPE

Rolling Stone

VAN HALEN
Hot & Happy
Without
David
Lee Roth

JAY LENO
Letterman's
Favorite Comic

PETER
FRAMPTON
A Comeback Saga:
Dead or Alive?

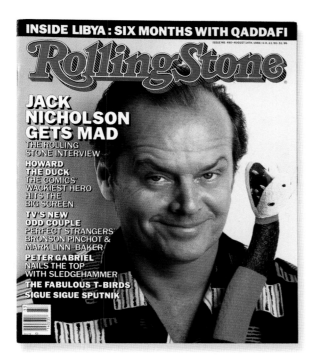

[RS 478/479] Though Bob Dylan has been one of ROLLING STONE's most frequent cover subjects (seventeen times), he's also been one of the most elusive. On one occasion, he refused to allow RS's photographer to shoot him; instead, he enlisted a buddy, Morgan Renard, to photograph him in the backstage men's room at Madison Square Garden (RS 278). For this cover, Dylan only showed up at the last minute for the shoot with Tom Petty. The session started without him, and the next thing Petty knew, "Bob arrived, came straight across the room and just stepped into the frame with me. I don't think he really said anything to anyone. After they'd shot two pictures, Bob leaned over to me and said, 'I gotta go,' and then left. I remember trying to get it across to Aaron [Rapoport] that he was actually gone." ROLLING STONE wasn't happy with the two shots, so after a rehearsal one night, Petty recalls, "We went back and did the shot they actually used. That time we were both there."

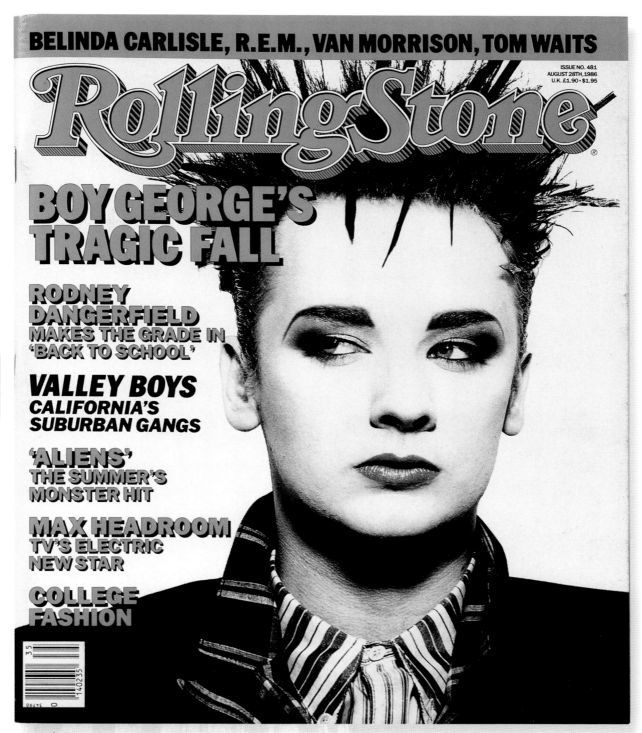

BELINDA CARLISLE, R.E.M., VAN MORRISON, TOM WAITS

Rolling Stone

ISSUE NO. 481
AUGUST 28TH, 1986
U.K £1.90 • $1.95

BOY GEORGE'S TRAGIC FALL

RODNEY DANGERFIELD
MAKES THE GRADE IN 'BACK TO SCHOOL'

VALLEY BOYS
CALIFORNIA'S SUBURBAN GANGS

'ALIENS'
THE SUMMER'S MONSTER HIT

MAX HEADROOM
TV'S ELECTRIC NEW STAR

COLLEGE FASHION

1980s

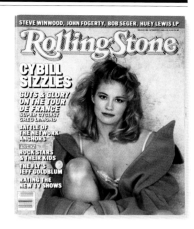

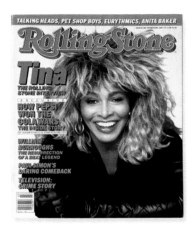

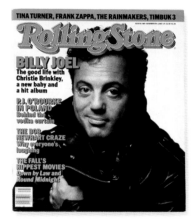

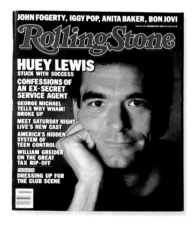

RS 482 | PAUL McCARTNEY
September 11th, 1986
PHOTOGRAPH BY HARRY DeZITTER

RS 483 | DON JOHNSON
September 25th, 1986
PHOTOGRAPH BY E.J. CAMP

RS 484 | CYBILL SHEPHERD
October 9th, 1986
PHOTOGRAPH BY MATTHEW ROLSTON

RS 485 | TINA TURNER
October 23rd, 1986
PHOTOGRAPH BY MATTHEW ROLSTON

RS 486 | BILLY JOEL
November 6th, 1986
PHOTOGRAPH BY ALBERT WATSON

RS 487 | HUEY LEWIS
November 20th, 1986
PHOTOGRAPH BY TIM BOOLE

SPECIAL ISSUE: THE HOTTEST IN MUSIC, MOVIES, TV

ISSUE 500 • MAY 21ST, 1987 • $2.50

RollingStone

Hot Throb: BON JOVI

1980s

RS 500 | JON BON JOVI | May 21st, 1987 | PHOTOGRAPH BY E.J. CAMP

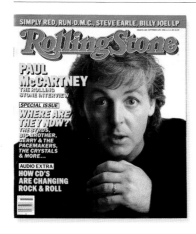

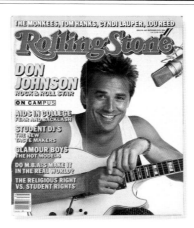

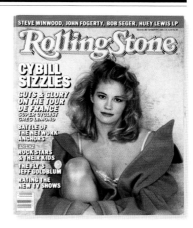

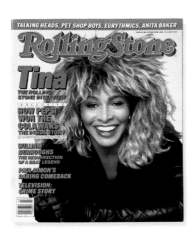

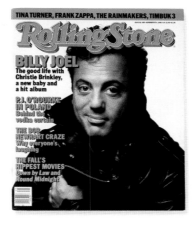

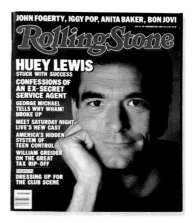

RS 482 | PAUL McCARTNEY
September 11th, 1986
PHOTOGRAPH BY HARRY DeZITTER

RS 483 | DON JOHNSON
September 25th, 1986
PHOTOGRAPH BY E.J. CAMP

RS 484 | CYBILL SHEPHERD
October 9th, 1986
PHOTOGRAPH BY MATTHEW ROLSTON

RS 485 | TINA TURNER
October 23rd, 1986
PHOTOGRAPH BY MATTHEW ROLSTON

RS 486 | BILLY JOEL
November 6th, 1986
PHOTOGRAPH BY ALBERT WATSON

RS 487 | HUEY LEWIS
November 20th, 1986
PHOTOGRAPH BY TIM BOOLE

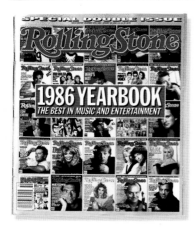

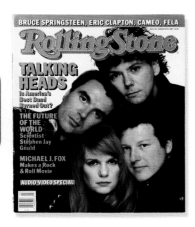

Run (Joe Simmons), D.M.C.

(Darryl McDaniels, also known as D) and Jam Master Jay (Jason Mizell) – the trio that has recently injected rap into the American mainstream with its double-platinum album *Raising Hell* – are blasting Michael Jackson and other glitzy pop stars. Run says, "Michael wants us to make a record with him, and we don't really want to make a record with Michael. We really dig Barry White."

"Michael's not really us," says Jay.

"He doesn't fit the program," says Darryl.

Run-D.M.C. is now at a crossroads. Having broken through to white radio with "Walk This Way," its collaboration with the hard-rock group Aerosmith, Run-D.M.C. must decide how to be pop and streetwise at the same time. Run-D.M.C. also faces another crisis. As its fame has increased, the trio has consistently been associated with violence. A riot between two youth gangs at the Long Beach Arena last August left forty-two people injured. It was the fifth time this past summer that a Run-D.M.C. concert led to mass arrests or serious injuries. While promoters have canceled Run-D.M.C. shows or added to the hysteria with talk of hiring extra security guards for concerts, more dispassionate observers have suggested that the group is getting a bum rap.

Yet the image has stuck. To much of white America, rap means mayhem and bloodletting.

[EXCERPT FROM RS 488 COVER STORY BY ED KIERSH]

1980s

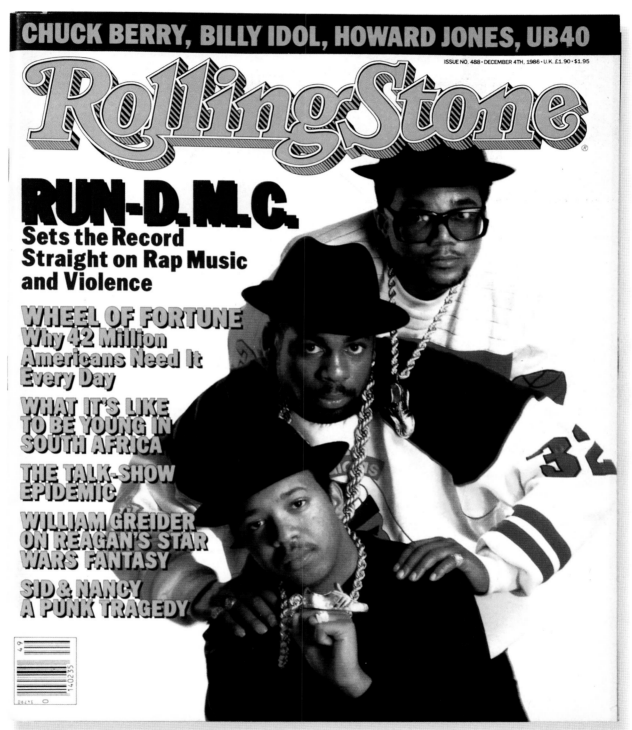

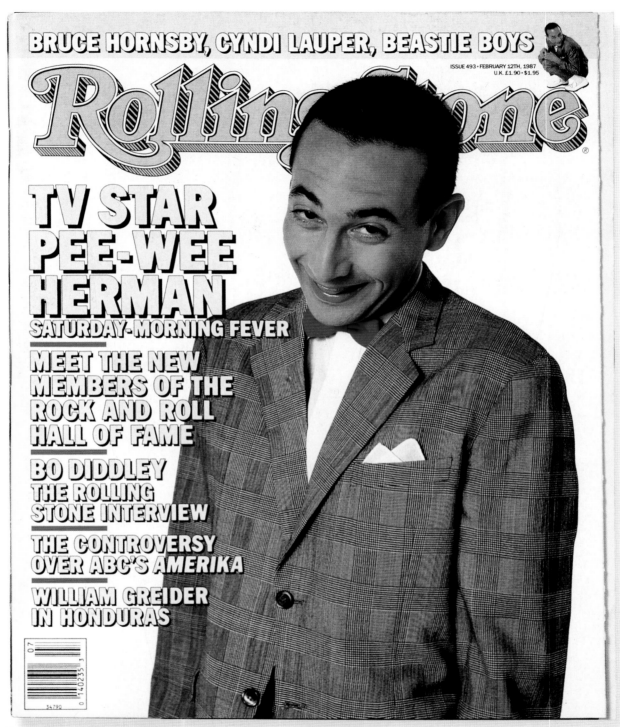

BRUCE HORNSBY, CYNDI LAUPER, BEASTIE BOYS

ISSUE 493 · FEBRUARY 12TH, 1987
U.K. £1.90 · $1.95

Rolling Stone®

TV STAR PEE-WEE HERMAN
SATURDAY-MORNING FEVER

MEET THE NEW MEMBERS OF THE ROCK AND ROLL HALL OF FAME

BO DIDDLEY THE ROLLING STONE INTERVIEW

THE CONTROVERSY OVER ABC'S AMERIKA

WILLIAM GREIDER IN HONDURAS

07
0 "14023"5 3
34790

RS 493 | PEE-WEE HERMAN | February 12th, 1987 | Photograph by Janette Beckman

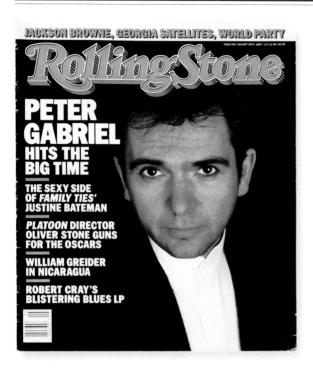

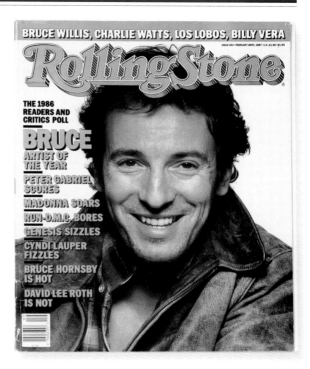

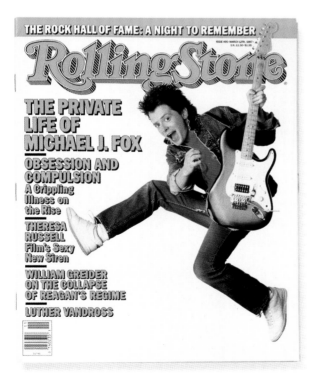

RS 492 | PETER GABRIEL
January 29th, 1987
PHOTOGRAPH BY ROBERT MAPPLETHORPE

RS 494 | BRUCE SPRINGSTEEN
February 26th, 1987
PHOTOGRAPH BY ALBERT WATSON

RS 495 | MICHAEL J. FOX
March 12th, 1987
PHOTOGRAPH BY DEBORAH FEINGOLD

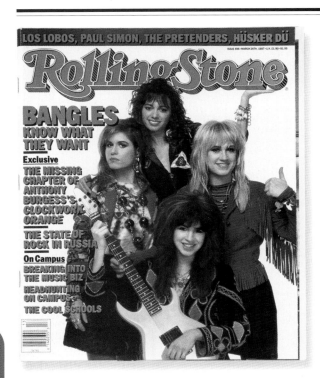

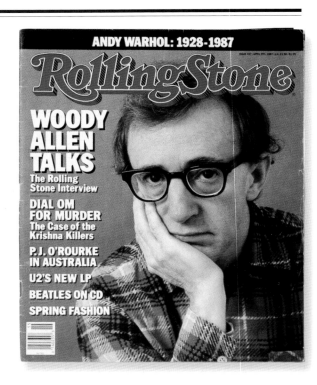

RS 496 | THE BANGLES
March 26th, 1987
PHOTOGRAPH BY BONNIE SCHIFFMAN

RS 497 | WOODY ALLEN
April 9th, 1987
PHOTOGRAPH BY BRIAN HAMILL

RS 499 | U2
May 7th, 1987
PHOTOGRAPH BY ANTON CORBIJN

[RS 498] For its twentieth anniversary, ROLLING STONE
produced three special issues: this one on style, one on the
best live performances ever (RS 501) and one on the best
albums recorded since the magazine's inception (RS 507).
Ranking among the greatest live performances were Cream
at London's Royal Albert Hall on November 26th, 1968 and
Bruce Springsteen at New York's Bottom Line from August 13th
to 17th, 1975. The top three albums were the Beatles' *Sgt. Pepper's
Lonely Hearts Club Band*, the Sex Pistols' *Never Mind the Bollocks,
Here's the Sex Pistols* and the Rolling Stones' *Exile on Main Street*.

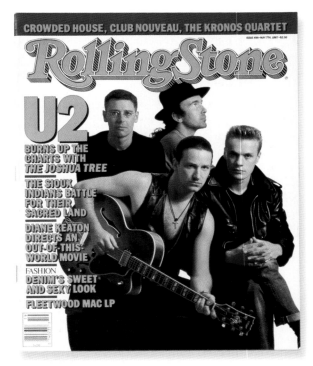

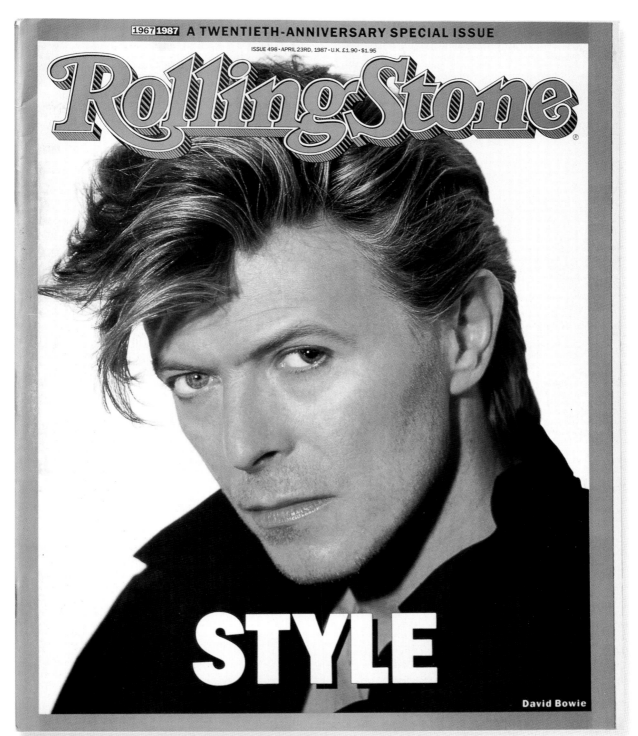

RollingStone

STYLE

David Bowie

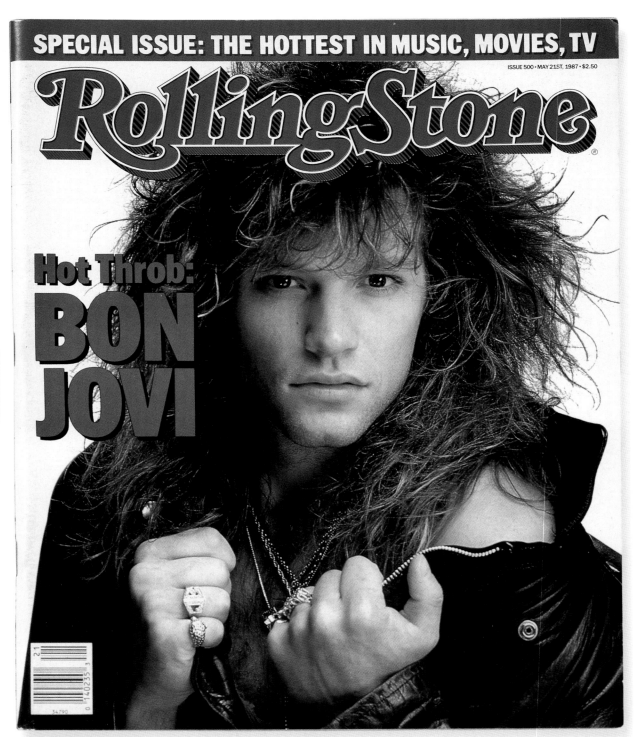

SPECIAL ISSUE: THE HOTTEST IN MUSIC, MOVIES, TV

ISSUE 500 • MAY 21ST, 1987 • $2.50

RollingStone

Hot Throb:
BON JOVI

1980s

RS 500 | JON BON JOVI | May 21st, 1987 | PHOTOGRAPH BY E.J. CAMP

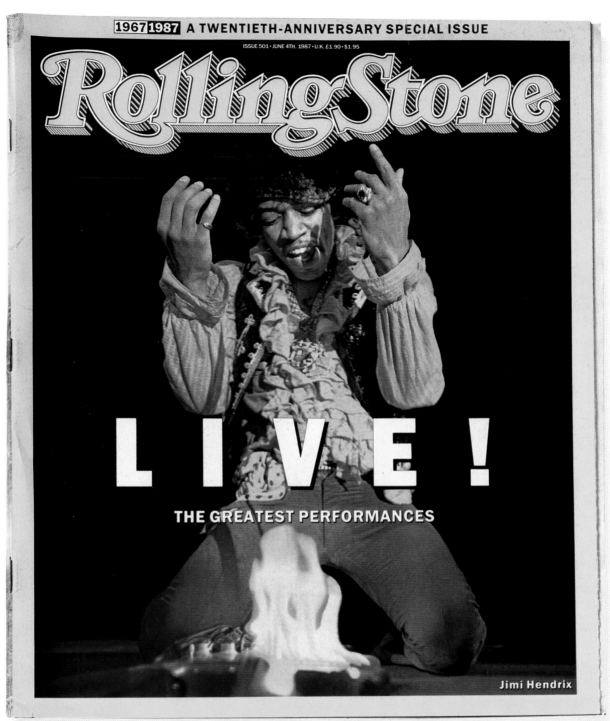

Rolling Stone

LIVE!

THE GREATEST PERFORMANCES

Jimi Hendrix

RS 501 | TWENTIETH ANNIVERSARY: THE GREATEST PERFORMANCES – JIMI HENDRIX

June 4th, 1987 | Photograph by Ed Caraeff

EDDIE MURPHY, PRINCE, THE JUDDS, THE NEVILLE BROTHERS

ISSUE 503 • JULY 2ND, 1987 • U.K. £1.90 • $1.95

RollingStone

PAUL SIMON
The Graceland Tour Hits the Road

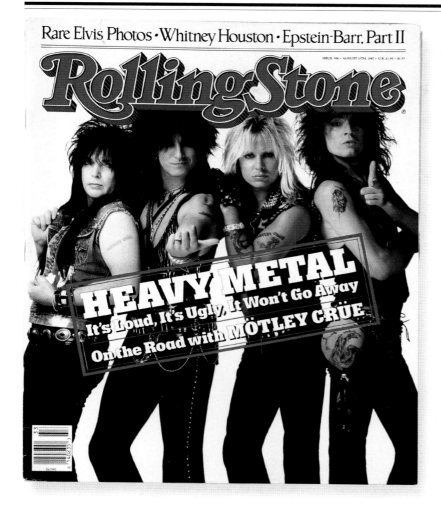

RS 506 | MÖTLEY CRÜE | August 13th, 1987 | Photograph by E.J. Camp

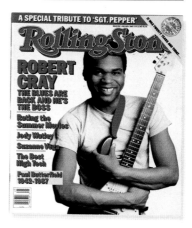

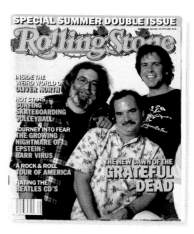

RS 502 | ROBERT CRAY
June 18th, 1987
Photograph by Deborah Feingold

RS 504/505 | THE GRATEFUL
DEAD
July 16th – July 30th, 1987
Photograph by Michael O'Neill

"*I remember very well they* told me that they couldn't put five guys on the cover [RS 500]. That was exactly how they sold it to us: 'You can't put five guys on the cover.' And then we saw Paul Simon and twelve guys on the cover [RS 503]. And we went, 'uh-huh!' "
—Jon Bon Jovi

[RS 503] The work of staff photographer Mark Seliger appears on the cover for the first time. He will shoot 122 more covers before he leaves the magazine in 2001.

1967-1987 A TWENTIETH-ANNIVERSARY SPECIAL ISSUE

ISSUE 507 • AUGUST 27TH, 1987 • U.K. £1.90 • $1.95

RollingStone

THE 100 BEST ALBUMS OF THE LAST TWENTY YEARS

1980s

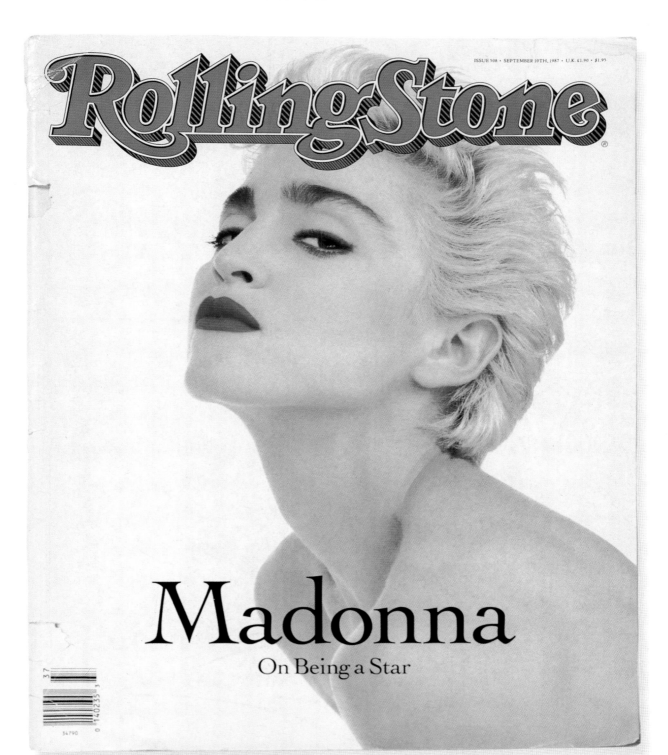

ISSUE 508 · SEPTEMBER 10TH, 1987 · U.K. £1.90 · $1.95

Madonna
On Being a Star

When Michael Jackson

kicks off his first solo tour in Tokyo this month, he will be sharing his two-bedroom suite with one of his closest friends. Michael's friend is a three-year-old named Bubbles.

Bubbles is a chimpanzee.

Bubbles is just one of the many real-life characters who populate the elaborate fantasy world that the superstar has constructed around himself. Playing and chatting with Bubbles or Louie the Llama or Crusher, his new 300-pound python, Michael can effortlessly become one of those Disney characters he so loves.

Bubbles goes everywhere with Michael. They are a classic TV-style duo, like Timmy and Lassie or Wilbur and Mister Ed. Bubbles was in the recording studio with Michael for much of the two years it took to make *Bad,* the follow-up to *Thriller.* Bubbles accompanied Michael to New York for Martin Scorsese's filming of the "Bad" video. Bubbles is a star of the new line of stuffed animals known as Michael's Pets, which will also be the basis for a children's cartoon series. Bubbles even has a crib in Michael's bedroom. And when Michael threw an elaborate dinner party at his Encino, California, mansion on a warm July night to begin the promotion of *Bad,* it was Bubbles, not the pop star, who worked the room, truly the life of the party.

[EXCERPT FROM RS 509 COVER STORY BY MICHAEL GOLDBERG AND DAVID HANDELMAN]

R*S 510* | BONO
October 8th, 1987
PHOTOGRAPH BY MATTHEW ROLSTON

DYLAN IN ISRAEL, R.E.M'S NEW ALBUM, PINK FLOYD, ROGER WATERS

ISSUE 511 • OCTOBER 22ND, 1987 • U.K. £1.90 • $1.95

Rolling Stone

The Return of
George Harrison

The Phony Freedom Fighters
How Reagan Duped Congress on Aid to the Contras

The Man Who Turns On America
NBC's Brandon Tartikoff

How Good Is Michael Jackson's 'Bad'?

RS 511 | GEORGE HARRISON | October 22nd, 1987 | PHOTOGRAPH BY WILLIAM COUPON

'Rolling Stone' turns twenty

years old with this issue. What was started with $7,000 in a loft above a printer in San Francisco is now one of America's leading publications, with offices in six cities and a paid circulation of more than one million.

That ROLLING STONE survived and prospered is due in part to the talent and devotion of the people who have worked on it; to the vitality and growth of the music and culture from which it came and which it covers; and to its own deeply held beliefs and values. This twentieth anniversary is, in a sense, an affirmation of what ROLLING STONE writes about and what it stands for.

We read and hear a lot about the Sixties these days. We are told that they were the most exciting of times, years of great passion and commitment. We are also told that those passions and ideals were full of sound and fury, signifying nothing, that no beliefs or tangible benefits came from that period, and that everyone grew up to be a stockbroker. A lot of people would like to have us believe that what we stood for and what we believed in was childish, shallow and powerless stuff.

In our series of twentieth-anniversary issues, we have attempted to assess those times. In this final anniversary issue we have asked people whose work has stood out and whose voices have often been heard in the pages of ROLLING STONE to talk about their experiences during the past two decades, their understanding of what has survived and what they see ahead.

ROLLING STONE, at age twenty, holds these things dear: high standards in its own craft – writing, reporting, photography, editing, design, publishing; rock & roll music and the popular arts it touches; a commitment to stimulating and nourishing musicians and artists; and having a voice of reason that will be heard in the politics and policies of this country.

We will continue to try our best. We ain't perfect. But we're good, and we're getting better.

—*Jann S. Wenner*
[OCTOBER 1987]

RS 512 | TWENTIETH ANNIVERSARY
November 5th – December 10th, 1987
TYPOGRAPHY BY JIM PARKINSON

Nearly two decades on, ROLLING STONE's twentieth-anniversary issue still stands as its second best-selling issue. It is also the only all-type cover to make it into the magazine's Top 100 bestsellers. It was the seventh issue designed by art director Fred Woodward.

• P.J. O'Rourke in Korea; The New Masters of Horror Fiction •
The Rock & Roll Hall of Fame; On Location: The U2 Movie

ISSUE 519 • FEBRUARY 11TH, 1988 • U.K £1.90 • $2.50

Rolling Stone

·STING·
THE ROLLING STONE INTERVIEW

RS 519 | STING | February 11th, 1988 | Photograph by Matt Mahurin

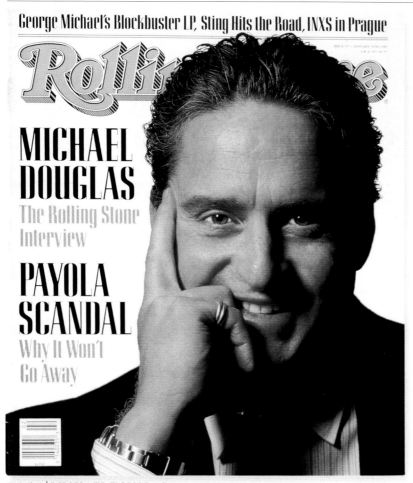

George Michael's Blockbuster LP, Sting Hits the Road, INXS in Prague

MICHAEL DOUGLAS
The Rolling Stone Interview

PAYOLA SCANDAL
Why It Won't Go Away

A Hostage in Beirut: Charles Glass's Own Story; Chuck Berry; Prince's Movie; Fleetwood Mac; New LPs: Springsteen & Sting

R.E.M. AMERICA'S BEST ROCK & ROLL BAND

SPECIAL DOUBLE ISSUE

1987 YEARBOOK
The Best in Music and Entertainment

RS 517 | MICHAEL DOUGLAS | January 14th, 1988 | Photograph by Albert Watson

RS 513 | PINK FLOYD
November 19th, 1987
Illustration by Melissa Grimes

RS 514 | R.E.M.
December 3rd, 1987
Photograph by Brian Smale

RS 515/516 | 1987 YEARBOOK
December 17th – December 31st, 1987
Various photographers

RS 521 | U2
March 10th, 1988
Photograph by Matthew Rolston

The Return of Robbie Robertson. William Greider Reports from Iowa
Mick Jagger's Surprising New Album. Terence Trent D'Arby, U2 Live

PINK FLOYD
THE INSIDE STORY
Roger Waters & David Gilmour talk about the battles that tore apart this legendary band

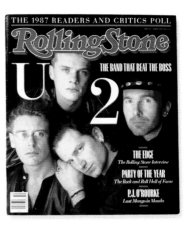

THE 1987 READERS AND CRITICS POLL

U2 THE BAND THAT BEAT THE BOSS

THE EDGE
The Rolling Stone Interview

PARTY OF THE YEAR
The Rock and Roll Hall of Fame

P.J. O'ROURKE
Last Mango in Manila

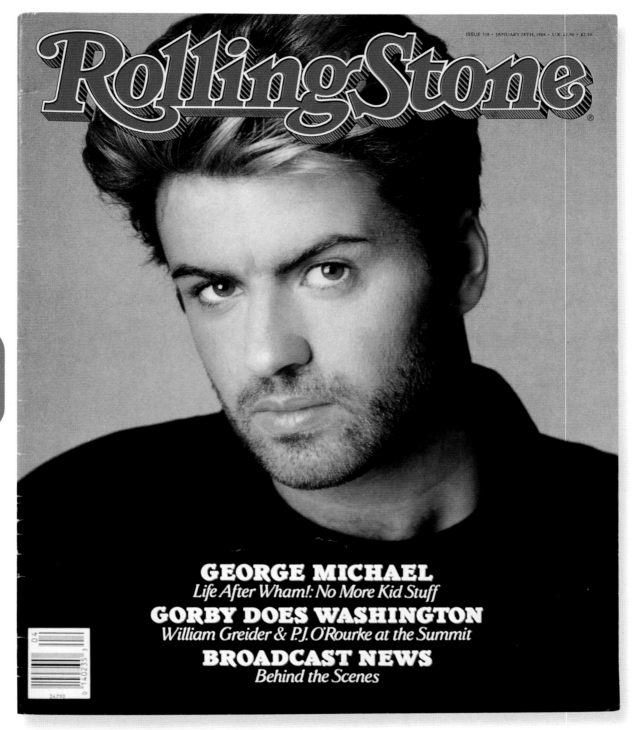

ISSUE 518 · JANUARY 28TH, 1988 · U.K. £1.90 · $2.50

RollingStone

GEORGE MICHAEL
Life After Wham!: No More Kid Stuff

GORBY DOES WASHINGTON
William Greider & P.J. O'Rourke at the Summit

BROADCAST NEWS
Behind the Scenes

RS 518 | GEORGE MICHAEL | January 28th, 1988 | PHOTOGRAPH BY MATTHEW ROLSTON

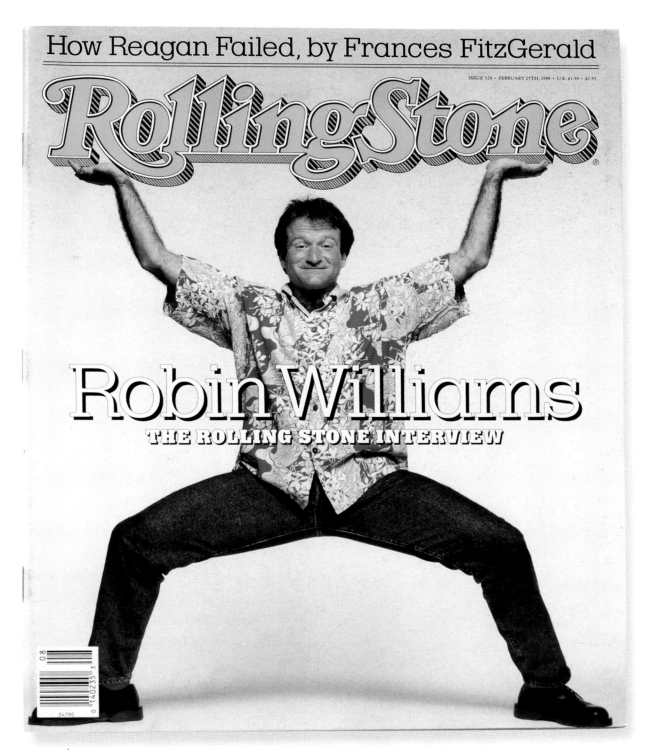

How Reagan Failed, by Frances FitzGerald

ISSUE 520 • FEBRUARY 25TH, 1988 • U.K. $1.90 • $1.95

RollingStone

Robin Williams
THE ROLLING STONE INTERVIEW

Rolling Stone

ROBERT PLANT
The Rolling Stone Interview

LED ZEPPELIN
Tribute to a Rock Legend

ZIGGY MARLEY
Reggae's Heir Apparent

1980s

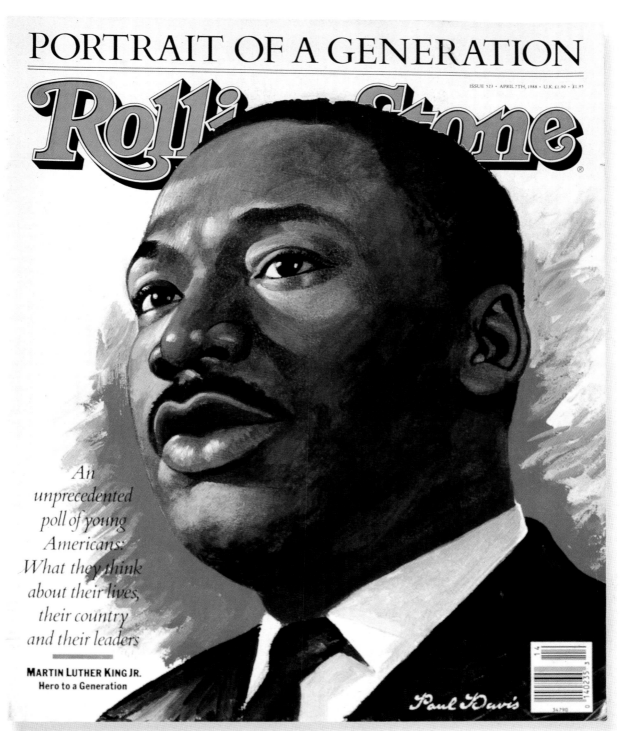

PORTRAIT OF A GENERATION

Rolling Stone

ISSUE 523 · APRIL 7TH, 1988 · U.K. £1.90 · $1.95

An
unprecedented
poll of young
Americans:
What they think
about their lives,
their country
and their leaders

MARTIN LUTHER KING JR.
Hero to a Generation

Paul Davis

RS 523 | MARTIN LUTHER KING JR. | April 7th, 1988 | ILLUSTRATION BY PAUL DAVIS

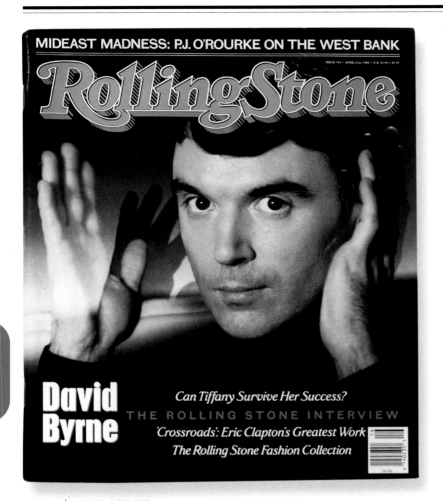

RS 524 | DAVID BYRNE | April 21st, 1988 | PHOTOGRAPH BY HIRO

RS 525 | BRUCE SPRINGSTEEN
May 5th, 1988
PHOTOGRAPH BY NEAL PRESTON

[RS 526] **At twenty, Lisa Bonet was looking for a new image. She'd just completed a stint on the wholesome** *Cosby Show* **and was pregnant with her first child by then-husband Lenny Kravitz. At the photo session, her publicist insisted that there be no nude shots. But once Matthew Rolston started shooting, her clothes started dropping faster than the camera could click. Later, when Bonet learned that** ROLLING STONE **didn't choose the totally nude shot for the cover (it appeared inside), she came to the magazine's offices to lobby – unsuccessfully – for it. The white blouse obviously did not hurt sales: the issue is one of the magazine's Top 25 bestsellers.**

Rock & roll is an obsessive state. You dared to enter into that obsessive state. What kind of insights have you gotten from it?

Rock music makes the obsessive okay and turns it into a creative act. Rock deflects that energy and channels it into something creative. Which is odd, because at a certain point you realize that it's not enough to just be obsessive in front of an audience. There's also craft to it. You have to achieve a balance between obsession and craftsmanship. Otherwise, you're just screaming in somebody's ear.

What do you think is going to happen to rock in the 1990s?

Rock's probably going to go two ways. There will be music from many cultures that crosses the generations, that speaks to the greater humanity that we are. That's one kind of thing. And I think we and other musicians are searching for a way to do that. We're certainly not alone. And I think, at the same time, there will always be younger musicians who have a more frantic set of hormones rushing through the body.

[EXCERPT FROM DAVID BYRNE INTERVIEW BY ROBERT FARRIS THOMPSON]

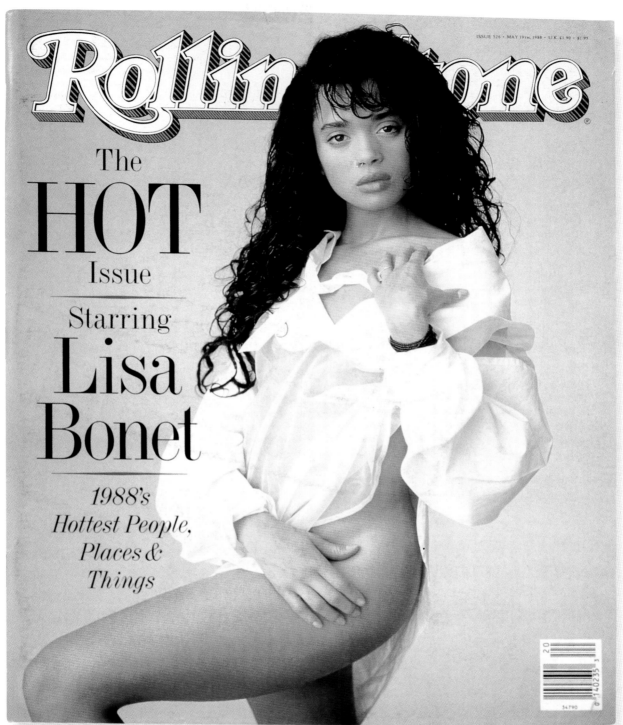

ISSUE 526 · MAY 19TH, 1988 · U.K. £1.90 · $1.95

Rolling Stone

The
HOT
Issue

Starring
Lisa
Bonet

*1988's
Hottest People,
Places &
Things*

RS 526 | LISA BONET | May 19th, 1988 | PHOTOGRAPH BY MATTHEW ROLSTON

ISSUE 527 • JUNE 2ND/1988 • $2.50

Rolling Stone

1980s

The Rolling Stone Interview

NEIL YOUNG

Talks About His New Album and the CSNY Reunion

DEATH OF A HIGH-SCHOOL NARC

RS 527 | NEIL YOUNG | June 2nd, 1988 | PHOTOGRAPH BY WILLIAM COUPON

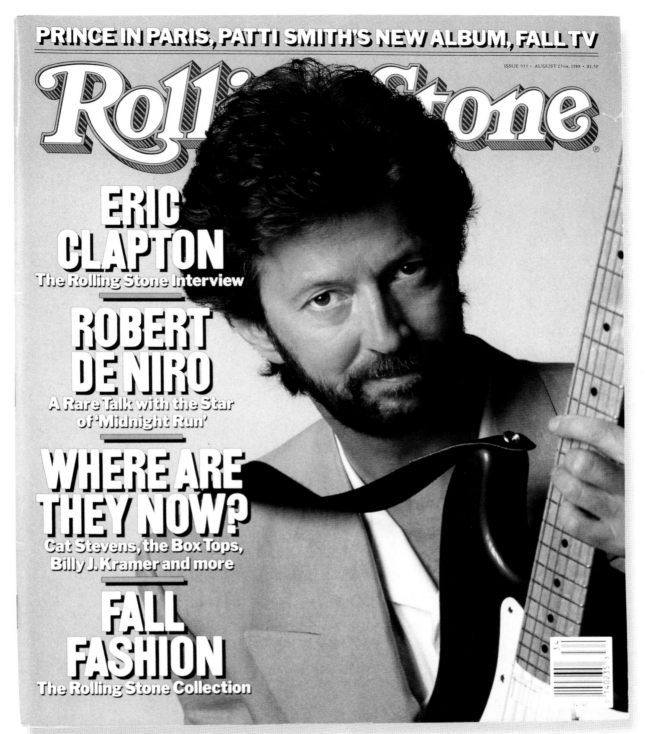

PRINCE IN PARIS, PATTI SMITH'S NEW ALBUM, FALL TV

Rolling Stone

ISSUE 533 • AUGUST 25th, 1988 $2.50

ERIC CLAPTON
The Rolling Stone Interview

ROBERT DE NIRO
A Rare Talk with the Star
of 'Midnight Run'

WHERE ARE THEY NOW?
Cat Stevens, the Box Tops,
Billy J. Kramer and more

FALL FASHION
The Rolling Stone Collection

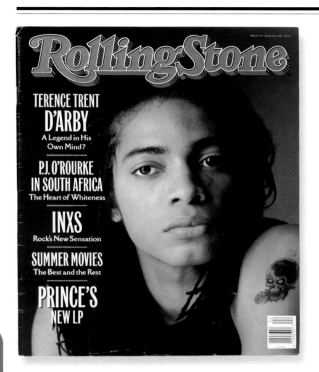

Rolling Stone

TERENCE TRENT
D'ARBY
A Legend in His
Own Mind?

**P.J. O'ROURKE
IN SOUTH AFRICA**
The Heart of Whiteness

INXS
Rock's New Sensation

SUMMER MOVIES
The Best and the Rest

PRINCE'S
NEW LP

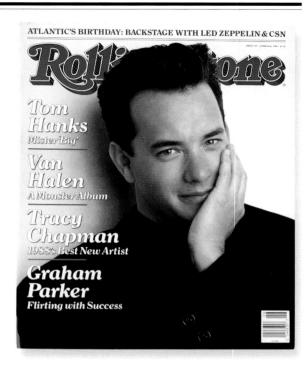

ATLANTIC'S BIRTHDAY: BACKSTAGE WITH LED ZEPPELIN & CSN

Rolling Stone

Tom
Hanks
Mister 'Big'

Van
Halen
A Monster Album

Tracy
Chapman
1988's Best New Artist

**Graham
Parker**
Flirting with Success

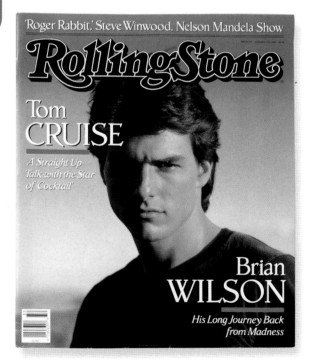

'Roger Rabbit,' Steve Winwood, Nelson Mandela Show

Rolling Stone

Tom
CRUISE

*A Straight-Up
Talk with the Star
of 'Cocktail'*

Brian
WILSON

*His Long Journey Back
from Madness*

The 100 Best Singles of the Last Twenty-five Years

Rolling Stone

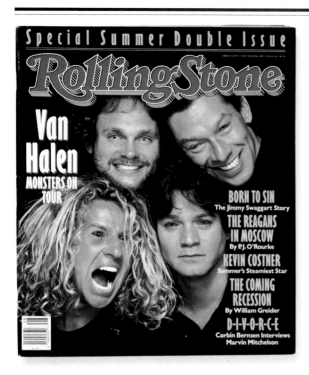

RS 528 | TERENCE TRENT D'ARBY
June 16th, 1988
PHOTOGRAPH BY MATTHEW ROLSTON

RS 529 | TOM HANKS
June 30th, 1988
PHOTOGRAPH BY HERB RITTS

RS 530/531 | VAN HALEN
July 14th – July 28th, 1988
PHOTOGRAPH BY TIMOTHY WHITE

RS 532 | TOM CRUISE
August 11th, 1988
PHOTOGRAPH BY HERB RITTS

RS 534 | THE 100 BEST SINGLES OF
THE LAST TWENTY-FIVE YEARS
September 8th, 1988
ILLUSTRATION BY STEVE PIETZSCH

RS 535 | TRACY CHAPMAN
September 22nd, 1988
PHOTOGRAPH BY HERB RITTS

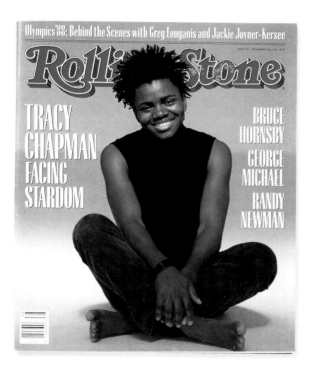

Bush, Noriega, Guns and Drugs: Exposing Operation Black Eagle

ROLLING STONE

ISSUE 538 • NOVEMBER 3RD, 1988 • $2.50

THE COMEDY ISSUE

1980s

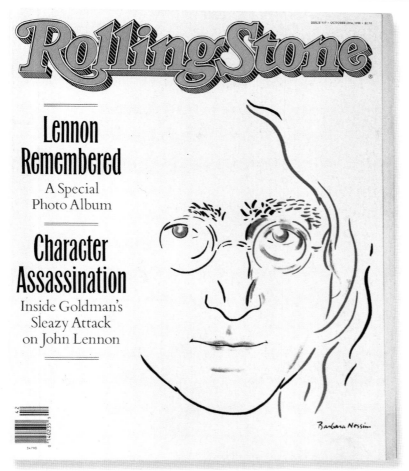

Lennon Remembered
A Special
Photo Album

Character Assassination
Inside Goldman's
Sleazy Attack
on John Lennon

RS 537 | JOHN LENNON | October 20th, 1988 | ILLUSTRATION BY BARBARA NESSIM

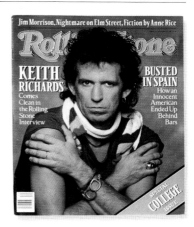

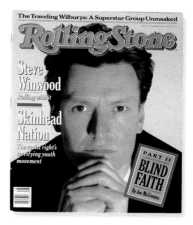

FOR TWENTY-SIX YEARS, JOHNNY Carson has prodded the content of American life, but Letterman aims at the form of television itself. Carson, a precise, surgical comedian, guided the nation through six presidencies and was, in fact, the president of comedy, governing cleanly, dispensing patronage, steering the dialogue, his staff supporting him as it would a head of state.

Then Letterman entered the talk-show mainstream by reinventing the genre called found comedy, which casts a cold video eye on the conventions of the landscape – dumb ads, bad TV, stores that advertise things they don't have. It was the high point of consumer comedy: Letterman got on the telephone and sent out cameras to try and gauge the disparity between what television had told us and what really existed. For six years and eight months, he has been shooting arrows at television, at the culture, and they never seem to fall back to earth, like the pencils that still hang from the acoustically dotted ceiling of his office. "I mean," he often says on the show, "what's the *deal* here?" [EXCERPT FROM RS 538 COVER STORY BY PETER W. KAPLAN]

RS 536 | KEITH RICHARDS
October 6th, 1988
PHOTOGRAPH BY ALBERT WATSON

RS 540 | STEVE WINWOOD
December 1st, 1988
PHOTOGRAPH BY HERB RITTS

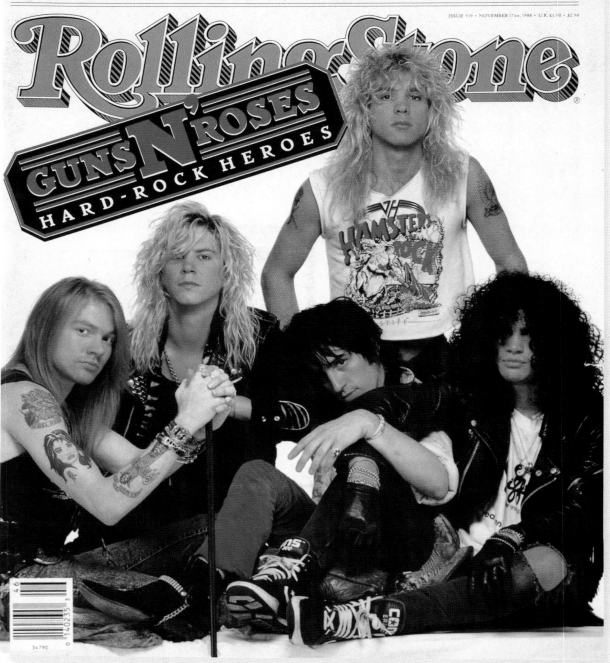

★ EXCLUSIVE: 'BLIND FAITH,' BY JOE McGINNISS, THE AUTHOR OF 'FATAL VISION' ★
U2'S 'RATTLE AND HUM,' MICK JAGGER, JAMES BROWN, FASHION TAKES THE NIGHT

ISSUE 539 · NOVEMBER 17TH, 1988 · U.K. £1.30 · $2.50

Rolling Stone

GUNS N'ROSES
HARD-ROCK HEROES

1980s

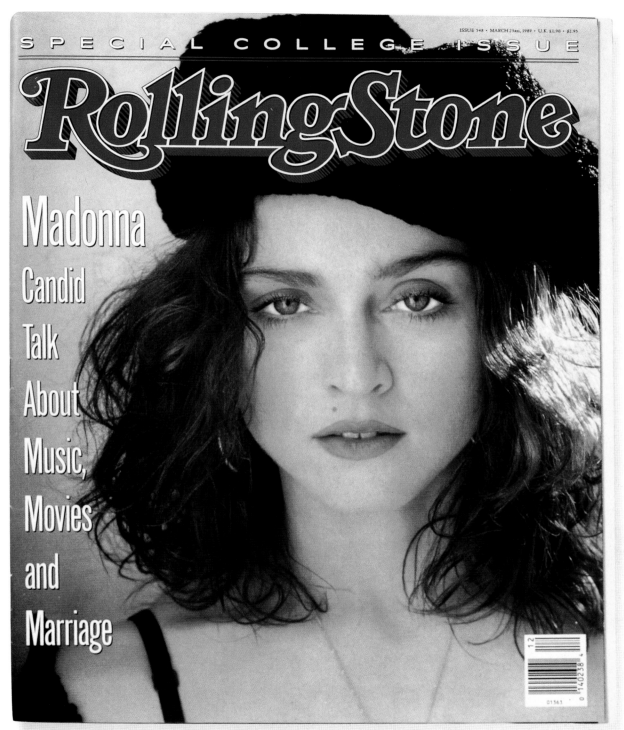

SPECIAL COLLEGE ISSUE

RollingStone

Madonna
Candid
Talk
About
Music,
Movies
and
Marriage

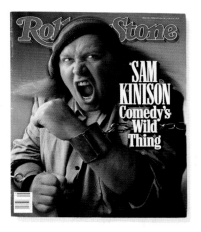

RS 541/542 | 1988 YEARBOOK
December 15th – December 29th, 1988
VARIOUS PHOTOGRAPHERS

RS 543 | MEL GIBSON
January 12th, 1989
PHOTOGRAPH BY HERB RITTS

RS 545 | JON BON JOVI
February 9th, 1989
PHOTOGRAPH BY TIMOTHY WHITE

RS 544 | ROY ORBISON
January 26th, 1989
PHOTOGRAPH BY ANN SUMMA

RS 546 | SAM KINISON
February 23rd, 1989
PHOTOGRAPH BY MARK SELIGER

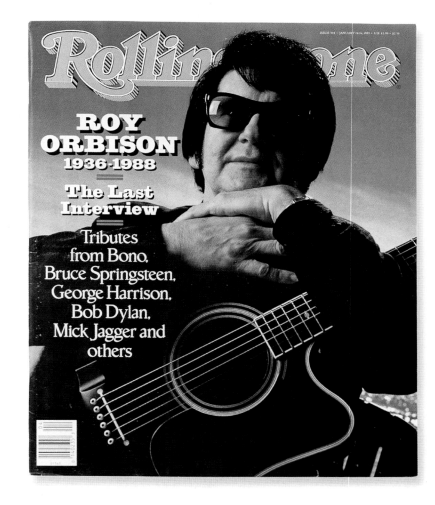

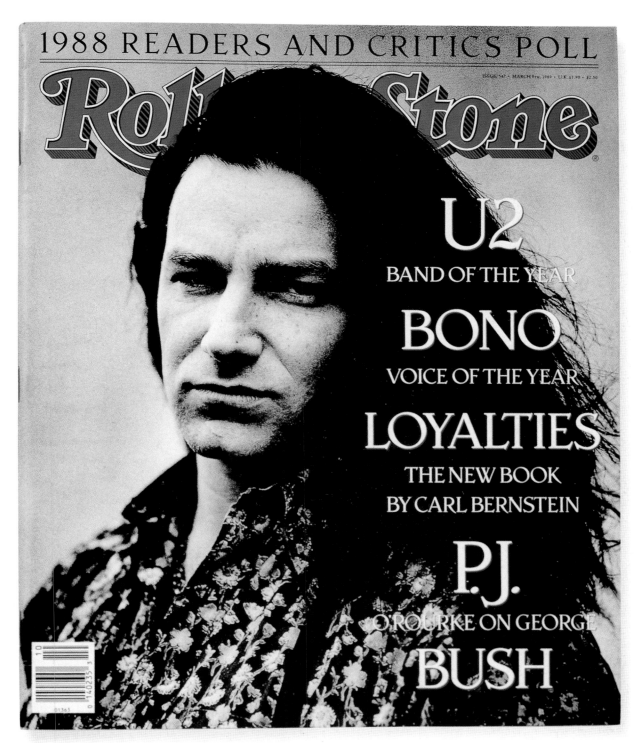

1988 READERS AND CRITICS POLL

ISSUE 547 • MARCH 9TH, 1989 • U.K. £1.90 • $2.50

U2
BAND OF THE YEAR

BONO
VOICE OF THE YEAR

LOYALTIES
THE NEW BOOK BY CARL BERNSTEIN

P.J.
O'ROURKE ON GEORGE

BUSH

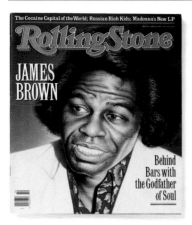

RS 549 | JAMES BROWN
April 16th, 1989
ILLUSTRATION BY GOTTFRIED HELNWEIN

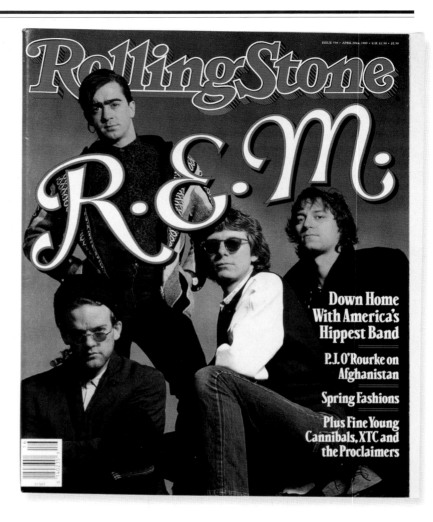

RS 550 | R.E.M.
April 20th, 1989
PHOTOGRAPH BY TIMOTHY WHITE

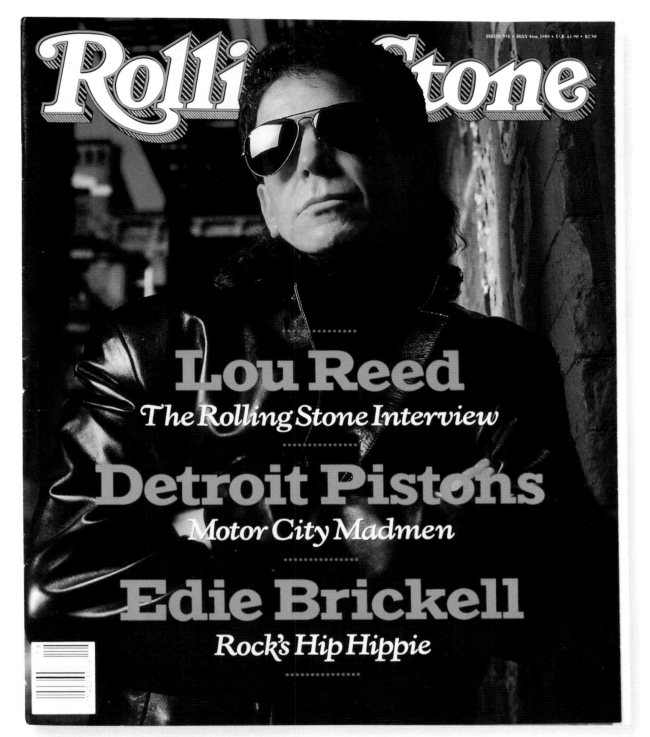

ISSUE 551 • MAY 4TH, 1989 • U.K. £1.90 • $2.50

Lou Reed
The Rolling Stone Interview

Detroit Pistons
Motor City Madmen

Edie Brickell
Rock's Hip Hippie

RS 551 | LOU REED | May 4th, 1989 | PHOTOGRAPH BY MARK SELIGER

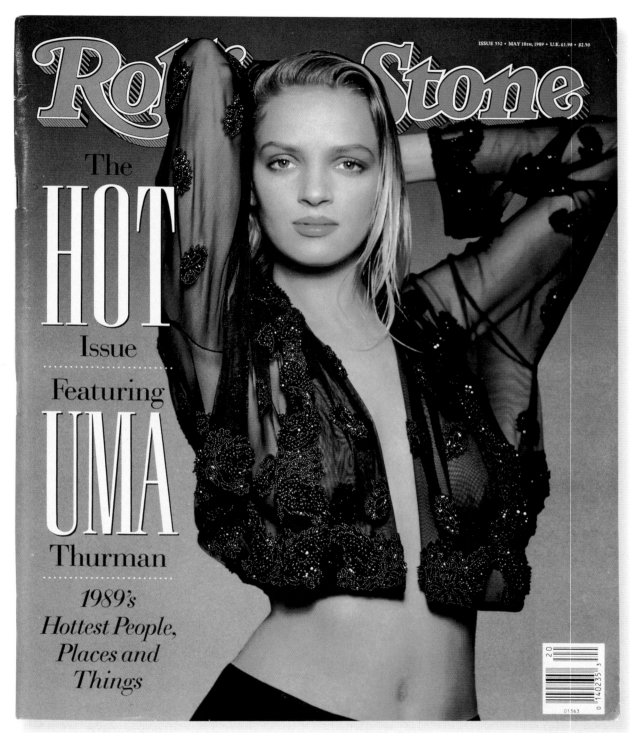

ISSUE 552 • MAY 18TH, 1989 • U.K. £1.90 • $2.50

Rolling Stone

The

HOT

Issue

Featuring

UMA

Thurman

*1989's
Hottest People,
Places and
Things*

1980s

RS 552 | UMA THURMAN | May 18th, 1989 | Photograph by Matthew Rolston

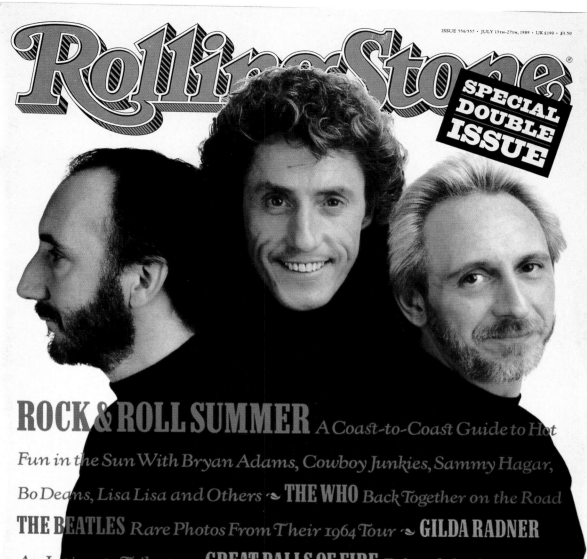

ROCK & ROLL SUMMER

A Coast-to-Coast Guide to Hot Fun in the Sun With Bryan Adams, Cowboy Junkies, Sammy Hagar, Bo Deans, Lisa Lisa and Others ➤ **THE WHO** *Back Together on the Road* **THE BEATLES** *Rare Photos From Their 1964 Tour* ➤ **GILDA RADNER** *An Intimate Tribute* ➤ **GREAT BALLS OF FIRE** *Behind the Scenes in Memphis With Dennis Quaid and Jerry Lee Lewis* ➤ **PEACE** *A Special Report by Lawrence Wright* ➤ **SPIKE LEE** *His Controversial New Movie* ➤ **THE CULT** *British Rockers Conquer America* ➤

ISSUE 556/557 · JULY 13TH–27TH, 1989 · UK £190 · $3.50

SPECIAL DOUBLE ISSUE

RS 556/557 | **THE WHO** | July 13th – July 27th, 1989 | PHOTOGRAPH BY DAVIES & STARR

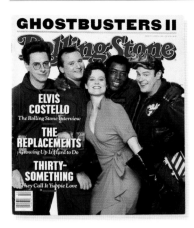

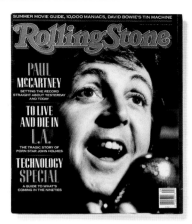

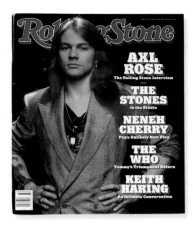

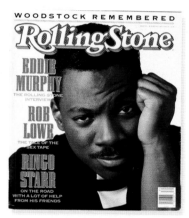

RS 554 | PAUL McCARTNEY
June 15th, 1989
PHOTOGRAPH BY HERB RITTS

RS 558 | AXL ROSE
August 10th, 1989
PHOTOGRAPH BY ROBERT JOHN

RS 553 | CAST OF
'GHOSTBUSTERS II'
June 1st, 1989
PHOTOGRAPH BY TIMOTHY WHITE

RS 559 | EDDIE MURPHY
August 24th, 1989
PHOTOGRAPH BY BONNIE SCHIFFMAN

HIS FRIENDS CALL HIM MONEY. He looks like money, like $40 million, if perchance one speculates. He looks crisp, controlled. He is twenty-eight yet not terribly youthful; he fancies himself much older, more world-weary. He stares straight ahead and seems to notice no one, but he sees all and hears even more. Unless he's erupting into his deft repertoire of character voices, his presence is shy, inscrutable. Usually he is sullen, almost somber – but this creates a quiet aura of power.

You've probably heard this before, but you don't smile much for someone with such a famous smile.

People come up to me and ask me to smile all the time. The thing I hear most is "Yo, smile! Why aren't you smiling? *Smile.* Smile for me!" And it gets irritating. Sometimes in restaurants, I'll see people across the room pressing their fingers into the corners of their mouths, showing me how to smile. I kid you not. When I'm driving down the street, people pull up to me and ask why I'm not smiling. Never mind that if I was driving around with a big smile, then people would think I was a lunatic.

Maybe you're just shy.

That, and I've got a mouth full of fillings. I'm a sugar freak – that's my one indulgence, so I get a lot of cavities, and I have to go to the dentist more often than most.

So the million-dollar smile is fake?

The million-dollar smile is hollow, actually. At any moment, the teeth could all fall out. It's the sad truth: The million-dollar smile is rotten. So I'll fucking smile when I want!

[EXCERPT FROM EDDIE MURPHY INTERVIEW BY BILL ZEHME]

1980s

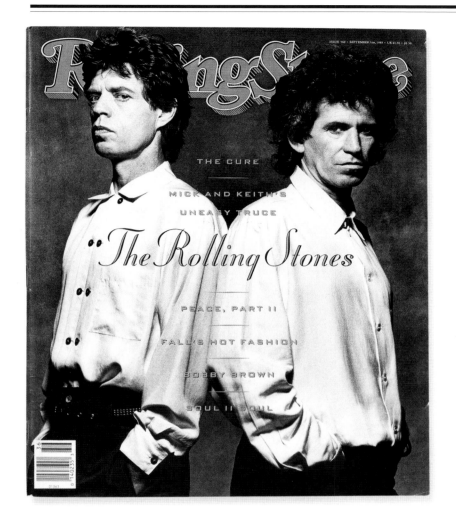

RS 560 | MICK JAGGER & KEITH RICHARDS
September 7th, 1989
PHOTOGRAPH BY ALBERT WATSON

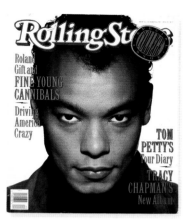

RS 562 | ROLAND GIFT
October 5th, 1989
PHOTOGRAPH BY ANDREW MACPHERSON

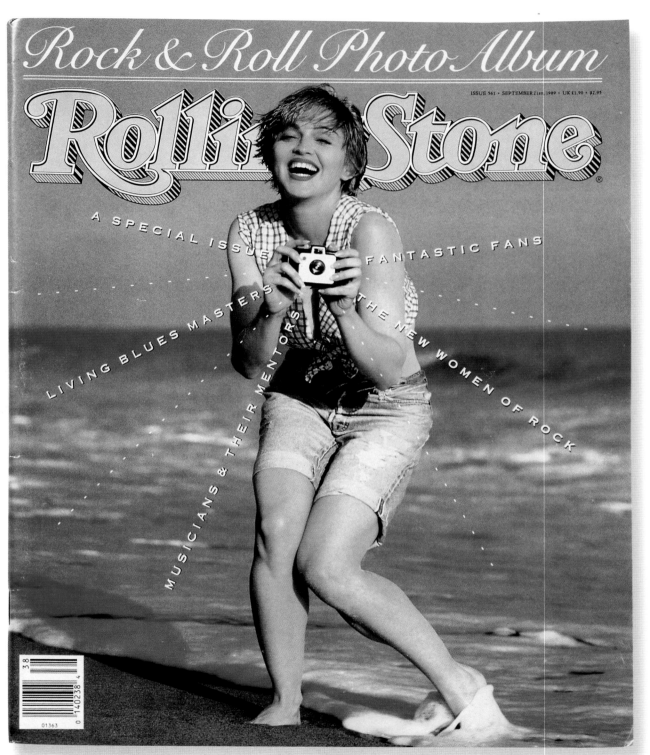

ISSUE 561 • SEPTEMBER 21st, 1989 • UK £1.90 • $2.95

Rolling Stone

A SPECIAL ISSUE

FANTASTIC FANS

LIVING BLUES MASTERS

MUSICIANS & THEIR MENTORS

THE NEW WOMEN OF ROCK

1980s

RS 561 | MADONNA
September 21st, 1989
PHOTOGRAPH BY HERB RITTS

AS ROCK STARS COME TO EXERCISE
increasing control over their images,
photographers face the challenge of
finding ways to exercise their own
powerful art, finding ways to say
something unique and penetrating
about people who are often extremely
wary – or manipulatively savvy –
about how they are represented.
Photographers must also search
for surprising aspects of the world
of music to bring to light.

In this Rock & Roll Photo Album,
ROLLING STONE's photographers do
both with wit and flair. Herb Ritts
captures a frolicsome Madonna
turning the tables on her fans – and
doctoring still another spin of the
carefully crafted image that has helped
make her one of the most recognizable
stars in the world.

[EXCERPT FROM RS 561 ESSAY
BY ANTHONY DeCURTIS]

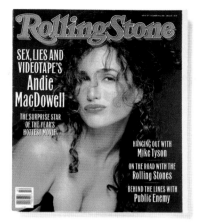

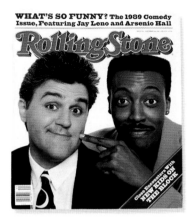

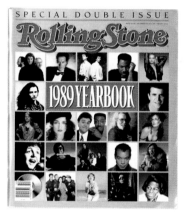

RS 563 | ANDIE MacDOWELL
October 19th, 1989
PHOTOGRAPH BY MATTHEW ROLSTON

RS 565 | THE 100 GREATEST
ALBUMS OF THE EIGHTIES
November 16th, 1989
ILLUSTRATION BY TERRY ALLEN

RS 564 | JAY LENO
& ARSENIO HALL
November 2nd, 1989
PHOTOGRAPH BY BONNIE SCHIFFMAN

RS 567/568 |1989 YEARBOOK
December 14th – December 28th, 1989
VARIOUS PHOTOGRAPHERS

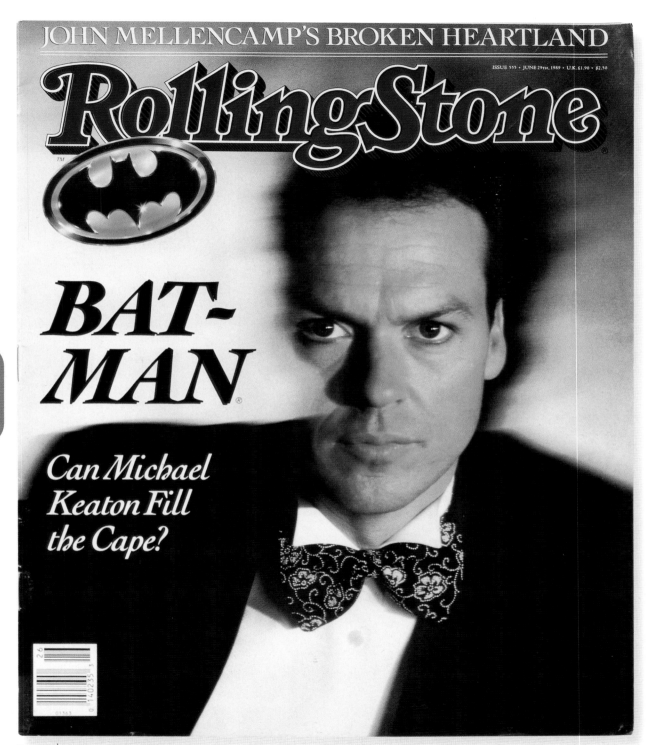

RollingStone

ISSUE 555 · JUNE 29TH, 1989 · U.K. £1.90 · $2.50

BAT-MAN

Can Michael Keaton Fill the Cape?

1980s

RS 555 | MICHAEL KEATON | June 29th, 1989 | Photograph by Bonnie Schiffman

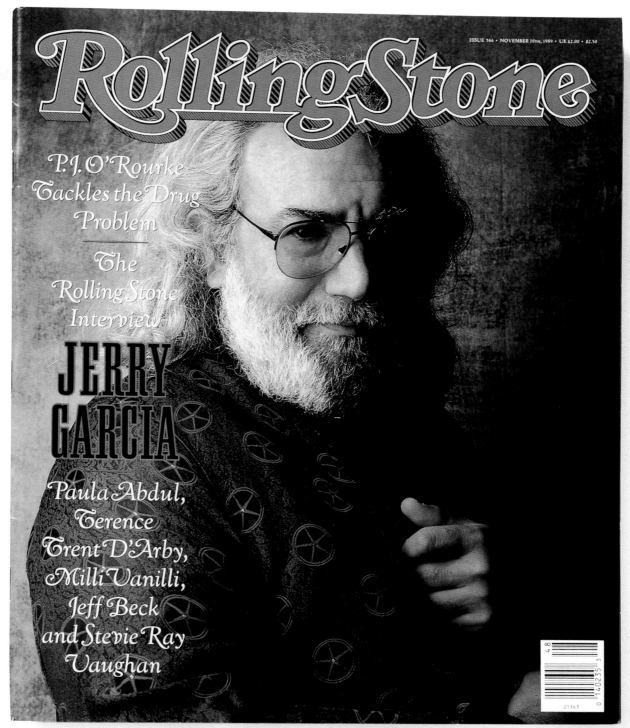

ISSUE 566 • NOVEMBER 30TH, 1989 • UK £2.00 • $2.50

RollingStone

P.J. O'Rourke
Tackles the Drug
Problem

The
Rolling Stone
Interview

JERRY GARCIA

Paula Abdul,
Terence
Trent D'Arby,
Milli Vanilli,
Jeff Beck
and Stevie Ray
Vaughan

RS 566 | JERRY GARCIA | *November 30th, 1989* | PHOTOGRAPH BY WILLIAM COUPON

ISSUE 572 • FEBRUARY 22ND, 1990 • $2.50 • UK £2.00

RollingStone

Janet Jackson

MICHAEL'S LITTLE SISTER GROWS UP

1990

Even by California's peerless standard, the day is exquisite: sunny, impossibly clear, surprisingly warm for late November. Janet Jackson sits on a bench in a narrow park overlooking the ocean and the beach in Pacific Palisades, on the edge of Los Angeles. She's out of the quasi-military regalia that constitutes what by now might be thought of as the Janet Jackson uniform and looking almost preppy in bluejeans, white sneakers with black stripes, a white Raiders cap, a ski sweater and a shirt with pictures of cartoon characters on it. Bugs Bunny and Woody Woodpecker peer over the collar of the sweater. Her large silver

earrings, with African designs, catch the glint of the sun as she speaks.

Pedestrians stroll by, joggers jog, the occasional person or couple saunters along the shore. The appearance of a dog within fifty yards in any direction triggers heart-rending paroxysms of longing in Puffy, the charmingly good-natured – and evidently quite lonely – mixed-breed bitch Jackson brought along to the interview. Fondness for pets is, of course, a Jackson family trait, and Janet had phoned my hotel that morning to ask if it would be all right if one of her dogs came along with her.

Puffy's function today is to help Jackson contend with her reluctance to deal with the press. She has not done any major interviews since her 1986 album *Control* – with its quintuple-platinum sales and string of hit singles – established her, at the age of twenty, as one of the most popular recording artists in the world. A preliminary meeting in Paris on the set of the video shoot for "Come

Back to Me," a luxurious ballad from Jackson's latest album, *Janet Jackson's Rhythm Nation 1814*, had taken place a month earlier at Jackson's request.

Like virtually everyone else in the public eye, Jackson doesn't feel she's been treated particularly well by the press, and she's sensitive about the media's portrayal of her brother Michael, to whom she is still extremely close. Also, after working so hard to break away from her family and build an independent identity, Janet isn't especially inclined to enter situations over which she doesn't have ultimate control. When she was first approached about doing this story, she requested the right to approve it before it was published – a request that was denied. Finally, you don't grow up in the preeminent entertainment family in America without learning that maintaining an air of mystery about yourself is an acutely effective marketing technique.

[EXCERPT FROM RS 572 COVER STORY BY ANTHONY DECURTIS]

RS 572 | JANET JACKSON | February 22nd, 1990 | PHOTOGRAPH BY MATTHEW ROLSTON

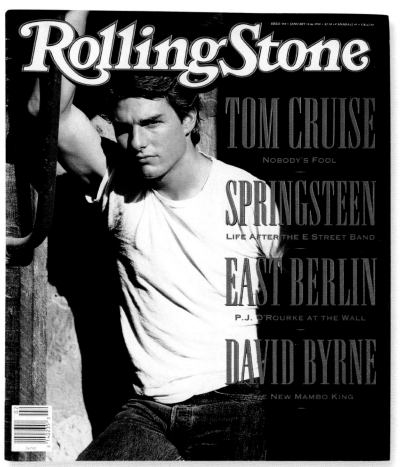

RS 569 | TOM CRUISE | January 11th, 1990 | PHOTOGRAPH BY HERB RITTS

1990s

RS 570 | BILLY JOEL
January 25th, 1990
PHOTOGRAPH BY TIMOTHY WHITE

"THE CRITICS DON'T SEE ME AS this authentic rock & roller. I'm not an authentic rock & roller. I never pretended to be one. I never hid my influences. The thing that pissed me off is when people compared me to Elton John when I was copying McCartney, you know? My God, I was straightforward about this stuff. I remember one guy said I was 'the Irving Berlin of narcissistic alienation.' I kinda like that – the Irving Berlin part anyway. Listen, I wrote some reviews when I was young for small rock magazines. But then I trashed this album by Al Cooper, and I realized that if I were him, I'd want to wring my neck. I didn't have the stomach for it. Now I say, 'You think I stink. I think your opinion stinks.' Have I read bad reviews onstage? Of course. Would I do it again? No. Nowadays it just bugs me when they say something about my wife or my kid.

"Listen, I might be an antique, just like the Stones, but antiques are of value. Antiques hold their value. We even get more valuable with age. And people want collectibles. Also, maybe people are finally getting tired of paying hard-earned money to see nothing up there. Maybe folks are tired of video stars who can't deliver live. They want substance, too."

—*Billy Joel*

ISSUE 570 · JANUARY 25TH, 1990 · $2.50 · UK £2.00

Rolling Stone

billy joel

On Fire Again:
The Rolling Stone
Interview

Guitar Heroes:
Jeff Beck
and Stevie Ray
Vaughan

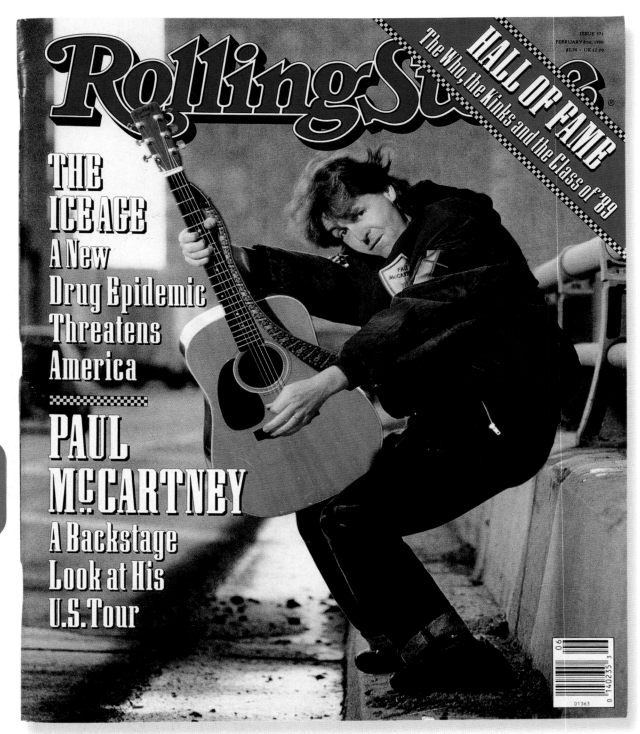

ISSUE 571
FEBRUARY 8th, 1990
$2.50 · UK £2.00

HALL OF FAME
The Who, the Kinks and the Class of '89

THE ICE AGE
A New Drug Epidemic Threatens America

PAUL McCARTNEY
A Backstage Look at His U.S. Tour

01363
0 140235 3

1990s

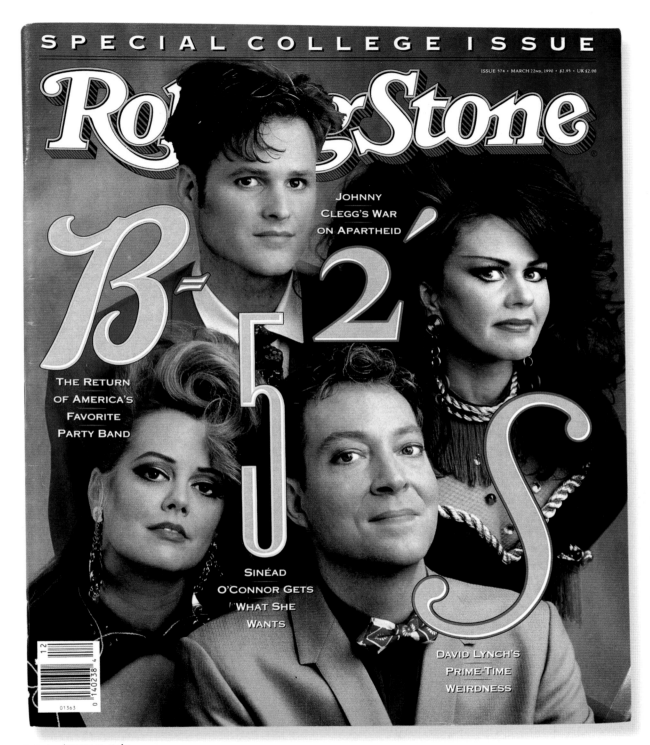

RS 573 | KEITH RICHARDS
& MICK JAGGER
March 8th, 1990
PHOTOGRAPH BY NEAL PRESTON

RS 575 | AEROSMITH
April 5th, 1990
PHOTOGRAPH BY MARK SELIGER

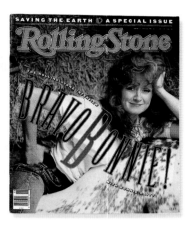

RS 577 | BONNIE RAITT
May 3rd, 1990
PHOTOGRAPH BY E.J. CAMP

For some of us, it began late at night: huddled under bedroom covers with our ears glued to a radio pulling in black voices charged with intense emotion and propelled by a wildly kinetic rhythm through the after-midnight static. Growing up in the white-bread America of the Fifties, we had never heard anything like it, but we reacted, and were converted. We were believers before we knew what it was that had so spectacularly ripped the dull, familiar fabric of our lives. We asked our friends, maybe an older brother or sister. We found out they called it rock & roll. It was so much more vital and alive than any music we had ever heard before. Rock & roll was much more than new music for us. It was an obsession, and a way of life.

For some of us, it began a little later, with our first glimpse of Elvis on the family television set. But for those of us growing up in the Fifties, it didn't seem to matter how or where we first heard the music. Our reactions were remarkably uniform. Here was a sonic cataclysm come bursting (apparently) out of nowhere, with the power to change our lives forever. Because it was obviously, inarguably *our* music. If we had any initial doubt about that, our parents' horrified – or at best dismissive – reactions banished those doubts. Growing up in a world we were only beginning to understand, we had finally found something for us.

[EXCERPT FROM ESSAY ON THE FIFTIES BY ROBERT PALMER]

ISSUE 576 · APRIL 19th, 1990 · $2.95 · UK £2.00

Rolling Stone

50s

*A Celebration
of Four Decades
of Rock*

16

0 140238 4

RS 576 | THE FIFTIES | April 19th, 1990 | ILLUSTRATION BY TERRY ALLEN & DENNIS ORTIZ-LOPEZ

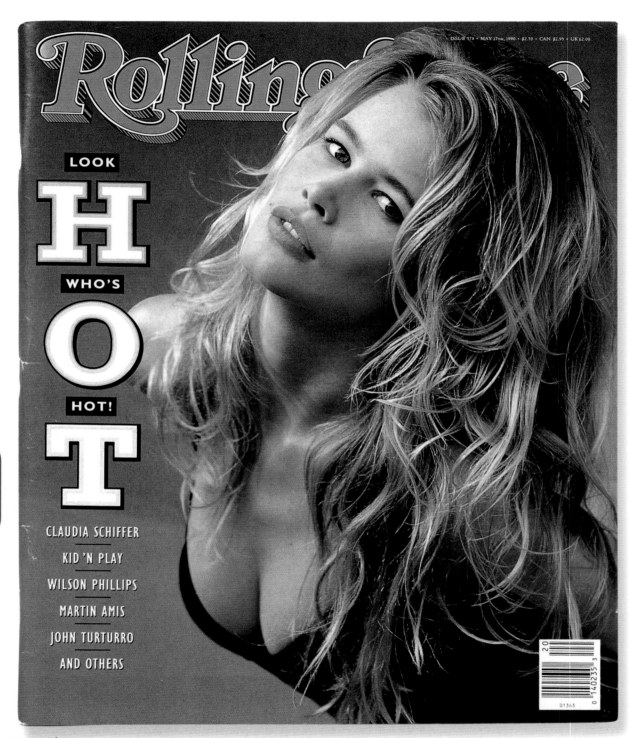

ISSUE 578 • MAY 17TH, 1990 • $2.50 • CAN $2.95 • UK £2.00

Rolling

LOOK

HOT

WHO'S

HOT!

CLAUDIA SCHIFFER

KID 'N PLAY

WILSON PHILLIPS

MARTIN AMIS

JOHN TURTURRO

AND OTHERS

RS 578 | CLAUDIA SCHIFFER | May 17th, 1990 | Photograph by Herb Ritts

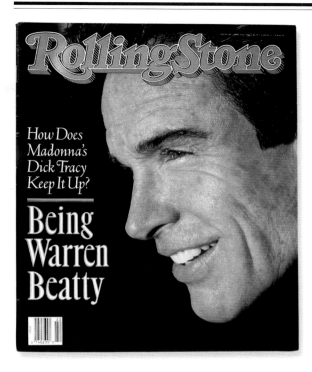

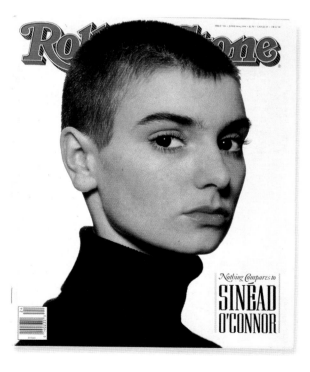

RS 579 | WARREN BEATTY
May 31st, 1990
PHOTOGRAPH BY HERB RITTS

RS 580 | SINÉAD O'CONNOR
June 14th, 1990
PHOTOGRAPH BY ANDREW MACPHERSON

HE IS A GHOST. HE IS HUMAN ECTOPLASM. HE IS HERE, and then he is gone, and then you aren't sure he was ever here to begin with. He has had sex with everyone, or at least tried. He has had sex with someone you know or someone who knows someone you know or someone you wish you knew, or at least tried. He is famous for sex, he is famous for having sex with the famous, he is famous. He makes mostly good films when he makes films, which is mostly not often. He has had sex with most of his leading ladies. He befriends all women and many politicians and whispers advice to them on the telephone in the dead of night. Or else he does not speak at all to anyone ever, except to those who know him best, if anyone can really know him. He is an adamant enigma, elusive for the sake of elusiveness, which makes him desirable, although for what, no one completely understands. He is much smarter than you think but perhaps not as smart as he thinks, if only because he thinks too much about being smart. He admits to none of this. He admits to nothing much. He denies little. And so his legend grows.

He has talked. And talked. For days, I have listened to him talk. I have listened to him listen to himself talk. I have probed and pelted and listened some more. For days. He speaks slowly, fearfully, cautiously, editing every syllable, slicing off personal color and spontaneous wit, steering away from opinion, introspection, humanness. He is mostly evasive. His pauses are elephantine. Broadway musicals could be mounted during his pauses. He works at this. Ultimately, he renders himself blank. In *Dick Tracy*, he battles a mysterious foe called the Blank. In life, he is the Blank doing battle with himself. It is a fascinating showdown, exhilarating to behold.

To interview Warren Beatty is to want to kill him.

[EXCERPT FROM WARREN BEATTY INTERVIEW BY BILL ZEHME]

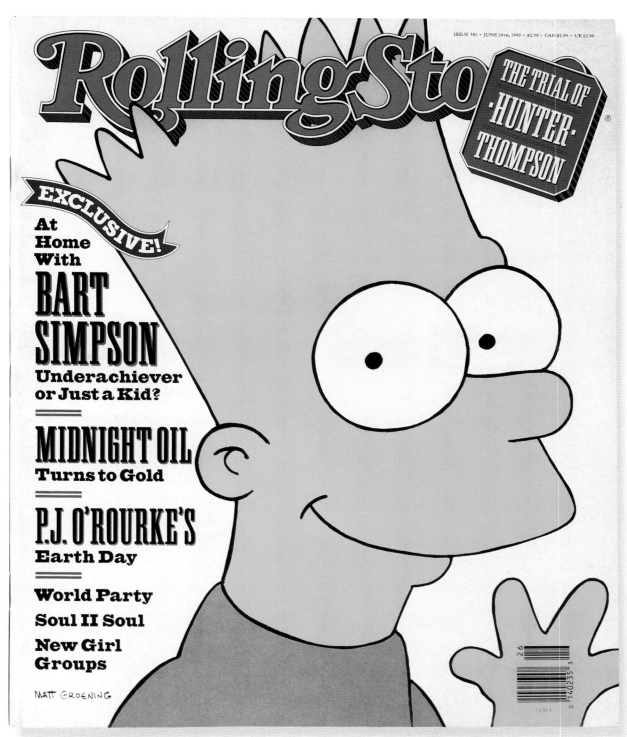

ISSUE 581 · JUNE 28TH, 1990 · $2.50 · CAN $2.95 · UK £2.00

Rolling Sto

THE TRIAL OF ·HUNTER· THOMPSON

EXCLUSIVE!

At Home With

BART SIMPSON

Underachiever or Just a Kid?

MIDNIGHT OIL

Turns to Gold

P.J. O'ROURKE'S

Earth Day

World Party

Soul II Soul

New Girl Groups

MATT GROENING

1990s

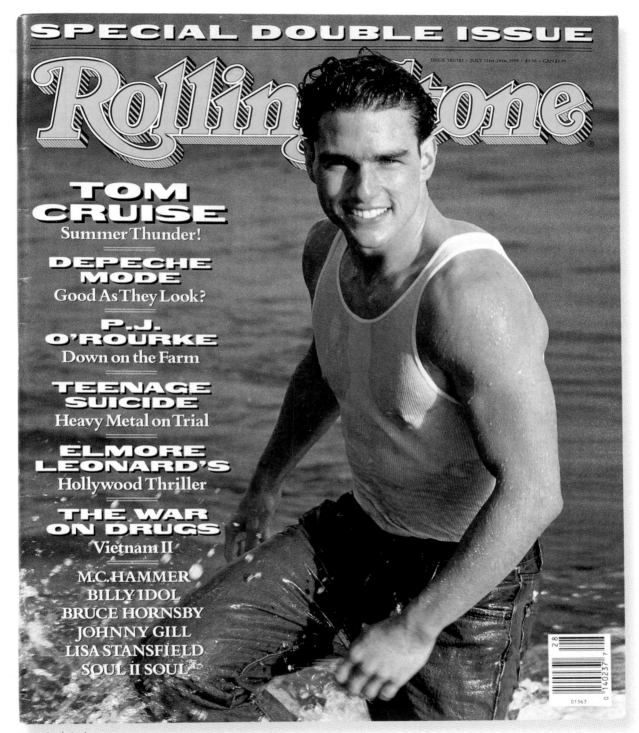

SPECIAL DOUBLE ISSUE

ISSUE 582/583 · JULY 12TH-26TH, 1990 · $3.50 · CAN $3.95

Rolling Stone

TOM CRUISE
Summer Thunder!

DEPECHE MODE
Good As They Look?

P.J. O'ROURKE
Down on the Farm

TEENAGE SUICIDE
Heavy Metal on Trial

ELMORE LEONARD'S
Hollywood Thriller

THE WAR ON DRUGS
Vietnam II

M.C. HAMMER
BILLY IDOL
BRUCE HORNSBY
JOHNNY GILL
LISA STANSFIELD
SOUL II SOUL

RS 582/583 | TOM CRUISE | July 12th – July 26th, 1990 | Photograph by Herb Ritts

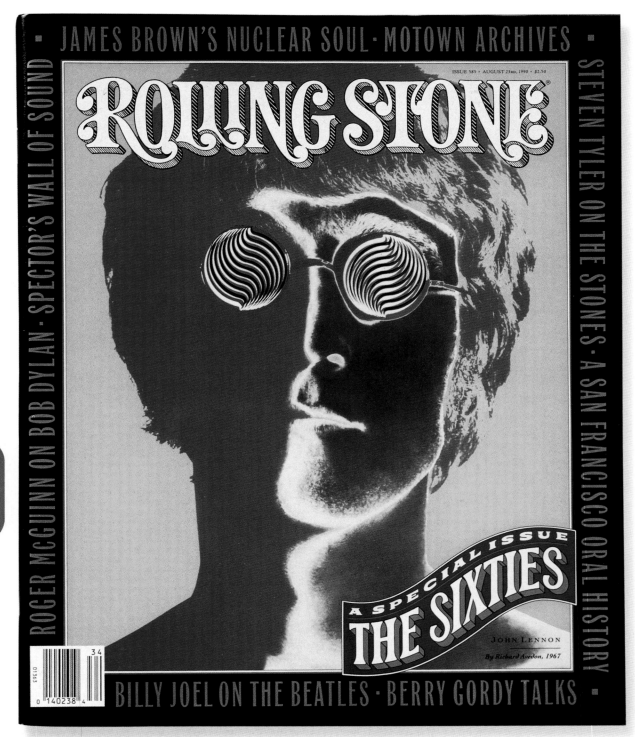

SPECTOR'S WALL OF SOUND

ROGER McGUINN ON BOB DYLAN ·

Rolling Stone

ISSUE 585 · AUGUST 23RD, 1990 · $2.50

STEVEN TYLER ON THE STONES · A SAN FRANCISCO ORAL HISTORY

1990s

A SPECIAL ISSUE
THE SIXTIES

JOHN LENNON
By Richard Avedon, 1967

BILLY JOEL ON THE BEATLES · BERRY GORDY TALKS

RS 585 | THE SIXTIES – JOHN LENNON | August 23rd, 1990 | Photograph by Richard Avedon

RS 584 | JULIA ROBERTS
August 9th, 1990
PHOTOGRAPH BY HERB RITTS

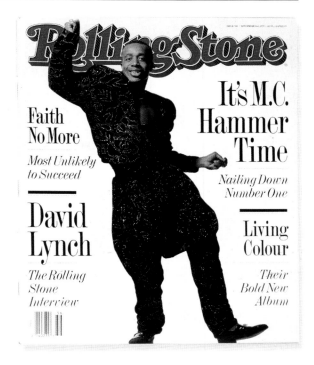

RS 586 | M.C. HAMMER
September 6th, 1990
PHOTOGRAPH BY FRANK W. OCKENFELS 3

FOR A LONG AND UNFORGETTABLE SEASON, ROCK was a voice of unity and liberty. In the 1950s, rock & roll meant disruption: It was the clamor of young people, kicking hard against the Eisenhower era's ethos of vapid repression. By the onset of the 1960s, that spirit had been largely tamed or simply impeded by numerous misfortunes, including the film and army careers of Elvis Presley, the death of Buddy Holly, the blacklisting of Jerry Lee Lewis and Chuck Berry and the persecution of DJ Alan Freed, who had been stigmatized by payola charges by Tin Pan Alley interests and politicians angered with his championing of R&B and rock & roll. In 1960, the music of Frankie Avalon, Paul Anka, Connie Francis and Mitch Miller (an avowed enemy of rock & roll) ruled the airwaves and the record charts, giving some observers the notion that decency and order had returned to the popular mainstream. But within a few years, rock would regain its disruptive power with a joyful vengeance until, by the decade's end, it would be seen as a genuine force of cultural and political consequence. For a long and unforgettable season, it was a truism – or threat, depending on your point of view – that rock & roll could (and should) make a difference: that it was eloquent and inspiring and principled enough to change the world – maybe even to save it.

[EXCERPT FROM THE SIXTIES ESSAY BY MIKAL GILMORE]

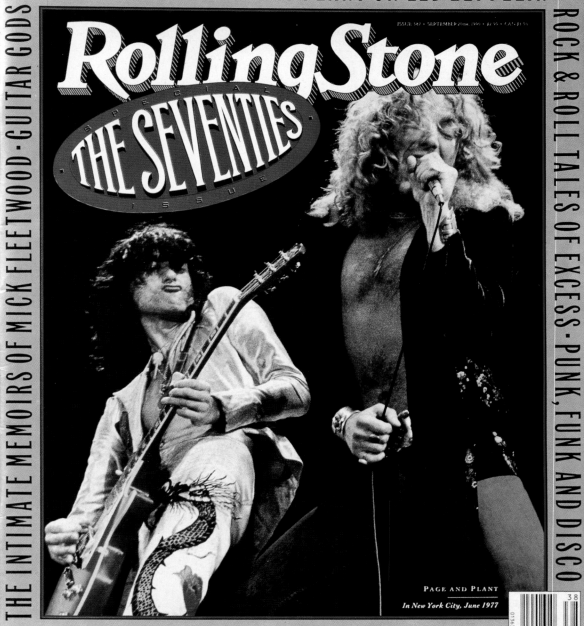

JIMMY PAGE AND ROBERT PLANT ON LED ZEPPELIN

GUITAR GODS · THE INTIMATE MEMOIRS OF MICK FLEETWOOD

ROCK & ROLL TALES OF EXCESS · PUNK, FUNK AND DISCO

ISSUE 587 · SEPTEMBER 20th, 1990 · $2.95 · CAN $3.50

Rolling Stone

SPECIAL THE SEVENTIES ISSUE

PAGE AND PLANT

In New York City, June 1977

1990s

DON HENLEY AND GLENN FREY ON THE EAGLES

RS 587 | THE SEVENTIES – JIMMY PAGE & ROBERT PLANT | September 20th, 1990 | Photograph by Bob Gruen

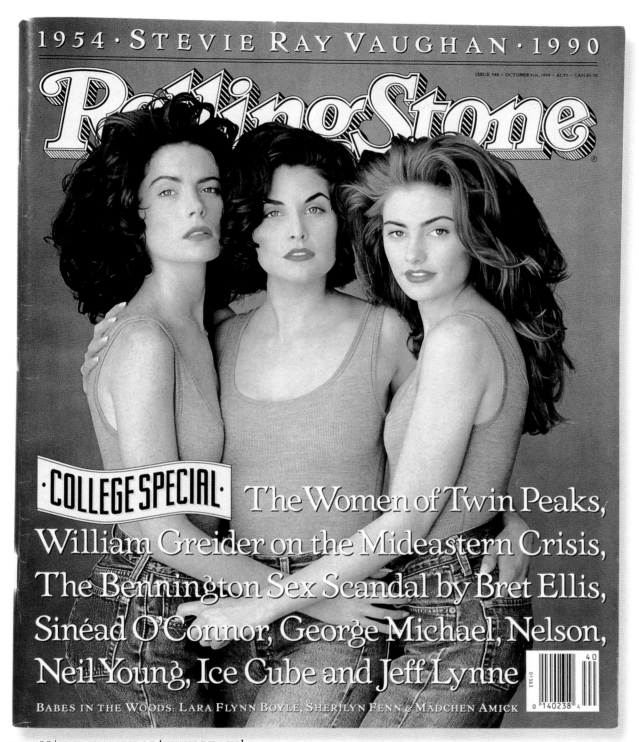

ISSUE 588 · OCTOBER 4TH, 1990 · $2.95 · CAN $3.50

RollingStone

·COLLEGE SPECIAL·

The Women of Twin Peaks,
William Greider on the Mideastern Crisis,
The Bennington Sex Scandal by Bret Ellis,
Sinéad O'Connor, George Michael, Nelson,
Neil Young, Ice Cube and Jeff Lynne

BABES IN THE WOODS: LARA FLYNN BOYLE, SHERILYN FENN & MÄDCHEN AMICK

RS 588 | THE WOMEN OF 'TWIN PEAKS' | October 4th, 1990 | Photograph by Matthew Rolston

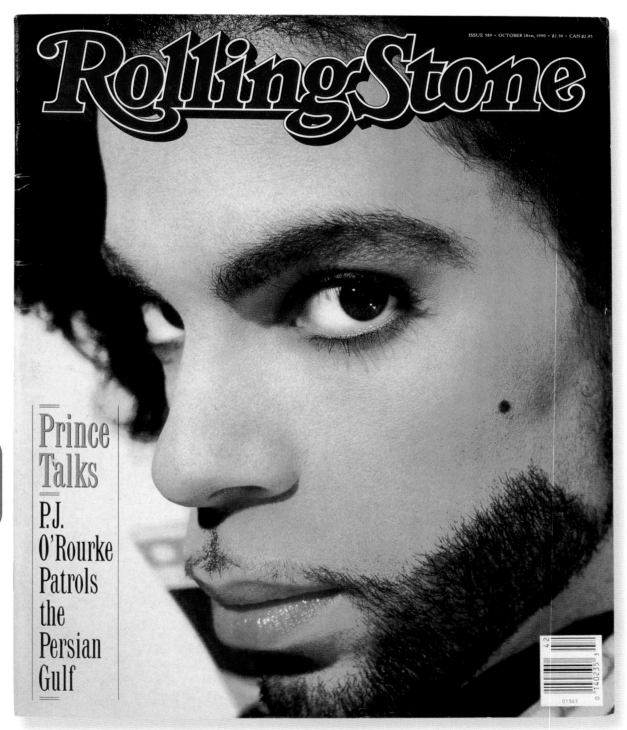

ISSUE 589 • OCTOBER 18TH, 1990 • $2.50 • CAN $2.95

RollingStone

Prince
Talks

P.J.
O'Rourke
Patrols
the
Persian
Gulf

01363

RS 589 | PRINCE | October 18th, 1990 | PHOTOGRAPH BY JEFF KATZ

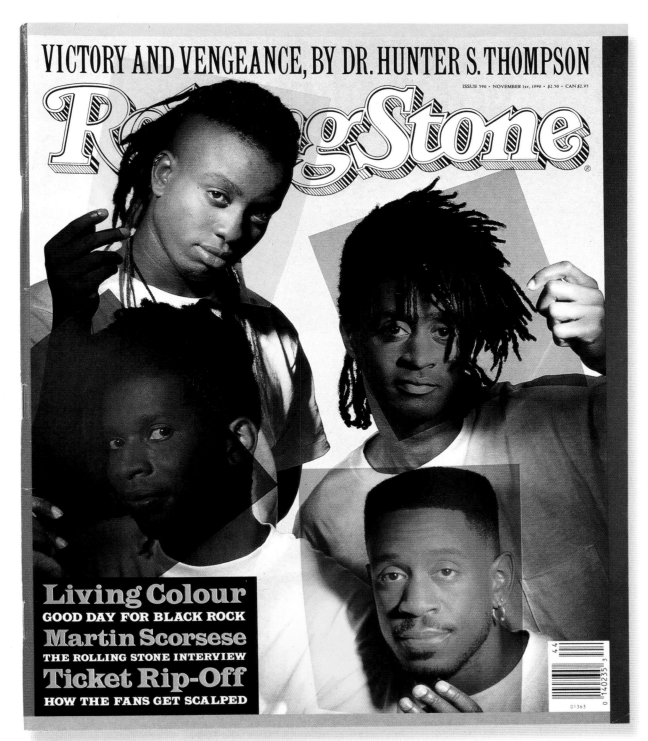

VICTORY AND VENGEANCE, BY DR. HUNTER S. THOMPSON

Rolling Stone

ISSUE 590 • NOVEMBER 1st, 1990 • $2.50 • CAN $2.95

Living Colour
GOOD DAY FOR BLACK ROCK
Martin Scorsese
THE ROLLING STONE INTERVIEW
Ticket Rip-Off
HOW THE FANS GET SCALPED

01363

RS 590 | LIVING COLOUR | November 1st, 1990 | Photograph by Mark Seliger

1990s

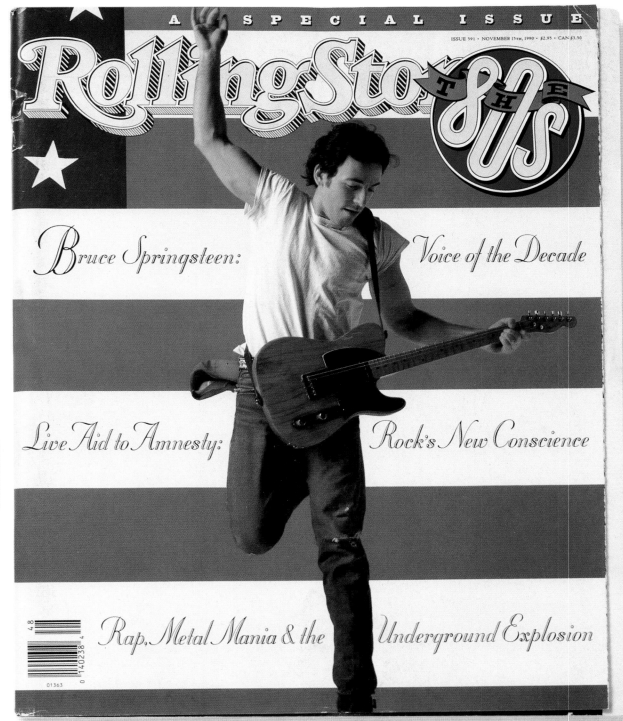

A SPECIAL ISSUE

ISSUE 591 • NOVEMBER 15TH, 1990 • $2.95 • CAN $3.50

Bruce Springsteen: *Voice of the Decade*

Live Aid to Amnesty: *Rock's New Conscience*

Rap, Metal Mania & the *Underground Explosion*

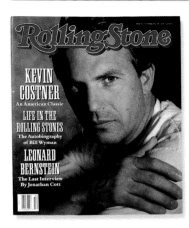

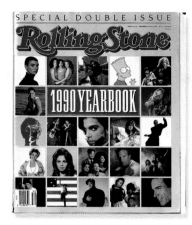

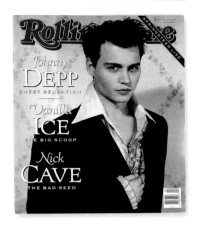

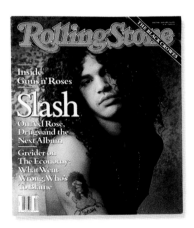

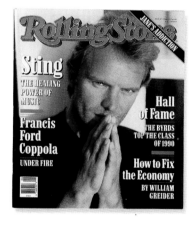

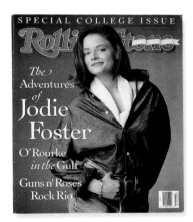

RS 592 | KEVIN COSTNER
November 29th, 1990
PHOTOGRAPH BY GWENDOLEN CATES

RS 593/594 | 1990 YEARBOOK
December 13th – 27th, 1990
VARIOUS PHOTOGRAPHERS

RS 595 | JOHNNY DEPP
January 10th, 1991
PHOTOGRAPH BY HERB RITTS

RS 596 | SLASH
January 24th, 1991
PHOTOGRAPH BY MARK SELIGER

RS 597 | STING
February 7th, 1991
PHOTOGRAPH BY HERB RITTS

RS 600 | JODIE FOSTER
March 21st, 1991
PHOTOGRAPH BY MATTHEW ROLSTON

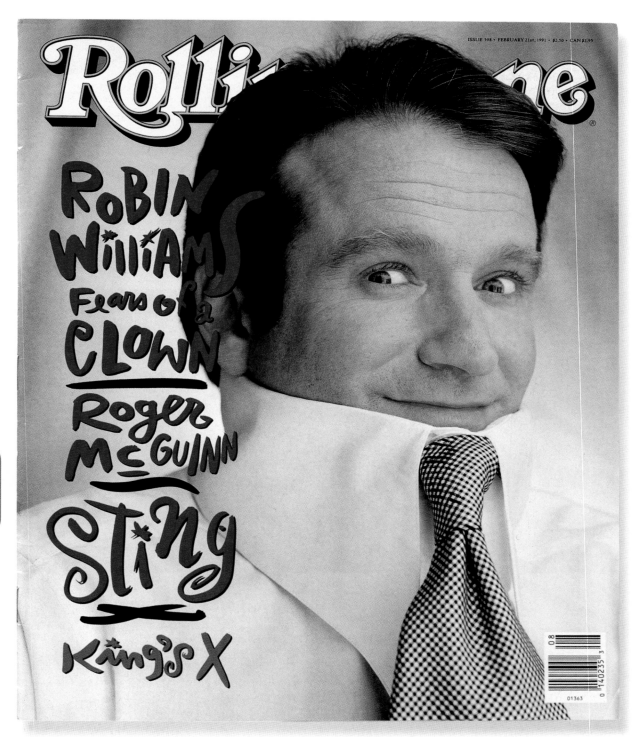

ISSUE 598 • FEBRUARY 21st, 1991 • $2.10 • CAN $2.95

Rolling Stone

ROBIN WILLIAMS
Fears of a CLOWN

ROGER McGUINN

Sting

King's X

ISSUE 599 · MARCH 7TH, 1991 · $2.50 · CAN $2.95

Rolling Stone

O'ROURKE IN THE GULF

Artist
of the Year

Sinéad
O'CONNOR

The
Rolling Stone
Interview

01563
0 140235 3

10

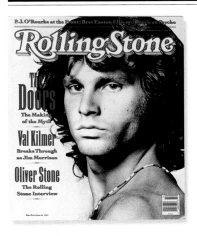

RS 603 | WILSON PHILLIPS
May 2nd, 1991
Photograph by Andrew Eccles

RS 601 | JIM MORRISON
April 4th, 1991
Photograph by Joel Brodsky

RS 602 | NEW FACES 1991
April 18th, 1991
Various photographers

RS 604 | WINONA RYDER
May 16th, 1991
Photograph by Herb Ritts

RS 605 | THE BLACK CROWES
May 30th, 1991
Photograph by Mark Seliger

"*This was a great chance to* re-create an era that I feel I would have really flourished in, [when] nothing I would have done would have been censored."

—*Madonna*

Madonna BIG-TIME GIRL TALK

The ROLLING STONE INTERVIEW *by* **CARRIE FISHER**

ISSUE 606 • JUNE 13TH, 1991 • $2.50 • CAN $2.95

RollingStone

RS 606 | MADONNA | June 13th, 1991 | Photograph by Steven Meisel

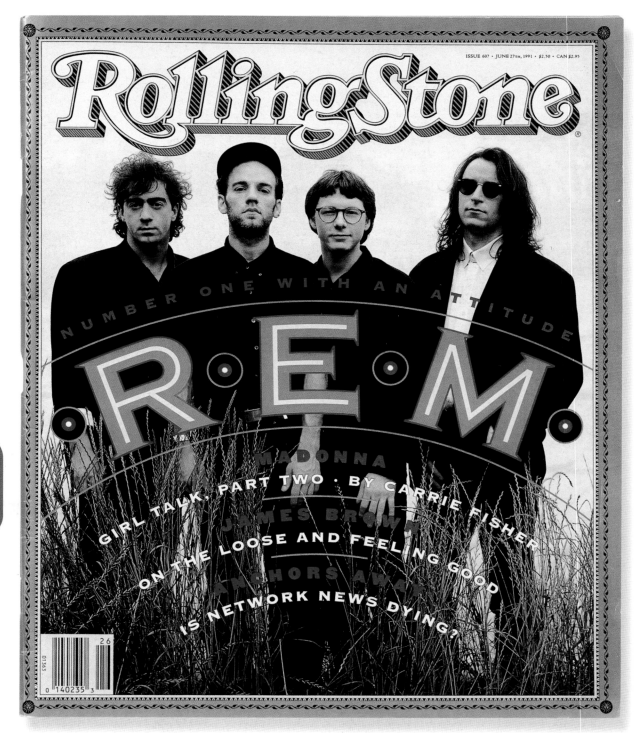

ISSUE 607 • JUNE 27TH, 1991 • $2.50 • CAN $2.95

RollingStone

NUMBER ONE WITH AN ATTITUDE

·R·E·M·

MADONNA

GIRL TALK, PART TWO · BY CARRIE FISHER

JAMES BROWN

ON THE LOOSE AND FEELING GOOD

ANCHORS AWAY

IS NETWORK NEWS DYING?

1990s

RS 607 | **R.E.M.** | June 27th, 1991 | Photograph by Frank W. Ockenfels 3

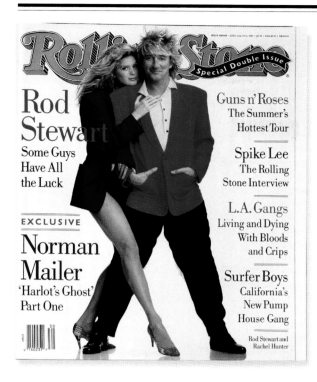

RS 608/609 | ROD STEWART
& RACHEL HUNTER
July 11th – July 25th, 1991
PHOTOGRAPH BY ANDREW ECCLES

RS 610 | TOM PETTY
August 8th, 1991
PHOTOGRAPH BY MARK SELIGER

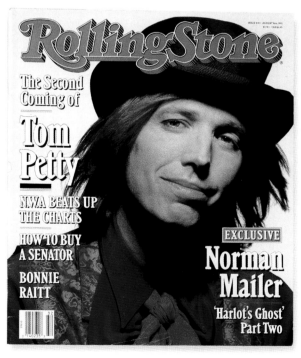

"THIS IS A DAY LIKE I THOUGHT being a pop star would be like when I was a kid. You get in the limo, you go across town to do a photo session, you buy a shirt and then wear it right away and get photographed for the cover of ROLLING STONE. You get in another limo with a couple of journalists who hang on your every word, and then go speak to Southeast Asia." —*Peter Buck*

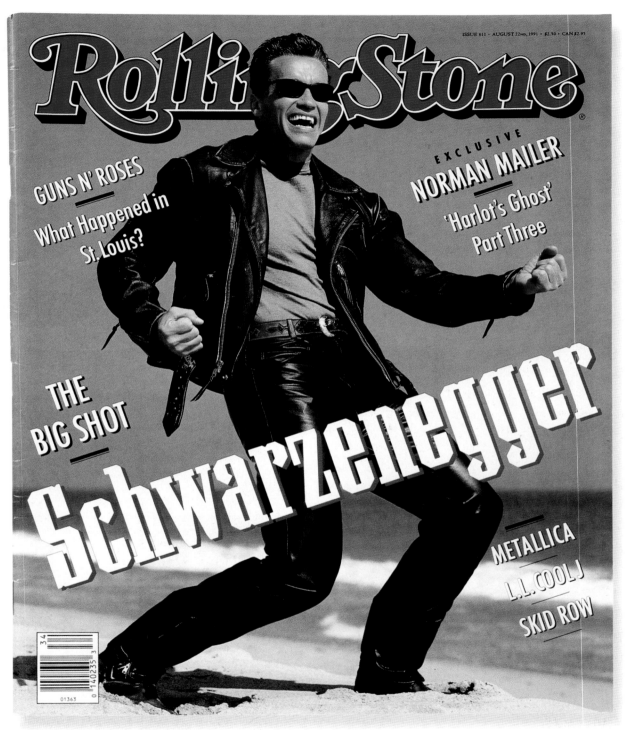

ISSUE 611 · AUGUST 22ND, 1991 · $2.50 · CAN $2.95

Rolling Stone

GUNS N' ROSES

What Happened in St. Louis?

EXCLUSIVE

NORMAN MAILER

'Harlot's Ghost' Part Three

THE BIG SHOT

Schwarzenegger

METALLICA

L.L. COOL J

SKID ROW

1990s

RS 611 | ARNOLD SCHWARZENEGGER | August 22nd, 1991 | PHOTOGRAPH BY HERB RITTS

MEN ARE IN CRISIS, whereas he is not. He does not know the meaning of "crisis." Or perhaps he does, but he pretends otherwise. He is Austrian, after all, and some things do not translate easily between cultures. (Lederhosen, for instance.) Throughout the world he is called Arnold, but that is because there are too many letters in Schwarzenegger. By now everyone has come to know that the literal meaning of Schwarzenegger is "black plowman," and like many black plowmen before him, Arnold knows exactly what it feels like when a horse falls on top of him. There is much pain, yes, but pain means little to Arnold, especially when there are stuntmen available. Anyway, Arnold is never in crisis. For this reason, it is imperative that Arnold be Arnold so that others may learn. And, from what society tells us, there has never been a more crucial epoch in history for Arnold to be alive, which is, at the very least, pretty convenient.

[EXCERPT FROM RS 611 COVER STORY BY BILL ZEHME]

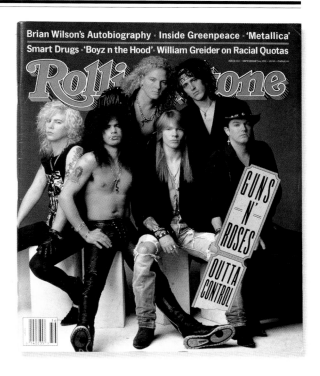

RS 612 | GUNS N' ROSES
September 5th, 1991
PHOTOGRAPH BY HERB RITTS

"PEOPLE WANT SOMETHING, AND THEY WANT IT AS soon as they can get it. Needy people. And I'm the same way, but I want it to be right – I don't want it to be half-assed. Since we put out *Appetite for Destruction*, I've watched a lot of bands put out two to four albums, and who cares? They went out, they did a big tour, they were big rock stars for that period of time. That's what everybody's used to now – the record companies push that. But I want no part of that."

—*Axl Rose*

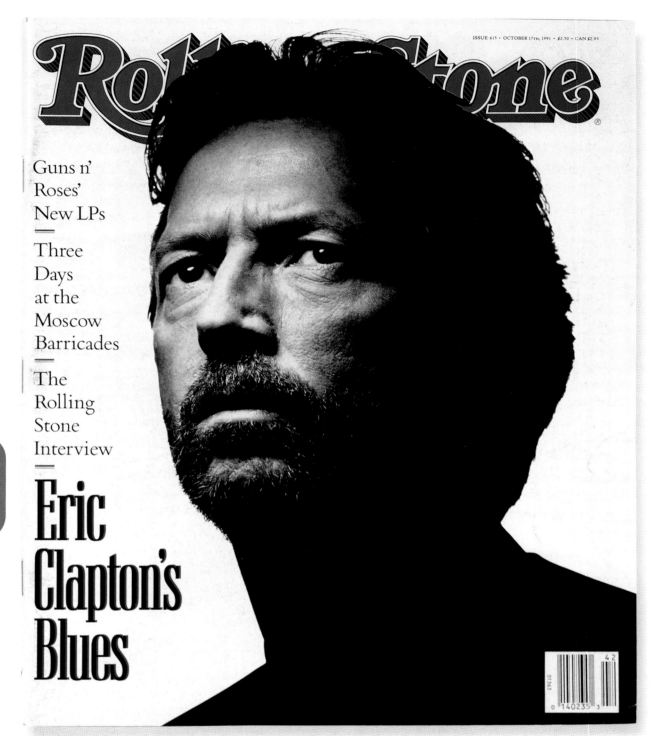

Rolling Stone

ISSUE 615 • OCTOBER 17TH, 1991 • $2.50 • CAN $2.95

Guns n' Roses' New LPs

Three Days at the Moscow Barricades

The Rolling Stone Interview

Eric Clapton's Blues

1990s

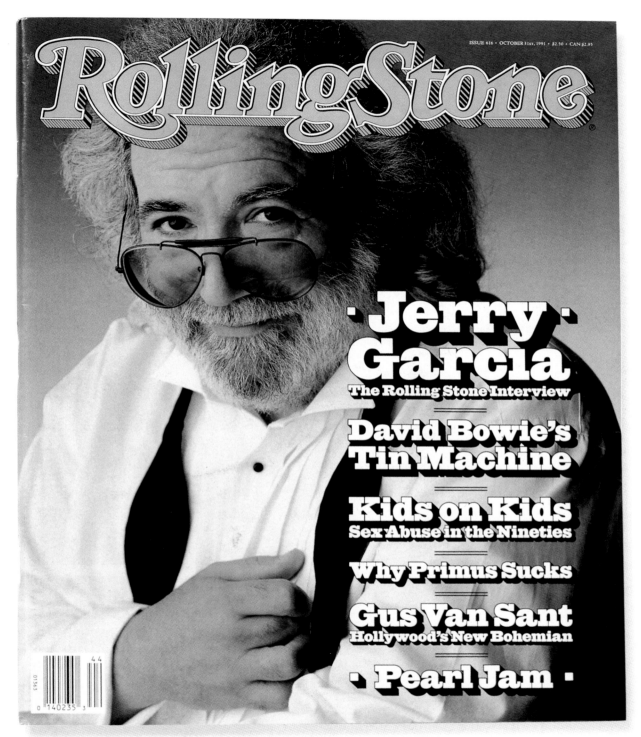

RollingStone

**· Jerry ·
Garcia**
The Rolling Stone Interview

**David Bowie's
Tin Machine**

Kids on Kids
Sex Abuse in the Nineties

Why Primus Sucks

Gus Van Sant
Hollywood's New Bohemian

· Pearl Jam ·

RS 616 | JERRY GARCIA | October 31st, 1991 | PHOTOGRAPH BY MARK SELIGER

RS 617 | METALLICA
November 14th, 1991
PHOTOGRAPH BY MARK SELIGER

RS 618 | U2
November 28th, 1991
PHOTOGRAPH BY ANTON CORBIJN

HERE I AM, WRITING ABOUT THIS RECORD WITH which I had a tangential involvement, still hopefully warm from the experience. U2 had asked Dan [Lanois] and myself to produce this album with them, but I'd already made plans for much of the period. The role I thus ended up with was luxurious: I came in now and again for a week at a time, listened to what had been going on and made comments and suggestions. I can think of worse jobs than hearing something you like and then telling the people who made it why they ought to like it, too . . .

Working on a U2 record is a long and demanding process. The pattern seems to go like this: A couple of weeks of recording throws up dozens of promising beginnings. A big list goes up on the blackboard, songs with strange names that no one can remember ("Is that the one with the slidy bass or the sheet-of-ice guitar?"). These are wheeled out, looked at, replayed, worked on, sung to, put away, bootlegged and wheeled out again, until they start to either consolidate into something or fall away into oblivion. The list on the blackboard begins to thin down, although Bono, the Mother Teresa of abandoned songs, compassionately continues arguing the case for every single idea that has ever experienced even the most transitory existence.

[EXCERPT FROM RS 618 COVER STORY BY BRIAN ENO]

"This must have been taken after one of Anton's jokes. It's not easy looking that serious."

—The Edge

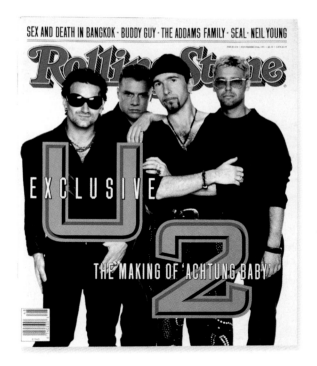

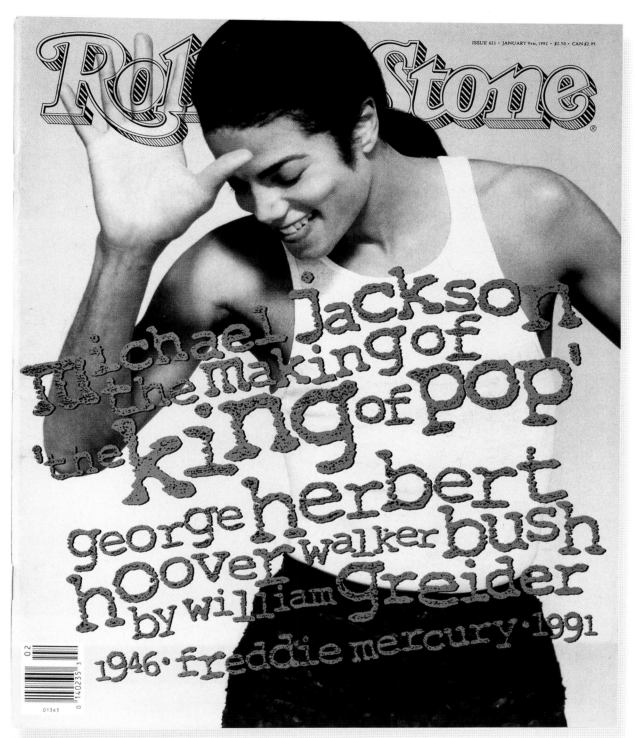

ISSUE 621 · JANUARY 9TH, 1992 · $2.50 · CAN $2.95

Michael Jackson
the making of
'the king of pop'

george herbert
hoover walker bush
by william Greider
1946 · freddie mercury · 1991

RS 621 | MICHAEL JACKSON | January 9th, 1992 | Photograph by Herb Ritts

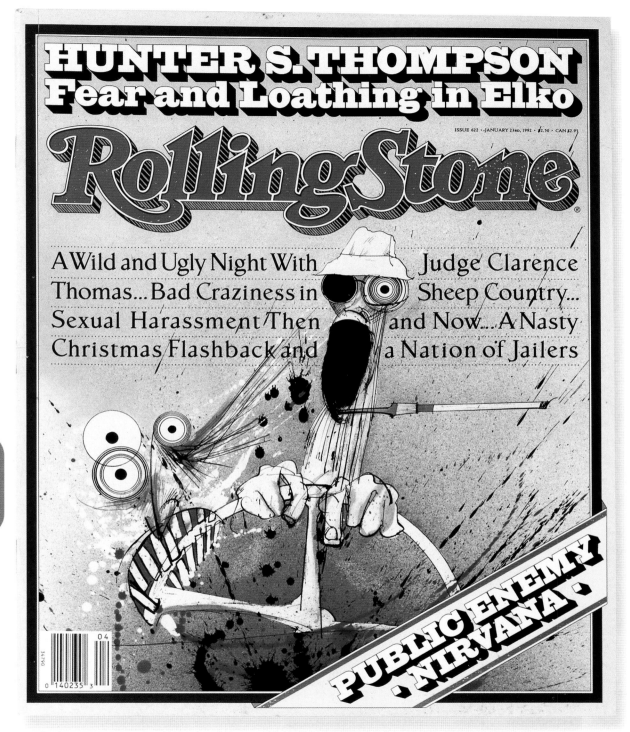

HUNTER S. THOMPSON
Fear and Loathing in Elko

ISSUE 622 · JANUARY 23RD, 1992 · $2.50 · CAN $2.95

Rolling Stone

A Wild and Ugly Night With
Thomas...Bad Craziness in
Sexual Harassment/Then
Christmas Flashback and

Judge Clarence
Sheep Country...
and Now...A Nasty
a Nation of Jailers

PUBLIC ENEMY
· NIRVANA ·

1990s

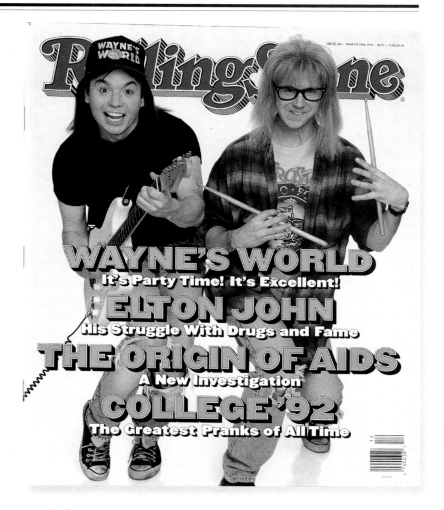

RS 619/620 | 1991 YEARBOOK
December 12th – December 26th, 1991
VARIOUS PHOTOGRAPHERS

RS 623 | JIMI HENDRIX
February 6th, 1992
PHOTOGRAPH BY GERED MANKOWITZ

RS 626 | MIKE MYERS & DANA CARVEY
March 19th, 1992
PHOTOGRAPH BY BONNIE SCHIFFMAN

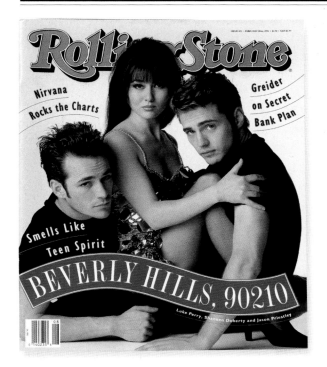

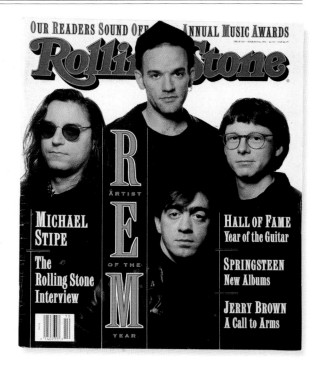

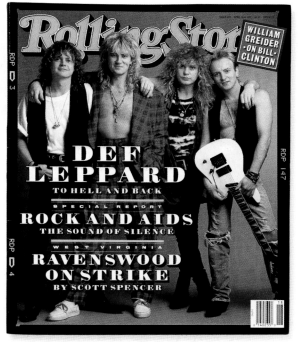

𝑅𝑆 624 | CAST OF 'BEVERLY HILLS, 90210'
February 20th, 1992
PHOTOGRAPH BY ANDREW ECCLES

𝑅𝑆 625 | R.E.M.
March 5th, 1992
PHOTOGRAPH BY ALBERT WATSON

𝑅𝑆 629 | DEF LEPPARD
April 30th, 1992
PHOTOGRAPH BY MARK SELIGER

"I'M DOWN ON MY ELBOW, AND SHE'S SITTING ON my kidneys, and Jason has his leg back up around her, holding her up. It looks like a wonderfully choreographed thing, but we're all in intense physical pain. I remember Jason would peek his head around her hairdo, and I'd look around the other side of her hairdo, and he'd go, 'ROLLING STONE,' and I'd go, *I know!*' "

—*Luke Perry*

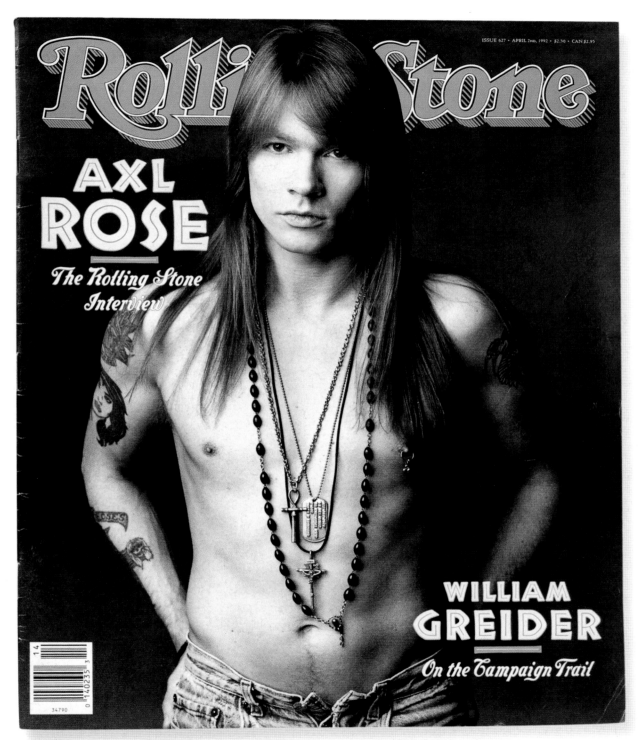

ISSUE 627 · APRIL 2ND, 1992 · $2.50 · CAN $2.95

Rolling Stone

AXL ROSE
The Rolling Stone Interview

WILLIAM GREIDER
On the Campaign Trail

RS 627 | AXL ROSE | April 2nd, 1992 | Photograph by Herb Ritts

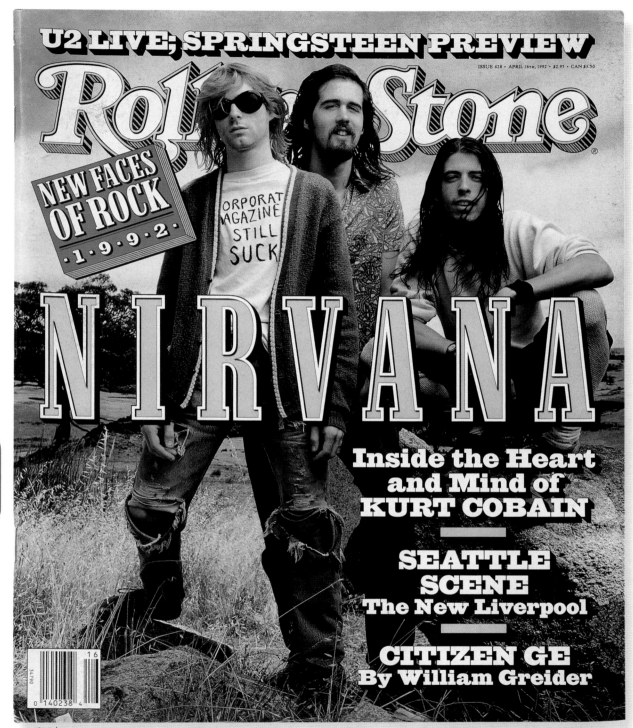

U2 LIVE; SPRINGSTEEN PREVIEW

ISSUE 628 · APRIL 16TH, 1992 · $2.95 · CAN $3.50

Rolling Stone

NEW FACES
OF ROCK
·1·9·9·2·

ORPORAT
AGAZINE
STILL
SUCK

NIRVANA

Inside the Heart and Mind of KURT COBAIN

SEATTLE SCENE
The New Liverpool

CITIZEN GE
By William Greider

16
34790
0 140238 4

1990s

RS 630 | SHARON STONE
May 14th, 1992 | PHOTOGRAPH BY ALBERT WATSON

RS 631 | TOM CRUISE
May 28th, 1992 | PHOTOGRAPH BY ALBERT WATSON

[NIRVANA'S] 'NEVERMIND' EMBODIES A CULTURAL moment; "Smells Like Teen Spirit" is an anthem for (or is it against) the "Why Ask Why?" generation. Just don't call [Kurt] Cobain a spokesman for a generation. "I'm a spokesman for *myself*," he says. "It just so happens that there's a bunch of people that are concerned with what I have to say. I find that frightening at times because I'm just as confused as most people. I don't have the answers for anything. I don't want to be a fucking spokesperson."

"That ambiguity or confusion, that's the whole thing," says *Nevermind* producer Butch Vig. "What the kids are attracted to in the music is that he's *not* necessarily a spokesman for a generation, but all that's in the music – the passion and [the fact that] he doesn't necessarily know what he wants but he's pissed. It's all these things working at different levels at once. I don't exactly know what 'Teen Spirit' means, but you know it means *something* and it's intense as hell."

[EXCERPT FROM RS 628 COVER STORY
BY MICHAEL AZERRAD]

"*I said,* 'I think that's a great shirt, I think that's great. That's a great shirt! – but let's shoot a couple, with and without it.' [Kurt Cobain] said, 'No, I'm not going to take my shirt off.' "

—*Mark Seliger*

[RS 632] To celebrate its twenty-fifth anniversary, ROLLING STONE published three special issues, beginning with this one, "The Great Stories," followed by "The Interviews" in October and "The Photographs" in November.

A LETTER FROM THE EDITOR

We see this issue as a kind of impressionistic history of the past quarter century. We started by choosing thirty of our best stories, then asked the writers to speak about themselves, about the reporting of their story and about the context of the work – i.e., what it's like to work at ROLLING STONE.

The paths that led editors and writers to ROLLING STONE are a part of [the] story. Joe Eszterhas was thought to be a narc by the mailroom guys when he first came to buy back issues (and went on to write major exposés of narcs in ROLLING STONE). Hunter S. Thompson's first assignment was to write about his nearly successful attempt to be elected sheriff in Aspen, Colorado. After that came "Fear and Loathing in Las Vegas," then the 1972 presidential campaign, and on, and on.

Within a few years we had assembled a legendary writing and reporting staff. In addition to Thompson and Eszterhas, there were Tim Cahill, Jonathan Cott, Tim Crouse, David Felton, Ben Fong-Torres, Howard Kohn, Michael Rogers, to name a few.

ROLLING STONE reporting and writing in the Eighties and the beginning of the Nineties has also leaned heavily on the talents of P.J. O'Rourke and William Greider. For P.J., the pen is the sword, and he has used it to drive liars, cheats, thieves and scoundrels out into the open. Bill Greider has been articulating

his own and ROLLING STONE's political conscience with eloquence since he joined us from the *Washington Post* more than a decade ago. His essay concludes this issue and recalls our sometimes lonely political mission through the Reagan-Bush years.

I am immensely proud of all the talent that has worked at ROLLING STONE over the years – in Lawrence Wright's words, "literary hellcats who brushed aside journalistic conventions and social taboos to get at new ways of telling the truth." Larry, who joined us in 1985, goes on to write in his piece here: "One accepts a ROLLING STONE assignment knowing that not only must it be the final word on a subject, it must be freshly seen and powerfully told."

—*Jann S. Wenner*

RS 632 | TWENTY-FIFTH ANNIVERSARY: THE GREAT STORIES
June 11th, 1992 | TYPOGRAPHY BY DENNIS ORTIZ-LOPEZ

1990s

YO-YO, Vanessa Williams, Janet Jackson,

ISSUE 633 • JUNE 25TH, 1992 • $2.50 • CAN $2.95

Rolling Stone

Cypress Hill's B-Real & Others Speak Out

L.A. BURNING: Ice-T, Jody Watley,

Fugazi,

RED HOT CHILI PEPPERS

The Black Crowes, Lindsey Buckingham

RS 633 | RED HOT CHILI PEPPERS | June 25th, 1992 | PHOTOGRAPH BY MARK SELIGER

SPECIAL DOUBLE ISSUE

Rolling Stone

ISSUE 634/635 · JULY 9th–23rd, 1992 · $2.95 · CAN $3.95

P.J. O'ROURKE: ON THE ROAD IN VIETNAM

SOUNDGARDEN: ROCK'S HEAVY ALTERNATIVE

INSIDE BATMAN

THE ROLLING STONE INTERVIEW WITH

DIRECTOR TIM BURTON BY DAVID BRESKIN

BEN & JERRY: THE CARING CAPITALISTS

PAULY SHORE: TOTALLY HIP COMEDY

GEARHEADS: THE BIRTH OF MOUNTAIN BIKING

RINGO STARR, SOCIAL DISTORTION,

HAMMER & LINDSEY BUCKINGHAM

1990s

RS 634/635 | BATMAN'S SUIT | July 9th – July 23rd, 1992 | PHOTOGRAPH BY HERB RITTS

GREIDER ON ROSS PEROT · JIMMY BUFFETT

RollingStone

AUGUST 6th, 1992 · $2.50 · CAN $2.95

Bruce
The
Rolling Stone
Interview

RS 636 | BRUCE SPRINGSTEEN | August 6th, 1992 | Photograph by Herb Ritts

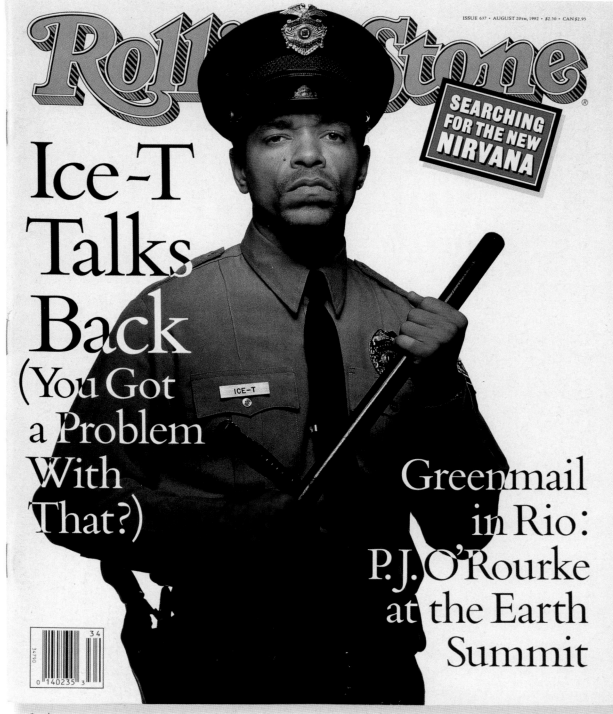

ISSUE 637 • AUGUST 20TH, 1992 • $2.50 • CAN $2.95

Rolling Stone

SEARCHING
FOR THE NEW
NIRVANA

Ice-T
Talks
Back
(You Got
a Problem
With
That?)

Greenmail
in Rio:
P.J. O'Rourke
at the Earth
Summit

1990s

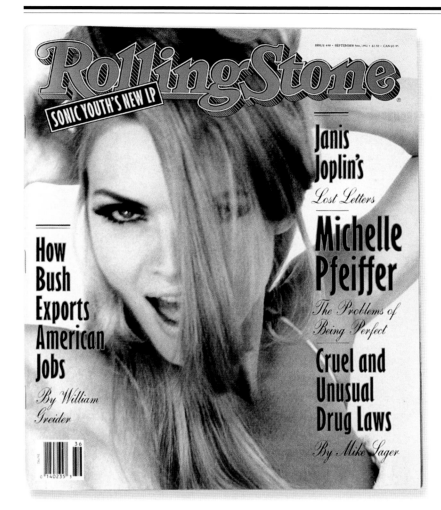

RS 638 | MICHELLE PFEIFFER
September 3rd, 1992 | PHOTOGRAPH BY HERB RITTS

"*I had to do* a lot of apologizing to my hard-core fans [for wearing a policeman's uniform]. That was sacrilegious in the ghetto. 'Why did you have to be a cop? Why you got to give credit to the Man?' I had to tell them the laws of Hollywood: The only way you can run around with a gun is to be a cop."

—*Ice-T*

COLLEGE SPECIAL

ISSUE 639 • SEPTEMBER 17TH, 1992 • $2.95 • CAN $3.50

RollingStone

LOLLAPALOOZA
On the Road With
The Chili Peppers,
Pearl Jam and
Soundgarden

CLINT EASTWOOD
He Shoots, He Scores

THE ROLLING STONE INTERVIEW

BILL CLINTON

By William Greider,
P.J. O'Rourke and
Hunter S. Thompson

DEEE-LITE
MICHAEL JACKSON
BOBBY BROWN

1990s

So what did we learn here?

Bill Clinton's favorite Beatle is Paul McCartney. He voted for the skinny Elvis stamp (which doesn't show much self-knowledge). Also, he bites his nails – though they're bitten in a tidy, thoughtful manner, not gnawed to the raw quick the way crazy people do it. I'm sure this is all valuable information. I mean, *eeeeeyew, Paul?* Especially at a moment in history when America cries out for a president whose favorite Beatle is Ringo.

—*P.J. O'Rourke*

MEMO FROM THE NATIONAL AFFAIRS DESK
DATE: August 4th, '92
FROM: Dr. Hunter S. Thompson
SUBJECT: THE THREE STOOGES GO TO LITTLE ROCK
I have just returned, as you know, from a top-secret Issues Conference in Little Rock with our high-riding Candidate, Bill Clinton – who is also the five-term Governor of Arkansas and the only living depositor in the Grameen Bank of Bangladesh who wears a ROLLING STONE T-shirt when he jogs past the hedges at sundown. Ah, yes – the hedges. How little is know of them, eh? And I suspect, in fact, that the truth will never be known. . . . I wanted to check them out, but it didn't work. My rented Chrysler convertible turned into a kind of Trojan Horse in reverse – and frankly, I was deeply afraid to stay for even one night in Little Rock, by myself, for fear of being tracked and seized and perhaps even jailed and humiliated, on instructions from some nameless Clinton factotum.

MAYBE WEIRD POLITICS RUNS IN TWENTY-YEAR CYCLES. The last time I became ensnared in Dr. Hunter S. Thompson's delusional reality was on the campaign trail in 1972, when Richard Nixon was trashing George McGovern and the Constitution. The Doctor's apocalyptic rumblings turned out to be the only accurate account of that doomed presidential election. This time around, the year had already turned strange by the time I found myself in the back room of a Little Rock, Arkansas, restaurant, sitting around a checker-clothed table with ROLLING STONE's political team. . . . HST appeared to believe that this meeting constituted a high-level political parley in which we would deliver the "ROLLING STONE vote" to Bill Clinton. P.J. O'Rourke, meanwhile, determined to play the right-wing hit man, had loaded up with hard facts from the *Statistical Abstract* to zing Clinton and unmask his mush-headed liberalism. Jann Wenner, our always wise and generous leader, seemed blissfully oblivious to the potential for humiliation.

—*William Greider*
[EXCERPTS FROM RS 639 COVER STORY]

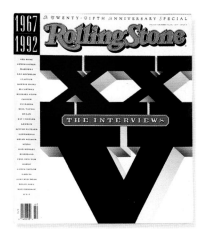

RS 640 | BONO
October 1st, 1992
PHOTOGRAPH BY NEAL PRESTON

RS 641 | TWENTY-FIFTH ANNIVERSARY: THE INTERVIEWS
October 15th, 1992

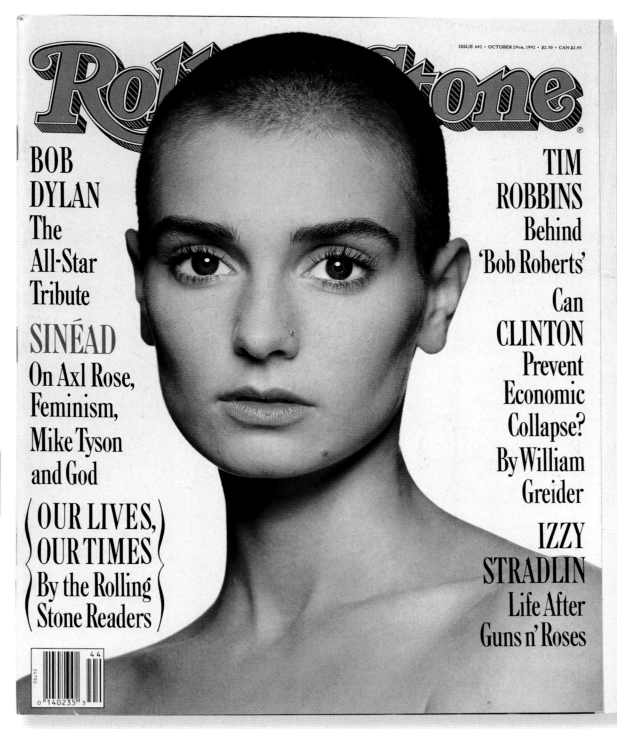

ROLLING Stone

ISSUE 642 · OCTOBER 29TH, 1992 · $2.50 · CAN $2.95

BOB DYLAN
The All-Star Tribute

SINÉAD
On Axl Rose, Feminism, Mike Tyson and God

{ OUR LIVES, OUR TIMES }
By the Rolling Stone Readers

TIM ROBBINS
Behind 'Bob Roberts'

Can CLINTON Prevent Economic Collapse?
By William Greider

IZZY STRADLIN
Life After Guns n' Roses

RS 642 | SINÉAD O'CONNOR | October 29th, 1992 | Photograph by Albert Watson

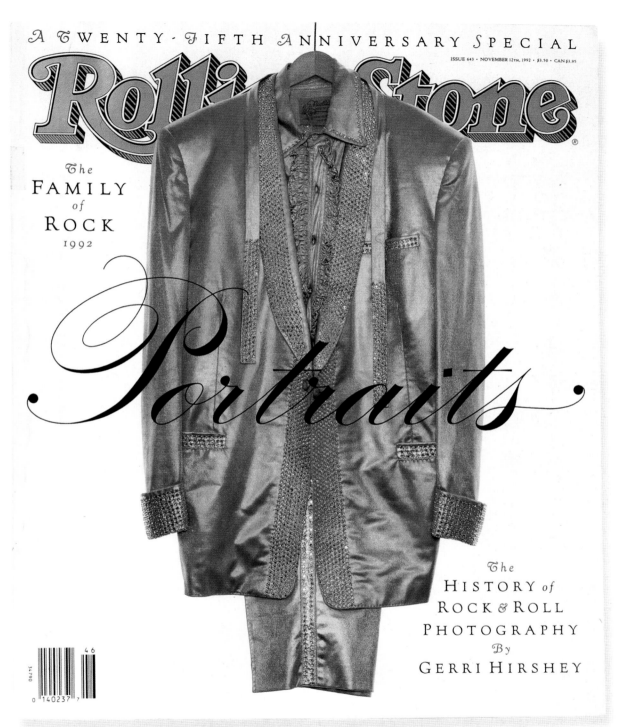

RS 643 | TWENTY-FIFTH ANNIVERSARY: THE PORTRAITS; ELVIS'S GOLD LAMÉ NUDIE SUIT
November 12th, 1992 | PHOTOGRAPH BY ALBERT WATSON

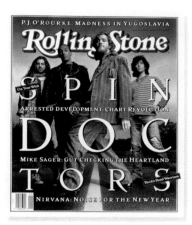

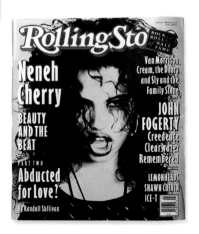

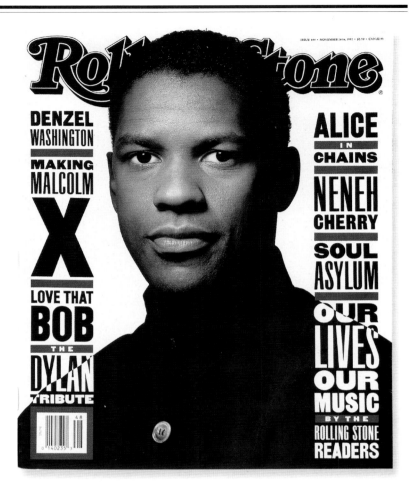

RS 644 | DENZEL WASHINGTON
November 26th, 1992
PHOTOGRAPH BY ALBERT WATSON

RS 645/646 | 1992 YEARBOOK
December 10th – 24th, 1992
VARIOUS PHOTOGRAPHERS

RS 647 | SPIN DOCTORS
January 7th, 1993
PHOTOGRAPH BY MARK SELIGER

RS 649 | NENEH CHERRY
February 4th, 1993
PHOTOGRAPH BY ELLEN VON UNWERTH

"IF YOU'RE CHARGED UP AND HAVE ALL this experience, what else is there? When you're young, you don't have any experience – you're charged up, but you're out of control. And if you're old and you're not charged up, then all you have is memories. But if you're charged and stimulated by what's going on around you and you also have experience, you know what to appreciate and what to pass by. And then you're really cruising."

—*Neil Young*

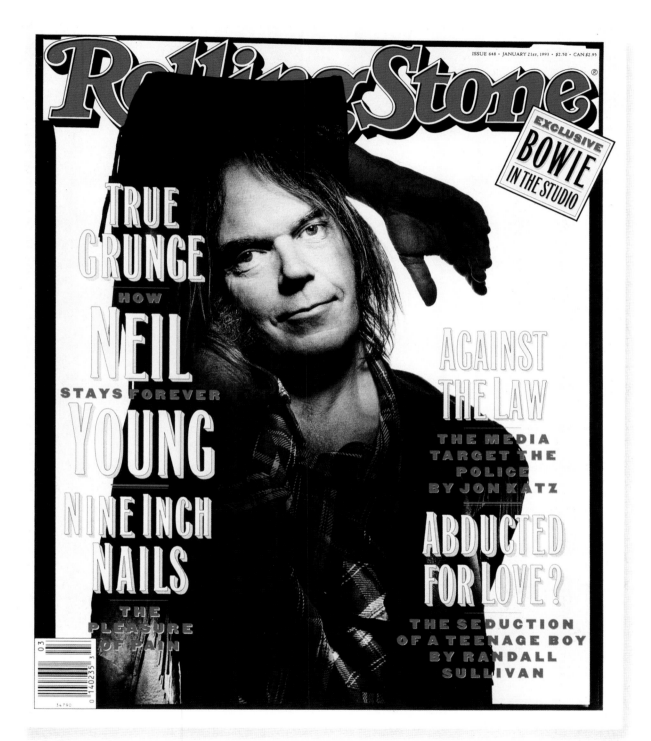

ISSUE 648 · JANUARY 21st, 1993 · $2.50 · CAN $2.95

Rolling Stone

EXCLUSIVE
BOWIE
IN THE STUDIO

TRUE
GRUNGE
HOW
NEIL
STAYS FOREVER
YOUNG
NINE INCH
NAILS
THE
PLEASURE
OF PAIN

AGAINST
THE LAW
THE MEDIA
TARGET THE
POLICE
BY JON KATZ

ABDUCTED
FOR LOVE?
THE SEDUCTION
OF A TEENAGE BOY
BY RANDALL
SULLIVAN

RS 648 | NEIL YOUNG | January 21st, 1993 | PHOTOGRAPH BY MARK SELIGER

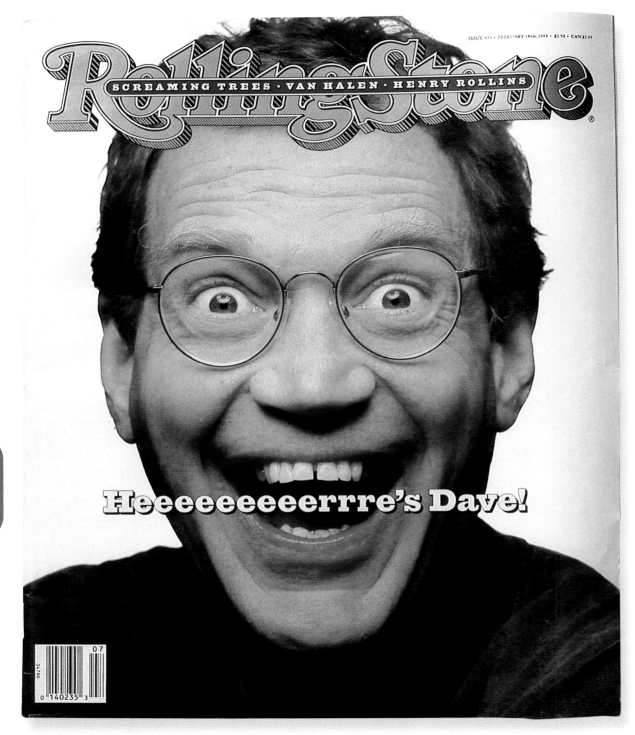

Rolling Stone

ISSUE 650 • FEBRUARY 18th, 1993 • $2.50 • CAN $2.95

SCREAMING TREES · VAN HALEN · HENRY ROLLINS

Heeeeeeeeerrre's Dave!

RS 650 | DAVID LETTERMAN | February 18th, 1993 | PHOTOGRAPH BY MARK SELIGER

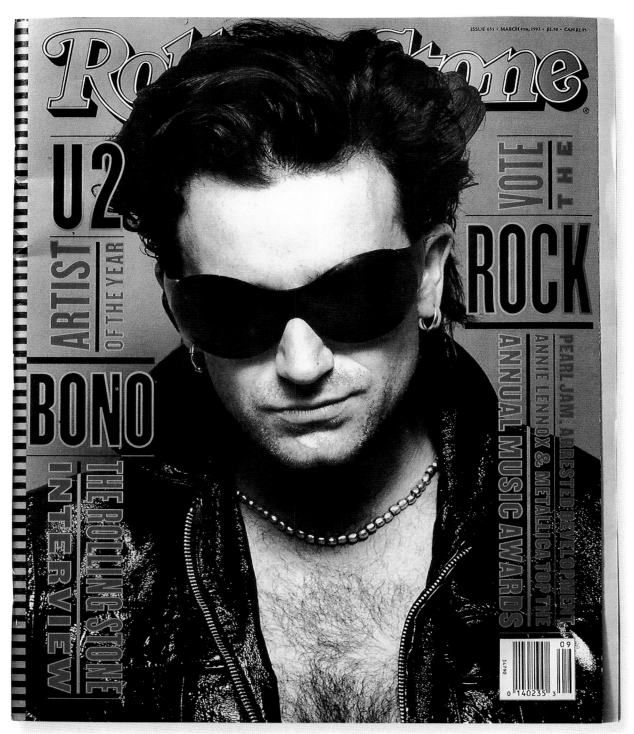

RS 651 | BONO | March 4th, 1993 | PHOTOGRAPH BY ANDREW MACPHERSON

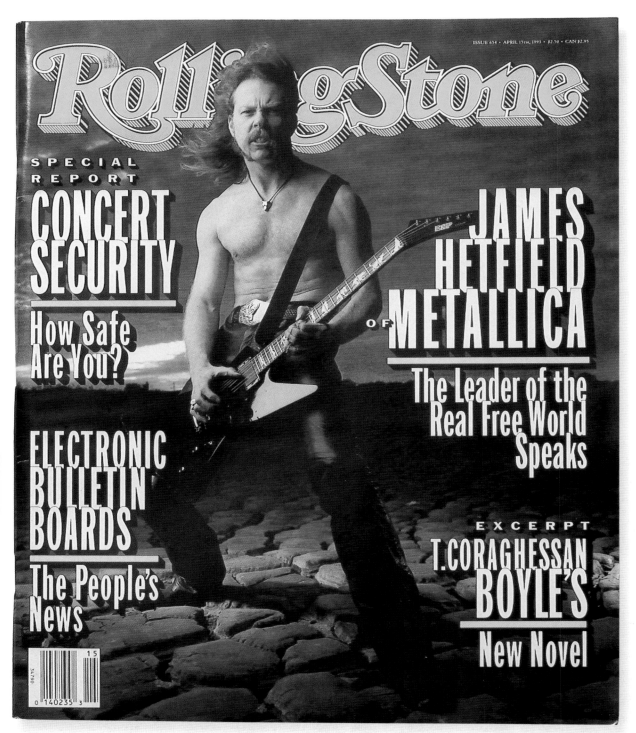

ISSUE 654 • APRIL 15TH, 1993 • $2.50 • CAN $2.95

Rolling Stone

SPECIAL
REPORT

CONCERT SECURITY

How Safe
Are You?

ELECTRONIC BULLETIN BOARDS

The People's
News

JAMES HETFIELD
OF **METALLICA**

The Leader of the
Real Free World
Speaks

EXCERPT
T.CORAGHESSAN BOYLE'S

New Novel

1990s

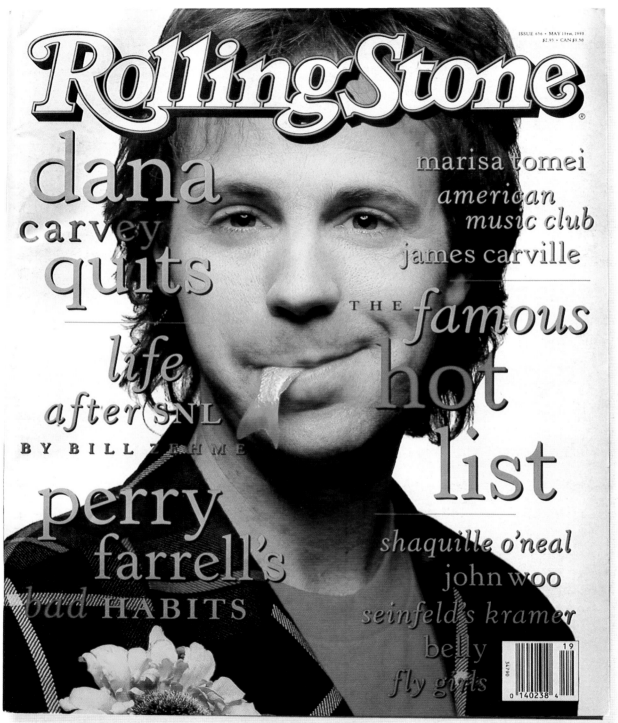

ISSUE 656 • MAY 13th, 1993
$2.95 • CAN $3.50

RollingStone

dana
carvey
quits

life
after SNL
BY BILL ZEHME

perry
farrell's
bad HABITS

marisa tomei
american
music club
james carville

THE famous
hot
list

shaquille o'neal
john woo
seinfeld's kramer
belly
fly girls

19
34790
0 140238 4

RS 656 | DANA CARVEY | May 13th, 1993 | PHOTOGRAPH BY MARK SELIGER

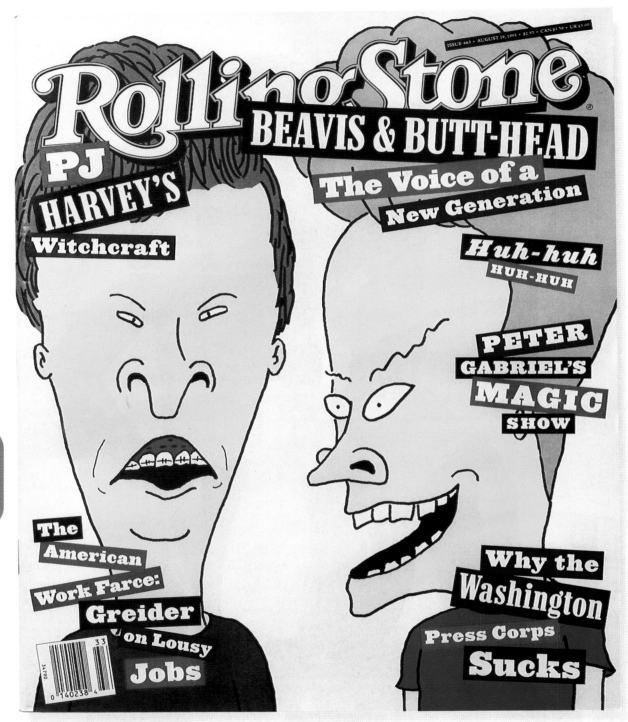

ISSUE 663 · AUGUST 19, 1993 · $2.95 · CAN $3.50 · UK £3.00

Rolling Stone

BEAVIS & BUTT-HEAD

PJ HARVEY'S Witchcraft

The Voice of a New Generation

Huh-huh HUH-HUH

PETER GABRIEL'S **MAGIC** SHOW

The American Work Farce: Greider on Lousy Jobs

Why the Washington Press Corps Sucks

1990s

RS 663 | BEAVIS & BUTT-HEAD | August 19th, 1993 | ILLUSTRATION BY MIKE JUDGE

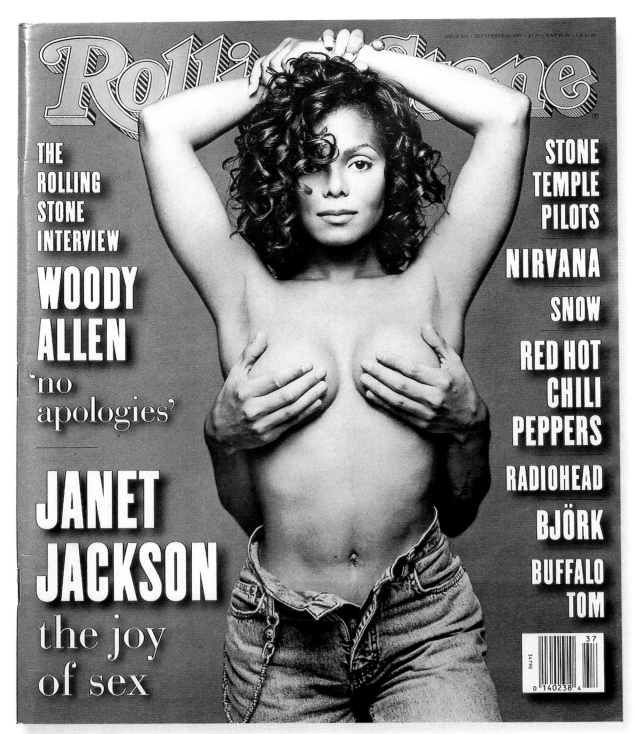

THE
ROLLING
STONE
INTERVIEW

WOODY
ALLEN

'no
apologies'

JANET
JACKSON

the joy
of sex

STONE
TEMPLE
PILOTS

NIRVANA

SNOW

RED HOT
CHILI
PEPPERS

RADIOHEAD

BJÖRK

BUFFALO
TOM

RS 665 | JANET JACKSON | September 16th, 1993 | PHOTOGRAPH BY PATRICK DEMARCHELIER

soul asylum
platinum punks

campus speech police · watch what you say · k.d. lang on country, cowgirls & "lesbian chic" · stone temple pilots · hard to the core · clinton at the crossroads · the search for meaning in the white house | lollapalooza 1993 · u2's zooropa · cypress hill · rupaul

Urge Overkill's Bubblegum Grunge · Life Without Parole The Case of Gary Fannon · Steve Miller The Gangster of Love Is Back

THE ROLLING STONE INTERVIEW
JERRY GARCIA: The Road Goes On Forever
Neil Young & Pearl Jam Live, Primus Speak

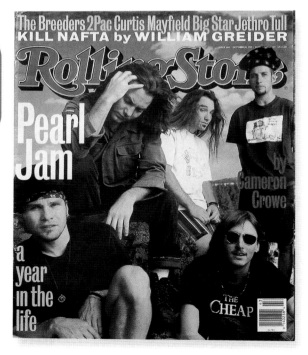

The Breeders 2Pac Curtis Mayfield Big Star Jethro Tull
KILL NAFTA by WILLIAM GREIDER

Pearl Jam

by Cameron Crowe

a year in the life

THE CHEAP

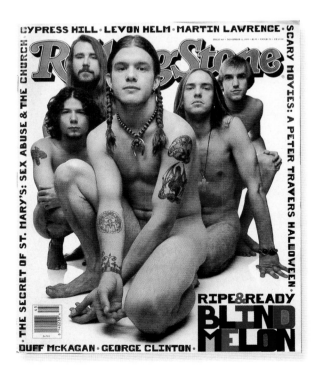

CYPRESS HILL · LEVON HELM · MARTIN LAWRENCE · SCARY MOVIES: A PETER TRAVERS HALLOWEEN

THE SECRET OF ST. MARY'S: SEX ABUSE & THE CHURCH

RIPE & READY BLIND MELON

DUFF McKAGAN · GEORGE CLINTON

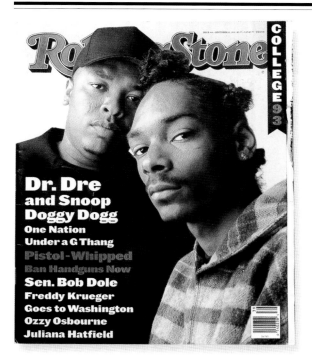

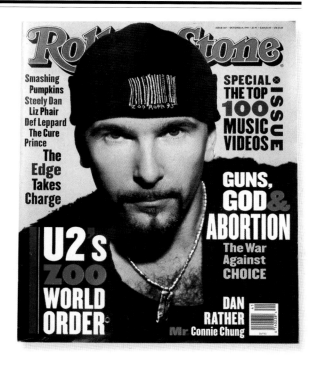

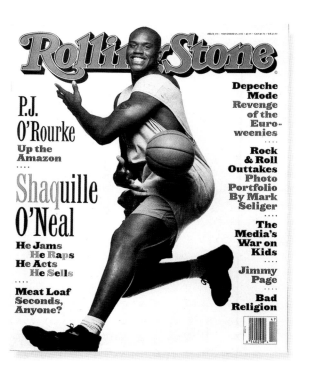

Rolling Stone

ISSUE 671 · DECEMBER 9, 1993 · $2.95 · CAN $3.50 · UK £3.00

Life in the Fast Lane

President CLINTON

The Rolling Stone Interview

NRA ON THE RUN

The New Politics of Gun Control

ADOLESCENCE IN AMERICA

The Years of Living Dangerously

1990s

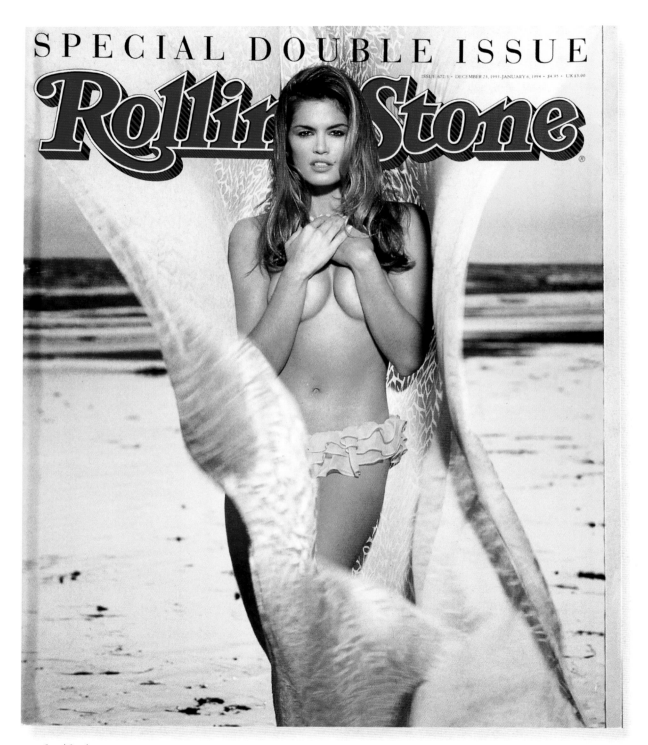

SPECIAL DOUBLE ISSUE

Rolling Stone

ISSUE 672/3 • DECEMBER 23, 1993-JANUARY 6, 1994 • $4.95 • UK £3.00

RS 672/673 | CINDY CRAWFORD | December 23rd, 1993 – January 6th, 1994 | PHOTOGRAPH BY HERB RITTS

the hot issue

RollingStone

ISSUE 682 • MAY 19, 1994 • $2.95 • CAN $3.50 • UK £3.00

Melrose Place's Bod Squad

P.J. O'Rourke in Little Rock

The Breeders

Meat Puppets

Gang Starr

1990s

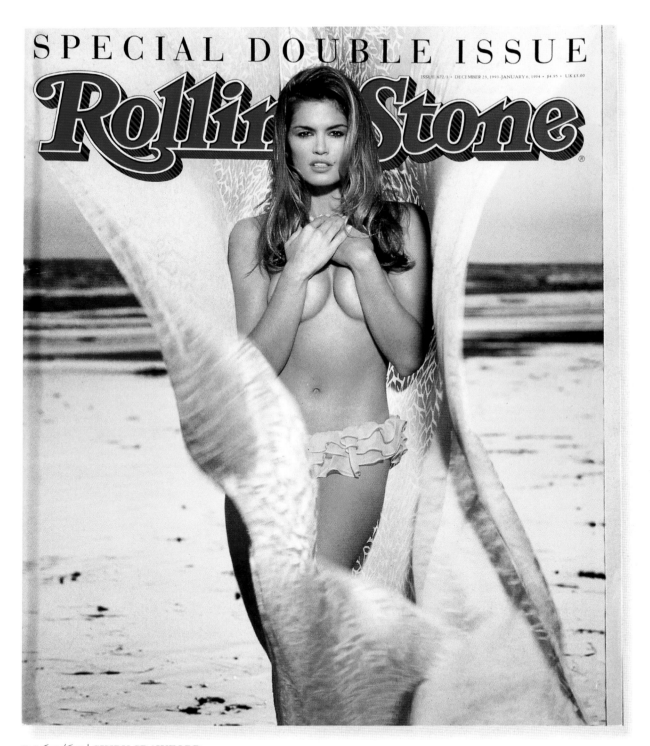

RS 672/673 | CINDY CRAWFORD | December 23rd, 1993 – January 6th, 1994 | PHOTOGRAPH BY HERB RITTS

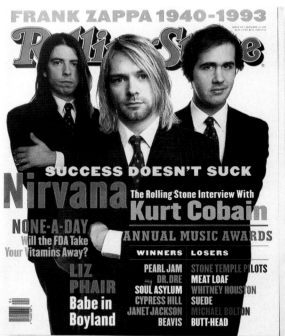

RS 674 | NIRVANA
January 27th, 1994
PHOTOGRAPH BY MARK SELIGER

RS 676 | BOB MARLEY
February 24th, 1993
PHOTOGRAPH BY ANNIE LEIBOVITZ

RS 678 | BEAVIS & BUTT-HEAD
March 24th, 1994
ILLUSTRATION BY MIKE JUDGE

Rolling Stone

VENUS IN
BLUEJEANS

Winona Ryder

*Thunder
Down Under*

Soundgarden,
Smashing
Pumpkins
and the
Breeders in
Australia

Cease FIRE

A Comprehensive
Strategy to
Reduce
Firearms
Violence

RS 677 | WINONA RYDER | March 10th, 1994 | PHOTOGRAPH BY HERB RITTS

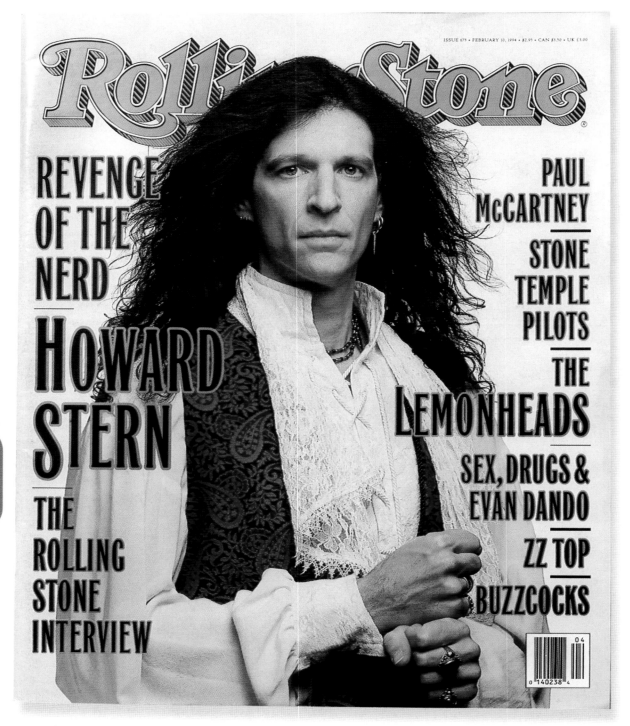

Rolling Stone

REVENGE OF THE NERD

HOWARD STERN

THE ROLLING STONE INTERVIEW

PAUL McCARTNEY

STONE TEMPLE PILOTS

THE LEMONHEADS

SEX, DRUGS & EVAN DANDO

ZZ TOP

BUZZCOCKS

1990s

RS 675 | HOWARD STERN | February 10th, 1994 | PHOTOGRAPH BY MARK SELIGER

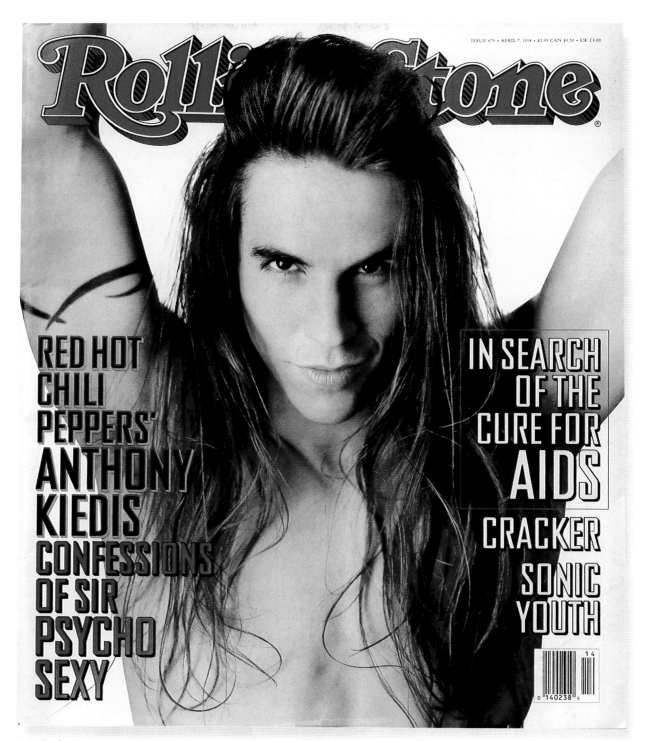

ISSUE 679 · APRIL 7, 1994 · $2.95 CAN $3.50 · UK £3.00

Rolling Stone

RED HOT
CHILI
PEPPERS'
ANTHONY
KIEDIS
CONFESSIONS
OF SIR
PSYCHO
SEXY

IN SEARCH
OF THE
CURE FOR
AIDS

CRACKER

SONIC
YOUTH

RS 679 | ANTHONY KIEDIS | April 7th, 1994 | PHOTOGRAPH BY MATTHEW ROLSTON

Pearl Jam on the Road · Crash Test Dummies Talk

Rolling Stone

[SPECIAL ISSUE]

Drugs *in* **America**

THE PHONY WAR
THE REAL CRISIS

RS 681 | DRUGS IN AMERICA
May 5th, 1994

1990s

The war on drugs is over.

After eight decades of interdiction, prohibition and punishment, the results are in: There are now more than 330,000 Americans behind bars for violating the drug laws. We are spending over $20 billion per year on criminal-justice approaches, but illegal drugs are available in greater supply and purity than ever before. Cynical phrases such as *zero tolerance* and *drug-free society* substitute for thoughtful policies and realistic objectives. It's time for a change. . . .

One often forgotten lesson of Prohibition is that it was followed not by a uniform national policy but by "local option." When, in 1933, the 21st Amendment to the Constitution repealed Prohibition, the states went their own ways: Some opted for state monopolies, others for licensing schemes, and some chose to remain dry. Some legalized all alcoholic beverages, others just beer and wine. Some imposed high taxes, others low taxes.

We need local solutions to local problems. What the federal government needs to do is repeal many of the laws and regulations that stifle local initiatives and block any movement away from the war on drugs. Let towns, cities, counties and states experiment with new approaches. It's the only way to find out what really works.

[EXCERPT FROM "TOWARD A SANE NATIONAL DRUG POLICY," RS 681,
BY JANN S. WENNER AND ETHAN NADELMAN]

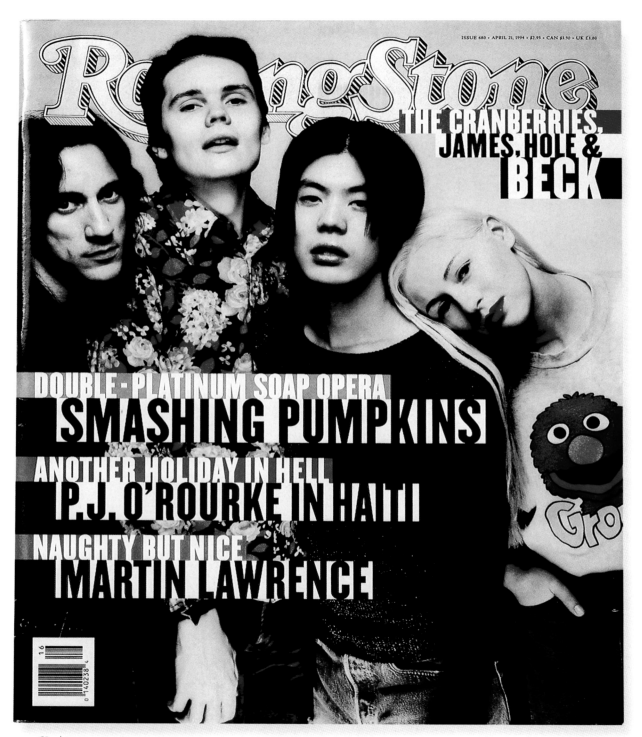

ISSUE 680 · APRIL 21, 1994 · $2.95 · CAN $3.50 · UK £3.00

Rolling Stone

THE CRANBERRIES, JAMES, HOLE & BECK

DOUBLE - PLATINUM SOAP OPERA
SMASHING PUMPKINS

ANOTHER HOLIDAY IN HELL
P.J. O'ROURKE IN HAITI

NAUGHTY BUT NICE
MARTIN LAWRENCE

RS 680 | SMASHING PUMPKINS | April 21st, 1994 | PHOTOGRAPH BY GLEN LUCHFORD

the hot issue

ISSUE 682 • MAY 19, 1994 • $2.95 • CAN $3.50 • UK £3.00

RollingStone

Melrose Place's Bod Squad

P.J. O'Rourke in Little Rock

The Breeders

Meat Puppets

Gang Starr

1990s

The Famous Hot List

STARRING

Leonardo DiCaprio
Gwyneth Paltrow
Green Day
Janeane Garofalo
Jon Stewart
Cassandra Wilson
The Mavericks

RS 682
THE WOMEN OF
'MELROSE PLACE'
May 19th, 1994
PHOTOGRAPH BY
MARK SELIGER

"*I haven't felt* the excitement of listening to as well as creating music, along with really writing for too many years now. I feel guilty beyond words about these things. For example, when we're backstage and the lights go out and the manic roar of the crowd begins, it doesn't affect me the way in which it did for Freddie Mercury, who seemed to love and relish in the love and admiration from the crowd which is something I totally admire and envy. The fact is, I can't fool you, any one of you. It simply isn't fair to you or to me. The worst crime I can think of would be to rip people off by faking it and pretending as if I'm having 100 percent fun."

—*Kurt Cobain's suicide note*

1990s

PEOPLE LOOKED TO KURT COBAIN because his songs captured what they felt before they knew they felt it. Even his struggles – with fame, with drugs, with his identity – caught the generational drama of our time. Seeing himself since his boyhood as an outcast, he was stunned – and confused, and frightened, and repulsed, and, truth be told, not entirely disappointed (no one forms a band to remain anonymous) – to find himself a star. If Cobain seemed more willing to play the fool than the hero and took drugs more for relief than pleasure, that was fine with his contemporaries. For people who came of age amid the designer-drug indulgence and the image-driven celebrity of the Eighties, anyone who could make an easy peace with success was fatally suspect. Whatever importance Cobain assumed as a symbol, however, one thing is certain: He and his band Nirvana announced the end of one rock & roll era and the start of another. In essence, Nirvana transformed the Eighties into the Nineties. —*Anthony DeCurtis*

SOME KIDS DON'T MAKE IT OUT OF HIGH SCHOOL ALIVE. They give up before they even try. Others stick around, wounded, just to see what happens. Introverted and depressed, Cobain maybe was born with a morbid disposition. Maybe he had a chemical imbalance that made him too sensitive to live in the world, so that even true love, a beautiful daughter, a brilliant band, detox, family life and his wholesome Northwestern community rootedness couldn't fill the hole in his soul. At twenty-seven, Cobain was tired of being alive. —*Donna Gaines*

ON APRIL 8TH, SHORTLY BEFORE 9 a.m., Kurt Cobain's body was found in a greenhouse above the garage of his Seattle home. Across his chest lay the twenty-gauge shotgun with which the twenty-seven-year-old singer, guitarist and songwriter ended his life. Cobain had been missing for six days.

An electrician installing a security system in the house discovered Cobain dead. Though the police, a private investigation firm and friends were on the trail, his body had been lying there for two and a half days, according to a medical examiner's report. A high concentration of heroin and traces of Valium were found in Cobain's bloodstream. He was identifiable only by his fingerprints. —*Neil Strauss*

LAST SPRING, KURT COBAIN sat at his kitchen table at 3 a.m., chain-smoking and toying with one of the medical mannequins he collected. "It's hard to believe that a person can put something as poisonous as alcohol or drugs in their system and the mechanics can take it – for a while," he said to me, absently removing and inserting the doll's lungs, liver, heart.

Kurt was slight, painfully thin; he'd wear several layers of clothes under his usual cardigan and ripped jeans just to appear a little more substantial. He knew well just how much abuse, self-inflicted and otherwise, that fragile frame could withstand. —*Michael Azerrad*

[EXCERPTS FROM RS 683]

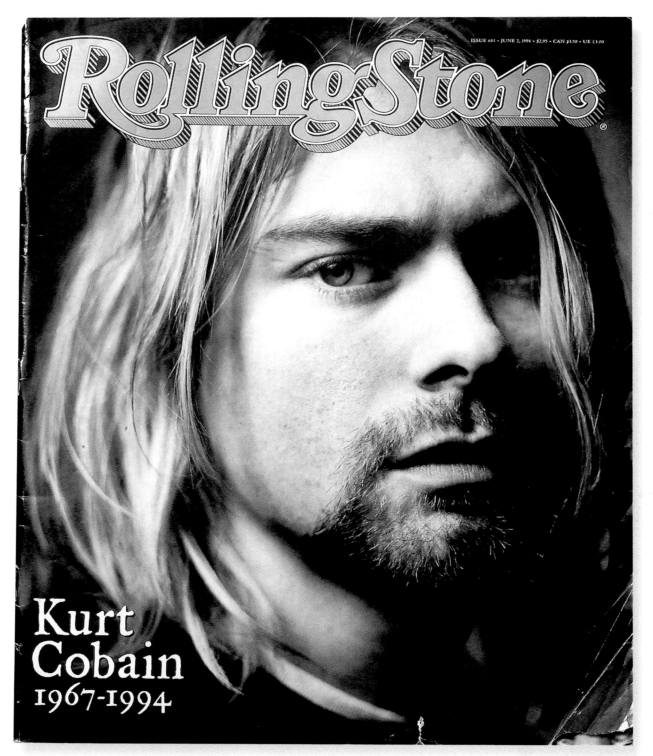

ISSUE 683 · JUNE 2, 1994 · $2.95 · CAN $3.50 · UK £3.00

RollingStone

Kurt Cobain
1967-1994

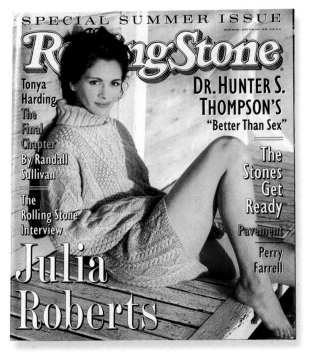

RS 684 | SOUNDGARDEN
June 16th, 1994
PHOTOGRAPH BY MARK SELIGER

RS 685 | COUNTING CROWS
June 30th, 1994
PHOTOGRAPH BY MARK SELIGER

RS 686/687 | JULIA ROBERTS
July 14th – July 28th, 1994
PHOTOGRAPH BY HERB RITTS

"IT'S JUST SUCH A COOL CHEMISTRY BETWEEN THE three of us [Beastie Boys]. I don't even completely understand how it all interconnects. It's just that the three of us together is much stronger than any one of us working individually. We've been together for so long and care about each other so much, it's really like brothers."

—*Adam Yauch*

ISSUE 688 • AUGUST 11, 1994 • $2.95 • CAN $3.50 • UK £1.00

Rolling Stone

**LIGHTS!
COMPUTERS!
ACTION!**
The Making
of *True Lies* and
Forrest Gump

BEASTIE-*ality*

The BEASTIE BOYS Funk Up Lollapalooza

PEARL JAM
on Capitol Hill

**The Selling of
WOODSTOCK '94**

1990s

Helmet The Black Crowes Nick Cave Seal

Rolling Stone

ISSUE 689 · AUGUST 25, 1994 · $2.95 · CAN $3.50 · UK £2.00

" String Us Up and We Still Won't Die "
The Rolling Stones
Out for Blood
Barry Diller
The Rolling Stone Interview

Lollapalooza's
Flaming Lips & Luscious Jackson

"THIS COVER WORKED OUT quite madly. The Rolling
Stones don't enjoy photo sessions as a band. Because
with the band, you have to get everyone in the mood,
and I've found that's very difficult. People get bored.
You have a good half-hour and someone else is having
a bad one. So you get very, very few pictures."

—*Mick Jagger*

Rolling Stone

NINE INCH NAILS' KILLER INSTINCT

INSIDE
TRENT
REZNOR'S
DARK
WORLD
OF
SEX,
PAIN
AND
ROCK &
ROLL

JOHN
MELLENCAMP
STRIPS DOWN

JOHN DEAN
REVIEWS
HALDEMAN'S
DIARIES

GARRY
SHANDLING

SOUNDGARDEN

FREEDY
JOHNSTON

AFGHAN
WHIGS

RS 690 | TRENT REZNOR | September 8th, 1994 | Photograph by Matt Mahurin

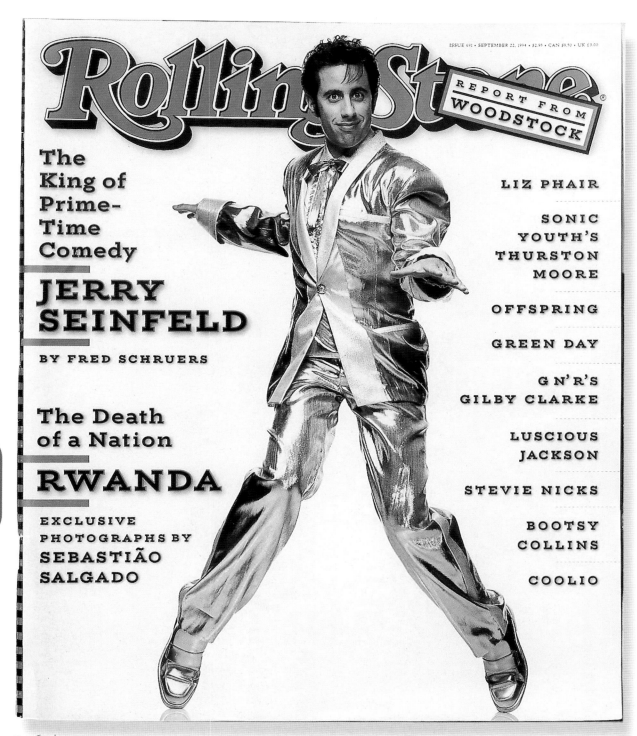

ISSUE 691 • SEPTEMBER 22, 1994 • $2.95 • CAN $3.50 • UK £3.00

RollingStone

REPORT FROM WOODSTOCK

The King of Prime-Time Comedy
JERRY SEINFELD
BY FRED SCHRUERS

The Death of a Nation
RWANDA

EXCLUSIVE PHOTOGRAPHS BY SEBASTIÃO SALGADO

LIZ PHAIR

SONIC YOUTH'S THURSTON MOORE

OFFSPRING

GREEN DAY

GN'R'S GILBY CLARKE

LUSCIOUS JACKSON

STEVIE NICKS

BOOTSY COLLINS

COOLIO

1990s

RS 691 | JERRY SEINFELD | September 22nd, 1994 | PHOTOGRAPHS BY MARK SELIGER

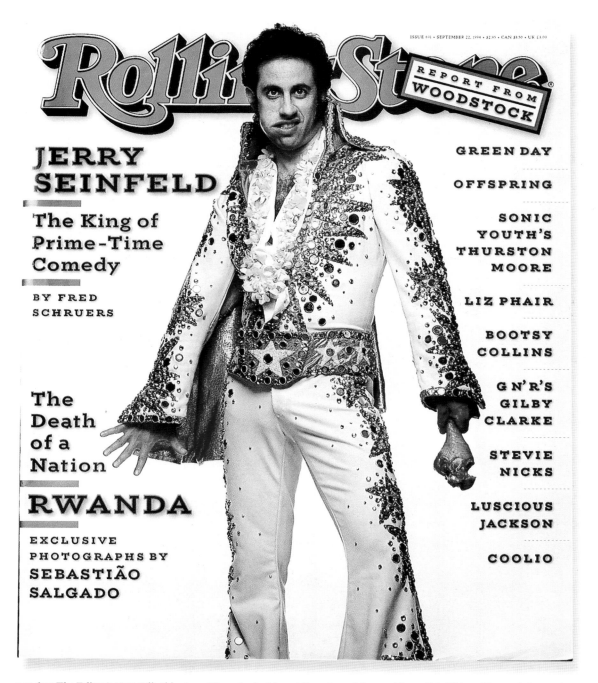

ISSUE 691 · SEPTEMBER 22, 1994 · $2.95 · CAN $3.50 · UK £1.00

Rolling Stone

REPORT FROM WOODSTOCK

JERRY SEINFELD

The King of Prime-Time Comedy

BY FRED SCHRUERS

The Death of a Nation

RWANDA

EXCLUSIVE PHOTOGRAPHS BY SEBASTIÃO SALGADO

GREEN DAY

OFFSPRING

SONIC YOUTH'S THURSTON MOORE

LIZ PHAIR

BOOTSY COLLINS

GN'R'S GILBY CLARKE

STEVIE NICKS

LUSCIOUS JACKSON

COOLIO

[RS 691] The Editor's Note tells this story: "So we're looking at these two pictures of Jerry Seinfeld, and in one he's wearing a gold lamé suit, and in the other he's got on this scary white jumpsuit, and we're saying to ourselves, 'Which do you think the readers will like – Jerry as the young Elvis or Jerry as the old Elvis?' Then we say to ourselves, 'Hey, ROLLING STONE is a democratic kind of place – let the readers decide.' So we put both pictures on the cover and sent it out random-like. But it's all the same magazine inside – take our word for it."

1990s

RS 692 | LIZ PHAIR
October 6th, 1994
PHOTOGRAPH BY FRANK W. OCKENFELS 3

RS 694 | LIV & STEVEN TYLER
November 3rd, 1994
PHOTOGRAPH BY ALBERT WATSON

RS 695 | GENERATION NEXT
November 17th, 1994
TYPOGRAPHY BY ERIC SIRY

"BEING ON THE COVER OF
ROLLING STONE? You know,
the old kiss of death. It's like
whoops, wait a minute. It's great,
no it isn't. *It is,* no it isn't."
—*Steven Tyler*

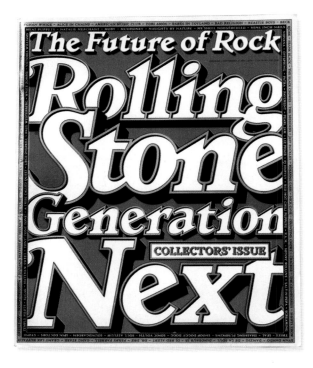

ERIC CLAPTON MAZZY STAR JEFF BUCKLEY

ISSUE 693 · OCTOBER 20, 1994 · $2.95 · CAN $3.50 · UK £1.89

Rolling Stone

College Special

What's the frequency, Michael?

R.E.M.
SEX & NOISE

ISSUE 696 · DECEMBER 1, 1994 · $2.95 · CAN $3.50 · UK £3.08

Rolling Stone

COMPUTER SPECIAL
CYBER NATION

ROLLING STONE'S INTERVIEW *With the* VAMPIRE

Brad Pitt Bites

NIRVANA
[UNPLUGGED]

JIMMY PAGE
and
ROBERT PLANT
[UNLEDDED]

LIVE

BABYFACE

GRANT LEE BUFFALO

RS 696 | BRAD PITT | *December 1st, 1994* | PHOTOGRAPH BY MARK SELIGER

SHERYL CROW | PEARL JAM | THE JAYHAWKS | BOB DYLAN | OASIS

ISSUE 697 • DECEMBER 15, 1994 • $2.95 • CAN $3.50 UK £3.00

Rolling Stone

EXCLUSIVE

Courtney Love

Talks About Music, Madness and the Last Days of **Kurt Cobain**

By **David Fricke**

The **O.J. Simpson Story**

By **Randall Sullivan**

FEAR AND LOATHING IN HORSE COUNTRY

Hunter S. Thompson

Polo Is My Life

RS 697 | COURTNEY LOVE | December 15th, 1994 | PHOTOGRAPH BY MARK SELIGER

RS 698/699 | DAVID LETTERMAN
December 28th, 1994 – January 12th, 1995
PHOTOGRAPH BY FRANK W. OCKENFELS 3

RS 700 | GREEN DAY
January 26th, 1995
PHOTOGRAPH BY DAN WINTERS

[RS 701] **This striking nude portrait of Demi Moore is one of only three covers to go to press without any cover lines. It is also the only textless cover that's not a tribute issue; the other two were published after John Lennon's death (RS 335) and following the passing of John's fellow Beatle George Harrison (RS 887).**

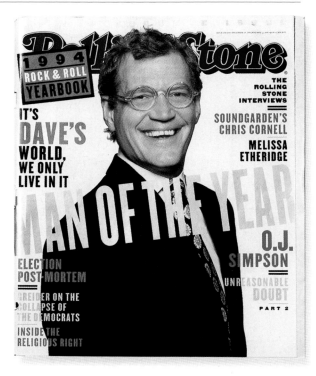

NOT LONG AFTER GREEN DAY PLAYED WOODSTOCK '94 – a performance that scored the band mass adulation – singer Billie Joe Armstrong received a letter from his mother.

"It was a hate letter," says Armstrong.

It seems Mrs. Armstrong ordered the concert on pay-per-view and had settled in to watch the event with a friend. That's when the melee occurred. Onstage, the Green Day set culminated in a titanic mud fight; Armstrong yanked down his pants; and bassist Mike Dirnt had his front teeth smashed when he was tackled by a security guard who thought he was a fan storming the stage. Finally a mud-covered Armstrong asked the fans to shout, "Shut the fuck up," and the band exited.

"She said that I was disrespectful and indecent," says Armstrong, "and that if my father was alive, he would be ashamed of me. She couldn't believe that I pulled my pants down and got in a fight onstage.

"Everything's fine now, but her letter was just unreal. She was not happy with my performance at all. She even talked shit about my wife, Adrienne, and said how she's supposed to be my loving wife, but she's never even come over and visited."

He pauses.

"It was pretty brutal."

[EXCERPT FROM RS 700 COVER STORY BY CHRIS MUNDY]

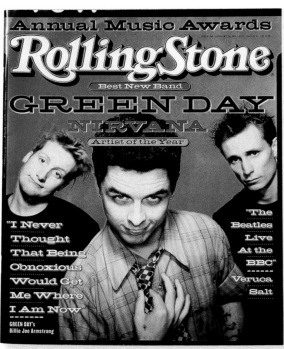

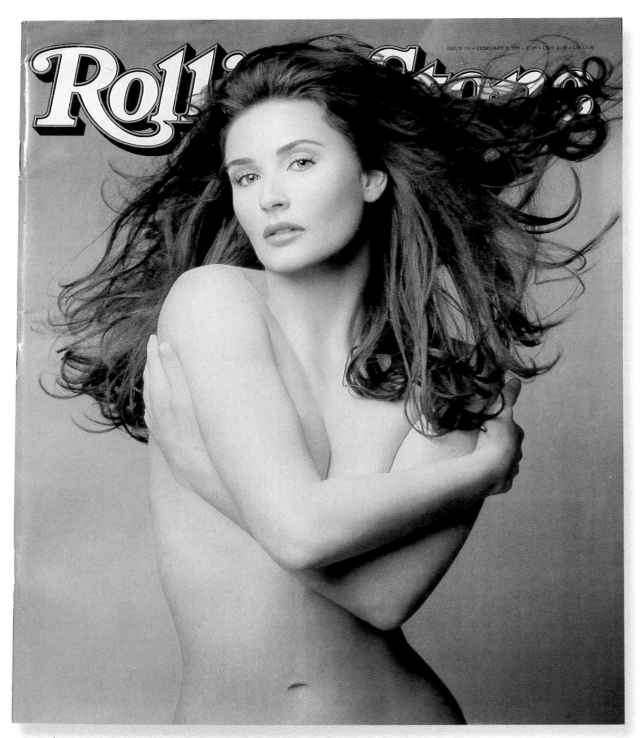

RS 701 | DEMI MOORE | February 9th, 1995 | PHOTOGRAPH BY MATTHEW ROLSTON

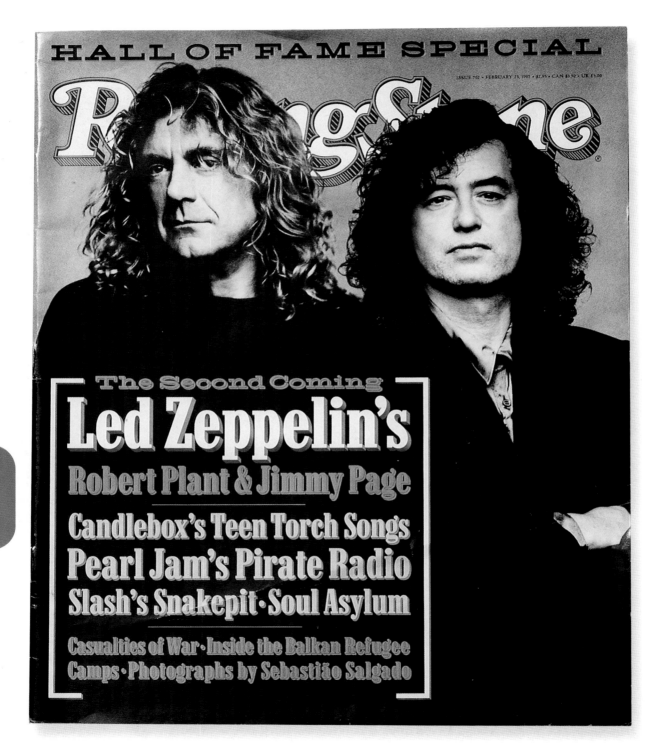

HALL OF FAME SPECIAL

Rolling Stone

ISSUE 702 · FEBRUARY 23, 1995 · $2.95 · CAN $3.50 · UK £3.00

The Second Coming

Led Zeppelin's
Robert Plant & Jimmy Page

Candlebox's Teen Torch Songs
Pearl Jam's Pirate Radio
Slash's Snakepit · Soul Asylum

Casualties of War · Inside the Balkan Refugee
Camps · Photographs by Sebastião Salgado

1990s

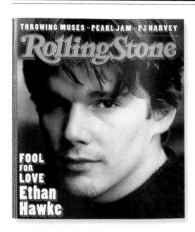

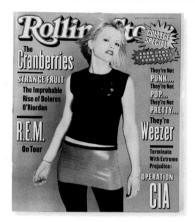

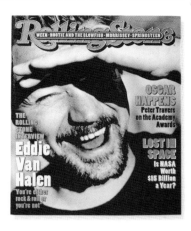

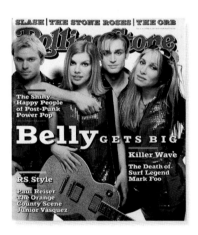

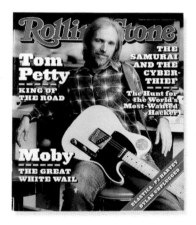

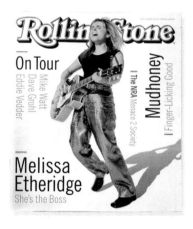

RS 703 | ETHAN HAWKE
March 9th, 1995
PHOTOGRAPH BY MARK SELIGER

RS 704 | DOLORES O'RIORDAN
March 23rd, 1995
PHOTOGRAPH BY CORRINE DAY

RS 705 | EDDIE VAN HALEN
April 6th, 1995
PHOTOGRAPH BY MARK SELIGER

RS 706 | BELLY
April 20th, 1995
PHOTOGRAPH BY MARK SELIGER

RS 707 | TOM PETTY
May 4th, 1995
PHOTOGRAPH BY MARK SELIGER

RS 709 | MELISSA ETHERIDGE
June 1st, 1995
PHOTOGRAPH BY PEGGY SIROTA

"There's no point in trying to pretend that you're immortal and that you've returned once again to do that ultimate version of 'Stairway to Heaven.' "
—*Robert Plant*

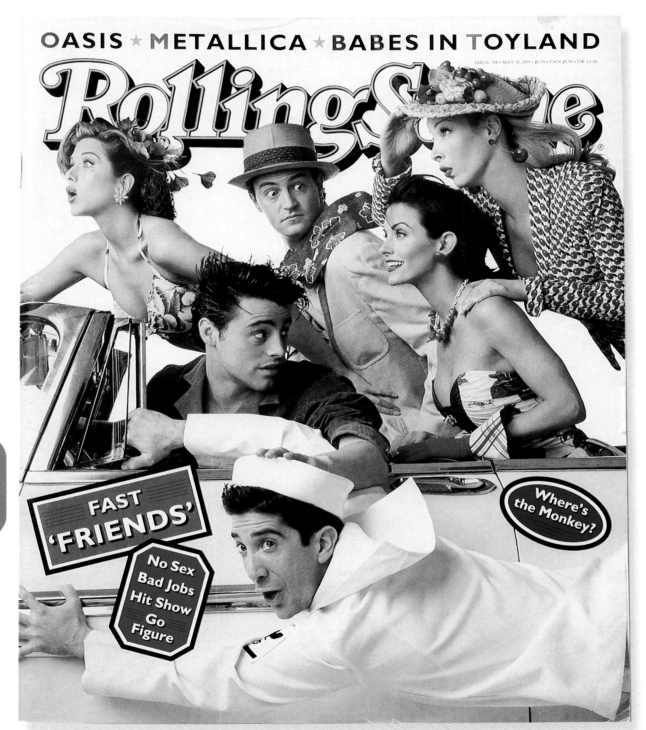

OASIS ★ METALLICA ★ BABES IN TOYLAND

ISSUE 708 • MAY 18, 1995 • $2.95 • CAN $3.50 • UK £3.00

Rolling Stone

1990s

FAST 'FRIENDS'

No Sex
Bad Jobs
Hit Show
Go
Figure

Where's the Monkey?

RS 708 | CAST OF 'FRIENDS' | May 18th, 1995 | Photograph by Mark Seliger

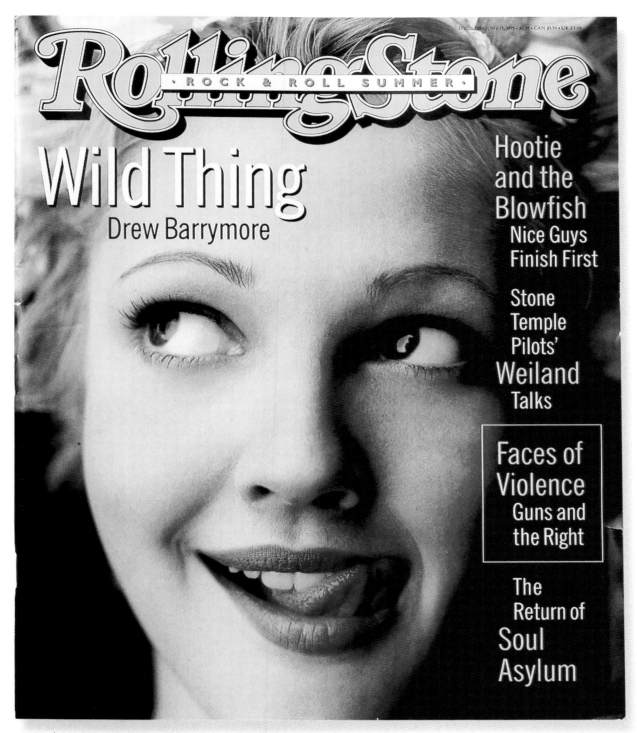

ISSUE 710 · JUNE 15, 1995 · $2.95 · CAN $3.50 · UK £3.00

RollingStone

· ROCK & ROLL SUMMER ·

Wild Thing
Drew Barrymore

Hootie and the Blowfish
Nice Guys Finish First

Stone Temple Pilots' Weiland Talks

Faces of Violence
Guns and the Right

The Return of Soul Asylum

RS 710 | DREW BARRYMORE | June 15th, 1995 | PHOTOGRAPH BY MARK SELIGER

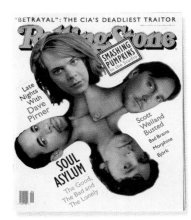

RS 711 | SOUL ASYLUM
June 29th, 1995
PHOTOGRAPH BY MATT MAHURIN

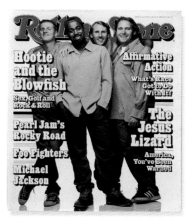

RS 714 | HOOTIE
AND THE BLOWFISH
August 10th, 1995
PHOTOGRAPH BY MARK SELIGER

PICTURE, IF YOU WILL, A HOTEL LOUNGE. [Soul Asylum singer Dave] Pirner sits on a sofa, engaged in what seems to be a heated conversation with a reporter. Drummer Sterling Campbell sits on a chair to their right, leaning in closely.

PIRNER: But look, Socrates was fucking Greek, man. I mean, what influence has that culture had on us as a people now? Those wrapped-up leaves with rice in them . . .

[*Soul Asylum's publicist arrives.*]

PIRNER: I mean, that shit doesn't taste that good, but it tastes pretty good. And you kind of sit there, and you eat it, and you go, "All right, these motherfuckers, they ate this shit, and they made a bunch of motherfuckers drag fucking rocks up a hill to build some big old colossal thing. And they tried to create this whole society." And what was the food left over from that? These fucking grape leaves wrapped around rice.

PUBLICIST: I have a recommendation to make as a publicist. You guys could stay up all night talking, but the on-the-record portion of the interview should be over at this point.

CAMPBELL: No, no, no, no.

PIRNER: I think I can be held accountable for anything that I should say. I'll tell you what I want to know, though. What's ROLLING STONE's angle here? Do they think we're rock stars and suck or what? What do they want to know about us, just between me and you?

PUBLICIST [*coughs*]: What would be the most natural, obvious question to answer that? The new record? Coming off the tremendous success of Grave Dancers Union?

PIRNER: I mean, what the fuck could possibly be interesting about us?

[*The publicist is silent.*]

PIRNER: Exactly. That's the right answer.

PUBLICIST [*flustered*]: Is the tape recorder running? Could you turn it off?

[EXCERPT FROM RS 711 COVER STORY BY NEIL STRAUSS]

[RS 712/713] Finding a dog that could pull the skivvies off of Jim Carrey was no simple task. A casting call went out across the land and canines galore showed up. The only one with the necessary skills was a crafty fellow named Poundcake. Unfortunately, he was white – and for the setup to mirror the classic Coppertone ad, the assertive doggie had to be black. After weeks of intensive training, Poundcake consented to having his snowy coat dyed black (reportedly with shoe polish). Poundcake, now ebony, had risen to the occasion when Mr. Carrey's handlers called to say he couldn't make the shoot that day. Unfortunately, rescheduling took a month, and poor Poundcake had to go through boot camp once again – not to mention having his roots touched up. A trouper to the end, Poundcake came through, putting that Coppertone mutt to shame with his briefs-snatching antics.

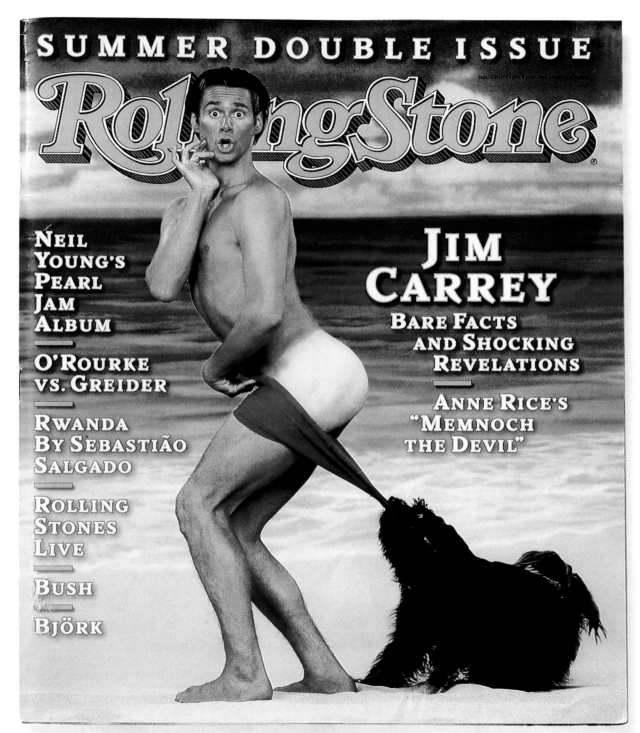

SUMMER DOUBLE ISSUE

Rolling Stone

NEIL
YOUNG'S
PEARL
JAM
ALBUM

O'ROURKE
VS. GREIDER

RWANDA
BY SEBASTIÃO
SALGADO

ROLLING
STONES
LIVE

BUSH

BJÖRK

JIM
CARREY

BARE FACTS
AND SHOCKING
REVELATIONS

ANNE RICE'S
"MEMNOCH
THE DEVIL"

RS 712/713 | **JIM CARREY** | July 13th – July 27th, 1995 | Photograph by Herb Ritts

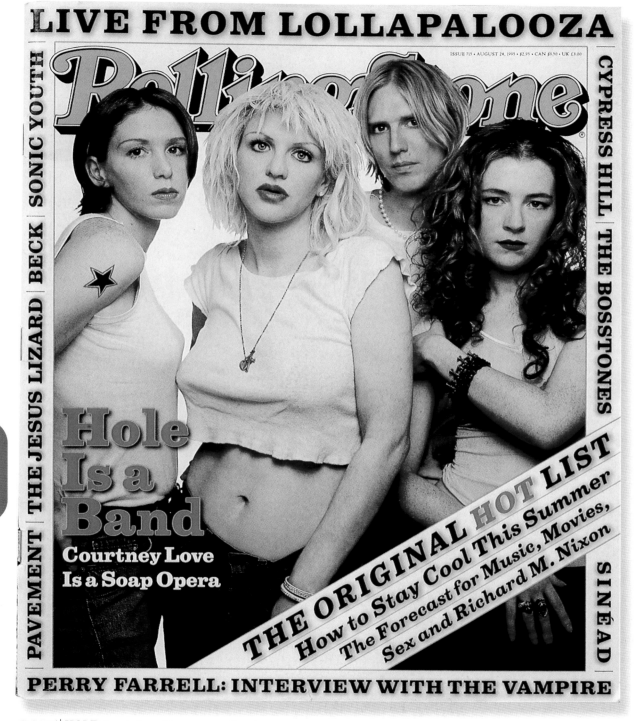

LIVE FROM LOLLAPALOOZA

Rolling Stone

ISSUE 715 · AUGUST 24, 1995 · $2.95 · CAN $3.50 · UK £3.00

SONIC YOUTH | BECK | THE JESUS LIZARD | PAVEMENT

CYPRESS HILL | THE BOSSTONES | SINÉAD

1990s

Hole
Is a
Band

Courtney Love
Is a Soap Opera

THE ORIGINAL HOT LIST
How to Stay Cool This Summer
The Forecast for Music, Movies,
Sex and Richard M. Nixon

PERRY FARRELL: INTERVIEW WITH THE VAMPIRE

RS 715 | HOLE | August 24th, 1995 | Photograph by Mark Seliger

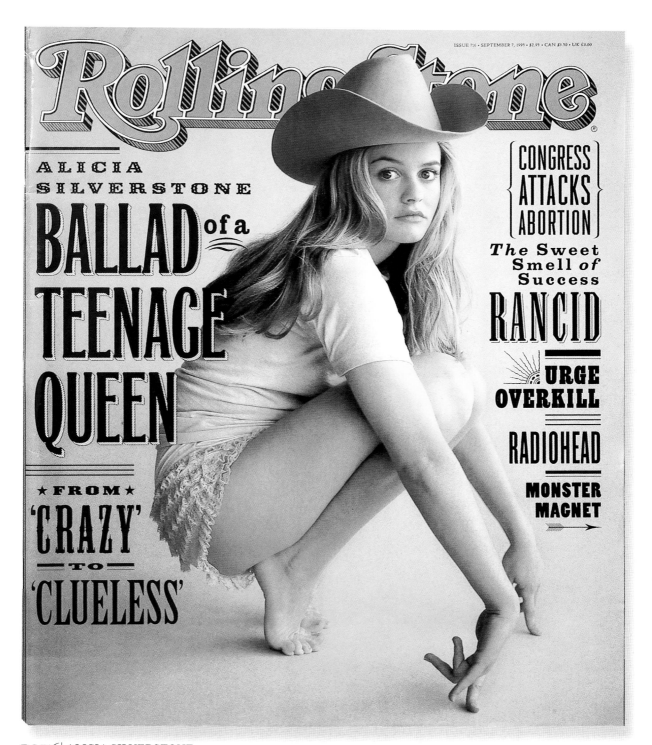

ISSUE 716 • SEPTEMBER 7, 1995 • $2.95 | CAN $3.50 | UK £3.00

Rolling Stone

ALICIA
SILVERSTONE

BALLAD of a
TEENAGE
QUEEN

★ FROM ★
'CRAZY'
TO
'CLUELESS'

CONGRESS
ATTACKS
ABORTION

The Sweet
Smell of
Success

RANCID

URGE
OVERKILL

RADIOHEAD

MONSTER
MAGNET

RS 716 | ALICIA SILVERSTONE | September 7th, 1995 | Photograph by Peggy Sirota

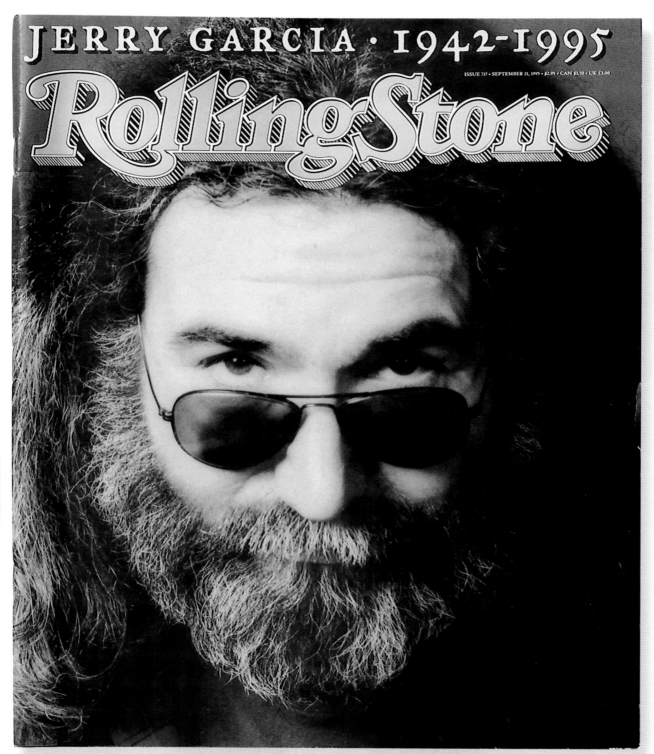

JERRY GARCIA · 1942-1995

RollingStone

ISSUE 717 · SEPTEMBER 21, 1995 · $2.95 · CAN $3.50 · UK £1.00

1990s

On August 9th, 1995, Jerry

Garcia died in his sleep at Serenity Knolls drug treatment center, in the Marin County community of Forest Knolls, north of San Francisco. He was fifty-three. . . . The memorial service transformed into a festive, open-air Grateful Dead theme park. . . . As the waft of marijuana and incense intensified, fans gathered at the alter and danced. . . .

—Alec Foege

HE WAS THE UNLIKELIEST OF POP STARS AND THE MOST RETICENT OF cultural icons.

Onstage he wore plain clothes – usually a sacklike T-shirt and loose jeans to fit his heavy frame – and he rarely spoke to the audience that watched his every move. Even his guitar lines – complex, lovely and rhapsodic, but never flashy – as well as his strained, weatherworn vocal style had a subdued, colloquial quality about them. Offstage he kept to family and friends, and when he sat to talk with interviewers about his remarkable music, he often did so in sly-witted, self-deprecating ways. "I feel like I'm sort of stumbling along," he said once, "and a lot of people are watching me or stumbling along with me or allowing me to stumble for them." It was as if Jerry Garcia – who, as the lead guitarist and singer of the Grateful Dead, lived at the center of one of popular culture's most extraordinary epic adventures – was bemused by the circumstances of his own renown.

—Mikal Gilmore

In rock & roll, there is Grateful

Dead music – and then there is everything else. No other band has been so pure in its outlaw idealism, so resolute in its pursuit of transcendence onstage and on record, and so astonishingly casual about both the hazards and rewards of its chosen, and at times truly lunatic, course. . . .

—David Fricke

FOR OUR VERY FIRST ISSUE – published in November 1967 – we lucked, journalistically speaking, into a story for the ages: the Grateful Dead getting busted at their Haight-Ashbury digs. The police had had it up to their badges with freaks flaunting various laws. Inviting local media along for the roust, they barged into the house at 710 Ashbury Street, where most of the Dead and their old ladies lived, and arrested two band members and nine associates and friends on dope charges (Jerry Garcia wasn't one of them; he was out at the time).

Baron Wolman, ROLLING STONE's first photographer, snapped shots of Bob Weir walking down the front steps, cuffed to Phil Lesh's girlfriend, and Ron "Pigpen" McKernan and Phil Lesh outside their bail bondsman's office across from the Hall of Justice. The next day, after a festive press conference at the house, Wolman shot photographs of a band of unrepentant freaks – now joined by Garcia, posing in front of 710, with Pigpen brandishing a rifle. The photos took up most of a two-page spread.

The lead, by an uncredited Jann S. Wenner, was textbook hook-'em news writing: " 'That's what ya get for dealing the killer weed,' laughed state narcotics agent Gerritt Van Ramm at the eleven members of the Grateful Dead household he and his agents had rounded up into the Dead's kitchen."

The band and the magazine always had a special relationship, despite the occasional negative album review or report on an unpleasant incident or ROLLING STONE's move to New York in 1977. Our common roots transcended trivia; our love of great music kept us bonded.

—Ben Fong-Torres

[EXCERPTS FROM RS 717]

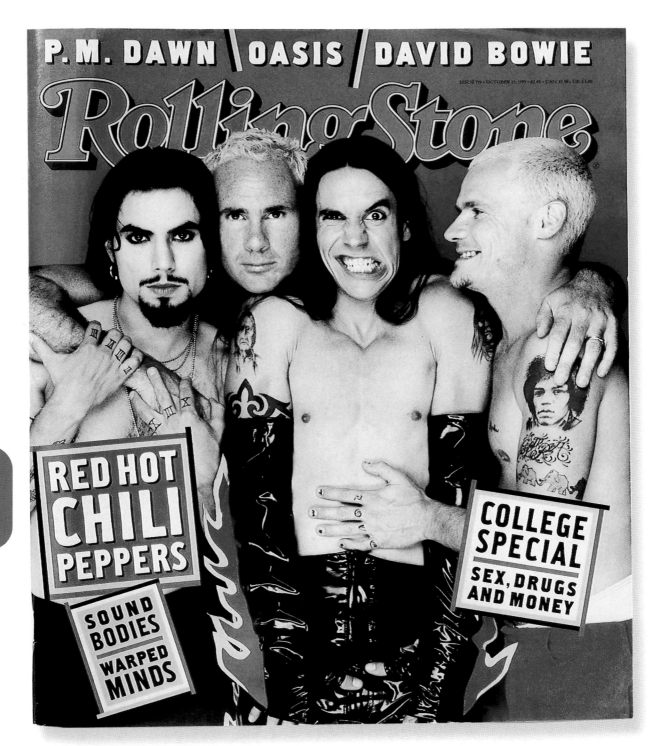

RED HOT CHILI PEPPERS

SOUND BODIES WARPED MINDS

COLLEGE SPECIAL SEX, DRUGS AND MONEY

$\mathcal{RS}\ 719$ | RED HOT CHILI PEPPERS | October 19th, 1995 | Photograph by Anton Corbijn

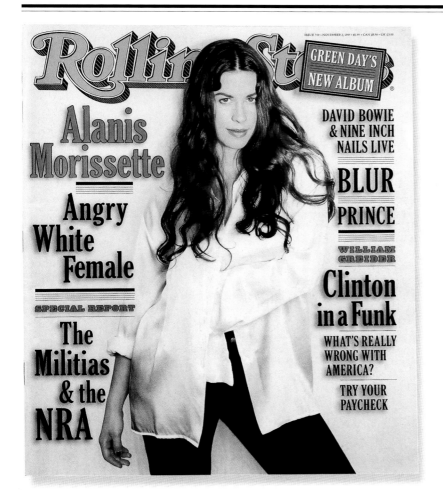

RS 720 | ALANIS MORISSETTE
November 2nd, 1995
PHOTOGRAPH BY FRANK W. OCKENFELS 3

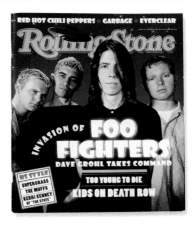

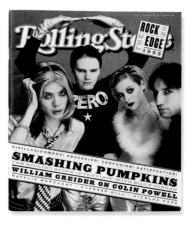

RS 718 | FOO FIGHTERS
October 5th, 1995
PHOTOGRAPH BY DAN WINTERS

RS 721 | SMASHING PUMPKINS
November 16th, 1995
PHOTOGRAPH BY MARK SELIGER

"I learned a lot of lessons from Nirvana. We don't want to spend too much time whoring ourselves around because not only does it make everyone sick of you, eventually you get sick of yourself."

—*Dave Grohl*

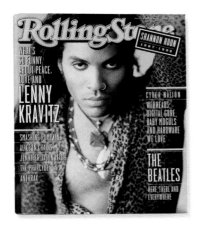 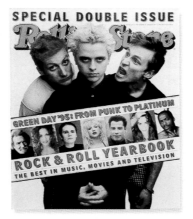 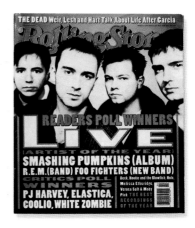

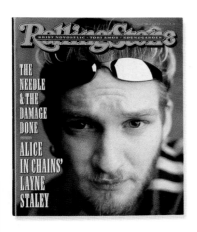 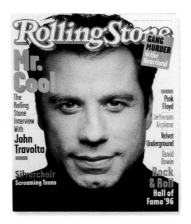 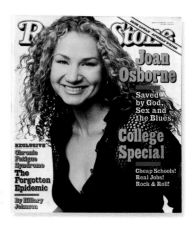

RS 722 | LENNY KRAVITZ
November 30th, 1995
PHOTOGRAPH BY MATTHEW ROLSTON

RS 724/725 | GREEN DAY,
VARIOUS
December 28th, 1995 – January 11th, 1996
PHOTOGRAPHS BY MARK SELIGER, VARIOUS

RS 726 | LIVE
January 25th, 1996
PHOTOGRAPH BY JULIAN BROAD

RS 727 | LAYNE STALEY
February 8th, 1996
PHOTOGRAPH BY MARK SELIGER

RS 728 | JOHN TRAVOLTA
February 22nd, 1996
PHOTOGRAPH BY MARK SELIGER

RS 730 | JOAN OSBORNE
March 21st, 1996
PHOTOGRAPH BY MARK SELIGER

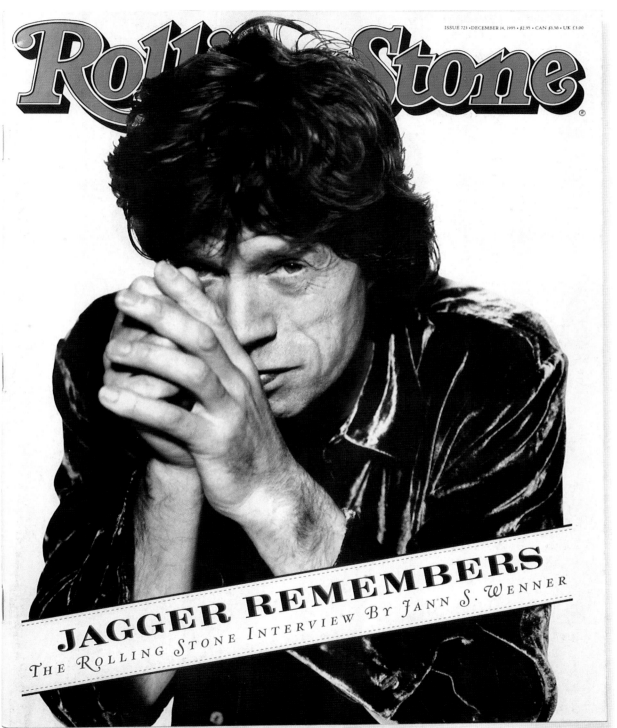

ISSUE 723 · DECEMBER 14, 1995 · $2.95 · CAN $3.50 · UK £3.00

Rolling Stone

JAGGER REMEMBERS
The Rolling Stone Interview By Jann S. Wenner

RS 723 | MICK JAGGER | December 14th, 1995 | PHOTOGRAPH BY PETER LINDBERGH

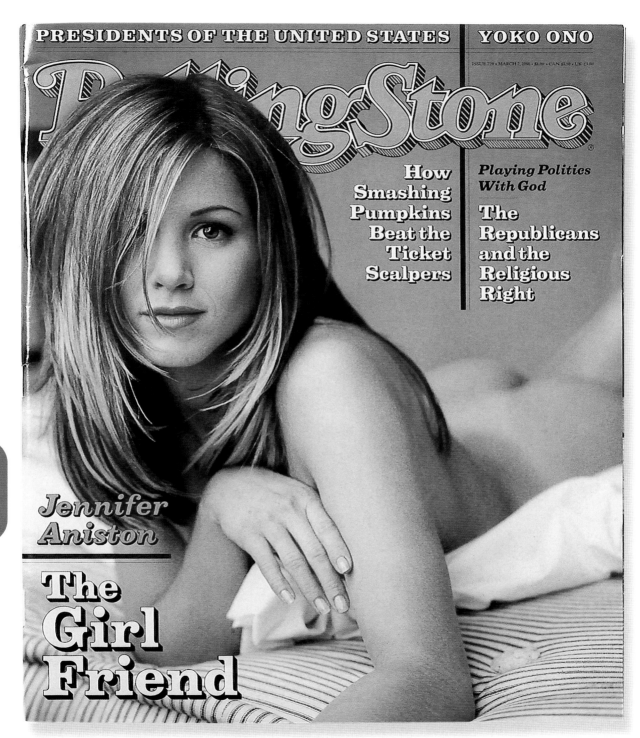

PRESIDENTS OF THE UNITED STATES YOKO ONO

Rolling Stone

ISSUE 729 • MARCH 7, 1996 • $3.99 • CAN $3.50 • UK £3.00

How Smashing Pumpkins Beat the Ticket Scalpers

Playing Politics With God
The Republicans and the Religious Right

1990s

Jennifer Aniston

The Girl Friend

RS 729 | JENNIFER ANISTON | March 7th, 1996 | Photograph by Mark Seliger

ISSUE 731 · APRIL 4, 1996 · $3.00 · CAN $3.50 · UK £3.00

Rolling Stone

SPECIAL REPORT
THE FALL OF APPLE
By Jeff Goodell

COOL JERK

Is *Sean Penn* the greatest actor of his generation or a menace to society?

The **DOGG WALKS**
Snoop Doggy Dogg Beats Murder Rap

Beatles Unplugged

SEVEN MARY THREE

2PAC

STEREOLAB

PULP

RS 731 | SEAN PENN | April 4th, 1996 | PHOTOGRAPH BY MARK SELIGER

CRACKER | PULP | STEVE EARLE | RAGE AGAINST THE MACHINE

ISSUE 732 · APRIL 18, 1996 · $3.00 · CAN $3.50 · UK £3.00

RollingStone

Three million albums, five hit singles...

Bush

Why won't anyone take Gavin Rossdale seriously?

ROLLING STONE
ONE HOT MINUTE
SPRING STYLE

P.J. O'Rourke on Pat Buchanan

PART TWO
The Fall of
APPLE
By Jeff Goodell

1990s

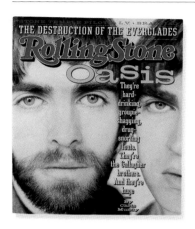

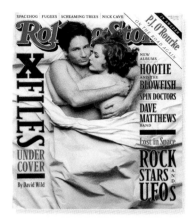

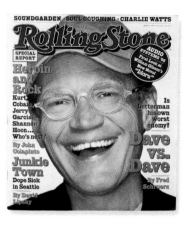

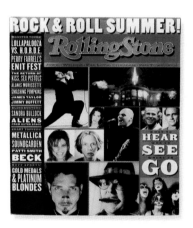

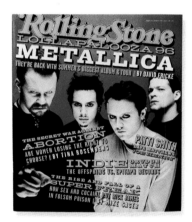

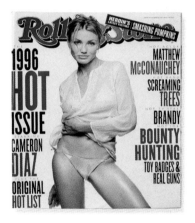

RS 733 | LIAM
& NOEL GALLAGHER
May 2nd, 1996
PHOTOGRAPH BY NATHANIEL GOLDBERG

RS 734 | DAVID DUCHOVNY
& GILLIAN ANDERSON
May 16th, 1996
PHOTOGRAPH BY MONTALBETTI/CAMPBELL

RS 735 | DAVID LETTERMAN
May 30th, 1996
PHOTOGRAPH BY ALBERT WATSON

RS 736 | ROCK & ROLL SUMMER
June 13th, 1996
VARIOUS PHOTOGRAPHERS

RS 737 | METALLICA
June 27th, 1996
PHOTOGRAPH BY ANTON CORBIJN

RS 741 | CAMERON DIAZ
August 22nd, 1996
PHOTOGRAPH BY MARK SELIGER

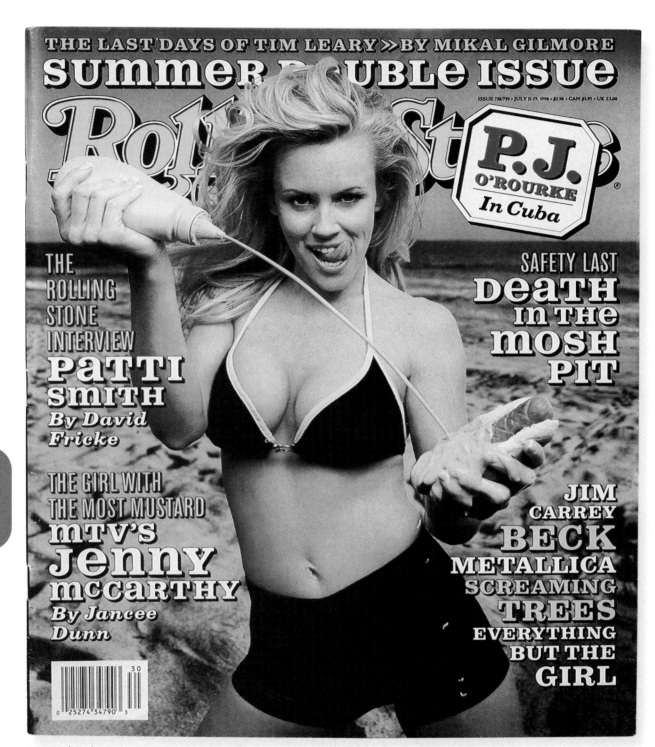

THE LAST DAYS OF TIM LEARY >> BY MIKAL GILMORE

SUMMER DOUBLE ISSUE

Rolling Stone

ISSUE 738/739 • JULY 11-25, 1996 • $3.50 • CAN $3.95 • UK £3.00

P.J. O'ROURKE
In Cuba

THE ROLLING STONE INTERVIEW
PATTI SMITH
By David Fricke

THE GIRL WITH THE MOST MUSTARD
MTV'S JENNY McCARTHY
By Jancee Dunn

SAFETY LAST
DEATH IN THE MOSH PIT

JIM CARREY
BECK
METALLICA
SCREAMING TREES
EVERYTHING BUT THE GIRL

1990s

0 25274 34790 3

RS 738/739 | JENNY McCARTHY | July 11th – July 25th, 1996 | Photograph by Mark Seliger

ELLA FITZGERALD 1917-1996 · BY MIKAL GILMORE

ISSUE 740 · AUGUST 8, 1996 · $3.00 · UK £3.00

Rolling Stone®

GOODBYE,
CALIFORNIA?
The Coming
Killer Quakes

Buddha and
the Beat
BEASTIE
BOYS,
SMASHING
PUMPKINS
AND RAGE
AGAINST THE
MACHINE
ROCK FOR
TIBET

EXCLUSIVE

The Secret Life
of Jerry Garcia
By Robert Greenfield

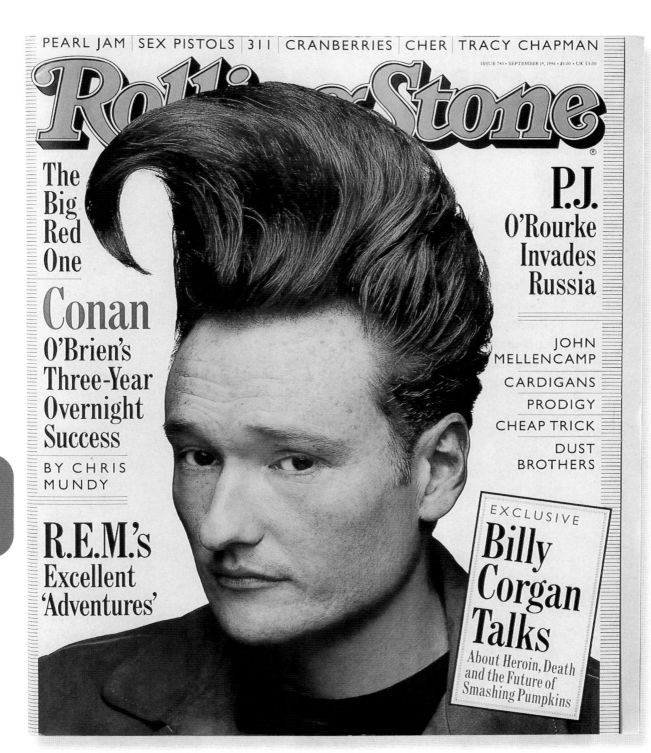

PEARL JAM | SEX PISTOLS | 311 | CRANBERRIES | CHER | TRACY CHAPMAN

ISSUE 743 · SEPTEMBER 19, 1996 · $3.00 · UK £3.00

Rolling Stone

The
Big
Red
One

Conan
O'Brien's
Three-Year
Overnight
Success

BY CHRIS
MUNDY

R.E.M.'s
Excellent
'Adventures'

1990s

P.J.
O'Rourke
Invades
Russia

JOHN
MELLENCAMP

CARDIGANS

PRODIGY

CHEAP TRICK

DUST
BROTHERS

EXCLUSIVE

Billy
Corgan
Talks

About Heroin, Death
and the Future of
Smashing Pumpkins

RS 743 | CONAN O'BRIEN | September 19th, 1996 | Photograph by Mark Seliger

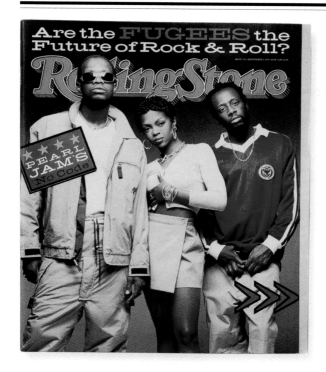

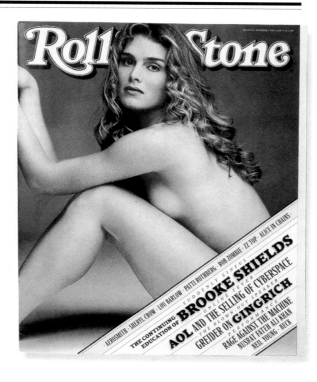

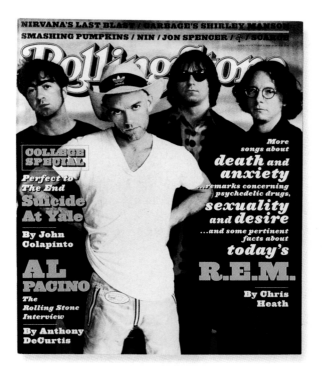

RS 742 | THE FUGEES
September 5th, 1996 | PHOTOGRAPH BY MATTHEW ROLSTON

RS 744 | BROOKE SHIELDS
October 3rd, 1996 | PHOTOGRAPH BY MARK SELIGER

RS 745 | R.E.M.
October 17th, 1996 | PHOTOGRAPH BY ANTON CORBIJN

YOU CAN CALL IT FATE OR YOU CAN CALL IT BREAKING AND
entering. The differences are marginal. The time was the late
Eighties, a simpler period. Back then, while David Letterman
was quietly building an empire in the hours past midnight, a
young Harvard grad named Conan O'Brien was making his way
as a writer for the recently resuscitated *Saturday Night Live*. Every
now and then, to get a break from the all-night writing binges,
O'Brien would sneak downstairs, pick the lock to Studio 6A and
attempt to write comedy while sitting at Letterman's desk.

"It wasn't like, 'Someday I will sit here,' " says O'Brien. "It was
more like, 'This is where he sits? Cool.' " He laughs – you know
the sound: high-pitched, slightly braying. "Really, the point of the
story is that NBC has terrible security, and I'm sure now every
night there will be a different weird person sitting at my desk."

[EXCERPT FROM RS 743 COVER STORY BY CHRIS MUNDY]

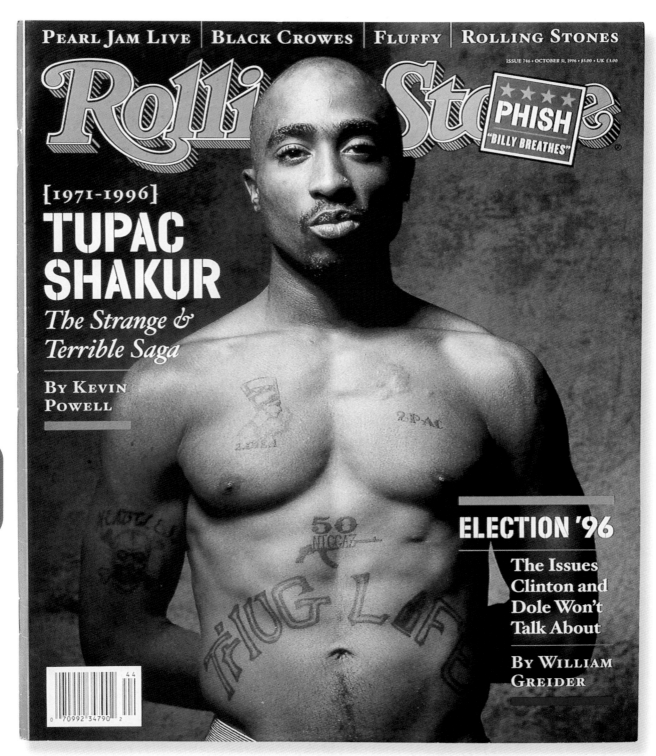

PEARL JAM LIVE | BLACK CROWES | FLUFFY | ROLLING STONES

ISSUE 746 • OCTOBER 31, 1996 • $3.00 • UK £3.00

Rolling Stone

PHISH
"BILLY BREATHES"

[1971-1996]
TUPAC SHAKUR
*The Strange &
Terrible Saga*

BY KEVIN
POWELL

ELECTION '96

**The Issues
Clinton and
Dole Won't
Talk About**

BY WILLIAM
GREIDER

1990s

At 4:03 p.m. on September

13th, Tupac Amaru Shakur, rapper and actor, died at the University of Nevada Medical Center in the Wild West gambling town of Las Vegas, the result of gunshot wounds he had received six days earlier in a drive-by shooting near the glittery, hotel-studded strip. Shakur, a.k.a. 2Pac, was twenty-five. The rapper is survived by his mother, Afeni Shakur, his father, Billy Garland, and a half sister, Sekyiwa.

RS 746 | TUPAC SHAKUR
October 31st, 1996
PHOTOGRAPH BY DANNY CLINCH

I DON'T KNOW WHETHER TO MOURN TUPAC SHAKUR OR to rail against all the terrible forces – including the artist's own self-destructive temperament – that have resulted in such a wasteful, unjustifiable end. I do know this, though: Whatever its causes, the murder of Shakur, at age twenty-five, has robbed us of one of the most talented and compelling voices of recent years. He embodied just as much for his audience as Kurt Cobain did for his. That is, Tupac Shakur spoke to, and for, many who had grown up within hard realities – realities that mainstream culture and media are loath to understand or respect. His death has left his fans feeling a doubly sharp pain: the loss of a much-esteemed signifier and the loss of a future volume of work that, no doubt, would have proved both brilliant and provocative.

So: A man sings about death and killing, and then the man is killed. There is a great temptation for many to view one event as the result of the other. And in Tupac Shakur's case, there are some grounds for this assessment: He did more than sing about violence; he also participated in a fair amount of it. As Shakur himself once said, in words that *Time* magazine appropriated for its headline covering his murder: WHAT GOES 'ROUND COMES 'ROUND. Still, I think it would be a great disservice to dismiss Shakur's work and life with any quick and glib headline summations. It's like burying the man without hearing him.

—*Mikal Gilmore*
[EXCERPT FROM RS 746 ESSAY]

This is a journey into the mind of Dennis Rodman. Think twice before volunteering to go further. Sometimes it will be funny, but sometimes it will be scary. Sometimes the paranoia and craziness will seep out of the page to get you. Sometimes you won't quite understand what Dennis Rodman is saying. Sometimes you will and wish you didn't. There will be casualties. Logic, love, basketball, fashion . . . these will all take a battering. You will not be lied to, but sometimes the truth will seem elusive. This trip will take in an array of guests, and not all of them will be pleased to find themselves in Rodman-land. It will be fun, in a way, but the kind of fun that gets all mixed up with trouble and sadness and never quite untangles itself. In the end, life won't seem simpler, and the world won't seem a safer place.

Don't forget: We are just tourists here. We will be going home. But Dennis Rodman can't leave. This is where he lives. . . .

Dennis Rodman lies back on the bus bed, the evening sunlight shining off his nose rings. "I totally feel like a rock star more than a basketball player. I totally think: Have I got to go and play basketball now?"

[EXCERPT FROM RS 749 COVER STORY BY CHRIS HEATH]

1990s

AMBUSH AT FORT BRAGG BY TOM WOLFE

Rolling Stone

ISSUE 749 · DECEMBER 12, 1996 · $3.00 · UK £3.00

DENNIS RODMAN'S FUN HOUSE

WITH WHOOPI GOLDBERG

TONI BRAXTON

EDDIE VEDDER

JEAN-CLAUDE VAN DAMME

MADONNA

HOOTIE AND THE BLO

PLUS

SMASHING PUMPKINS

DAVE MATTHEWS

DAVID BOWIE

LUSCIOUS JACKSON

BUSH

STONE TEMPLE PILOTS

RUSH

THE LILYS

RS 749 | DENNIS RODMAN | *December 12th, 1996* | PHOTOGRAPH BY ALBERT WATSON

Be careful when you gossip:

A little rumor can go a long way. Especially when the subject is Marilyn Manson.

"For a solid year, there was a rumor that I was going to commit suicide on Halloween," says Manson. He is sitting in a hot tub (yes, a hot tub!) in his hometown of Fort Lauderdale, Florida. "I started to think, 'Maybe I have to kill myself, maybe that's what I was supposed to do.' Then, when we were performing on Halloween, there was a bomb threat. I guess someone thought they would take care of the situation for me. It was one of those moments where chaos had control." He pauses, raises his tattoo-covered arm from the water and stares nervously through a pair of black wraparound sunglasses at the spa door. It opens a crack, then closes. No one enters. "Sometimes I wonder if I'm a character being written, or if I'm writing myself," Manson continues. "It's confusing."

Never has there been a rock star quite as complex as Marilyn Manson, frontman of the band of the same name. In the current landscape of reluctant rock stars, Manson is a complete anomaly: He craves spectacle, success and attention. And when it comes to the traditional rock-star lifestyle, he can outdo most of his contemporaries. Manson and his similarly pseudonymed band mates – bassist Twiggy Ramirez, drummer Ginger Fish, keyboardist Madonna Wayne Gacy and guitarist Zim Zum – have shat in Evan Dando's bathtub and, just last night, they coaxed Billy Corgan into snorting sea monkeys. When it comes to getting serious about his work, Manson is among the most eloquent and artful musicians. And among the most misunderstood. The rumor-hungry fans who see him as a living demon who's removed his own ribs and testicles know just as little about Manson as the detractors who dismiss him as a Halloween-costumed shock rocker riding on Trent Reznor's coattails.

[EXCERPT FROM RS 752 COVER STORY BY NEIL STRAUSS]

1990s

ANNUAL MUSIC AWARDS ISSUE

ISSUE 752 · JANUARY 23, 1997 · $3.00 · UK £3.00

RollingStone

BEST
NEW ARTIST

Marilyn Manson's
Beautiful
Nightmare

BY NEIL
STRAUSS

ALBUM
OF THE YEAR

Beck's
"Odelay"

ARTIST
OF THE YEAR

Smashing
Pumpkins

THE HOMECOMING QUEEN
MURDER
BY PETER WILKINSON

DAVID BOWIE! PAVEMENT! SILVERCHAIR! MOBY!

Rolling Stone

ISSUE 754 · FEBRUARY 20, 1997 · $3.00 · UK £4.00

The X FILES!

GILLIAN ANDERSON
AS The PRINCESS of PARANOIA!

CHRIS CARTER AS THE BEAST WITHIN!

PHISH
AMERICA'S BIGGEST JAM BAND!

1990s

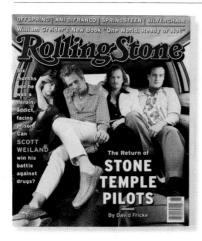

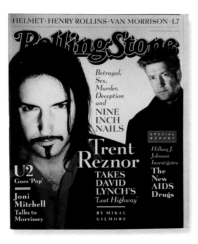

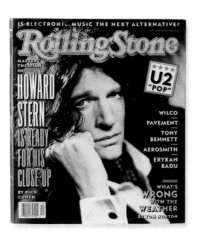

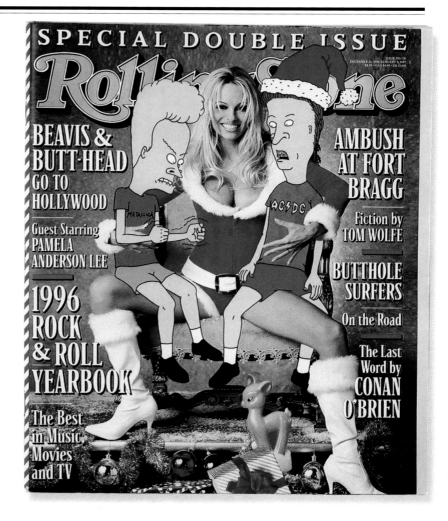

RS 750/751 | BEAVIS & BUTT-HEAD
WITH PAMELA ANDERSON LEE
December 26th, 1996 – January 9th, 1997
PHOTOGRAPH BY MARK SELIGER, ILLUSTRATION BY MIKE JUDGE

RS 753 | STONE TEMPLE PILOTS
February 6th, 1997
PHOTOGRAPH BY MARK SELIGER

RS 755 | TRENT REZNOR & DAVID LYNCH
March 6th, 1997
PHOTOGRAPH BY DAN WINTERS

RS 756 | HOWARD STERN
March 20th, 1997
PHOTOGRAPH BY MARK SELIGER

RS 762 | JAKOB DYLAN
June 12th, 1997
PHOTOGRAPH BY MARK SELIGER

MUCH OF TONIGHT'S AUDIENCE
has no idea who Jakob's father is;
everyone I've talked to couldn't
care less: *Bob Dylan's just a guy in
my social studies book.*

"*Jaaaaaaaykob!*"

So handsome, with those
sharp Armani shoulders, the
startling, Samoyed-blue eyes,
that cool, funky hat destined to
become a video talisman . . .

"*Jaaaaaykob! Tell it!*"

What the recordmen don't
know, the little girls understand.
Jakob Dylan is a young man of
certain passion, singing his own
words with a shy, fitful intensity
that seems, sometimes, to take
him out and above this big,
hot room. It's not the raspy,
unremarkable voice so much
as the delivery that draws
them, some strain of the ageless
troubadour DNA that goosed
vestal virgins in the shadows
of Stonehenge.

[EXCERPT FROM RS 762 COVER STORY
BY GERRI HIRSHEY]

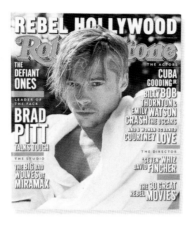

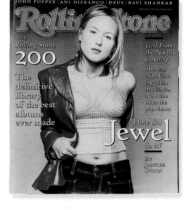

RS 757 | BRAD PITT
April 3rd, 1997
PHOTOGRAPH BY MARK SELIGER

RS 758 | BECK
April 17th, 1997
PHOTOGRAPH BY ANTON CORBIJN

RS 759 | NO DOUBT
May 1st, 1997
PHOTOGRAPH BY NORBERT SCHOERNER

RS 760 | JEWEL
May 15th, 1997
PHOTOGRAPH BY MATTHEW ROLSTON

1990s

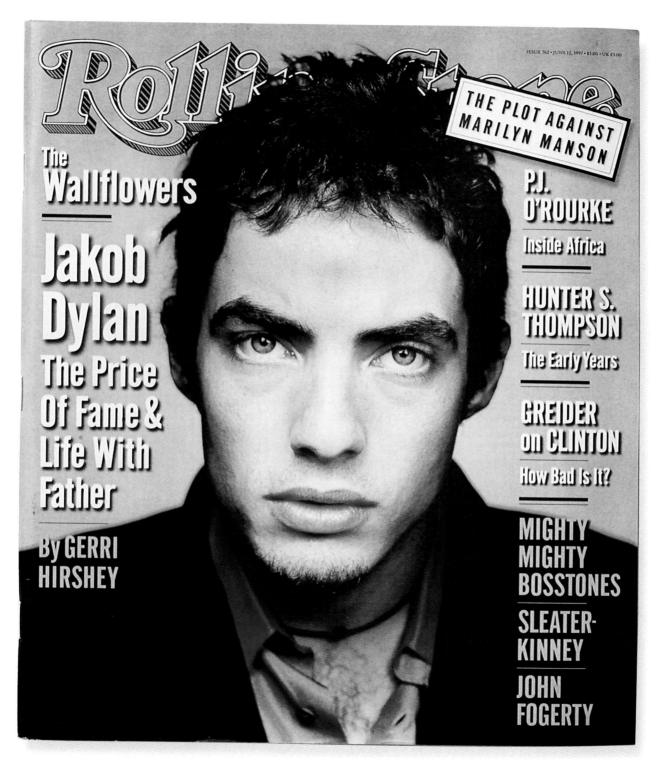

ISSUE 762 · JUNE 12, 1997 · $3.00 · UK £3.00

Rolling Stone

THE PLOT AGAINST
MARILYN MANSON

The Wallflowers

Jakob Dylan
The Price Of Fame & Life With Father

By GERRI HIRSHEY

P.J. O'ROURKE
Inside Africa

HUNTER S. THOMPSON
The Early Years

GREIDER on CLINTON
How Bad Is It?

MIGHTY MIGHTY BOSSTONES

SLEATER-KINNEY

JOHN FOGERTY

1990s

HERE, BEFORE THINGS GET TOO SILLY AND AGITATED, is a cut out'n'keep guide to the five Spice Girls. This is what you will need to know:

Geri Haliwell is twenty-four. She is known as Ginger Spice.... When Geri was young, she once poohed in the bath with her brother and sister. She is the most talkative Spice Girl and the one who is generally first to shout "girl power," the key concept in Spice Girl philosophy.

Melanie Brown (Mel B) is twenty-two. She is known as Scary Spice.... When she was young, Mel B used to have a boogie collection behind her bunk bed. Now she has a pierced tongue.

Emma Bunton is twenty-one. She is known as Baby Spice. She has blond hair, which she often wears in bunches.... When she was young, she was a child model. She recently announced, as a joke, "I don't want to be a cutie – I want to be a hot, sexy bitch," but she's now rather perturbed that the statement has been taken seriously.

Victoria Aadams is twenty-two. She is known as Posh Spice.... When she was young, Victoria used to beg her father not to take her to school in the Rolls-Royce. She was teased for that and for her nose. She likes to dress in Prada and Gucci and hates the way she looks when she smiles.

Melanie Chisholm is twenty-three. She is known as Sporty Spice.... When she was young, Melanie used to eat cat food. She wears lots of Adidas sportswear. A tattoo on her upper right arm is of two Japanese symbols: woman and strength. Girl power, in other words.

These names – Ginger, Scary, Baby, Posh, Sporty – have been a successful part of the Spice Girls package: a perfect simultaneous pop expression of heterogeneity (they're each their own person) and homogeneity (they're all disciples in the Church of Spice).

[EXCERPT FROM RS 764/765 COVER STORY BY CHRIS HEATH]

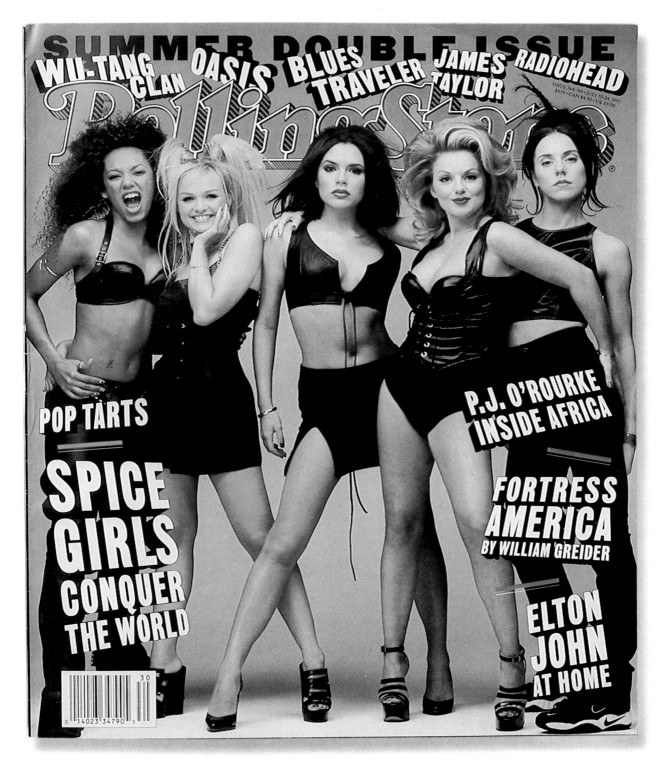

SUMMER DOUBLE ISSUE

WU-TANG CLAN OASIS BLUES TRAVELER JAMES TAYLOR RADIOHEAD

ISSUE 764/765 • JULY 10-24, 1997
$3.95 • CAN $4.50 • UK £3.00

Rolling Stone

POP TARTS

SPICE GIRLS CONQUER THE WORLD

P.J. O'ROURKE INSIDE AFRICA

FORTRESS AMERICA
BY WILLIAM GREIDER

ELTON JOHN AT HOME

0 14023 34790 5
30

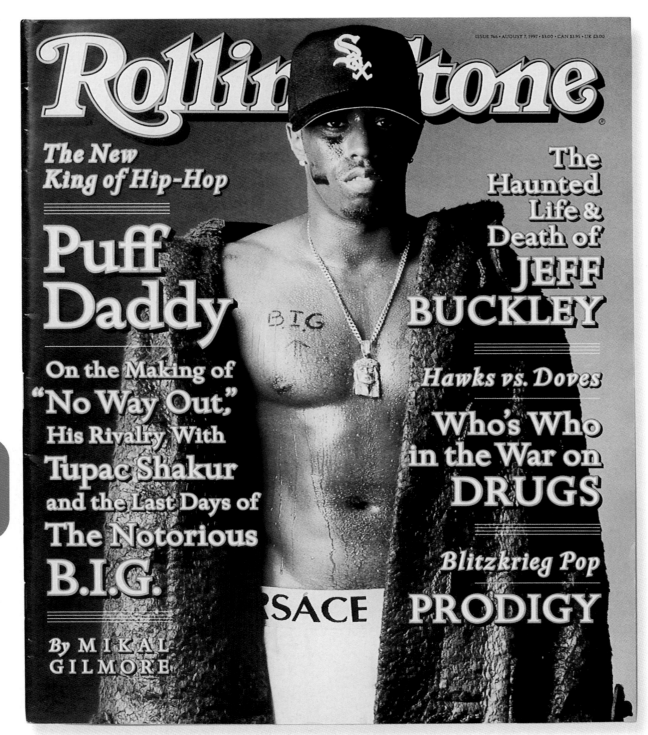

ISSUE 766 • AUGUST 7, 1997 • $3.00 • CAN $3.95 • UK £3.00

Rolling Stone

The New King of Hip-Hop

Puff Daddy

On the Making of "No Way Out," His Rivalry, With Tupac Shakur and the Last Days of The Notorious B.I.G.

By MIKAL GILMORE

The Haunted Life & Death of JEFF BUCKLEY

Hawks vs. Doves

Who's Who in the War on DRUGS

Blitzkrieg Pop PRODIGY

1990s

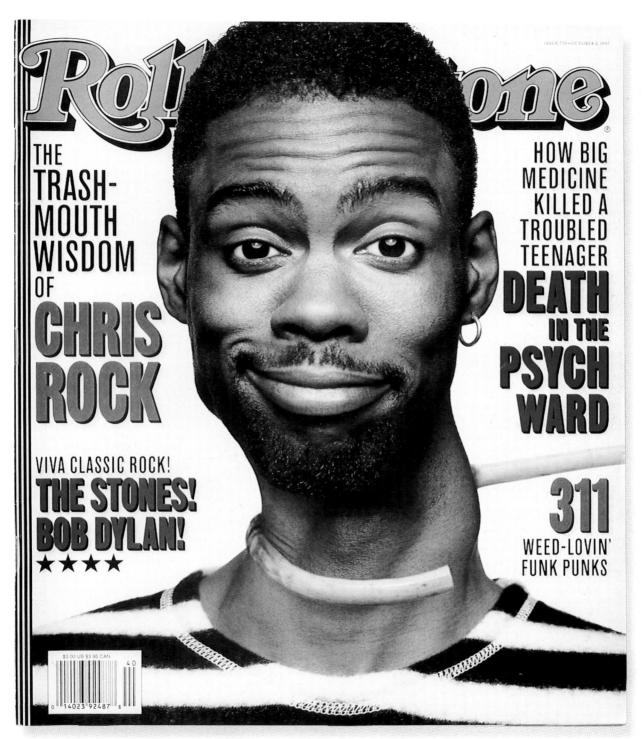

ISSUE 770 • OCTOBER 2, 1997

Rolling Stone

THE TRASH-MOUTH WISDOM OF

CHRIS ROCK

VIVA CLASSIC ROCK!

THE STONES! BOB DYLAN!

★★★★

HOW BIG MEDICINE KILLED A TROUBLED TEENAGER

DEATH IN THE PSYCH WARD

311

WEED-LOVIN' FUNK PUNKS

$3.00 US $3.95 CAN

40

0 14023 92487 8

RS 770 | CHRIS ROCK | October 2nd, 1997 | Photograph by Mark Seliger

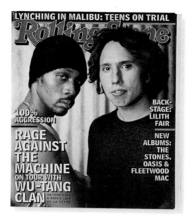

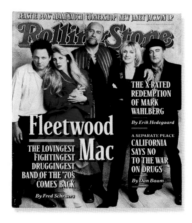

RS 769 | NEVE CAMPBELL
September 18th, 1997
PHOTOGRAPH BY MATTHEW ROLSTON

RS 767 | THE PRODIGY'S
KEITH FLINT
August 21st, 1997
PHOTOGRAPH BY PETER ROBATHAN

RS 768 | RZA &
ZACH DE LA ROCHA
September 4th, 1997
PHOTOGRAPH BY MARK SELIGER

RS 771 | SALT-N-PEPA
October 16th, 1997
PHOTOGRAPH BY PEGGY SIROTA

RS 772 | FLEETWOOD MAC
October 30th, 1997
PHOTOGRAPH BY MARK SELIGER

Women have been at the heart of rock & roll all along. They were wailing loudest at rock's beginning – in its blues and gospel prehistory. At times, they've sung stalwart background or had their sounds and looks arranged by the whims and marketing plans of men. And at other moments – like now – they've held forth in the boldest of spotlights. They've been worshipped and objectified, overdubbed and underpaid. Like their male counterparts, they can be deeply passionate or chillingly calculated. But they have never – ever – been quiet.

[EXCERPT FROM RS 773 COVER STORY
BY GERRI HIRSHEY]

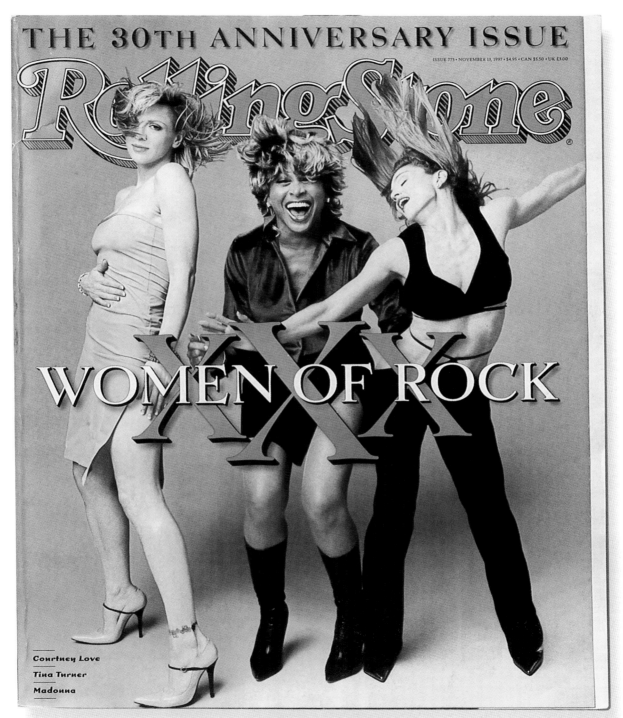

THE 30TH ANNIVERSARY ISSUE

ISSUE 773 · NOVEMBER 13, 1997 · $4.95 · CAN $5.50 · UK £3.00

ROLLING STONE

WOMEN OF ROCK

Courtney Love
Tina Turner
Madonna

RS 773 | THIRTIETH ANNIVERSARY WITH WOMEN OF ROCK: COURTNEY LOVE,
TINA TURNER & MADONNA | November 13th, 1997 | Photograph by Peggy Sirota

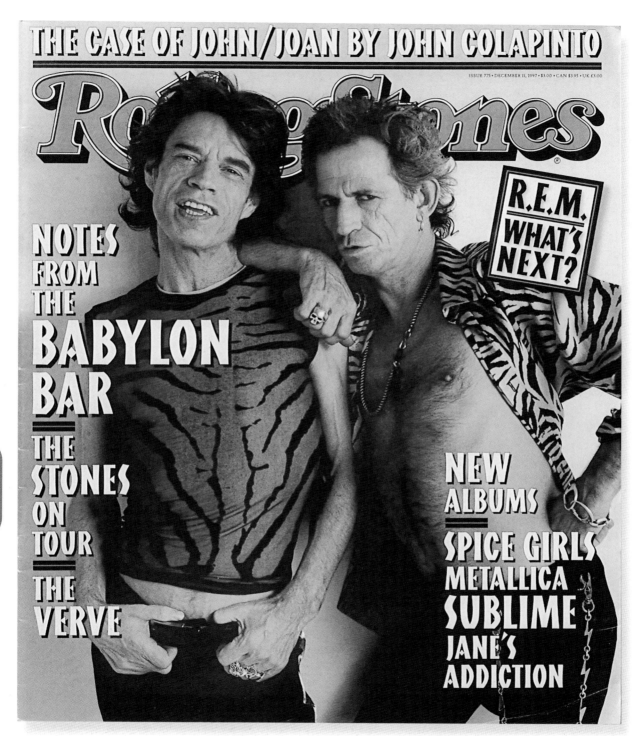

THE CASE OF JOHN/JOAN BY JOHN COLAPINTO

ISSUE 775 · DECEMBER 11, 1997 · $3.00 · CAN $3.95 · UK £3.00

Rolling Stones

R.E.M. WHAT'S NEXT?

NOTES FROM THE **BABYLON BAR**

THE STONES ON TOUR

THE VERVE

NEW ALBUMS

SPICE GIRLS
METALLICA
SUBLIME
JANE'S ADDICTION

1990s

RS 775 | MICK JAGGER & KEITH RICHARDS | *December 11th, 1997* | PHOTOGRAPH BY MARK SELIGER

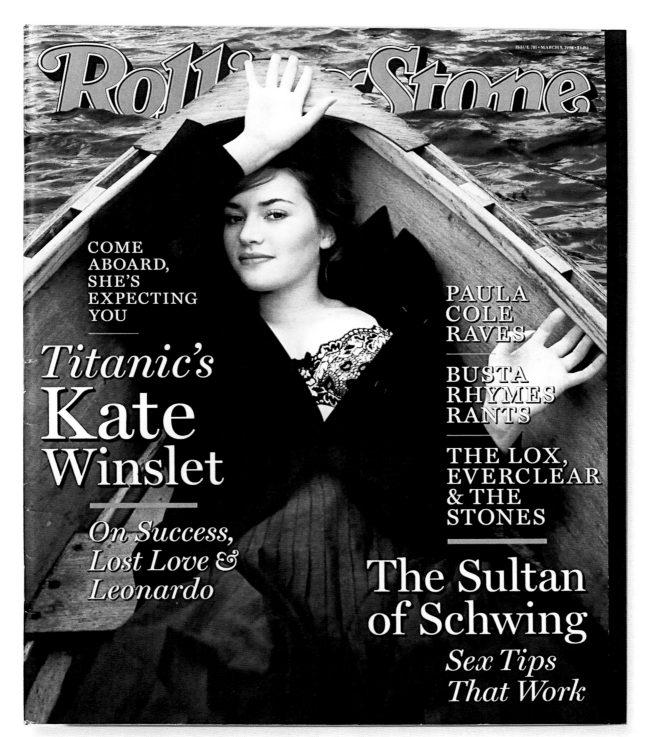

Rolling Stone

ISSUE 781 · MARCH 5, 1998 · $3.00

COME
ABOARD,
SHE'S
EXPECTING
YOU

Titanic's
Kate
Winslet

*On Success,
Lost Love &
Leonardo*

PAULA
COLE
RAVES

BUSTA
RHYMES
RANTS

THE LOX,
EVERCLEAR
& THE
STONES

The Sultan
of Schwing
*Sex Tips
That Work*

RS 781 | KATE WINSLET | March 5th, 1998 | PHOTOGRAPH BY PEGGY SIROTA

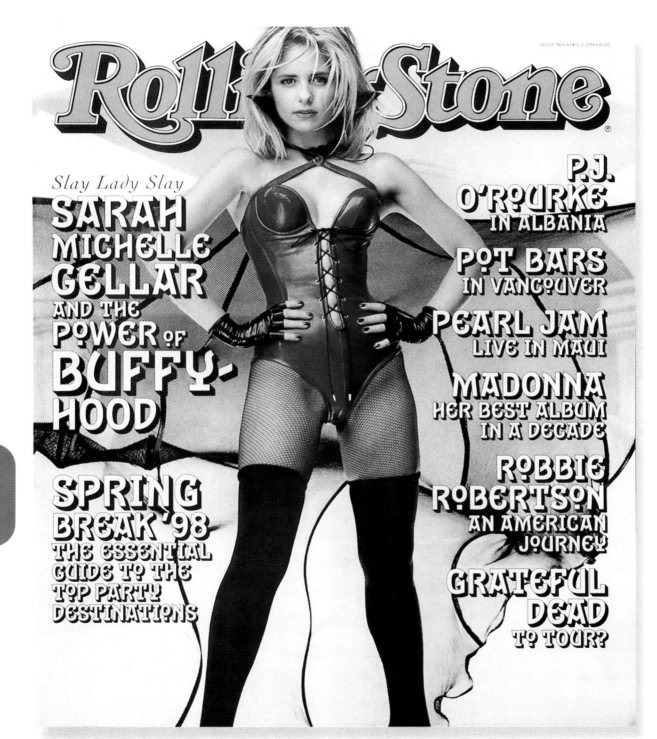

Rolling Stone

1990s

Slay Lady Slay

SARAH MICHELLE GELLAR AND THE POWER OF BUFFY-HOOD

SPRING BREAK '98
THE ESSENTIAL GUIDE TO THE TOP PARTY DESTINATIONS

P.J. O'ROURKE
IN ALBANIA

POT BARS
IN VANCOUVER

PEARL JAM
LIVE IN MAUI

MADONNA
HER BEST ALBUM IN A DECADE

ROBBIE ROBERTSON
AN AMERICAN JOURNEY

GRATEFUL DEAD
TO TOUR?

RS 783 | SARAH MICHELLE GELLAR | April 2nd, 1998 | PHOTOGRAPH BY MARK SELIGER

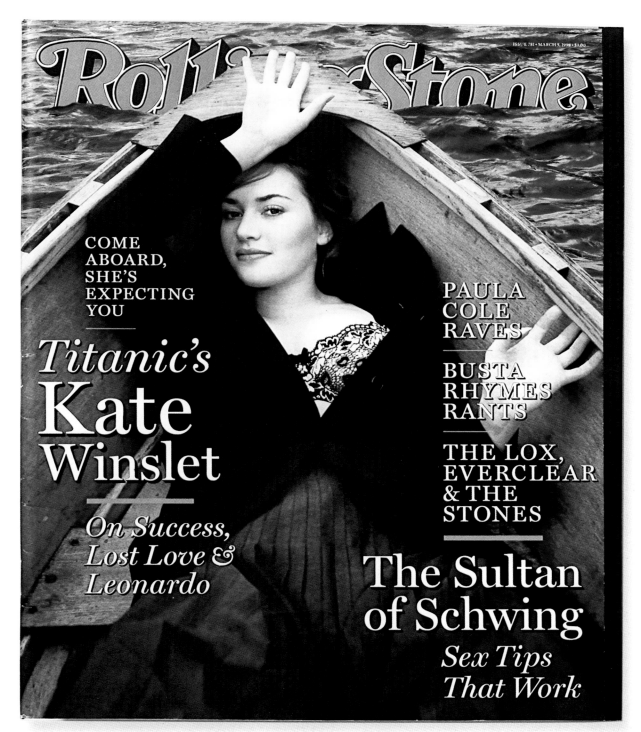

ISSUE 781 • MARCH 5, 1998 • $3.00

Rolling Stone

COME
ABOARD,
SHE'S
EXPECTING
YOU

Titanic's Kate Winslet

*On Success,
Lost Love &
Leonardo*

PAULA
COLE
RAVES

BUSTA
RHYMES
RANTS

THE LOX,
EVERCLEAR
& THE
STONES

The Sultan of Schwing

*Sex Tips
That Work*

RS 781 | KATE WINSLET | March 5th, 1998 | PHOTOGRAPH BY PEGGY SIROTA

1990s

SOUTH PARK IS A POISONED PLACE IN THE HEART, a taste-free zone where kids say the darnedest, most fucked-up things. If *Seinfeld* made television history by positing that adults are petty, nasty, self-serving beasts, *South Park* has, during its nine-episode history, suggested that such lousy behavior doesn't begin at the age of eighteen.

By facing the ugly truth that our inner children are baby-faced sadists with big eyes, the show has broken our sweetest taboo and revealed childhood as a dangerous and obscene place. As the warning before the show explains, "The following program contains coarse language, and, due to its content, it should not be viewed by anyone."

"That's how we pitched the show when we went around town," says Parker. "There's this whole thing out there about how kids are so innocent and pure. That's bullshit, man. Kids are malicious little fuckers. They totally jump on any bandwagon and rip on the weak guy at any chance. They say whatever bad word they can think of. They are total fucking bastards, but for some reason everyone has kids and forgets about what they were like when they were kids."

[EXCERPT FROM RS 780 COVER STORY BY DAVID WILD]

SPECIAL DOUBLE ISSUE

RollingStone

THE
GIRLS OF
SCREAM
2 | AND
THE
PLEASURES
OF TERROR
TONGUE TRICKS, DIRTY TALK AND
SHOCKING SLUMBER-PARTY SECRET

1997 | The Best Music,
Movies and TV
ROCK
& ROLL
YEARBOOK
2 DYLANS, 3 HANSONS, 5 SPICES
AND 101 REASONS TO WATCH TELEVISION

SUBLIME'S
LIFE AFTER
DEATH

TORI
SPELLING
and her
Scream-mates
in hot water

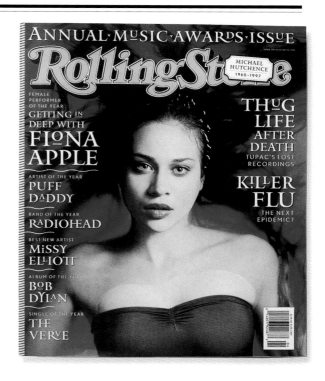

ANNUAL·MUSIC·AWARDS·ISSUE

RollingStone

MICHAEL
HUTCHENCE
1960-1997

FEMALE
PERFORMER
OF THE YEAR
GETTING IN
DEEP WITH
FIONA
APPLE

ARTIST OF THE YEAR
PUFF
DADDY

BAND OF THE YEAR
RADIOHEAD

BEST NEW ARTIST
MISSY
ELLIOTT

ALBUM OF THE YEAR
BOB
DYLAN

SINGLE OF THE YEAR
THE
VERVE

THUG
LIFE
AFTER
DEATH
TUPAC'S LOST
RECORDINGS

KILLER
FLU
THE NEXT
EPIDEMIC?

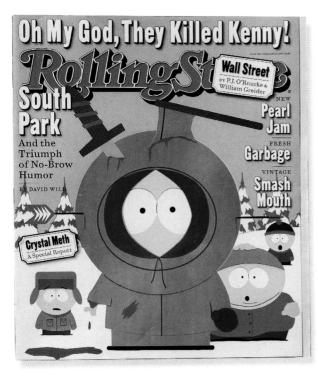

Oh My God, They Killed Kenny!

RollingStone

Wall Street
BY P.J. O'Rourke &
William Greider

South
Park
And the
Triumph
of No-Brow
Humor
BY DAVID WILD

NEW
Pearl
Jam

FRESH
Garbage

VINTAGE
Smash
Mouth

Crystal Meth
A Special Report

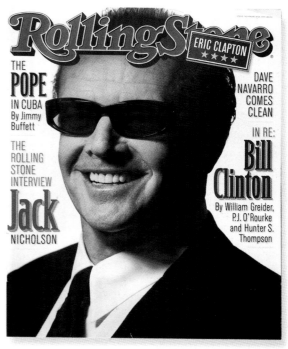

RollingStone

ERIC CLAPTON
★★★★

THE
POPE
IN CUBA
By Jimmy
Buffett

THE
ROLLING
STONE
INTERVIEW
Jack
NICHOLSON

DAVE
NAVARRO
COMES
CLEAN

IN RE:
Bill
Clinton
By William Greider,
P.J. O'Rourke
and Hunter S.
Thompson

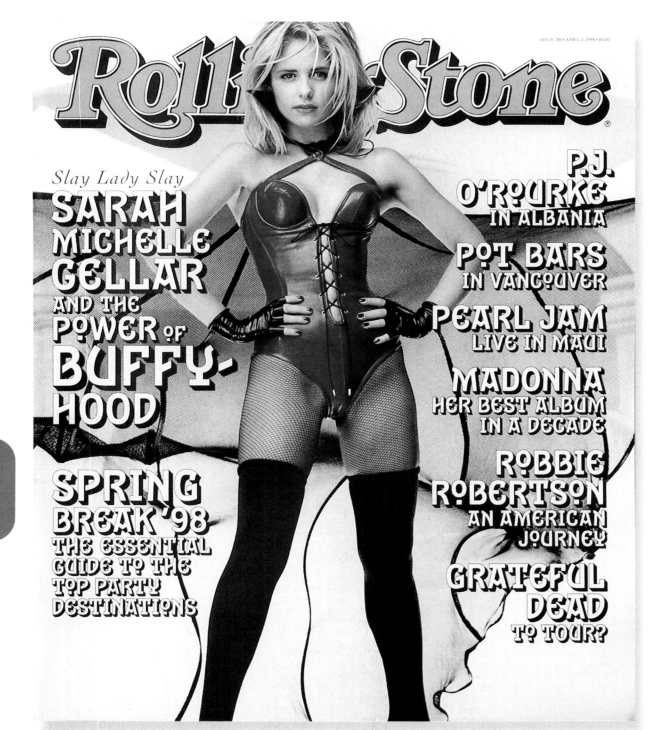

ISSUE 783 • APRIL 2, 1998 • $3.00

Slay Lady Slay

SARAH MICHELLE GELLAR AND THE POWER OF BUFFY-HOOD

SPRING BREAK '98 THE ESSENTIAL GUIDE TO THE TOP PARTY DESTINATIONS

1990s

P.J. O'ROURKE IN ALBANIA

POT BARS IN VANCOUVER

PEARL JAM LIVE IN MAUI

MADONNA HER BEST ALBUM IN A DECADE

ROBBIE ROBERTSON AN AMERICAN JOURNEY

GRATEFUL DEAD TO TOUR?

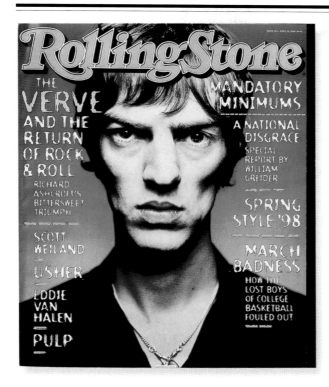

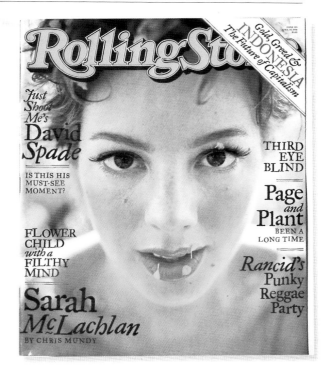

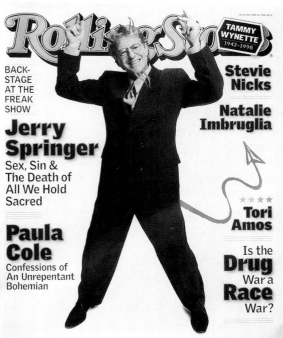

RS 784 | RICHARD ASHCROFT
April 16th, 1998
PHOTOGRAPH BY MARK SELIGER

RS 785 | SARAH McLACHLAN
April 30th, 1998
PHOTOGRAPH BY PEGGY SIROTA

RS 786 | JERRY SPRINGER
May 14th, 1998
PHOTOGRAPH BY MARK SELIGER

HER LOOK IS DESIGNER FLOWER CHILD –
Stevie Nicks with an eye on fashion runways –
but in person, Sarah McLachlan doesn't play the
part. Perhaps it is because she doesn't bother to hide
her business savvy. Or because her favorite pastime
is burping louder than anyone else in the room.
Whatever the reasons, the Sarah McLachlan who
stands before you is not the one you recognize from
the wispy photographs. For instance, she does not say,
"I'm very lucky," but rather, "Don't think I don't count
the horseshoes on my ass daily." Demure she is not.

[EXCERPT FROM RS 785 COVER STORY BY CHRIS MUNDY]

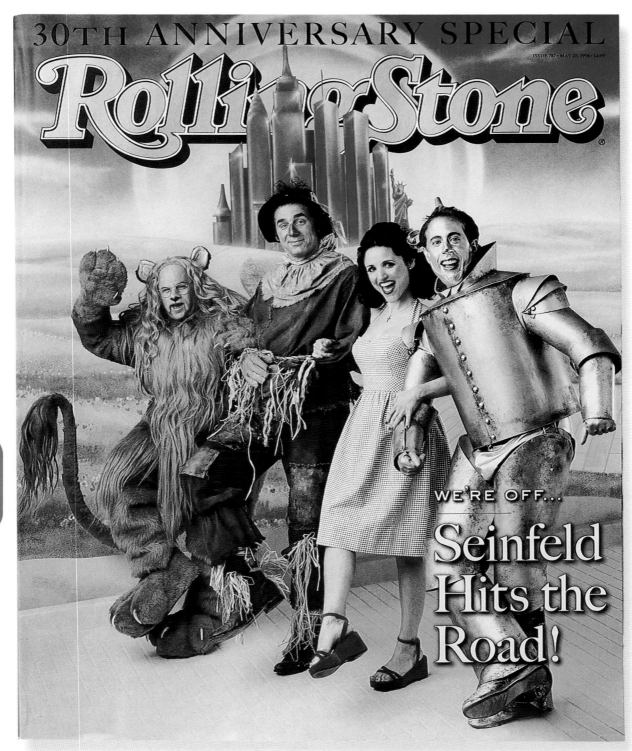

ISSUE 787 • MAY 28, 1998 • $4.95

RollingStone

1990s

WE'RE OFF...

Seinfeld
Hits the
Road!

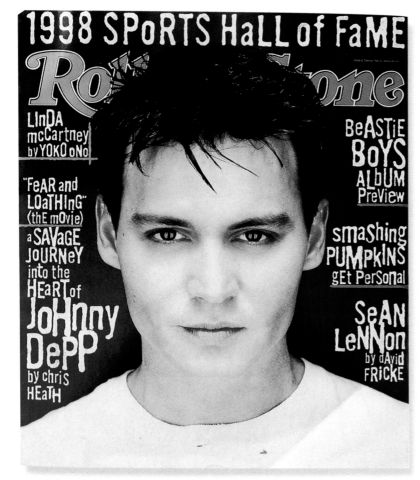

1998 SPORTS HaLL of FaME

Ro···one

LinDa mccARtney by YOKO oNo

"FeAR and LOaTHiNG" (thE mOvie) a SAVaGE JoURNeY into the HEaRT of JoHNny DePP by chris HEaTH

BeASTiE BoYS ALbUM PreView

smASHiNG PUMPKiNS gEt PerSonAL

SeAN LeNNon by dAvid FRiCKE

RS 788 | JOHNNY DEPP | June 11th, 1998 | Photograph by Dan Winters

[RS 788] Johnny Depp has been favored with three covers; this is his second. This appearance was timed to his portrayal of Hunter S. Thompson's alter ego, Raoul Duke, in the film adaptation of what Thompson called "the Vegas book": *Fear and Loathing in Las Vegas.*

RS 787 | THIRTIETH ANNIVERSARY SPECIAL: CAST OF 'SEINFELD'
May 28th, 1998
Photograph by Mark Seliger

IT'S OVER. WHEN THE LIGHTS come up at the end, the cast takes its curtain call. The four of them hug each other, tightly, two by two, with moist eyes. Seinfeld takes the microphone. "Ladies and gentlemen . . . " he begins and the way he does so, it is as though he is going to say more, and as if only emotion or a desire for once not to find the funny way through to his destination stops him; anyway, the statement ends almost immediately, "that is a wrap."

The cast mingles round, hugging and tearing up, and the audience joins them on the floor. Champagne and sushi circulate. Seinfeld himself slips away backstage through his alter ego's bathroom, and stands in the craft-service area with his sister and her family. "I'm very happy," he tells them. "The past months . . . the guy in the circus with the steel balls . . ." He mimes a circular juggling motion to explain what he means. "Well, I better go and wash away my makeup."

[EXCERPT FROM RS 787 COVER STORY BY CHRIS HEATH]

"*Kramer has* no brain, George has no courage, Jerry has no heart, and Elaine has no friends."
—*Jason Alexander*

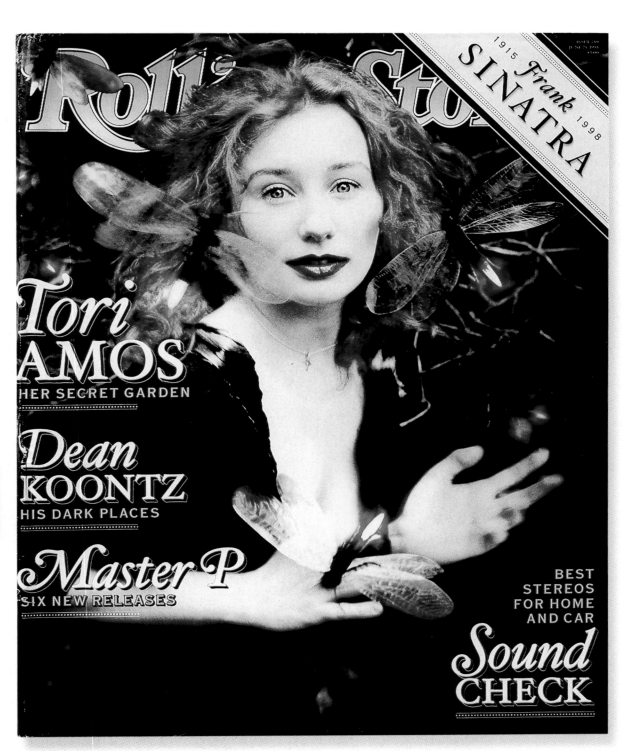

ISSUE 789
JUNE 25 1998
$3.95

1915 Frank 1998
SINATRA

Tori
AMOS
HER SECRET GARDEN

Dean
KOONTZ
HIS DARK PLACES

Master P
SIX NEW RELEASES

BEST
STEREOS
FOR HOME
AND CAR
Sound
CHECK

RS 789 | TORI AMOS | June 25th, 1998 | PHOTOGRAPH BY DAVID LaCHAPELLE

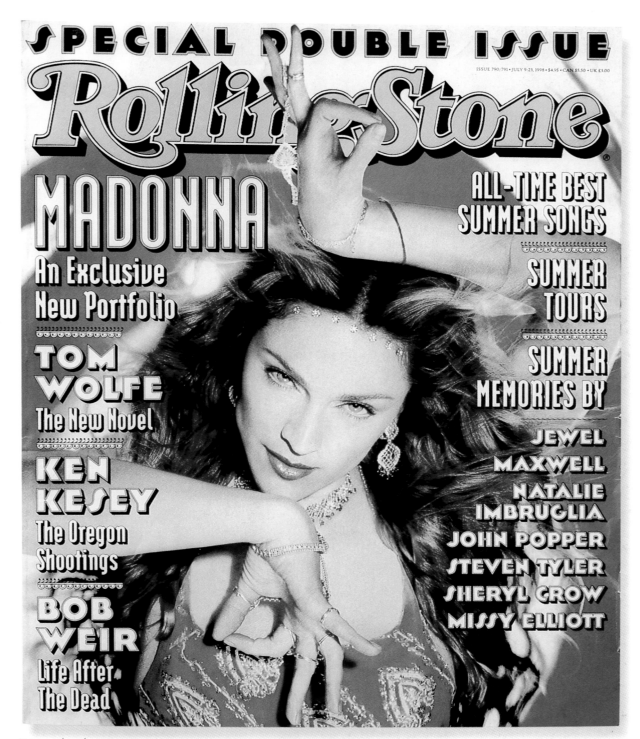

SPECIAL DOUBLE ISSUE

Rolling Stone

ISSUE 790/791 • JULY 9-23, 1998 • $4.95 • CAN $5.50 • UK £3.00

MADONNA
An Exclusive New Portfolio

TOM WOLFE
The New Novel

KEN KESEY
The Oregon Shootings

BOB WEIR
Life After The Dead

ALL-TIME BEST SUMMER SONGS

SUMMER TOURS

SUMMER MEMORIES BY

JEWEL
MAXWELL
NATALIE IMBRUGLIA
JOHN POPPER
STEVEN TYLER
SHERYL CROW
MISSY ELLIOTT

RS 790/791 | MADONNA | July 9th – July 23, 1998 | Photograph by David LaChapelle

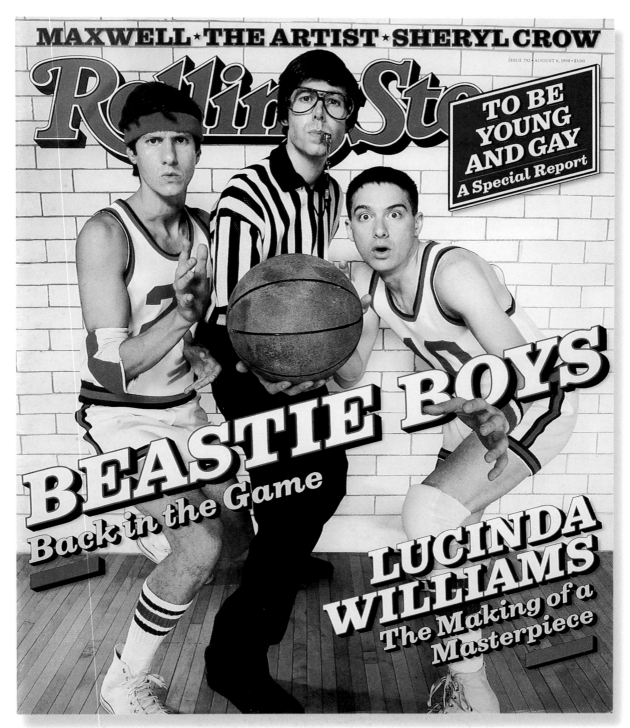

MAXWELL ★ THE ARTIST ★ SHERYL CROW

Rolling Stone

ISSUE 792 • AUGUST 6, 1998 • $3.00

TO BE
YOUNG
AND GAY
A Special Report

BEASTIE BOYS
Back in the Game

LUCINDA
WILLIAMS
The Making of a
Masterpiece

1990s

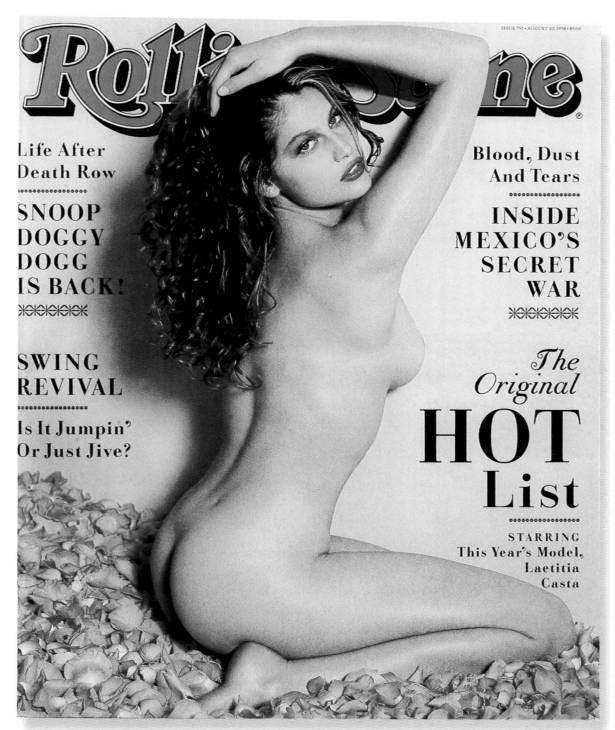

ISSUE 793 · AUGUST 20, 1998 · $3.00

Life After Death Row

SNOOP DOGGY DOGG IS BACK!

SWING REVIVAL

Is It Jumpin' Or Just Jive?

Blood, Dust And Tears

INSIDE MEXICO'S SECRET WAR

The Original **HOT** List

STARRING
This Year's Model, Laetitia Casta

RS 793 | LAETITIA CASTA | August 20th, 1998 | PHOTOGRAPH BY HERB RITTS

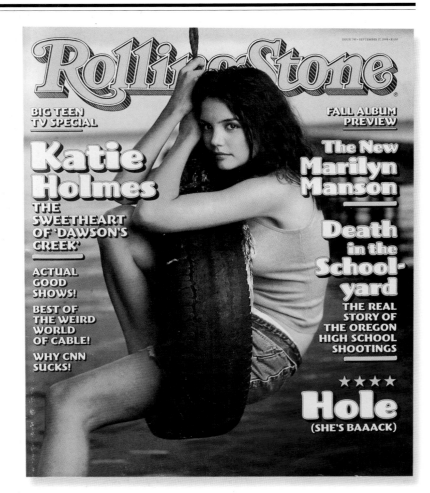

R*S* 795 | KATIE HOLMES
September 17th, 1998
PHOTOGRAPH BY MARK SELIGER

R*S* 794 | SHANIA TWAIN
September 3rd, 1998
PHOTOGRAPH BY MARK SELIGER

R*S* 796 | JANET JACKSON
October 1st, 1998
PHOTOGRAPH BY MARK SELIGER

R*S* 798 | MASTER P, WYCLEF JEAN & JAY-Z
October 29th, 1998
PHOTOGRAPH BY MATT MAHURIN

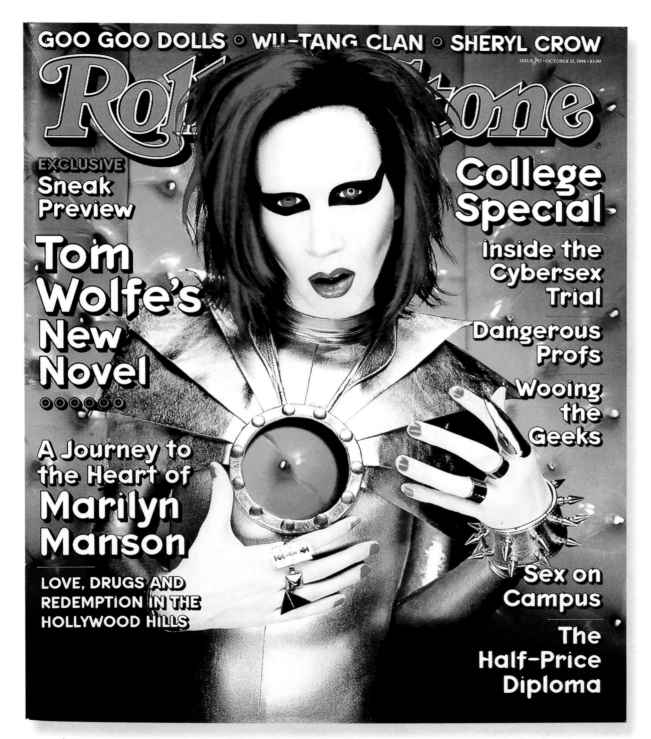

GOO GOO DOLLS ○ WU-TANG CLAN ○ SHERYL CROW

ISSUE 797 • OCTOBER 15, 1998 • $3.00

Rolling Stone

Sneak
Preview

Tom
Wolfe's
New
Novel
○○○○○

A Journey to
the Heart of
Marilyn
Manson

LOVE, DRUGS AND
REDEMPTION IN THE
HOLLYWOOD HILLS

College
Special

Inside the
Cybersex
Trial

Dangerous
Profs

Wooing
the
Geeks

Sex on
Campus

The
Half-Price
Diploma

RS 797 | MARILYN MANSON | October 15th, 1998 | PHOTOGRAPH BY MARK SELIGER

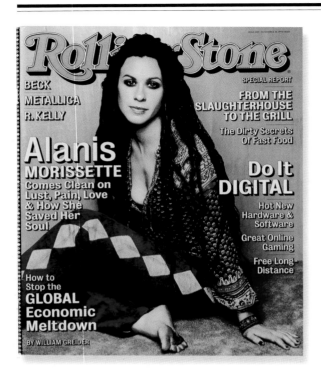

ROLLING STONE

BECK
METALLICA
R. KELLY

SPECIAL REPORT

Alanis
MORISSETTE
Comes Clean on
Lust, Pain, Love
& How She
Saved Her
Soul

FROM THE
SLAUGHTERHOUSE
TO THE GRILL
The Dirty Secrets
Of Fast Food

Do It DIGITAL

Hot New
Hardware &
Software

Great Online
Gaming

Free Long-
Distance

How to
Stop the
**GLOBAL
Economic
Meltdown**
BY WILLIAM GREIDER

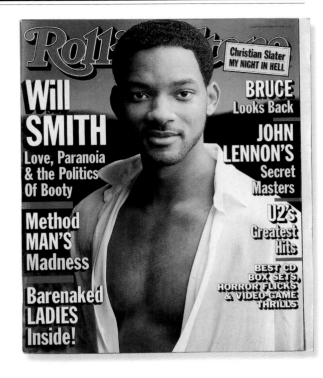

ROLLING STONE

Christian Slater
MY NIGHT IN HELL

**Will
SMITH**
Love, Paranoia
& the Politics
Of Booty

**Method
MAN'S
Madness**

**Barenaked
LADIES
Inside!**

BRUCE
Looks Back

**JOHN
LENNON'S**
Secret
Masters

**U2's
Greatest
Hits**

BEST CD
BOX SETS,
HORROR FLICKS
& VIDEO GAME
THRILLS

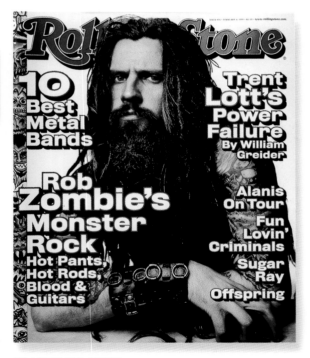

ROLLING STONE

**10
Best
Metal
Bands**

**Rob
Zombie's
Monster
Rock**
Hot Pants,
Hot Rods,
Blood &
Guitars

**Trent
Lott's
Power
Failure**
By William
Greider

**Alanis
On Tour**

**Fun
Lovin'
Criminals**

**Sugar
Ray**

Offspring

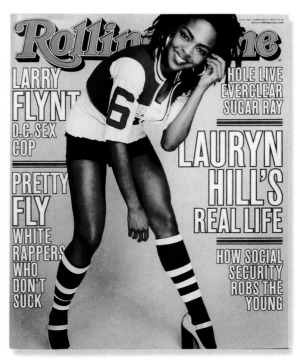

ROLLING STONE

LARRY
FLYNT
D.C. SEX
COP

PRETTY
FLY
WHITE
RAPPERS
WHO
DON'T
SUCK

HOLE LIVE
EVERCLEAR
SUGAR RAY

**LAURYN
HILL'S
REAL LIFE**

HOW SOCIAL
SECURITY
ROBS THE
YOUNG

1990s

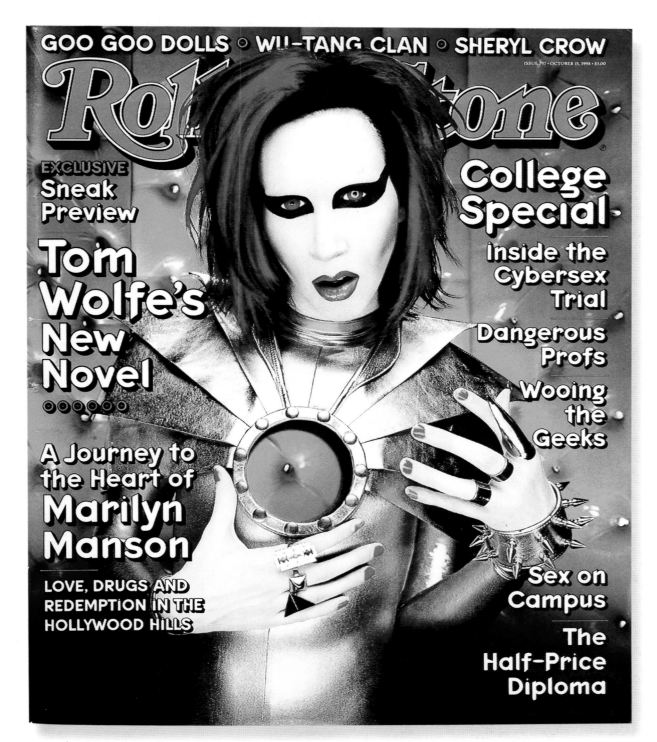

GOO GOO DOLLS ○ WU-TANG CLAN ○ SHERYL CROW

Rolling Stone

ISSUE 797 • OCTOBER 15, 1998 • $3.00

EXCLUSIVE
Sneak
Preview

Tom
Wolfe's
New
Novel
ⓞⓞⓞⓞⓞⓞ

A Journey to
the Heart of
Marilyn
Manson

LOVE, DRUGS AND
REDEMPTION IN THE
HOLLYWOOD HILLS

College
Special

Inside the
Cybersex
Trial

Dangerous
Profs

Wooing
the
Geeks

Sex on
Campus

The
Half-Price
Diploma

RS 797 | MARILYN MANSON | *October 15th, 1998* | PHOTOGRAPH BY MARK SELIGER

The current situation gives off whiffs of high school ("But why? We never went all the way") rather than high crimes. So why not settle for a high school conduct-committee solution? Suspend the president for a certain interval – 90 days, 120 days – let the vice president and his wife take over the White House, and then, after validation by the three-preacher Penitence Panel already chosen, let the president return and serve out his term.

— *Tom Wolfe*
[EXCERPT FROM RS 799]

"WHEN I LOOK AT THE CRUCIFIXION of Clinton, I look at the crucifixion of my generation. They are finally nailing us for introducing new ideas about sexual mores, sexual freedom, personal freedom: 'OK, you wanted sexual freedom, we're gonna give it to you – to the point where it is going to saturate and sicken the whole planet.' "
— *Patti Smith*

"To the rest of the world, America looks like a teenager in a masturbatory frenzy of voyeurism and *Schadenfreude*: ratings vs. decency, a Salem witch hunt for evidence vs. the human right to some kind of privacy, even in the wrong.

Stop it – America is better than this." —*Bono*

"I GUESS YOU COULD SAY KEN Starr is acting responsibly – if Clinton had, in fact, killed Monica Lewinsky after blowing a load on her dress. Clinton engaged in reckless adolescent behavior, but it's not for me to forgive him. It's none of my business. I mean, if he had done it on my dress, yeah, then I think we'd have an issue here; but as far as I know, he didn't ruin any of my clothes.

In the end, something really terrible is going to happen. Truly catastrophic, like some guy is going to get anthrax in a bottle and put it in our soft drinks or something. We will look back on these days with the kind of nostalgia that people have when they talk about nickel movies. We'll look back and go, 'Oh, remember the days when all we worried about was the president blowing his load on someone's dress?' "
— *Jon Stewart*

"IT'S GOOD THAT AMERICA HAS someone else to scrutinize, take apart, invade. I think he's done a good job for the country, and I think there's no reason why he shouldn't be getting laid just like a rock star would. Do they have backstage passes for the Oval Office? Did Monica Lewinsky have to sleep her way to the president? Go through the tour manager first? I don't think he deserves to be impeached; but if he does get impeached, he always has a job with me. He can be my tour manager, test-drive the girls for me."
— *Marilyn Manson*

"THIS IS A SLOW POLITICAL COUP D'ETAT. It is pretty obvious that we've got our tit in the wringer and we don't really know how to get out of it. I'm a big Clinton supporter. I think he understands the mechanics of the job better than anyone who has ever held the position, and that's really what I want. The degree to which he is able to wear his heart on his sleeve, for a man who has lived his life in the executive branch of the government, is somehow more impressive to me than the negative side of all this. I think the video deposition and his day in Ireland were the two times I was most moved for him. If you've ever had to settle a lawsuit in which you were not in the wrong, you understand what this feels like."
— *Jack Nicholson*

1990s

Rolling Stone

NOVEMBER 12, 1998 · $3.50

BEN STILLER
'N SYNC · R.E.M.
PETER WOLF

The Clinton Conversation

THE STINK AT THE
OTHER END OF
PENNSYLVANIA
AVENUE

EDDIE VEDDER,
TOM WOLFE,
JACK NICHOLSON,
PATTI SMITH,
MARILYN MANSON,
ROBERT REDFORD,
LOU REED, ICE CUBE,
WILLIE NELSON,
LUCINDA WILLIAMS,
SEAN LENNON,
MICHAEL DOUGLAS,
BILL MAHER,
SHIRLEY MANSON,
JON STEWART,
SUSAN SARANDON,
JIMMY BUFFETT

Speak Out

Newt Gingrich
BY WILLIAM GREIDER

THE HOT-AIR
BUFFOON

Bill Bennett
BY DAVID BROCK

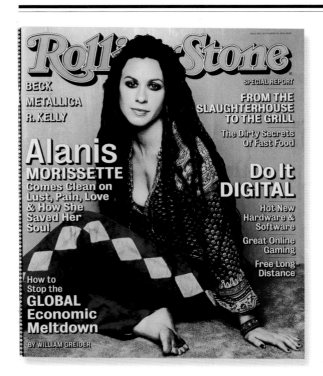

Rolling Stone

BECK
METALLICA
R. KELLY

SPECIAL REPORT

FROM THE
SLAUGHTERHOUSE
TO THE GRILL

The Dirty Secrets
Of Fast Food

Alanis
MORISSETTE
Comes Clean on
Lust, Pain, Love
& How She
Saved Her
Soul

**Do It
DIGITAL**

Hot New
Hardware &
Software

Great Online
Gaming

Free Long-
Distance

How to
Stop the
GLOBAL
Economic
Meltdown

BY WILLIAM GREIDER

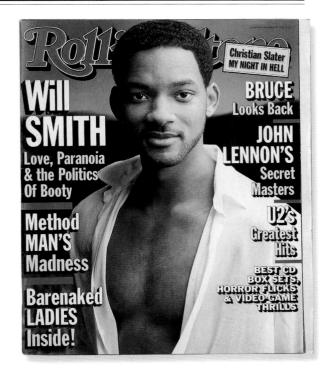

Rolling Stone

Christian Slater
MY NIGHT IN HELL

**Will
SMITH**
Love, Paranoia
& the Politics
Of Booty

**Method
MAN'S
Madness**

**Barenaked
LADIES
Inside!**

BRUCE
Looks Back

**JOHN
LENNON'S**
Secret
Masters

**U2's
Greatest
Hits**

BEST CD
BOX SETS,
HORROR FLICKS
& VIDEO-GAME
THRILLS

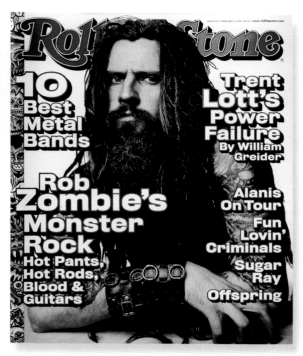

Rolling Stone

**10
Best
Metal
Bands**

**Trent
Lott's
Power
Failure**
By William
Greider

**Rob
Zombie's
Monster
Rock**
Hot Pants,
Hot Rods,
Blood &
Guitars

**Alanis
On Tour**

**Fun
Lovin'
Criminals**

**Sugar
Ray
Offspring**

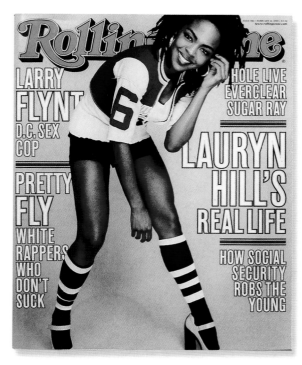

Rolling Stone

**LARRY
FLYNT**
D.C. SEX
COP

**PRETTY
FLY**
WHITE
RAPPERS
WHO
DON'T
SUCK

HOLE LIVE
EVERCLEAR
SUGAR RAY

**LAURYN
HILL'S**
REAL LIFE

HOW SOCIAL
SECURITY
ROBS THE
YOUNG

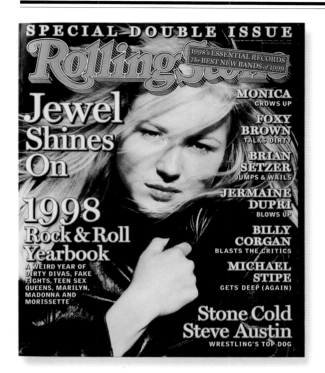

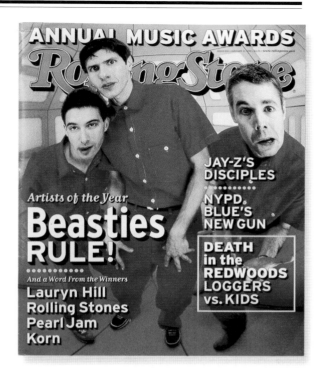

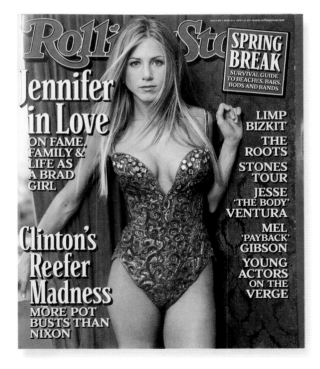

RS *810* | BRITNEY SPEARS
April 15th, 1999
PHOTOGRAPH BY DAVID LACHAPELLE

"I SAID TO [BRITNEY], 'YOU DON'T
want to be buttoned-up, like
Debbie Gibson. Let's push it
further and do this whole Lolita
thing.' She got it. She knew it would
get people talking and excited."
—*David LaChapelle*

"*Holy roller*
religious people
made such a big
deal about that
photo, and I didn't
really get it. That's
the way I've always
been, and I thought
that photo was a
good representation
of who I really am."
—*Britney Spears*

1990s

RS *808* | MARK MCGRATH | March 18th, 1999 | PHOTOGRAPH BY MARK SELIGER

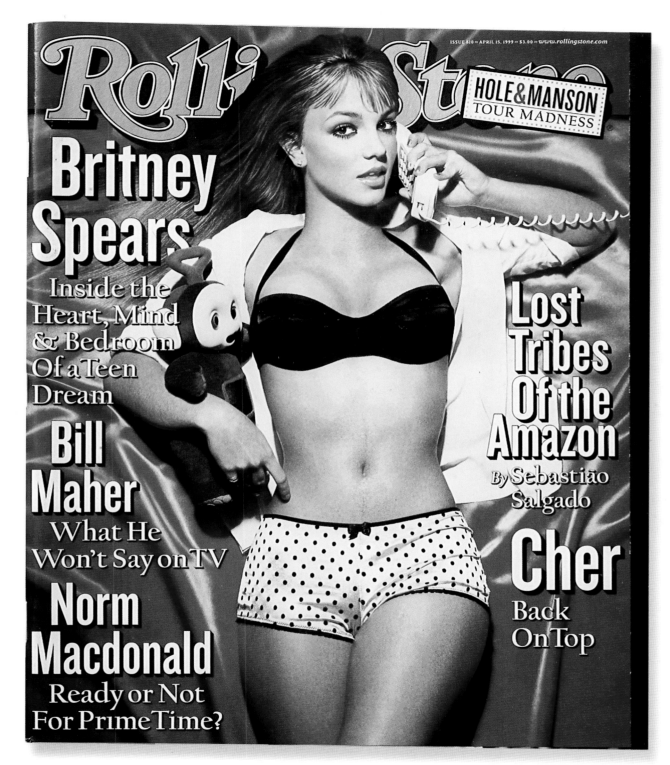

ISSUE 810 · APRIL 15, 1999 · $3.00 · www.rollingstone.com

Rolling Stone

HOLE & MANSON TOUR MADNESS

Britney Spears
Inside the Heart, Mind & Bedroom Of a Teen Dream

Bill Maher
What He Won't Say on TV

Norm Macdonald
Ready or Not For Prime Time?

Lost Tribes Of the Amazon
By Sebastião Salgado

Cher
Back On Top

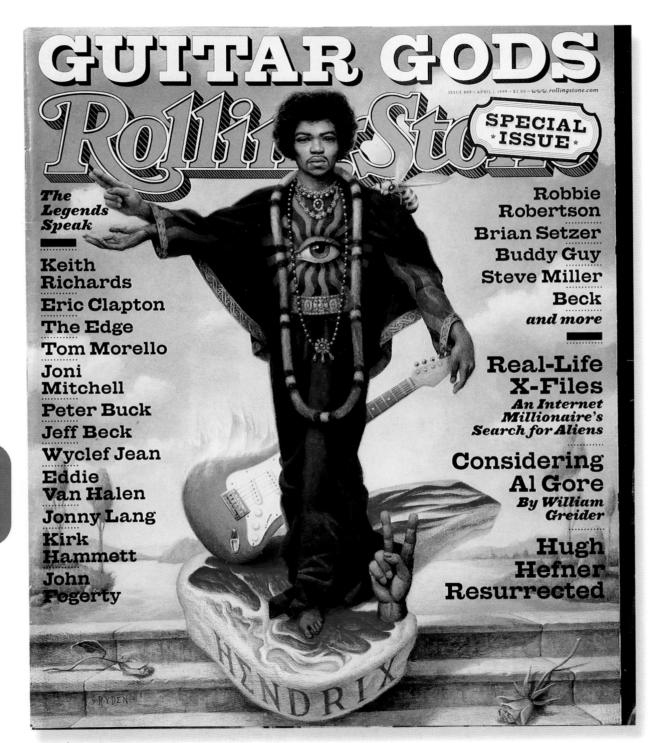

GUITAR GODS

Rolling Stone

ISSUE 809 • APRIL 1, 1999 • $3.00 • www.rollingstone.com

SPECIAL ISSUE

The Legends Speak

Keith Richards
Eric Clapton
The Edge
Tom Morello
Joni Mitchell
Peter Buck
Jeff Beck
Wyclef Jean
Eddie Van Halen
Jonny Lang
Kirk Hammett
John Fogerty

Robbie Robertson
Brian Setzer
Buddy Guy
Steve Miller
Beck
and more

Real-Life X-Files
An Internet Millionaire's Search for Aliens

Considering Al Gore
By William Greider

Hugh Hefner Resurrected

1990s

HENDRIX

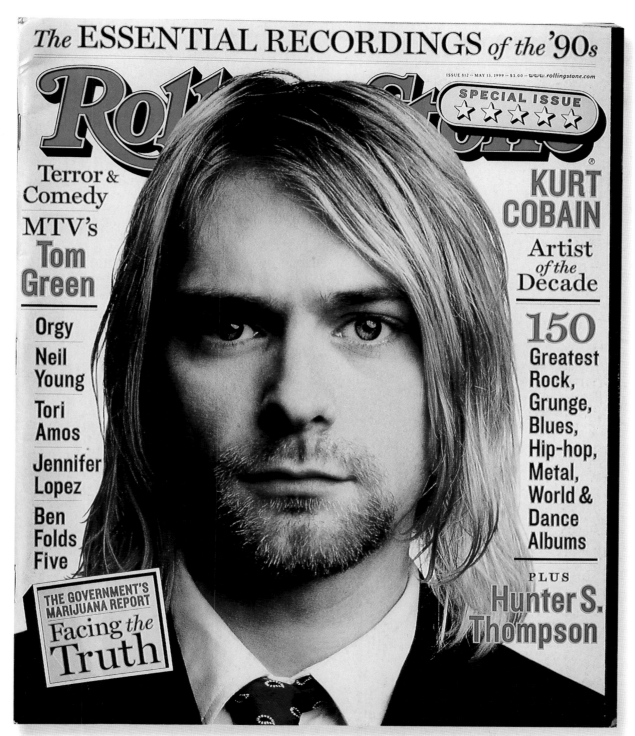

The ESSENTIAL RECORDINGS of the '90s

ISSUE 812 — MAY 13, 1999 — $3.00 — www.rollingstone.com

Rolling Stone

SPECIAL ISSUE

Terror & Comedy

MTV's **Tom Green**

Orgy

Neil Young

Tori Amos

Jennifer Lopez

Ben Folds Five

THE GOVERNMENT'S MARIJUANA REPORT
Facing *the* Truth

KURT COBAIN

Artist *of the* Decade

150 Greatest Rock, Grunge, Blues, Hip-hop, Metal, World & Dance Albums

PLUS
Hunter S. Thompson

RS 812 | KURT COBAIN | May 13th, 1999 | PHOTOGRAPH BY MARK SELIGER

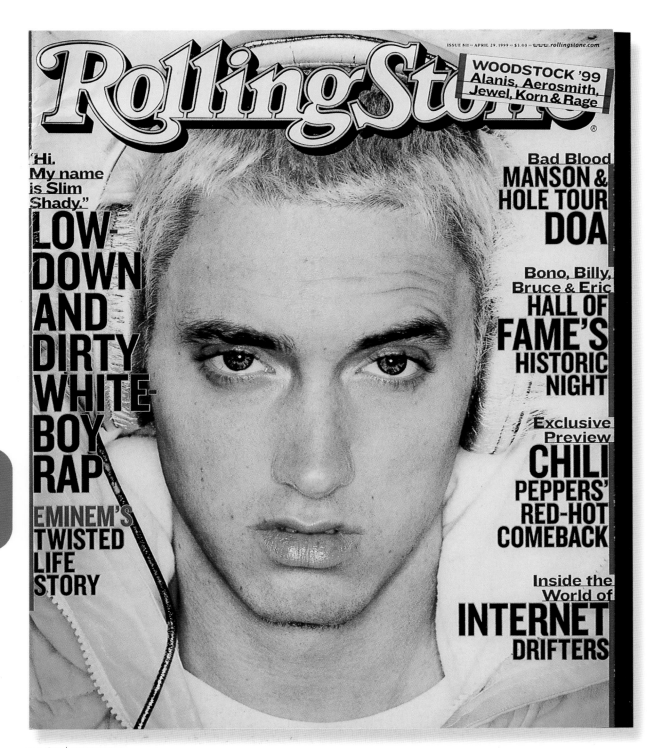

ISSUE 811 ~ APRIL 29, 1999 ~ $3.00 ~ www.rollingstone.com

Rolling Stone

"Hi.
My name
is Slim
Shady."

LOW-DOWN AND DIRTY WHITE-BOY RAP

EMINEM'S TWISTED LIFE STORY

Bad Blood
MANSON & HOLE TOUR DOA

Bono, Billy, Bruce & Eric
HALL OF FAME'S HISTORIC NIGHT

Exclusive Preview
CHILI PEPPERS' RED-HOT COMEBACK

Inside the World of
INTERNET DRIFTERS

1990s

RS 811 | EMINEM | April 29th, 1999 | Photograph by David LaChapelle

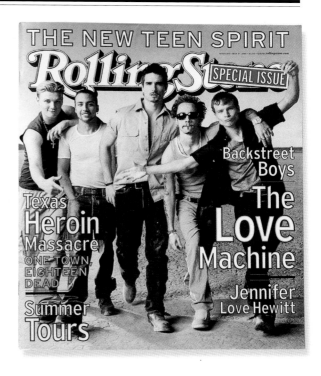

RS 813 | JENNIFER LOVE HEWITT
May 27th, 1999
PHOTOGRAPH BY STEWART SHINING

RS 813 | BACKSTREET BOYS
May 27th, 1999
PHOTOGRAPH BY MARK SELIGER

RS 815 | JAR JAR BINKS
June 24th, 1999
IMAGE CREATED BY INDUSTRIAL LIGHT & MAGIC

[RS 813] To celebrate the rise of teen culture (and to take advantage of rising teen purchasing power), ROLLING STONE published two covers for this special issue on the New Teen Spirit, putting the *Party of Five* princess on one and the reigning boy-band sensation on the other. The issue featured twenty-five stars – including Alanis Morissette, Snoop Dogg, Marilyn Manson, Lenny Kravitz and Joe Perry – reminiscing about their awkward high school years.

RS 814 | MIKE MYERS | June 10th, 1999 | Photograph by Mark Seliger

[MIKE] MYERS is a strange man to spend time with. He tells you a lot without showing any willingness to open himself up. Though his conversation is littered with jokes, he almost seems slightly put-off if you particularly laugh at them. He has the demeanor of a man who comes from a sweeter and kinder world than the one most of us live in and who in private tries to re-create that around him. One evening, a little frustrated, he launches into the following speed rap: "The root gratitude of it is that I love doing this stuff. It's very cool that I get to do what I do. You know, I swear on my father's grave, I could give a shit about the money. It doesn't mean anything to me. I could happily live in a socialist utopia of 'To each according to his needs and from each according to his abilities' and just have me and [my wife] Robin and an apartment that works."

[EXCERPT FROM RS 814 COVER STORY
BY CHRIS HEATH]

RS 816/817 | NICOLE KIDMAN | July 8th – July 22nd, 1999 | PHOTOGRAPH BY HERB RITTS

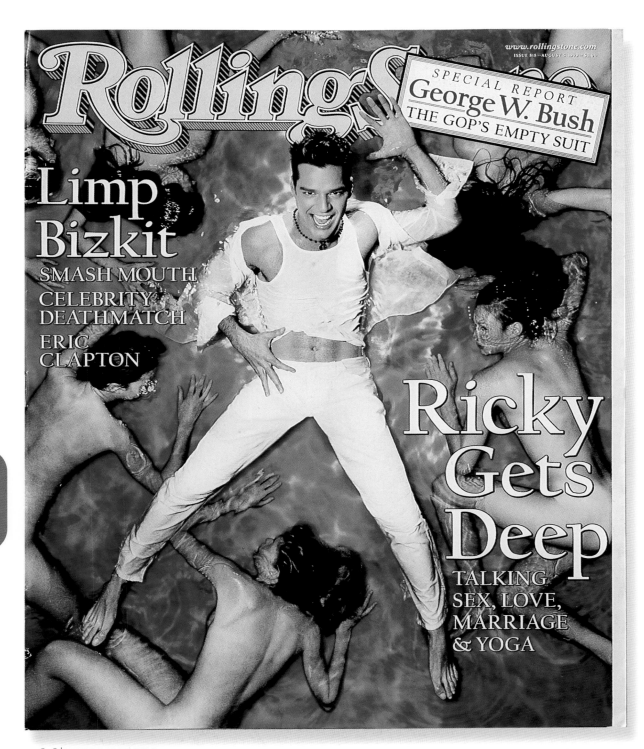

Rolling Stone

SPECIAL REPORT
George W. Bush
THE GOP'S EMPTY SUIT

Limp Bizkit
SMASH MOUTH
CELEBRITY
DEATHMATCH
ERIC
CLAPTON

1990s

Ricky Gets Deep
TALKING
SEX, LOVE,
MARRIAGE
& YOGA

RS 818 | RICKY MARTIN | August 5th, 1999 | Photograph by David LaChapelle

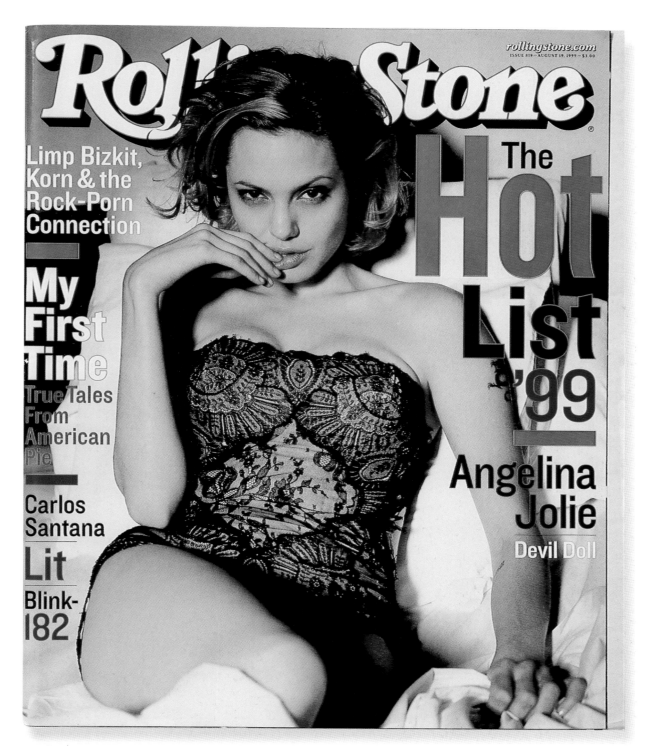

RS 819 | ANGELINA JOLIE | August 19th, 1999 | Photograph by Mark Seliger

"*Brad says,*

'I've got a real weird idea. For this movie I'm doing [*Fight Club*], I'm going to have to be pretty big. I'm going to have chipped teeth and a nice shaved head. And I thought about you shooting me in dresses – what do you think of that?' And I say, 'That sounds pretty funny.' And he says, 'But we're not talking about me in drag; we're talking about me coming from another planet.' "

—*Mark Seliger*

RS 820 | SUMMER CONCERTS 1999
September 2nd, 1999
VARIOUS PHOTOGRAPHERS

RS 822 | THE GREATEST CONCERTS OF THE NINETIES – EDDIE VEDDER
September 30th, 1999
PHOTOGRAPH BY LANCE MERCER

RS 821 | DAVID SPADE
September 16th, 1999
PHOTOGRAPH BY MARK SELIGER

RS 823 | TRENT REZNOR
October 14th, 1999
PHOTOGRAPH BY MARK SELIGER

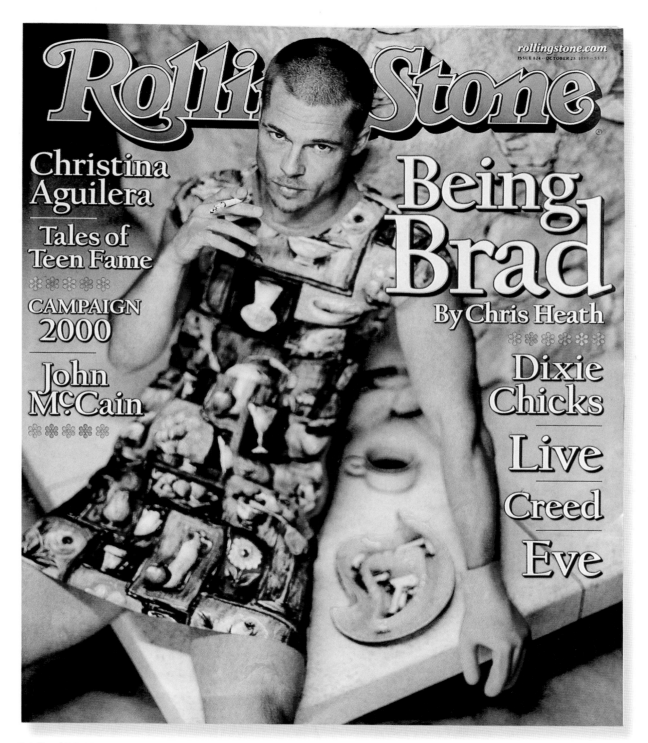

RS 824 | BRAD PITT | October 28th, 1999 | PHOTOGRAPH BY MARK SELIGER

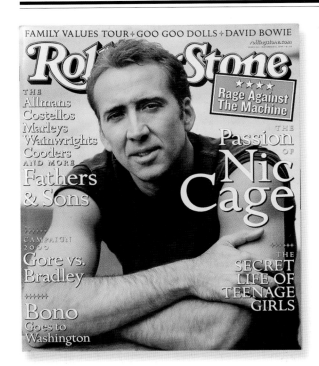

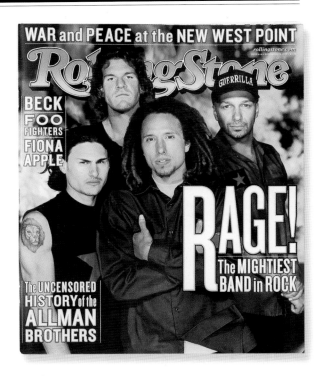

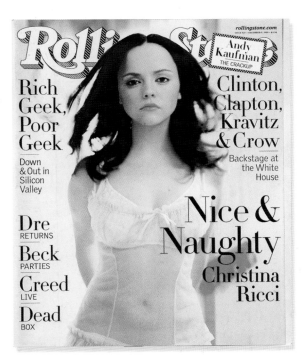

\mathcal{RS} 825 | NICOLAS CAGE
November 11th, 1999
PHOTOGRAPH BY PETER LINDBERGH

\mathcal{RS} 826 | RAGE AGAINST THE MACHINE
November 25th, 1999
PHOTOGRAPH BY MARTIN SCHOELLER

\mathcal{RS} 827 | CHRISTINA RICCI
December 9th, 1999
PHOTOGRAPH BY PEGGY SIROTA

[RS 828/829] "You are about to take an insider's tour of the history of rock & roll, ROLLING STONE and three decades of photojournalism, all at once," wrote the editors by way of introducing this special issue. The issue not only showcased photographs by all of the magazine's greatest contributors – Baron Wolman, Herb Ritts, Annie Leibovitz, Anton Corbijn, Mark Seliger, David LaChapelle, and others – but also told the fabled stories behind those fantastic shots.

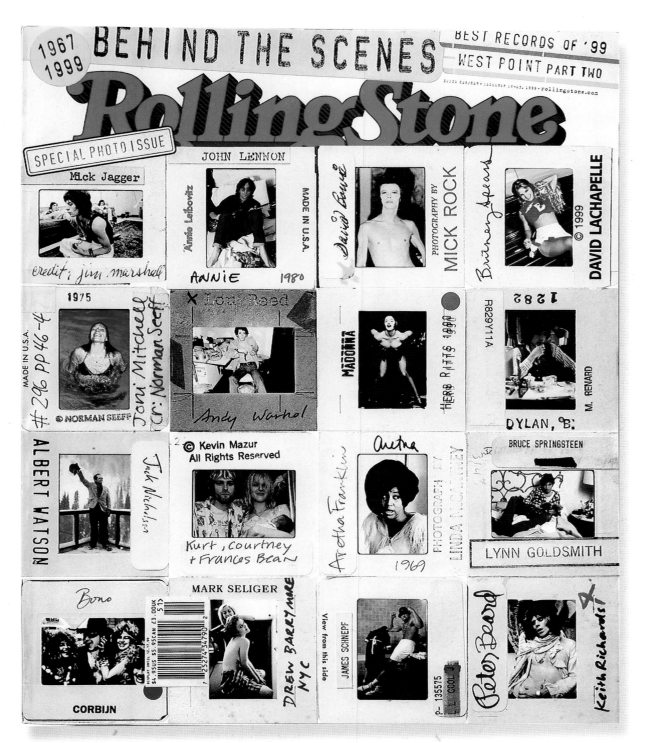

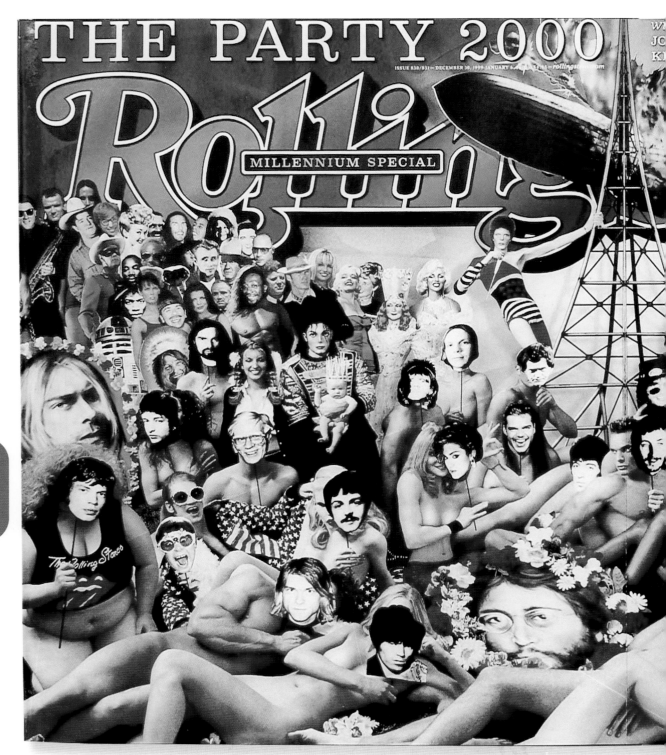

1990s

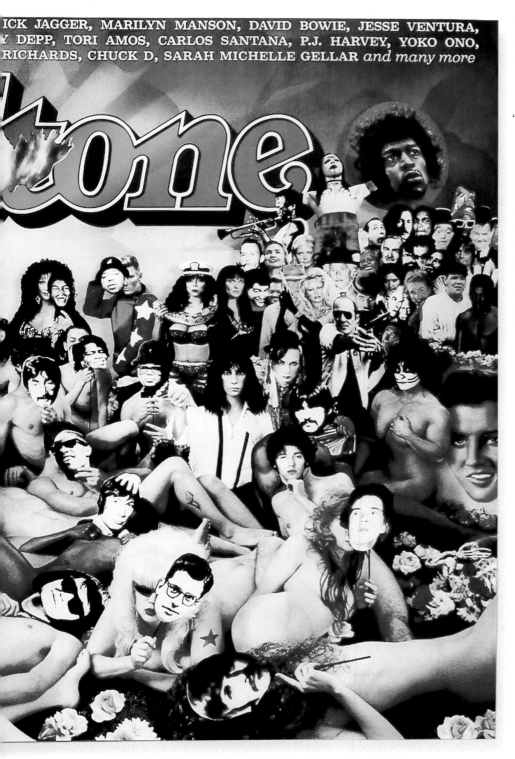

ICK JAGGER, MARILYN MANSON, DAVID BOWIE, JESSE VENTURA, Y DEPP, TORI AMOS, CARLOS SANTANA, P.J. HARVEY, YOKO ONO, RICHARDS, CHUCK D, SARAH MICHELLE GELLAR *and many more*

RS 830/831
THE PARTY 2000
December 30th , 1999 –
January 6th, 2000
PHOTOGRAPH BY
DAVID LaCHAPELLE

"I JUST WANTED TO throw a party. I wanted to capture that kind of anarchy and chaos and all that communal sexuality. That's why La Toya Jackson and Vanilla Ice are there – whenever you throw a party, there are strangers who show up uninvited and push their way to the front, with no rhyme or reason. And that's what rock history is like."
 —*David LaChapelle*

rollingstone.com
ISSUE 833—FEBRUARY 3, 2000—$3.00

Rolling Stone

The
Name of
the Father
and the
Making of
a New
American
Family

2000s

2000

It was beginning to get ridiculous: the speculation . . . the rumors . . . the jokes. For three long years, Melissa Etheridge and her partner, filmmaker Julie Cypher, were asked the same question over and over: Who is the biological father of your two children? Once it was a tad amusing to the couple. Then, with the release of Etheridge's album *Breakdown,* her first in more than three years, the badgering intensified.

"We just got so tired of this secret," says Etheridge, who didn't even tell the rest of her family the father's name until the couple's first child, Bailey, was a year old. "It wears you out. And keeping this big secret goes against how we are choosing to live our lives: very openly." There was also the consideration that Bailey, now three, will attend school soon: "I didn't want my kids to ever be in a position where someone could come up to them and know something they don't."

Thus, after much discussion, the two have decided to reveal the identity of their two children's biological father. It is a man whose name, it is safe to say, has never come up on a short list of candidates. As you can see, it is – of all people – David Crosby, founding member of the Byrds and Crosby, Stills and Nash, a rock & roll bad boy with a four-decade-long career, a wife of twelve years and a thirty-five-year-old son.

A few questions:

What do the kids call you?

"I am Mama, Julie is Mamo," says Etheridge.

Not to put too fine a point on it, but how did the fertilization occur?

"It was artificial insemination, done privately," says Cypher.

It was decided that she should carry the babies because of Etheridge's work. "I was more the homebody, so to speak," Cypher says. "And I'm a health nut, a fanatic, so I was really good at making babies."

Some more questions:

Does Crosby share parental duties?

"It's not a parental thing for David," says Etheridge. "David and Jan totally understood that we are the parents."

"So we see them every once in a while," says Cypher.

Why break the news here?

Etheridge and Cypher decided to come to ROLLING STONE with their story after the two ran into editor and publisher Jann S. Wenner at VH1's Concert of the Century last October in Washington, D.C. "Julie was on a mission to tell everybody," says Etheridge. "She told Jann, and I made some sort of joke. I said, 'Oh, yeah, let it be known in ROLLING STONE.' And I remember leaving there going, 'Huh. Well, that's an idea. It's musical, which is really cool, it's funky, and we could tell the story the way we wanted to, before the world – well, I don't know about the world but whoever is interested in it – picked up on it and did what they were going to do."

[EXCERPT FROM RS 833 COVER STORY BY JANCEE DUNN]

RS 833 | MELISSA ETHERIDGE & DAVID CROSBY WITH FAMILIES | February 3rd, 2000 | PHOTOGRAPH BY MARK SELIGER

THE MUSIC AWARDS ISSUE

rollingstone.com
ISSUE 832 • JANUARY 20, 2000 • $3.99

Rolling Stone

Rick Danko
1942-1999

BOYS
ON TOP
Readers Poll
Artists
of the Year

2000s

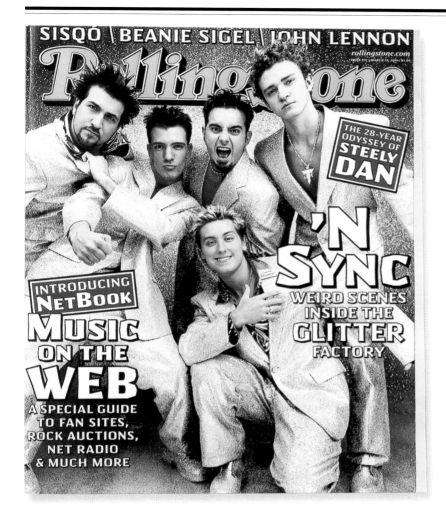

RS 837 | 'NSYNC
March 30th, 2000
PHOTOGRAPH BY STEWART SHINING

RS 835 | LEONARDO DiCAPRIO
March 2nd, 2000
PHOTOGRAPH BY MARK SELIGER

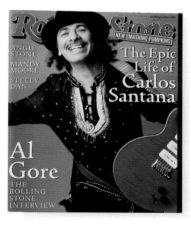

RS 836 | CARLOS SANTANA
March 16th, 2000
PHOTOGRAPH BY MARK SELIGER

"*There are restrictions to* [shooting] the covers. There is definitely a format that you need to follow. First, acquiesce to the idea that someone is going to put something on it. You can't be a page pig and decide that your photo is going to be the only thing on there."

—*Mark Seliger*

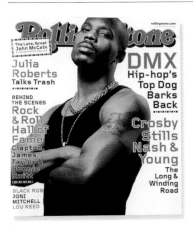

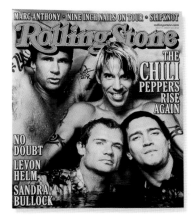

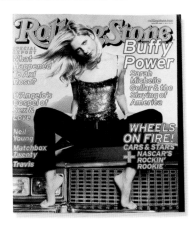

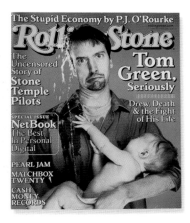

RS 838 | DMX
April 13th, 2000
PHOTOGRAPH BY ALBERT WATSON

RS 839 | RED HOT CHILI
PEPPERS
April 27th, 2000
PHOTOGRAPH BY MARTIN SCHOELLER

RS 840 | SARAH MICHELLE
GELLAR
May 11th, 2000
PHOTOGRAPH BY STEWART SHINING

RS 842 | TOM GREEN
June 8th, 2000
PHOTOGRAPH BY MARK SELIGER

RS 847 | LIVE 2000
August 17th, 2000
VARIOUS PHOTOGRAPHERS

RS 852 | JAKOB DYLAN
October 26th, 2000
PHOTOGRAPH BY MARK SELIGER

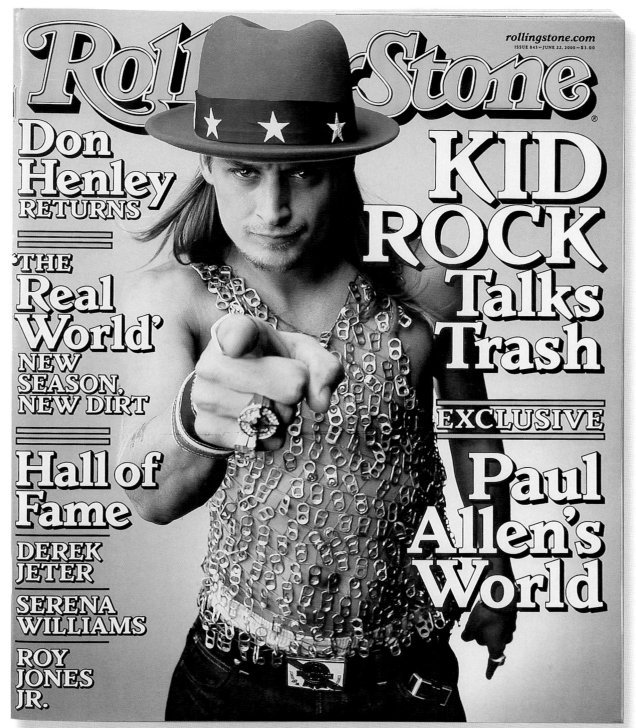

rollingstone.com
ISSUE 843 ~ JUNE 22, 2000 ~ $3.00

Rolling Stone

Don Henley RETURNS

'The Real World' NEW SEASON, NEW DIRT

Hall of Fame

DEREK JETER

SERENA WILLIAMS

ROY JONES JR.

KID ROCK Talks Trash

EXCLUSIVE

Paul Allen's World

RS 843 | KID ROCK | June 22nd, 2000 | PHOTOGRAPH BY MARK SELIGER

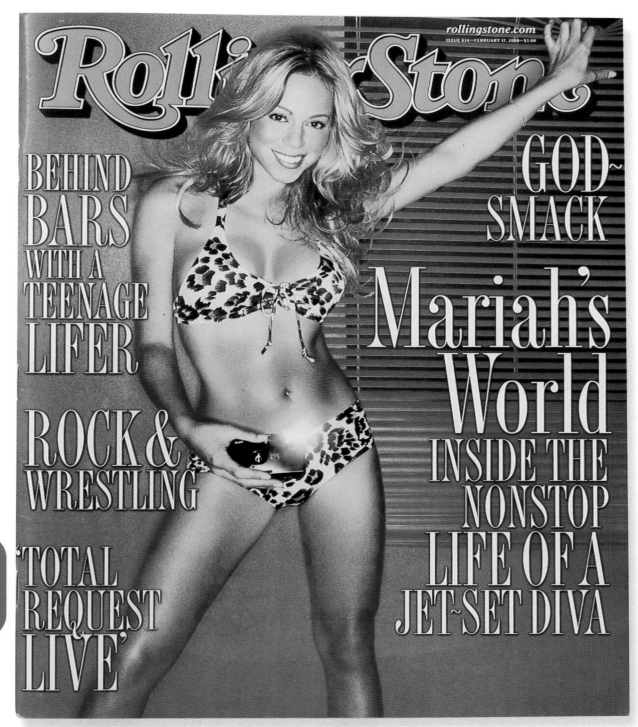

Rolling Stone

rollingstone.com
ISSUE 834~FEBRUARY 17, 2000~$3.00

BEHIND BARS WITH A TEENAGE LIFER

ROCK & WRESTLING

'TOTAL REQUEST LIVE'

GOD~ SMACK

Mariah's World
INSIDE THE NONSTOP LIFE OF A JET~SET DIVA

2000s

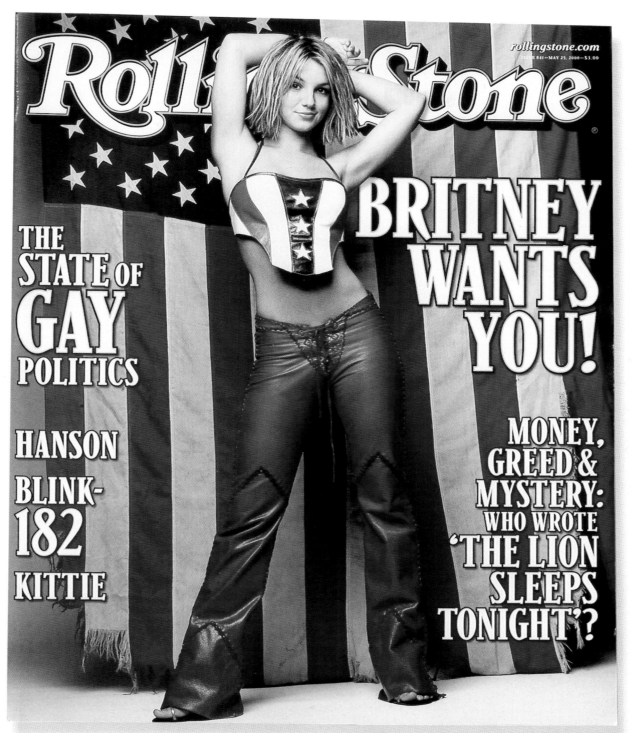

THE STATE OF GAY POLITICS

HANSON

BLINK-182

KITTIE

BRITNEY WANTS YOU!

MONEY, GREED & MYSTERY: WHO WROTE 'THE LION SLEEPS TONIGHT'?

rollingstone.com
ISSUE 841 · MAY 25, 2000 · $3.00

RS 841 | BRITNEY SPEARS | May 25th, 2000 | PHOTOGRAPH BY MARK SELIGER

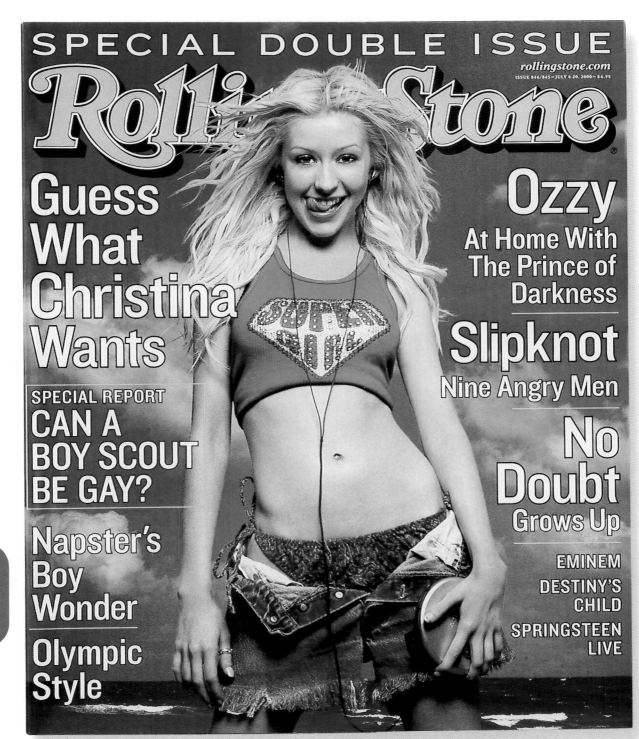

SPECIAL DOUBLE ISSUE

Rolling Stone

rollingstone.com
ISSUE 844/845 • JULY 6-20, 2000 • $4.95

Guess What Christina Wants

SPECIAL REPORT
CAN A BOY SCOUT BE GAY?

Napster's Boy Wonder

Olympic Style

Ozzy
At Home With The Prince of Darkness

Slipknot
Nine Angry Men

No Doubt
Grows Up

**EMINEM
DESTINY'S CHILD
SPRINGSTEEN
LIVE**

2000s

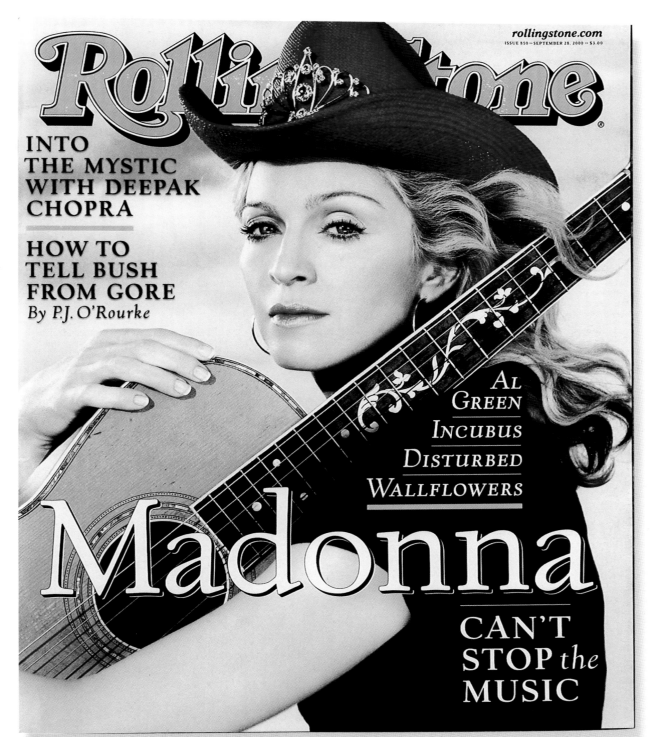

rollingstone.com
ISSUE 850 ~ SEPTEMBER 28, 2000 ~ $3.00

Rolling Stone

INTO
THE MYSTIC
WITH DEEPAK
CHOPRA

HOW TO
TELL BUSH
FROM GORE
By P.J. O'Rourke

AL
GREEN
INCUBUS
DISTURBED
WALLFLOWERS

Madonna

CAN'T
STOP *the*
MUSIC

RS 850 | MADONNA | September 28th, 2000 | Photograph by Jean-Baptiste Mondino

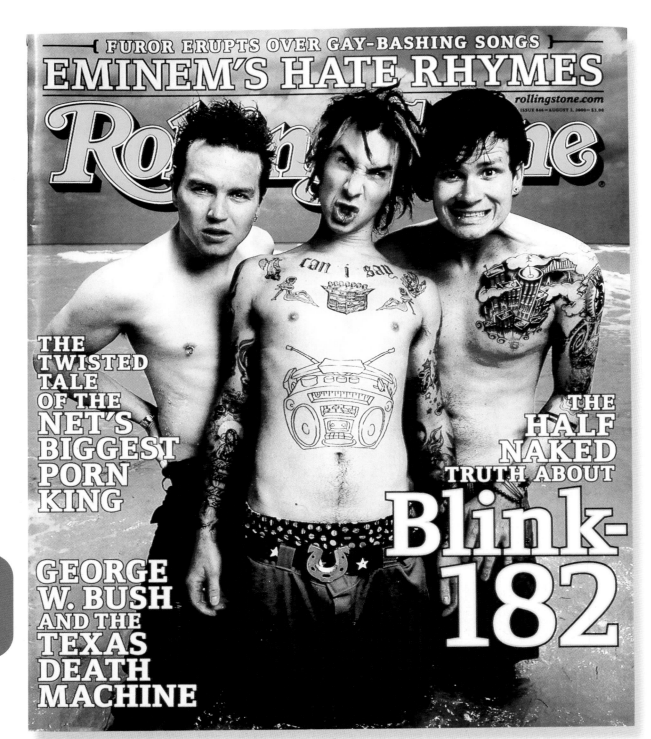

FUROR ERUPTS OVER GAY-BASHING SONGS

EMINEM'S HATE RHYMES

Rolling Stone

rollingstone.com
ISSUE 846—AUGUST 3, 2000—$3.00

THE TWISTED TALE OF THE NET'S BIGGEST PORN KING

GEORGE W. BUSH AND THE TEXAS DEATH MACHINE

can i say

THE HALF NAKED TRUTH ABOUT Blink-182

RS 846 | BLINK-182 | August 3rd, 2000 | PHOTOGRAPH BY MARK SELIGER

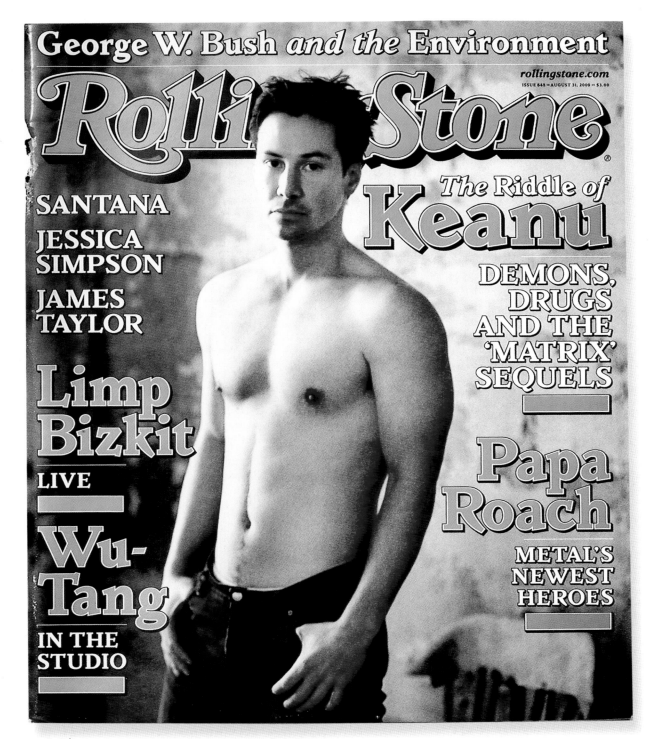

George W. Bush *and the Environment*

rollingstone.com
ISSUE 848 · AUGUST 31, 2000 · $3.00

Rolling Stone

®

SANTANA

JESSICA
SIMPSON

JAMES
TAYLOR

Limp
Bizkit

LIVE

Wu-
Tang

IN THE
STUDIO

The Riddle of
Keanu

DEMONS,
DRUGS
AND THE
'MATRIX'
SEQUELS

Papa
Roach

METAL'S
NEWEST
HEROES

RS 848 | KEANU REEVES | August 31st, 2000 | PHOTOGRAPH BY MARK SELIGER

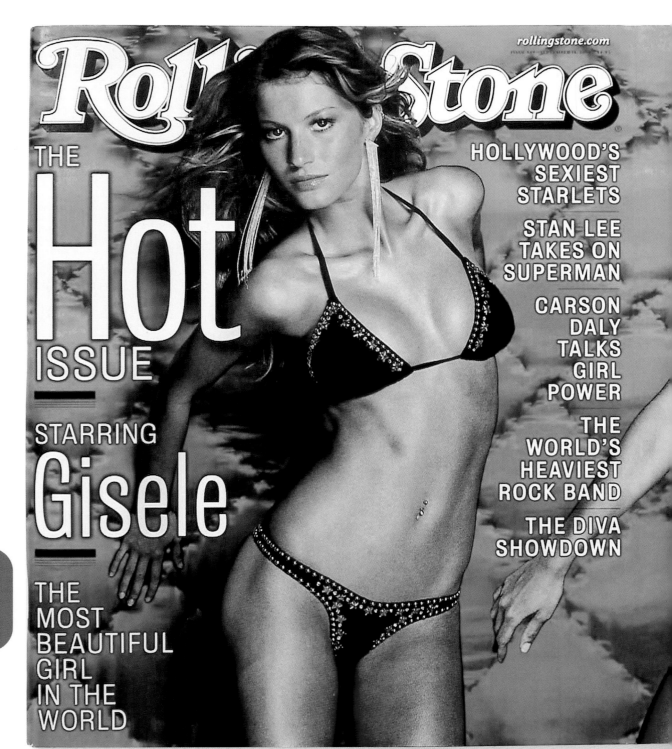

ROLLING STONE.COM
ISSUE 849 · SEPTEMBER 14, 2000 · $4.95

Rolling Stone

THE

Hot

ISSUE

STARRING

Gisele

THE MOST BEAUTIFUL GIRL IN THE WORLD

HOLLYWOOD'S SEXIEST STARLETS

STAN LEE TAKES ON SUPERMAN

CARSON DALY TALKS GIRL POWER

THE WORLD'S HEAVIEST ROCK BAND

THE DIVA SHOWDOWN

2000s

THE WORLD
ACCORDING TO
THE WAYANS
BROTHERS

TRIUMPH
THE INSULT
COMIC DOG

MTV'S
FREAKIEST
NEW STAR

THE
GREATEST
CAR ON
EARTH

THE
ONLY SEX
MANUAL
YOU'LL
EVER NEED

THIS
YEAR'S
MODELS

THE
NEXT
LEADING
MAN

RS 849 | GISELE
September 14th, 2000
PHOTOGRAPH BY
MARK SELIGER

HISTORICAL RECONSTRUCTION, when done well, is like a game of charades with vivid hints. Some of the events in *Almost Famous* beg deciphering. Let's clarify a few things [with Cameron Crowe].

What about that scene where Russell, on a bad acid trip, climbs up on the roof of a fan's house and yells, "I am a golden god"?

Robert Plant – he was joking around and said it while looking over the Sunset Strip. He and Jimmy Page saw the movie, and when Billy Crudup's character is complaining about the story and says, "I didn't say, 'I am a golden god,'" Plant shouted, "Well, I did!"

Who is Russell Hammond, really?

I saw Glenn Frey at a dinner party recently, and I realized that so much of Russell is Glenn. He was the coolest guy I had ever met in 1972. I was backstage at a concert interviewing everybody – the Eagles, King Crimson, Ballin' Jack, Chaka Khan. In the Eagles' dressing room, everyone's talking about Glenn – the one guy who isn't there. He's out looking for babes. Everyone's like, "The thing about Glenn," "Oh, one time Glenn and I . . ." And then, like a one-act play, Glenn appears. He walks in a little buzzed, he's got a long-neck Bud, and he's like, "How ya doin'?" Just classic. That whole thing of "Tonight, friends – tomorrow, the interview" was him. And there's one line he really did say to me: "Look, just make us look cool."

[EXCERPT FROM RS 851 COVER STORY
BY ANTHONY BOZZA]

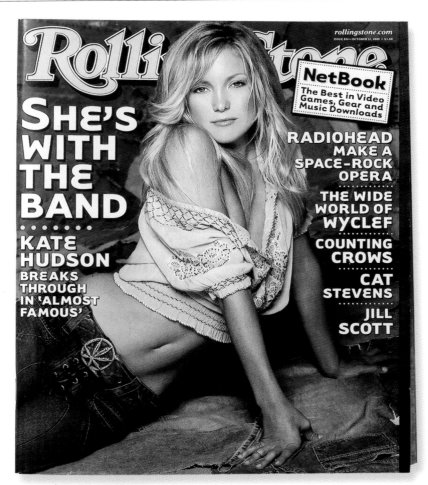

RS 851 | KATE HUDSON
October 12th, 2000
PHOTOGRAPH BY HERB RITTS

[RS 851] **When Cameron Crowe started writing for** ROLLING STONE **in the 1970s, few could have guessed he would become one of Hollywood's most beloved directors, the man behind** *Fast Times at Ridgemont High, Say Anything* **and** *Jerry Maguire.* **But Crowe's own story was every bit as incredible as those he told on celluloid: When he joined the magazine's stable of writers, he was only fifteen. Crowe's misadventures on the road finally made it to the screen in** *Almost Famous* **– costarring RS 851 cover girl Kate Hudson – a movie that exponentially increased the number of unsolicited record reviews the magazine received from its eager young readers.**

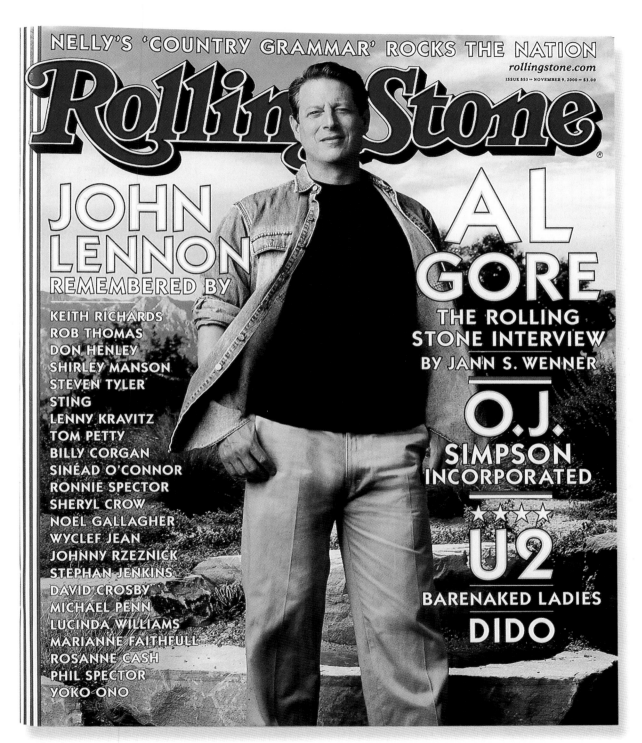

NELLY'S 'COUNTRY GRAMMAR' ROCKS THE NATION

rollingstone.com

ISSUE 853 ~ NOVEMBER 9, 2000 ~ $3.00

Rolling Stone

JOHN
LENNON
REMEMBERED BY

KEITH RICHARDS
ROB THOMAS
DON HENLEY
SHIRLEY MANSON
STEVEN TYLER
STING
LENNY KRAVITZ
TOM PETTY
BILLY CORGAN
SINÉAD O'CONNOR
RONNIE SPECTOR
SHERYL CROW
NOEL GALLAGHER
WYCLEF JEAN
JOHNNY RZEZNICK
STEPHAN JENKINS
DAVID CROSBY
MICHAEL PENN
LUCINDA WILLIAMS
MARIANNE FAITHFULL
ROSANNE CASH
PHIL SPECTOR
YOKO ONO

AL GORE

THE ROLLING
STONE INTERVIEW
BY JANN S. WENNER

O.J.
SIMPSON
INCORPORATED

★★★★★
U2
BARENAKED LADIES
DIDO

RS 853 | AL GORE | November 9th, 2000 | PHOTOGRAPH BY MARK SELIGER

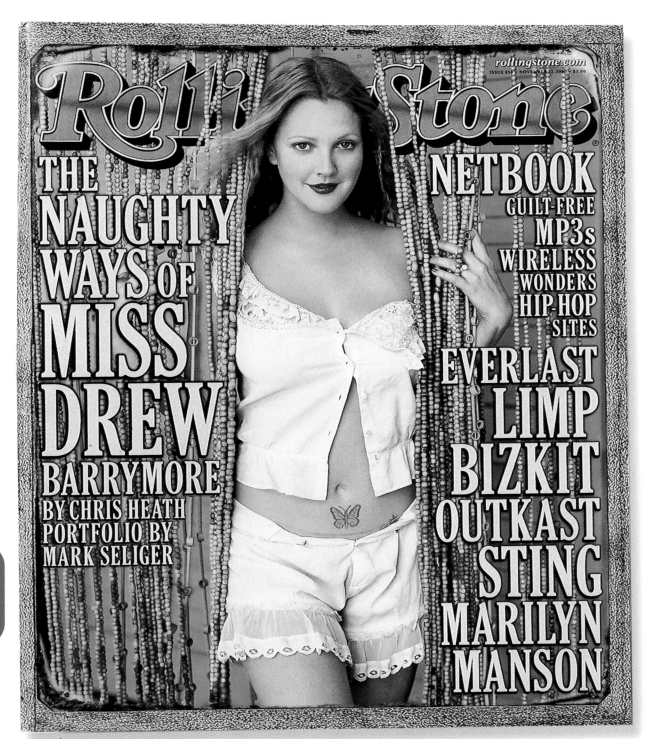

ROLLING STONE®

rollingstone.com

ISSUE 854 · NOVEMBER 23, 2000 · $3.00

THE NAUGHTY WAYS OF MISS DREW BARRYMORE

BY CHRIS HEATH
PORTFOLIO BY
MARK SELIGER

NETBOOK
GUILT-FREE
MP3s
WIRELESS
WONDERS
HIP-HOP
SITES

EVERLAST
LIMP
BIZKIT
OUTKAST
STING
MARILYN
MANSON

2000s

RS 854 | DREW BARRYMORE | November 23rd, 2000 | PHOTOGRAPH BY MARK SELIGER

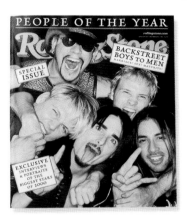

"*Drew is my quintessential*

muse. She was responsible for elevating my work. She gave me the trust and time to let me create. Then she would embellish it and make it really powerful. . . . Usually when I talk to somebody beforehand, they're giving me their formula on what they want and what they won't do. She just let me go. That blew me away."

—*Mark Seliger*

RS 855 | POP 100! THE 100
GREATEST POP SONGS
December 7th, 2000
ILLUSTRATION BY WARD SUTTON

RS 856/857 | BACKSTREET
BOYS
December 14th – December 21st, 2000
PHOTOGRAPH BY DAVID LACHAPELLE

RS 858/859 | ROCK & ROLL
YEARBOOK 2000
December 28th, 2000 – January 4th, 2001
VARIOUS PHOTOGRAPHERS

RS 860 | U2
January 18th, 2001
PHOTOGRAPH BY MARK SELIGER

CRAZY TOWN | AEROSMITH | COLDPLAY

rollingstone.com
ISSUE 864 • MARCH 15, 2001 • $3.95

Rolling Stone

CLINTON'S
DRUG
PARDONS

P.J.
O'ROURKE'S
WASHINGTON
DIARY

Dave Matthews
DEPRESSION, DRINKING & HOW
HIS NEW ALBUM SAVED HIM

COLLEGE
LIFE 2001

HOT SEX at
WELLESLEY,
The NEW JOB
INTERVIEW
& INTERNET
TUTORING

2000s

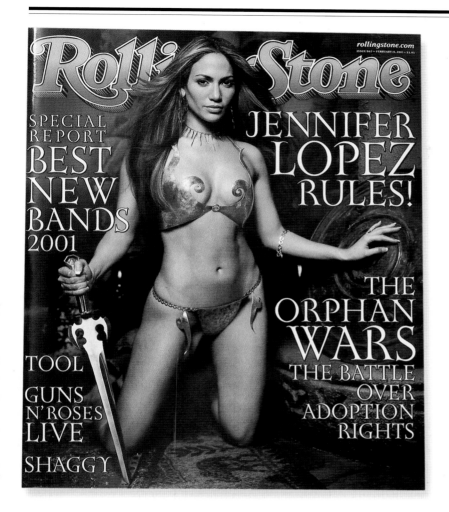

$\mathcal{RS}\ 862$ | JENNIFER LOPEZ | February 15th, 2001 | PHOTOGRAPH BY MARK SELIGER

[RS 862] The custom-made metal brassiere Jennifer Lopez wore for this cover now resides in the Rock and Roll Hall of Fame and Museum in Cleveland.

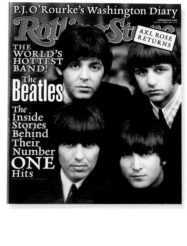

$\mathcal{RS}\ 863$ | THE BEATLES
March 1st, 2001
PHOTOGRAPH BY ROBERT FREEMAN

$\mathcal{RS}\ 861$ | JOHNNY KNOXVILLE
February 1st, 2001
PHOTOGRAPH BY MARK SELIGER

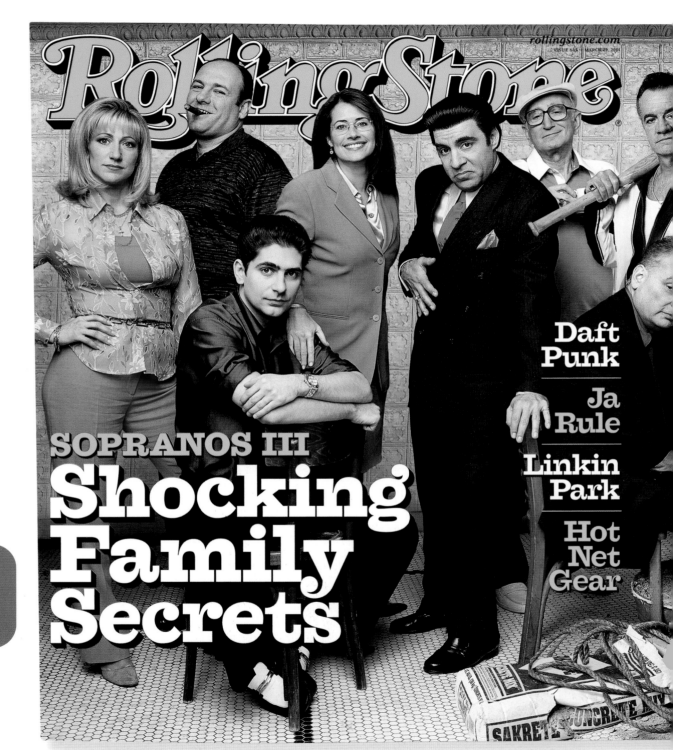

rollingstone.com
ISSUE 865 · MARCH 29, 2001

Rolling Stone

SOPRANOS III
Shocking Family Secrets

Daft Punk

Ja Rule

Linkin Park

Hot Net Gear

2000s

RS 865 | CAST OF
'THE SOPRANOS'
March 29th, 2001
PHOTOGRAPH BY MARK SELIGER

U2
Tour
Preview

P.J.
O'Rourke
On The
Tax Cut

Bush's
Concealed
Weapon

Who Gets Whacked? Edie Falco, James Gandolfini, Michael Imperioli, Lorraine Bracco, Steven Van Zandt, Dominic Chianese, David Chase (seated), Tony Sirico, Joe Pantoliano, Drea de Matteo, Aida Turturro, Robert Iler, Jamie-Lynn Sigler (from left)

RS 875 | 'NSYNC: JC CHASEZ, LANCE BASS, CHRIS KIRKPATRICK, JUSTIN TIMBERLAKE & JOEY FATONE
August 16th, 2001
Photographs by Mark Seliger

The editor's letter explains this multicover extravaganza: "For the first time in ROLLING STONE's history, we are publishing six separate, simultaneous covers. The five Brady-esque portraits of the members of 'NSync will travel to newsstands, supermarkets, bookstores and other destinations where single copies are sold; subscribers' copies feature a group shot." For the record, Chris Kirkpatrick was the only member to choose his own background hue: purple, his favorite color.

RS 865 | CAST OF 'THE SOPRANOS'
March 29th, 2001
PHOTOGRAPH BY MARK SELIGER

U2 Tour Preview

P.J. O'Rourke On The Tax Cut

Bush's Concealed Weapon

Who Gets Whacked? Edie Falco, James Gandolfini, Michael Imperioli, Lorraine Bracco, Steven Van Zandt, Dominic Chianese, David Chase (seated), Tony Sirico, Joe Pantoliano, Drea de Matteo, Aida Turturro, Robert Iler, Jamie-Lynn Sigler (from left)

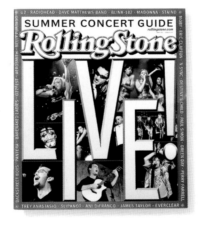

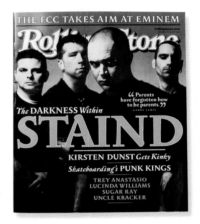

2000s

RS 866 | JULIA STILES
April 12th, 2001
PHOTOGRAPH BY PATRIC SHAW

RS 867 | STEVEN TYLER
& JOE PERRY
April 26th, 2001
PHOTOGRAPH BY MARK SELIGER

RS 868 | PAMELA ANDERSON
& TOMMY LEE
May 10th, 2001
PHOTOGRAPH BY STEVE WAYDA

RS 870 | THE ROCK
June 7th, 2001
PHOTOGRAPH BY MARK SELIGER

RS 871 | LIVE 2001
June 21st, 2001
VARIOUS PHOTOGRAPHERS

RS 873 | STAIND
July 19th, 2001
PHOTOGRAPH BY MARK SELIGER

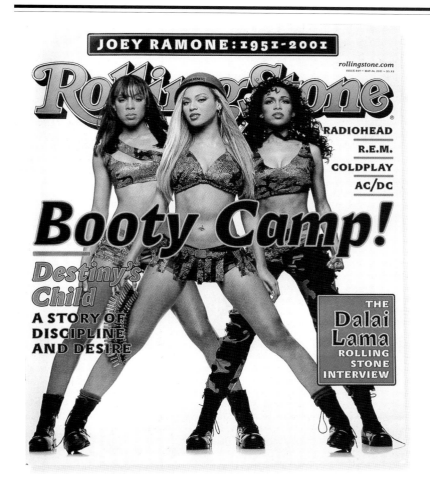

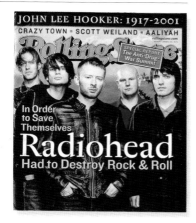

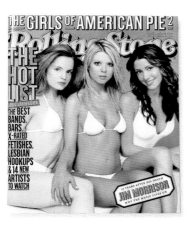

𝑅𝑆 869 | DESTINY'S CHILD
May 24th, 2001
PHOTOGRAPH BY ALBERT WATSON

𝑅𝑆 874 | RADIOHEAD
August 2nd, 2001
PHOTOGRAPH BY LEE JENKINS

𝑅𝑆 876 | THE GIRLS OF
'AMERICAN PIE 2'
August 30th, 2001
PHOTOGRAPH BY JIM WRIGHT

RS 875 | 'NSYNC: JC CHASEZ, LANCE
BASS, CHRIS KIRKPATRICK, JUSTIN
TIMBERLAKE & JOEY FATONE
August 16th, 2001
PHOTOGRAPHS BY MARK SELIGER

The editor's letter explains this multicover extravaganza:
"For the first time in ROLLING STONE's
history, we are publishing six separate, simultaneous
covers. The five Brady-esque portraits of the members of
'NSync will travel to newsstands, supermarkets, bookstores
and other destinations where single copies are sold;
subscribers' copies feature a group shot." For the record,
Chris Kirkpatrick was the only member to choose his own
background hue: purple, his favorite color.

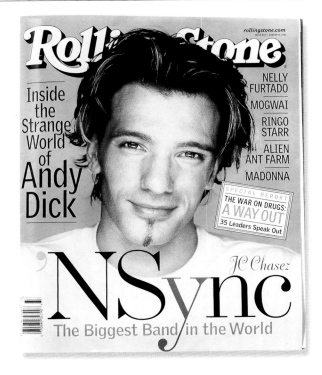

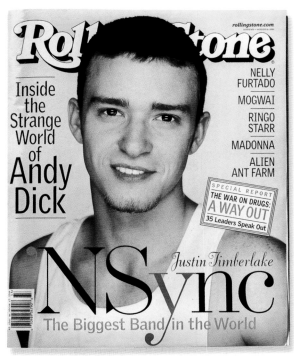

2000s

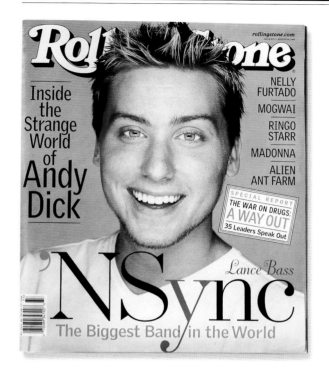

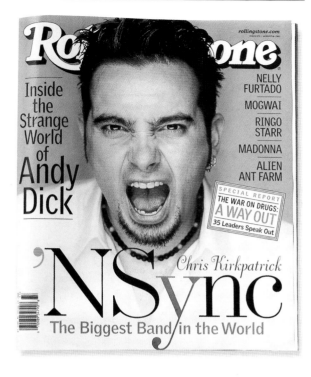

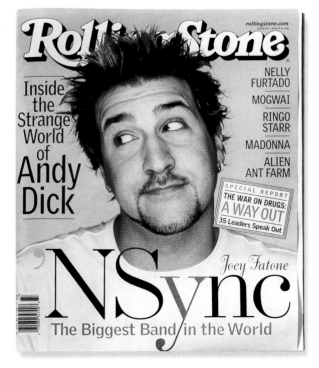

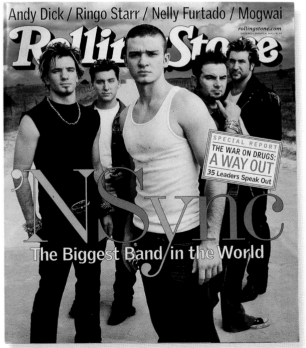

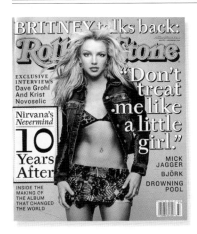

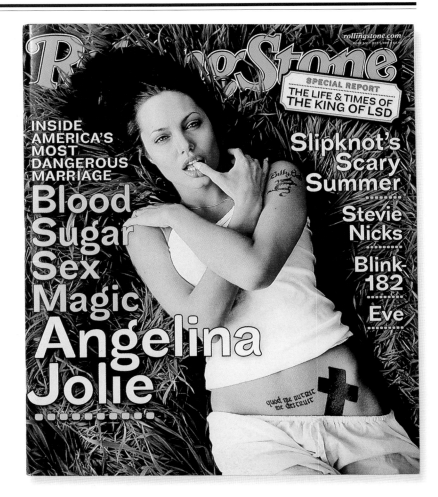

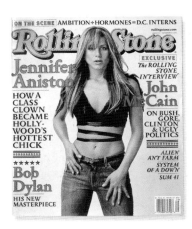

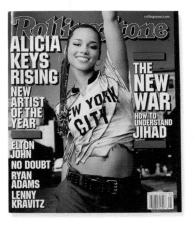

R S 872 | ANGELINA JOLIE
July 5th, 2001
PHOTOGRAPH BY DAVID LACHAPELLE

R S 877 | BRITNEY SPEARS
September 13th, 2001
PHOTOGRAPH BY PATRICK DEMARCHELIER

R S 878 | JENNIFER ANISTON
September 27th, 2001
PHOTOGRAPH BY HERB RITTS

R S 881 | ALICIA KEYS
November 8th, 2001
PHOTOGRAPH BY MARK SELIGER

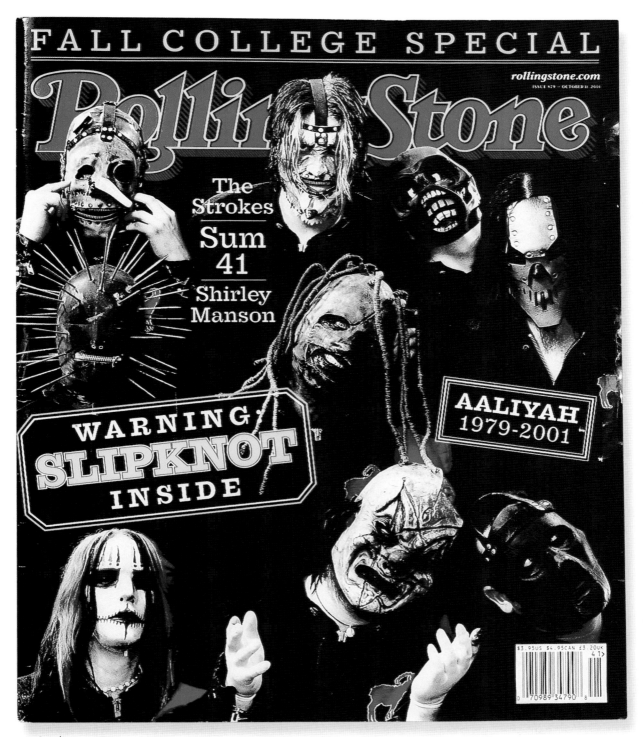

FALL COLLEGE SPECIAL

rollingstone.com
ISSUE 879 – OCTOBER 11 2001

Rolling Stone

The
Strokes
Sum
41
Shirley
Manson

WARNING:
SLIPKNOT
INSIDE

AALIYAH
1979-2001

$3.95US $4.95CAN £3.20UK

0 70989 34790 8

RS 879 | SLIPKNOT | October 11th, 2001 | PHOTOGRAPH BY MARTIN SCHOELLER

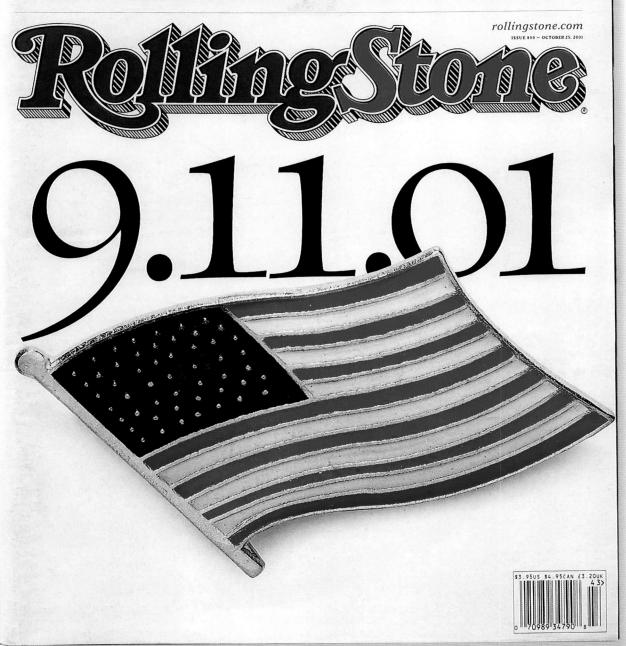

A SPECIAL ISSUE | THE REALITIES OF GROUND ZERO . . .
HEROES OF NEW YORK . . . ELEGIES FOR AMERICA . . . MUSICIANS
UNITED . . . INSIDE THE HOLY WAR . . . MEMO TO THE PRESIDENT

rollingstone.com
ISSUE 880 ~ OCTOBER 25, 2001

Rolling Stone

9.11.01

$3.95US $4.95CAN £3.20UK

LETTER FROM THE EDITOR

New York City is our home.

It's been our home since 1977, when we moved the magazine here from San Francisco. The entire staff comes to work every day in an office tower next to Rockefeller Center that is four and a half miles north of where the World Trade Center stood. Most of us live in the city, some within a couple of blocks of the financial district, some close enough to it to have wondered why that airliner was flying so low on the beautiful new morning of September 11th.

On that Tuesday, the best of who we are was turned against us. Our open borders and immigration policies were exploited; our beneficent technology turned into tools of terror: the WTC towers, modern wonders of American engineering; four fully fueled Boeing jets, the most popular aircraft in the world and a testament to the superiority of American technology. The video images of the second jetliner knifing into the tower, the sharklike final turn, will be with us forever. The cold transaction of steel into steel, brought about by men armed with knives and razor blades.

There is cause to be worried about the future, about our economy, about our safety, about the men and women who are being called into service to protect us. September 11th is a pivot upon which we will view our future and our past.

—Jann S. Wenner

BUSH HAS JUST FINISHED HIS BIG talk to congress. The talk was planned to prepare us for war. It's going to get messy, everyone agrees. It's going to last for years and probably decades, everybody ruefully concedes. Nothing will ever be the same, everybody eventually declares.

Then why does it all sound so familiar? Because we are talking not just about war this time, but about the war above the war: the Real War. This war has already been waged, and it's not between the United States and the Taliban, but between the ancient, gut-wrenching, bone-breaking, flesh-slashing way things have always been and the timorous and fragile way things might begin to be. Could begin to be. Must begin to be, if our lives and our children's lives are ever to know honest peace.

—Ken Kesey

"WITH TERRORISM, WHETHER you kill five people or five thousand, it is still a disregard for normal human values, what you expect in a civilized society. I never believed in violence as a way of achieving the political ends that we mentioned in songs like 'Street Fighting Man.' The people that believe in it – I have no time for them whatsoever.

"People are saying to me, and I felt the same way: 'I couldn't do anything for a week. My life, all my things, feel so trivial.' But to some extent, after the shock and mourning comes the adjustment to real life. During times of war, my parents tried to carry on as normally as much as you can, with adjustments. You can't let terrorists completely change your lifestyle. They would love that. That's a victory." *—Mick Jagger*

"I'm not leaving New York.

And neither is anyone else. We're here. We are quintessential Americans – we're not only American but New York–American."

—Lou Reed

I WAS ROCKETED OUT OF BED shortly before 9 A.M. by a bang that was shuddery even by New York's clamorous standards. Making our way down to the street, my girlfriend and I saw smoke filling the sky to the south, very nearby, and knots of puzzled people beginning to form on the corners below. Was it just a fire? A blown-out gas main? What? Then another explosion shook the scene, and suddenly an inconceivable word was in the air: terrorists.

Having raced back to the apartment to gather up our two dogs, I could hear the sounds of chaos and catastrophe mounting outside – sirens and screams and the horrendous, rumbling crunch of something unimaginably huge collapsing. Back down in the street, police and firefighters were everywhere. People were fleeing up Greenwich Street in unbridled panic. I braced myself against the wall of a building and stared up toward the twin towers of the World Trade Center, the neighborhood's most familiar and dominant sight. One of them – astonishingly, impossibly – gone. The other was hideously split and flaming.

—Kurt Loder [EXCERPTS FROM RS 880]

RollingStone

LETTER FROM THE EDITOR

New York City is our home.

It's been our home since 1977, when we moved the magazine here from San Francisco. The entire staff comes to work every day in an office tower next to Rockefeller Center that is four and a half miles north of where the World Trade Center stood. Most of us live in the city, some within a couple of blocks of the financial district, some close enough to it to have wondered why that airliner was flying so low on the beautiful new morning of September 11th.

On that Tuesday, the best of who we are was turned against us. Our open borders and immigration policies were exploited; our beneficent technology turned into tools of terror: the WTC towers, modern wonders of American engineering; four fully fueled Boeing jets, the most popular aircraft in the world and a testament to the superiority of American technology. The video images of the second jetliner knifing into the tower, the sharklike final turn, will be with us forever. The cold transaction of steel into steel, brought about by men armed with knives and razor blades.

There is cause to be worried about the future, about our economy, about our safety, about the men and women who are being called into service to protect us. September 11th is a pivot upon which we will view our future and our past.
— *Jann S. Wenner*

BUSH HAS JUST FINISHED HIS BIG talk to congress. The talk was planned to prepare us for war. It's going to get messy, everyone agrees. It's going to last for years and probably decades, everybody ruefully concedes. Nothing will ever be the same, everybody eventually declares.

Then why does it all sound so familiar? Because we are talking not just about war this time, but about the war above the war: the Real War. This war has already been waged, and it's not between the United States and the Taliban, but between the ancient, gut-wrenching, bone-breaking, flesh-slashing way things have always been and the timorous and fragile way things might begin to be. Could begin to be. Must begin to be, if our lives and our children's lives are ever to know honest peace.
— *Ken Kesey*

"WITH TERRORISM, WHETHER you kill five people or five thousand, it is still a disregard for normal human values, what you expect in a civilized society. I never believed in violence as a way of achieving the political ends that we mentioned in songs like 'Street Fighting Man.' The people that believe in it – I have no time for them whatsoever.

"People are saying to me, and I felt the same way: 'I couldn't do anything for a week. My life, all my things, feel so trivial.' But to some extent, after the shock and mourning comes the adjustment to real life. During times of war, my parents tried to carry on as normally as much as you can, with adjustments. You can't let terrorists completely change your lifestyle. They would love that. That's a victory."
— *Mick Jagger*

"I'm not leaving New York.

And neither is anyone else. We're here. We are quintessential Americans – we're not only American but New York–American."
— *Lou Reed*

I WAS ROCKETED OUT OF BED shortly before 9 A.M. by a bang that was shuddery even by New York's clamorous standards. Making our way down to the street, my girlfriend and I saw smoke filling the sky to the south, very nearby, and knots of puzzled people beginning to form on the corners below. Was it just a fire? A blown-out gas main? What? Then another explosion shook the scene, and suddenly an inconceivable word was in the air: terrorists.

Having raced back to the apartment to gather up our two dogs, I could hear the sounds of chaos and catastrophe mounting outside – sirens and screams and the horrendous, rumbling crunch of something unimaginably huge collapsing. Back down in the street, police and firefighters were everywhere. People were fleeing up Greenwich Street in unbridled panic. I braced myself against the wall of a building and stared up toward the twin towers of the World Trade Center, the neighborhood's most familiar and dominant sight. One of them – astonishingly, impossibly – gone. The other was hideously split and flaming.
— *Kurt Loder* [EXCERPTS FROM RS 880]

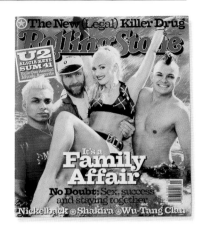

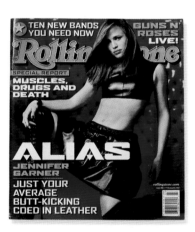
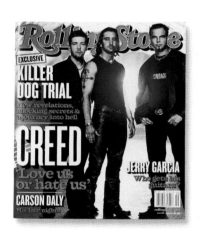
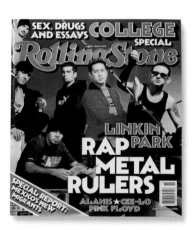

RS 883/884 | BRITNEY SPEARS
December 6th – December 13th, 2001
PHOTOGRAPH BY MARK SELIGER

RS 885/886 | ROCK & ROLL
YEARBOOK 2001
December 20th, 2001 – January 3rd, 2002
VARIOUS PHOTOGRAPHERS

RS 888 | NO DOUBT
January 31st, 2002
PHOTOGRAPH BY DAVID LACHAPELLE

RS 889 | JENNIFER GARNER
February 14th, 2002
PHOTOGRAPH BY ISABEL SNYDER

RS 890 | CREED
February 28th, 2002
PHOTOGRAPH BY LEN IRISH

RS 891 | LINKIN PARK
March 14th, 2002
PHOTOGRAPH BY MARTIN SCHOELLER

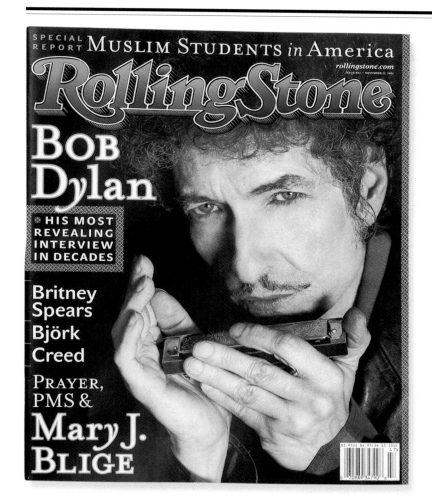

RS 892 | TOM WELLING
AND KRISTIN KREUK
OF 'SMALLVILLE'
March 28th, 2002
PHOTOGRAPH BY STEWART SHINING

"THERE ARE SO MANY WAYS
to photograph something,
so many interpretations.
There's something about a
photograph that can intrigue
you. You can put it away and
you want to see it again."
—Herb Ritts

RS 882 | BOB DYLAN | November 22nd, 2001 | PHOTOGRAPH BY HERB RITTS

Rolling Stone

HE LEFT THIS WORLD AS HE lived in it: conscious of God, fearless of death and at peace, surrounded by family and friends. He often said, "Everything else can wait, but the search for God cannot wait."

[FROM A STATEMENT BY OLIVIA AND DHANI HARRISON]

HE HAD BEGUN WORKING ON A NEW solo album when he was diagnosed with throat cancer in 1997. He later underwent surgery to have a nodule removed from his lung. . . . In May 2001, he again underwent surgery for lung cancer and, soon after, went to Switzerland for further treatment. The cancer, unfortunately, had spread to his brain. By the late fall, he was desperate to save his life, traveling first to Staten Island University Hospital in New York, and then to the UCLA Medical Center in Los Angeles. As all this was going on, in late November, keyboardist Jools Holland released a new album, with a track co-written by Harrison and Dhani, on which Harrison also plays guitar. It's called "Horse to the Water," and, in a perfect Harrison touch, the publishing credit reads RIP Music Ltd. 2001, a nod to the graveyard sendoff "rest in peace."

If anyone could view his own imminent death with a humorous detachment, Harrison could. This is a man, after all, who titled an album *All Things Must Pass* and wrote a song for it called "Art of Dying." Ever since he discovered Eastern religion in the mid-Sixties, he believed that this life was transient and that every human soul was on a journey to perfection. He moved in and out of the public eye, in and out of commercial favor, but his faith never wavered.

—*Anthony DeCurtis*

"*He was a giant, a great,* great soul, with all the humanity, all the wit and humor, all the wisdom, the spirituality, the common sense of a man and compassion for people. He inspired love and had the strength of a hundred men.

"He was like the sun, the flowers and the moon, and we will miss him enormously. The world is a profoundly emptier place without him."

—*Bob Dylan*

"GEORGE WAS SO MANY THINGS to the world: He was an innovative guitar player, a songwriter with words of wisdom and a man who introduced Eastern philosophy and music to the West. But in his private life, he was a man of wit and humor who made his friends laugh."

—*Yoko Ono*

"GEORGE REALLY TREASURED HIS friends. He once brought me four ukuleles in a week. I said, 'George, I don't think I need four ukuleles.' He said, 'Well, this one is better than the other ones. And it's just good to have them here – you never know when we're going to all be over and need them.' George's idea of a band was that everybody hung. From what he told me, the Beatles were that way. They were very, very tight. He really wanted the Traveling Wilburys to be like that. Like, 'If we're going to the party, we're all going.' I'm so glad I got to be in a band with him. He taught me so much."

—*Tom Petty*

"GEORGE AND I KIND OF FORMED – without talking too much about it, although we did have a laugh here and there – a bond, in that we felt we were fulfilling the same role within our respective bands. It was a nod and a wink to say, 'Well, they'd be nowhere without us.'

He was a guy who only looked out for the best in people. I'm going to miss him. And if there is anything like heaven and shit like that, hopefully John and him are saying, 'How you doing, pal, want a drink?' "

—*Keith Richards*

"WITHOUT GEORGE, it all wouldn't have been possible. I'll miss him dearly and I'll always love him – he's my baby brother."

—*Paul McCartney*

[EXCERPTS FROM GEORGE HARRISON TRIBUTE]

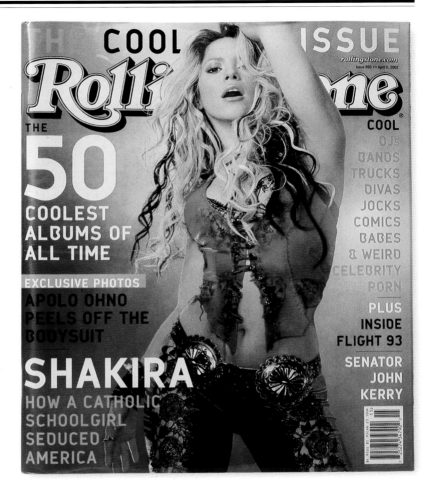

RS 893 | SHAKIRA
April 11th, 2002
PHOTOGRAPH BY MARTIN SCHOELLER

RS 894 | THE WOMEN OF
'THE SWEETEST THING'
April 25th, 2002
PHOTOGRAPH BY STEWART SHINING

RS 895 | THE OSBOURNES
May 9th, 2002
PHOTOGRAPH BY SOPHIE OLMSTED

RS 896 | KIRSTEN DUNST
May 23rd, 2002
PHOTOGRAPH BY DAVID LACHAPELLE

"*What is a*
functional family?
I know I'm
dysfunctional by
a long shot, but
what guidelines
do we all have to go
by? The Waltons?"
—*Ozzy Osbourne*

2000s

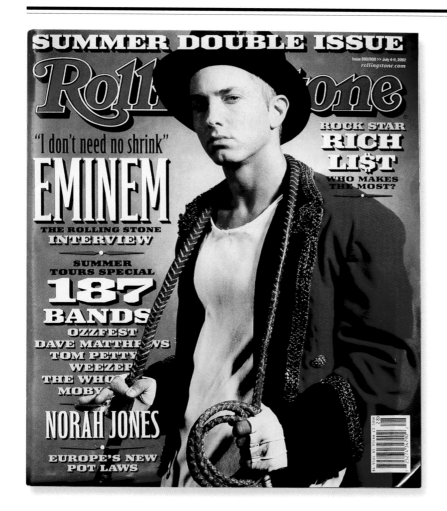

SUMMER DOUBLE ISSUE

Rolling Stone

Issue 899/900 >> July 4-11, 2002
rollingstone.com

"I don't need no shrink"

EMINEM

THE ROLLING STONE
INTERVIEW

SUMMER
TOURS SPECIAL

187
BANDS
OZZFEST
DAVE MATTHEWS
TOM PETTY
WEEZER
THE WHO
MOBY

NORAH JONES

EUROPE'S NEW
POT LAWS

ROCK STAR
RICH
LI$T
WHO MAKES
THE MOST?

Rolling Stone

Video-Game Special

Girls
Gone Wild
INSIDE THE
TOPLESS
EMPIRE

Lisa
Lopes
1971-2002

Weezer
★★★★

Who
Owns
Kurt
Cobain?
COURTNEY VS.
NIRVANA AND
THE LOST MUSIC

Plus: Layne Staley's Last Days

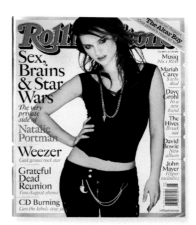

Rolling Stone

The Altar Boy

Sex,
Brains
& Star
Wars
*The very
private
side of*
Natalie
Portman

Weezer
Geek genius rock star

Grateful
Dead
Reunion
Two August shows

CD Burning
Can the labels stop

Music
No.1 R&B

Mariah
Carey
$28M
deal

Dave
Grohl
*In a
new
band*

The
Hives
*Break
out*

David
Bowie
*New
album*

John
Mayer
*Hyper
melodies*

"*It's obvious*
to me that I sold
double the records
because I'm white.
In my heart I truly
believe I have a talent,
but at the same time
I'm not stupid."

—*Eminem*

RS 899/900 | EMINEM
July 4th – July 11th, 2002
PHOTOGRAPH BY JEFF RIEDEL

RS 897 | KURT COBAIN
June 6th, 2002
PHOTOGRAPH BY CHARLES HOSELTON

RS 898 | NATALIE PORTMAN
June 20th, 2002
PHOTOGRAPH BY ALBERT WATSON

RS 902 | DAVE
MATTHEWS BAND
August 8th, 2002
PHOTOGRAPH BY MARTIN SCHOELLER

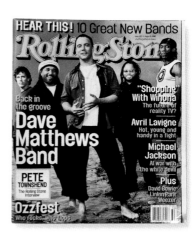

HEAR THIS! 10 Great New Bands

Rolling Stone

Back in
the groove
Dave
Matthews
Band

PETE
TOWNSHEND
The Rolling Stone
Interview

Ozzfest
Who rocks · who flops

"Shopping"
With Winona
The future of
reality TV?

Avril Lavigne
Hot, young and
handy in a fight

Michael
Jackson
At war with
the white devil

Plus
David Bowie
Linkin Park
Weezer

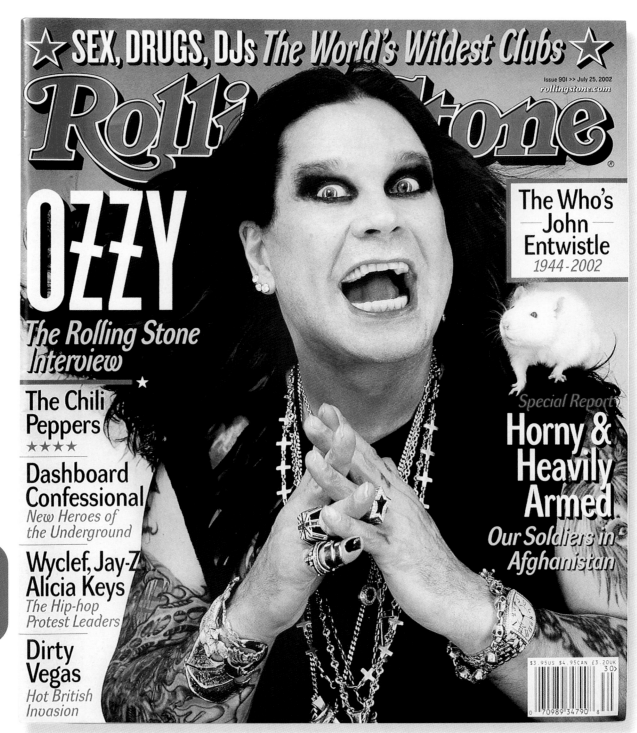

☆ **SEX, DRUGS, DJs** *The World's Wildest Clubs* ☆

Issue 901 >> July 25, 2002
rollingstone.com

Rolling Stone

®

OZZY
The Rolling Stone Interview

★

The Chili Peppers
★★★★

Dashboard Confessional
New Heroes of the Underground

Wyclef, Jay-Z Alicia Keys
The Hip-hop Protest Leaders

Dirty Vegas
Hot British Invasion

The Who's
John
— Entwistle —
1944-2002

Special Report
Horny & Heavily Armed
Our Soldiers in Afghanistan

$3.95US $4.95CAN £3.20UK

30>

0 70989 34790 8

RS 901 | OZZY OSBOURNE | July 25th, 2002 | Photograph by Martin Schoeller

2000s

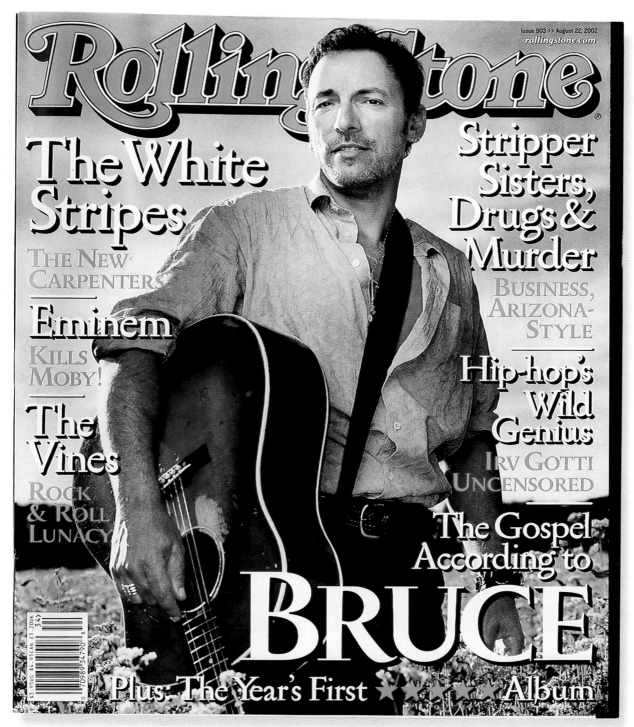

Issue 903 >> August 22, 2002
rollingstone.com

Rolling Stone

The White Stripes

THE NEW CARPENTERS

Eminem
KILLS MOBY!

The Vines
ROCK & ROLL LUNACY

Stripper Sisters, Drugs & Murder

BUSINESS, ARIZONA- STYLE

Hip-hop's Wild Genius
IRV GOTTI UNCENSORED

The Gospel According to
BRUCE

Plus, The Year's First ★★★★ Album

RS 903 | BRUCE SPRINGSTEEN | August 22nd, 2002 | PHOTOGRAPH BY MARTIN SCHOELLER

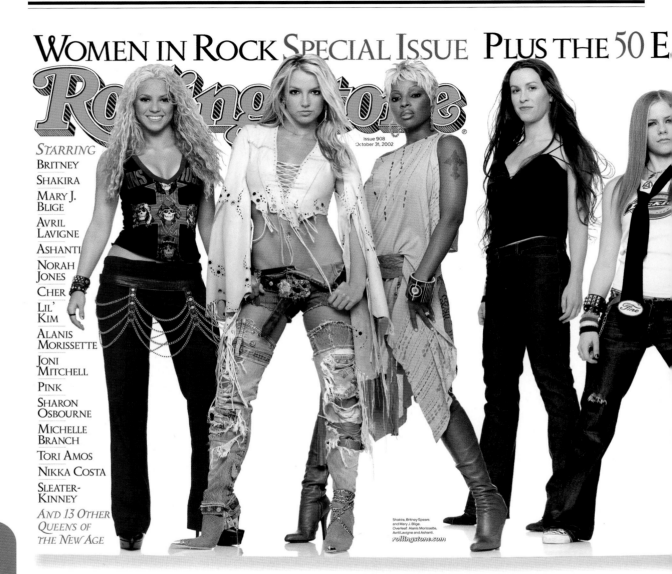

WOMEN IN ROCK SPECIAL ISSUE PLUS THE 50 E

STARRING
BRITNEY
SHAKIRA
MARY J.
BLIGE
AVRIL
LAVIGNE
ASHANTI
NORAH
JONES
CHER
LIL'
KIM
ALANIS
MORISSETTE
JONI
MITCHELL
PINK
SHARON
OSBOURNE
MICHELLE
BRANCH
TORI AMOS
NIKKA COSTA
SLEATER-
KINNEY
*AND 13 OTHER
QUEENS OF
THE NEW AGE*

Issue 908
October 31, 2002

Shakira, Britney Spears
and Mary J. Blige.
Overleaf: Alanis Morissette,
Avril Lavigne and Ashanti.
rollingstone.com

RS 908 | WOMEN IN ROCK | October 31st, 2002 | PHOTOGRAPH BY ALBERT WATSON

...NTIAL ALBUMS

FEATURING

THE SUPREMES

JANIS JOPLIN

P.J. HARVEY

DUSTY
SPRINGFIELD

DEBORAH
HARRY

IRMA
THOMAS

PATTI
SMITH

PATSY
CLINE

DIONNE
WARWICK

MADONNA

ARETHA
FRANKLIN

CAROLE
KING

TINA
TURNER

JOAN
JETT

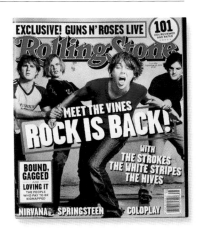

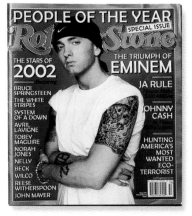

RS 904 | ASIA ARGENTO
September 5th, 2002
PHOTOGRAPH BY TONY DURAN

RS 906 | JENNIFER
LOVE HEWITT
October 3rd, 2002
PHOTOGRAPH BY MATTHEW ROLSTON

RS 905 | THE VINES
September 19th, 2002
PHOTOGRAPH BY MARTIN SCHOELLER

RS 911 | EMINEM
December 12th, 2002
PHOTOGRAPH BY MARY ELLEN MATTHEWS

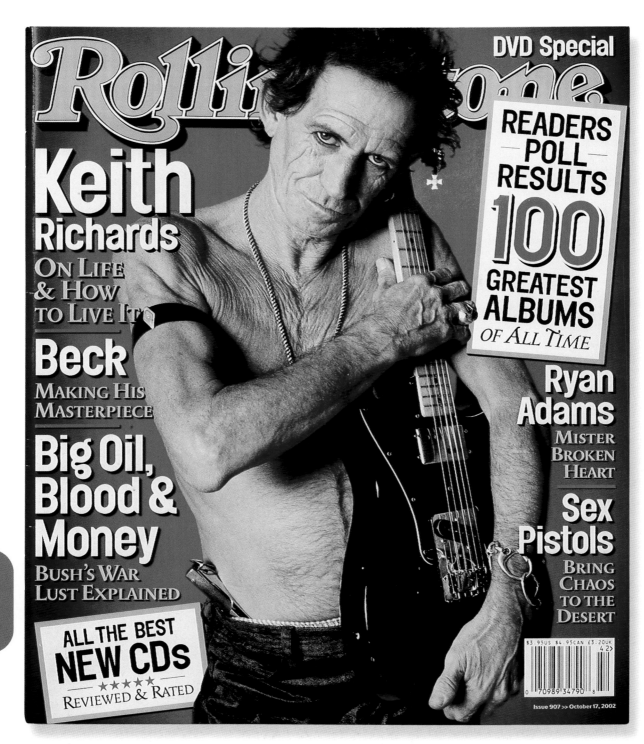

DVD Special

Rolli one.

READERS
- POLL -
RESULTS
100
GREATEST
ALBUMS
OF ALL TIME

Keith
Richards
On Life
& How
to Live It

Beck
MAKING HIS
MASTERPIECE

Big Oil,
Blood &
Money
BUSH'S WAR
LUST EXPLAINED

**Ryan
Adams**
MISTER
BROKEN
HEART

**Sex
Pistols**
BRING
CHAOS
TO THE
DESERT

ALL THE BEST
NEW CDs
★★★★★
REVIEWED & RATED

$3.95US $4.95CAN £3.20UK
4 2>

0 70989 34790 8

Issue 907 >> October 17, 2002

RS 907 | KEITH RICHARDS | October 17th, 2002 | PHOTOGRAPH BY SANTE D'ORAZIO

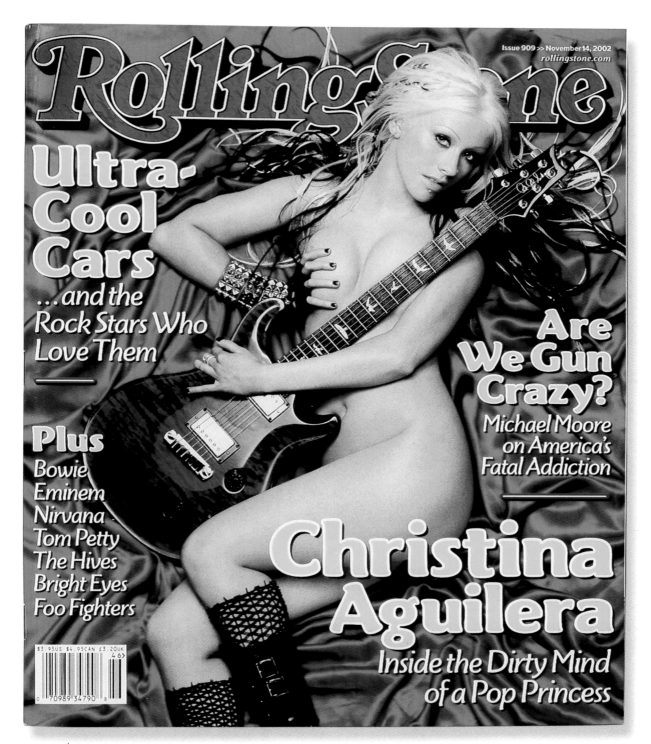

Issue 909 >> November 14, 2002
rollingstone.com

Rolling Stone

Ultra-Cool Cars

...and the
Rock Stars Who
Love Them

Plus
Bowie
Eminem
Nirvana
Tom Petty
The Hives
Bright Eyes
Foo Fighters

Are We Gun Crazy?
Michael Moore
on America's
Fatal Addiction

Christina Aguilera
Inside the Dirty Mind
of a Pop Princess

$3.95US $4.95CAN £3.20UK
46>
0 70989 34790 8

RS 909 | CHRISTINA AGUILERA | November 14th, 2002 | PHOTOGRAPH BY ALBERT WATSON

RS *912/913* | ROCK & ROLL
YEARBOOK 2002
December 26th, 2002 – January 9th, 2003
VARIOUS PHOTOGRAPHERS

[RS 910] For our special Simpsons package, ROLLING STONE brainstormed with Matt Groening and the Simpsons art department to come up with the most iconic album covers to lampoon. Alas, we could only put three of them – Nirvana's *Nevermind*, Bruce Springsteen's *Born in the U.S.A.* and the Beatles' *Abbey Road* – on the front of our magazine. Herewith are some that didn't make the cut: Fleetwood Mac's *Rumours*, starring Homer and Marge as Mick Fleetwood and Stevie Nicks; Homer as both Michael Jackson on *Thriller* and David Bowie's *Aladdin Sane*; and Carl, Moe, Homer and Lenny, in front of a brick wall, spoofing the Ramones' self-titled debut. Of course in this instance, the word *Ramones* has been strategically vandalized to read RAMOES.

"*I started out animating on* The Simpsons and now I'm the creative director over at Fox, so I do lots of magazine covers. I've done a lot of really cool ones, but those were by far the coolest covers I've ever done. I don't have any Simpsons work hanging up in my house, but I have the three covers framed. Matt Groening also sent me a letter thanking me, and he said that now he has something to show his mom."

—*Julius Preite*

2000s

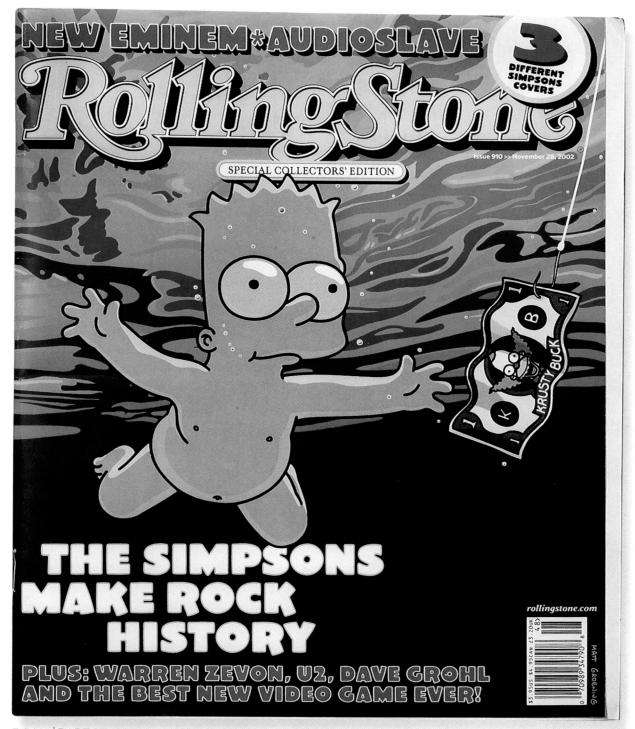

RS 910 | BART SIMPSON | November 28th, 2002 | ILLUSTRATION BY JULIUS PREITE

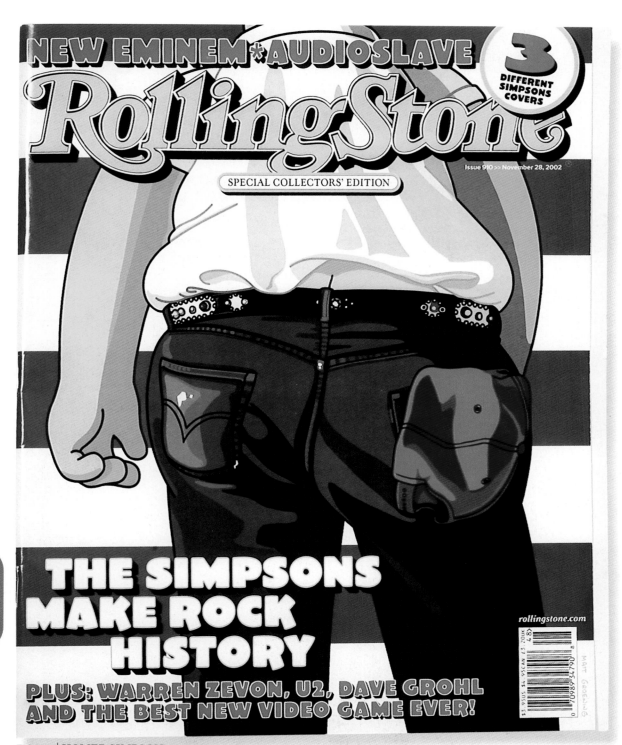

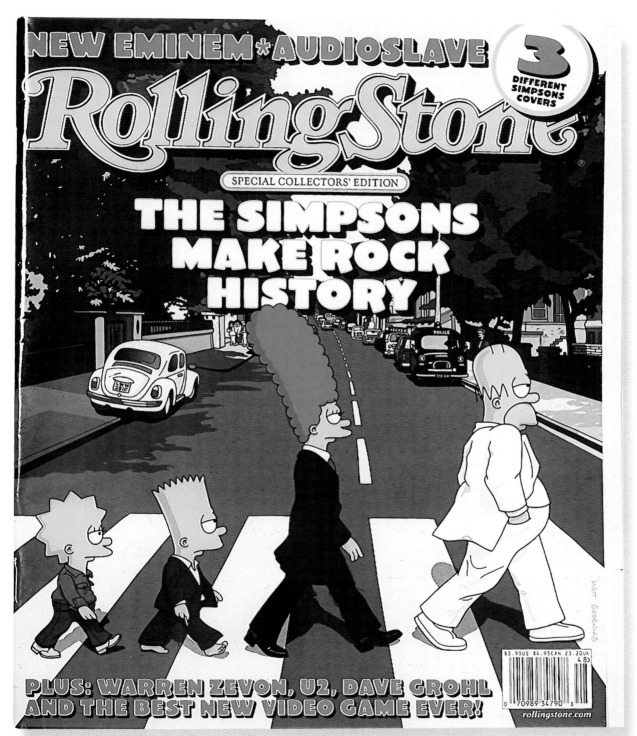

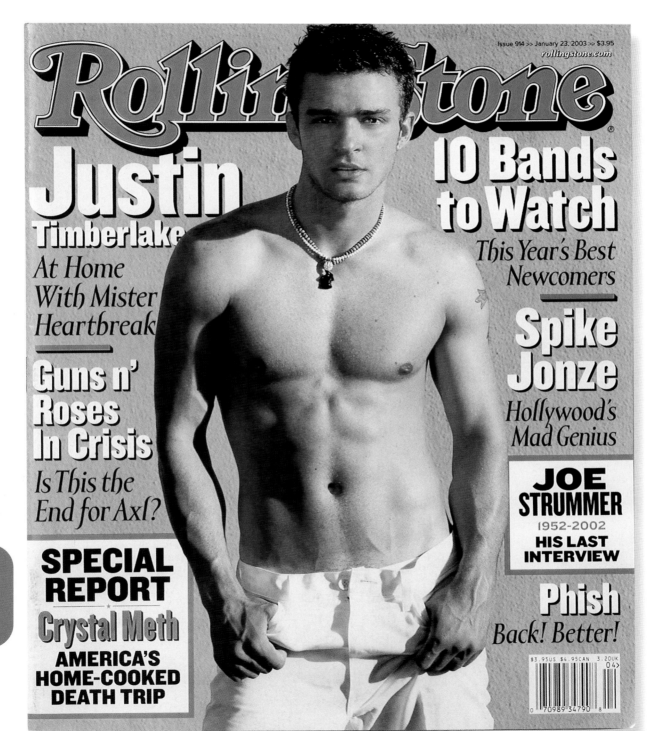

Issue 914 >> January 23. 2003 >> $3.95
rollingstone.com

Rolling Stone

Justin
Timberlake
At Home
With Mister
Heartbreak

**Guns n'
Roses
In Crisis**
Is This the
End for Axl?

**SPECIAL
REPORT**
Crystal Meth
AMERICA'S
HOME-COOKED
DEATH TRIP

10 Bands
to Watch
*This Year's Best
Newcomers*

Spike
Jonze
*Hollywood's
Mad Genius*

**JOE
STRUMMER**
1952-2002
**HIS LAST
INTERVIEW**

Phish
Back! Better!

$3.95US $4.95CAN 3.20UK
04>
0 70989 34790 8

2000s

[RS 914] **Justin Timberlake's first cover as a solo artist was also Herb Ritts's forty-sixth and final cover for ROLLING STONE. The photographer died of complications from pneumonia on December 26th, 2002.**

"I'M A VERY LOVING, CARING person," [Timberlake] was saying, "and if I start dating you – you know, as a girl – it may take me a long time to give myself away to you, but once I do, that's it. You can have whatever you want. But I've had my heart broken plenty of times."

He pressed his lips together and fluttered a sad noise.

"Three times, actually," he continued. "I was fifteen the first time. She cheated on me, and I broke up with her. That's reason enough, right? 'Oops, sorry, see you.' I'd been going with her for a year. The second one I saw for a year and a half. And the third one" – and here he paused, thinking of Spears – "was for three and a half years. It was the same with her as with the first girl who broke my heart and the second. They've all gone down the same way. All of them. Three strikes, I'm out. I mean, she has a beautiful heart, but if I've lost my trust in someone, I don't think it's right for me to be with them. I'm not going to let my baggage with somebody else become my baggage with a new person. But I'll tell you, man, I have little, little hope. Three strikes. Little hope."

So that's the way it is with him. The girls he loves apparently cheat on him. It's an embarrassing thing, especially for a star of Timberlake's magnitude; but worse, it's a terrible personal tragedy, excruciating to the heart and a burden on the soul.

[EXCERPT FROM RS 914 COVER STORY BY ERIK HEDEGAARD]

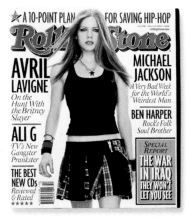

RS 915 | SHANIA TWAIN
February 6th, 2003
PHOTOGRAPH BY MICHAEL THOMPSON

RS 916 | THE BEATLES
February 20th, 2003
VARIOUS PHOTOGRAPHERS

RS 917 | PHISH
March 6th, 2003
PHOTOGRAPH BY MARTIN SCHOELLER

RS 918 | AVRIL LAVIGNE
March 20th, 2003
PHOTOGRAPH BY MARTIN SCHOELLER

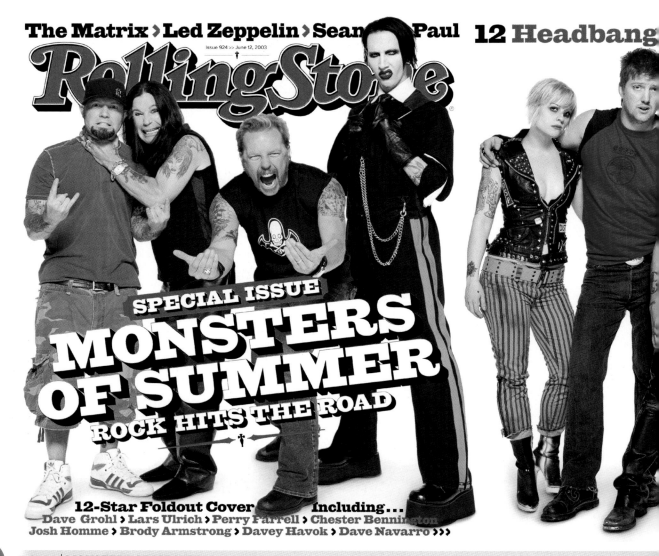

The Matrix › **Led Zeppelin** › Sean Paul **12 Headbang**

Issue 924 >> June 12, 2003

Rolling Stone

SPECIAL ISSUE

MONSTERS OF SUMMER

ROCK HITS THE ROAD

12-Star Foldout Cover Including...
› Dave Grohl › Lars Ulrich › Perry Farrell › Chester Bennington
Josh Homme › Brody Armstrong › Davey Havok › Dave Navarro ››

RS 924 | MONSTERS OF SUMMER | June 12th, 2003 | PHOTOGRAPH BY ANDREW MACPHERSON

2000s

[RS 924] It's never easy assembling this many egos, but for our Monsters of Summer
issue, that turned out to be the least of our problems. The concept was that the cover
would unfold to three times its regular size, thereby allowing us to cram twelve major
players from the summer's biggest tours onto the front of our magazine. It was only
after we designed the cover that we discovered our printing presses could handle just
one foldout, not two. As a result, Linkin Park singer Chester Bennington, AFI vocalist
Davey Havok, Metallica drummer Lars Ulrich and Perry Farrell were relegated to the
flip side of the foldout. Thanks to the wonders of modern technology, they all appear here.

[RS 914] Justin Timberlake's first cover as a solo artist was also Herb Ritts's forty-sixth and final cover for ROLLING STONE. The photographer died of complications from pneumonia on December 26th, 2002.

"I'M A VERY LOVING, CARING person," [Timberlake] was saying, "and if I start dating you – you know, as a girl – it may take me a long time to give myself away to you, but once I do, that's it. You can have whatever you want. But I've had my heart broken plenty of times."

He pressed his lips together and fluttered a sad noise.

"Three times, actually," he continued. "I was fifteen the first time. She cheated on me, and I broke up with her. That's reason enough, right? 'Oops, sorry, see you.' I'd been going with her for a year. The second one I saw for a year and a half. And the third one" – and here he paused, thinking of Spears – "was for three and a half years. It was the same with her as with the first girl who broke my heart and the second. They've all gone down the same way. All of them. Three strikes, I'm out. I mean, she has a beautiful heart, but if I've lost my trust in someone, I don't think it's right for me to be with them. I'm not going to let my baggage with somebody else become my baggage with a new person. But I'll tell you, man, I have little, little hope. Three strikes. Little hope."

So that's the way it is with him. The girls he loves apparently cheat on him. It's an embarrassing thing, especially for a star of Timberlake's magnitude; but worse, it's a terrible personal tragedy, excruciating to the heart and a burden on the soul.

[EXCERPT FROM RS 914 COVER STORY
BY ERIK HEDEGAARD]

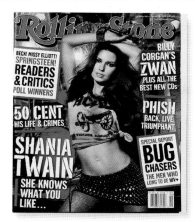

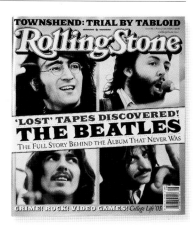

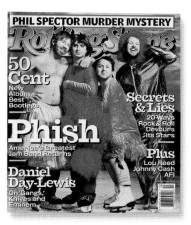

RS 915 | SHANIA TWAIN
February 6th, 2003
PHOTOGRAPH BY MICHAEL THOMPSON

RS 916 | THE BEATLES
February 20th, 2003
VARIOUS PHOTOGRAPHERS

RS 917 | PHISH
March 6th, 2003
PHOTOGRAPH BY MARTIN SCHOELLER

RS 918 | AVRIL LAVIGNE
March 20th, 2003
PHOTOGRAPH BY MARTIN SCHOELLER

VIOLENCE HAS BEEN A CONSTANT IN the life of twenty-six-year-old 50 Cent – government name Curtis Jackson, nickname Boo-Boo. His mother, a drug dealer, was killed when he was eight. At twelve, he became a dealer, and was nearly shot to death at twenty-four. His first hip-hop mentor, Jam Master Jay, was killed execution-style last year. Just four days before this very evening, an empty SUV owned by Busta Rhymes was hit with six bullets while parked in front of 50 Cent's manager's office. And right now, there are people who want 50 dead.

50 gets through his days in bulletproof trucks, walking with four to six bodyguards just inches away, ushering him briskly through streets and doors, but his body language and demeanor show him unmoved by the threats on his life. He never refuses to stop for an autograph or a photo request, even when it exposes him to danger. Is he worried about his grandparents, who still live in Queens, New York, in the house where he grew up? He says his reputation is enough to protect them. "They [his would-be killers] know how I am. Anything go on around there, they need to move everything they love. They mammy, they pappy, they kids, all that shit. That'd start some real nasty shit. And they don't wanna go through that." He seems confident he won't be killed, unperturbed by being hunted. "It don't matter to me," he says. "That shit is not important when you got finances. Do I look uneasy to you?"

[EXCERPT FROM RS 919 COVER STORY BY TOURÉ]

RS 920 | LISA MARIE PRESLEY
April 17th, 2003
PHOTOGRAPH BY MATTHEW ROLSTON

RS 922 | AMERICAN ICONS
May 15th, 2003
ILLUSTRATION BY ANDY COWLES

RS 921 | GOOD CHARLOTTE
May 1st, 2003
PHOTOGRAPH BY DAVID LACHAPELLE

RS 923 | ASHTON KUTCHER
May 29th, 2003
PHOTOGRAPH BY MARTIN SCHOELLER

[RS 922] Rather than assemble a retrospective on its history, ROLLING STONE chose to celebrate its thirty-fifth anniversary by documenting the people, inventions and images that define our times. Selected subjects included Elvis Presley, the Stratocaster, the iPod, the peace sign, Jack Daniels, the concept of the leading man—and, of course, the American flag that decorates the cover.

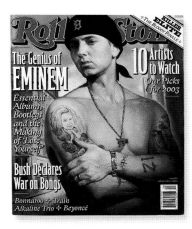

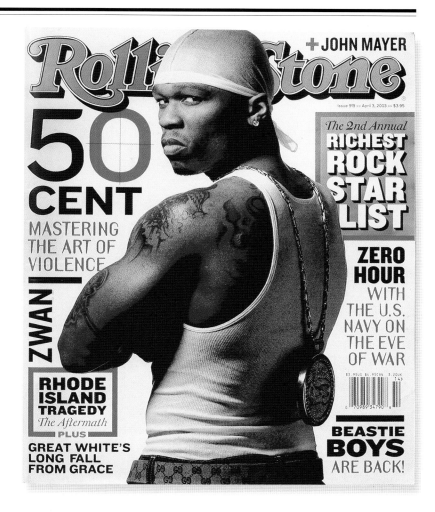

RS 926 | CLAY AIKEN
July 10th, 2003
PHOTOGRAPH BY MATTHEW ROLSTON

RS 919 | 50 CENT
April 3rd, 2003
PHOTOGRAPH BY ALBERT WATSON

RS 927 | EMINEM
July 24th, 2003
ILLUSTRATION BY ROBERTO PARADA

[RS 926] In summer 2003, Clay Aiken won the hearts and minds of the American public with his improbable run through *American Idol*. Despite his second-place finish, to Ruben Studdard, ROLLING STONE put Clay on the cover and was rewarded with one of its top-selling issues of 2003. Fans of Studdard weren't so happy and campaigned for their man to get a cover of his own. Three issues later, we caved in and were rewarded with one of our worst-sellers of the year.

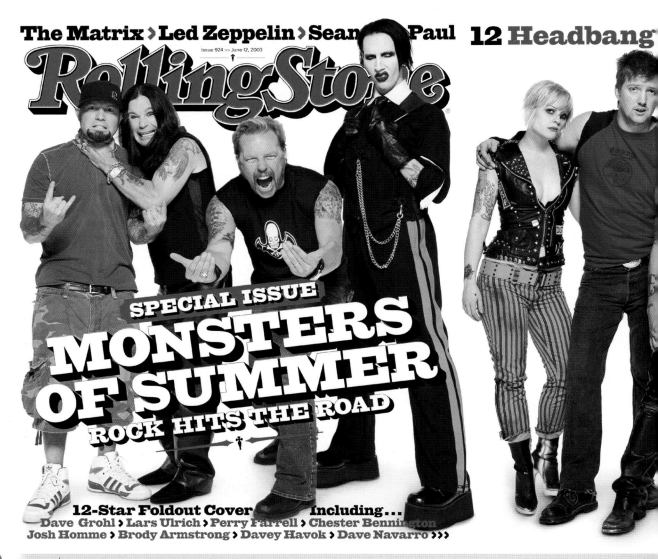

The Matrix › Led Zeppelin › Sean ... Paul **12 Headbang**

Rolling Stone

Issue 924 >> June 12, 2003

SPECIAL ISSUE

MONSTERS OF SUMMER
ROCK HITS THE ROAD

12-Star Foldout Cover **Including...**
Dave Grohl › Lars Ulrich › Perry Farrell › Chester Bennington
Josh Homme › Brody Armstrong › Davey Havok › Dave Navarro ›››

RS 924 | MONSTERS OF SUMMER | June 12th, 2003 | PHOTOGRAPH BY ANDREW MACPHERSON

[RS 924] It's never easy assembling this many egos, but for our Monsters of Summer issue, that turned out to be the least of our problems. The concept was that the cover would unfold to three times its regular size, thereby allowing us to cram twelve major players from the summer's biggest tours onto the front of our magazine. It was only after we designed the cover that we discovered our printing presses could handle just one foldout, not two. As a result, Linkin Park singer Chester Bennington, AFI vocalist Davey Havok, Metallica drummer Lars Ulrich and Perry Farrell were relegated to the flip side of the foldout. Thanks to the wonders of modern technology, they all appear here.

Interviews... With the Stars of Summer

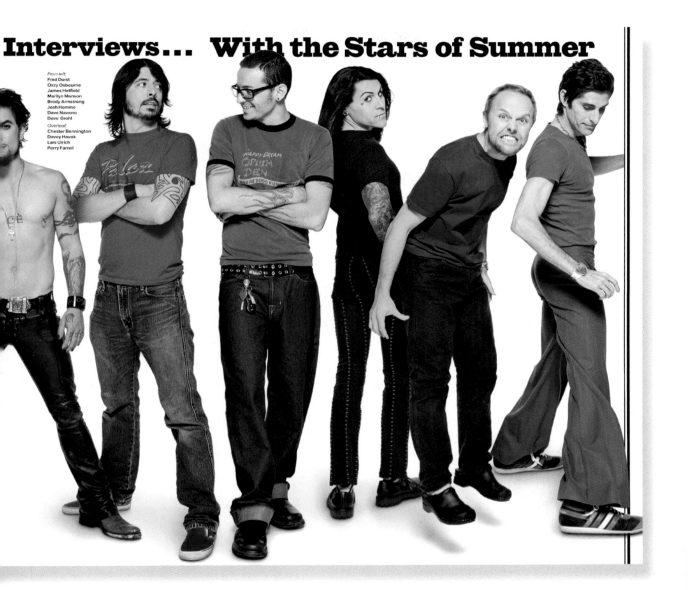

From left:
Fred Durst
Ozzy Osbourne
James Hetfield
Marilyn Manson
Brody Armstrong
Josh Homme
Dave Navarro
Dave Grohl

Overleaf:
Chester Bennington
Davey Havok
Lars Ulrich
Perry Farrell

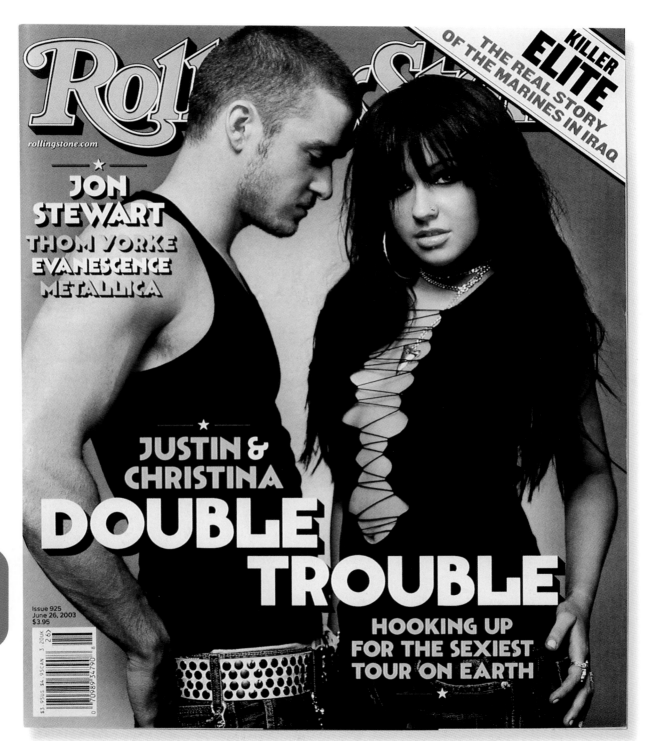

Rolling Stone

rollingstone.com

KILLER ELITE

THE REAL STORY OF THE MARINES IN IRAQ

★ JON STEWART

THOM YORKE

EVANESCENCE

METALLICA

★ JUSTIN & CHRISTINA

DOUBLE TROUBLE

HOOKING UP FOR THE SEXIEST TOUR ON EARTH

Issue 925
June 26, 2003
$3.95

2000s

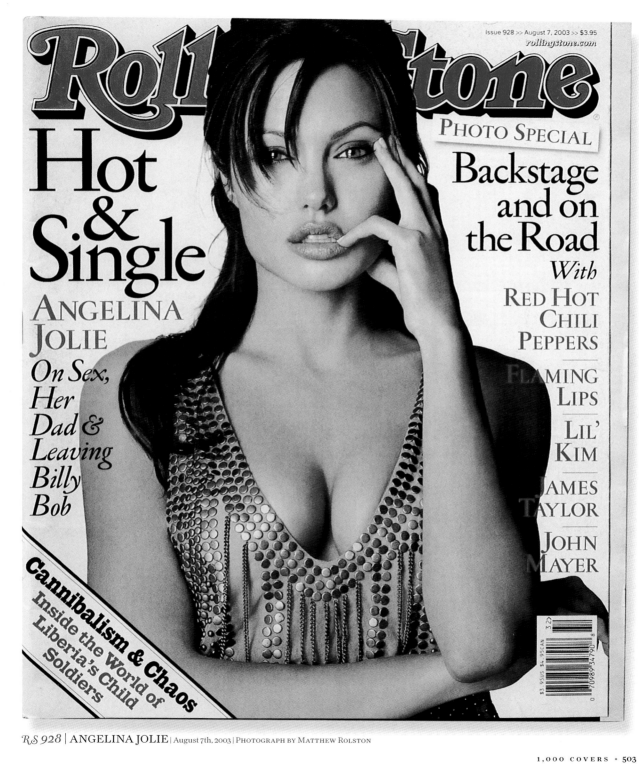

Issue 928 >> August 7, 2003 >> $3.95
rollingstone.com

Rolling Stone

PHOTO SPECIAL

Hot & Single

ANGELINA JOLIE

On Sex, Her Dad & Leaving Billy Bob

Backstage and on the Road

With

RED HOT CHILI PEPPERS

FLAMING LIPS

LIL' KIM

JAMES TAYLOR

JOHN MAYER

Cannibalism & Chaos
Inside the World of Liberia's Child Soldiers

RS 928 | ANGELINA JOLIE | August 7th, 2003 | Photograph by Matthew Rolston

RS 931 | THE 100 GREATEST
GUITARISTS OF ALL TIME –
JIMI HENDRIX
September 18th, 2003
PHOTOGRAPH BY JILL GIBSON

"*I think* every
photo shoot I've
done has been
tasteful. I'll never
be a vamp-vixen-
sex-goddess."
—*Britney Spears*

RS 929 | RUBEN STUDDARD
August 21st, 2003
PHOTOGRAPH BY ANDREW MACPHERSON

RS 934 | MISSY ELLIOTT,
ALICIA KEYS & EVE
October 30th, 2003
PHOTOGRAPH BY MAX VADUKUL

RS 930 | MARY-KATE AND
ASHLEY OLSEN
September 4th, 2003
PHOTOGRAPH BY MATTHEW ROLSTON

RS 935 | THE STROKES
November 13th, 2003
PHOTOGRAPH BY MAX VADUKUL

2000s

Issue 932 >> October 2, 2003 >> $4.95
rollingstone.com

Britney

ON JUSTIN, THAT KISS AND BEING ALONE

David Bowie
John Mayer
Bill Murray

MARTIN SCORSESE'S HISTORY OF THE BLUES

The 2003 Hot List

VIGGO MORTENSEN
SCARLETT JOHANSSON
RYAN ADAMS
BRAND NEW
OBIE TRICE
AIMEE MULLINS

Special Report
{ AMERICA'S DIRTY WAR }
THE DEADLY COST OF RADIOACTIVE TANK BUSTERS

$4.95US $5.95CAN
40>
7 25274 34790 0

RS 932 | BRITNEY SPEARS | October 2nd, 2003 | PHOTOGRAPH BY MATTHEW ROLSTON

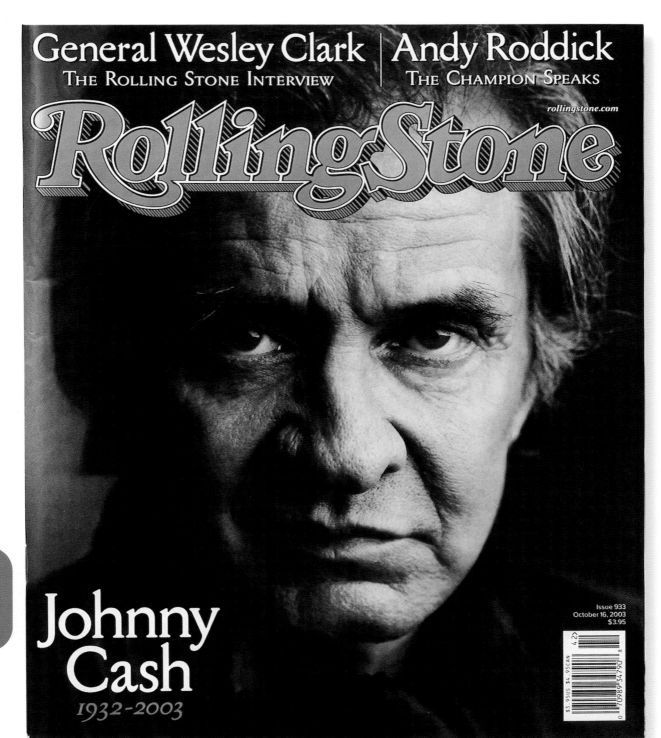

General Wesley Clark
THE ROLLING STONE INTERVIEW

Andy Roddick
THE CHAMPION SPEAKS

rollingstone.com

Rolling Stone

Johnny
Cash
1932-2003

Issue 933
October 16, 2003
$3.95

For so long it seemed that

even death would have to back off from a final confrontation with the daunting eminence of Johnny Cash. Even after the singer was found to have an incurable, degenerative disease in 1997, he did not back down. Despite frequent hospitalizations, he recorded some of the best music of his career, made himself available for interviews, oversaw reissues of his extensive catalog of albums and made a heart-stopping video that racked up six nominations at this year's MTV Video Music Awards. On the night nearly six years ago when, from a concert stage in Michigan, he first publicly announced that he was ill, he said of his disease, "I refuse to give it some ground in my life." As always with Johnny Cash, his word proved rock-solid.

But when June Carter Cash, his wife of thirty-five years and the exquisite love of his life, died in May, it became anybody's guess how long Cash would be able to tolerate this world without her. This was the woman for whom he had written "Meet Me in Heaven": "At the end of the journey," he sang, "When our last song is sung/Will you meet me in heaven someday?" Perhaps Bono put it best when the subject of Cash's death came up. "Maybe it's not that sad," he said. "I mean, it's sad for us. But June went off to prepare the house. And he wasn't long behind her."

—*Anthony DeCurtis*

"EVERY MAN COULD RELATE TO HIM, but nobody could be him. To be that extraordinary and that ordinary was his real gift. That, and his humor and his bare-boned honesty. When I visited him at home one time, he said the most beautiful, poetic grace. He said, 'Shall we bow our heads?' We all bowed our heads. Then, when he was done, he looked at me and Adam Clayton and said, 'Sure miss the drugs, though.'"

—*Bono*

"IN PLAIN TERMS, JOHNNY was and is the North Star; you could guide your ship by him. The greatest of the greats then and now."

—*Bob Dylan*

"I HAD BEEN IN AWE OF HIM SINCE I saw him play in 1958, at San Quentin Prison, where I was an inmate. He'd lost his voice the night before over in Frisco and wasn't able to sing very good, but he won over the prisoners. He chewed gum, looked arrogant and flipped the bird to the guards – he did everything the prisoners wanted to do. He was a mean mother from the South who was there because he loved us. When he walked away, everyone in that place had become a Johnny Cash fan. There were five thousand inmates in San Quentin and about thirty guitar players; I was among the top five guitarists in there. The day after Johnny's show, man, every guitar player in San Quentin was after me to teach them how to play like him. It was like how, the day after a Muhammad Ali fight, everybody would be down in the yard shadowboxing; that day, everyone was trying to learn 'Folsom Prison Blues.'"

—*Merle Haggard*

[EXCERPTS FROM JOHNNY CASH TRIBUTE]

RS 936 | JESSICA SIMPSON
November 27th, 2003
PHOTOGRAPH BY MAX VADUKUL

2000s

RS 938/939 | JUSTIN
TIMBERLAKE
December 25th, 2003 - January 8th, 2004
PHOTOGRAPH BY ALBERT WATSON

[RS 938/939] The face of Justin
Timberlake graced both our first and
last issues in the year 2003. That feat,
along with his appearance on RS 925
(with Christina Aguilera), makes
Timberlake the first artist to notch
three ROLLING STONE covers in
a single calendar year.

For RS 937, 'Rolling Stone'
convened a panel of 273 musicians, producers, journalists and others to choose the 500 best albums ever made. These are the Top 25.

1.	*SGT. PEPPER'S LONELY HEARTS CLUB BAND*	THE BEATLES
2.	*PET SOUNDS*	THE BEACH BOYS
3.	*REVOLVER*	THE BEATLES
4.	*HIGHWAY 61 REVISITED*	BOB DYLAN
5.	*RUBBER SOUL*	THE BEATLES
6.	*WHAT'S GOING ON*	MARVIN GAYE
7.	*EXILE ON MAIN STREET*	THE ROLLING STONES
8.	*LONDON CALLING*	THE CLASH
9.	*BLONDE ON BLONDE*	BOB DYLAN
10.	*THE BEATLES [THE WHITE ALBUM]*	THE BEATLES
11.	*THE SUN SESSIONS*	ELVIS PRESLEY
12.	*KIND OF BLUE*	MILES DAVIS
13.	*THE VELVET UNDERGROUND*	THE VELVET UNDERGROUND & NICO
14.	*ABBEY ROAD*	THE BEATLES
15.	*ARE YOU EXPERIENCED?*	THE JIMI HENDRIX EXPERIENCE
16.	*BLOOD ON THE TRACKS*	BOB DYLAN
17.	*NEVERMIND*	NIRVANA
18.	*BORN TO RUN*	BRUCE SPRINGSTEEN
19.	*ASTRAL WEEKS*	VAN MORRISON
20.	*THRILLER*	MICHAEL JACKSON
21.	*THE GREAT TWENTY-EIGHT*	CHUCK BERRY
22.	*PLASTIC ONO BAND*	JOHN LENNON
23.	*INNERVISIONS*	STEVIE WONDER
24.	*LIVE AT THE APOLLO*	JAMES BROWN
25.	*RUMOURS*	FLEETWOOD MAC

Bush's Crimes Against the Environment BY ROBERT F. KENNEDY JR.

RollingStone

SPECIAL COLLECTORS ISSUE

— THE —

500 GREATEST ALBUMS OF ALL TIME

$4.95US $5.95CAN

RS 937 | THE 500 GREATEST ALBUMS OF ALL TIME | December 11th, 2003 | TYPOGRAPHY BY ANDY COWLES

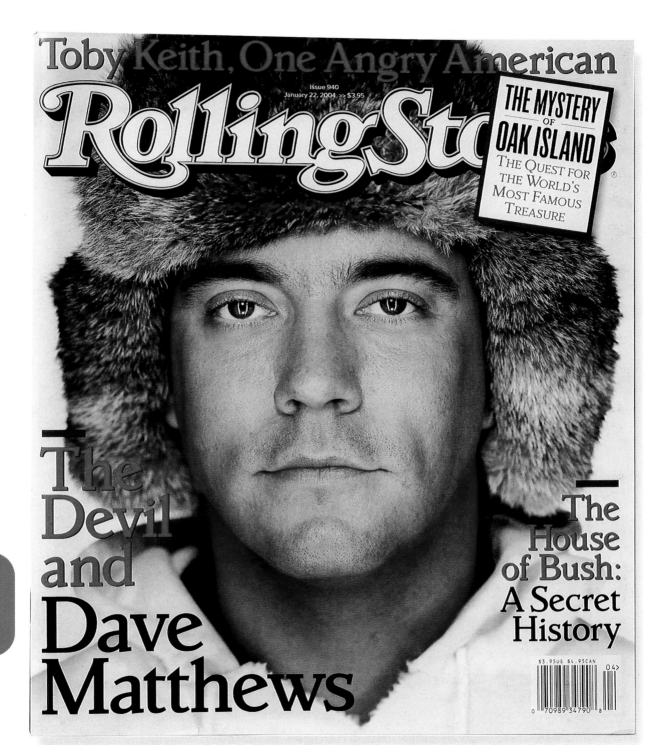

Toby Keith, One Angry American

RollingStone

Issue 940
January 22, 2004 >> $3.95

The Devil and Dave Matthews

The House of Bush: A Secret History

$3.95US $4.95CAN
0 70989 34790 8
04>

2000s

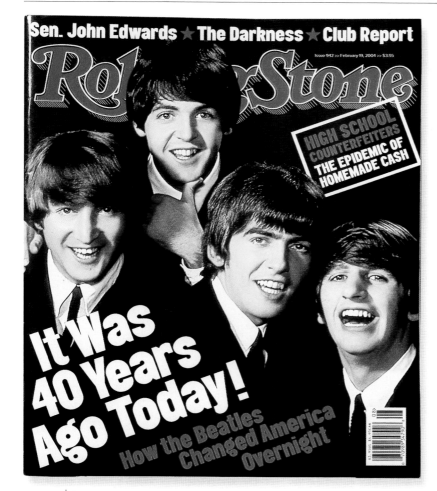

RS 942 | THE BEATLES | February 19th, 2004 | PHOTOGRAPH BY JOHN DOMINIS

RS 941 | HOWARD DEAN
February 5th, 2004
PHOTOGRAPH BY STEPHEN DANELIAN

[RS 941] When this issue hit
newsstands on January 16th, 2004,
Howard Dean was being touted as
the savior of the Democratic Party.
Three days later, following the Iowa
Democratic Caucus, he suffered one
of the most spectacular meltdowns
in American political history with
his notorious "Scream" speech.
Sales suffered accordingly.

"When I put the fuzzy hat on,
I laughed and said, 'This will be on the cover.' I
thought it would be the shot that made me look
the most stupid. Even though I've been teased
about it at the coffee shop at home, I liked it."
—Dave Matthews

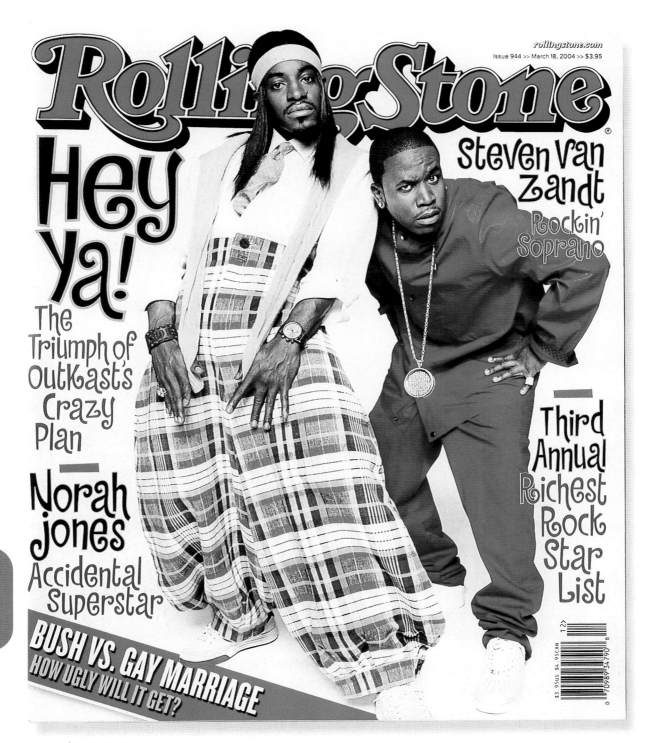

rollingstone.com
Issue 944 >> March 18, 2004 >> $3.95

Rolling Stone

Hey ya!

The Triumph of OutKast's Crazy Plan

Norah Jones
Accidental Superstar

Steven Van Zandt
Rockin' Soprano

Third Annual Richest Rock Star List

BUSH VS. GAY MARRIAGE
HOW UGLY WILL IT GET?

2000s

RS 944 | OUTKAST | March 18th, 2004 | PHOTOGRAPH BY ANDREW MACPHERSON

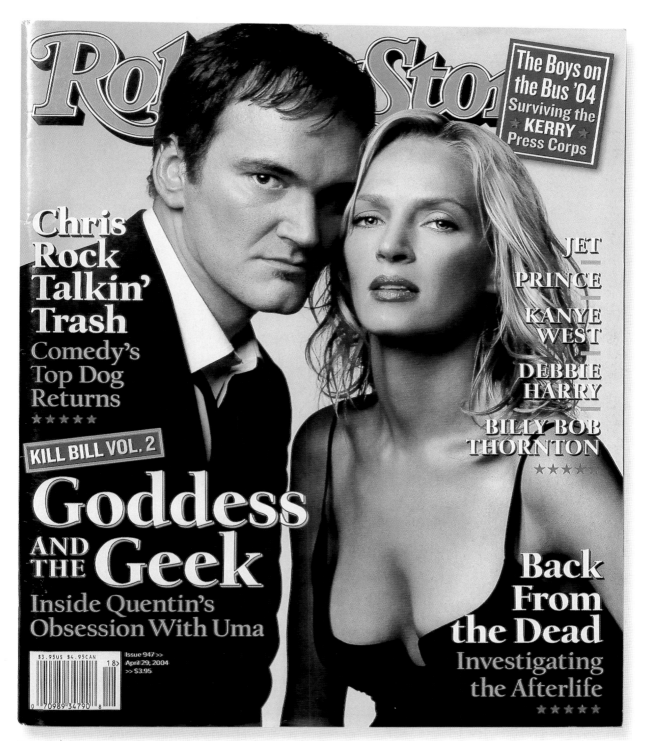

ROLLING STONE

The Boys on the Bus '04
Surviving the KERRY Press Corps

Chris Rock Talkin' Trash
Comedy's Top Dog Returns
★★★★★

JET
PRINCE
KANYE WEST
DEBBIE HARRY
BILLY BOB THORNTON
★★★★

KILL BILL VOL. 2

Goddess
AND THE Geek
Inside Quentin's Obsession With Uma

$3.95US $4.95CAN
Issue 947 >>
April 29, 2004
>> $3.95

0 70989 34790 8

Back From the Dead
Investigating the Afterlife
★★★★★

RS 947 | QUENTIN TARANTINO & UMA THURMAN | April 29th, 2004 | PHOTOGRAPH BY ALBERT WATSON

[RS 948] One of the covers has got to have the distinction – and this is the one: the worst-selling issue in the history of ROLLING STONE.

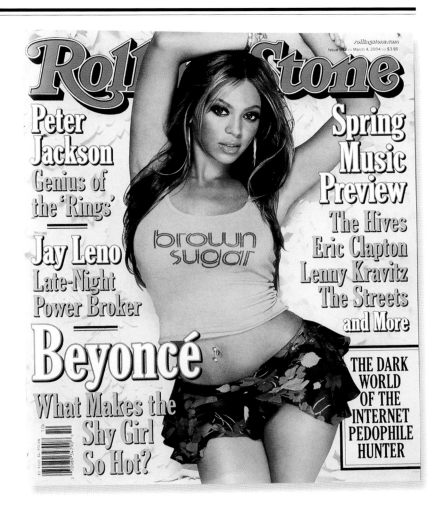

2000s

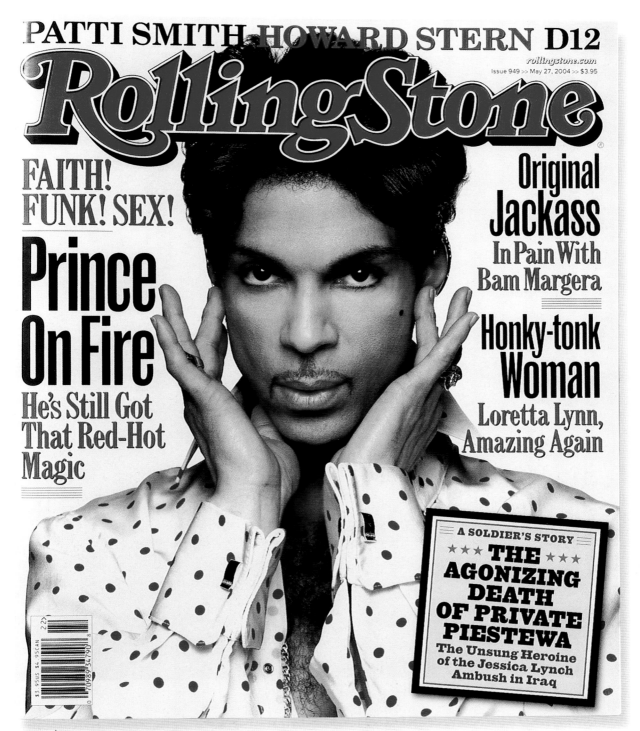

PATTI SMITH HOWARD STERN D12

Rolling Stone

rollingstone.com
Issue 949 >> May 27, 2004 >> $3.95

FAITH!
FUNK! SEX!

Prince
On Fire

He's Still Got
That Red-Hot
Magic

Original
Jackass
In Pain With
Bam Margera

Honky-tonk
Woman
Loretta Lynn,
Amazing Again

A SOLDIER'S STORY
★★★ THE ★★★
AGONIZING
DEATH
OF PRIVATE
PIESTEWA
The Unsung Heroine
of the Jessica Lynch
Ambush in Iraq

RS 950 | EMINEM & D12
June 10th, 2004
PHOTOGRAPH BY MARTIN SCHOELLER

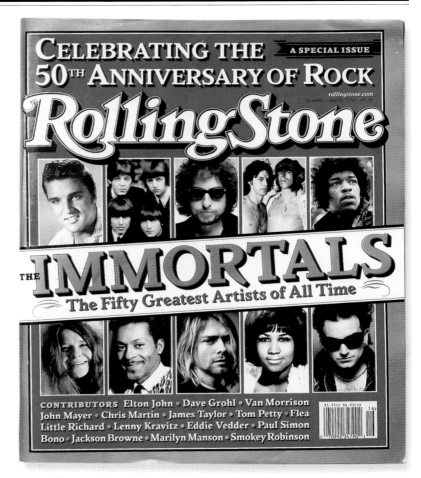

RS 946 | THE FIFTIETH ANNIVERSARY OF ROCK: THE IMMORTALS
April 15th, 2004 | VARIOUS PHOTOGRAPHERS

THE IMMORTALS ARE THE GREATEST ROCK & ROLL ARTISTS OF ALL TIME. THEY ARE also more than that. The fifty men, women and bands celebrated in the following pages are the singers, songwriters, record makers and performers who are continually in the music – as pioneers, teachers and stars; touching our souls and pulling us to our feet, on a daily basis – even when they are no longer with us. And this is not just a list. It is a fundamental lesson in the history of rock & roll and its continuing power to inspire and transform. The Immortals is a tribute to those who created rock & roll, written by their peers and heirs, those who have learned from their innovations, struggles and legacies.

This year, rock & roll turns fifty, and this is the first of three special issues ROLLING STONE is publishing to mark the occasion. Scholars have debated the precise birth date for as long as the music has been around. We chose July 5th, 1954 – the day Elvis Presley recorded "That's All Right" at Sun Studio in Memphis. On that date, the nineteen-year-old truck driver not only made his first and most important single. He created a new world – initiating a way of life and expression – that, even at fifty, is still evolving. There is no better standard for rock & roll immortality. [EXCERPT FROM RS 946]

2000s

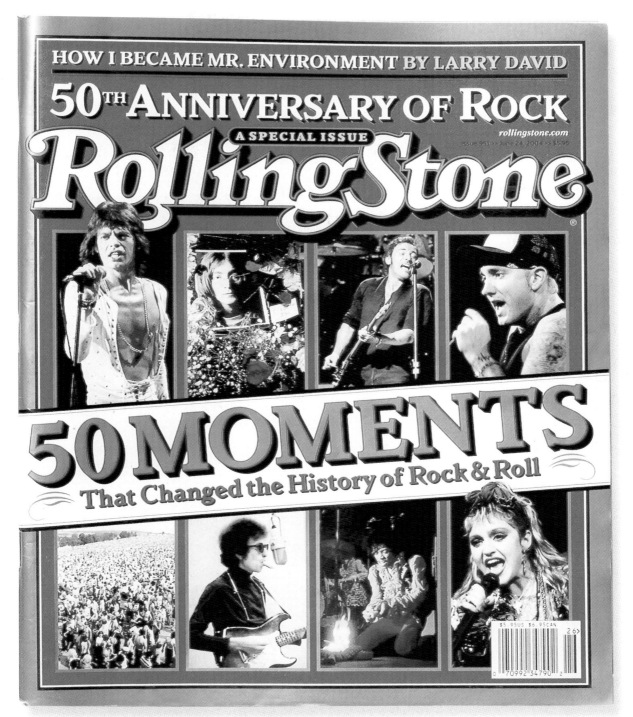

RS 951 | THE FIFTIETH ANNIVERSARY OF ROCK: FIFTY MOMENTS THAT CHANGED
THE HISTORY OF ROCK & ROLL | June 24th, 2004 | VARIOUS PHOTOGRAPHERS

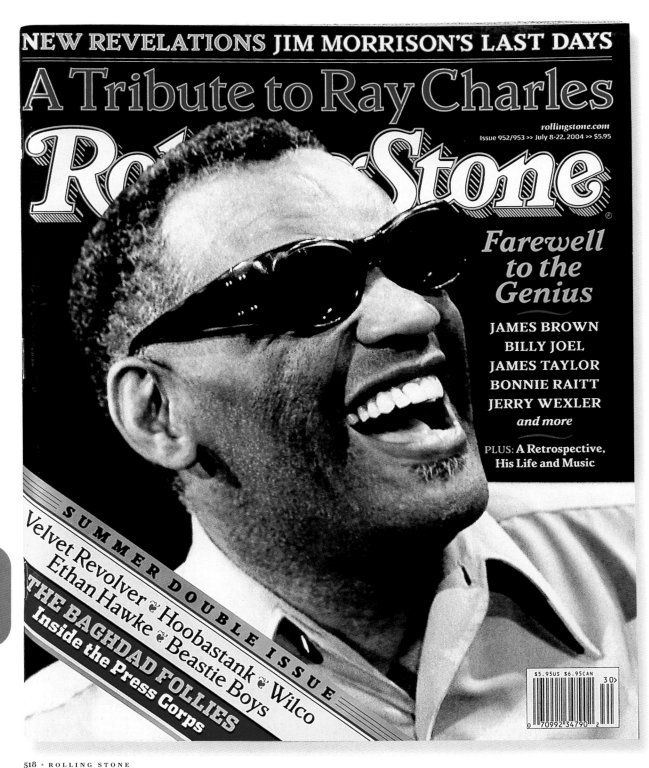

NEW REVELATIONS JIM MORRISON'S LAST DAYS

A Tribute to Ray Charles

rollingstone.com
Issue 952/953 >> July 8-22, 2004 >> $5.95

Rolling Stone

Farewell to the Genius

JAMES BROWN
BILLY JOEL
JAMES TAYLOR
BONNIE RAITT
JERRY WEXLER
and more

PLUS: A Retrospective,
His Life and Music

SUMMER DOUBLE ISSUE

Velvet Revolver ❦ Hoobastank ❦ Wilco
Ethan Hawke ❦ Beastie Boys
THE BAGHDAD FOLLIES
Inside the Press Corps

2000s

$5.95US $6.95CAN

30>

0 70992 34790 2

"*Ray Charles' music got me*

through high school. I loved him so much that back in 1963, after the Beach Boys got going, we used to do a live version of 'What'd I Say.' We did it because we wanted to turn people on to Ray Charles. It was always a real thrill for me to sing that song and think of Ray, so you can just imagine how I felt when, in 1986, Ray sang a version of our song 'Sail On Sailor.' Maybe most of all what I remember him for is his sensitive singing on cuts like 'I Can't Stop Loving You.' You can be sure the whole world will never stop loving you, Ray."

—*Brian Wilson*

"WHEN PEOPLE SAY, 'YOU AND Ahmet [Ertegun] produced Ray Charles,' put big quotation marks around produced. We were attendants at a happening. We learned from Ray Charles. My dear friend [writer] Stanley Booth once remarked, 'When Ahmet and Jerry got ready to record Ray Charles, they went to the studio and turned the lights on. Ray didn't need them.'"

—*Jerry Wexler*

"HE WAS THE FIRST TRUE CROSSOVER artist. I remember putting off a few of my so-called hipper friends when the *Jazz* album came out. They said, "Man, he's selling out." But Ray was rock & roll. He was rhythm & blues. He was jazz. He was country. He had such reach – and far-reaching effect."

—*Keith Richards*

"THIS MAY SOUND LIKE SACRILEGE, but I think Ray Charles was more important than Elvis Presley. I don't know if Ray was the architect of rock & roll, but he was certainly the first guy to do a lot of things. He was not a snob about style. Who the hell ever put so many styles together and made it work? He was a true American original."

—*Billy Joel*

"RAY WAS ALWAYS positive about what he was doing, and I admire him most for that. I tell you one thing: He could see a lot better than those with eyes."

—*James Brown*

"DEATH," RAY CHARLES TOLD ME when he first learned that cancer was devouring his body, "is the one motherfucker that ain't ever going away."

I met Ray Charles in 1975, when he agreed to let me ghostwrite his autobiography. He was vulgar, refined, funny, sexy, spontaneous, outlandish, brave, brutal, tender, blue, ecstatic. He would wrap his arms around his torso, hugging himself in a grand gesture of self-affirmation. In normal conversation, he preached and howled and fell to the floor laughing. He was, in his own words, "raw-ass country."

Because my job was to take the material of our dialogues and weave them into a first-person narrative, I had to make sure the dialogues were deep. I began tentatively by saying, "Now if this question is too tough . . ."

"How the fuck can a question be too tough? The truth is the truth."

The truth – at least Ray's truth – came pouring out: that his life had been rough; that his life had been blessed; that he had been a junkie; that he had given up junk only when faced with prison; that he still drank lots of gin and smoked lots of pot and worked just as tirelessly; that he had a huge appetite for women; that he wasn't even certain how many children he had fathered; that he was unrepentant about it all.

"When my mother died, I didn't understand death," he told me. "What do you mean, she's gone forever? I was fifteen, living at a school for the blind 160 miles away from home. She was all I had in the world. No, she couldn't be dead. Can't make it without her.

"That's when I saw what everyone sees: You can't make a deal with death. No, sir. And you can't make a deal with God. Death is coldblooded, and maybe God is, too."

—*David Ritz*

[EXCERPTS FROM RAY CHARLES TRIBUTE]

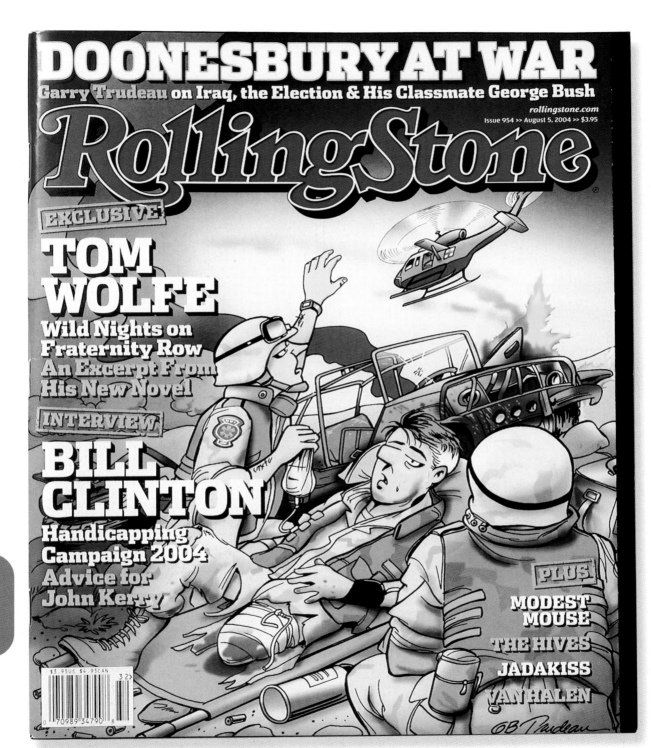

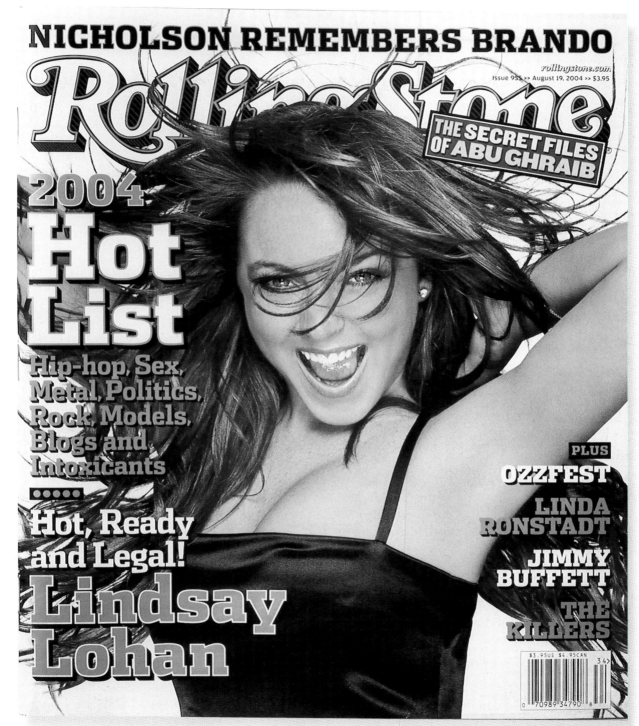

NICHOLSON REMEMBERS BRANDO

Rolling Stone

rollingstone.com
Issue 955 >> August 19, 2004 >> $3.95

THE SECRET FILES OF ABU GHRAIB

2004 Hot List

Hip-hop, Sex, Metal, Politics, Rock, Models, Blogs and Intoxicants

•••••

Hot, Ready and Legal!
Lindsay Lohan

PLUS

OZZFEST

LINDA RONSTADT

JIMMY BUFFETT

THE KILLERS

$3.95US $4.95CAN

0 70989 34790 8 34>

RS 955 | LINSDAY LOHAN | August 19th, 2004 | PHOTOGRAPH BY MATTHEW ROLSTON

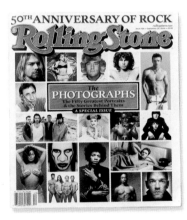

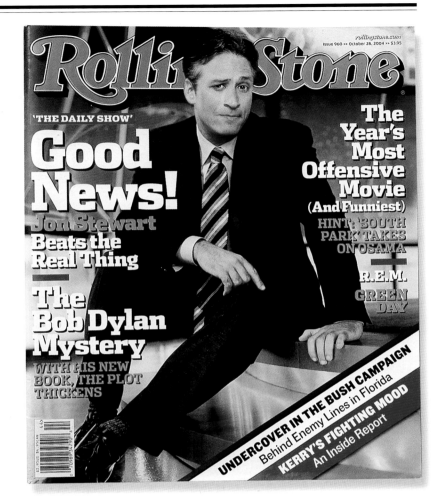

RS 956 | TOM CRUISE
September 2nd, 2004
PHOTOGRAPH BY TONY DURAN

RS 958 | THE FIFTIETH
ANNIVERSARY OF ROCK:
THE FIFTY GREATEST
PORTRAITS
September 30th, 2004
VARIOUS PHOTOGRAPHERS

RS 960 | JON STEWART | October 28th, 2004 | PHOTOGRAPH BY MICHAEL O'NEILL

"I THINK WE'VE CHANGED THE WORLD DRAMATICALLY. WHEN WE WERE picked up for broadcast by CNN International – I don't want to say a week later but maybe two weeks later – the border between Pakistan and India stood down. Direct correlation? I don't know what else you can point to."
—*Jon Stewart*

[RS 957] This cover, starring the incendiary documentary maker Michael Moore, followed a rather graphic depiction of the Iraq war by Doonesbury creator Garry Trudeau (RS 954) in a series of political covers that led up to Election Day 2004. After Moore came the Vote for Change Tour, a nine-day concert tour of the swing states organized to mobilize voters (RS 959); *Daily Show* host Jon Stewart (RS 960); and then–presidential nominee John Kerry (RS 961).

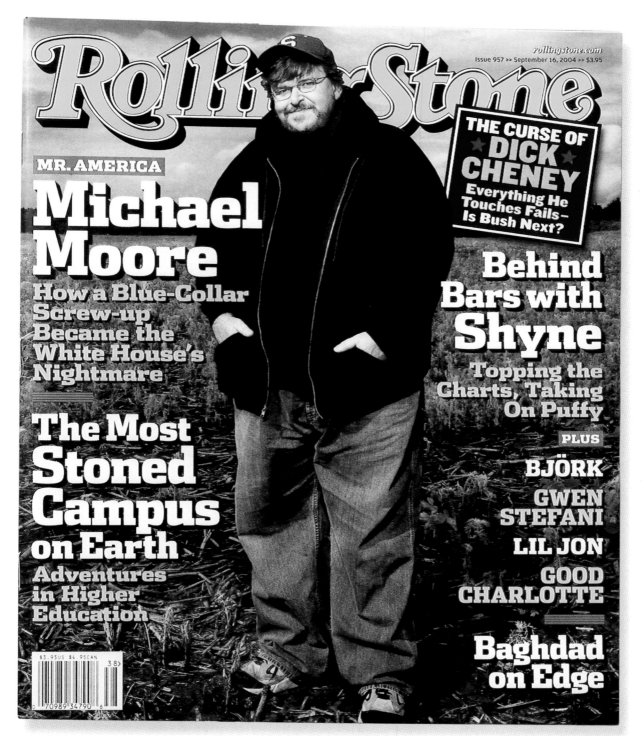

Rolling Stone

Issue 957 >> September 16, 2004 >> $3.95
rollingstone.com

THE CURSE OF
★ DICK ★
CHENEY
Everything He
Touches Fails –
Is Bush Next?

MR. AMERICA
Michael Moore
How a Blue-Collar
Screw-up
Became the
White House's
Nightmare

The Most Stoned Campus on Earth
Adventures
in Higher
Education

Behind Bars with Shyne
Topping the
Charts, Taking
On Puffy

PLUS
BJÖRK
GWEN STEFANI
LIL JON
GOOD CHARLOTTE

Baghdad on Edge

$3.95US $4.95CAN
3 8>
0 70989 34790 8

RS 957 | MICHAEL MOORE | September 16th, 2004 | PHOTOGRAPH BY ALBERT WATSON

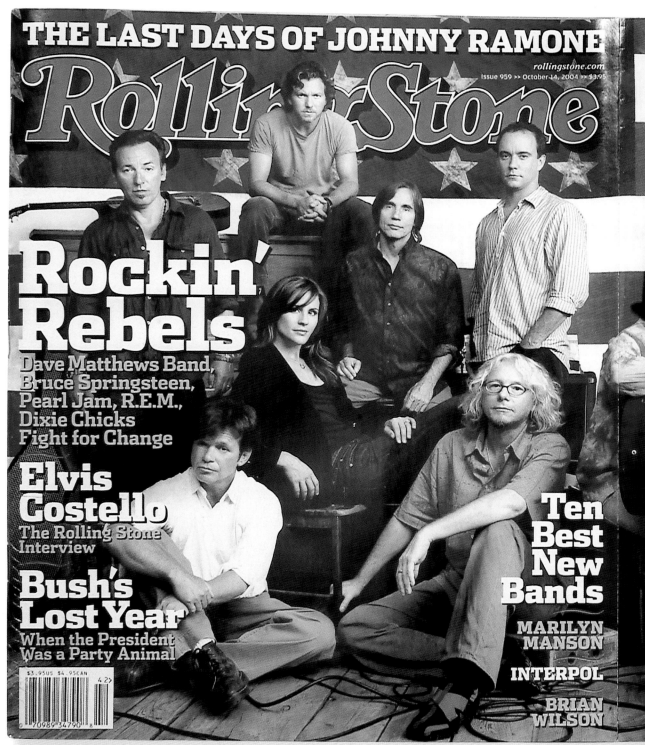

THE LAST DAYS OF JOHNNY RAMONE

rollingstone.com
Issue 959 >> October 14, 2004 >> $3.95

Rolling Stone

Rockin' Rebels
Dave Matthews Band,
Bruce Springsteen,
Pearl Jam, R.E.M.,
Dixie Chicks
Fight for Change

Elvis
Costello
The Rolling Stone
Interview

Bush's
Lost Year
When the President
Was a Party Animal

Ten
Best
New
Bands

MARILYN
MANSON

INTERPOL

BRIAN
WILSON

$3.95US $4.95CAN

2000s

From left: Bruce Springsteen, John Mellencamp, Eddie Vedder, Emily Robison, Jackson Browne, Dave Matthews, Mike Mills, Steve Van Zandt, Patti Scialfa, Bonnie Raitt, Ben Gibbard, Stone Gossard, Martie Maguire, Boyd Tinsley

RS 959
MUSICIANS
FROM THE VOTE
FOR CHANGE
TOUR
October 14th, 2004
PHOTOGRAPH BY
NORMAN JEAN ROY

[RS 963] Finishing what it started with RS 937 (which compiled the 500 best albums ever recorded), ROLLING STONE pulled together an all-star panel of 172 voters to select the 500 greatest songs of all time. These are the Top 25.

1.	"LIKE A ROLLING STONE"	BOB DYLAN
2.	"(I CAN'T GET NO) SATISFACTION"	THE ROLLING STONES
3.	"IMAGINE"	JOHN LENNON
4.	"WHAT'S GOING ON"	MARVIN GAYE
5.	"RESPECT"	ARETHA FRANKLIN
6.	"GOOD VIBRATIONS"	THE BEACH BOYS
7.	"JOHNNY B. GOODE"	CHUCK BERRY
8.	"HEY JUDE"	THE BEATLES
9.	"SMELLS LIKE TEEN SPIRIT"	NIRVANA
10.	"WHAT'D I SAY"	RAY CHARLES
11.	"MY GENERATION"	THE WHO
12.	"A CHANGE IS GONNA COME"	SAM COOKE
13.	"YESTERDAY"	THE BEATLES
14.	"BLOWIN' IN THE WIND"	BOB DYLAN
15.	"LONDON CALLING"	THE CLASH
16.	"I WANT TO HOLD YOUR HAND"	THE BEATLES
17.	"PURPLE HAZE"	THE JIMI HENDRIX EXPERIENCE
18.	"MAYBELLINE"	CHUCK BERRY
19.	"HOUND DOG"	ELVIS PRESLEY
20.	"LET IT BE"	THE BEATLES
21.	"BORN TO RUN"	BRUCE SPRINGSTEEN
22.	"BE MY BABY"	THE RONETTES
23.	"IN MY LIFE"	THE BEATLES
24.	"PEOPLE GET READY"	THE IMPRESSIONS
25.	"GOD ONLY KNOWS"	THE BEACH BOYS

RS 961 | JOHN KERRY
November 11th, 2004
PHOTOGRAPH BY ALBERT WATSON

RS 962 | EMINEM
November 25th, 2004
PHOTOGRAPH BY NORMAN JEAN ROY

RS 963 | THE 500 GREATEST
SONGS OF ALL TIME
December 12th, 2004
TYPOGRAPHY BY AMID CAPECI

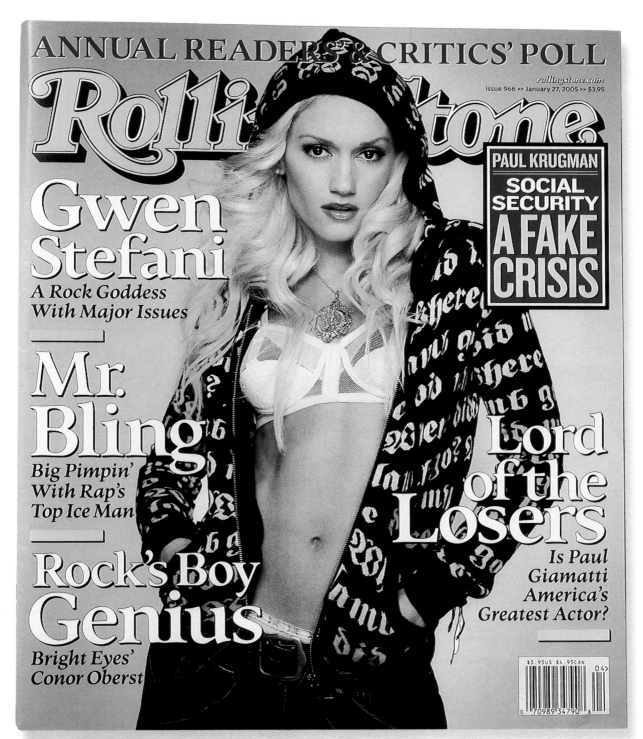

ANNUAL READERS & CRITICS' POLL

Rolling Stone.

rollingstone.com
Issue 966 | January 27, 2005 >> $3.95

Gwen
Stefani
A Rock Goddess
With Major Issues

Mr.
Bling
Big Pimpin'
With Rap's
Top Ice Man

Rock's Boy
Genius
Bright Eyes'
Conor Oberst

PAUL KRUGMAN
SOCIAL
SECURITY
A FAKE
CRISIS

Lord
of the
Losers
Is Paul
Giamatti
America's
Greatest Actor?

$3.95US $4.95CAN
04>
0 70989 34790 8

RS 966 | GWEN STEFANI | January 27th, 2005 | PHOTOGRAPH BY MAX VADUKUL

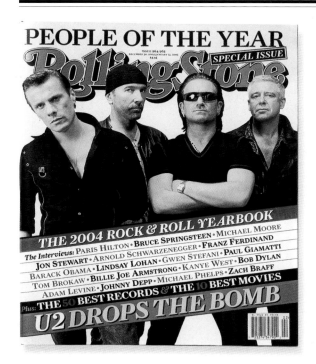

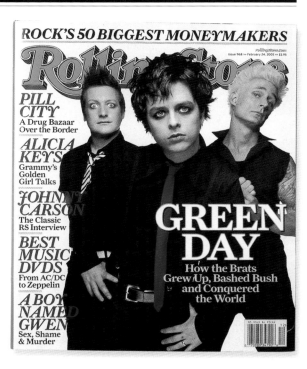

RS 964/965 | U2
December 30th, 2004 – January 13th, 2005
PHOTOGRAPH BY RUVEN AFANADOR

RS 968 | GREEN DAY
February 24th, 2005
PHOTOGRAPH BY JAMES DIMMOCK

RS 969 | BOB MARLEY
March 10th, 2005
PHOTOGRAPH BY ANNIE LEIBOVITZ

2000s

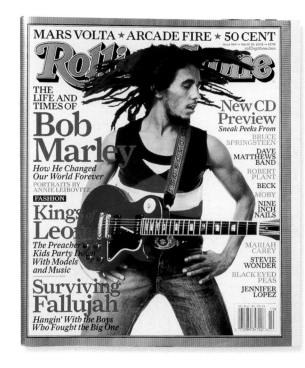

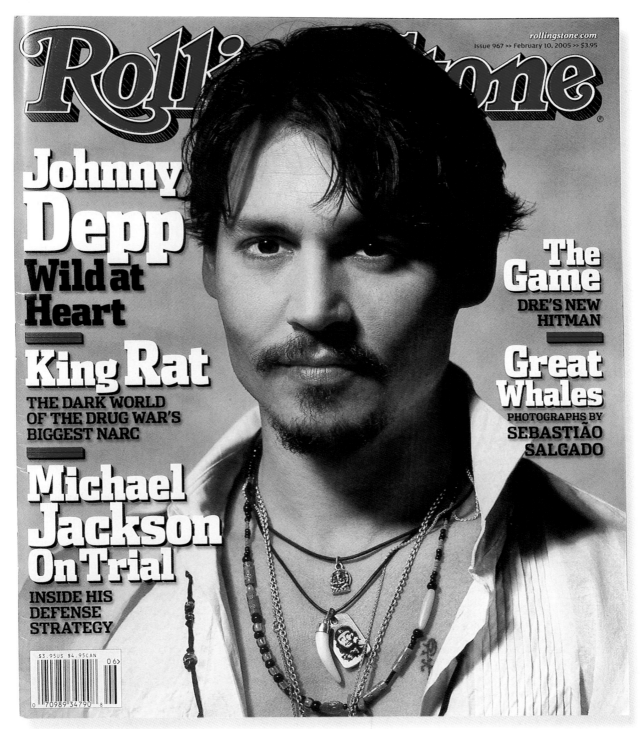

Rolling Stone

rollingstone.com
Issue 967 >> February 10, 2005 >> $3.95

Johnny **Depp**
Wild at Heart

King Rat
THE DARK WORLD
OF THE DRUG WAR'S
BIGGEST NARC

Michael **Jackson**
On Trial
INSIDE HIS
DEFENSE
STRATEGY

The Game
DRE'S NEW
HITMAN

Great Whales
PHOTOGRAPHS BY
SEBASTIÃO
SALGADO

$3.95US $4.95CAN
06>
0 70989 34790 8

RS 967 | JOHNNY DEPP | February 10th, 2005 | PHOTOGRAPH BY ALBERT WATSON

These are sad days here at

ROLLING STONE. This morning I cried as I struck "National Affairs Desk: Hunter S. Thompson" from the masthead – after thirty-five years. Hunter's name is now listed with Ralph Gleason's on what Hunter would have called "the honor roll." Hunter was part of the DNA of ROLLING STONE, one of those twisting strands of chemicals around which a new life is formed. He was such a big part of my life, and I loved him deeply. He was a man of energy, physical presence, utter charm, genius talent and genius humor. It's very hard to have to give him up and to say goodbye . . .

Once I had Hunter all to myself, and now I don't have him at all. He was a careful, deliberate and calculating man, and his suicide was not careless, not an accident and not selfish. He was in a wheelchair toward the end of his life, and he decided he would not be able to live with extreme physical disability; it just wasn't him. He had already lived longer than he, or any of us, had expected. He had lived a great life, filled with friends, his genius talent and righteousness.

—*Jann S. Wenner*

[EXCERPT FROM HUNTER S. THOMPSON TRIBUTE]

"IT ALWAYS SEEMED TO ME THAT Hunter was a man fighting for the rights of American Independence. Inside he felt this deep outrage, because people were fucking with his beloved Constitution. In that way he was a real American, a pioneer, a frontiersman, with a huge and raging mind. He should be lying in state next to the Lincoln Memorial. That's how they should have done it. He was a genuine son of the Kentucky pioneers."

—*Ralph Steadman*

"HE WAS INCISIVE. HE WAS DEEP. He played with facts, he slept with facts, he bathed with facts. They warmed him like a blanket. Facts were key, and they weren't arbitrary, they weren't ambiguous. They were precise. He was very, very precise.

"He was a great, great man. America has lost a great thinker."

—*Michael Stepanian*

"A FEW YEARS AGO HE SENT ME A wonderful photograph of himself leaping up on a golf course, like a gymnast, with both feet off the ground. He looks incredibly graceful. There's a wonderful passage from *The Great Gatsby*: 'Gatsby believed in the green light, the orgiastic future that year by year recedes before us. It eluded us then, but that's no matter – tomorrow we will run faster, stretch our arms out farther.' The picture of Hunter reminds me of that."

—*Lynn Nesbit*

"*He makes us* laugh – we can't help it. When we're around or about [him], we all want to be brilliant."

—*Jack Nicholson*

"BUY THE TICKET, TAKE THE RIDE." These are the words that echo in my skull. The words that our Good Doctor lived by and, by God, died by. He dictated, created, commanded, demanded, manipulated, manhandled and snatched life up by the short hairs and only relinquished his powerful grasp when he was ready. We are here, without him. But in no way are we left with nothing. We have his words, his insights, his humor and his truth. For those of us lucky enough to have been close to him, which often meant rather lengthy and dangerous occasions that would invariably lead to uncontrollable fits of laughter, we have the memory of his Cheshire grin leading us wherever he felt we needed to go. Which was always the right direction, however insane it may have seemed. Yes, the doctor always knew best. I have, seared onto my brain, the millions of hideous little adventures that I was blessed enough to have lived through with him and, frankly, in certain instances, blessed to have lived through. He was/is a brother, a friend, a hero, a father, a son, a teacher, a partner in crime. Our crime: fun. Always, fun.

—*Johnny Depp*

[EXCERPT FROM HUNTER S. THOMPSON TRIBUTE]

"HE WAS A VERY MORAL MAN. To him, what's right was right. Anything else was wrong, and the bastards better pay for it.

"I'd get these faxes from him that would use up all of the paper in my machine: twenty pages of writing and drawings, in that jagged hand. They'd just keep on comin'. I'd think, 'Shit, I better put more paper in – Hunter's calling.' "

—*Keith Richards*

2000s

Tales From a Weird & Righteous American Saga

RollingStone

Issue 970
March 24, 2005
$3.95
rollingstone.com

GONZO

DR. HUNTER S. THOMPSON
1937-2005

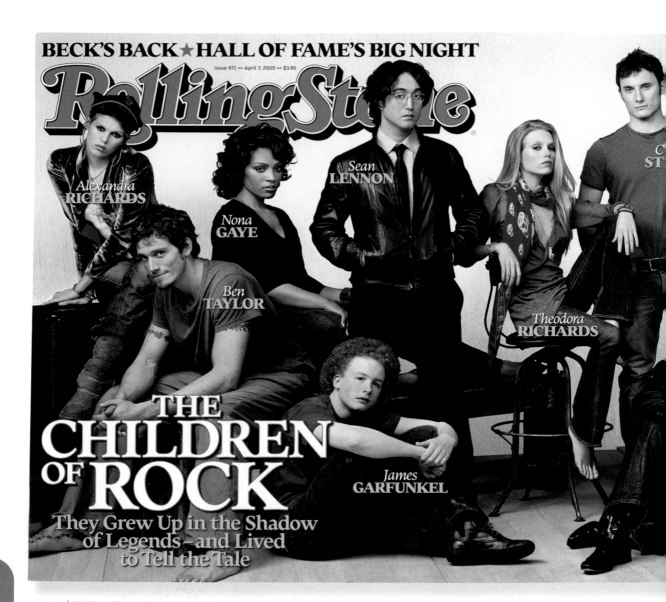

BECK'S BACK ★ HALL OF FAME'S BIG NIGHT

Rolling Stone

Issue 971 >> April 7, 2005 >> $3.95

Alexandra **RICHARDS**

Nona **GAYE**

Sean **LENNON**

Ben **TAYLOR**

Theodora **RICHARDS**

C
ST

THE CHILDREN OF ROCK

James **GARFUNKEL**

They Grew Up in the Shadow
of Legends – and Lived
to Tell the Tale

RS 971 | THE CHILDREN OF ROCK | April 7th, 2005 | PHOTOGRAPH BY NORMAN JEAN ROY

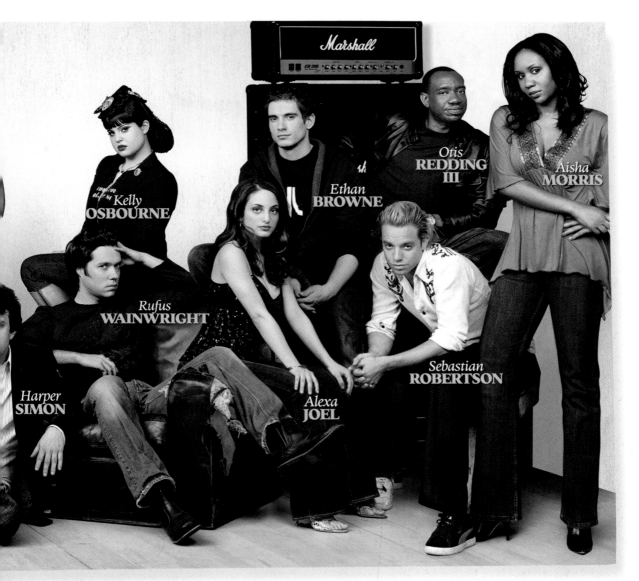

Kelly
OSBOURNE

Ethan
BROWNE

Otis
**REDDING
III**

Aisha
MORRIS

Rufus
WAINWRIGHT

Sebastian
ROBERTSON

Harper
SIMON

Alexa
JOEL

"*I think one of the reasons we all got along*

[at the photo shoot] is because nobody was like, 'Oh, that's Stevie Wonder's
daughter!' 'That's Marvin Gaye's daughter!' 'That's Paul Simon's son.' I
mean, I can't tell you how many times I meet people and someone will say,
'This is Billy Joel's daughter!' I used to get mad and say, 'My name is Alexa!'
Harper [Simon] and I were talking about how it was really nice, for once, to
just discuss our own work and what we wanted to do with our own lives."
—*Alexa Joel*

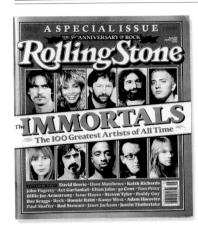

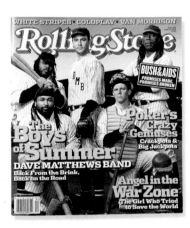

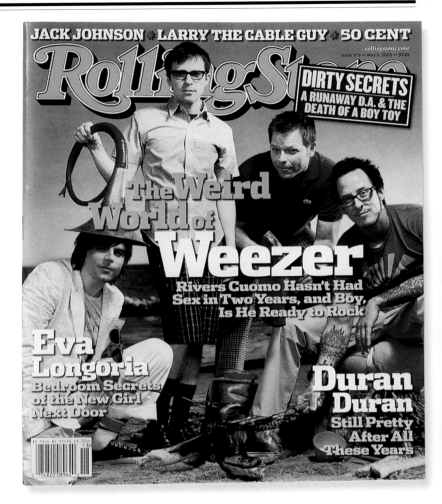

BEFORE WE TURN IN FOR THE NIGHT, [ORLANDO] BLOOM TALKS ABOUT a phenomenon he experienced while filming *Kingdom of Heaven* in Spain. That phenomenon was himself. It was the first time he had to deal with mobs of screaming fans outside his hotel – so many that police barricades had to be erected. He eventually had to hire Brad Pitt's security guard. "I think I'm mentioning this because I feel slightly bad that I didn't cope with it better," he says. "I really feel like if I were ever back in Spain, I'd make an effort to spend time with those people. Because they were all so sweet. I felt like I froze."

Either Bloom is truly a good guy or he's a great actor. Perhaps even both.

[EXCERPT FROM RS 974 COVER STORY BY NEIL STRAUSS]

2000s

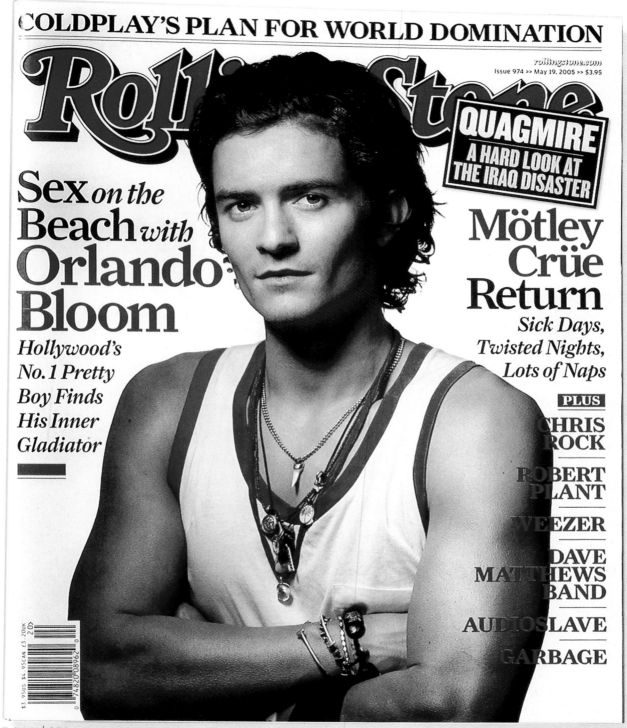

COLDPLAY'S PLAN FOR WORLD DOMINATION

Rolling Stone

rollingstone.com
Issue 974 >> May 19, 2005 >> $3.95

QUAGMIRE
A HARD LOOK AT
THE IRAQ DISASTER

Sex *on the* Beach *with* Orlando Bloom

*Hollywood's
No. 1 Pretty
Boy Finds
His Inner
Gladiator*

Mötley Crüe Return

*Sick Days,
Twisted Nights,
Lots of Naps*

PLUS

CHRIS ROCK

ROBERT PLANT

WEEZER

DAVE MATTHEWS BAND

AUDIOSLAVE

GARBAGE

$3.95US $4.95CAN £3.20UK
20

RS 974 | ORLANDO BLOOM | May 19th, 2005 | PHOTOGRAPH BY ALBERT WATSON

1,000 COVERS • 535

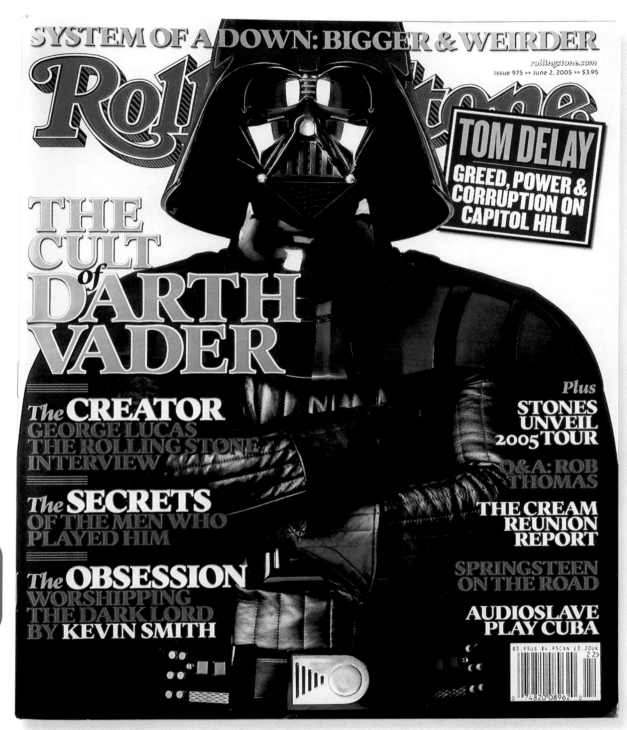

SYSTEM OF A DOWN: BIGGER & WEIRDER

Rolling Stone

rollingstone.com
Issue 975 >> June 2, 2005 >> $3.95

TOM DELAY
GREED, POWER &
CORRUPTION ON
CAPITOL HILL

THE
CULT
of
DARTH
VADER

Plus
**STONES
UNVEIL
2005 TOUR**

Q&A: ROB
THOMAS

**THE CREAM
REUNION
REPORT**

SPRINGSTEEN
ON THE ROAD

**AUDIOSLAVE
PLAY CUBA**

The **CREATOR**
GEORGE LUCAS
THE ROLLING STONE
INTERVIEW

The **SECRETS**
OF THE MEN WHO
PLAYED HIM

The **OBSESSION**
WORSHIPPING
THE DARK LORD
BY **KEVIN SMITH**

$3.95US $4.95CAN £3.20UK

0 74820 08962 0

R S 975 | DARTH VADER | June 2nd, 2005 | Photograph by Albert Watson

COLDPLAY'S PLAN FOR WORLD DOMINATION

Rolling Stone

rollingstone.com
Issue 974 >> May 19, 2005 >> $3.95

QUAGMIRE
A HARD LOOK AT THE IRAQ DISASTER

Sex on the Beach with Orlando Bloom

*Hollywood's
No. 1 Pretty
Boy Finds
His Inner
Gladiator*

Mötley Crüe Return

*Sick Days,
Twisted Nights,
Lots of Naps*

PLUS

CHRIS ROCK

ROBERT PLANT

WEEZER

DAVE MATTHEWS BAND

AUDIOSLAVE

GARBAGE

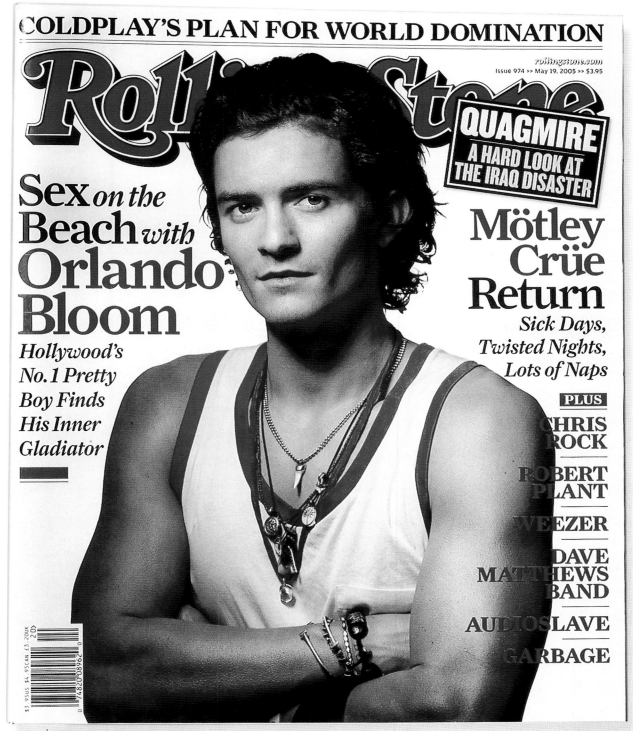

RS 974 | ORLANDO BLOOM | May 19th, 2005 | PHOTOGRAPH BY ALBERT WATSON

1,000 COVERS • 535

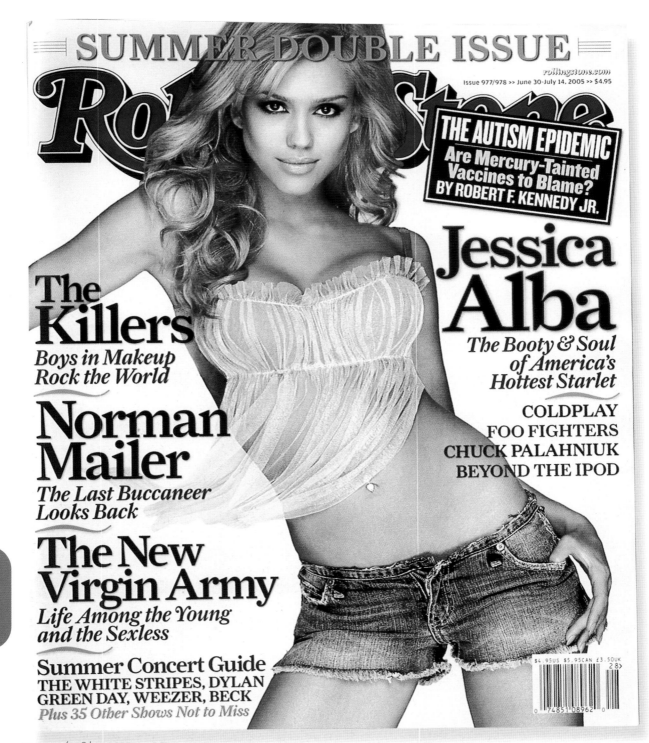

SUMMER DOUBLE ISSUE

Rolling Stone

rollingstone.com
Issue 977/978 >> June 30-July 14, 2005 >> $4.95

THE AUTISM EPIDEMIC
Are Mercury-Tainted Vaccines to Blame?
BY ROBERT F. KENNEDY JR.

The Killers
*Boys in Makeup
Rock the World*

Norman Mailer
*The Last Buccaneer
Looks Back*

The New Virgin Army
*Life Among the Young
and the Sexless*

Summer Concert Guide
THE WHITE STRIPES, DYLAN
GREEN DAY, WEEZER, BECK
Plus 35 Other Shows Not to Miss

Jessica Alba
*The Booty & Soul
of America's
Hottest Starlet*

COLDPLAY
FOO FIGHTERS
CHUCK PALAHNIUK
BEYOND THE IPOD

$4.95US $5.95CAN £3.50UK
28
0 74851 08962 0

2000s

RS 977/978 | JESSICA ALBA | June 30th – July 14th, 2005 | PHOTOGRAPH BY MATTHEW ROLSTON

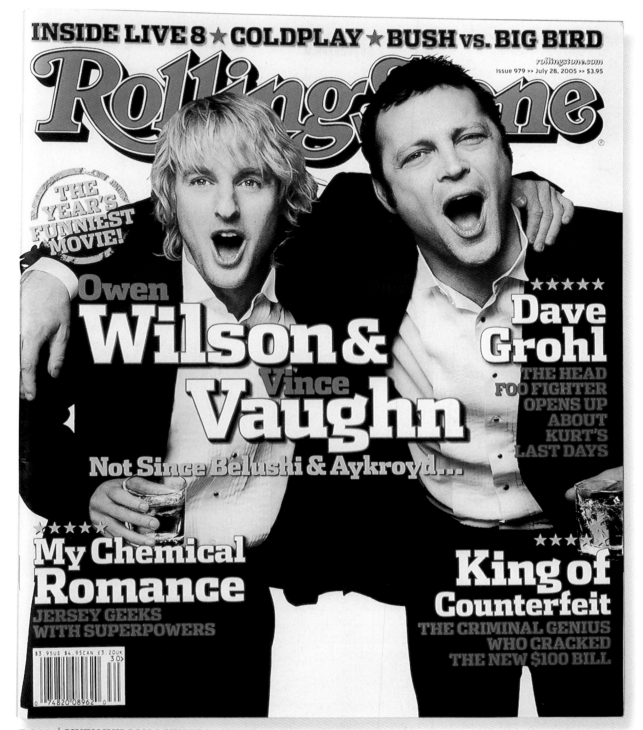

rollingstone.com

Issue 979 >> July 28, 2005 >> $3.95

Rolling Stone

THE YEAR'S FUNNIEST MOVIE!

Owen
Wilson &
Vince
Vaughn

Not Since Belushi & Aykroyd...

★★★★★
Dave Grohl
THE HEAD FOO FIGHTER OPENS UP ABOUT KURT'S LAST DAYS

★★★★
My Chemical Romance
JERSEY GEEKS WITH SUPERPOWERS

★★★
King of Counterfeit
THE CRIMINAL GENIUS WHO CRACKED THE NEW $100 BILL

$3.95US $4.95CAN £3.20UK
30>

0 74820 08962 0

RS 979 | OWEN WILSON & VINCE VAUGHN | July 28th, 2005 | Photograph by Max Vadukul

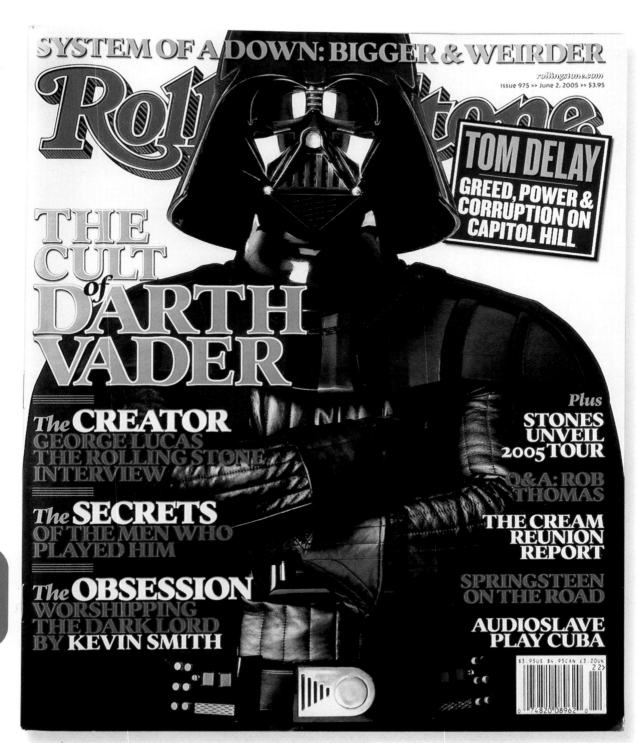

SYSTEM OF A DOWN: BIGGER & WEIRDER

Rolling Stone

rollingstone.com
Issue 975 >> June 2, 2005 >> $3.95

TOM DELAY
GREED, POWER &
CORRUPTION ON
CAPITOL HILL

THE
CULT
of
DARTH
VADER

The **CREATOR**
GEORGE LUCAS
THE ROLLING STONE
INTERVIEW

The **SECRETS**
OF THE MEN WHO
PLAYED HIM

The **OBSESSION**
WORSHIPPING
THE DARK LORD
BY **KEVIN SMITH**

Plus
**STONES
UNVEIL
2005 TOUR**

Q&A: ROB
THOMAS

**THE CREAM
REUNION
REPORT**

SPRINGSTEEN
ON THE ROAD

**AUDIOSLAVE
PLAY CUBA**

$3.95US $4.95CAN £3.20UK

0 74820 08962 0

2000s

RS 975 | DARTH VADER | June 2nd, 2005 | PHOTOGRAPH BY ALBERT WATSON

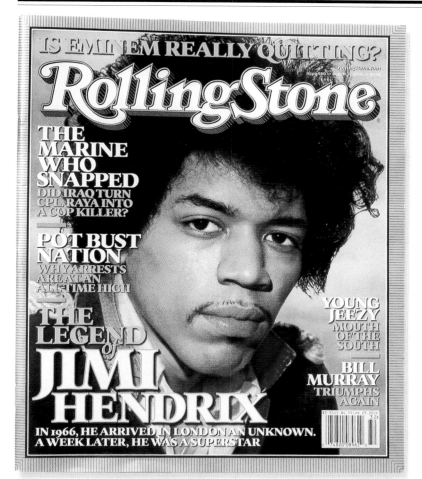

RS 980 | JIMI HENDRIX
August 11th, 2005
PHOTOGRAPH BY HARRY GOODWIN,
PHOTO-ILLUSTRATION BY MICHAEL ELINS

RS 981 | COLDPLAY
August 25th, 2005
PHOTOGRAPH BY ANTON CORBIJN

"*It took about twenty minutes*
to get suited up. There's no Darth Vader
underwear; I wore my own. It starts off with
the pants, followed by the boots and upper
coverings, which come in a few layers. There's
a leather jacket, then a fiberglass chest piece.
Then there's a leather jock piece, which looks
a little funny. Then it's the helmet and the cape.
As each piece comes on, layer by layer, you feel
the essence of Darth Vader overcoming you."
—*Hayden Christensen*

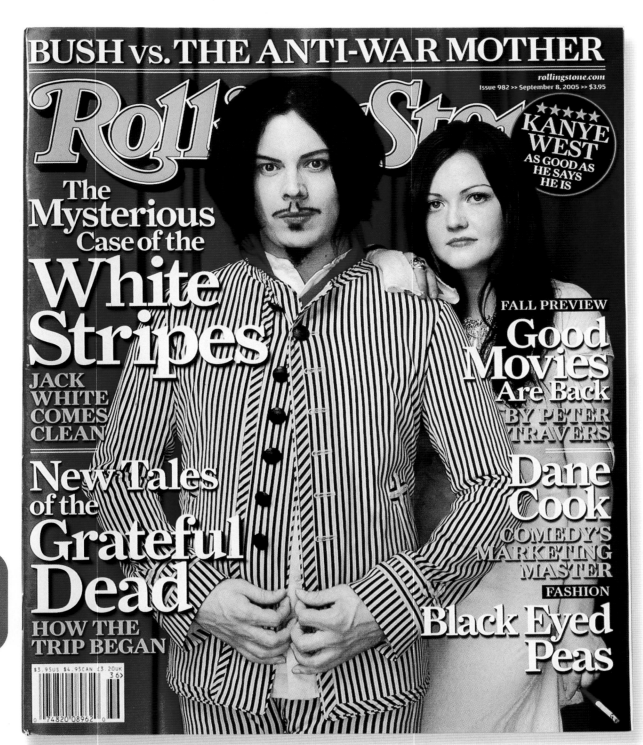

BUSH vs. THE ANTI-WAR MOTHER

Rolling Stone

rollingstone.com
Issue 982 >> September 8, 2005 >> $3.95

★★★★★ **KANYE WEST** AS GOOD AS HE SAYS HE IS

The Mysterious Case of the White Stripes

JACK WHITE COMES CLEAN

New Tales of the Grateful Dead

HOW THE TRIP BEGAN

FALL PREVIEW
Good Movies Are Back
BY PETER TRAVERS

Dane Cook
COMEDY'S MARKETING MASTER

FASHION
Black Eyed Peas

$3.95US $4.95CAN £3.20UK

36>

0 74820 08962 0

2000s

RS 982 | THE WHITE STRIPES | September 8th, 2005 | Photograph by Martin Schoeller

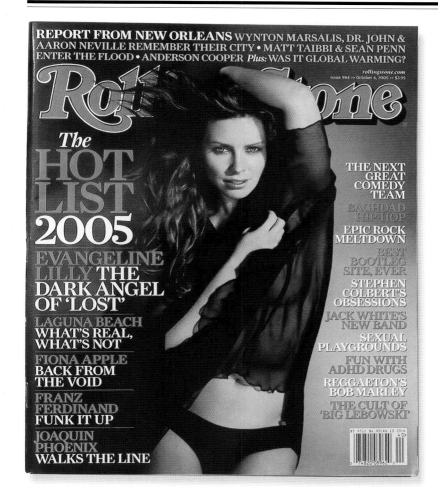

[RS 984] When it came time to pick the face of our Hot List 2005, we wanted to go with Evangeline Lilly, the sexy star of TV's *Lost*. The business side of the magazine said no. Their reason? The show, in its first season, was not significant enough to warrant a cover girl. How did we get our way? It may have had something to do with the 2005 Emmy Awards, which were handed out during the making of the issue. Winner for best drama series? *Lost.*

"The White Stripes' colors

were always red, white and black. It came from peppermint candy. I also think they are the most powerful color combination of all time, from a Coca-Cola can to a Nazi banner. Those colors strike chords with people. In Japan, they are honorable colors. When you see a bride in a white gown, you immediately see innocence in that. Red is anger and passion. It is also sexual. And black is the absence of all that." —*Jack White*

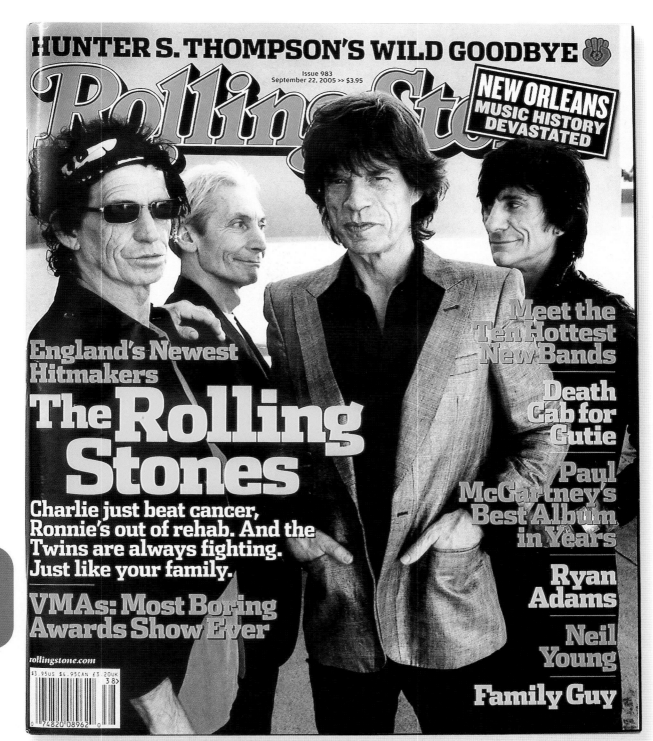

HUNTER S. THOMPSON'S WILD GOODBYE

Rolling Stone

Issue 983
September 22, 2005 >> $3.95

NEW ORLEANS
MUSIC HISTORY
DEVASTATED

England's Newest
Hitmakers
The Rolling Stones

Charlie just beat cancer,
Ronnie's out of rehab. And the
Twins are always fighting.
Just like your family.

VMAs: Most Boring
Awards Show Ever

rollingstone.com

Meet the
Ten Hottest
New Bands

Death
Cab for
Cutie

Paul
McCartney's
Best Album
in Years

Ryan
Adams

Neil
Young

Family Guy

$3.95US $4.95CAN £3.20UK
38>

0 74820 08962 0

2000s

RS 983 | THE ROLLING STONES | September 22th, 2005 | PHOTOGRAPH BY ANTON CORBIJN

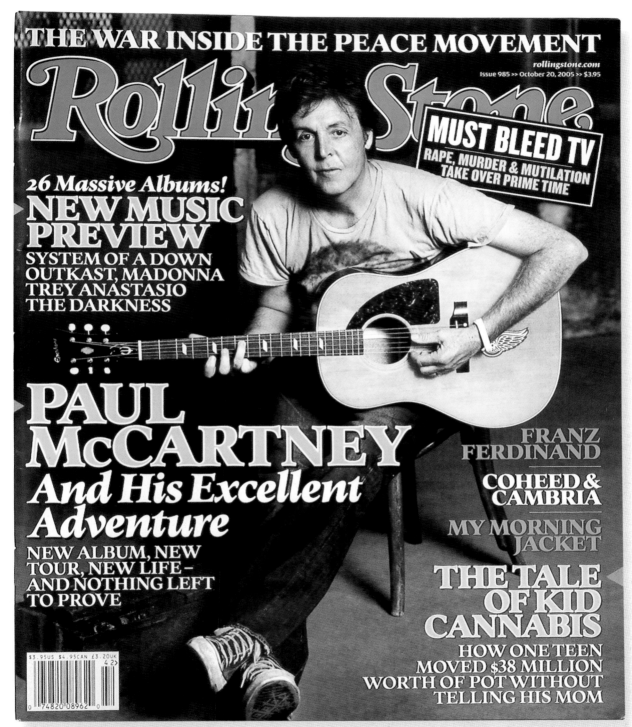

THE WAR INSIDE THE PEACE MOVEMENT

Rolling Stone

rollingstone.com
Issue 985 >> October 20, 2005 >> $3.95

MUST BLEED TV
RAPE, MURDER & MUTILATION
TAKE OVER PRIME TIME

26 Massive Albums!
NEW MUSIC PREVIEW
SYSTEM OF A DOWN
OUTKAST, MADONNA
TREY ANASTASIO
THE DARKNESS

PAUL McCARTNEY
And His Excellent Adventure
NEW ALBUM, NEW
TOUR, NEW LIFE –
AND NOTHING LEFT
TO PROVE

FRANZ FERDINAND

COHEED & CAMBRIA

MY MORNING JACKET

THE TALE OF KID CANNABIS
HOW ONE TEEN
MOVED $38 MILLION
WORTH OF POT WITHOUT
TELLING HIS MOM

$3.95US $4.95CAN £3.20UK
42>
0 74820 08962 0

RS 985 | PAUL McCARTNEY | October 20th, 2005 | Photograph by Max Vadukul

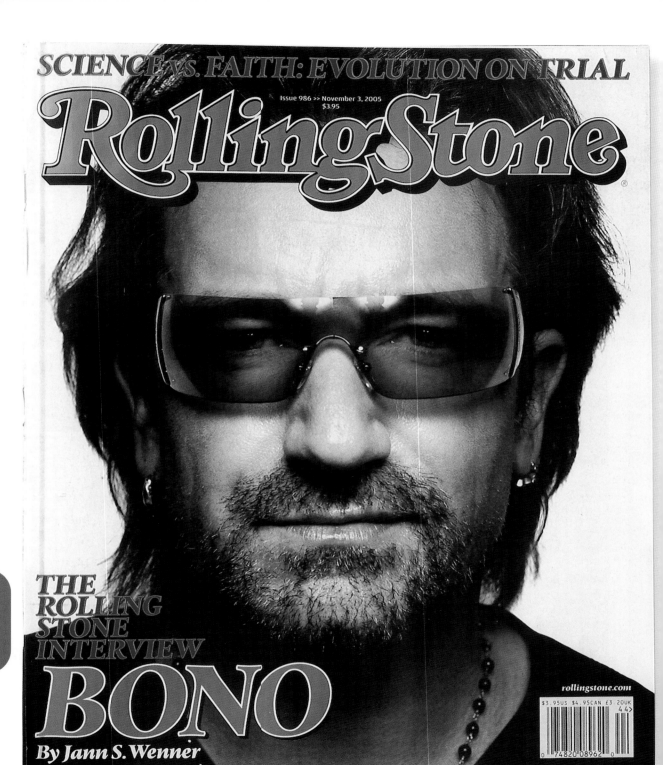

SCIENCE vs. FAITH: EVOLUTION ON TRIAL

Issue 986 >> November 3, 2005
$3.95

Rolling Stone

THE
ROLLING
STONE
INTERVIEW
BONO
By Jann S. Wenner

rollingstone.com

$3.95US $4.95CAN £3.20UK
4 4>
0 74820 08962 0

WHAT ROLE DID RELIGION PLAY IN YOUR CHILDHOOD?

I knew that we were different on our street because my mother was Protestant. And that she'd married a Catholic. At a time of strong sectarian feeling in the country, I knew that was special. We didn't go to the neighborhood schools – we got on a bus. I picked up the courage they had to have had to follow through on their love.

Did you feel religious when you went to church?

Even then I prayed more outside of the church than inside. It gets back to the songs I was listening to; to me, they were prayers. "How many roads must a man walk down?" That wasn't a rhetorical question to me. It was addressed to God. It's a question I wanted to know the answer to, and I'm wondering, who do I ask that to? I'm not gonna ask a schoolteacher. When John Lennon sings, "Oh, my love/For the first time in my life/My eyes are wide open" – these songs have an intimacy for me that's not just between people, I realize now, not just sexual intimacy. A spiritual intimacy.

You never saw rock & roll – the so-called devil's music – as incompatible with religion?

Look at the people who have formed my imagination. Bob Dylan. Nineteen seventy-six – he's going through similar stuff. You buy Patti Smith: *Horses* – "Jesus died for somebody's sins/But not mine. . . ." And she turns Van Morrison's "Gloria" into liturgy. She's wrestling with these demons – Catholicism in her case. Right the way through to *Wave,* where she's talking to the pope.

The music that really turns me on is either running toward God or away from God. Both recognize the pivot, that God is at the center of the jaunt. So the blues, on one hand – running away; gospel, the Mighty Clouds of Joy – running towards.

And later you came to analyze it and figure it out.

The blues are like the Psalms of David. Here was this character, living in a cave, whose outbursts were as much criticism as praise. There's David singing, "Oh, God – where are you when I need you?/You call yourself God?" And you go, *this* is the blues.

Both deal with the relationship with God. That's really it. I've since realized that anger with God is very valid.

[EXCERPT FROM BONO INTERVIEW BY JANN S. WENNER]

RS 986 | BONO
November 3rd, 2005
PHOTOGRAPH BY PLATON

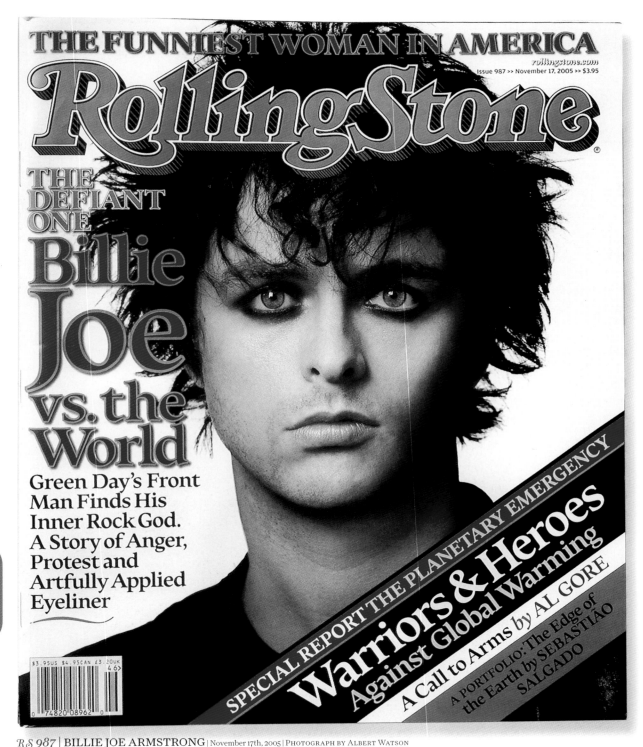

THE FUNNIEST WOMAN IN AMERICA

rollingstone.com
Issue 987 >> November 17, 2005 >> $3.95

RollingStone

THE DEFIANT ONE
Billie Joe vs. the World

Green Day's Front Man Finds His Inner Rock God. A Story of Anger, Protest and Artfully Applied Eyeliner

2000s

$3.95US $4.95CAN £3.20UK
46>

0 74820 08962 0

SPECIAL REPORT THE PLANETARY EMERGENCY

Warriors & Heroes
Against Global Warming

A Call to Arms by AL GORE

A PORTFOLIO: The Edge of the Earth by SEBASTIÃO SALGADO

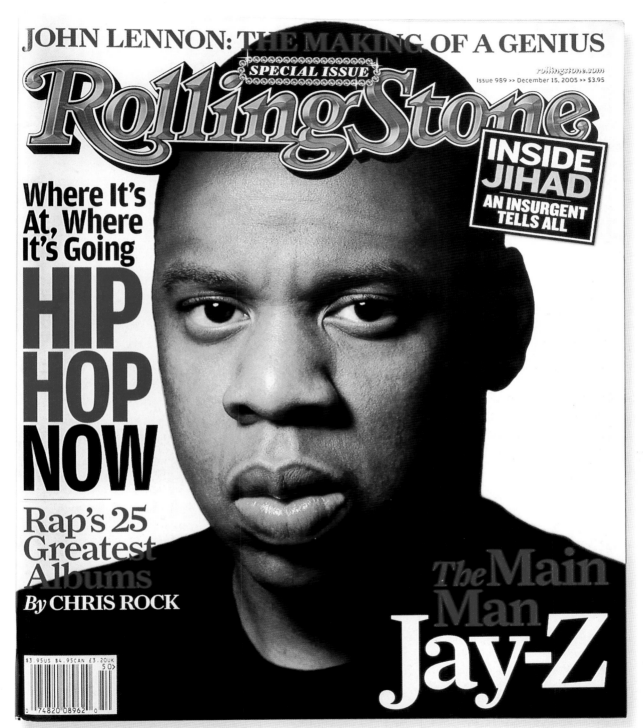

JOHN LENNON: THE MAKING OF A GENIUS

SPECIAL ISSUE

rollingstone.com
Issue 989 >> December 15, 2005 >> $3.95

RollingStone

INSIDE JIHAD
AN INSURGENT TELLS ALL

Where It's At, Where It's Going

HIP HOP NOW

Rap's 25 Greatest Albums

By CHRIS ROCK

$3.95US $4.95CAN £3.20UK
50>

0 74820 08962 0

The Main Man
Jay-Z

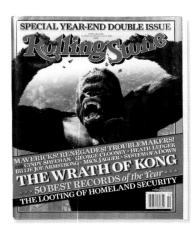

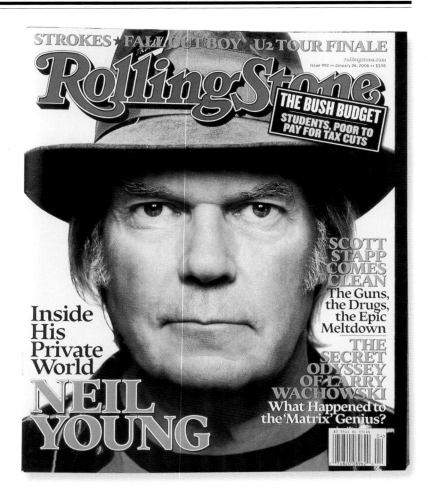

\mathcal{RS} 988 | MADONNA
December 1st, 2005
PHOTOGRAPH BY STEVEN KLEIN

\mathcal{RS} 990/991 | KING KONG
December 29th, 2005 – January 12th, 2006
PHOTOGRAPH BY WETA DIGITAL LTD

[RS 988] Madonna is the woman
to appear most often beneath the
ROLLING STONE logo: seventeen
times, ranking her in a tie for fourth
place along with Bono, Bob Dylan
and Bruce Springsteen. This cover
is her ninth solo showing; she has
appeared eight times with others.

\mathcal{RS} 992 | NEIL YOUNG
January 26th, 2006
PHOTOGRAPH BY PLATON

"*In America, they want you*
to accomplish these great feats, to pull off
these David Copperfield–type stunts. But let
someone ask you about what you're doing,
and if you turn around and say, 'It's great,'
then people are like, 'What's wrong with
you?' You want me to be great, but you don't
ever want me to say I'm great?"
—Kanye West

2000s

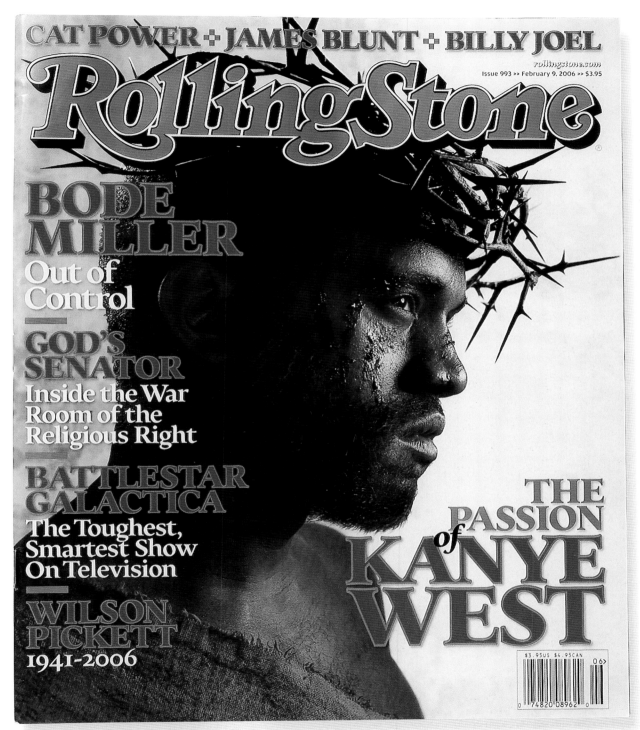

CAT POWER + JAMES BLUNT + BILLY JOEL

RollingStone

rollingstone.com
Issue 993 >> February 9, 2006 >> $3.95

BODE MILLER
Out of Control

GOD'S SENATOR
Inside the War Room of the Religious Right

BATTLESTAR GALACTICA
The Toughest, Smartest Show On Television

WILSON PICKETT
1941-2006

THE PASSION
of
KANYE WEST

$3.95US $4.95CAN

0 74820 08962 0

06>

RS 993 | KANYE WEST | February 9th, 2006 | PHOTOGRAPH BY DAVID LACHAPELLE

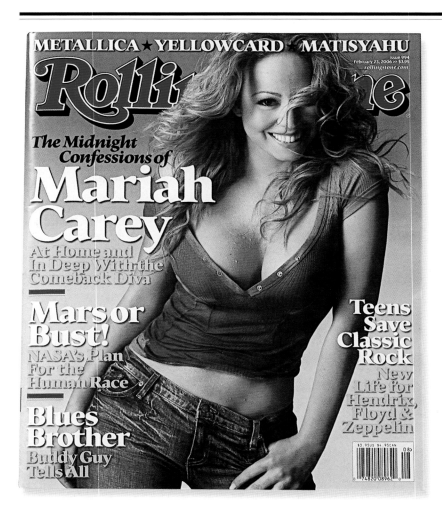

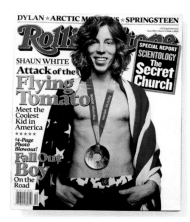

RS 995 | SHAUN WHITE
March 9th, 2006
PHOTOGRAPH BY PLATON

[RS 995] Shaun White is the third
Olympic athlete to appear on the
cover, along with swimmer Mark
Spitz (RS 133) and Muhammad Ali
(RS 78, RS 197 and RS 264). White
had just won a gold medal for
snowboarding when this issue
came out. He was all of nineteen
years old at the time.

RS 994 | MARIAH CAREY | February 23rd, 2006 | PHOTOGRAPH BY BRIGITTE LACOMBE

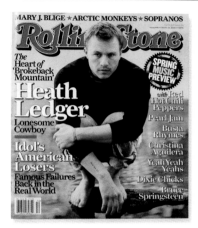

RS 996 | HEATH LEDGER
March 23rd, 2006
PHOTOGRAPH BY SAM JONES

[RS 996] **When Heath Ledger appeared on this cover, the actor had just emerged as a talent to be reckoned with, thanks to his star-making role as the gay cowboy Ennis Del Mar in Ang Lee's** *Brokeback Mountain.* **His performance earned the twenty-six-year-old his first Oscar nomination, for Best Actor.**

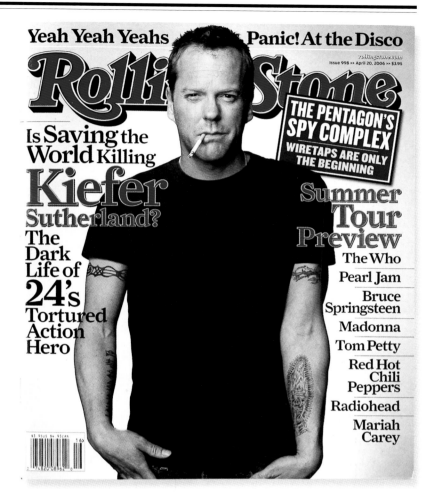

RS 998 | KIEFER SUTHERLAND | April 20th, 2006 | PHOTOGRAPH BY SAM JONES

GEORGE W. BUSH'S PRESIDENCY appears headed for colossal historical disgrace. Barring a cataclysmic event on the order of the terrorist attacks of September 11th, after which the public might rally around the White House once again, there seems to be little the administration can do to avoid being ranked on the lowest tier of U.S. presidents. And that may be the best-case scenario. Many historians are now wondering whether Bush, in fact, will be remembered as the very worst president in all of American history. . . .

The president came to office calling himself "a uniter, not a divider" and promising to soften the acrimonious tone in Washington. He has had two enormous opportunities to fulfill those pledges: first, in the noisy aftermath of his controversial election in 2000, and, even more, after the attacks of September 11th, when the nation pulled behind him as it has supported no other president in living memory. Yet under both sets of historically unprecedented circumstances, Bush has chosen to act in ways that have left the country less united and more divided, less conciliatory and more acrimonious.

There are too many imponderables still to come in the two and a half years left in Bush's presidency to know exactly how it will look in 2009, let alone in 2059. There have been presidents who have left office in seeming disgrace, only to rebound in the estimates of later scholars. But so far the facts are not shaping up propitiously for George W. Bush. He still does his best to deny it. Having waved away the lessons of history in the making of his decisions, the present-minded Bush doesn't seem to be concerned about his place in history. "History. We won't know," the told the journalist Bob Woodward in 2003. "We'll all be dead."

[EXCERPT FROM RS 999 COVER STORY BY SEAN WILENTZ]

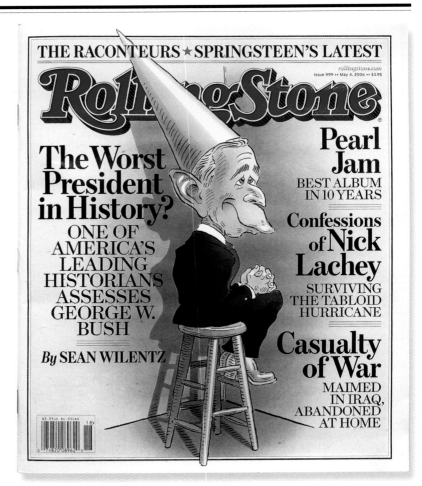

RS 999 | PRESIDENT GEORGE W. BUSH
May 4th, 2006 | ILLUSTRATION BY ROBERT GROSSMAN

[RS 997] In the original concept for this cover, *American Idol* judges Simon Cowell, Paula Abdul and Randy Jackson had an additional bedmate: the show's host, Ryan Seacrest. But after it was laid out, the slumber party looked too crowded, and it was decreed that someone had to go. Votes were cast, and Ryan was cut. A savvy editor, noticing the book in Randy's hands, then made this suggestion: If Ryan couldn't be on the magazine's cover, why not put him on the cover of Randy's book? A faux autobiography was mocked up, Photoshop was enlisted, and the show's crew of four was back together again. (For the record, the book actually held by Jackson was a pulp romance novel.)

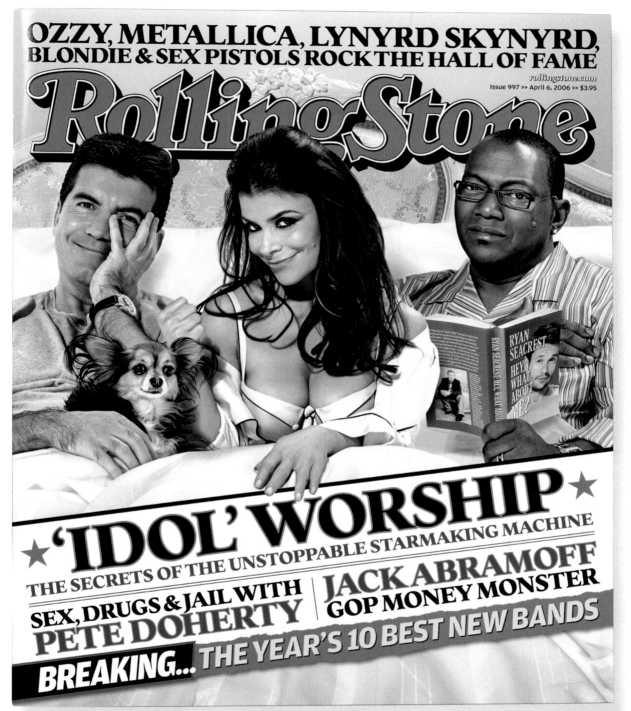

OZZY, METALLICA, LYNYRD SKYNYRD, BLONDIE & SEX PISTOLS ROCK THE HALL OF FAME

RollingStone

rollingstone.com
Issue 997 >> April 6, 2006 >> $3.95

RYAN SEACREST HEY, WHAT ABOUT ME?

★ 'IDOL' WORSHIP ★
THE SECRETS OF THE UNSTOPPABLE STARMAKING MACHINE

SEX, DRUGS & JAIL WITH PETE DOHERTY | JACK ABRAMOFF GOP MONEY MONSTER

BREAKING... THE YEAR'S 10 BEST NEW BANDS

RS 997 | SIMON COWELL, PAULA ABDUL & RANDY JACKSON OF 'AMERICAN IDOL'

April 6th, 2006 | PHOTOGRAPH BY MICHAEL ELINS

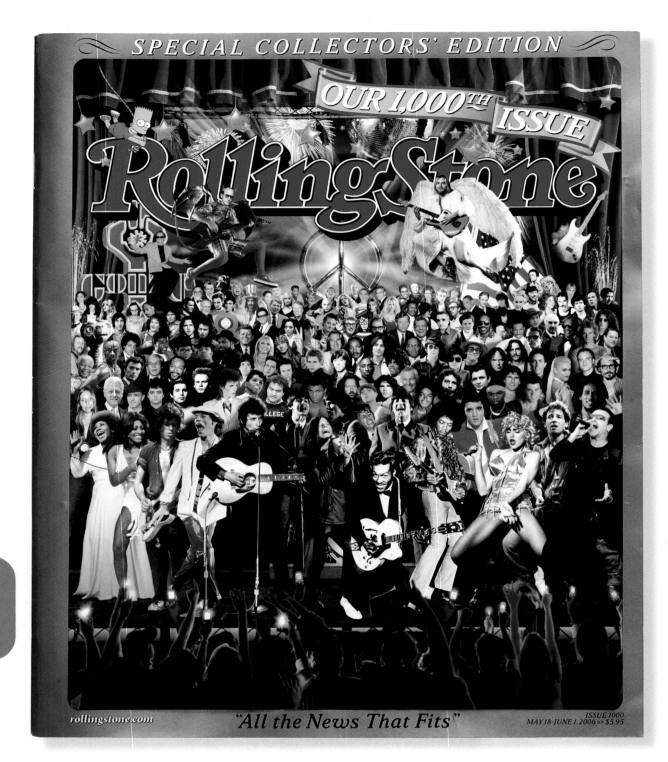

SPECIAL COLLECTORS' EDITION

OUR 1,000TH ISSUE

Rolling Stone

rollingstone.com

"All the News That Fits"

ISSUE 1000
MAY 18-JUNE 1, 2006 >> $5.95

2000s

This collectors' edition, in honor of ROLLING STONE's thousandth issue, celebrated the best covers the magazine ever produced. Capping off the issue was this splashy 3-D collage. Photo-illustrator Michael Elins began work on this landmark cover in the fall of 2005, an entire season before it was published. The editor's letter explained the process thus: "Elins meticulously built up the crowd, layer by layer, on his computer; in total, hundreds of layers create the 3-D effect. After the initial image was completed, Elins sent the enormous computer file to National Graphics, in Wisconsin, a printing company that patented lenticular technology, in which a thin, flexible plastic lens is adhered to the existing image. The project was so complex – Would the lens stick to the cover? Would the staples support the extra weight? – that the cover had to be finished in January" – three months before the the actual issue was completed.

The famous faces that appear on the cover were chosen by the magazine's editors. So that you can actually see who everyone is, the cover has been reproduced here in two dimensions rather than three.

"I WANTED IT TO BE LIKE A DREAM where you walk into the ultimate ROLLING STONE party."
—*Michael Elins*

To mark one thousand issues, we wanted to create a cover both extraordinary and celebratory. In searching for ideas, we discovered that technology for 3-D printing had come a long way and had never been used for a magazine cover as ambitious and mass-market as this one. It took two months to manufacture, and more than two million were made. *Sgt. Pepper's Lonely Hearts Club Band,* which came out in 1967, the same year as ROLLING STONE, was an album that changed our world forever. The 3-D idea, and a homage to the Beatles, seemed just right. . . .

For me, it's been a gas reading the stories behind the covers in this issue, shooting the breeze about all the fun we've had along the way. In many of the pieces, my name comes up, and I've gotten some pretty nice props here, but as many big decisions as I've made over the years as the editor of ROLLING STONE, the magazine stands, in all its glory, as a collaborative effort.

—*Jann S. Wenner*
[APRIL 23RD, 2006]

INDEX

[RS 3] The Beatles and friends on location for *Magical Mystery Tour*: (from left, top row) Jeni Crowley, John Lennon, Spencer Davis, Jesse Robins, Paul McCartney, Maggie Right, Mel Evans, Alex Mardes, Bill Wall, Neil Aspinal, Shirley Evans, Ringo Starr; (from left, second row) Sylvia Nightingale, Pauline Davis & baby, Derek Royal, Mandy West, Linda Lawson, Amy Smedley, unknown couple; (from left, third row) Freda Kelley, Barbara Icing, Loz Harvey, George Claydon, Alf Mandos; (from left, front row) Michael Gladden, George Harrison, Nat Jackly, Leslie Cavendish, Ivor Cutler–*Photographer Unknown* [RS 4] Donovan–*Baron Wolman*; Jimi Hendrix, Otis Redding–*Photographer Unknown* [RS 8] Monterey Pop Festival Organizers John Phillips and Lou Adler–*Photographer Unknown* [RS 9] John Lennon and Paul McCartney in *Yellow Submarine*–*Photographer Unknown* [RS 11] Rock Fashion – Julianna Wolman–*Baron Wolman* [RS 20] Ringo Starr, Paul McCartney, John Lennon and George Harrsion–*Photographs from 16 magazine, Courtesy Gloria Stavers* [RS 28] Japanese Rock – Unidentified & Kenji "Julie" Sawada of Julie & the Tigers–*Naoko Lash* [RS 50] Altamont–*Michael Maggia/Photographies West* [RS 55] Abbie Hoffman–*Bill Myers/Praxis* [RS 107] Texas C&W Festival, Marvin Gaye, Hubert Humphrey–*Annie Leibovitz* [RS 115] George McGovern at the 1972 Democratic Convention–*Ralph Steadman* [RS 204] Joan Baez & Bob Dylan–*Ken Regan/Camera 5* [RS 207] Grace Slick, Jerry Garcia, Steve Miller, John Cipollina and Dan Hicks–*Jim Marshall* [RS 211] Peter Frampton–*Francesco Scavullo*; Peter Frampton–*Bud Lee*; Inset: SLA Hideout–*Alison Weir* [RS 230] Rod Stewart–*David Montgomery/Radio Times* [RS 234] Princess Caroline–*Norman Parkinson/Sygma* [RS 241] Robert De Niro–*Leonard De Raemy/Sygma* [RS 246] Mark Hamill, Carrie Fisher, Chewbacca and Harrison Ford–*Terry O'Neill* [RS 250] Johnny Rotten (left)–*Bob Gruen*; Johnny Rotten (right)–*Dennis Morris* [RS 262] Brooke Shields–*Maureen Lambray © 1977* [RS 304] Bonnie Raitt, Bruce Springsteen, Carly Simon, James Taylor, Jackson Browne, Graham Nash and John Hall–*Annie Leibovitz* [RS 309] Teva Ladd, Bryan Wagner, Connie Burns, James Warmoth, Karen Morrison, Peter Bowes, Jacqueline Eckerle, Phillip Snyder, David Heck, Stephan Preston, Walter Adams Jr.–*Photographers Unknown* [RS 322] Billy Dee Williams, Mark Hamill, Carrie Fisher and Harrison Ford–*Annie Leibovitz* [RS 342] Ringo Starr–*Michael Childers/Sygma* [RS 359/360] The Rolling Stones at Madison Square Garden–*Lynn Goldsmith* [RS 366] Warren Beatty–*Jack Mitchell/Outline* [RS 371] David Letterman–*Herb Ritts/Visages* [RS 400/401] Darth Vader, Ewok, Carrie Fisher and Gamurian Guard–*Aaron Rapoport* [RS 403] Sting–*Lynn Goldsmith/LGI* [RS 413] Eric Clapton, Jeff Beck, Jimmy Page, Joe Cocker, Charlie Watts, Bill Wyman, Kenney Jones, Paul Rodgers and Ronnie Lane–*Bonnie Schiffman* [RS 415] The Beatles–*John Launois/Black Star* [RS 421] Marvin Gaye–*Neal Preston/Camera 5* [RS 424] Bob Dylan–*Ken Regan/Camera 5* [RS 426] Tom Wolfe–*Annie Leibovitz/Contact Press Images*; Steven Spielberg–*Hiro*; Little Richard–*Ralph Morse/Life Magazine © Time Inc.* [RS 428] Bill Murray–*Barbara Walz/Outline* [RS 445] David Lee Roth–*Bradford Branson/Visages* [RS 454] Mick Jagger–*Albert Watson*; Bob Dylan, Madonna–*Ken Regan/Camera 5*; Paul McCartney–*Linda McCartney*; David Bowie–*Greg Gorman*; Chrissie Hynde, Phil Collins–*Aaron Rapoport*; Bono–*Photographer Unknown*; Bob Geldof–*Simon Fowler*; Ric Ocasek–*William Coupon*; Sting, John Taylor–*Eric Boman*; Robert Plant–*Ilpo Musto*; Eric Clapton–*David Montgomery*; Sade–*Brian Aris/Outline*; Pete Townshend–*Davies & Starr*; Bryan Ferry–*Lothar Schmid*; Tina Turner, Mark Knopfler, Bryan Adams; –*Deborah Feingold/Outline* [RS 456] Prince–*Raspberry Beret video still © 1985 PRN Productions* [RS 458] Bruce Springsteen–*Neal Preston/Camera 5* [RS 467] Elvis Presley–*Springer/Bettmann Film Archive*; Ray Charles, Buddy Holly–*James J. Kriegsmann*; Fats Domino, Jerry Lee Lewis, Chuck Berry, James Brown, Little Richard,

the Everly Brothers, Sam Cooke–*Michael Ochs Archives* [RS 469]
Jim McMahon–*Ken Regan/Camera 5* [RS 497] Woody Allen–*Brian
Hamill/Photoreporters* [RS 544] Roy Orbison–*Ann Summa/Onyx*
[RS 553] Harold Ramis, Bill Murray, Sigourney Weaver, Ernie Hudson
and Dan Aykroyd–*Timothy White* [RS 588] Lara Flynn Boyle, Sherilyn
Fenn and Mädchen Amick–*Matthew Rolston* [RS 602] Chris
Isaak–*Randee St. Nicholas/Visages*; Charlatans U.K., De la Soul,
Nuno Bettencourt–*Mark Seliger* [RS 614] Pee-wee Herman–*Janette
Beckman/Outline* [RS 624] Luke Perry, Shannen Doherty and Jason
Priestly–*Andrew Eccles* [RS 660/661] Jason Alexander, Jerry Seinfeld,
Julia Louis-Dreyfus and Michael Richards–*Mark Seliger* [RS 676] Bob
Marley–*Annie Leibovitz/Contact Press Images* [RS 682] Laura Leighton,
Josie Bissett, Heather Locklear, Daphne Zuniga and Courtney Thorne-
Smith–*Mark Seliger* [RS 708] Jennifer Aniston, Matthew Perry, Lisa
Kudrow, Courteney Cox, David Schwimmer and Matt LeBlanc–
Mark Seliger [RS 724/725] Green Day, Jerry Garcia, Sheryl Crow, Billy
Corgan, Courtney Love–*Mark Seliger*; John Travolta–*Richard Foreman*;
Alanis Morissette– *Frank W. Ockenfels 3*; Coolio–*Albert Watson*
[RS 734] David Duchovny and Gillian Anderson–*Montalbetti/Campbell
for RS Australia* [RS 736] Perry Farrell, Billy Corgan–*Kevin Mazur*;
"Independence Day"–*film still*; Alanis Morissette, Beck–*Frank W.
Ockenfels 3*; Jimmy Buffett–*Randy Davey/LGI*; James Taylor–*Andrew
Brucker*; Sandra Bullock–*Kate Garner/Visages*; Chris Cornell–*Mark
Seliger*; John Popper–*Tom Wolff*; Kiss–*Costello/Retna* [RS 748] Eddie
Vedder–*Ross Halfin/Photofeatures* [RS 761] U2–*Albert Watson*;
Inset: Allen Ginsberg–*Fred W. McDarrah* [RS 767] Keith Flint–
Peter Robathan/Katz/Outline [RS 774] Cheri Oteri, Will Ferrell, Molly
Shannon and Chris Kattan–*Mark Seliger* [RS 787] Jason Alexander,
Michael Richards, Julia Louis-Dreyfus and Jerry Seinfeld–*Mark Seliger*
[RS 799] Bill Clinton–*Mark Seliger/Outline* [RS 812] Kurt Cobain–
Mark Seliger/Outline [RS 815] Jar Jar Binks–*Image created exclusively for
ROLLING STONE by Industrial Light & Magic, San Rafael, California, May
1999. Visual-effects supervision by Dennis Muren. SWI Image coordinator:
Christine Owens. SWI image production assistant: Fay David. Animation
director: Rob Coleman. Technical director: Damian Steel. CG animator:
Kevin Martel. Photoshop artist: Claudine Gossett. © 1999 Lucasfilm Ltd. &
TM. Digital work by ILM. All rights reserved. Used under authorization*
[RS 820] Alanis Morissette, Wyclef Jean, DMX, Sheryl Crow,
Jewel–*Tara Canova*; Jonathan Davis, Anthony Kiedis and Flea, Fred
Durst, James Hetfield, Zack de la Rocha–*Kevin Mazur*; Kid Rock–*Len
Irish*; Bruce Springsteen–*Mark Seliger*; Dave Matthews–*Rahav Segev*;
Trey Anastasio–*Jay Blakesberg*; Tom Rowlands–*Rob Beccaris*
[RS 828/829] Mick Jagger–*Jim Marshall*; John Lennon–*Annie Leibovitz*;
David Bowie–*Mick Rock*; Britney Spears–*David LaChapelle*; Joni
Mitchell–*Norman Seeff*; Lou Reed–*Andy Warhol*; Madonna–*Herb Ritts*;
Bob Dylan–*M. Renard*; Jack Nicholson–*Albert Watson*; Kurt Cobain,
Courtney Love and Frances Bean Cobain–*Kevin Mazur*; Aretha
Franklin–*Linda McCartney*; Bruce Springsteen–*Lynn Goldsmith*;
Bono–*Anton Corbijn*; Drew Barrymore–*Mark Seliger*; LL Cool J–
James Schnepf; Keith Richards–*Peter Beard* [RS 830/831] The Party
2000–*David LaChapelle*; Historical photos *AP/Wide World Photo, Corbis,
LGI/Corbis, Retuers/Corbis, UPI/Corbis, Michael Ochs Archives, Photofest*
[RS 833] Jan Crosby, Bailey, Melissa Etheridge, Beckett, Julie Cypher
and David Crosby–*Mark Seliger* [RS 847] Eminem, Dr. Dre–*Kevin
Mazur*; Britney Spears–*J.K./All Action/Retna*; James Hetfield–*Kevin
Winter/Image Direct*; Eddie Vedder, Kid Rock, Macy Gray–*Kelly A. Swift*;
Bruce Springsteen–*Ethan Miller/Corbis*; Dave Matthews–*Rahav Segev*;
Anthony Kiedis–*Yael/Retna*; Ozzy Osbourne–*Mark Seliger*; Mick
Thompson–*Frank Forcino/London Features* [RS 855] John Lennon
and Paul McCartney, Britney Spears, Eminem, Mick Jagger and Keith
Richards, Madonna, Prince–*Ward Sutton* [RS 863] Paul McCartney,
Ringo Starr, John Lennon and George Harrison–*Robert Freeman/©
Apple Corps Ltd., circa 1965* [RS 865] Edie Falco, James Gandolfini,

Michael Imperioli, Lorraine Braco, Steven Van Zandt, Dominic
Chianese, David Chase, Tony Sirico, Joe Pantoliano, Drea
de Matteo, Aida Turturro, Robert Iler and Jamie-Lynn Sigler–
Mark Seliger [RS 868] Pamela Anderson and Tommy Lee–*Steve
Wayda/Corbis/Outline* [RS 871] Madonna, Destiny's Child–*Kevin Mazur*;
Bono–*Dave Hogan/ImageDirect*; Slipknot–*Martyn Goodacre/Retna UK*;
Nelly Furtado–*David Atlas/Retna*; Moby–*Kevin Winter/ImageDirect*;
'NSync–*Framl Micelotta/ImageDirect*; Eric Clapton–*Steven
Tackeff/ImageDirect*; Dave Matthews–*David Atlas/Retna*; Steven
Tyler–*Scott Gries/ImageDirect* [RS 894] Cameron Diaz, Christina
Applegate and Selma Blair–*Stewart Shining* [RS 895] Sharon, Ozzy,
Jack and Kelly Osbourne–*Sophie Olmsted/Courtesy of* Revolver *magazine*
[RS 897] Kurt Cobain–*Charles Hoselton/Retna* [RS 908] Shakira,
Britney Spears, Mary J. Blige, Alanis Morissette, Avril Lavigne and
Ashanti–*Albert Watson* [RS 910] Bart Simpson; Homer Simpson; Lisa,
Bart, Marge and Homer Simpson–*Julius Preite. The Simpsons ™ and
© 2002 Twentieth Century Fox Film Corp. All rights reserved*
[RS 916] John Lennon, Paul McCartney, George Harrison, Ringo
Starr–*Ethan Russell/Camera Press/RetnaEthan Russell © Apple Corps Ltd.
AP* [RS 924] Fred Durst, Ozzy Osbourne, James Hetfield, Marilyn
Manson, Brody Armstrong, Josh Homme, Dave Navarro, Dave Grohl,
Chester Bennington, Davey Havok, Lars Ulrich and Perry
Farrell–*Andrew MacPherson* [RS 931] The 100 Greatest Guitarists of
All Time – Jimi Hendrix–*Jill Gibson ©/MichaelOchsArchives.com*
[RS 933] Johnny Cash–*Mark Seliger/Outline* [RS 942] The Beatles–
John Dominis/Time Life Pictures/Getty Images [RS 946] Elvis
Presley–*Photographer Unknown*; The Beatles–*Robert Freeman/©
Apple Corps Ltd./Everett Collection*; Bob Dylan, Mick Jagger and
Keith Richards–*© Annie Leibovitz/Contact Press Images*; Jimi Hendrix,
Janis Joplin–*© Jim Marshall*; Bono–*© Andrew MacPherson*; Aretha
Franklin–*Everett Collection*; Kurt Cobain–*Mark Seliger/Corbis
Outline*; Little Richard–*Michael Ochs Archives* [RS 951] Mick Jagger,
Jimi Hendrix–*© Jim Marshall ®*; John Lennon memorial–*Lynn
Goldsmith/Corbis*; Bruce Springsteen–*Hans Gutknecht/LADN/
WireImage.com*; Eminem–*Peter Thompson/FilmMagic.com*;
Madonna–*Neal Preston/Corbis*; Bob Dylan–*Rex USA*; crowd shot–*John
Dominis/Time Life Pictures/Getty Images* [RS 952/953] Ray Charles–*©
CBS/Courtesy Everett Collection* [RS 954] Doonesbury's B.D. –*G.B.
Trudeau. Doonesbury © 2004 G.B. Trudeau, distributed by Universal Press
Syndicate* [RS 958] Kurt Cobain, Red Hot Chili Peppers–*Mark Seliger*;
Britney Spears–*David LaChapelle*; Dave Matthews–*Martin Schoeller*;
Jim Morrison—*Joel Brodsky*; Justin Timberlake–*Herb Ritts*; Pete
Townshend—*Annie Leibovitz/Contact Press Images*; U2–*Anton Corbijn*;
Madonna–*Herb Ritts*; Sean Combs–*Michael Thompson*; John Lennon and
Paul McCartney–*David Bailey*; Janet Jackson–*Patrick Demarchelier*;
Marilyn Manson–*Matt Maburin*; Jimi Hendrix–*Gered Mankowitz*; Elvis
Presley–*Jay Leviton*; Tupac Shakur–*Danny Clinch*; Michael
Stipe–*Platon/CPI* [RS 959] Bruce Springsteen, John Mellencamp, Eddie
Vedder, Emily Robison, Jackson Browne, Dave Matthews, Mike Mills,
Steven Van Zandt, Patti Scialfa, Bonnie Raitt, Ben Gibbard, Stone
Gossard, Martie Maguire and Boyd Tinsley–*Norman Jean Roy* [RS 971]
Alexandra Richards, Ben Taylor, Nona Gaye, James Garfunkel, Sean
Lennon, Theodora Richards, Chris Stills, Harper Simon, Rufus
Wainwright, Kelly Osbourne, Alexa Joel, Ethan Browne, Sebastian
Roberston, Otis Redding III and Aisha Morris–*Norman Jean Roy*
[RS 972] James Taylor–*Baron Wolman/Retna*; Tina Turner–*MR
Photo/Corbis*; Eric Clapton–*Terry O'Neill/Warner Bros. Records/Michael
Ochs Archives*; Jerry Garcia–*Photofest*; Eminem–*Jack Chuck/Corbis
Outline*; Joni Mitchell–*Henry Diltz*; Frank Zappa–*Michael Ochs Archives*;
Tupac Shakur–*© Danny Clinch/Corbis Outline*; Elvis Costello–*Photofest*;
Axl Rose–*© Herb Ritts Foundation/Visages* [RS 980] Jimi Hendrix–
Harry Goodwin/Michael Ochs Archives. Photo-Illustration by Michael Elins
[RS 990/991] King Kong–*Weta Digital LTD/Universal Studios*